For our mothers, daughters, artists, animators, and dreamers!

Copyright © 2017 Disney Enterprises, Inc.

All rights reserved. Published by Disney Editions, an imprint of Disney Book Group. No part of this book may be reproduced or transmitted in any form or by any means, electronic or mechanical, including photocopying, recording, or by any information storage and retrieval system, without written permission from the publisher.

For information address Disney Editions, 1101 Flower Street, Glendale, California 91201.

Book and Jacket Design
Tamara N. Khalaf

Charts (pages 87, 90, 93, 275, 330, 354)
Steven Reeser

ISBN 978-1-4847-2781-2
FAC-029191-19095
Printed in Malaysia
Reinforced binding
First Limited Hardcover Edition, September 2017
10 9 8 7 6 5 4 3

The Official Disney Fan Club
D23.com

Page 4: Checking Department reviews final cels for the Donald Duck short *Officer Duck* (1939).

Page 6: Final frame of noble Diana from *Fantasia* (1940).

Page 9: Walt, Sharon, and Diane Disney departing for school outside their Woking Way home.

INK & PAINT

The Women of Walt Disney's Animation

by

Mindy Johnson

Los Angeles • New York

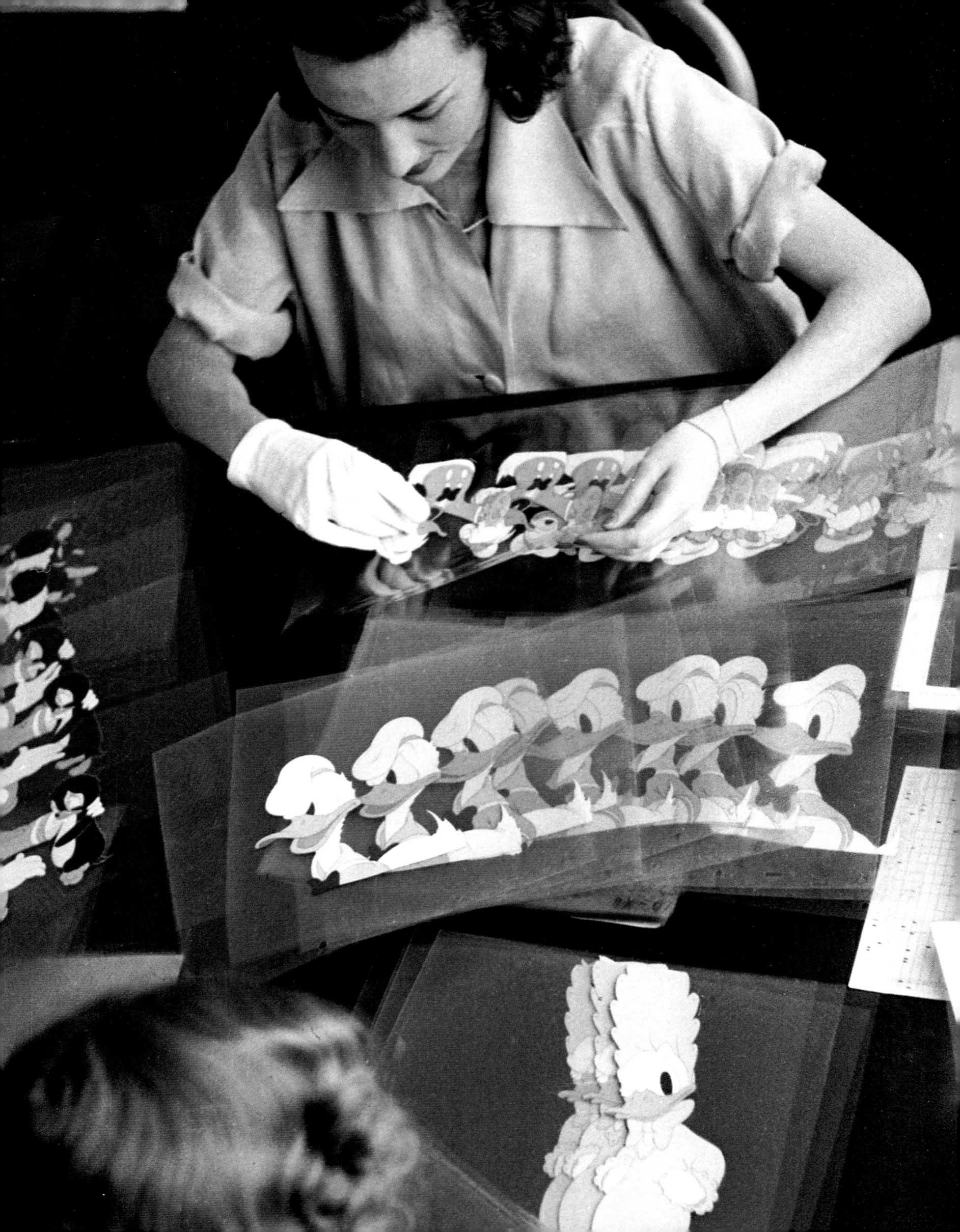

CONTENTS

7 Foreword
8 "What I Know About Girls" by Walt Disney

BEGINNINGS
10 An Invisible History
16 Celluloid Beginnings
28 The Women of Walt's World

1920s
36 Kingswell Beginnings
50 Hyperion Horizons

1930s
64 Hyperion Heydays
84 Assembly Line Approach
96 World of Ink & Paint
126 The Fairest One of All
146 Feature Film Expansion

1940s
172 Burbank Beginnings
190 The War Years
212 Rebuilding

1950s
236 Animating Classics
258 Wide-Screen Horizons
270 Xerographic Beginnings

1960s
286 Triumphs & Loss

1970s
306 Transitions & Training

1980s
324 Low Points & Redemption
334 Computers & Characters
346 Digital Frontiers

PRESERVATION
358 Retaining the Artistry

366 Artists
372 Index
379 Bibliography
384 Acknowledgments

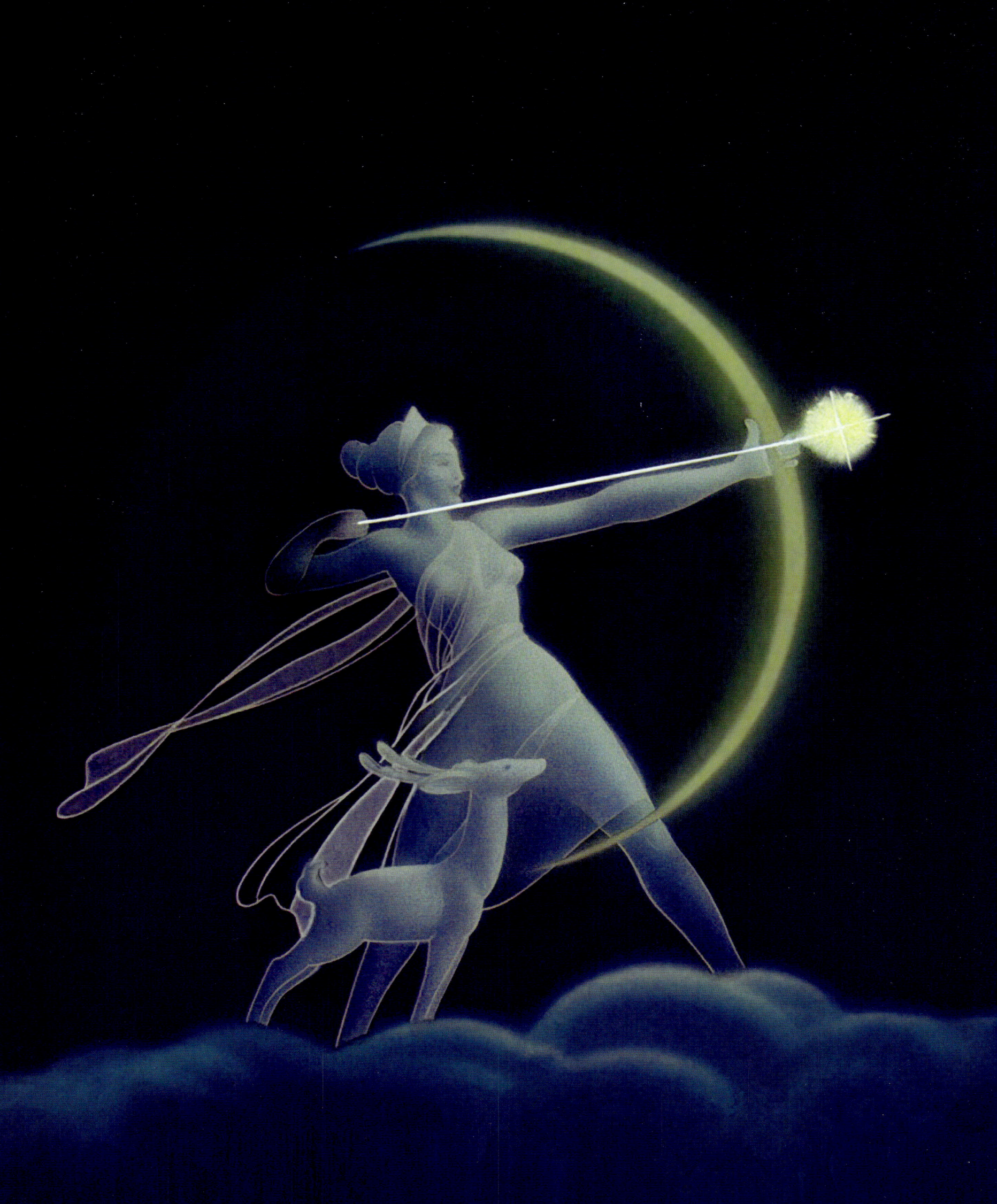

FOREWORD

I've played an awful lot of witches. As a woman, I also played femme fatales, little children, animals, and yes, a few grannies, but there always seemed to be a lot of witches. So many that directors sometimes expected me to show up for a recording session by dismounting a broom and leaving it outside, double-parked.

In 1952, Disney, the studio (sadly, I never met the man), asked me to voice Witch Hazel the first in my long string of animated witches, many of which went by the same name. It was for a popular Donald Duck cartoon entitled Trick or Treat. I did a lot of cackling and shrieking as I menaced poor Donald and his nephews.

Not long after, Chuck Jones handed me a script and I couldn't believe it . . . another Witch named Hazel who was going to do to Bugs pretty much the same things the other Witch Hazel had done to Donald Duck. Years ago, Witch Hazel was a product you could buy as an astringent for cleaning your skin and I always thought it was a clever name for a witch, but Legendary Disney animator Marc Davis later told me they'd named their Hazel after a beloved nurse on the studio lot.

These two Witch Hazels were my first witches, but far from my last. I played Broom-Hilda for Filmation Studios and, of course, there were all those witches in the Fractured Fairy Tales cartoons for Jay Ward and so many others.

I never minded playing witches. What's interesting is that I can't recall ever playing a truly nasty witch, the kind you long to see melted into a puddle or shoved into an oven. My witches were sweet, funny, sly and sometimes a little dotty, but whatever the tone, the one thing that united my various witches was the element of magic.

I learned early on that I belonged at a microphone. That's where I found my magic and it just happened to take on a number of forms including witches. But I've also learned, there's a little magic in all of us, male or female. We may not always know how to tap into it, to turn it to our, and the world's advantage, but it's there. You just have to know where to look for it.

The world of cartoons had long been a boy's club, but not exclusively as this amazing volume reveals. Now, thanks to Mindy Johnson's work, you won't have to look far to find the magic of so many talented women artists within animation. As a woman, I've been honored to be a part of this magical animated world throughout my entire career, and the best I can hope for you, dear readers and friends, is a bright future working your magic in all that you do. After all, as one of my witches declared: "There's a little of the witch in all of us . . ."

– **June Foray**
*With Mark Evanier and Earl Kress

In addition to her legendary animation and radio voice-over career, June Foray worked to establish the annual Annie Awards recognizing the best of animation artistry, and was a seminal force behind establishing the Academy Award for Best Animated Feature Film.

"What I Know About Girls" by Walt Disney

Parents magazine from January 1949

> *"Dad did drive us to school every morning, along with two other classmates of mine in junior high school. It was a long drive. He dropped us off, then continued on with Sharon to Westlake School, just beyond Beverly Hills. Then he'd go on over the hill to Burbank. They eventually bought a lot just around the corner from Westlake and built the home that mother continued to live in after his death. I've often said that Dad got a lot of the material he contributed to* Parent Trap *from driving us to school. When we were very young he had a captive, and very happy, audience in us, but when two other preteenagers joined us for those few years, Dad and Sharon, in the front seat, were the captive audience. And he took it all in, and enjoyed it."*
>
> — Diane Disney Miller

What I know about girls, I learned to a great extent behind the wheel of my automobile.

I live only 10 minutes by car from the studio in Burbank, but I spend an hour getting there. The other 50 minutes are consumed playing school bus to a load of excited young females.

I would recommend this school bus method very highly to any dad who wants to know what his children are thinking. Sometimes, I admit, it's something of a shock. I never knew females could be so aggressive!

My oldest daughter, Diane, who is 15, goes to Marlborough, a girls' school in Hollywood. Sharon, who is 12, attends the Westlake School for Girls, a little farther out. Altogether it takes me about an hour to pick up their chums and deliver my garrulous cargo to their respective destinations. It's been worth every moment.

I learn, for instance (to the accompaniment of Fred Waring and others on our radio) that Joe is a "jerk" and a girl shouldn't be seen dead with him. . . . I know who's going to date whom for every school dance, who dances just too divinely for words, and who should stay off his feet (and everyone else's).

Every morning of my life, I live an hour in a feminine world which looks on everything from baseball to the prom in terms of the boyfriend, and others like him who haven't quite been metamorphosed into boyfriends, plus some who, from hearsay at least, never will.

If I haven't said it before, I must say it now. "School bus college" can do much toward the education of a parent. It's an education which as a person I can't afford to miss, because it's an education in the healthiest and most important natural interest I can ever expect a daughter to have—the unfolding of her interest in a life mate. Maybe it's selfish, but I happen to want to be in on that interest.

I want to be very close to my daughters. It's a lot of trouble (but what a lot of fun!) to raise them. I'm just selfish enough to want to be "in" even a little when the girls make that selection. I don't want to dictate their choice in the least. I'd only like, if I can, to prevent them from making a serious mistake. "Dad, what do you think of John?" is a question I definitely want to hear before, not after, Diane's or Sharon's marriage.

Up to this time, from all I have overheard, at least one boy is going to have some order to fill. He'll have to look like Tyrone Power, but be taller, and not look as though he always needed a shave! The other one (so far) will have a lot of leeway. All he has to do is look like Daddy!

What I know about girls I also learned in my home workshop. It's not a bad place for an education, either. As a hobbyist, you might say I'm a putterer. Nothing so complicated if it can't be built with a screwdriver, glue, sandpaper and a whittling knife. I used to build things like trains and got nothing but yawns and polite "how nices" from the family, while I hunted up nephews to give the trains to.

One day the wife of a studio associate, a fine Painter in her own right, happened to mention that she needed models of rickshaws for some Oriental oils she was doing. I volunteered to make her one. What that rickshaw did for me and my family still astounds me. I became overnight "The Man of the House." The woman got as excited as Dodger fans at a World Series game in Yankee Stadium. It took me a little while, but I finally found out that trains leave women cold, while "cute" things, rickshaws, and buggies "send" them.

The fact that women like cute things is a lesson I also learned in another phase of my education about the gentle sex—the studio. Women, for example, like Donald Duck for reasons quite opposed to the interior logic of us poor males. We like the Duck because he never lacks a snappy comeback and has more spunk than a Southern Association umpire. To the women, Donald is cute. That's supposed to explain everything and generally does—to women.

Men prefer characters like Goofy who give them belly laughs. Women prefer situation comedy to slapstick and don't laugh as quickly at a funny fall. They like the kind way Donald Duck treats his nephews and don't like it as well as men when that kindness puts him on the spot.

What I know about girls I also learned from my wife. A man can't be married to a woman like Mrs. Disney for a generation without learning something about the nice and—let's face it—annoying things about her sex. (I imagine she has a catalog about me too, which should make me very glad *Parents* magazine didn't ask her to write what she knows about men.)

I don't think it's ever safe, however, for a husband to discuss his wife right out in public. So I'll pass on quickly.

Keeping company with my daughters away from home I learned, of course, that teenagers have a lot of healthy interests besides the male sex—interests which sometimes they do and sometimes they don't share together.

Diane likes baseball. She's interested in horses, too, and at one time planned to study animal husbandry. She's also interested in football—an interest we share.

Both Diane and Sharon love dancing. They like swimming. And, if I might boast a little, they're good at it. Diane has a lot of form. Sharon swims naturally, takes to water like a fish. I can't help thinking how much luckier kids are today in this respect than we were. When I was a boy in Kansas City, we had one swimming pool in the whole town. We kids used to do our swimming in a muddy river which was full of water moccasins.

What I know about women I learned in no small degree from a close family life together. As I look back on my life with Mrs. Disney before the

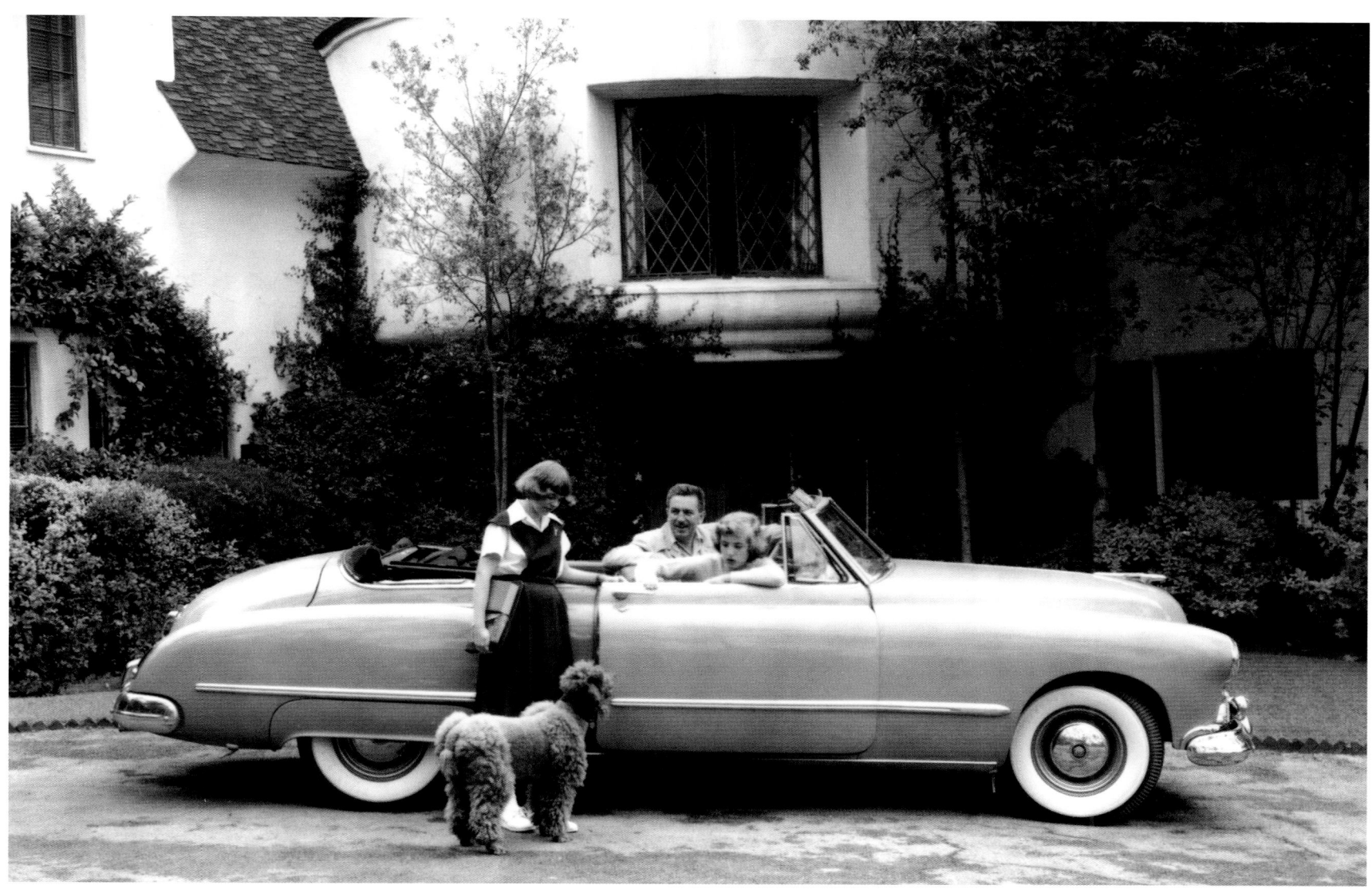

girls came, and since, the thing that stands out is the fact that it's been a lot of fun. I think it's because we've tried to get along with a minimum of rules. Too, we've tried to make our home a satisfying place to be without depending too much on outside contacts.

For example, I have tried to avoid bringing my work home with me. I don't think there's any object in my house that has any connection with the studio, except for a screen and projector on which, however, I seldom show a picture of our own. Then, we have tried to do as many things together as we possibly could—healthy, wholesome, constructive things, both as spectators and as participants.

One of the most serious problems I find confronts parents is how to make children obey. For some reason this has never been much of a problem around our home. Maybe it's because we started very early to have the girls do things through a sense of fair play, rather than responsibility to parents or fear of them.

When we'd go out for a ride on the merry-go-round, for example, we would have an understanding in advance of how many times we'd ride. When the times were up, that was that. A bargain was a bargain! One was expected to be a good sport. . . .

Mrs. Disney and I found that treating the girls as individuals and encouraging them to think for themselves was a far more satisfactory way of bringing them up than by trying to regulate every step of their conduct with an elaborate set of rules.

The most disillusioning thing I know about women I learned by watching my two girls grow up. They taught me that daughters are fickle. There was a time not so long ago when the ambition of both was to hurry and grow up so they could marry Dad. Now, I've been stood up by Diane, and it will be only a few years, I feel, before Sharon will find someone more interesting than a 46-year-old father, even if she still goes to the studio with me on Saturdays and putters around the office to keep me company while I clean up the odds and ends accumulated over a week. Diane used to do that. Now she's too busy with appointments that are telltale of her new interests—appointments with hairdressers and dressmakers.

I also know that the day Sharon says to me, "Sorry, Dad, but I won't be along today. I've got to see my dressmaker," my reign as the sole male object of her affection will be over. She might as well say, "Move over, Dad, and make room for Bill."

Finally, what I know about girls I learned by inference from men—to be specific from the old King in *Cinderella*. You all know how according to the fairy tale, it happened that the King proclaimed a festival which was to last three days and to which all the beautiful maidens were invited in order that his son might choose a bride.

I got wondering one day why the King did this, and the answer I got was so simple that there wasn't any doubt that it was right.

The old King felt exactly as I know I'll feel when my girls desert me. He felt old and lonesome. He looked around the big, empty castle and thought of all the fun he used to have bouncing the little Prince on his knee and riding him piggyback around the royal parlor.

Then he struck his knee, just as I'll do some day, and said: "By golly, what I need is some grandchildren!"

AN INVISIBLE HISTORY

"People didn't think that women had a history worth knowing."
— Gerda Lerner

Two sides hold the balance of humanity. For centuries, male and female experiences have moved the world forward, yet our collective view of history reflects only half of the overall experience. Historian and scholar Gerda Lerner, who pioneered the study of women's history in the 1960s, observed, "A male-oriented conceptual framework has dominated the questions by which the past of humankind has been organized." Lerner's declaration, deemed radical at the time, simply brought to light something women have known for centuries. As author Jane Austen wrote in 1817, "Men have had every advantage of us in telling their own story . . . the pen has been in their hands."

From our earliest beginning, women have indeed had a hand in the shaping of society, yet the recounting of world events, shared experiences, and daily understandings have traditionally been recorded, documented, preserved, and taught from a male perspective.

Over centuries, this perpetual propensity has led to a distorted view of our collective past. What has been presented as a universal history ultimately is centered on male experiences, observations, and order, while the feminine historical experience remains unexamined, unrecorded, and is virtually nonexistent. "Women, ignorant of their own history," noted Lerner, "[do] not know what women before them had thought and taught. So generation after generation, they [struggle] for insights others had already had before them."

As a result of this limited sense of history, the contributions of many extraordinary women have been generally overlooked, marginalized, or outright omitted from our collective history. Half of the human experience is missing.

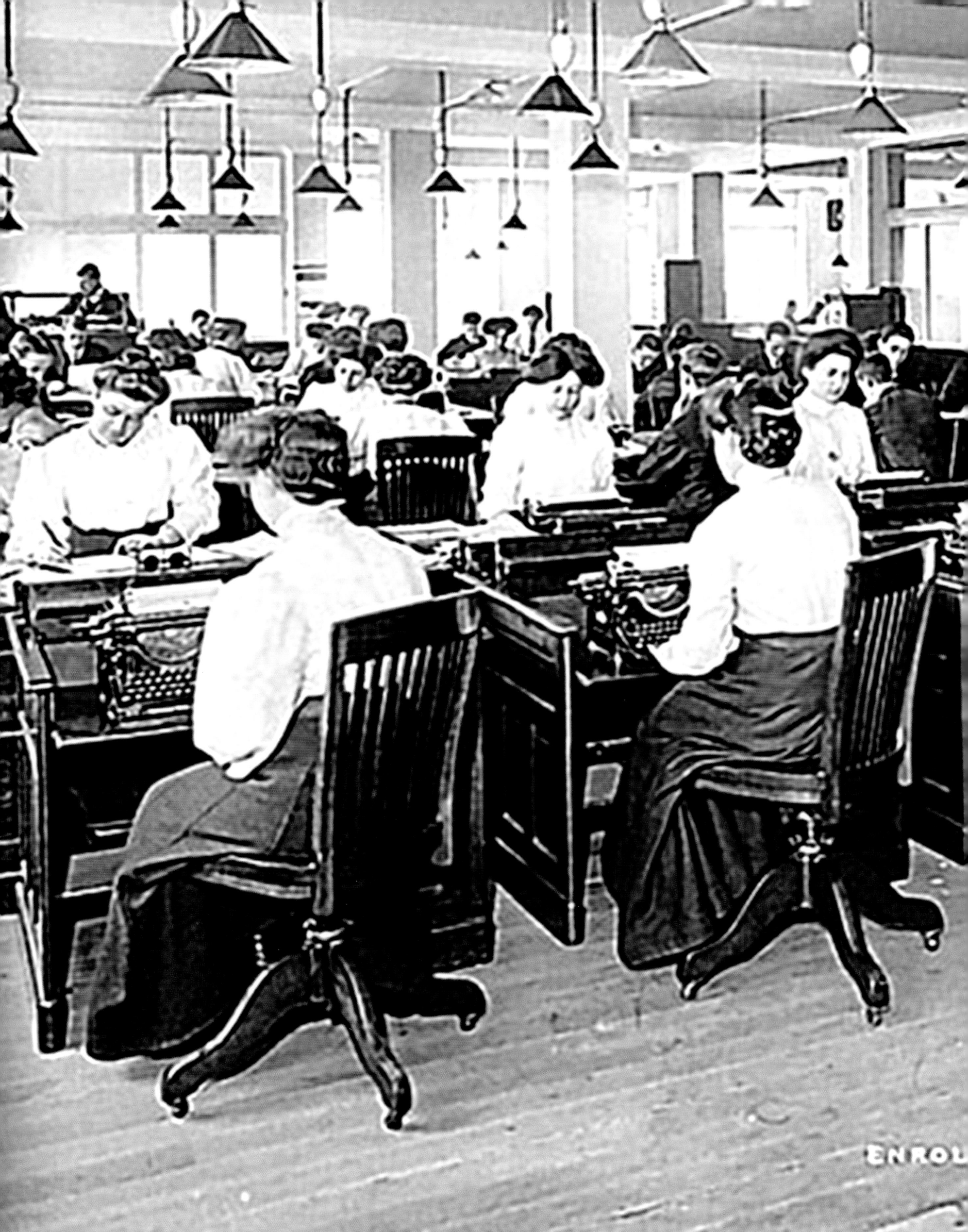

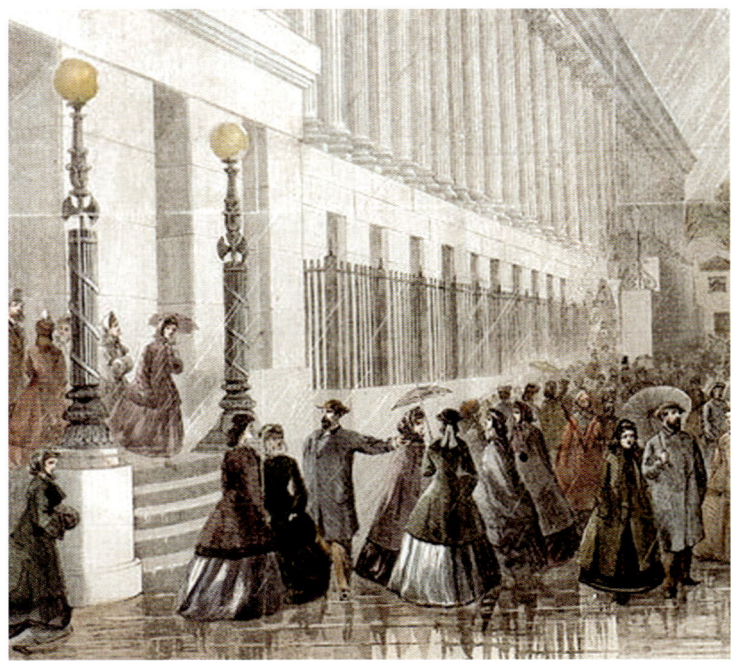

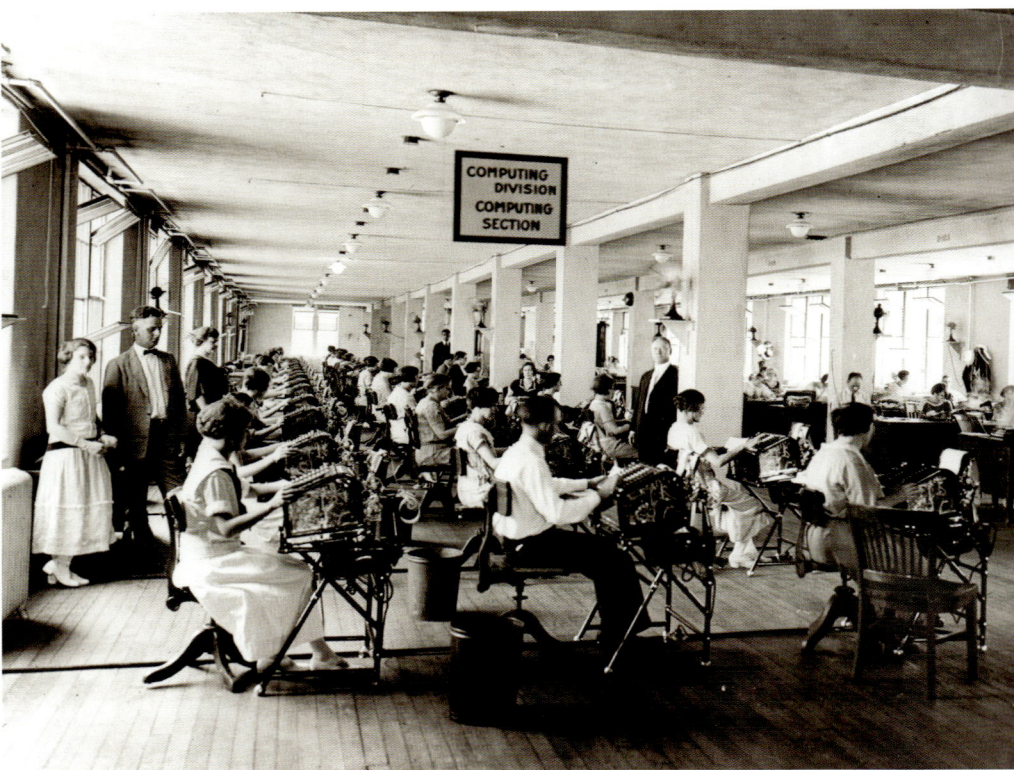

"WOMEN'S WORK"

For centuries, a gender-specific division of labor was seen as a "natural arrangement," stemming back to primordial assignments of labor into "hunters" and "gatherers." Male roles implied strength, responsibilities, and strides marked across the outer world, while certain areas of work, generally within the household, were believed to be the domain of women and mothers. Roles designated as "women's work" have long been cast into an invisible realm of unsung accomplishment, quietly achieved and rarely acknowledged or recorded.

As an experiment, women were first brought into the workplace as clerical workers in this country at the onset of the Civil War. With the men leaving to fight, US Treasurer Francis Elias Spinner first suggested women could temporarily fill positions at the Treasury Department. Fearing for the loss of sanctity within their male domain, the remaining men objected, including Secretary of the Treasury Salmon P. Chase, who was reluctant to accept the idea.

Despite such resistance, Jennie Douglas was selected in 1862 on a trial basis to trim the nation's newly instated paper currency. Pleased with the results, Spinner noted, "The first day Miss Douglas spent on the job settled the matter in her behalf and in women's favor." With Douglas's success, more "government girls" were hired. When these hires quickly outperformed their male predecessors, most of their male counterparts were surprised. Secretary Chase quickly acted to protect the men's dominance and set the pay for women at not quite half the rate of the men.

Though women had established their permanent presence in the workplace by the end of the Civil War in 1865, Congress still waited several years before passing legislation in 1870 that would "allow" women equal pay. Few industries, however, honored the law.

Women comprised a mere 3 percent of the eighty thousand clerical workers in America in 1870. Proving to be perfectly capable employees, "skirted" staff steadily entered the workforce en masse, and by 1920, women constituted nearly 50 percent of the three million clerical workers of industry. It was extraordinary growth, but it was also within a limited range of positions, including typing, stenography, and secretarial roles. While the typewriter unlocked suitable employment for women, it became so synonymous with their gender that the roles and workers themselves were often referred to as "type-girls," or simply "typewriters."

Despite often having the same skills and training as their male cohorts, female employees were rarely taken seriously since their work was regarded as secondary to the perceived womanly "priority" of romance and marriage.

Meanwhile, a 1919 secretarial guidebook prompted women to remain silently passive if the boss had other intentions, stating, "She must learn not to see that his glance is too fervid, not to feel that hand that rests on hers." Rather, she was advised to respond with "tact and politeness, for it is not the rebuff that counts so much as the way in which it is done."

With the passing of the Nineteenth Amendment to the US Constitution in 1920, women won the vote—a say in the order of their lives. Times were changing as women found their voices and opportunities beyond the expected roles of society. By 1928, women held 88 percent of the secretarial positions within various industries at the time. Writer Upton Sinclair's labeling of the "white-collar worker" in the 1930s highlighted the strata of division developing within the labor force, with women's roles still relegated to that of the lower-level office worker.

At every secretary's desk throughout most offices of industry in the 1940s sat a copy of Marie L. Carney's *The Secretary and Her Job*. Loaded with practical details on general office methodologies, Carney's book also offered tips for young single women: "You'll find opportunities for dates with men. The quality and quantity of them depends on the sort of daily contacts your job offers, together with your own attractiveness."

Page 11: Female typists, circa 1900s.

This page (left): *Harper's Weekly* print of female clerks leaving the US Treasury Department, circa 1865.

Right: Female and male employees of the Treasury Department Computing Division, circa 1919.

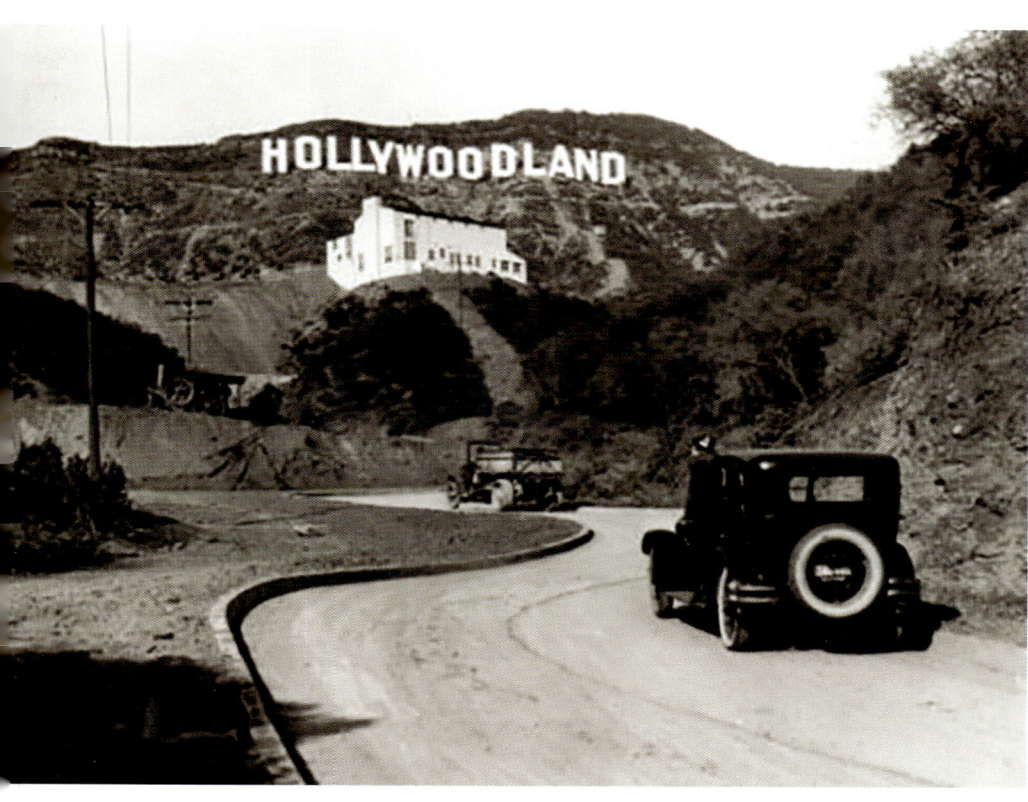

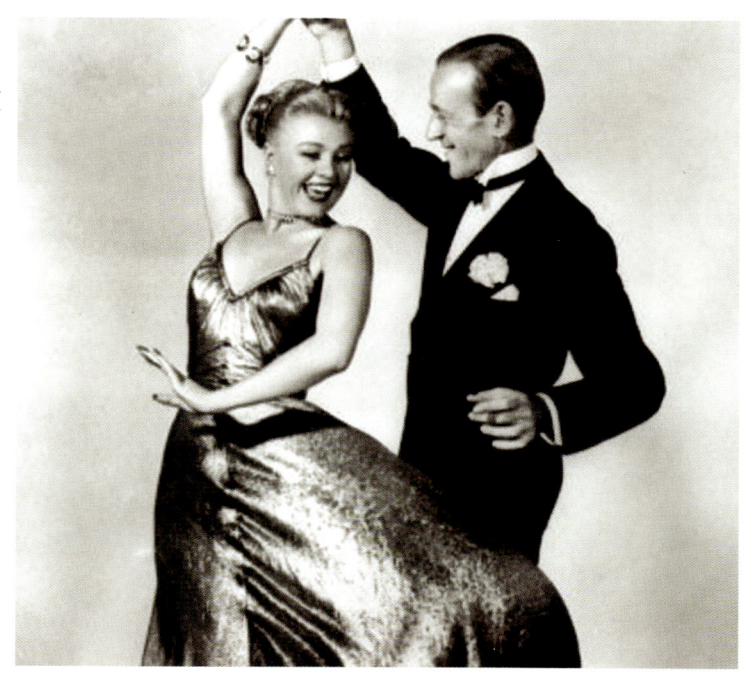

Left: The newly erected Hollywoodland sign in 1923.

Right: Legendary dance team Ginger Rogers and Fred Astaire.

> "*Ginger Rogers did everything Fred Astaire did, backwards . . . and in high heels.*"
>
> —Bob Thaves / Cartoonist

"PRETTY GIRLS WHO TRACE & COLOR"

The 1920s and 1930s marked a coming of age for the motion-picture industry. Studios rose to prominence, and the hierarchy of production roles was defined. The advent of sound and other technologies transformed "the flickers" into films, and movies became a regular part of everyday life. And within this transition, Walt Disney assembled the greatest collection of artists in the twentieth century to transform the novelty of animation into a thriving art form.

Fascination with the glamour of the film industry grew. Theatergoing audiences quickly devoured movie magazines with behind-the-scenes details on their favorite live-action and animated stars. Stories on the making of Mickey Mouse shorts, *Snow White and the Seven Dwarfs*, and other Disney favorites were frequently featured with simplified overviews of the extensive animation process. Early articles defined the world of Ink & Paint simply as a place where "hundreds of girls trace and paint the Animators' drawings onto the celluloids." Visiting journalists with little understanding of the animation production process focused on the girls' "perky appearances" or "darling figures" rather than the detailed and challenging contributions these artists made.

The simplistic term of "tracing" was still used to identify the highly developed artistry of inking. The virtuosity of color was marginalized, as the Rembrandt-esque range of shades and tones that the Ink & Paint Departments introduced in the 1930s was flippantly associated with a new novelty of the day (crayons and paint books), making the "simple" application of color now possible for everyone.

It was a "forbidden realm" set behind closed doors. Studio write-ups noted that the "tedious and detailed work" completed in this department was deemed "best suited for women," as they were "considered more sensitive to detail than men, having demonstrated the ability to do more finished types of work." As it was a predominantly feminine domain, the activities and processes of the Ink & Paint Department weren't really examined by, or open to, the male-laden divisions of the studio. Men were generally advised to stay away from the halls of Ink & Paint, which only heightened the mystique and ambiguity of the critical work completed behind this celluloid curtain.

Left to their imaginations, single male Animators perceived the ample corridors of unmarried females more as a pool of potential dates than as the workplace of comparable artists. Pent-up energies from working in a gag factory fueled the use of humor to dispel the mystery of this feminine domain. Clever names cloaked the artistry accomplished there, since anything completed by "stinkers and fainters" in a place dubbed "the nunnery" certainly couldn't be deemed important.

Some male Animators became vocal about their work being "diluted" or "homogenized" as it was passed through the many facets of the production pipeline. The blame was easily laid on the unknown workings of Ink & Paint rather than on those within their ranks who worked as Inbetweeners or Cleanup artists.

BALANCING HISTORY

For nearly seventy years, the artists within the Walt Disney Studio's Ink & Paint Department—women with inks, pens, paints, and brushes—masterfully matched and vibrantly dimensionalized the penciled lines of Disney's legendary Animators. It is an epic story of celluloid, color, artistry, and technology,

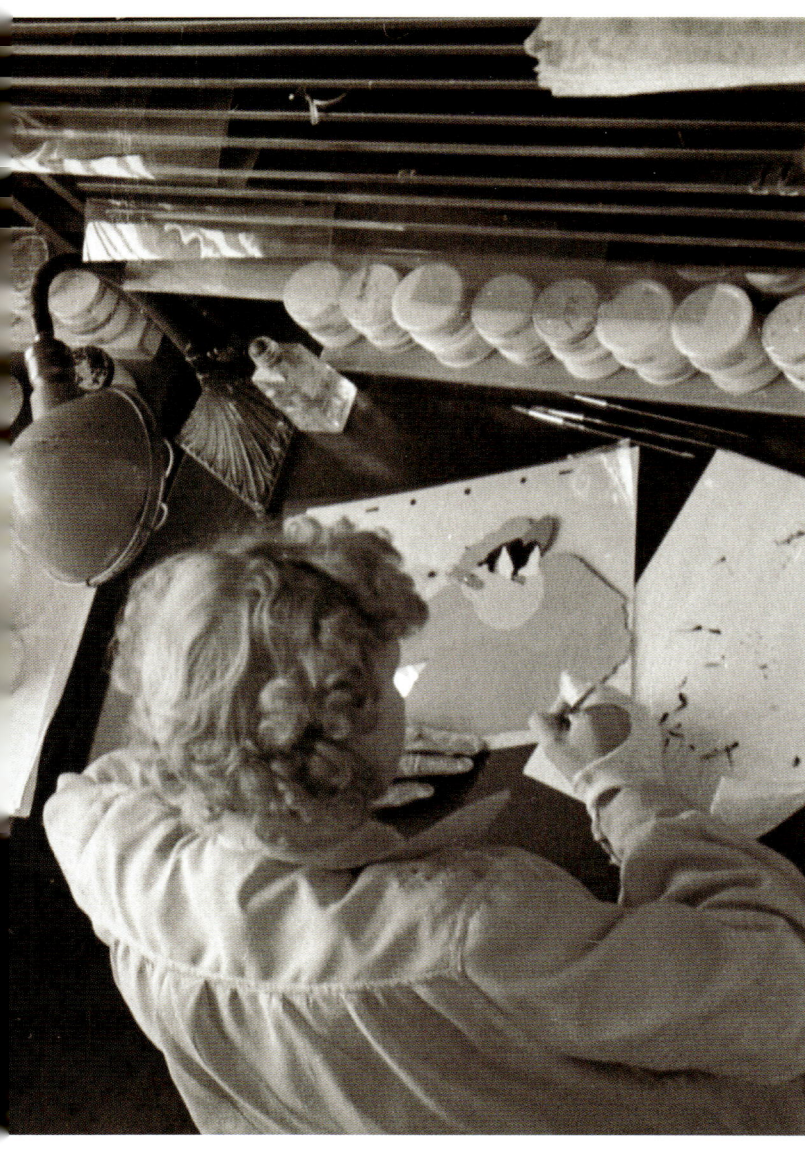

An early Painter completing cels for camera at Walt Disney's Hyperion studio.

all accomplished permanently, vibrantly, without erasers, and, as Bob Thaves suggests, "backwards and in high heels."

Within the limited marketplace for feminine employment in the 1920s, 1930s, and 1940s, animation offered an exciting and creative alternative to secretarial work. As artists, women could find professional roles within Ink & Paint, which offered decent pay and an entry into the world of Hollywood. Wilma Baker, who started as a Painter at Walt Disney Studios in 1937, recalled, "The hours were long, but I enjoyed working in that business; it was fun. I didn't affiliate with many of the male workers, because we did not work with them, but when you're doing 'women's work,' as they called it in those days, it was just us gals."

Outside visitors of any kind were discouraged in Ink & Paint. To produce the best animation possible, there was a need to maintain a quiet, dustless environment for the sake of the artwork and artistry accomplished in this part of production. This restriction served a dual purpose, as Walt Disney consciously sought to provide a comfortable place for women to work without unwanted harassments, which was sadly not the case at many other studios of the day.

Sealed in quiet, clean, and cool environs, this feminine stronghold was a sophisticated domain of color and artistry. Work was efficiently completed to the standards of Walt Disney as paper drawings were artistically transformed into prismatic cels teeming with the colors of life, carefully crafted to engage, enthrall, and enchant.

Every animated project—short or feature length—came through Ink & Paint. Special effects for live-action features, educational films, commercials, and television segments were all touched by the artistry of the studio's Inkers and Painters. As Gretchen Albrecht, the last Department Head of this hand-rendered Ink & Paint film production team, noted, "Think about it. The artists in Animation might work every other film, because if they were involved in the initial development process through production, then they would skip a film. As artists in Ink & Paint, we all worked together, all the time, on every animated film the studio ever produced."

"We were in the best of the years in the animation industry," observed longtime Painter, Grace Godino. "Even though as artists, we had to subdue individual talents for the work itself, we sort of felt like since we were cogs in this wheel, that it was worthwhile. We worked for the studio because we wanted it to succeed. I don't think they have quite that feeling now—it's more for the bucks.

"We didn't have that," Godino continued. "We felt lucky to have a job, but also in a field where we were working with [other] artists. They understood us and we understood them."

Over the decades, the roles and contributions of the women of line and color grew in complexity and mastery. Talented artists quickly advanced within the ranks of the Ink & Paint Department and on to other areas of animation production as well. Of her time as an industry Inker and Painter in the 1940s, Mary Jane Frost recalled, "I wasn't aware of discrimination, but looking back I can see that there had to be. But I don't remember really that we were stuck in that department. I don't remember thinking if I wanted to go on and go higher that I couldn't." Renowned Disney artist Mary Blair's experience was similar, stating she felt "unlimited" in her work at Disney, noting "no discrimination against women. It [advancement] is merely a matter of ability."

Indeed, the last century marked an extraordinary time of advancements for women within every aspect of animation; yet very little is known about this history, as it has never been adequately documented, preserved, or told. The indexes for most historical volumes on animation focus on men, generally listing the same four women—Margaret Winkler, Lillian Disney, Mary Blair, and Retta Scott—with minimal accounts. Beyond these four legendary women, however, are countless more, who from the very beginning, played a vital role in defining the animated films created at the Walt Disney Studios.

Perhaps as a reflection of the transparent canvas they created on, the accomplishments of the women of Ink & Paint have been largely overlooked. Yet it is their work—the final full-color forms of animated mastery—that we ultimately view on-screen. To ignore their vivid contributions, and the contributions of women in general, is to experience only half of the artistry of animation. As one of the many noted women of this unsung department stated, "Without the artists of Ink & Paint, you'd be looking at nothing more than pencil sketches on the screen."

Ink & Paint | 15

Top: Ink & Paint Checkers working at Disney's Hyperion studio.

Bottom: Early Inkers working at Disney's Hyperion studio.

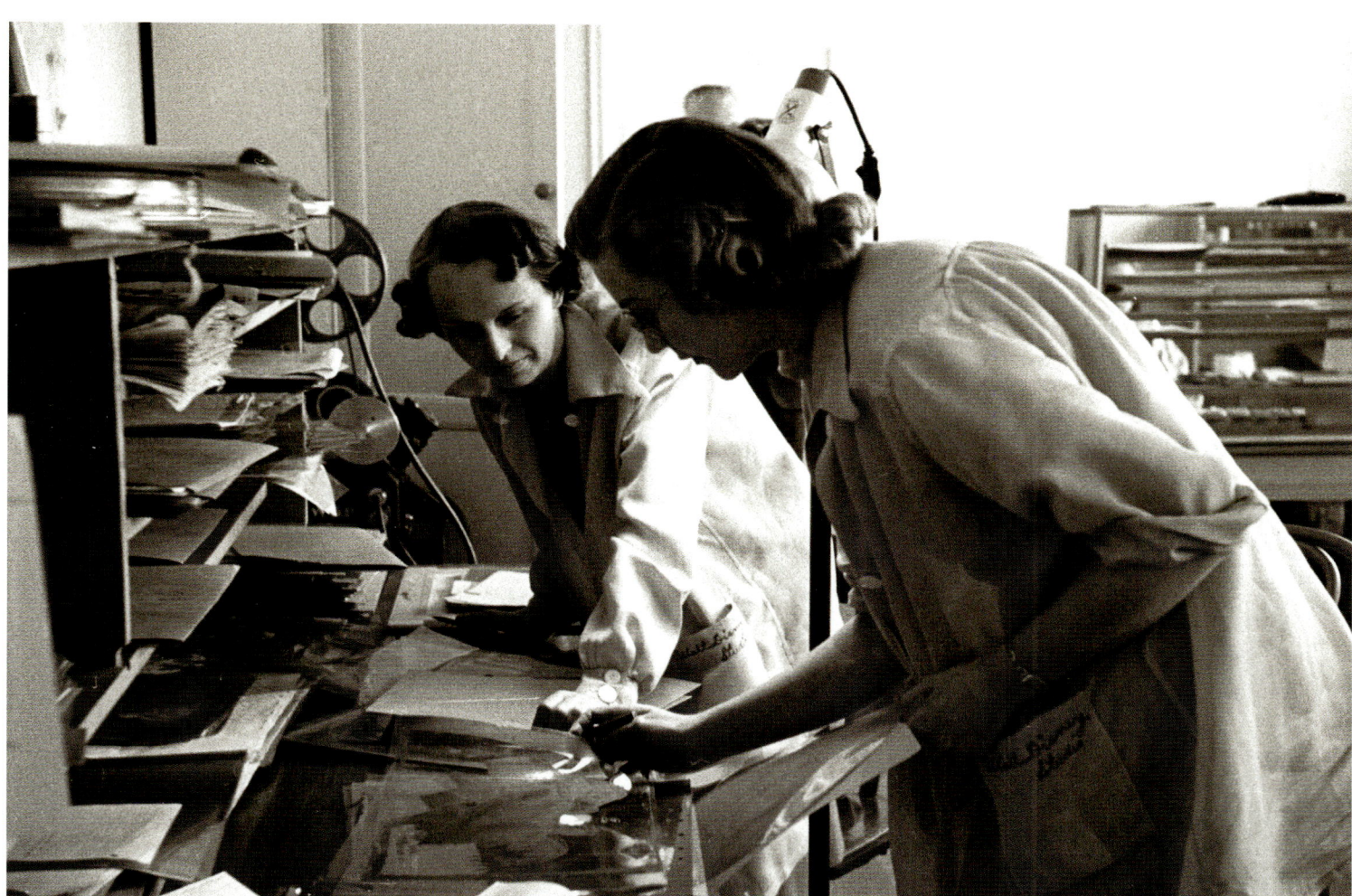

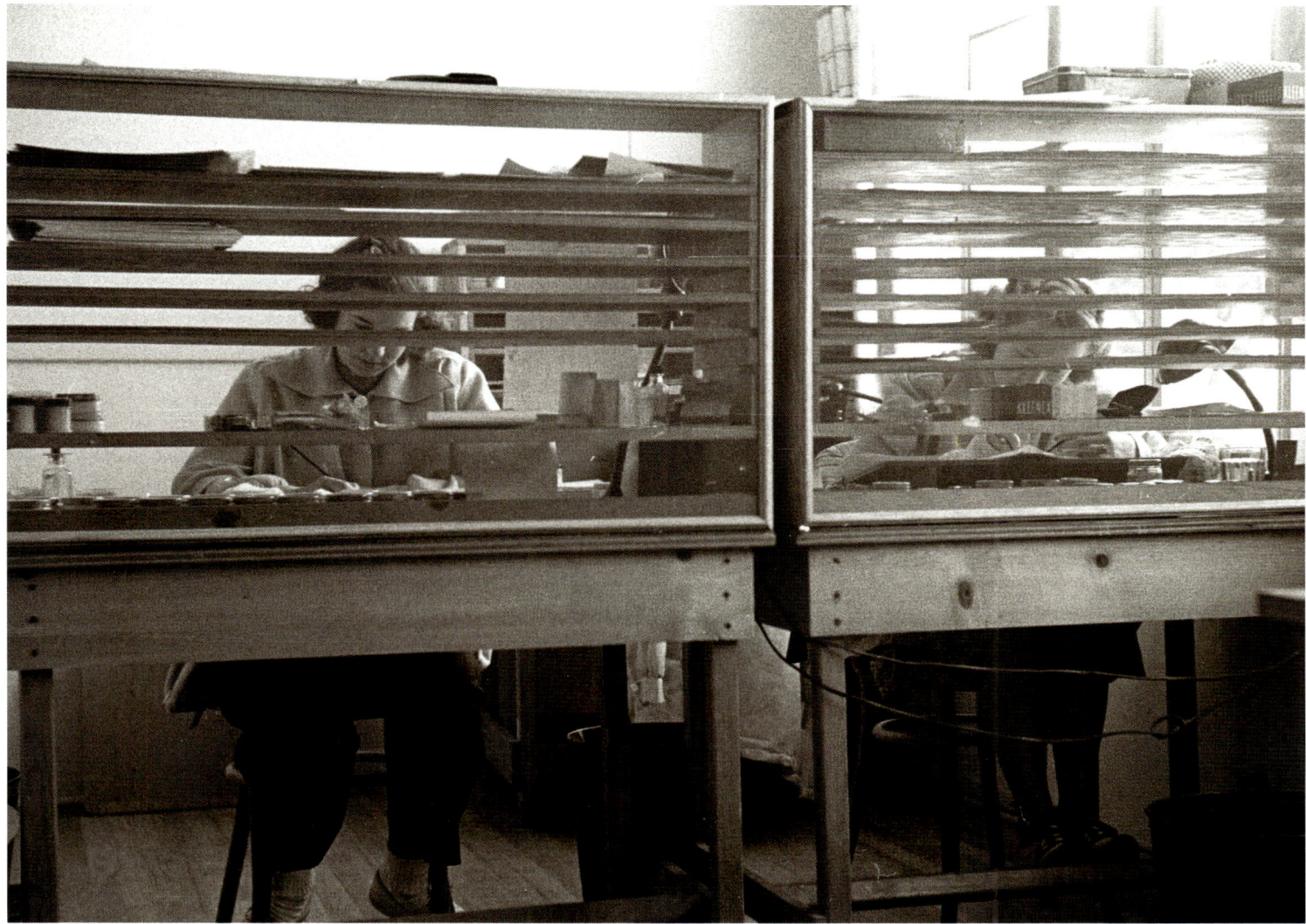

CELLULOID BEGINNINGS

> *"Whereas the still picture can suggest only a fragment of fact or fiction, the cartoon in motion is without limit in communicating ideas, events, and human relations."*
> — Walt Disney

For centuries, images and story have captivated the imagination. From prehistoric paintings depicting a hunt on the walls of caves to shared snapshots capturing moments or events, our fascination with imagery and story has evolved throughout the ages in a long progression of artistry and technology.

The Persistence of Vision, or the visual principle causing static pictures to appear to move, began to take form through a number of technologies. Simple projections of shadows on the wall and later, imagery projected on a screen proved popular forms of entertainment and education. Zoetropes and Magic Lanterns provided dazzling imagery and dramatic scenes via a series of shadow forms on painted slides shown in sequence to relay a story. This precinematic amusement became widely popular as color and light dramatically heighten the narrative experience.

By the 1800s, the populace's hunger for engaging distractions proved financially rewarding, and new realms of entertainment industries began to come and go. Amusements were soon found in parlor games, where ancient gaming principles were formulated and packaged into everyday pleasures for the masses. With the advent of the industrial age, the combination of economic growth, entrepreneurial invention, and surging immigration incited a dramatic demand for economical distractions within a social context suitable for the lower classes. Soon dioramas, circuses, music halls, and theaters became a standard part of everyday life.

BILLIARD BALLS, BIBLE STORIES & LEGAL BATTLES

To meet the growing shortage of ivory in the mid-1860s, billiard-ball manufacturer Phelan & Collander offered a $10,000 reward for a suitable substitution to ivory balls for this popular parlor game. A young printer, John Wesley Hyatt of Albany, New York, developed a combination of wood pulp and shellac that didn't replace billiard balls, but easily formed into Checkers, dominoes, and other popular parlor game pieces. In 1870, Hyatt and his brothers trademarked the name "celluloid," and the Celluloid Manufacturing Company was born.

By the 1870s, the burgeoning industry of photography was expanding. Glass plates proved too fragile, and the need for a lighter, more flexible backing caused photographer John Carbutt to manufacture gelatin dry plates in 1879. After a thin layer of celluloid was sliced from its original block form, the sliced sheet was then pressure heated, resulting in a clear, lightweight piece more suitable for plate photography. Though marketed as "flexible negative film," Carbutt's sheets of celluloid were ultimately brittle and unusable within a rolled film context.

Around this time, the Reverend Hannibal Goodwin, an Episcopalian priest and amateur chemist, sought a way to make his Sunday school Bible classes more motivational through photography. Working independently in his makeshift attic lab, Goodwin developed a method of making a transparent, flexible roll film and filed for patent on May 2, 1887. Two years after Goodwin's application, inventor and industrialist George Eastman and young research chemist Henry Reichenbach filed patent applications for their production of transparent roll film for Eastman's Kodak cameras. Their process utilized a precise blend of nitrocellulose solution poured over glass, resulting in a transparent, flexible film that could be peeled off and cut into strips. Despite the time difference and varied approaches, a lengthy legal battle ensued between Eastman and the reverend. Forecasting the enormous growth in amateur photography, Eastman recognized the importance of roll film: "The field for it is immense.... if we can fully control it, I would not trade it for the telephone." Their legal battle was settled nearly a dozen years later.

MOVING MAGIC

The advancing field of photography presented a shift within the paradigms of the nineteenth century. The ability to capture an actual moment in time with a single image soon became part of everyday life. Photography opened doors to distant and exotic parts of the world through postcards, stereopticons, and magic-lantern slides. Cameras were found in upper-class homes as a pastime, utilized in industries as an educational advancement, and applied in scientific study.

In 1872, Eadweard Muybridge studied the progressive movements of a horse's gallop through a series of photographs taken by twelve cameras set up with trip wires triggered as the horse passed by. Through these photographs, Muybridge successfully documented motion proving the airborne theory of "unsupported transit." Muybridge's continued exploration into motion with his multicamera setup led to the technique of series photography, which expanded the paradigm of scientific and artistic studies of the day and paved the way for various mechanical developments for recording motion. Muybridge's experiments, and the advent of soft-roll celluloid film, led to the development of a new frontier—moving pictures.

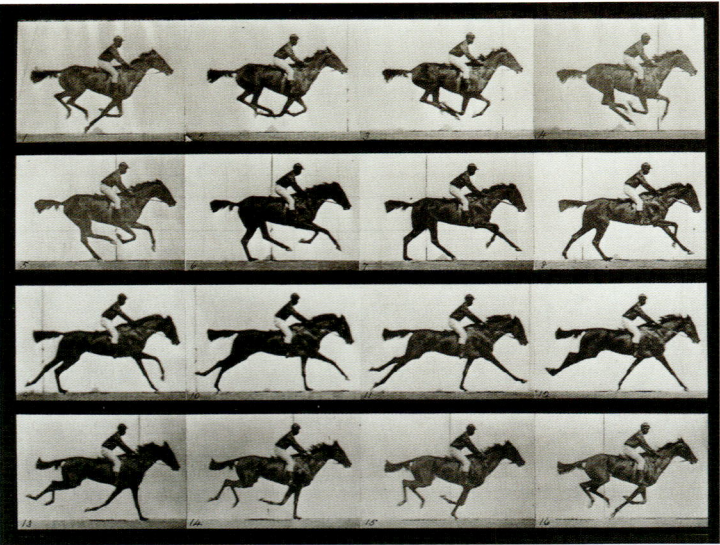

William Dickson, an employee of Thomas Edison's company, developed the first film camera that was able to utilize rolls of emulsion-coated celluloid. Edison's continued work with recorded images and movement resulted in the Kinetoscope, a small mechanical exhibition device permitting individual viewings of short films, hand-cranked and viewed through a small peephole. Popular as novelties at fairgrounds and within urban shop locations, rows of Kinetoscopes could feature a wide range of short films for individual viewers to experience.

Short, one-minute actualities explored basic scenes and events in everyday life: a man sneezing; a customer receiving a shave at a barbershop; segments of theatrical plays; boxing matches—all of which delighted audiences, who simply dropped a coin in the slot. To meet the demand for this experience, Edison quickly established a studio to create content for his innovation. By January 1893, Edison and his teams began production at the Black Maria studio on the grounds of Edison's New Jersey laboratory. In this revolving black box with a removable roof, Spanish dancer Carmencita performed her tantalizing choreography and became the first woman to appear on film.

Seeking to instill further believability in these basic segments, Edison began exploring color within his shorts by hand-tinting each frame of film with various color dyes. The first color motion picture featured the serpentine dance of Broadway dancer Annabelle Moore. In 1895, Moore's motion-picture movements caused quite a stir when viewers caught a brief peek above her knee. Scandal later ensued when one of the first commercially released actualities, *The Kiss* (1896), conveyed a lingering kiss over the course of approximately eighteen seconds.

As the experience of moving pictures via the Kinetoscope spread around the world, others copied, transformed, and even improved on Edison's designs. Two brothers from France—Louis and Auguste Lumière—developed a projection system capable of exhibiting moving images for large groups of people within a formal setting. On the evening of December 28, 1895, an event in the Salon Indien du Grand Café would forever change the moving picture. Master filmmaker Georges Méliès

Page 17: Noted MGM film editor, and Disney family member (by marriage), Blanche Sewell.

This page: Early photographic study of motion by Edweard Muybridge.

Page 19 (top, left to right): Film frame from *Carmencita* (1894), featuring dancer Carmencita, the first woman recorded on film. Produced in the US at the Edison Studios by William Dickson. Broadway dancer Annabelle Whitford appearing in the colorized Edison actuality *Butterfly Dance* (1895), hand-colored by Mrs. Edmund Kuhn. Final frame from an early hand-colored Edison short, *Umbrella Girls* (1890s).

Center (left to right): Hand-colorized film frames of silent short actuality *The Kiss* (1896). Hand-colorized enlargement of *The Kiss* (1896), one of the earliest films shown publicly, featuring stage stars Mae Irwin and John Rice in the final scene of the stage musical *The Widow Jones*.

Bottom (left to right): Tinted scene from Lucien Nonguet and Ferdinand Zecca's *La vie et la passion de Jesus Christ* (1903), one of the earliest colorized feature-length narrative films, tinted and stenciled by Pathe color labs. Segundo de Chomon's color work in Gaston Velle's film *La Poule aux oeufs d'or* (The Hen That Laid the Golden Eggs) (1905).

Ink & Paint | 19

Celluloid Beginnings

later recalled, "We found ourselves in front of a small screen. . . . After a few moments, a horse pulling a cart started to move towards us, followed by other cars, then passersby—in short, all the animation of a street. As we watched, we were open-mouthed, struck dumb, surprised beyond anything we could express."

After that fateful night, Paris elites paid a full franc to experience a program of ten short films about a minute in length each. Within weeks, long lines were forming and audiences were enthralled. Capitalizing on this success, the Lumière brothers quickly dispatched representatives around the world to exhibit films, and audiences responded with strong demand for more. A global industry was born!

LADY LABOR & COLOR

From the beginning of this new technological experience, the gray world of the cinema soon gave way to a cacophony of chroma. The introduction of color captivated audiences and expanded the possibilities this new art form presented. As early as the 1890s, color was hand applied, frame by frame, to the emulsion side of final film prints. The porousness of the film's emulsion absorbed the various colored dyes utilized to enhance the story or experience. With a spectrum of hues added to black-and-white footage, landscapes became vividly cinematic, characters or key props could be emphasized to heighten the story, and fantastical faerie worlds took audiences to a new level of imagination.

Color, hand applied to film, had been long established with the advent of photography. The hand-tinting of photographs, postcards, and stereopticon slides was a thriving industry for artists, but significantly more so for women. Colorized glass slides, magic-lantern projections, and other novelties preceding moving pictures were painted by women trained in this unique industry. One, Gladys R. Scott, began work as a colorist in the illustrated song-slide firm of Scott and Van Altena in New York City in the late 1800s. She eventually married the owner, John Scott, who later recalled his wife's work in a letter:

She colored hundreds of those song slides. . . . She was our fastest colorist. She also colored motion picture films, notably for [John Randolph] Bray, Universal, and [Jules] Brulatour, . . . The films were completely colored—not only a touch of color here and there—a very difficult job because the color while hewing close to the edge [of objects] had to be uniform in density so as not to flicker on the screen.

Due to the delicate detail often conveyed within the lantern-slide and other colorist industries, it was common practice to hire women or young girls with better eyesight for this work. Historian Joshua Yumibe notes: "Early on, these female laborers tended to be the wives of the male employees involved in the productions. Females were not only cheaper to employ, but they were also thought to be innately suited with their supposed sensitivity, nimble fingers, and feminine color sense to the detailed work of coloring films."

A job within colorization provided possible access into one of the earliest production roles open to women in the burgeoning film industry. This practice of gender-based hiring was in line with the established textile, garment, ceramic, and design industries, which had long employed women. To bring color to black-and-white celluloid, women and young girls by the hundreds lined rows of desks with light boxes, magnifying glasses, and horsehair or stippling brushes to painstakingly apply the dye directly to select elements within the frames of final film prints.

Suggested color and tone within the earliest Edison dance films, actualities, and reenactments immediately resonated with audiences. In-house color units were quickly established within the various filmmakers' studios to meet this demand. Based on early letters within the Edison archives, the wife of Edison Studios technician Edmund Kuhn was likely one of the main in-house colorists. At the April 1896 debut of Thomas Edison's Vitascope projector, a *New York Times* reporter noted: "The

Left: Stenciled color from early stop-motion animation wizard Segundo de Chomón's fairy film *A Trip to Jupiter* (1909).

A hand-painted magic lantern slide utilized in early Victorian-era cinemas.

Top: Final frame from an early film by visual effects pioneer Georges Méliès, hand-colored by Madame Thuillier's colorists.

Bottom: An early colorist's workstation. Film is unspooled from the top reel and thread across the main backlit box to a take-up reel on the far left. Various colored dyes, bottled on the right, are applied directly to the film to achieve the final color.

tinting of the pictures is one of the most delicate tasks that confronts [Edison], for, when one considers the size of the pictures of his film, there can seem to be no exaggeration in his statement that to make a pink cheek a pin-point touch of color is all that can be used, and that the black stocking of a dancer is only one thirty-second of an inch in length."

As the length and scope of films grew, costs and artistic complexity expanded as well. Edison outsourced his colorization process to address this problem. A 1901 ad from Harbach and Company, based in New York, promoted such services: "If 1 to 3 figures. $2.75 per .50 ft. 4 figures, $3.25." By 1902, Harbach distributed top films of the day, touting their colorization services with: "Edison's films—Our Coloring." Later, as *Moving Picture World* noted: "A number of female colorists became renown for their work, including: Miss Sarah Levy and Miss Tompkins of New York, and Miss Martini of New Jersey."

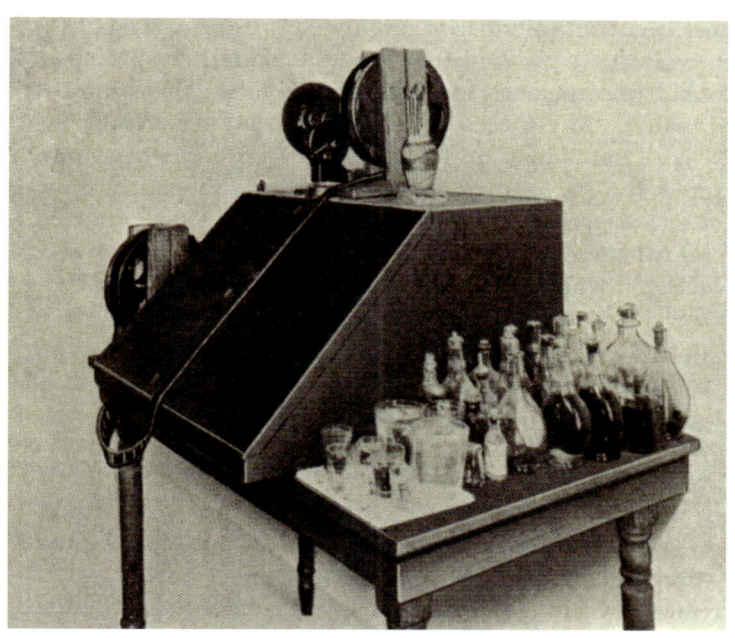

COLORING MÉLIÈS'S FILMS

Fairy pantomimes were popular theater fare at the turn of the twentieth century. With the advent of the cinema, it was only a matter of time before this fanciful genre would be explored in film. Legendary filmmaker and the father of visual effects, Georges Méliès, understood the impact of color. Emphasizing spectacle and effects, his early trick and fairy films became strongly associated with color, providing a vibrant punctuation of tones to heighten the audience's belief in his fantasies. As Méliès stated, narrative served "merely as a pretext for the 'stage effect,' the 'tricks.'"

In his uniquely constructed studio of glass, Méliès told his stories on sets designed and painted in shades of gray ranging from nearly white to almost black. A narrow spectrum of color was applied by hand to the final prints to bring his fairy worlds to life. Méliès outsourced his colorizations for a time to the Pathé Frères company, but due to costs he switched over to and worked for nearly a decade with an independent firm in Paris run by Elisabeth Thuillier. Initially, Thuillier ran a French lantern-slide and postcard coloring company, which expanded its range to include artisanal film colorization working for Raoul Grimoin-Sanson and Méliès's Star Films.

As the enterprising Thuillier noted, "I colored all of Méliès's films, and this work was done entirely by hand. I employed two hundred and twenty workers in my workshop. Each was paid one franc for every working day." Thuillier separated the labor by hue with an assembly-line approach to increase productivity. "I spent my nights selecting and sampling the colors," Thuillier stated, "and during the day, the workers applied the color according to my instructions. Each specialized worker applied only one color, and we often exceeded twenty colors on a film. It took long days to color a film."

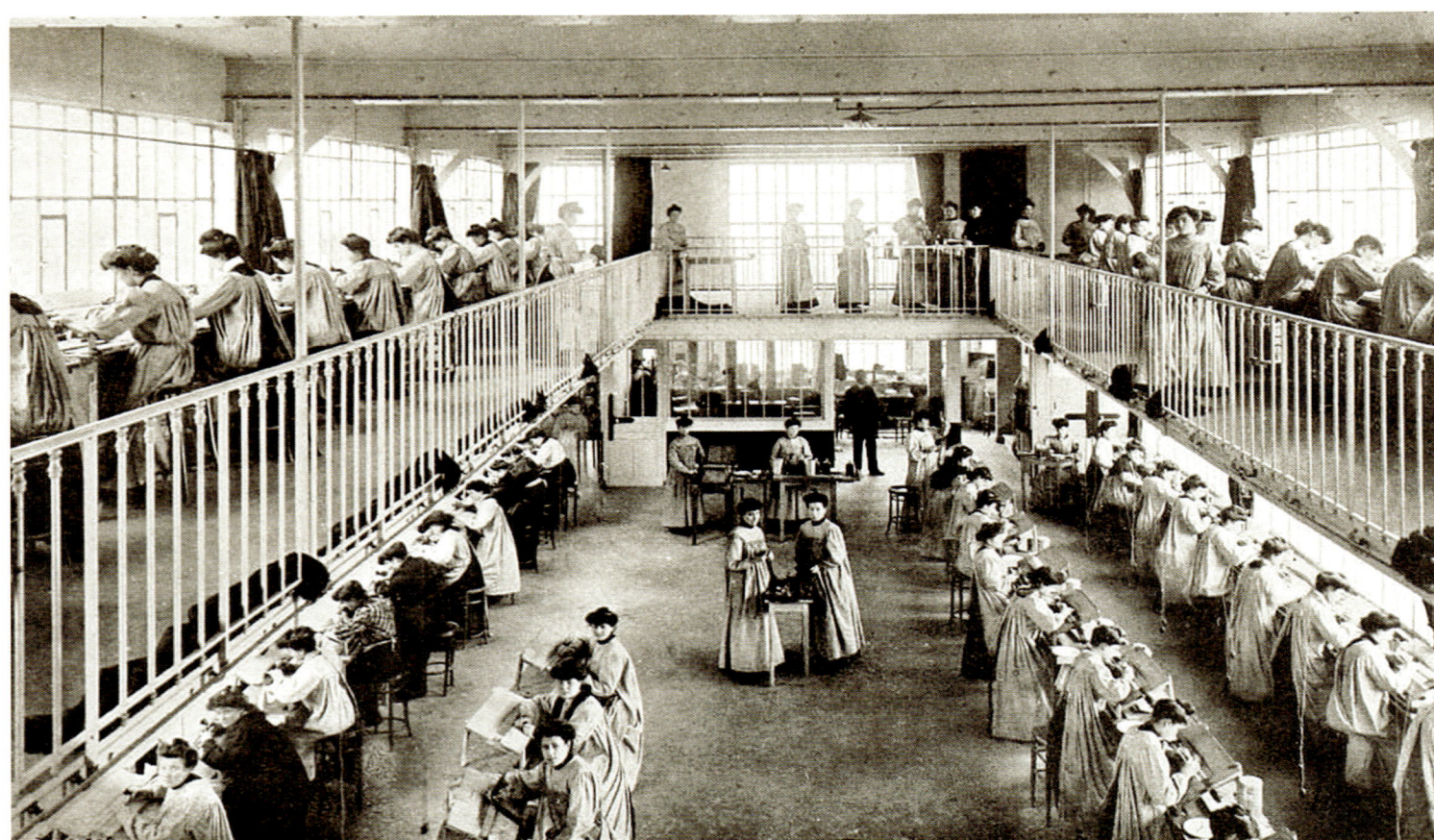

Top: Female colorists at work at the Pathé Film Labs.

Bottom: Germaine Berger (back row, center) and other colorists at the Pathé Studio.

With the cost of labor involved in this intricate work, the outsourcing of colorization soon became standard for filmmakers of the day. The success of color within Méliès's films caused noted Hollywood producer William Selig to reach out to the brother and production partner of Georges Méliès to inquire about their color services. Gaston Méliès explored the possibilities in his response:

> Of course I can send the films to Paris and have them colored there, then send back here, but I am afraid that the expenses are rather big, on account of the freight and of the Customs Duties. The American law says that domestic films can be sent abroad and come back free of duties in the US providing that there has been no alteration made to them and that their value has not been increased; the coloring increases the value of the films, therefore, the Customs Duties will have to be paid on the coloring and on the value of the film itself.

"Moving paintings" would be a costly endeavor, with coloring costs for a three-hundred-meter film running about a thousand francs per print, with usually sixty prints per title.

THE HENS OF PATHÉ

By the turn of the century, the industry of film had developed, and audiences all over the world sought color in their cinema experiences. Charles Pathé innovated the color industry with his coloring studio in Paris. A 1903 Pathé advertisement in England declared, "We undertake to color the films at a price to be agreed upon. We also color the films supplied by our customers, even if they are not of our own make." By 1906, Pathé was selling three to four thousand meters of color footage a day and began to outsource footage to Elisabeth Thuillier's color firm to meet this growing demand.

It was quickly determined that the limited Pathé facilities for color required expansion. Henri Fourel, the director of the Vincennes Pathé lab, oversaw the hiring of additional female colorists; soon, their ranks grew from sixty-five women to over two hundred. With this expansion, Pathé sought to have Thuillier run his lab. Though she initially agreed, Thuillier stepped back upon learning she would share her authority with Mme. Florimond, another Pathé manager (whose husband was the chief technician who later developed Pathé's mechanized stenciling methods).

The most common ways of adding color to black-and-white films then were hand coloring, tinting, toning, and stenciling. Separate stencils were cut for each color utilized within each frame. The colorist would hold the necessary stencil in one hand while applying the appropriate dye with a brush. Though

painstaking and time-consuming, it was a method that worked effectively, as long as the stencil was properly cut. In an attempt to control the market and reduce costs, Pathé began to mechanize its production methods.

Pathé later expanded the stenciling process into various worldwide markets and by 1908 had created a standardized mechanized stenciling system. Precision, machine-cut stencils were created for each colored area as it ran the length of the film. Synced with a sprocket wheel, the stencil was pulled along in contact with a positive final print of the film, as a velvet ribbon looped through a tank of dye, applying the color through the stencil onto the print. To achieve a final print, this process had to be repeated for each color.

"My sister Lucie and I interviewed at the color workshop in Vincennes where we were hired on the spot because we knew how to draw," recalled Germaine Berger of her time as a Pathé colorist. She was fourteen and a half years old at the time. "By law, you had to be sixteen before you were eligible for employment, so they obtained an exemption for me."

Though one of over 160 colorists, cutting-machine operators, and ink technicians, Berger had never even been to the movies. "In that day and age, women were not seen in public. Going out was taboo; we didn't have the right. It just wasn't done in that era. But my brother, who was the youngest in the family, was permitted to go to the cinema every Thursday," recounted Berger. "And I, who had a career in the film industry, was not allowed." Only women were permitted in the workshop; men worked as machinists and electricians. Berger explained, "It was too finely detailed a job for men, something I understood only as I grew older. In those days, men didn't touch anything, except for the actual manufacture of the film stock, with the large galley proofs. Women couldn't do that back then."

Berger's artistic talents served her best since she had only a minimal amount of technical training. "I personally did cutting because I had excellent eyesight and eyeglasses were not permissible," Berger remembered. Once workers demonstrated competence and a proper "feel" for a particular color, they were permitted to work solely on that color. "Yes, only one color," Berger recalled. "For example, blue and 'flesh' tones were difficult to perfect: you had to cut a stencil around trees in order to discern whether a part of the tree was incorporated into the sky or remained green. Thus, the longer they left us with a solitary color, the more expert we would become. After several years experience in this aspect, if we showed a particular flair and talent professionally, then they'd let us do everything."

The hours were long, with ten-hour days and frequent unpaid overtime. Working conditions were severe, and management was strict, noted Berger, who added, "The Pathé house forbade many things. They did not encourage chattering and socializing. We had all we needed in that room. For lunch, one could either eat outside or in the workshop. It was all very supervised." The women's paychecks, however, were higher on average than those of many of the male factory workers, who had less-specialized skills. With their income contributing directly to the overall household, many women employees were able to build up considerable savings. With their sizable nest eggs, the women colorists soon became known as the *poules de chez Pathé*—the "Hens of Pathé"!

Feminine First

HELENA SMITH DAYTON

Believed to be the first American woman Animator and one of the earliest inventors of "clay cartoons," Helena Smith Dayton was renown for her whimsically sculpted characters depicting everyday scenes from life. In 1916, she began experimenting with clay photography, becoming one of the earliest artists to hit upon the novelty of "animated sculpture." Dayton's adaptation of Shakespeare's *Romeo and Juliet* debuted in 1917. "I was sitting at my typewriter, when my fingers began to itch for something to mould," recalled Dayton. The next day, after spotting a storefront advertisement, Dayton impulsively purchased art clay and began sculpting. "From then on," she remarked, "I tried to fashion people as I saw them, the humorous always being uppermost in my thoughts." The press defined her work as "statues that run, dance and fight. The figures are first fashioned in clay, then changed to different poses, photographed one by one and projected upon the screen without a break so they jump about on the screen."

"I think these clay cartoons reflect the spirit of the day," Dayton stated, defining her work as "gigglesome bits of statuary." Designing, sculpting, and painting each piece, Dayton filled the shelves of her New York studio with her "mud folk." Dayton painstakingly animated her figures at the rate of sixteen poses to a foot of film. One reel of film averaged sixteen thousand separate poses for each figure—with many of her scenes featuring three to even thirty figures. "I have never had a lesson in my life," Dayton noted. "I get my effects in my own ways, with a hairpin or an orangewood stick or anything I can get hold of. Real sculptor's tools would be too big for this work even if I knew how to use them. So I must sharpen up a match and go ahead with that and my fingers."

A true Renaissance woman, Dayton took her playfulness seriously in her work as an accomplished painter, published author, playwright, and social activist. The *Times Dispatch* stated: "She has a twinkle in her eye as though she saw beneath the solemn surface of humanity its hidden childishness." A society regular and hostess for the notable Washington Square "Studio Teas," Dayton was one of twenty-five artists who showcased their work in various "Humorists Salons" that took New York by storm. "Everyone needs to laugh," she declared, "no matter what the age." Dayton's animated artistry kept her fans laughing so much, her bank account swelled to $12,000 by 1917—the equivalent of $255,000 by today's value.

Final frame of the first hand-animated and colored film by Winsor McCay, *Little Nemo* (1911).

THE COLOR OF CINEMA

Less detailed and time-consuming in its application, the process of tinting provided an inexpensive alternative to hand-colorization (while still supporting moods and effects for the story and the experience of color for audiences). This technique added overall color to the entire film or specific scenes to denote changes of action or emotion.

Along with other studio heads of the day, Mack Sennett utilized color in many of his early films via simple tinting. With each new production, the studio created basic tinting instructions that would accompany final prints to the lab for processing. Such instructions included: "film is to be tinted a light blue for night effect."

Even with the advent of mechanical applications, color costs continued to increase, but were worth the return as the impact of color surged. A Minneapolis theater owner wrote to early Hollywood pioneer William Selig, "We ran *Cinderella* in colors and altho [sic] we showed it here twice before . . . I would have given anything had you seen the way we put it on this time. So many people remarked how much more beautiful the picture was colored and how much nicer it was this time than last[,] and it certainly was a big howling success[,] and thanks to your generosity I was able to pull out with a handsome profit."

By 1905, a unified system of color-coding was developed by Professor Albert H. Munsell. An artist and educator at the Massachusetts Normal Art School, Munsell intended to define an easier manner of describing color for his students. This numerical method of coding colors based on human response provided a more accurate definition of the true color versus the generalized use of color names. Munsell's organization was arranged three-dimensionally and based on three areas of definition:

- HUE is a specific level of color. Colors are broken down into five principal hues (red, yellow, green, blue, and purple) and five additional intermediate hues set halfway between the principal hues. These levels are coded with the number 5—5Red, 5Yellow-Red, 5Yellow, 5Green-Yellow, 5Green, and so on.
- VALUE, or lightness, is based on the color's value between black and white.
- CHROMA is the purity or saturation of the particular color.

FUNNY FACES & DINOSAURS

With the moving picture industry in full swing, movie palaces and theater chains began dotting cities and towns around the world. As audiences flocked to experience "the flickers," theater owners quickly sought new novelties and amusements to keep their patrons returning for more.

The year 1906 saw the earliest forms of formal animation with Russian Alexandr Shireav's stop-motion choreography. When J. Stuart Blackton filmed a series of chalk drawings using stop-motion and cutout animation techniques for *Humorous Phases of Funny Faces* on the screen, the effect worked. Audiences loved it, and animation took hold. French filmmaker Émile Cohl created

Final frame of J. Stuart Blackton's *Humorous Phases of Funny Faces* (1906).

a series of drawings working with a white pencil on black paper to incorporate into his 1908 film, *Un drame chez les fantoches*.

Winsor McCay, a popular newspaper comic-strip artist, is credited with exploring the movement of imagery in a manner defining contemporary animation. His regular comic strips already featured a cinematic sense of successive movements and isolated segments to convey narrative. Working in India ink and drafting on transparent rice paper, McCay singularly crafted four thousand drawings for his film *Little Nemo*. McCay carefully timed movements with a stopwatch as he flipped through the drawings for smoothness of action. Each individual drawing was photographed in succession, and J. Stuart Blackton directed the live-action prologue of McCay introducing his moving drawings. Once the film was completed, McCay hand-tinted each frame to match the color of his comic strip, and *Little Nemo* debuted in New York at the Colonial Theatre in April 1911.

McCay's next film, *Gertie the Dinosaur*, marked a landmark in animation. Designed as a novelty act for McCay to interact with, his unique approach to shaping a character's personality through movement defined a breakthrough in character animation. Audiences responded, and a novelty soon became an industry.

ADVANCING TECHNIQUES

New York was the hub of the early silent-film and animation industries. In the beginning, numerous animation studios came and went; yet several key developments within the animation process began to take form. For example, keeping the drawings in proper alignment for consistent registration was one of the earliest challenges. If one image was off or out of alignment by even the slightest fraction of an inch, vibrations or a shimmering effect would prove visually distracting. Winsor McCay created a wooden holder that rested against the paper's trimmed bottom edge. Taking a technique from industrial draftsmen, he placed crosshairs in the corners of each individual sheet.

In 1913, a young Canadian Animator, Raoul Barré, developed the first formal animation studio, as well as the first peg system to maintain registration of each drawing. Punching two consistently placed holes in each piece of paper allowed pages to be held in place while the Animator drew and as the drawings were blackened and later photographed, reducing unwanted movement or jitter. This approach later expanded into a three–peg bar system and became the industry standard.

Even earlier, a New York City newspaperman, John Randolph Bray, began working at the *Brooklyn Daily Eagle* as a cartoonist. There, he met and married Margaret Till, a German immigrant and translator at Columbia University. Thanks to this dynamic woman, Bray pursued exploring this new art form. "I decided to go in for myself [freelance], so I asked my wife if she objected. She said no. I said, 'Well, I won't know if I'll make any money or not for a year or so,' and she said, 'That's all right; I'll get a job and we'll work together,' so she got a job for one year, and I started my freelance work."

With Margaret's "woman behind the man" support, Bray was able to establish himself as a leading illustrator and cartoonist in the burgeoning New York cartoon industry. He dabbled in stop-motion, but soon turned to drawn animation. In 1913, Bray formed his own animation studio, which was organized and run by Margaret, who by many accounts was a formidable boss. Together, they developed the earliest division of roles within the animation process. Male artists were hired to streamline production, and a few women were later employed in the Bray Art Department to handle various roles.

In July 1914, Bray began to apply gray shades to his drawings to eliminate the visible flicker from the all-white paper backgrounds. This introduction of cel shades to the background marked the first introduction of celluloid to animation, but a more direct application of celluloid occurred at the same time in the hands of a young animation artist and mechanical inventor, Earl Hurd.

Feminine First

MILDRED WALKER

In late April 1916, early cartoonist Pat Sullivan made several announcements about his forthcoming slate of animated cartoons for Universal Studios. *Motion Picture News* posted the notice with Sullivan declaring, "Work and some imagination make good cartoons."

Otto Messmer, creator of the Felix the Cat character, recalled the Sullivan staff (which he was a part of) "had a few girls here to process [the drawings], blacken [them] in." But as announced in the *Motion Picture News* releases, the newest additions to the Sullivan staff "fashioning" animated content included a young artist, Mildred Walker. Few details were offered: "Mildred Walker is another artist on the Sullivan staff. She has just entered this field, and Mr. Sullivan is exploiting her work . . . The first of her animated drawings will appear shortly."

Walker is believed to be the first woman artist to enter the emerging world of hand-drawn animation. The 1916 release referred to her as "an artist" doing "cartoon work for the pictures," which sets her apart from the "blackeners" of Sullivan's studios. Very little is known about Walker, or exactly what her animated stories entailed, but she does show up as a witness to Sullivan's sudden marriage in 1917.

26 | Celluloid Beginnings

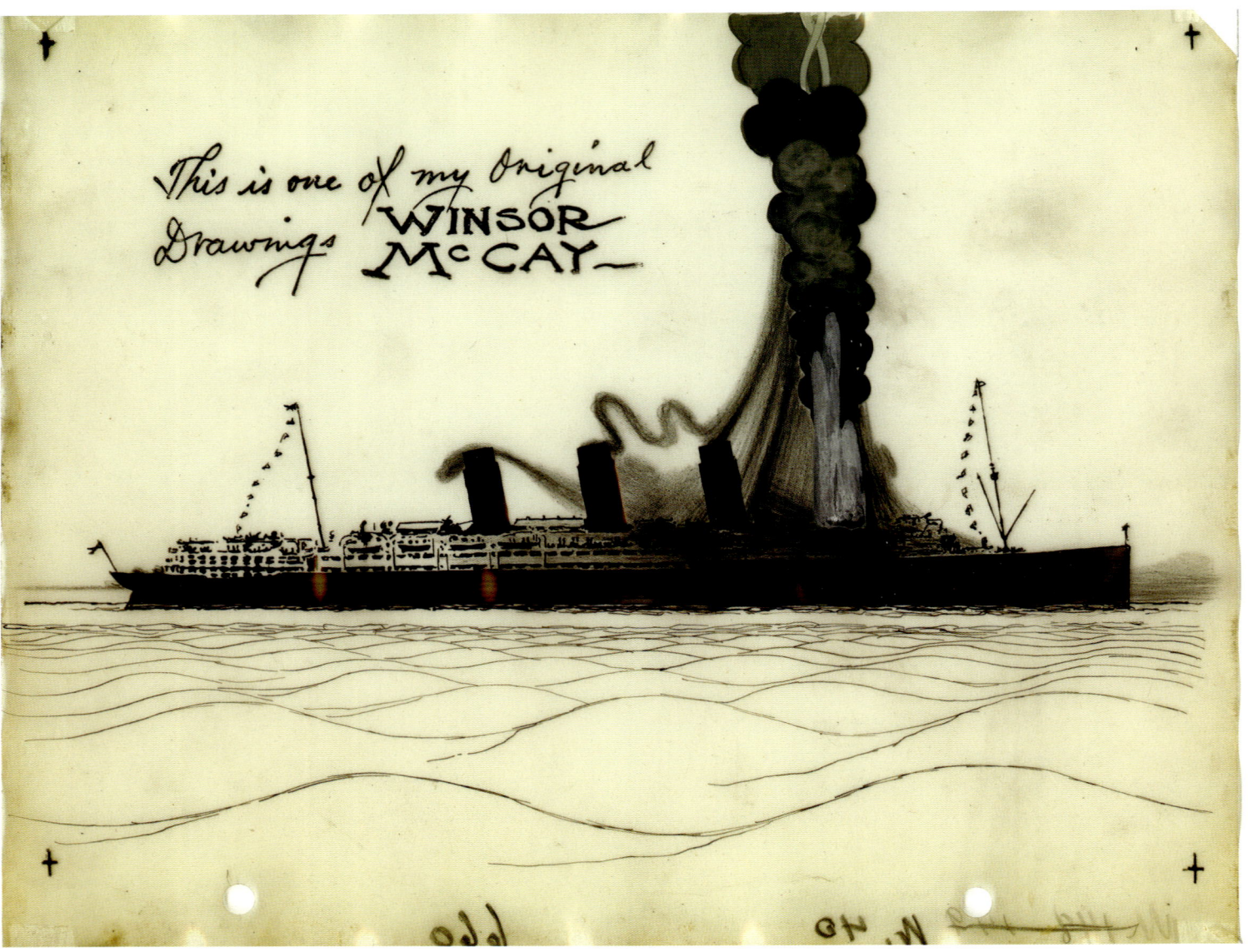

Production cel from Winsor McCay's early silent animated short film *The Sinking of the Lusitania* (1918), marking the earliest animated dramatic documentary.

CEL ANIMATION

An Animator from Kansas City, Earl Hurd quickly obtained rights for the use of celluloid with his 1914 patent application. The illusion of movement in Hurd's process was achieved, as he noted, "by drawing upon a series of transparent sheets. In my process a single background is used for the entire series of pictures necessary to portray one scene. The background shows all of those portions of the scene that remain stationary and may conveniently be drawn, printed, or painted on cardboard or other suitable sheet.

"I prefer to paint the figures of the background on strong blacks and whites upon a medium dark gray paper," he noted, "and when the transparent sheet carrying the movable objects is placed over this gray tone of the background, the objects on the transparent sheet appear to stand out in relief, giving what may be termed a 'poster effect.'"

"He was one of the pioneers," noted early Animator Dick Huemer. "The whole idea of using cels was his, instead of doing it the way McCay did with everything on paper and traced." Later in 1914, Hurd and Bray united their claims, patented their designs, and formed the Bray-Hurd Processing Company to collect royalties on other studios' uses of their patented method. The Bray-Hurd method revolutionized the animation industry and quickly became the standard approach to a burgeoning animation process.

With the use of transparent cels, only the actual moving elements of a drawing would need to be redrawn, thereby increasing output. A colorless transparency was critical so as not to affect or distort the painted backgrounds. Flexibility was key, as it permitted the necessary manipulation throughout the entire production process of inking, painting, camera, and final storage.

The earliest cels were composed of cellulose nitrate, plasticized with camphor for flexibility, and a white, waxy solid substance called triphenyl phosphate (which was added to reduce flammability). These highly flammable cels were thick, held an apparent yellowish cast, and were prone to darken, wrinkle, and emit hazardous gases as they aged.

Screened as novelty fillers between the main attractions, animated shorts featured comical characters in a series of gags and actions. One of the earliest animated series produced thanks to the benefits of celluloid animation depicted an animated character interacting with humans. In 1918, Max Fleischer's *Out of the Inkwell* series featured the rotoscoped character Koko the Clown, inspired by vaudeville "Yama Mama" dancer Bessie McCoy. Created under contract at Bray Studios, Koko's animated adventures solidified the future of cartoons for theatergoing audiences.

Ink & Paint | 27

Top: Earl Hurd (left) and John Bray (right).

Bottom (left & right): Patent documents for Earl Hurd and John Bray's application of celluloid technology to animation.

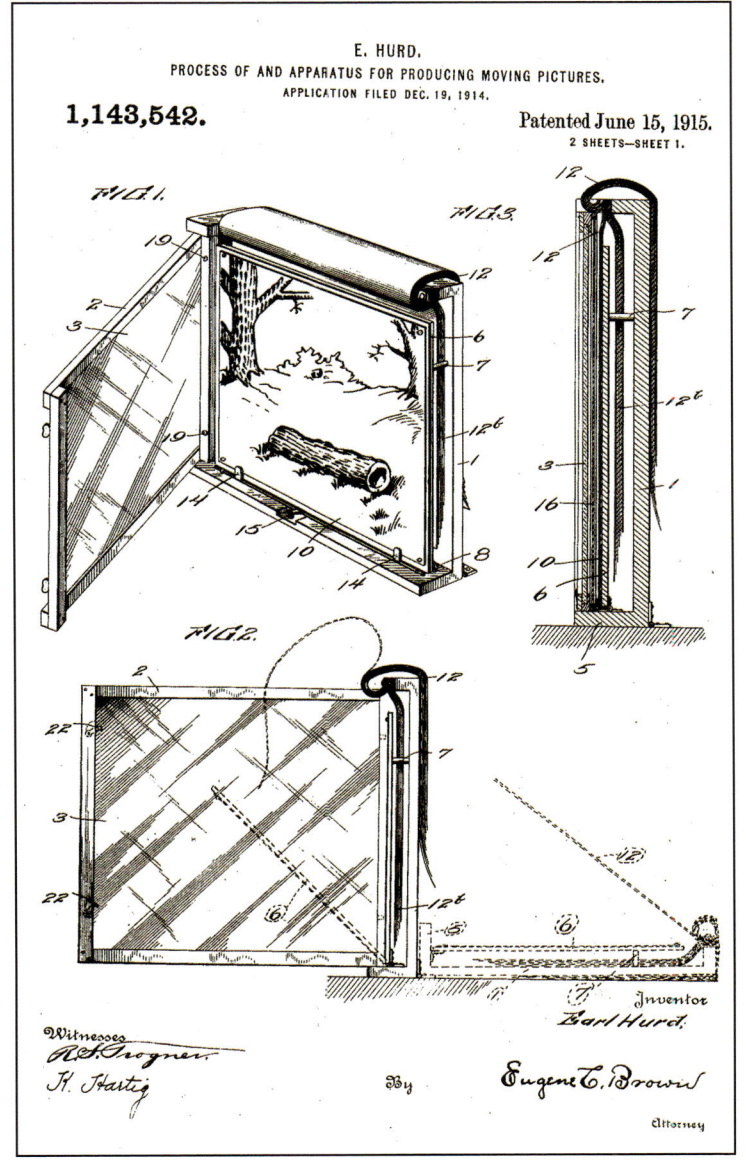

THE WOMEN OF WALT'S WORLD

> *"Every evening after supper my grandmother would take down from the shelf the well-worn volumes of* Grimm's Fairy Tales *and* Hans Christian Andersen."
> — Walt Disney

A boy was born to Flora and Elias Disney of Chicago, Illinois, on December 5, 1901. The fourth of the five Disney children, Walter Elias Disney had a younger sister and three older brothers, including Roy, eight years his senior. From an early age, Walt's creative tendencies were evident. "The world of make-believe has always delighted and absorbed me," he declared, "ever since I was a little boy." Throughout his adolescence and early professional life, several key women held significant roles in developing the fundamental creativity of this young boy who would grow to become one of the world's most beloved storytellers.

The evening tradition of his grandmother's shared stories formed a lasting impression on young Walt Disney. "We would gather around her and listen to the stories that we knew so well we could repeat them word for word. Grandma Disney was quite a wit and she was always into mischief," recalled Walt. Stories and humor were a strong legacy that stemmed from the Disney family. "After my grandmother's death, my mother continued the evening story hour. It was the best time of the day for me." Walt Disney's mother, Flora Call, was a good-natured and gentle-hearted woman. "He loved her very dearly," recalled Walt Disney's oldest daughter, Diane. "He said she had a wonderful sense of humor. His father had none."

By all accounts, growing up in the Disney household was a typical blend of hard work and gentle warmth. Diane Disney Miller observed, "I think that what Dad got from his father was a strong work ethic. From his mother I think he learned warmth and humor."

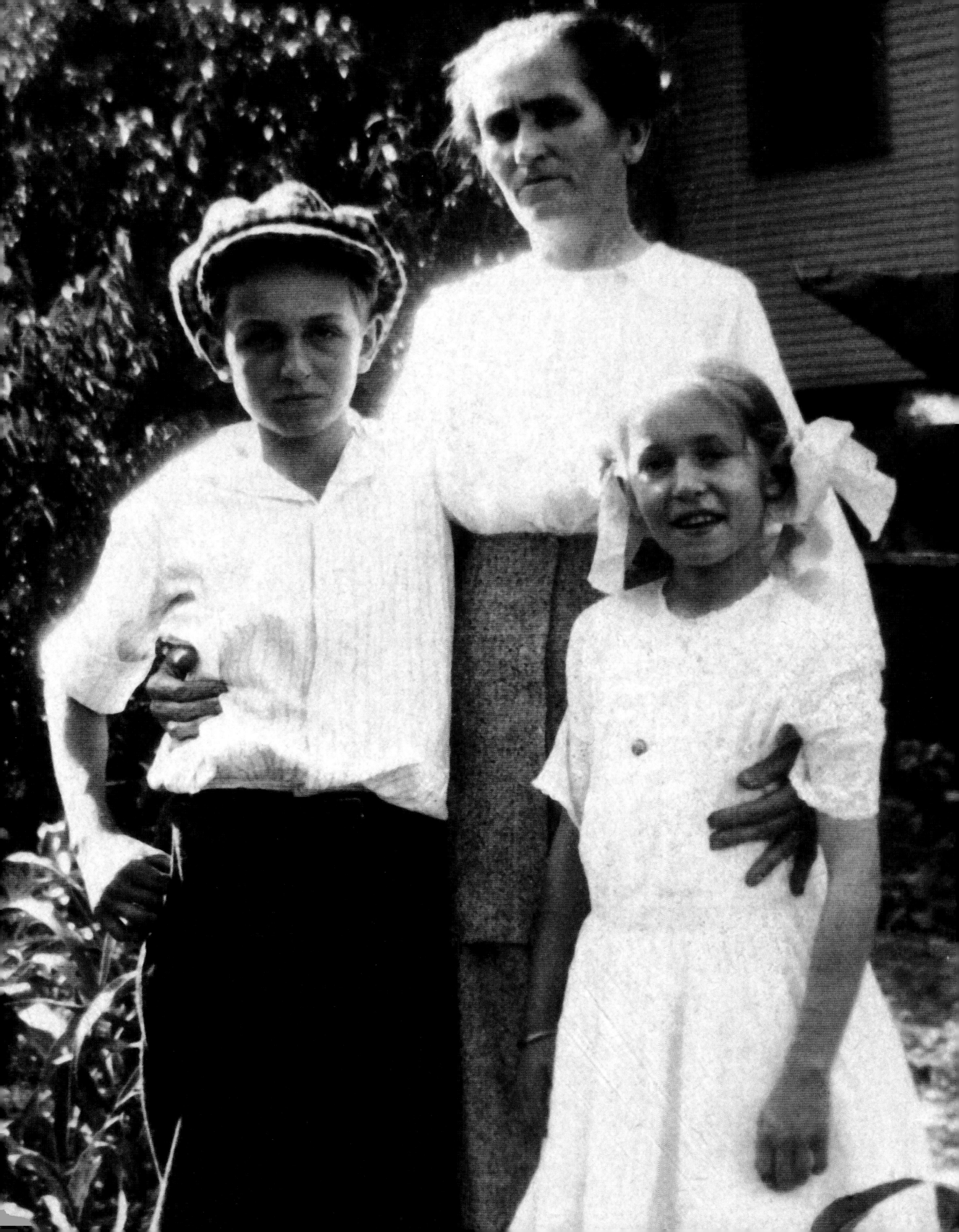

The Women of Walt's World

Page 29: Young Walt Disney with his mother, Flora, and sister, Ruth Disney.

This page (left): Walt Disney's paternal grandmother, Mary Richardson Disney; and (right) Walt Disney's aunt Margaret, wife of Robert Disney.

Walt, the youngest of the Disney boys, was closest in age to his younger sister, Ruth. "My mother and father gave us every opportunity for education," Ruth recalled, "and for extra education when we showed interest and talent." Writing in 1988, Ruth recalled of her mother, "Before her marriage she had taught school. She was a great family manager and very capable of doing anything she undertook. My father liked to have her take care of most of the money matters. She had a very even temperament, never displaying anger or lack of self-control, yet she held her own in any situation requiring it." Flora held a sweet disposition, which helped the Disney family when finances were difficult.

PAPER TABLETS & SPILT MILK

"I had an aunt, who was a very favorite aunt that would come and visit us," Walt recalled. "She was the only one of all the aunts that I would call 'Auntie.' Her name was Aunt Margaret. She'd bring me a big tablet and these Crayola things. I was always drawing Aunt Margaret pictures. And she'd just rave over them, and she'd keep them." Roy remembered her as "a wonderful character with an infectious laugh, and she was always enamored with Walt from the time he was a little fellow." Many years later, when Walt got his first job as an artist at the Gray Advertising Company in Kansas City, Walt Disney recalled, "The first thing I did, I ran down to see Auntie Margaret. I thought that Auntie would be happy to know after all that encouragement she gave me that somebody was paying me fifty dollars a month to draw pictures." Sadly, at that point, Margaret was elderly and frail from fighting a bout of pneumonia. She was unable to share in his excitement, and Walt later recalled that it was "kind of a heartbreak." Margaret died shortly thereafter.

Dorothy Disney-Puder knew Walt as the youngest of her three uncles, who adored her. Dorothy was often a willing participant in Walt's early attempts at filmmaking. "I can remember him doing cartooning and experimenting with the movie camera," stated Dorothy. She recalled her starring role, at five years old, in one of her uncle's earliest films. "He had me stroll down the walk in front of the house carrying a full milk bottle and wheeling my baby dolly carriage. I pretended to accidentally break the bottle, spilling the milk over everything. And then he reversed the film so that I backed up, and the milk came back up into the bottle."

"WANTING-TO-DO" VS. "HAVING-TO-DO"

While still a student in Kansas City, Walt Disney found himself in the classroom of an extraordinary teacher, Daisy A. Beck. Reflecting on his favorite teacher in a 1955 article of the *California Teachers Association Journal*, Disney noted, "Getting through the seventh grade was one of the toughest trails of my whole limited span of schooling. You've got to be good to teach the seventh. You have to know a lot about human nature in the bud. How to get into stubborn resisting young minds and how to make the classroom complete with everything that tends to lure a kid's attention to the world outside. That's the kind of teacher Daisy A. was. She had the knack of making things I had thought dull and useless seem interesting and exciting. The outstanding teacher of my youth instilled in us a permanent sense of wanting-to-do rather than having-to-do."

Other teachers during Walt's time at Benton Grammar School also held importance to Walt, including art teachers Katherine Shrewsbury and Ora E. Newsome, as well as Ethel Fischer. The lasting impression of these early educators on Walt Disney was evident in the lifelong correspondence Walt exchanged with Daisy Beck. She later married, becoming Mrs. W. W. Fellers, and continued teaching until retirement, though as Walt reflected in 1955, "persons like Miss Daisy A. . . . never retire from your memory."

THE DOUGHNUT QUEEN FROM NEUFCHÂTEAU

During his time as an ambulance driver at the end of World War I, young Walt found a kindred spirit in the form of Harriet Alice Howell. A professor of elocution at the University of Nebraska

Left: Daisy A. Beck as a young schoolteacher; and (right) Harriet Alice Howell.

in Lincoln, forty-four-year-old Howell volunteered as a canteen worker for the American Red Cross with the outbreak of the First World War. Posted in the small village of Neufchâteau in eastern France, Howell met a young Walt Disney in the later days of the war. Walt recalled, "[Howell] was respected by everybody. She had a wonderful canteen." Thriving on the interaction with the young soldiers who visited her canteen, Howell recalled, "The little notice at my door said, 'Doughnuts for the dough-boys. Fried-fresh-free.' They used to come for miles around."

Walt Disney maintained a warm friendship with Howell over the years. Dubbed the "Doughnut Queen from Neufchâteau," Howell visited and regularly corresponded with her old friend, bestowing upon him the battered flag that once flew over her Red Cross canteen in France. Howell wrote to Walt, "I have a deeply cherished wish that each year on December fifth, at least, this flag may wave over the Disney lot." Walt's daughters, Diane and Sharon, annually ensured this cherished flag draped over the entrance hall to their Woking Way home on his birthday.

With the outbreak of World War II, Howell once again returned to volunteerism by aiding the British War Relief Society. Her correspondence continued with Walt throughout the war, but on July 6, 1944, one month after D-day, when the allied landing at Normandy turned the tide of World War II, Howell suffered a stroke. She passed on the afternoon of July 8. Her honorary pallbearers included General Pershing and Walt Disney.

LAUGH-O-GRAMS

A young animating entrepreneur in Kansas City, Walt Disney was busy with his newest venture, Newman's Laugh-O-grams. Contracted to animate six short cartoons with the Tennessee branch of Pictorial Clubs Film Distribution, Walt was creating his take on a series of short fairy tales, the first of which was Little Red Riding Hood.

A former bookkeeper and film booker at Select Pictures Corporation, twenty-six-year-old Nadine Simpson was working at the Film Exchange in Kansas City. Simpson lent copies of their latest Film Exchange short films for Walt's staff of artists to study. Animator Rudy Ising recalled, "When Nadine would get us one of the *Aesop's Fables*, we'd run it. I'd cut out a whole repeat of the film and look at how they'd change it back. And we'd look at some of the timing of the animation. Then Nadine and I would splice it together again and put it in."

Simpson joined the Laugh-O-gram staff full time on November 11, 1922, as a stenographer-bookkeeper. "That's what they called them in those days," Simpson stated. "Now they call them secretaries. But in those days they were stenos. . . . [I was paid] twenty-five dollars a week. That was good money though in those days. I mean for that time it wasn't bad." The office at Suite 218 was "very nice," according to Simpson who recalled her office was "like a little reception room." On the other side of a partition near her desk was "Walt's drawing board. And we could see him sitting there at the drawing board all day, drawing."

ALICE IN CARTOONLAND

Trying every option to keep his studio going, Walt Disney studied what audiences were watching in order to "crack the market. I desperately tried to get something that would get ahold, to catch on," Walt remembered. "They had the cartoons working with humans, which was originated with Max Fleisher, so I thought the reversal of that. I took a real person and put them into the drawing. I made this first one called *Alice's Wonderland*."

A precious little girl with long ringlet curls, young Virginia Davis frequently modeled for ads, which "they used to flash . . . on the screen . . . in between motion pictures," she later recalled. When Walt Disney spotted one of her ads in a local theater, he found his star. Davis remembered that Walt "called my mother and told her that he had this idea, and he came and talked to her." Recounting his idea of a young girl named Alice and her adventures in "Cartoonland," Walt explained that "he wanted to make a test film, and he would have to take it around to see if he could sell the idea." Agreements were signed on April 13, 1923, and the small team began to assemble the scenario.

ALETHA REYNOLDS

One week after Nadine Simpson's arrival, Walt hired his first female artist, twenty-year-old Aletha Pearl Reynolds. Living with her parents, Reynolds was a commercial artist on staff for five months. As Rudy Ising recalled, she fulfilled a number of roles, including "editorial work in the collection of squibs reproduced . . . under the head or title of 'Lafflets.'" Working at Laugh-O-gram at a salary of twelve dollars per week, Reynolds was hired to do "general artwork . . . including the inking-in of films and the making of tracings, sketches and drawings of scenes." The earliest Laugh-O-grams were photographed primarily as lines inked on paper with occasional use of celluloid. The later surviving shorts from this series utilized inked characters. In Kansas City, Reynolds worked on paper as well as celluloid, which was purchased in large sheets and cut or trimmed to the proper size, then punched with holes to assure the proper alignment of the drawings.

The lively group continued to complete their contracted films. However, when the Tennessee branch of Pictorial Clubs went out of business, there was no money to cover their mounting debt and expenses. To keep the various productions and income flowing, Walt Disney scrambled to take odd jobs, cultivate projects, and create additional films. Without adequate income, various members of the small staff began to find paying work elsewhere, cut back to part-time, and worked for reduced pay to keep the tiny Laugh-O-gram studios open. By April 8, 1923, Reynolds had quit her job and found commercial work elsewhere.

Filming of the live-action scenes took place at the Laugh-O-gram studios and at the Davis home. Little Virginia wore her mother's favorite tam cap, and her aunt Louise played Alice's mother for the bedroom scenes, which were filmed in Davis's own bedroom.

Production was basic, and the approach to creating "Cartoonland" was simple. As Animator Hugh Harman recalled, the sets "were nothing more than white [backdrops] on which cartoon scenes were painted." Davis recalled Walt's process for achieving the correct responses from her: "With no sound, he could be giving me directions at the same time [he was filming], and then he drew in everything later. All the work was done in pantomime. He'd say, 'A bear's chasing you!' Or 'Look sad—you've just been hit over the head.' He'd tell me these things and then I'd react." Working with Walt was easy for Davis. "Did you ever have a favorite uncle, someone you idolized who would . . . just light up your day? That's where I was with Walt." Unfortunately, production soon stalled as Walt ran out of money and scrambled to find work to keep his fledgling studio open.

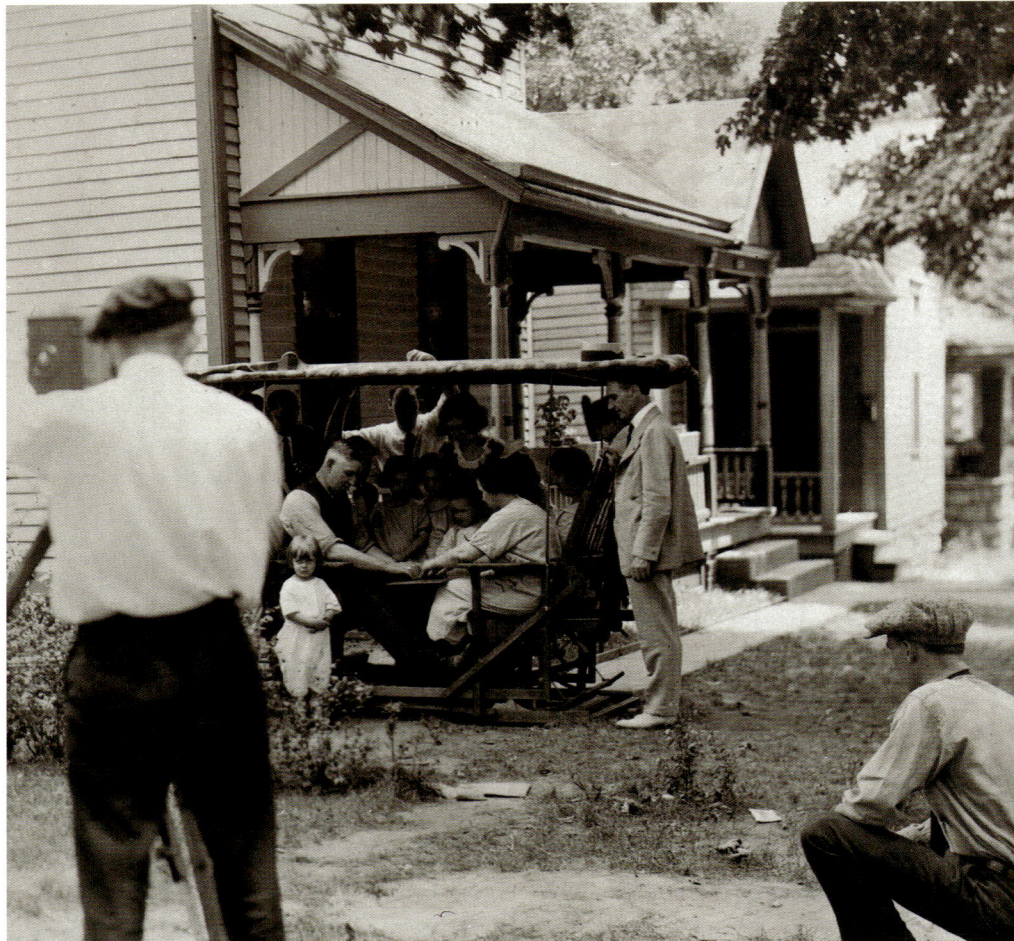

SUPPORTIVE FRIENDS IN KANSAS CITY

Walt Disney met Dr. John V. Cowles Sr. and his wife, Minnie, while pursuing side work to keep the lights on at Laugh-O-grams studios. The local physician and his wife assisted in raising much-needed capital for Walt and helping to pay bills when the Laugh-O-grams studios folded. Dr. and Mrs. Cowles continued to support and encourage Walt for some time in a variety of ways, as Minnie would often bring sandwiches for the little studio staff in the evenings. Walt later recalled Dr. Cowles told him, "Stay with it, Diz. Here's another few dollars. I hope it'll get you by."

Years later, Walt was able to repay the kindness and support of the Cowles family. According to their family lore, Mickey Mouse's sweetheart, Minnie, was named after Mrs. Cowles. In the 1950s, when Walt Disney Studios was thriving with live-action films, Walt Disney hired John and Minnie's son, John V. Cowles Jr., an architect, to work on film sets and design the one-eighth-scale railroad Walt ran through his Holmby Hills backyard.

BANKRUPTCY & REBUILDING

While still a young man dealing with financial challenges, Walt Disney remembered this time period as "probably the blackest time of my life." No longer able to afford the three-dollar rental on his apartment, Nadine Simpson remembered that Walt's "landlady kicked him out." He moved into the Laugh-O-gram studios and slept on the sofa in his office to save money. Once a week, Walt would walk to Union Station, where a dime garnered him soap, a towel, and a bath. Food presented another challenge. "A couple of Greeks who ran a restaurant below my office gave me

Page 32: Walt Disney (kneeling) and Red Lyon filming the birthday party of Minnie Jeanett Cowles, daughter of Dr. John and Minnie Cowles (1922).

This page (left): Nadine Simpson Missakian; and (right) Edna Frances and Roy Disney.

credit to run up the food bills for a time," Walt recalled. When the restaurant stopped extending credit, Simpson said, "Tell him that I will type his menus for him in exchange for your meals." Simpson continued to keep the boys in food by giving them tickets to an event at her church. "They had an ice cream social there . . . when the boys were starving. They gave out tickets for prizes and I gave them two dollars worth of tickets. I want you to know that they won a ham and all of the groceries. I think Monsignor Tierney must have just fixed that up so they could win."

Working for Walt, Simpson recalled that she "never heard him say a cross word." He was full of "drive and ambition and [was] always a very humble, very unassuming, very pleasant person." Walt recognized Simpson's kindnesses and found a lasting way to thank her. "He kept telling me to go to a good young photographer he knew and have my portrait made," Simpson recalled. "I said I didn't want to and it was a long time before I finally went." Sparks flew as Simpson and the photographer, Baron Missakian, began dating and later married.

As animation began on *Alice's Wonderland*, Simpson stayed with the little company "until they folded" on Tuesday, May 1, 1923. Roy Disney later noted of Walt's circumstances, "In six months' time he delivered the pictures, and when the first one came due, the damn company went into bankruptcy. . . . If Walt had gone on like that in life, he never would have gone anyplace." Roy, who was living on the West Coast receiving treatments for his health at the time, wrote to his younger brother Walt, "Kid, I think you should get out of there." Looking to rewrite his story, Roy suggested Walt move to Hollywood and stay with their uncle Robert. "My only hope," Walt discerned, "lay in live-action movies."

ROY'S SWEETHEART, EDNA

Roy's Disney's longtime girlfriend, Edna Francis, was born on January 1, 1890, in Reese, Kansas, near Wichita. "My father was a railroad man," Edna recalled. "We moved around. They used to be railroad towns, but…some of those places aren't on the maps." The Francis family later lived just a block west of the Disney's in Kansas City. Living with her widowed mother and two brothers, Edna worked as a clerk at Travelers Insurance Company. Roy Disney served in the Navy with Edna's brother, and they worked together at the First National Bank in Kansas City. "My brother brought Roy home and they took my sister and me to a dance," Edna recalled of their first meeting. "Roy had only two dance lessons and he wasn't very good."

Shortly after Edna and Roy began "going together," she was introduced to Walt. Edna remembered the young teenager was "so good looking—he had such big brown eyes. It was Roy's younger brother that was interested in cartooning and drawing, and he was so interested in what he was doing." When Roy headed west for health reasons in the early 1920s, Edna invited Walt to dinner occasionally and looked out for him, as he struggled to make ends meet while starting his fledgling film company in Kansas City. The night before Walt left for California, Edna invited him over to her home and fed him a good warm meal. The next morning, Walt recalled, "[I] packed all my worldly goods in a pasteboard suitcase . . . [and] with that wonderful audacity of youth," boarded a train for Hollywood. A new beginning lay ahead!

THE 1920s

1920
- Women vote in the United States for the first time
- The Harlem Renaissance begins
- The League of Nations is established
- Prohibition begins

1921
- The Roscoe "Fatty" Arbuckle scandal casts a shadow on the film industry
- The lie detector is invented
- Margaret Sanger creates the American Birth Control League
- The first Miss America Beauty Pageant is held in Atlantic City

1922
- Insulin is discovered
- Rebecca Fulton is the first woman in the US Senate, serving for one day
- The tomb of King Tut is discovered
- The Triangle Shirtwaist Factory fire kills 146 women and children

1923
- The Charleston dance becomes popular
- *Time* magazine is founded
- The Teapot Dome scandal unfolds
- Alice Paul proposes the Equal Rights Amendment

1924
- The first Winter Olympics are held
- J. Edgar Hoover is appointed FBI director
- Miriam Fergus of Texas and Nellie Ross of Wyoming are the first women elected governor
- The flapper dress is the leading style for women

1925
- Performer Josephine Baker becomes a global sensation
- Hitler's *Mein Kampf* is published
- F. Scott Fitzgerald publishes *The Great Gatsby*
- The Scopes "Monkey Trial" occurs

1926
- A. A. Milne publishes *Winnie-the-Pooh*
- Legendary magician Harry Houdini dies after being punched
- Gertrude Ederle becomes the first woman to swim the English Channel
- The Book-of-the-Month Club sends out its first selections

1927
- Babe Ruth sets the single-season home run record
- The BBC is founded
- *The Jazz Singer* debuts and ushers in the age of sound
- Charles Lindbergh flies solo across the Atlantic Ocean

1928
- Amelia Earhart becomes the first woman to fly across the Atlantic Ocean
- Bubble gum and sliced bread are invented
- The final volume of the original edition of the *Oxford English Dictionary* is published
- Penicillin is discovered

1929
- The first Academy Awards are held in Hollywood
- The stock market crashes and the Great Depression begins
- The Saint Valentine's Day Massacre occurs
- Virginia Woolf's *A Room of One's Own* is published

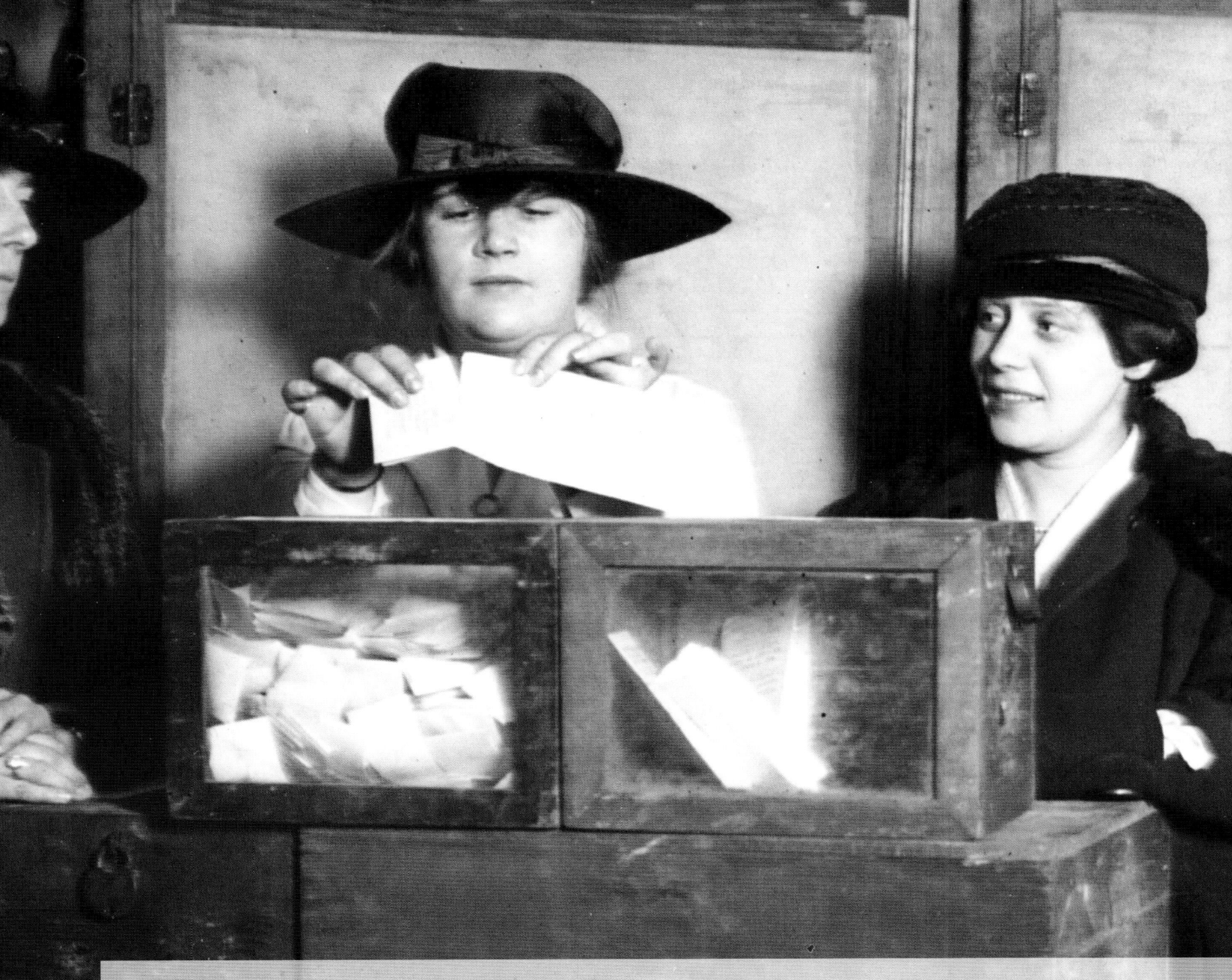

THE JAZZ AGE

The Twenties roared! Shaking off the devastation and loss of the "war to end all wars," Flappers and Modernists defined the progression of the times. Louis Armstrong and the sounds of "jazz" were born in New Orleans, while the flowering youth of the day managed to find libations at the height of Prohibition. Women, daring to be seen in pants, first adorned magazine covers in ski-suit attire as early as 1927.

Finding work within office settings became a respectable option for many young middle-class women. The First World War created problems for office workers, but unions soon garnered various privileges within industrial settings. The once-wide gulf between white-collar and factory workers began to narrow.

Mobility became viable for average families, and travel was all the rage as Henry Ford mass-produced his Model Ts and defined the eight-hour workday within a five-day workweek. The legendary Route 66 opened up the American West, funneling the masses to a burgeoning film industry located in a sunny valley of orange groves called Hollywoodland.

Divorce rates grew as women left the stability of small towns and sought independence in the city. New derogatory terms for women entered the English language, reflecting how society was reacting to the way women were exercising their newfound independence. Terms such as "dumb Dora" and "chunk of lead" defined undesirable women, while "red-hot mama" and "sexy" appeared in basic vocabulary for the first time. One might want to spend time with a "sheba," or the female equivalent of the male "sheik" a la screen heartthrob Rudolph Valentino.

In 1923, a young Animator named Walt Disney made his way to California.

KINGSWELL BEGINNINGS

"We lived in one room and Roy did the cooking."
— **Walt Disney**

Late in July 1923, a young Walt Disney boarded a train in Kansas City and headed west to start fresh in Hollywood. "I came to Hollywood broke," Walt recalled. "My ambition at that time was to drop cartoons and get into the live end of the business." Setting up residence with his uncle Robert Disney, Walt intended to forge a career as a film director. Pounding the pavement of the early motion-picture industry with his first film footage tucked under his arm, Walt occasionally took work as a film extra to get by. "I just didn't get anywhere," Walt recalled. "I was going day by day. Those were tough times but I learned a lot." By September 1923, Walt declared, "I was back making my cartoons."

Building a makeshift camera stand in his uncle's garage, Walt reinitiated his animated efforts, setting meetings around Hollywood to interest studios and distributors in his cartoon fairy tale adaptation, *Alice's Wonderland*. Yet the answer was a resounding no, as animation was considered an oddity and not suited for Hollywood. Though he was rejected by the industry, fate soon smiled on Walt with the acquaintance of a friendly neighbor who would indirectly alter the course of young Disney's life.

Hazel Sewell, the vivacious wife of a local pharmacist, began helping the fledgling Animator with his cinematic endeavors. "She worked with Walt," noted Hazel's granddaughter, Nannette Latchford, "when they were just starting out in the garage." Hazel frequently pitched-in with the brothers earliest productions, as well. This neighborly gesture forged a lasting bond with Walt Disney, as Hazel Sewell would eventually become his sister-in-law and later redefine the artistry of animation.

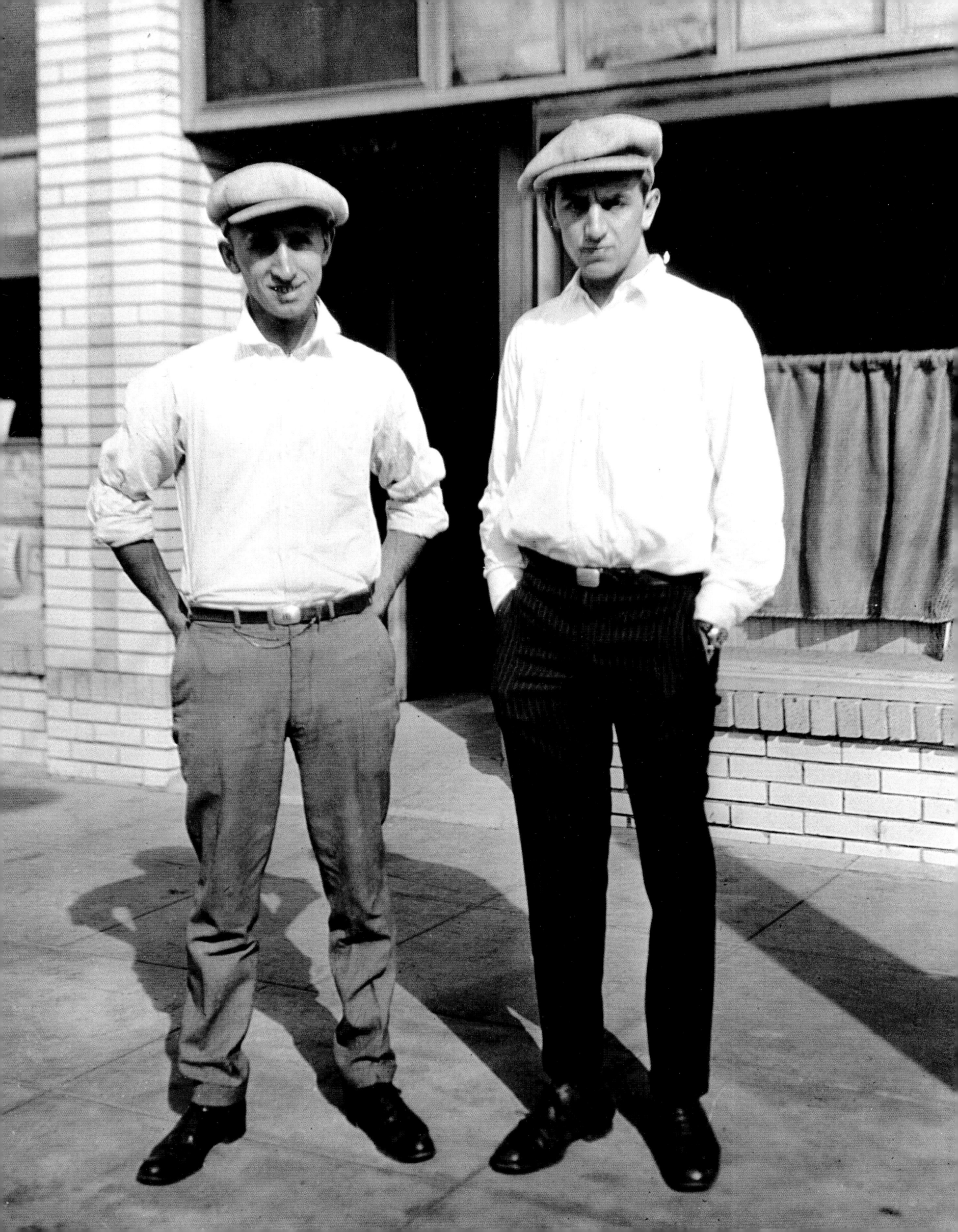

Kingswell Beginnings

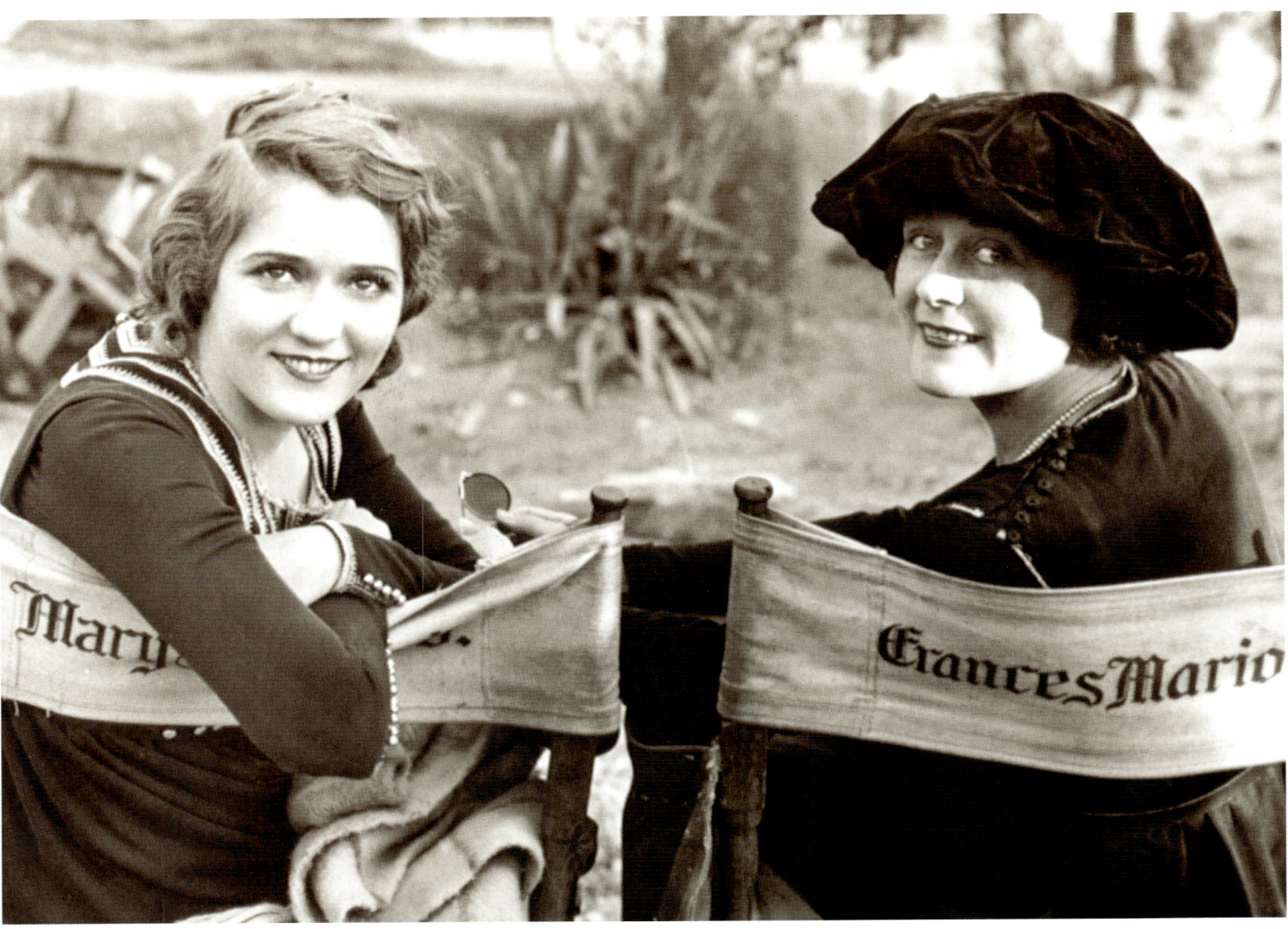

Pages 34/35: Suffragists casting their first votes in the 1920 election.

Page 37: Roy and Walt Disney standing outside their Disney Brothers Studio located on Kingswell Avenue, in Los Feliz, California, circa 1924.

This page: Silent film superstar and producer Mary Pickford and legendary screenwriter Marion Frances.

"SILENT" LADIES

In the earliest days of the "flickers," women wielded more power in front of and behind the camera than at any other point in history. Leaders of the silent-film industry included a powerhouse array of women, including groundbreaking actresses/producers Mary Pickford, Gloria Swanson, Clara Kimball Young, and Norma Talmadge; award-winning screenwriters Frances Marion, Anita Loos, Elinor Glyn, and June Mathis; producer/director Lois Weber; directors Dorothy Arzner and Alice Guy-Blaché; and many other women who shaped the earliest development of film production. Pickford enlightened a generation of Modernists, stating, "I like to see my own sex achieve. I think I admire most in the world the girls who earn their own living. I am proud to be one of them."

These pioneering women of the earliest silent era made their mark, but when Hollywood's main studios began to form in the early 1920s, many positions of power and roles behind the camera were quickly cut off from women. As the film industry grew and roles become defined, a male-dominated hierarchy took hold in Hollywood. Several key women continued to hold positions as writers and certainly as stars of the day, but women were soon relegated to limited fields, including acting, costuming, and editing, which were all deemed "acceptable" work for women, particularly in the silent era. One of these early noted women of Hollywood later sparked a chain of events that would have an interesting impact on the life and career of Walt Disney.

A PIONEERING LADY CUTTER

Born October 27, 1898, in Oklahoma, Blanche Irene Sewell moved to Southern California from Idaho in 1910 with her widowed father and younger siblings to live with her aunt Viola. While still in high school, Sewell had aspirations to be an actress but found a more technical summer job by bluffing. Friends who worked in a film laboratory brought home some film negative and showed her how to clean it. Now able to say she'd had experience handling film negative, Sewell quickly made her way to the production side of celluloid as a negative cutter and earned between twenty and twenty-five dollars per week at her newly "skilled" profession. Living within close proximity to the Vitagraph and D. W. Griffith studios, Sewell took a position as an assistant to Viola Lawrence, cutting a number of films for director Allan Dwan.

Initially deemed the work of women because of the detailed "knitting-esque" qualities involved with the process, editorial jobs became more male dominated with the advent of sound, as it was now considered a technical role. Despite these perceived changes, a few key women still rose to the top of the field. A protégé of Margaret Booth's, Sewell quickly established herself and became one of the more noted editors at MGM. With her deft shaping of emotional stories, Sewell was later considered to be Irving Thalberg's favorite cutter. Silent-film star Constance Talmadge spoke highly of Sewell as well, declaring "her judgment to be almost infallible, her critical ability supreme, and the courage of her convictions unfaltering."

Feminine First

MARGARET WINKLER

The industry of animation owes its popular prominence to one woman who championed these early celluloid novelties. Producer and Distributor Margaret J. Winkler almost single-handedly turned inked drawings into internationally beloved characters. "I had several years' good training for it, too, working for Warner Brothers," Winkler told a Boston reporter. "I was secretary to H. M. Warner, and in that capacity traveled from New York to the coast and around to film conventions, meeting film people and learning much."

Harry Warner recognized Winkler's keen business acumen, and as Warner's studio divested itself of novelty shorts, Harry suggested she handle the distribution of Max Fleischer's Out of the Inkwell series. Winkler soon expanded her responsibilities from distribution and moved into producing.

"I started out as an independent with one subject to sell, Felix the Cat," she later noted. "Before that, Felix hadn't done very well, but I had good luck with him." Winkler's savvy business acumen "put life into Felix." After languishing in a limited run on the Paramount schedule, the fledgling cartoon became a household name and worldwide phenomenon within a year. Developing promotional campaigns, handling press releases, advertisement, and full distribution for titles, Winkler built her company into the leading international distributor of animation and short subjects.

Acceptance wasn't always forthcoming from male peers. The *Boston Traveler* voiced the frequent attitudes Winkler dealt with: "Gentlemen, one of the few remaining fields in which you have not had to face feminine competition is being invaded . . . [by] a woman distributor!" Winkler, however, was ready to counter this view: "I think the industry is full of wonderful possibilities for an ambitious woman, and there is no reason why she shouldn't be able to conduct business as well as the men."

Dubbed the "Live Wire" in the American trade papers, Winkler was the only woman in the male-dominated world of movie distribution in the earliest days of cinema. During her brief years distributing and producing short subjects, Winkler brought three of the leading animated characters to the screen and established animation as a viable entertainment commodity. She also launched the craze for character merchandise which escalated when a Felix doll accompanied Charles Lindbergh on his 1927 Atlantic solo crossing.

As the first female member of the Motion Picture Producer's Guild, Winkler was often mistaken for a man as she operated and corresponded with those in the industry as M. J. Winkler, adding a fictitious "J" to her name to disguise her gender and not frighten theater owners. When the managing director of New York's Strand Theatre professed to being so impressed with the comics distributed by M. J. Winkler, he wrote to "Mr." Winkler requesting "he" appear at his theater for further booking consultations.

Winkler later recalled the owner became somewhat scared when "Miss" Winkler arrived. "But he soon got over it, after I convinced him that M. J. Winkler was none other than myself."

Sewell was described in a *Photoplay* magazine article: "Small, slim[,] and brown-eyed, she looks like the kind of woman men protect and ranks with the top males in her profession." She was the only woman editor at Metro Studios and handled their A-list talent's titles. This role called on her to directly touch the highly flammable cellulose nitrate product and was detailed in the following manner: "She works in slacks or dark skirts, with a white glove on her left hand to protect it from the thousands of feet of oily film that pass through her fingers in the course of a day."

Sewell built a solid reputation as a cutter in an industry that was quickly defining the axiom, "a picture can be made or ruined in the cutting room." Noted for her ability to assemble a tight, emotional story from thousands of feet of footage, Sewell was dedicated to her craft. As *Photoplay* reported in its piece: "On a deadline she works through the night, and in any case never gets home before 8:30. Too tired to eat, she bathes, takes a glass of wine and reads herself to sleep."

In the early 1920s, Sewell was cutting for leading silent-film director Marshall Neilan. He took Sewell with him to Metro Studios, where she established herself as a major cutter. Around this time, Sewell welcomed her older brother Glenn, his wife, Hazel, and their young daughter, Marjorie, to Hollywood and lived with them in a house near Metro. It was in the very same neighborhood where Sewell's sister-in-law befriended two young filmmakers who set up their first studio three blocks away on Kingswell Avenue.

"WE CAN DO BUSINESS"

Having corresponded earlier with the cartoon producer in New York, Disney wrote again to Margaret Winkler—the leading distributor in the burgeoning world of cartoons, who turned the animated character Felix the Cat into a major cinematic star. Walt's August 1923 letter to Winkler sold his approach: "In the past, all cartoons combining live actors have been produced in an amateur manner. . . . It is my intention to employ only trained and experienced people for my casts and staff that I may inject quality humor, photography and detail into these comedies." Winkler responded, "If your comedies are what you say they are and what I think they should be, we can do business."

At Winkler's request, Walt sent his film off to New York for review while continuing to work on the animation camera stand in his uncle Robert's garage. Roy Disney was still in the hospital recovering from tuberculosis, and as Walt recalled, "Both of us were unemployed, and neither could get a job. We solved the problem by going into business for ourselves. We established the first animated cartoon studio in Hollywood."

Sisters-in-law Hazel Sewell and Blanche Sewell, circa early 1920s.

Roy Disney recalled, "Most parents then were stage-struck with their kiddies and all imagined their child [being] another Baby Peggy at the time. The father quit his job of thirty years in Kansas City." Selling their family home, they made their way to California.

Conducting research on his distributor, Walt wrote to Harry Warner regarding Winkler's "responsibility and standing." Warner's response clinched the alliance:

> Miss M. J. Winkler was my secretary for a number of years, and since she has gone into business for herself, she has done very well, and I believe she is responsible for anything she may undertake. In my opinion, the main thing you should consider is the quality of goods you are going to give her, and if that is right, I don't think you need any hesitancy in having her handle your merchandise.

After receiving further word on Winkler's credentials, Walt signed and sent back the completed contract to begin production on his Alice Comedies.

EARLY ALICE ADVENTURES

Disney Brothers' first film, *Alice's Day at Sea*, involved live-action sequences that bookended a lively animated underwater sequence with young Alice dancing and cavorting with various sea creatures. Walt Disney's first heroine was the highest-paid employee at the tiny studio. In addition to writing and directing, "Walt did all the animation," Roy recalled, while he himself "cranked the old-fashioned camera." Hundreds of images a day were rendered in order to complete the thousands of drawings necessary for the film.

Kathleen Dollard assisted in various roles as the live-action filming was being shot on location. She then retreated to the tiny Disney Brothers office to ink Walt's drawings onto nine-and-a-half-by-twelve-inch cels and then fill in or "blacken" the areas to an opaque level, as needed, before Roy photographed the completed cels.

Roy's earliest ledger records the various expenses the fledgling studio incurred late in 1923: a five-dollar monthly rent paid to McRae & Abernathy, the light bill, the purchase of a desk, rental on costumes, various office supplies, and the purchase for an ad in the daily newspaper, the *Los Angeles Examiner*, placing a notice for HELP WANTED.

In early December 1923, Walt, who had just turned twenty-two, still had extensive work to do on *Alice's Day at Sea*, so they hired their second employee, Ann B. Loomis. Loomis started on December 8, assisting Walt, Roy, and Dollard on a part-time basis to "blacken" (ink) and "opaque" (paint) the nearly ten thousand cels required for the animated sequence of the movie. Once the footage was edited within the live-action sequences, *Alice's Day at Sea* was completed and shipped on December 15, 1923, to Margaret Winkler's New York office for distribution.

Working in close quarters and putting in long hours, Dollard often supported her bosses beyond their work at the little studio. "She was a wonderful cook," recalled Dollard's nephew, Jim Hatlo. "My mom liked to tell the story that when Roy and Walt were essentially starving young artists in Southern California, Aunt Kathy would cook dinner for them. They'd come over and she'd fix them meals because she felt sorry for them."

Quickly expanding their production operation, on Monday, October 8, 1923, Walt and Roy rented a small space in the back of a real-estate company just a few blocks west of their uncle Robert's house. The tiny space behind the McRae & Abernathy Company at 4651 Kingswell Avenue was just big enough to "swing a cat in," and at five dollars a month, the brothers had their first offices. On October 15, upon reviewing Walt's first Alice cartoon, Winkler sent a telegram to Walt stating: "Believe series can be put over will pay fifteen hundred each negative for first six." Walt Disney was in business!

ALICE'S KINGSWELL BEGINNING

On October 16, 1923, Walt and Roy Disney signed their first contract with M. J. Winkler Productions to distribute and promote a series of Alice Comedies (which would mix animation and live action); the very first animation studio in Hollywood began virtually overnight. The first order of business for the twenty-two-year-old Animator and his older brother was to secure their little leading lady.

Walt dispatched a letter to the mother of Virginia Davis, the young actress who had played Alice in Kansas City, where production of the series had commenced. "Walt wrote that he had a distributor and proceeded to do a great selling job to my mother," Davis later recalled. Clarifying the circumstances, Walt's letter noted that Winkler insisted that "who ever I star in the series must be under contract to me for a series of twelve pictures with option on further series."

Lillian Bounds and Walt Disney outside the Disney Brothers Studio on Kingswell Avenue.

Feminine First

KATHLEEN DOLLARD

On October 16, 1923, the Disney Brothers Cartoon Studio officially began. After securing their lead actress, the final accomplishment on the first day was to hire their very first employee—an Ink & Paint girl. She was a twenty-three-year-old named Miss Kathleen G. Dollard, who was hired to "blacken" cels.

A young girl from Ohio, Dollard made her way to Hollywood in the early 1920s to find work in the motion-picture industry. "She was my favorite aunt," recalled Jim Hatlo, son of internationally syndicated cartoonist Jimmy Hatlo. "Aunt Cassie—as I called her—was eight years older than my mom so she was an auxiliary parent for her younger siblings. She literally had a twinkle in her eye and always had an impish expression. She had a wonderful, dry sense of humor. Very vivacious and a lot of fun to be around."

Living with her sister's family, Dollard became friends with another outgoing "gal," Hazel Sewell. Several months later, a couple of Sewell's friends were in need of someone to work in their new studio, and Sewell recommended her friend Dollard to Walt and Roy Disney to help them start their company.

Though initially hired as a "blackener" to trace and darken the penciled lines of each drawing with ink onto celluloid, Dollard was soon spending her days doing numerous other tasks needed to complete a production. She worked in the back of the tiny offices of McRae & Abernathy at a makeshift station that was cobbled together in the same manner as Walt's animation desk and Roy's camera stand, which were fashioned from a little purchased lumber and dry-goods cartons that had been "swiped from an alley off Hollywood Boulevard."

Upon delivering their first picture, the Disney brothers soon expanded their operation as Winkler's correspondence signaled the beginning of a supportive alliance. "While *Alice's Day at Sea* is satisfactory, still I think you will agree with me that there are some improvements to be made along general lines. . . ." Encouraging Walt, she continued, "I am confident, however[,] that as we go along, each subject will grow better. The progress that I have made in the film industry has been due to the fact that I know just what my people want and I always try to give it to them with the assistance of my organization."

Production then began on the next Disney short, *Alice Hunting in Africa*.

It seems that with the long hours of production, Dollard's warm sense of humor and good home cooking were an enticing combination. As Hatlo recalled, "My mom always said, 'Walt actually proposed to her; however, my aunt Kathy turned him down because she didn't think he'd amount to anything.' We always had a good laugh about that."

STAFFING UP: LILLIAN BOUNDS

In January 1924, Walt interviewed another young woman who applied as the third "blackener" with the fledgling studio. Kathleen Dollard had recommended a stenographer who was the sister of her friend Hazel Sewell. Hazel's sister Lillian Bounds, the youngest of ten siblings, left Idaho in December 1923 to live with the Sewells after attending business college.

"I came to Los Angeles to visit my sister and was living at her place near Vermont Avenue," Lillian (later Lillian Disney) recalled. The Sewell home, at 4618 Hollywood Boulevard, was across the street from the empty lot where Walt and Roy filmed scenes for their Alice Comedies. "A friend of my sister [who] was filling in celluloids, worked in the tiny studio that Walt and Roy had and she told me that they were going to hire another girl to do the inking and painting."

Lillian later remembered Dollard's warning: "[She said,] I have a job for you, but I'm telling you about it on one condition: don't vamp the boss." Lillian continued, "Since the studio was within walking distance from where I was living, it sounded like a good opportunity. So, I went over to see Walt."

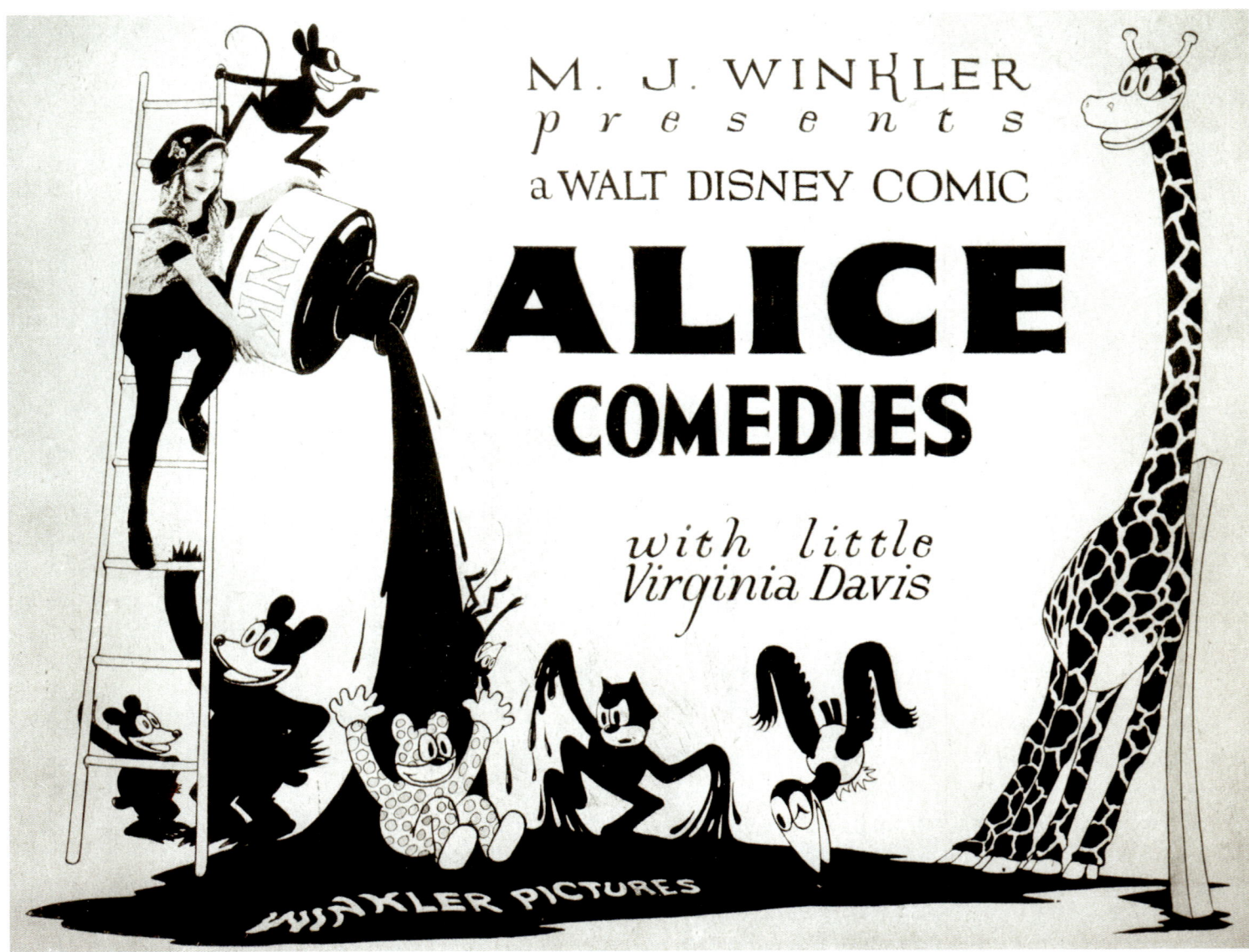

Early 1920s lobby card for Disney's Alice Comedies distributed by Margaret J. Winkler's distribution company.

Joined by her niece Marjorie Sewell so she wouldn't get lost on her way to the studio, Lillian walked from Hollywood Boulevard north onto Vermont Avenue and then continued two blocks to Kingswell Avenue, where the Disney Brothers Cartoon Studio was another two doors down. Lillian met Walt for the first time at that interview in the "tiny office" in the "little studio," recalling, "I had no idea of vamping him, I never had such a thought in my mind. He didn't even have a suit. [He] was wearing a brown coat, sweater, raincoat, and pants."

Lillian "got the job at fifteen dollars a week," earning as much as her friend Dollard. She decided "to work for [the Disneys] because . . . I didn't have to take the bus" to get to work. Lillian started right away on Monday, January 14, 1924. "When I first went to work for Walt I was painting cels—black-and-white in those days, of course," she noted. "I had no particular artistic ability, but the job didn't really require any. It was just a matter of copying."

With the volume of drawings to translate onto celluloid, the work was tedious and the hours were long. "She was a very pleasant little thing," Roy, Lillian's future brother-in-law, remembered. "She was short, blonde. We knew her sister who was living here . . . and through that connection she came to work at the studio. It was only a little temporary work. It wouldn't last long. Lasted the rest of her life."

GUIDANCE, SUGGESTIONS & PRAISE

Production, meanwhile, continued on the studio's next short, *Alice Hunting in Africa*. It was completed and quickly sent off to Margaret Winkler in January 1924. Later that month, Winkler responded by providing guidance and encouragement for the fledgling filmmaker when she wrote, "One thing that I must say on this subject is that you have made a great improvement on your timing. The comedy situations, however, are still lacking and I wish you would do your utmost to see that this end of the series be improved." Striving for quality with a supportive hand, Winkler continued, "Please let me impress on you that future productions must be of a much higher standard than those we have already seen. By this I mean only the comedy situations. The other parts being satisfactory."

To meet the quality level Winkler was seeking, Walt's production schedules were extended, and the new "blackening" hires often worked late to help with whatever might be needed. In February 1924 the staff at Disney Brothers increased to six with the addition of their first Animator, Rollin C. Hamilton. At the rate of fifteen dollars a week, Hamilton helped complete and ship the young studio's third film.

As she achieved worldwide distribution and success with her other animated interests, Margaret Winkler continued to coach the young filmmaker to make what she felt her audiences sought.

The first star of the Alice Comedies, Virginia Davis.

"Having been in this business as long as I have been, and knowing just what the public wants, I feel that you will not take the wrong attitude when I try to help matters.

"Improvements along the lines which I suggest, must ultimately help you as well as myself," Winkler noted, "and after all we are both striving for one common purpose, to bring into being something which is just a little bit better than anything that anyone else can make. Toward this end I want to help you all I can."

Upon delivering *Alice's Spooky Adventure*, Walt wrote to Winkler, "I am trying to comply with your instructions by injecting as much humor as possible and believe I have done better on this production." Heeding Winkler's advice, Walt had professional critics attend previews for feedback and noted in his correspondence to Winkler, "We are making big improvement on each one." Continuing with his long-range vision for the Alice Comedies, Walt added, "It is my desire to be a little different from the usual run of slap stick *[sic]* and hold them more to a dignified line of comedy."

Winkler's previous mentoring and support was productive. And all the parties benefited. "I will be frank with you," she wrote Disney, "and say that I have been waiting for just such a picture as *Alice's Spooky Adventure* before using effort to place it in all the territories throughout the world. It may make you feel good to know that on the strength of this last one I was able to place the series in Southern New Jersey, Eastern Pennsylvania, Delaware, Maryland, and [the] District of Columbia. I am very optimistic about the future and believe that we have something here of which we will be proud."

RIGHT NEXT DOOR

With production quickly beginning on their fourth short, *Alice's Wild West Show*, and with recent staff expansion, the studio space at the back of the real-estate office on Kingswell Avenue was no longer viable. For thirty-five dollars a month, a lease was negotiated on the adjoining storefront at 4649 Kingswell (with a separate garage rented for seven dollars a month). On Sunday, February 24, 1924, the entire studio staff moved next door to their new location.

The tiny storefront, no more than eighteen feet wide and thirty-six feet in length, consisted of two main areas: the camera room and the outer animation/office area. Kathleen Dollard, Lillian Bounds, and Ann Loomis were positioned at desks lined against the wall separating the entrance and near the storefront window for better light. Walt, Roy, and the Animators were aligned in desks along the opposite wall towards the back of the space. Roy's camera stand filled the back corner opposite the tiny restroom, which was often used as a darkroom. The large table in the camera room "had two levels," recalled Thurston Harper. "The lower level [was] used to store clean cels." Here, Roy would "punch holes in the cels and animation paper by use of a hand-operated machine," and later Ub Iwerks would "set up his special drawing board to do all the posters, backgrounds, letter all titles, subtitles[,] et cetera," Harper recalled.

Winkler's support continued:

I am happy to see the spirit in which you take any criticism

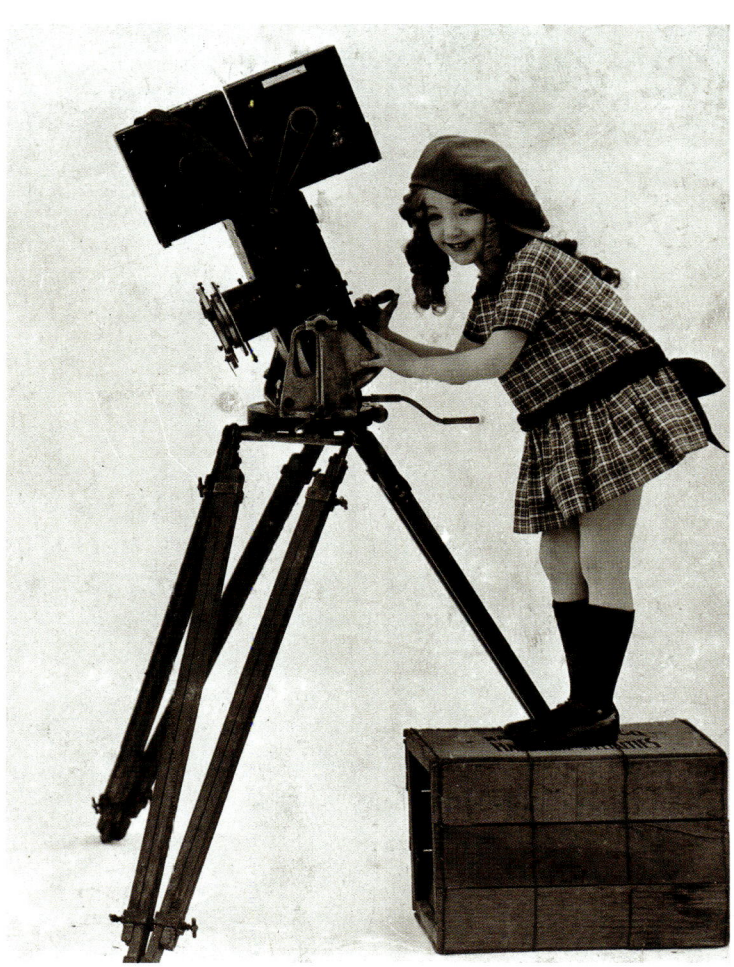

that is sent you. I think you can appreciate as well as I that we are both striving toward one goal: to make a cracker-jack *[sic]* single reel. *Alice's Wild West Show* is a very good subject. If you can continue to make each following one at least as good, I am sure there will be absolutely no fault to find.

PRODUCTION PROGRESS

Once the staff had settled into their new shop, production continued on their fifth Alice Comedy, *Fishy Story*. Production roles were defined with Walt directing and Roy filming. Rollin C. Hamilton and Walt animated while Dollard, Lillian, and Loomis inked each of the cels utilizing a minimalist palette of black ink made from watered-down paint.

As a young girl growing up in the neighborhood, Ruthie Tompson (who later worked at Disney Studios in Ink & Paint), often wandered past the fledgling studio. "Two girls sat at the window painting on cels in different shades of gray: it was Lillian and [Walt's] sister, Ruth. They were kind of isolated—sitting in the window—away from the guys. They must have had a wall there 'cause I just saw them through the window," said Tompson when later recounting her childhood memories. "So I stood and watched for a long time, and every time I went by, I stopped."

Tompson's curiosity opened quite a door when, "one of the days that I went by, Walt came out and he said, 'Why don't you go inside and see what's going on.' That's when I went in; that's all I needed.

"I walked in and everyone was really nice," added Ruthie. "They were great with us kids, very patient, letting us look around." Providing a glimpse into an interior that was never photographed,

44 | Kingswell Beginnings

Page 44 (top): Walt's photo of the studio staff outside Disney Brothers Studios in June 1925 with Irene Hamilton, Rudy Ising, Hazelle Linston, Ub Iwerks, Rollin Hamilton, Thurston Harper, Walker Harman, Hugh Harman, and Roy Disney.

Bottom: Interior diagram of the Disney Brothers Studio on Kingswell Avenue highlighting where the "blackeners" sat.

Tompson later described the layout this way: "[When] you [would] come inside, these fellas, five or six guys[,] were seated all around. That was the personnel. They were drawing pictures like mad. Roy was the cameraman and he was out in the back. That's where I used to sit on the bench beside him while he was shooting. I was more impressed with the lights and the people and everything. I stopped often on my way home from grammar school."

There were other lures at the studio for Tompson as well. "Going into the 'animation lab' was a wonderful experience—watching the drawings being made and later traced onto celluloid with pens, and then painted onto celluloid with pens, and then painted," she said. "What kid wouldn't be fascinated? I'd sit there all day. Roy would finally say, 'Don't you think it's time for you to go home for dinner?'"

Despite an increasingly demanding schedule, the tiny production crew remained quite approachable and accessible, as Ruthie Tompson recalled. "I think it was Walt [who] herded all the kids in the neighborhood, and we all played games and did things. He was just another kid with us," according to Tompson. "He was very friendly and very enthusiastic about everything."

Soon, the kids in the neighborhood were woven into the various adventures Alice encountered in the ongoing series. "My cousin and my sister and I all got in the act," Tompson continued, "and he [Walt] gave us each a quarter for. I thought they were taking animation pictures, but it turns out that at that early stage he was trying to combine live action with cartoons." The Disney Brothers Cartoon Studio's contract at this point called for one new Alice Comedy a month. Their next film, *Dog Catcher*, featured many of the children in the neighborhood and marked the last Alice picture that Walt animated. Roy continued to operate the Pathé camera on the animated sequences, while veteran cinematographer Harry W. Forbes was added to shoot the live-action sequences.

EXPANDING STAFF

Recognizing the demands of increased production, Walt wrote to his friend from Kansas City, Ub Iwerks, to persuade him to move to Hollywood and join their studio. "At the present time I have one fellow [Ham Luske] helping me on the animating, three girls [Kathleen, Lillian, and Ann Loomis] that do the inking[,] etc., while Roy handles the business end—I have a regular cast of kids that I use in the picture[,] and little Virginia is the star."

In June 1924, Walt held a series of successful meetings with Margaret Winkler in Hollywood, while the rest of his staff continued working on the seventh short of the series, *Alice the Peacemaker*. Newly married to Charles Mintz, Margaret Winkler Mintz, and Walt negotiated a new contract to continue the series, and the Disney Brothers Cartoon Studio quickly expanded. In addition to Iwerks, Mike Marcus, a professional cameraman who moved from Minnesota, joined the team as Roy's replacement on the animation camera. Later, the last employee hired at the Disney Brothers Cartoon Studio was a janitor by the name of John Lott. Lott was brought in to help Roy with prepping cels for reuse.

"The sink was used for washing cels," Thurston Harper recalled, "which Roy attended to until he hired a part-time worker when his tasks were too many and varied. Roy kept books and accounts, punched holes in cels and animation paper, and spelled Mike Marcus on the camera, along with any duties that came up."

STUDIO COURTSHIPS

Shortly after young Lillian Bounds started at the studio, Walt began courting her. "We used to work nights," Lillian recalled. "By that time he had a Ford roadster with one seat and an open back. He used to take us home after work. When he started taking me home from work I began to look at him like he was somebody." It seems the feelings were mutual, as Lillian noted. "He took the other girl [Kathleen Dollard] home first."

Then one night, while the two were working late with some dictation, "suddenly, [Walt] leaned over and kissed me." Lillian laughed when recounting this. "[Blushing] was customary in those days."

To Lillian, Walt was a "wonderful man in every way: kind, gentle, brilliant, lots of energy and humility. He was enthusiastic about everything. He never thought anything would turn out badly." In Lillian, Walt found "a good listener. I'd talk to her about what I hoped to do, and she'd listen."

Roy and his longtime girlfriend, Edna Francis, who was still working at the Travelers Insurance Company in Kansas City, continued corresponding long distance. In 1923, as Disney Brothers was mounting its first production, Edna lent Walt money after he sent her a letter stating, "Don't tell Roy I wrote, but we need money. Can you lend us some, and if so, how much?"

Barely drawing an income, Walt put all his funds back into the company. The highest-paid employee at the fledgling studio, Lillian lent her support when times were tough. "I would fold up the checks and keep them. Roy would say to Walt, 'Find out if Lilly has any checks' when they needed money!"

Properly courting Lillian was problematic as Walt lacked presentable clothing and transportation. "When he got to my sister's, he was embarrassed to stop in front of the house," said Lillian. "One night he asked, 'If I get a suit, can I come and see you?'" Lillian agreed. "When he came to my house [he wore the suit]. It was gray-green and double-breasted, and he looked very handsome. My family liked him immediately. There was never any embarrassment about Walt. He met people easily. He was completely natural.

"Our first big date," recalled Lillian, "was *No, No, Nanette*, which was appearing in Los Angeles. [At] about that time, Walt bought a secondhand Moon automobile . . . We used to take rides in it out to Pomona and Riverside [towns in California], driving through the orange groves; and Walt would take me out to Tea Rooms on Hollywood Boulevard."

Lillian and Walt worked together by day and dated after hours. "I didn't have any other dates and neither did he," recalled a smitten Lillian. "He was fun even if he didn't have a nickel. We would go to see a picture show or take a drive. We would drive up to Santa Barbara [California] sometimes." Lillian saw the dreamer in Walt very early on: "He was always talking about what he was going to do."

THE MRS. DISNEYS

In the spring of 1924, Roy proposed to his longtime girlfriend, Edna Francis. "He just sent me a telegram," recalled Edna. "He said—'Gosh . . . about time we got married.' That's a funny way to do it . . . but it worked out fine." After traveling to Hollywood with her mother several months before their wedding, Edna occasionally helped out with "blackening" and "opaquing" the cels for the little studio.

Of the relationship between her husband and Walt in the early days of the Disney Brothers Cartoon Studio, Edna noted, "[Walt] never thought of anything, I think, except his work and Lilly. Walt knew what he wanted to do. He was the originator of all these things and Roy was the one that was always financing—helping him out that way . . . Roy worked too—he worked the camera—did everything he could."

Young Walt Disney would frequently join the Sewell family for Hazel's fried-chicken dinners. By January 1925, Blanche Sewell was also living with her brother, Glenn; his wife, Hazel; their young daughter, Marjorie; and Lillian Bounds. A warm home full of family, the Sewell household was a lively place. "It was a family full of laughter, full of music," Diane Disney-Miller noted. "They really knew how to have a good time." These boisterous Sewell dinners also offered the opportunity for Blanche to cast her editor's eye to stories Walt was shaping. Such welcome surroundings appealed more to Walt than retreating to Roy's cooking in their tiny rented room near the studio. "All of a sudden, Walt was at our house an awful lot," recalled Hazel's daughter, Marjorie. "My mother was an excellent cook. They never could really decide whether he was there because of Aunt Lilly or because of my mother's cooking. But I guess it was Aunt Lilly."

For nearly two years of producing animated shorts, Walt made the rounds to the local theaters to see what the other studios were creating. Lillian frequently joined him, but she later recalled one particular event just before they were married. "My sister [Hazel] and I were visiting a friend that night, so Walt decided to go to the movies. A cartoon short by a competitor was advertised outside, but suddenly, as he sat in the darkened theater, his own picture came on. Walt was so excited he rushed down to the manager's office. The manager, misunderstanding, began to apologize for not showing the advertised film. Walt hurried over to my sister's house to break his exciting news, but we weren't home yet. Then he tried to find Roy, but he was out too. Finally he went home alone." Reflecting many years later, Lillian added, "Every time we pass a theater where one of his films is advertised on the marquee I can't help but think of that night."

In April 1925, Edna became Mrs. Disney in a small wedding at Uncle Robert's house. Lillian was Edna's maid of honor, while Walt was Roy's best man. Edna and Roy set up house in a furnished apartment near the Kingswell studio, and the new Mrs. Disney frequently assisted with office work as well as cel "blackening." Roy E. Disney, the only child of Roy and Edna, recalled, "Mother was a true partner with my father. She traveled with him . . . to visit colleagues [and] she'd cook them chicken dinner at our home. She was good friends with many Disney employees; she had a unique gift for understanding people." Not too long after, Walt proposed to Lillian and on July 13, 1925, Walt and Lillian were married at her family home in Idaho. Her niece Marjorie remembered that Lillian "giggled throughout the entire ceremony." The couple honeymooned at Mount Rainier and stopped off in Portland, Oregon, where Lillian met Walt's parents, Flora and Elias. "They were very warm and friendly and loved Walt very much," recalled Lillian. "They wanted him to be happy, which is why they were so happy with me."

As was the fashion for a new wife at the time, "I quit work when we married," recalled Lillian, "but would join in at the studio if there was an emergency." They set up house together in a one-room apartment near the studio: "Our first home was a little apartment off Vermont Avenue." The young Disney couples quickly settled into marital bliss and the rigors of studio life. "Often, he'd go to the studio at night," remembered Lillian. "He had a little office there and I would sleep on the davenport while he worked. Sometimes I would wake up and ask, 'How late is it?' 'Oh, it's not late,' he'd say, even though it was three o'clock in the morning."

Left: Dawn O'Day appearing as Alice in *Alice's Egg Plant*.

Right: Lois Hardwick was Disney's fourth and final Alice.

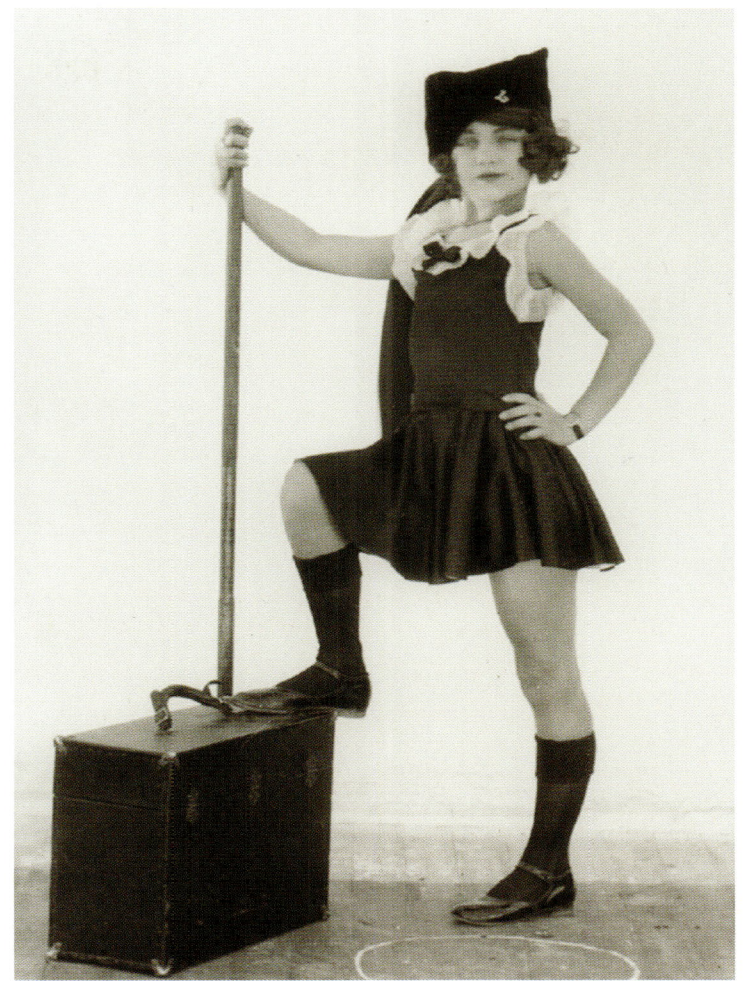

IN FULL SWING

As production continued, the marketing and distribution efforts of Margaret Winkler Mintz in New York continued as well. The Alice Comedies were officially announced in the *Los Angeles Times* with a brief teaser on the fledgling studio entitled "Actors Mix With Cartoons: In Hollywood a young cartoonist by the name of Walt Disney is making a series of twelve animated cartoon productions. Real people are seen acting with pen-and-ink actors."

In August 1924, Walt delivered the eighth Alice Comedy: *Alice Gets in Dutch*. The addition of Ub Iwerks to the small staff, along with growing sophistication to the plots and characters, caused an increase in production costs for the subsequent pictures. As Walt recalled, "We were never interested in how much money we could make, only in how good a job we could do on film." Lillian recalled Walt's focus on quality from the start: "After we had dinner, Walt used to drive around to catch the cartoons at the theaters. He knew what time they were going on and he would drive to each theater. He studied them all, Felix the Cat, Out of the Ink Well, etc., and tried to learn from them."

Production continued to complete the initial contract with Mintz, and by December 31, 1924, the Disney Brothers Cartoon Studio was under contract for their second series of Alice Comedies, calling for eighteen films. To achieve this larger order, Walt and Roy sought to cut production costs with their live-action talent expenditures, opting to pay their talent per day of actual work versus placing her under contract. As Virginia Davis recalled, "My mother said, 'Never mind.'" Choosing to move on from her role as the first Alice, young Davis' career continued for a number of years with a variety of occupations. Years later, when Hollywood was no longer calling, Walt offered Davis a role within the studio's Ink & Paint Department, and she worked there as a Painter from early 1939 to mid-1940.

OTHER ALICES

The Alice Comedies were still the studio's main focus at this time. A number of actresses filled the role of Alice as the series continued for three more years. One, six-year-old Dawn Paris, whose professional name was Dawn O'Day, appeared in only *Alice's Egg Plant* in 1925. As the sole provider for herself and her mother, O'Day also needed to move on to find more lucrative income within Hollywood. "Sometimes there was a part," O'Day later recalled. "There was a bit, there was extra work, there was a large part. It went up and down, and there were terrible times where you didn't pay the rent."

Walt and Roy found their next Alice in Margie Gay, a bubbly four-year-old bobbed brunette. A pint-sized version of the popular silent star Colleen Moore, Gay marked a turning point in the Alice Comedies, and audiences delighted in her animated antics. Gay continued in the role over the next two years, making thirty Alice shorts. Later, when Mintz placed her younger brother George in the role of Production Supervisor for Winkler Pictures, he replaced Gay with twelve-year-old Lois Hardwick. Born in California, Hardwick was the daughter of a laborer, William, and his wife, Frances. By late December 1926, the short *Circus Story* was in production with Walt's fourth and final Alice. As Davis noted about this Alice successor, "Lois Hardwick . . . was a lot older, about eleven years old, and had a lot more training. She was

Early Alice Comedies promotional artwork featuring the third actress to portray Disney's female lead, Margie Gay.

very good." Despite the changing face of Alice over the years, the Alice Comedies established Walt Disney as a viable presence in popular animated cartoon shorts.

EARLY PROCESSES

By June 1925, dramatic fluctuations had occurred within the staffing at Disney Studios. The studio's first hire, Kathleen Dollard, had left several months prior, but by the summer Walt and his brother expanded the staff to meet the demands the Alice production schedule was still placing on the small studio. Some of the new hires were Hugh Harman and his brother Walker, as well as Rudy Ising, who made their way west at the urging of Walt. As Hugh recalled, "Rudy and I decided that it would be a good thing to come [to California], and find out what the Hollywood scene was like." Hugh and Ub Iwerks worked as Animators, Ising began as a cameraman, and Walker (who started on June 24, 1925) was an "blackener."

With the addition of many of his Kansas City "gang" of Animators, Walt quickly expanded his "blackening" forces with the hiring of his sister, Ruth Disney; Hazel A. Linston; and Irene Hamilton, the sister of Animator Rollin Hamilton.

With these additions, production deadlines were being met, but the style of animation was changing. The familiarity of characters and expanding story lines honed the studio artists' work to a more refined approach. "At first, you'd trace the character off a model sheet, but eventually we got out of that habit," said Ising, who later became an Animator at the studio. "Ub was the one that really started that. The model sheets were still made, as sort of a guide. The Animators pinned it up on their animation table, but they didn't trace it anymore because it limited the animation too much."

With this newfound freedom, the Animators' final drawings developed a more fluid and illusionary quality requiring a more refined approach to the "blackening" of the final cels.

TOOLS & TECHNIQUES

Early "blackening" on the Alice Comedies involved nothing more than uniformly outlining a character in ink and filling in any open large areas. Anyone and everyone helped out. But as characters developed specific elements, each of these visual accents had to fall within the exact same place for the same character every time. Increased sophistication of gags and style required imaginative techniques, and the development of inking artistry increased.

The basic tools used in the initial shorts reflected the unpolished look and feel of these early films. For the "blackeners," pens and paints were the tools employed to accomplish the simple ink drawings that went before the camera. Ink pens and basic black paint were purchased at a nearby stationery store. Additional local vendors were the source of the minimal materials and supplies needed. Even Lillian's brother-in-law, Glenn Sewell, the local pharmacist, provided materials to the animation studio start-up. Paper and celluloid were punched to establish the proper registration to keep character movements consistent across all drawings and cels throughout each picture.

Ink & Paint | 49

Elements from Oswald the Lucky Rabbit's short, *The Fox Chase* (1928).

Dick Huemer, who didn't become an Animator with the studio until 1933, noted Walt's earliest efforts to achieve quality: "Disney animation paper originally only had two holes like everybody else's. Then he added slits for better registry."

Throughout the early days in the animation industry, all action was painted on a single piece of celluloid and laid over a single background. With the growing complexity of the characterizations developed in the Alice shorts, the Disney Brothers Cartoon Studio became the first animation studio to use more than one piece of celluloid to a frame of film. Cels could be stacked, allowing multiple layers of characters and movement. Action was broken down across anywhere from two to later five pieces of celluloid for each frame. The earliest cels were crude, as Rudy Ising recalled: "They were made by DuPont, and DuPont actually worked with us on developing them, so the cels got thinner and thinner. But the first ones were, I would say, almost a sixteenth of an inch thick; they were pretty heavy."

During this time, new techniques were put into place that polished the look as well as expedited the animation process. With the development and utilization of "cycles," "tracebacks," and other shortcuts, the Alice Comedies reached a new level of refinement. Tracebacks involved the need to redraw or trace any part of the character or scene that didn't move in the following succession of images. Tracing the original image saved time, and it was critical to be extremely accurate with the traceback from the original drawing to ensure the image appeared static once all the images were animated together. But when translated to cels, even though the character didn't move, the uniformity and energy of the lines still needed to be maintained.

The density of these early cels created problems, particularly when characters changed cel levels. In their book *Walt in Wonderland*, Russell Merritt and J. B. Kaufman explained the limitations experienced with cels of that time: "If an active character stopped moving, and the cameraman overlaid his cel with those of a new character who had assumed the action, the change would be painfully obvious—as with the two quarreling roosters in *Alice's Egg Plant* who keep changing colors."

To address this issue, cel matching was developed utilizing slightly differing shades applied to the different cel levels so the paints would match. Paint "let-downs"—the gradual layered reduction of the primary shade into a series of lighter shades stemming from the primary shade—provided the varied range of colors necessary for cel matching.

The Bray-Hurd Patent Company established patent ownership on every aspect of cel usage within animation. After a lengthy dispute with animation companies in New York, J. R. Bray was seeking licensing royalties for cel usage by the entire animation industry. As his was the only animation house in California, Walt was not involved, but having utilized cel animation for years, he eventually joined in paying the Bray-Hurd licenses. Cost was a constant consideration. Expenditures were kept to a minimum so funds could be returned to each production. Celluloids, a costly and fragile resource, were reused. "We used to wash cels," Ising said. "When the picture was finished, we'd wash the cels off and use them again, and again, and again, until they got too many pen scratches."

HYPERION HORIZONS

> *"We all worked for Walt Disney without knowing he was a 'great man,' because he was a kid along with us!"*
> — Ruthie Tompson

With a renewed contract, production escalated to one Alice short being ready every three weeks. To meet these demands, even more staff had to be added to the little, but growing, studio. Once again, the Disney Brothers Cartoon Studio's production space was turning out to be inadequate. So, on July 6, after considering two different locations, Walt and Roy put down a four-hundred-dollar deposit on a forty-by-sixty-foot lot on Hyperion Avenue, east of their Kingswell location. While both brothers were still newly wed, Walt and Roy oversaw the construction of a one-story building to house their burgeoning studio. Designed strictly for the purposes of animation, the new facility was complete with small partitioned offices for Walt and Roy as well as larger open areas for the Animation, Background, and Tracing & Opaquing departments.

By mid-February 1926, the scrappy young staff of nine had moved into their new customized studio at 2719 Hyperion Avenue. Situated on the northeast corner of Hyperion Avenue and Griffith Park Boulevard, the Disney studios were positioned between a pipe-organ factory at 2711 Hyperion and a vacant lot to the east. Although the new building was not that much bigger than their Kingswell headquarters, it was looked upon more fondly by Walt, who described it as a "little green and white structure with a red tile roof, and a nice little plot of grass in front of us."

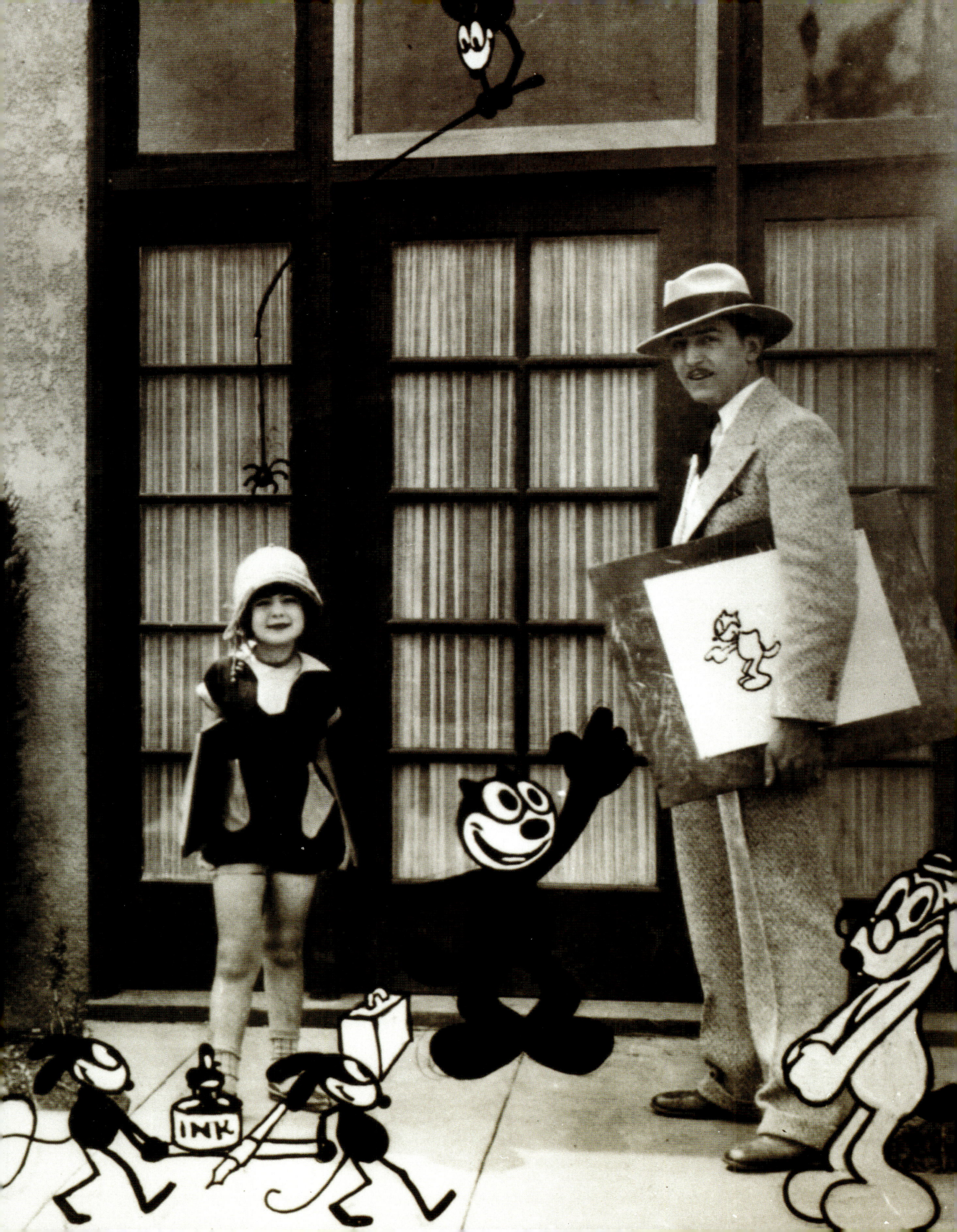

Even inside, the Hyperion Avenue building's layout looked quite similar to the Kingswell studio interior. There was one large room for the artists that was separated with a partition to divide the men and women, while Walt and Roy now had offices near the front entrance. Rudy Ising recalled Walt's office as being complete with a "desk and chairs in walnut, large overstuffed divan, and chair, floor lamp, et cetera." A "large long table for painting backgrounds" lined the western wall near the camera rooms and darkrooms, along with tables for the Animators. Between Roy's office and a small storage area along the east side of the building were tables set for Irene Hamilton and Walker Harman, for tracing and opaquing the cels. Next to the main building, a small shed stored old drawings and canisters of film. To provide some amount of privacy, Walt had a small stage built behind their building where they could continue shooting the Alice Comedies.

With the move to the Hyperion location, the Disney Brothers Cartoon Studio became Walt Disney Studios. Walt and Lillian moved residences as well, and with this added prosperity Lillian recalled, "Our next place was an apartment near Hollywood Boulevard. That was the first time we bought some furniture."

In the earliest days of the film and animation industries, the various jobs and production roles were not yet defined. The atmosphere was informal, and with the pace increasing at Walt Disney Studios, all employees were expected to join in and lend a hand within every phase of production. To meet the demanding schedules, Lillian returned to work—and like everyone in the tiny studio, she had a multifaceted role. "When he moved to the Hyperion studio, I became his secretary," Lillian recalled. "I wasn't very good. I made too many mistakes, but then I wasn't trained to be a secretary. Walt always used to say that I was such a bad secretary he had to marry me."

Page 51: Margie Gay and Walt Disney outside the early Hyperion studio.

This page: Historian Hans Perk's interior diagram of the early Walt Disney Studios on Hyperion Avenue, circa 1929.

MALE "BLACKENERS" & "OPAQUERS"

From the very beginning, animation was strictly a man's industry. Early animation houses on the East Coast hired men as "blackeners." This proved to be a training ground for earnest Animators such as a very young Dick Huemer. In 1915, working for one of the early animation houses, Huemer "got seven dollars a week as a Tracer," he remembered.

But as their skill and understanding of the early animation process developed, and as they generally were unable to achieve the exacting detail required for this aspect of animation, male "Tracers" for the most part were quickly moved up into animation roles. Though men were hired as part of his early staff, Walt also broke new ground with a largely female Tracing & Opaquing staff. "At one time, men did the inking, but it didn't work out too well," remembered Grace Bailey, who later ran the Ink & Paint division for many years. "I think [renowned Animator] Les Clark actually started out in Inking and Painting. I know Walt and Roy used to pitch in and help, too."

As the *Alice Comedies* garnered more attention and reached national distribution status, a twenty-two-year-old "blackener" named Robert Edmunds was added to the staff. After meeting Walker Harman at a dance class, Edmunds occasionally stayed with the Harmans. "He was broke at the time, couldn't get a job here," Hugh Harman recalled. "We were supporting him, so we figured it would be better to get him a job." In addition to his early "blackening," Edmunds holds the distinction of being "the first story man in the cartoon business," said Harman, "starting with [the] Disney [studio]. He would just write his ideas for gags and stories; that was his whole job. Nobody else there had such a job."

Three months later, Edmunds left to become a lumberjack in Northern California. Shortly afterwards, a twenty-year-old cel Painter, Paul Smith, was hired for eighteen dollars a week. Smith, who went on to work as an Animator on the Alice Comedies, later stated, "Walt Disney just lived cartoons; that was his whole life . . . He talked of nothing else, ever." Of Walt's late nights at the studio, Lillian also noted, "He spent the time going over his Animators' work trying to find ways to improve the cartoons."

DISNEY FAMILY LIFE

With production continuing at consistent pace, the Disney brothers enjoyed a level of prosperity. As Lillian recalled, "Roy and Walt bought adjoining lots on [the corner of Lyric Avenue and] St. George Street and built two little houses on them. We put up two little Pacific Ready-cut homes." Walt and Lilly were positioned on the corner lot, and right next door, "Roy and Edna lived in the other one." Early in 1927, Walt and Roy moved into their new homes. "Each one," recalled Lillian, "had two bedrooms, a dining room, a living room[,] and a kitchen." After

Ink & Paint | 53

End card seen on early Oswald animated short films.

staying late one night when he became preoccupied with a production, Walt surprised Lillian on their first Christmas in the Lyric Avenue house with a hatbox tied up with a ribbon. Upon receiving her gift, Lillian was upset Walt would pick out a hat without her approval, but immediately melted upon opening the box and discovering a chow chow puppy inside. "I've never seen anybody so crazy over an animal," Walt later remarked. They named her Sunnee.

Living next door to each other, Lillian and Edna often held dinners together, and the brothers regularly made their way together to the studio just a few blocks away. Even with the close proximity, Walt was always working, striving to improve each production. Likely to keep Lillian company, Walt invited his mother-in-law to live with them. As Marjorie Sewell, Lillian's niece, recalled, "Walt was so good to my grandmother. He treated her like she was a queen. We used to go for rides on Sunday, because Grandmother loved that. And we would always stop in an ice cream parlor on the way home. Walt and I would bring out ice cream cones, including one for the dog[,] and Walt would stand by the curb and feed the dog her ice cream cone."

Diane Disney Miller later recalled her parents' enthusiasm for various activities to combat the pressures of the studio. "He and Mother, in . . . the late 1920s became very athletic conscious and they joined the Hollywood Athletic Club. He always admired and respected athletes tremendously. They took it up with a vengeance. That's when he got his polo ponies and they really sort of plunged into it."

"TOO MANY CATS"

By April 1927, Walt Disney Studios was in production on its fiftieth Alice Comedy short. Mainstream Hollywood was a boomtown, thanks largely to the success of the "Big Five" studios (20th Century Fox, RKO Pictures, Paramount Pictures, Warner Bros., and Metro-Goldwyn-Mayer) firmly establishing the motion-picture industry. These conglomerates owned their own production studios, distribution divisions, and theater chains. The "Little Three" studios—Universal Pictures, Columbia Pictures, and United Artists—were quite successful in their own right, while a number of smaller studios were making their mark in Hollywood as well.

Theater owners were clamoring for new and fresh material to keep their patrons happy. So, although still considered a novelty, animated shorts were becoming a regular staple at movie theaters and a part of their marquee billings. Carl Laemmle of Universal Pictures expressed interest to Charles Mintz in running a new cartoon series featuring a rabbit. As Mintz wrote to Walt, "They seem to think there are too many cats on the market." Margaret Winkler Mintz named the character Oswald and suggested Walt Disney would be the right creative producer for the project.

Walt and several of his Animators sat down to draw various rabbits. The final Oswald Margaret Mintz selected bore an apparent resemblance to another animated character, Felix the Cat. Universal approved, and production quickly began on the Oswald the Rabbit series. As Hugh Harman recalled, "It was

announced to us one morning, when we went in, that we were starting Oswalds. We all got together in Walt's little office . . . and dreamed up this first story."

Production on the studio's next popular series was under way. In early March 1927, with the increasing demands of a new series, Roy and Walt added to their tiny staff once again. A young soda jerk, Les Clark, was hired, and in the first step toward structuring departmental divisions, Walt divided his staff into two separate animation units, with one headed by Ub Iwerks and the other by Friz Freleng. Walt also initiated landmark changes within the realms of Tracing and Opaquing.

> "*Mickey Mouse is, to me, a symbol of independence.*"
> —**Walt Disney**

"A WONDERFUL IDEA"

In late February 1928, Lillian accompanied Walt on a trip to New York for the purpose of renegotiating contracts with Margaret Winkler Mintz's husband, Charles Mintz. Charles now oversaw Winkler-Mintz Productions, as Margaret had left to start their family. The years of creating the Alice and Oswald series granted Walt Disney a level of maturity and belief in the quality of his productions. Walt carried two of his latest Oswald prints with him to "find how things stand [with other distributors] before seeing Charlie." The couple spent time in Chicago before heading to New York. "I went along, too, for a second honeymoon," Lillian added. "It didn't turn out that way."

Lillian recalled that Charles, "was paying them $2,250 a film [, which was] not as much as it sounds when you take the costs out, but still quite a sum of money to us in those days." When Charles countered with a mere $1,800 per film, Walt protested, "But that's impossible. We couldn't make a profit." Dropping an even bigger bombshell, Charles announced he owned all rights to the Oswald series, declaring, "Either you come with me at my price, or I'll take your organization from you. I have your key men signed up." A devastating blow, Lillian recalled, "I was in New York with him when he lost Oswald. He wired Roy that everything was fine and he was coming home." In March 1928, Walt and Lillian made their fateful return to Hollywood. "On the train trip back to California," Lillian recalled, "he started thinking about a mouse as a character. 'They're cute things and they can do anything,' he said. He started playing around with names and proposed Mortimer Mouse. I said it didn't sound very good." Ub Iwerks later stated, "Lilly gave it a name." As Lillian later recalled of their return to Hollywood on March 18, 1928, "Roy came to greet us at the train and he asked eagerly, 'Have you got something lined up?' 'No,' Walt said, 'but I've got a wonderful idea.'"

MOUSE MATES: MICKEY & MINNIE

With a new animated character—Mickey Mouse—Walt, Roy, and Ub Iwerks quickly kicked around a few ideas inspired by the first transatlantic flight by Charles Lindbergh nearly a year earlier. The idea of their new hero debuting his daring exploits within the world of aviation seemed fitting, and as every good hero had a favorite gal, Mickey's first film also marked the birth of Walt Disney's first animated female lead, Minnie Mouse.

The cartoon counterpoint and favorite fancy of Mickey Mouse, Minnie was a dainty powerhouse combining a dynamic blend of gentility and moxie. As Walt later noted about the Mickey and Minnie cartoons, "We kidded the modern scene." The object of Mickey's ongoing devotion, this feminine mouse provided the perfect yin-yang balance, for without Minnie, there simply is no Mickey. "Mickey is so simple and uncomplicated, so easy to understand that you can't help liking him," Walt once noted of his alter ego. "Why, Mickey's even been faithful to one girl, Minnie, all his life."

Wholeheartedly plunging into Mickey's exploits, Minnie is capable of handling herself in any situation—especially when keeping Mickey's over-amorous efforts in line. Lighthearted and clever, Minnie is far from a damsel in distress. From the start, she is an independent female who will "squeak" her mind and put any character in his place, if necessary. But no matter the circumstances, it was clear Mickey was her number one mouse.

The first Mickey and Minnie Mouse cartoon, *Plane Crazy*, was in full production nearly a month later. "There were no storyboards at all," noted Iwerks. "I did the animation for *Plane Crazy*." Working in secrecy and animating on a two-peg registration system, Iwerks remained sequestered from the rest of the staff as they completed the contracted Oswald cartoon through June. "The deserting men didn't know that Walt knew they were going to leave," recalled Iwerks. "I worked in a locked room at Hyperion. I had dummy studies around so that I could make a quick switch if anyone came in." Working into the night, Iwerks produced an average of seven hundred drawings a day, ultimately yielding over eight thousand separate drawings for the film.

Creating a makeshift studio in his home garage on Lyric Avenue, Walt set up three benches for Lillian and Edna Disney and Kathleen Dollard Smith. Now married, Smith, who had been the studio's first employee, returned for just over a month to secretly help with tracing and opaquing the cels for *Plane Crazy*. Edna recounted, "Even when we were sitting at the kitchen table, we used to just paint those cels. It was when they were starting Mickey Mouse and they were trying to keep something secret."

Hazel Sewell worked at the studio during the day to oversee work on the contracted Oswald productions. "Everyone helped Walt," Lillian remembered. "Roy was jack-of-all-trades and Edna and I filled in celluloid." The thousands of completed cels were then shuttled to the Hyperion studio at the end of each day for camera. Longtime employee and cameraman Mike Marcus shot the film at night so the other employees would not become suspicious, and Walt cleaned up any evidence of the work the next morning.

"I just tried to do it as best I could," noted Edna when remembering the voluminous detailed work. Time was of the essence and the hours were long. Roy and Walt pitched in with opaquing

Ink & Paint | 55

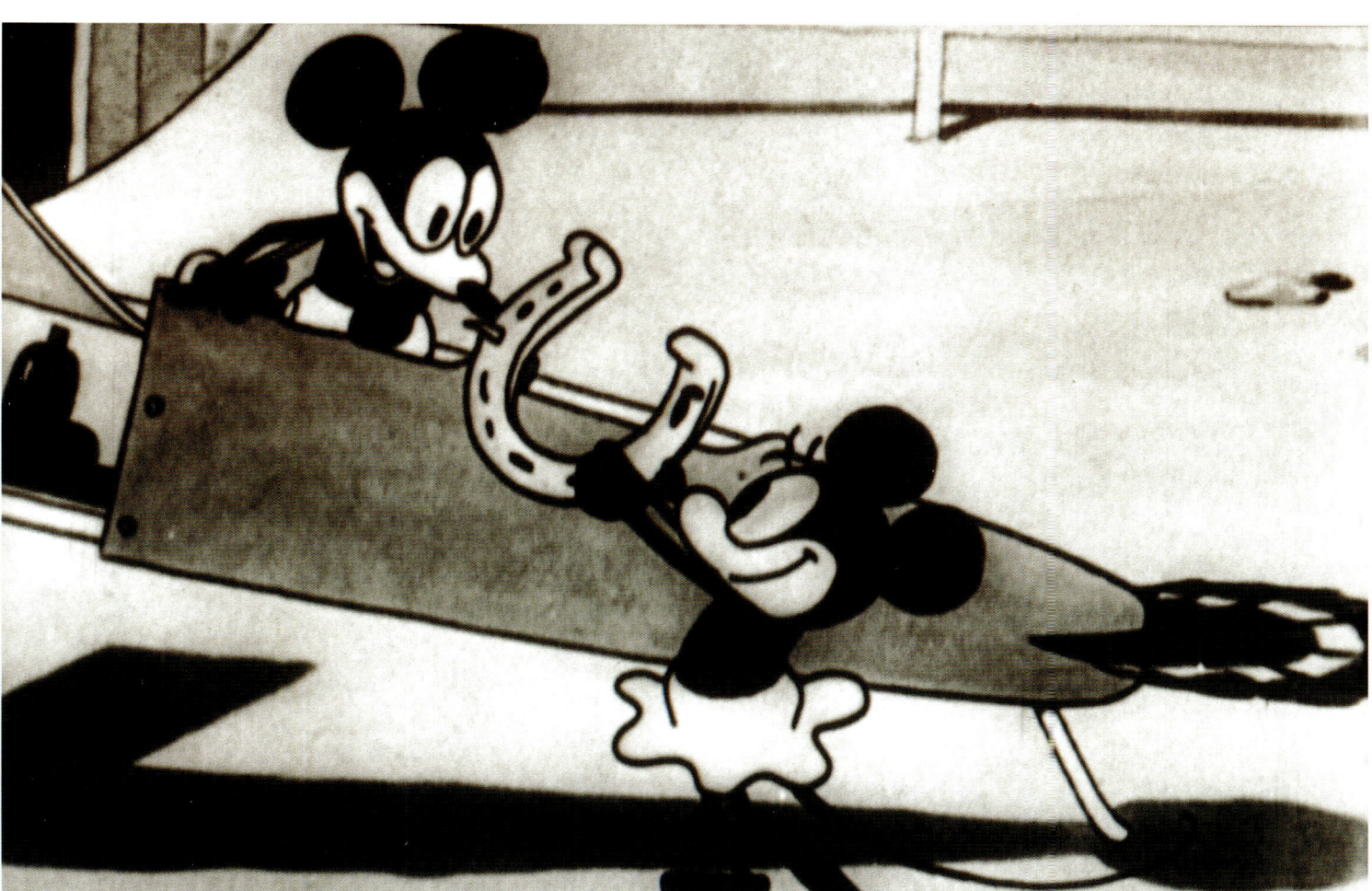

Top: Final frame from Mickey and Minnie's first film, *Plane Crazy* (1928).

Bottom: Mickey and Minnie dance the tango in their second film, *The Gallopin' Gaucho* (1928).

Feminine First

HAZEL SEWELL: INKING & PAINTING

From the beginning, Hazel Sewell, Lillian's older sister and long-time friend of Roy and Walt, supported the young filmmakers with a home-cooked meal or hands-on help whenever needed. "She was the only woman who could stand up to Walt," recalled Nannette Latchford of her feisty and outspoken grandmother. "They had a very wonderful and very fun relationship. She would talk back to him and he would talk back to her, yet they really adored each other and they often joked about 'the two crazy guys who were never going to amount to anything drawing cartoons.' They always had a good laugh about that."

In her time at Walt Disney Studios, Sewell transformed and redefined the most dramatic level of artistry within Ink & Paint. "There weren't classes to take, or teachers out there," reflected Latchford. "This was a new thing to everyone, including Walt and Roy. My grandmother had to define and develop every part of the process she was involved with." Walt Disney placed Sewell in charge of the "blackening" for each film. In this assignment, Sewell became the first woman to establish and run a major division within the animation industry. "She wasn't an artist," Latchford noted, "but she could draw. She was feisty and funny. She was very honest and said what she felt like saying. She had an incredible mind and while she was strict, she was one of the gentlest, sweetest women I've ever known." Under Sewell's direction, the Walt Disney Studios developed and evolved the techniques utilized to complete the final celluloid sheets that went before camera. A team of women—and for a short while, men, including Friz Freleng's younger brother, Allen—worked under Sewell. The initial success of the Oswald series afforded Walt the chance to hire additional staff, and by late 1927, the studio's overall personnel reached approximately twenty, with the addition of new Tracers and Opaquers including Esther Benson, a former maid; Mary Tebb; and Lillian's cousin Ruby Bounds, who helped out for a few weeks.

With these new staff members under Sewell's charge, Walt Disney Studios led the way with the animation industry's first all-female division. Placing women into this role was a logical step. As longtime Disney Painter Jean Erwin later noted, "It's too tedious for a man. They've tried men, doing inking and painting. But you need a lot of patience. You find very few men with that patience that a woman had to do that." In time, women began to transition into other studios, as the "Tracing & Opaquing" realms became a respectable entr'acte into the movie business for young girls.

To meet the expanding animation needs of the early Oswalds, Sewell advanced the sophistication of the tracing and opaquing required for each film. With varying techniques, skill, and artistry required for each discipline, a line had to be drawn between the two realms. Under Sewell's sage leadership, separate divisions were established, techniques refined, procedures determined, and multiple check points instituted to ensure accuracy and quality within the department's output. By differentiating the two disciplines, roles transformed from merely tracing onto cels and filling in the lines into the fine arts of Inking and Painting.

While the materials utilized by Animators—paper and pencils—remained the same, the complexities of Sewell's department increased with each production. Better materials and tools were required to address persistent problems with commercial paints not adhering to cels, or the paint not drying fast enough. In October 1927, Ub Iwerks purchased several stone mills to achieve the desired paint blends. These Charles Ross & Son flat stone mills were exclusively used for the fine grinding of paints, lacquers, and enamels. Water cooled and complete with a ½ horsepower motor, the mills were small but sufficient for grinding and blending batches of paints to achieve the maximum dispersion of the pigments into the various paint vehicles. Iwerks set up a small lab in Sewell's department and developed the earliest formulas mixed with the small mills to refine the paints.

"She was a working mother at an unusual time," Latchford observed. "She enjoyed her work and did it well. She really loved it. For the ten years or so my grandmother was in her role, she saw a lot of change in the company and in animation." For Sewell, transition was under way in all aspects of her life, as she filed for divorce from her pharmacist husband, Glenn, in the late 1920s. Shortly thereafter, she and her thirteen-year-old daughter, Marjorie, moved in with Walt and Lillian. The Lyric Avenue house became a feminine stronghold. As young Marjorie recalled, "Walt was very fond of my mother and very good to me . . . He used to wait for me to come home. He'd be at the top of the stairs when I came in at night, especially if I was late . . . I tell you, I broke the ice for his girls."

Mickey and Minnie play with sound in their third film, *Steamboat Willie* (1928).

when possible. "We worked night and day," Lillian added with a laugh. "We ate stews and pot roasts, which luckily were cheap in those days. We were down so low that we had a major budget crisis when I tripped on the garage stairs and ruined my last pair of silk stockings."

Finally, on May 21, 1928, the Mickey Mouse trademark was registered, and a few days later Walt's first wholly owned cartoon short, *Plane Crazy*, was copyrighted.

As the final scenes of *Plane Crazy* headed into Tracing & Opaquing, Iwerks continued with animating Mickey's second adventure, *The Gallopin' Gaucho*, inspired by the swashbuckling leading man of the silent silver screen, Douglas Fairbanks. The backgrounds and characterizations expanded to a new level of sophistication while the masculine and feminine dynamic between Mickey and Minnie played out on a new cinematic scale.

Walt headed back to New York with *Plane Crazy* to shop his new character. Unfortunately, the response to his animated creation was disappointing. "Everywhere, he got the same story: 'Cartoons are dead,'" Iwerks remembered. "He just could not sell it."

Lillian added, "Nobody was interested in them because talkies had just come in and the theaters wanted shorts with sound."

Hollywood was in a state of transition. Award-winning screenwriter and pioneer in the earliest days of Hollywood, Frances Marion, recalled just how Al Jolson, the star of *The Jazz Singer*, stunned the world with sound. "Jolson's singing aroused the kind of response the audiences never had felt before, and they surprised themselves by applauding his songs as if they were attending a vaudeville show instead of being in a movie theater. It was this reaction which made all the studios grow increasingly uneasy."

Undaunted by his New York experiences, Walt regrouped. "It occurred to me that in a world gone sound-mad since the release of Al Jolson's *The Jazz Singer*, a cartoon with action synchronized to sound would be something of a sensation," he said. "My third Mickey, *Steamboat Willie*, was planned with this in mind."

TIN PANS & SLIDE WHISTLES

Audiences expected people to speak, but not drawings. Walt was insistent the sound would be realistic and believable. "The whole story was kicked together in a night," recalled Ub Iwerks. "I animated a scene to music: Mickey at the wheel whistling rhythmically." With a simple musical setup, sound entered the world of animation.

"By some miracle we managed to figure out the basic method for synchronizing sound and action that we still use," recalled Walt. "When the picture was half finished, we had a showing with sound. A couple of my boys could read music and one of them could play a mouth organ. We put them in a room where they could not see the screen and arranged to pipe their sound into the room where our wives and friends were going to see the picture." Walt sent for Lillian, Edna, and Hazel to serve as an audience. Iwerks's wife, Mildred, as well as Wilfred Jackson's fiancée, Jane Ames, were also in attendance for what was hoped to be an historic event.

Indeed, history had been made. As Walt later relayed, "The boys worked from a music and sound-effects score. After several false starts, sound and action got off with the gun. The mouth-organist played the tune, [and] the rest of us in the sound department bammed tin pans and blew slide whistles on the beat. The effect on our little audience was nothing less than electric. It was terrible, but it was wonderful! And it was something new!"

Final frame from the first of the Silly Symphonies, *The Skeleton Dance* (1929).

Ecstatic with the results, the team repeated their performance with multiple encores to Walt's jubilant shouts of "This is it, this is it! We've got it!" The merry band of synchronized Animators finally wrapped their performance around two in the morning only to find their feminine audience had drifted into the hallway, bored with the overly repetitious show.

November 18, 1928, marked the debut of *Steamboat Willie*. The industry trade magazine *Variety* raved, "This one represents a high order of cartoon ingenuity, cleverly combined with sound effects." Audiences around the world fell in love with this musical mouse. With this success, sound was added to *Plane Crazy* and *Gallopin' Gaucho*, while Mickey, along with his co-star Minnie, later rose to become the top stars of animation. Many years later, Lillian reflected on the triumph of Walt's first mouse characters. "Whenever I see Mickey Mouse, I have to cry. Because he reminds me so much of Walt."

> *We wanted a series which would let us go in for more of the fantastic and fabulous and lyric stuff.*
>
> —Walt Disney

THE "SILLYS"

The advent of sound opened up new possibilities to the film industry, expanding the roles of dialogue and score. Studios began aligning their slates with musically driven narratives, and for animation, the impact was inevitable. The idea originated with Walt's new musical director, Carl Stalling: a series of cartoon shorts with music as the focus with action animated to fit the score. The format provided the perfect platform for every facet of the Disney cartoon factory to grow. Story, Animation, Tracing & Opaquing, and Camera—every division of the little studio was called upon to rise to the demands required for this new approach to the medium.

The first of this series was to feature a band of choreographed skeletons. (The idea originated from Stalling's youth, when he saw an intriguing ad that featured a dancing skeleton.) Though quick and crude in execution, the detail and animation were groundbreaking. Beginning January 1, 1929, Ub Iwerks animated the entire sequence, with some assistance from Les Clark and Wilfred Jackson.

Stalling's score was infused with Edvard Grieg's "March of the Dwarfs." Working in a style of eccentric movement popular in vaudeville and with early films stars of the day, including Charlie Chaplin and Buster Keaton, Iwerks's masterpiece features a quartet of skeletal figures comically dancing around a graveyard with bone-chilling antics, intricately timed to Stalling's score.

Matching Iwerks's style for every grinning ghoul, Mary

Final frame from an early Silly Symphony, *Springtime* (1929).

Tebb, one of the young Tracers and Opaquers at the studio, brought each skeletal frame to celluloid life. Joining the studio in 1927, Tebb single-handedly inked the thousands of cels required for this inaugural short. The new style of this series commanded a higher level of line uniformity to achieve a seamless flow to every dancing vertebra and skull. "How did I do it? I don't know," said Tebb. "I was young. I see it now and I'm amazed."

Tebb later echoed the commitment she felt in her work. "That dedication was the greatest thing in the world—our dedication to Walt and the product, our unquestioning attitude. No one ever said to Walt, 'Aw[,] that's too much work, I don't want to do it.' Oh no. You'd take it home and spend all night if you had to. Walt had something, that power. It was just his personality, his genius, I guess."

By late 1929, twenty-five employees were on staff at the small but growing studio. With the continued demand for Mickey Mouse, as well as the range of possibilities he envisioned with the Silly Symphony series, Walt began to institute a division of labor. Iwerks would oversee the Silly Symphonies unit, while director Burt Gillett took charge of the Mickey Mouse cartoons. A separate artist, Carlos Manriquez, was brought in to focus fully on layout, which freed up the Animators to focus on their work. In addition to teaching animation classes in the evening at the studio, Iwerks concentrated on key sketches for others to animate in between.

The women's roles at the studio expanded as well.

TRACING & OPAQUING

Utilizing more than one piece of celluloid to a frame of film increased the visual sophistication of storytelling. Two to four basic cel levels relayed the overall animated action against the black, white, and gray backgrounds. As an early studio handout clarified, "In the beginning, all action was painted on a single piece, whereas, now the actions are broken down and there are used from two to five pieces of celluloid to each frame of film. The second cel is the main action position or the Key Cel."

Thus, if only one cel were required, that cel would be shot on the second level with a blank cel on top of it. "Animators make all drawings to be painted for the second cel only," the memo continued, "regardless of the cel position or exposure sheet, as the second cel gives you the color as it will appear on the scene after it is photographed."

To ensure clarity of communication for specific details throughout this new production pipeline, an exposure sheet or X-sheet was created for the entire film. Each X-sheet carefully detailed the timing of each individual drawing, movement, and cue (as well as designated the particular cel layer it was to occur on). Miscellaneous notes and directives were also added for each department. This detailed sheet would travel with the artwork as it progressed down the line, charting details, notations, and adjustments each artist might contribute.

With two separate production units functioning at Disney Studios, the pipeline of work flowing into Hazel Sewell's department increased exponentially. More staff was hired to trace and

Feminine First

LOTTE REINIGER

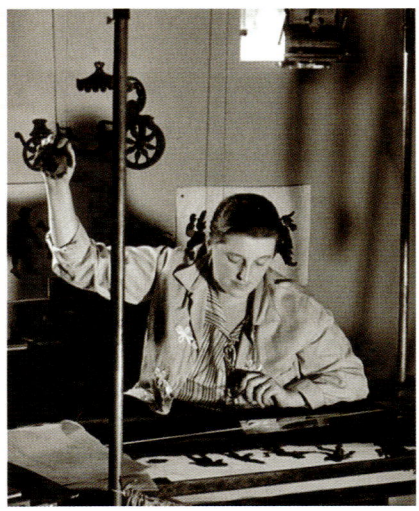

One of the earliest women to make a major mark in animation was German-born Charlotte "Lotte" Reiniger, who created the first of her silhouette animations as titles for Paul Wegener's 1916 feature film *Rübezahls Hochzeit* (Rumpelstiltskin's Wedding). This form of shadow animation stemmed from the long-established folk tradition of silhouette cutting, or scherenschnitte, an art form primarily demonstrated by women artists in the early 1900s.

At a time when women were not permitted to explore serious art training, silhouette cutting emerged from a woman's regular craft skills and provided a rare creative outlet. "I could cut out silhouettes almost as soon as I could manage to hold a pair of scissors," Reiniger reflected. After making a series of acclaimed short animated films, Reiniger cracked the world of feature-length animation when *The Adventures of Prince Achmed* debuted in 1926. Reiniger's vivid creation of light, shadow, color, and form opened a new vista of imagination, but as a silent film, this landmark feat of animation was quickly lost in the crushing wave of "talking" pictures debuting around this time. Reiniger followed with a second feature-length shadow-animated film nearly a decade before the making of a feature-length animated film was under way at Walt Disney Studios.

paint, including six women and two men (who worked briefly to meet the demands). Sewell identified the distinct skills required for each discipline and divided her artists into two separate areas based on their talents and abilities. To head her Tracing Department, she assigned Marie Henderson, while Grace Christianson ran the Opaquing Department.

Initially, the Tracers would uniformly outline a character; but with the new Silly Symphony series, the fine art of Inking began to develop. As a studio write-up declared, "Now, all lines have accents and naturally all accents have to fall in the same place for the same character." The Tracers worked from the Animators' drawings to transfer the lines to celluloid, translating each character's form. Once a scene was completed and dried, Tracers sent their scenes over to the Opaquers, or women who painted within the designated areas, ensuring the black, white, and gray paint was thoroughly applied to avoid light leaks once in camera.

The detail demanded by the Silly Symphony series required new approaches. Speed and accuracy were the goal. Lines were simple and functional, but a new level of quality was required for these visual tone poems, from concepts to characters and backgrounds. New shades of white and gray were introduced for opaquing, giving a distinctly different dimension to the Sillys.

To achieve clean lines, painting was introduced to the B-side of the cel. Black, white, and four shades of gray paint lined the shelves of the little studio. When a woman needed paint for her work, she stepped up to the shelves and helped herself. This monochromatic range constituted the entire palette of the early black-and-white Silly Symphonies. Black was the only cel color that did not change when viewed through the nitrate cels, so it could be utilized on any cel level. White, however, and the limited range of grays, required adjustments based on the level of cel they appeared on. Blue or red pencil notations occasionally made by the Animator on the drawings indicated which shade and level each color appeared on. Once a scene was shot and processed for final assemblage, cels were carefully washed and laid flat to dry for another round of use.

Noting the development of the early Silly Symphonies, Roy Disney stated, "They were a stepping-stone, and really Walt had longer pictures in mind. But he had to have better artistry, better results, so those Silly Symphonies were really little vignettes in training and developing for better work later on."

TEN-FOOT-HIGH MICE

Even with Walt's new Silly Symphonies, animation was still a Hollywood outsider and considered nothing more than "fillers" between the studio's main feature films. Blanche Sewell, the former sister-in-law to Walt Disney's head of Tracing & Opaquing, Hazel Sewell, was now a top-rated film editor at MGM. To help advance Disney's art form, Blanche arranged for a screening of Walt's latest productions for some of Hollywood's leading production talent.

In her autobiography, legendary screenwriter Frances Marion recalled the events: "Margaret Booth and Blanche Sewell, film editors whose opinions were highly valued by the bosses, told Victor Fleming, George Hill, and me about a young chap named Disney who had made some unique animated cartoons. When Blanche introduced him she called him 'Walt,' and this abbreviation of his name seemed to fit the tall, shy youth who wore a shabby suit and whose apprehensive glance at us told very clearly of many past disappointments. . . . 'It's rather crudely done. . . .' Blanche cut him short. 'Don't apologize, Walt. I wouldn't have called them in here if I didn't think your stuff was great!'"

"The projectionist ran the Mickey Mouse reel," Marion continued. "We doubled with laughter. We congratulated Walt. 'It's terrific!'" The projectionist put up *Springtime*, the latest Silly Symphony completed by the small studio. As Marion put it, "I was lost in dreams! 'Mr. Mayer has to see these,' I said impetuously. 'I'm going to bring him right down here!'"

"I returned, practically dragging the reluctant [boss,] who had learned to distrust overenthusiasm." Stopping the film before its end, "Ridiculous!" Mayer shouted abruptly. "Women and men dance together. Boys and girls dance together . . . But flowers!

Final frame from an early Silly Symphony, Summer (1930).

Bah!" Running the Mickey Mouse short brought more dire results. "Stop that film! Stop it at once!" Mayer shouted. "Every woman is scared of a mouse, admit it. . . . And here you think they're going to laugh at a mouse on the screen that's ten feet high!"

Upon Mayer's abrupt exit, the others reassured Walt. "'Don't be discouraged,' we said to young Disney. 'Your little ten-feet-high mouses [sic] will scamper all over the world.' . . . That's why Fleming and Hill, Blanche, Margaret, and I applauded wildly when Mickey Mouse made his triumphant appearance and was hailed as a newly risen star." Years later, Walt and Blanche Sewell's careers intersected again when she became lead editor on *The Wizard of Oz* (1939), a film green-lit for production only after the world wide success of *Snow White and the Seven Dwarfs* (1937). Blanche remained a lead editor at MGM until her death in 1949.

OTHER STUDIOS

One of the earliest animated characters with a memorable personality (and a wide following) was Felix the Cat. He was world renowned, thanks in part to Margaret Winkler's pioneering promotional efforts, and primary competition for Walt Disney at the start. To create the Felix cartoons, which were from the Sullivan Studios in New York, Blackeners sat on pillows in straight-backed chairs, lined up against a wall. Animation was completed on paper initially, but by 1925 cels were utilized to convey backgrounds and stationary elements, which were then placed over the character drawings. Nearly three thousand drawings were required for each three-minute Felix the Cat short, which was no small feat.

As author John Canemaker noted about the Sullivan offices, "There were no women Inkers at the studio during Felix's heyday. The Blackeners dipped flexible crow-quill pens into bottles of black India ink and carefully traced over the Animator's original pencil drawings. Brushes were used to blacken in characters." Al Eugster, who was an Animator at Sullivan Studios as a young man, recalled, "Then we'd have to erase the pencil lines. That was a mean job, if I had a large job to blacken in. That was sort of monotonous, [the] blackening. But it was part of cartoons, so I accepted it."

Max Fleischer's Out of the Inkwell series was all the rage in the 1920s. The studio was garnering attention as well. On September 2, 1925, *Film Daily* announced Fleischer had hired Beth Brown as editor in chief for its Out of the Inkwell series, noting that Brown assisted Fleischer in writing scenarios.

Early Animator Edith Vernick came to work for Fleischer several months later. Though she would mainly focus on training other Animators and, later, supervising the company's Inbetween Department in 1931, Vernick was noted for her hard-talking style and controversial methods in running her department. Occasionally animating when needed, Vernick's work often went uncredited, but her touch is evident in one of Fleischer's later shorts, *The Fresh Vegetable Mystery* (1939).

THE 1930s

1930
- The dwarf planet Pluto is discovered
- Gandhi holds his Salt March to the sea
- The first frozen foods developed by Clarence Birdseye go on sale
- Filmmaker Sergei Eisenstein arrives in Hollywood

1931
- Al Capone is imprisoned for income tax evasion
- The Empire State Building is completed
- The United States designates "The Star-Spangled Banner" as an official national anthem
- Jane Addams is the first American woman to receive the Nobel Peace Prize

1932
- Amelia Earhart becomes the first woman to fly solo across the Atlantic
- The Lindbergh baby is kidnapped
- Secretary of Labor Frances Perkins is the first female cabinet member
- Hattie Caraway of Arkansas becomes the first woman elected to the Senate

1933
- Adolf Hitler is appointed chancellor of Germany
- FDR launches the New Deal and survives an assassination attempt
- The first Nazi concentration camp is established
- Prohibition ends in the United States

1934
- Bonnie and Clyde are killed by police
- The cheeseburger is created
- Lettie Pate Whitehead is the first woman director of a major corporation
- Babe Didrikson pitches a full inning for the Philadelphia Athletics (in a spring training game)

1935
- Ma Barker and her son are killed in a police shoot-out
- Social Security is enacted in the United States
- Humorist Will Rogers is killed in a plane crash
- Mary McLeod Bethune organizes the National Council of Negro Women

1936
- The Hoover Dam is completed
- King Edward VIII abdicates the British throne
- The Berlin Olympics are held in Nazi Germany
- The Spanish Civil War begins

1937
- Amelia Earhart vanishes attempting to fly around the world
- The Golden Gate Bridge is opened
- The *Hindenberg* disaster occurs
- Ingrid Christensen becomes first woman to set foot on Antarctica

1938
- Hitler annexes Austria, and Kristallnacht occurs
- Superman first appears in comic books
- The Volkswagen Beetle is first manufactured
- Fair Labor Standards Act establishes minimum wage

1939
- World War II begins in Europe
- The first commercial airline flight over the Atlantic occurs
- The helicopter is invented
- *The Wizard of Oz* premieres in Hollywood

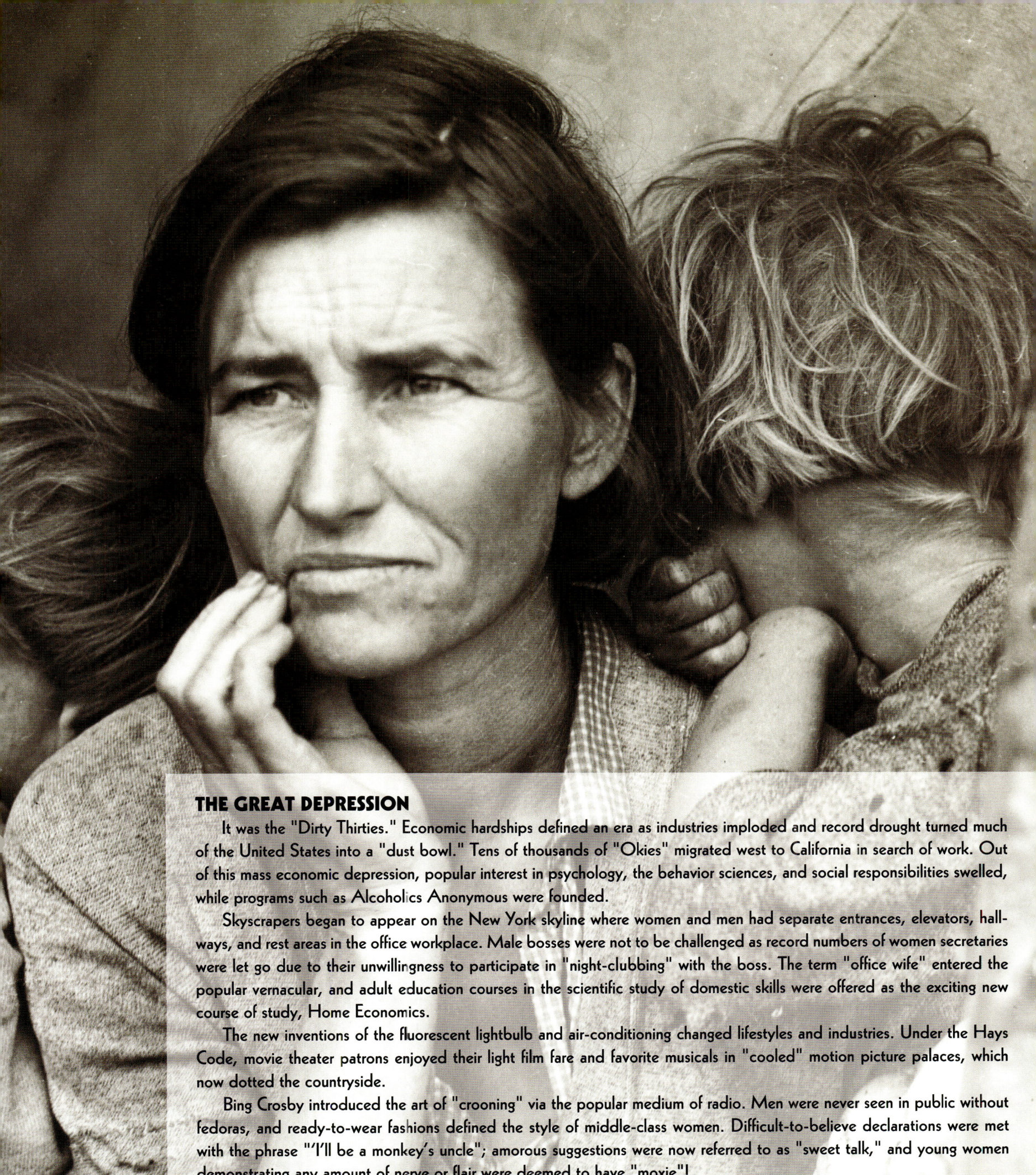

THE GREAT DEPRESSION

It was the "Dirty Thirties." Economic hardships defined an era as industries imploded and record drought turned much of the United States into a "dust bowl." Tens of thousands of "Okies" migrated west to California in search of work. Out of this mass economic depression, popular interest in psychology, the behavior sciences, and social responsibilities swelled, while programs such as Alcoholics Anonymous were founded.

Skyscrapers began to appear on the New York skyline where women and men had separate entrances, elevators, hallways, and rest areas in the office workplace. Male bosses were not to be challenged as record numbers of women secretaries were let go due to their unwillingness to participate in "night-clubbing" with the boss. The term "office wife" entered the popular vernacular, and adult education courses in the scientific study of domestic skills were offered as the exciting new course of study, Home Economics.

The new inventions of the fluorescent lightbulb and air-conditioning changed lifestyles and industries. Under the Hays Code, movie theater patrons enjoyed their light film fare and favorite musicals in "cooled" motion picture palaces, which now dotted the countryside.

Bing Crosby introduced the art of "crooning" via the popular medium of radio. Men were never seen in public without fedoras, and ready-to-wear fashions defined the style of middle-class women. Difficult-to-believe declarations were met with the phrase "'I'll be a monkey's uncle"; amorous suggestions were now referred to as "sweet talk," and young women demonstrating any amount of nerve or flair were deemed to have "moxie"!

In 1937, the animated film *Snow White and the Seven Dwarfs* changed history.

HYPERION HEYDAYS

> *"Everyone was so young and excited about what was being created."*
> — **Dolores Voght**

By 1930, Mickey Mouse was a worldwide phenomenon and the Silly Symphonies were well established. The new decade opened with financial difficulties nationwide, due to the Great Depression, yet with the ongoing successes at Disney Studios, staffing demands increased as production ramped up. Now boasting fifty employees, the burgeoning Walt Disney Studios felt the need for expansion. In an effort to maintain an environment where the "freedom to create" was encouraged, additions were made to the rear, side, and front of the Hyperion building.

The newly coined Tracing & Opaquing Department expanded as well, with Hazel Sewell's all-female stronghold employing approximately fifteen women. New attitudes toward women in the workplace brought fresh freedoms, social opportunities, and financial independence—enticing options for young women eager to work at the house of Mickey and Minnie Mouse.

One, Marcellite Garner, came to Disney in February 1930 and began working in Sewell's department. "She kind of scared me a little bit," recalled Garner, "but she was nice as far as that goes. I was just young and it was my first job really of any consequence. I was probably more scared of everything in general. Sometimes she could get a little bit fussy when she used to call me and say, 'You didn't turn out enough drawings today. How come?'

"Some of the girls were much faster than others naturally," Garner added. "I worked into specializing in very fine inking of some of the little tiny characters that had to be done in real fine lines. For some reason, I could do it and, of course, sometimes it took longer."

Pages 62/63: Dorothea Lange's landmark photo *Migrant Mother* (1936), featuring Florence Owens Thompson and her children, defined the plight of women during the Great Depression.

Page 65: Female artists entering the gates of Walt Disney Studios on Hyperion Avenue in the 1930s.

This page: Female workers taking a break on the lawns of the Walt Disney Hyperion studios.

Roles were defined but still very informal with no definite job boundaries, and it was often "all hands on deck" when it came to getting a picture out on time. The studio's telephone operator was also a Painter who hopped from her paint post to the switchboard as she covered the incoming calls. Yet, even with the long hours, antics abounded. As a studio write-up recalled, "In those days, everything was in one room, and flimsy ten-foot partitions separated the girls from the fellows. This only served to make the girls more attractive targets for paper clips, erasers, and paper wads—or perhaps an apple core from the desk of some bully."

As a new Inker, Garner remembered, "This divided the Animators and the Inkers—the things that used to go on over and under the partition. It was really a fun place to work and [was] so relaxed." On hot afternoons, Roy Disney would often come in with ice cream cones for the gang.

CAMPUS LIFE

In the spring of 1931, the Walt Disney Studios became a small campus with the addition of a separate two-story Animator's building positioned behind the small Hyperion building. As the Animators moved out, the partition was removed and the newly dubbed Tracing & Painting Department occupied the entire original building. Prominently displayed across the top of the new structure sat a sizable dimensional sign featuring the young studio's star. Visible even at night, the glowing blue and red of this neon billboard announced to the world that this was the home of Mickey Mouse. "People started tossing their unwanted cats over the wall," wrote Animator Jack Kinney, "figuring a mouse studio would probably welcome the little darlings. Naturally, the girls in Ink & Paint did. They fed them and played with them."

Walt's office moved to the second floor of the new building, where Dolores Voght—who had initially been a secretary for Roy—became Walt's longtime secretary. Voght kept Walt's personal and studio affairs running smoothly. In 1930, a daily studio publication declared that she held "the most enviable secretarial job in the world." With her own office positioned outside of Walt's inner sanctum, Voght was the main gatekeeper for the boss. "The Hyperion studio was a fun place to work," Voght remembered. "We all worked like dogs, but we enjoyed every minute of it."

"I came here right out of high school," said Katherine Kerwin, a longtime Painter and animation Checker, who supported Scott's sentiments and added, "I started in class here in December '34. It was the height of the Depression and nobody had jobs or anything. Nobody had cars . . . it was really difficult."

Competition was high for the work available. From 130 potential candidates, young Yuba O'Brien was one of three women selected to work as an Inker and Painter in 1936. As the sole breadwinner for her family, O'Brien and her parents lived comfortably on her fifteen-dollar weekly paycheck in a house a block away from the studio, and she was eventually able to afford a family car.

Having a job was one thing, but getting to work was another. Frank Thomas and Ollie Johnston, the studio's renowned Animators, noted, "Many of the young people traveled as much as two hours each way by bus and streetcar to get to work, and they often worked till ten at night." Even with the long hours, punctuality factored into pay, as June Patterson later recalled of the studio's "signing-in" policy. "If you were there by nine, you got the black pen," she said. "They'd change pens exactly at

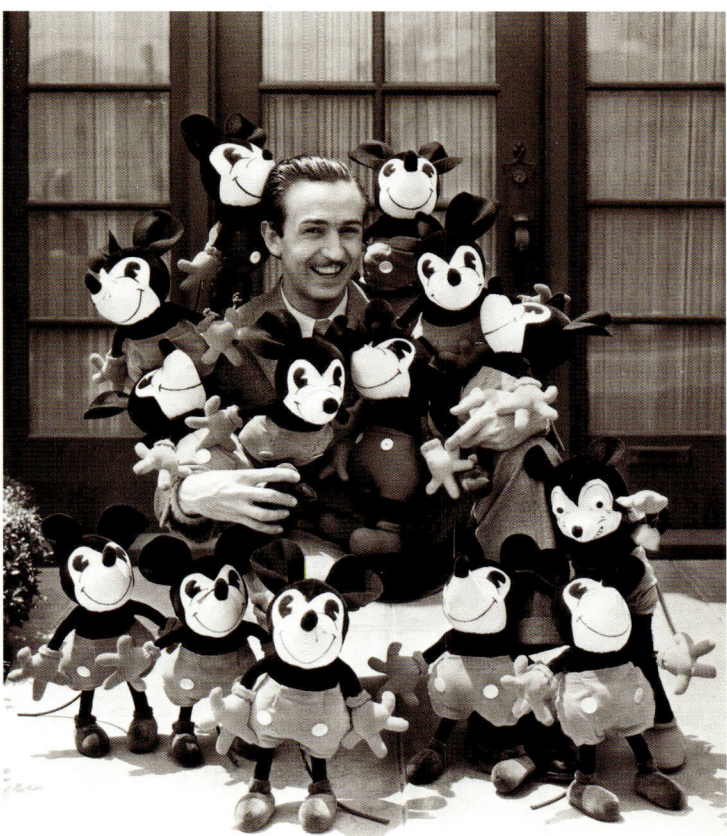

Walt Disney and a "gathering" of Charlotte Clark's Mickey Mouse dolls.

nine—when you got the red pen. I was in the red every time. I was docked for every minute I was late." But as Painter Ruthie Tompson revealed, "A lot of us cheated and signed somebody in."

Located on the main floor of the new addition was a small square receptionist cubby that quickly became the central hub and watering hole of Disney Studios. Holding court was a short, cheerful blonde with a whip-sharp sense of humor, Mary Flannigan. "She was a great gal," Animator Don Lusk remembered. Though her real job was as a receptionist in the new Animation Building, Flannigan maintained a small snack counter where a pot of coffee was always brewing and cigarettes, gum, soft drinks, and a range of candy and snacks were always stocked. Many of the staff had charge accounts with Flannigan and she often loaned money or floated accounts until payday. To Animator Jack Kinney, she was a vital part of the Disney Studio's team: "We really appreciated the attention and bright spirit Mary provided."

SOUNDS & VOICES

At any given moment, the Sound Department team might corral the troops into the recording room and have them yell, scream, clap, sing, and imitate all manner of sounds from various creatures and scenarios emanating from the story teams. One such volunteer was given the remarkable opportunity to lend her voice to the studio's first leading lady, Minnie Mouse.

In 1930, during the production of *The Cactus Kid*, director Burt Gillett came to the Tracing Department asking if anyone could speak Spanish. "I said, 'Well[,] I can't speak it, but I can read it,'" said Inker Marcellite Garner. She and another young Inker, Marge Raltson, headed over to the soundstage, where they learned that Minnie would also have to sing. "We were both scared to death, but I said, 'Sure I would.' Evidently, it worked out that my voice fit the character."

CHARLOTTE CLARK

The success of Walt Disney's lovable mouse stars inspired a local seamstress, Caroline Geis Clark, to create a Mickey doll. "Charlotte" Clark enlisted young Bob Clampett to draw some pictures of these animated characters. Sitting through three showings of *Steamboat Willie* at the Fox Theater in Glendale, Clampett produced preliminary drawings of Mickey Mouse used to fashion a pattern. Clampett later became a renowned Animator for Warner Brothers.

Clark constructed the first Mickey Mouse doll in early 1930. The hand-sewn and carefully stuffed rendition was presented to Walt. Pleased with the doll's design and construction, Walt and Roy not only granted permission for Clark to produce the dolls, they also rented a bungalow near the studio on Hyperion Avenue to set Clark up in business. At the bungalow, affectionately known as the "Doll House," Clark supervised six women who produced three to four hundred Mickey and Minnie dolls a week, each marked with a rubber stamp on the bottom of the doll's foot to indicate its authenticity.

Soon, the appeal was so strong, larger manufacturers were sought to handle the demand. Following various agreement issues with George Borgfeldt & Company, the US licensee, Walt and Roy authorized McCall Pattern Company to reproduce the Charlotte Clark pattern for home sale. Suddenly, Minnie and Mickey Mouse made their way into homes all across the country—even at the height of the Depression. For nearly three decades, long after the "Doll House" operation was closed, Clark's simple idea paid off. Walt continued to rely on her expertise to work with doll manufacturers in creating specialty dolls for various Disney characters. Clark's talented efforts marked the beginning of the consumer products success of Walt Disney Studios.

From that point on, Garner was often called on to record with Walt, who provided the voice of Mickey Mouse. "Of course he was great to work with," the Inker enthused. "In order to set the stage for me to get the spirit of whatever Minnie was doing, he'd tell me the story and he'd be each character, as he'd tell it. He was a wonderful actor when it comes right down to it." With the completion of a production soundstage on the Disney campus in 1931, the Walt Disney Studios gave up its rented space at Tec-Art Studios on Melrose Avenue and moved into the new facilities. With all facets of production in one location, most of the women on campus were pressed into service for the sound-effects teams.

Everyone contributed to the success of each cartoon, as later Ink & Paint hire Ruthie Tompson remembered. "If we read the story and we had an idea for a gag or anything and they used the gag, they'd pay us for it," she said. "I watched a rough reel of a

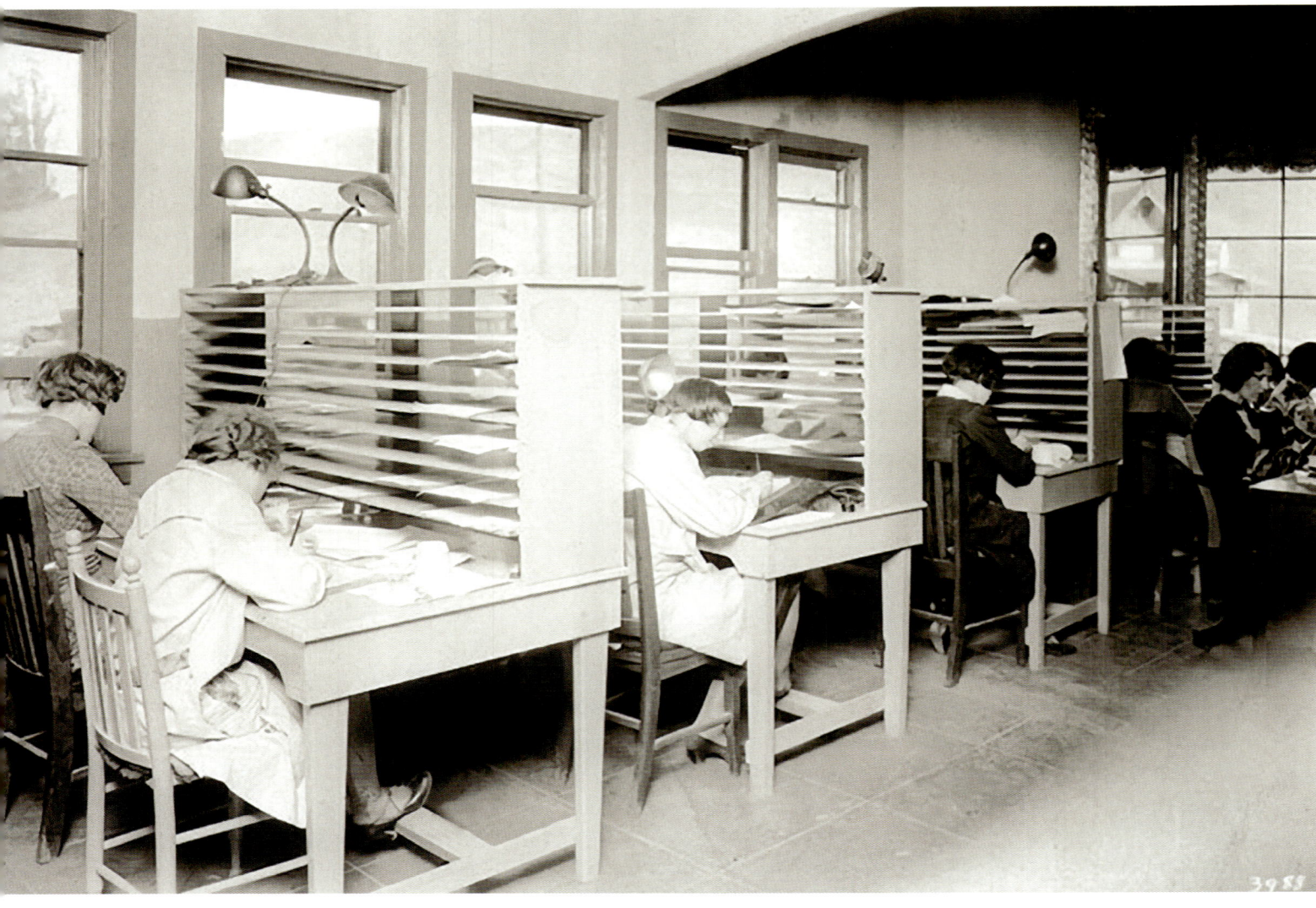

The studio's Tracing & Painting Department housed in the refurbished original Hyperion building, circa 1931.

Pluto [short]. He was chasing a parrot around chair legs and a tune came to my head, and I sang it or whistled it or did something, and one of the girls said, "Why don't you send that in?' I said, 'What for?' They said, 'Five dollars maybe, if they use it.' So I sent it in and I got five dollars. I was so surprised . . . they used it in the short. If they used it continuously . . . as a running gag, they'd pay more, accordingly to how much they used it."

For Katherine Kerwin, it was both creative and lucrative. "Walt wanted everyone to do anything they could," she recalled. "One thing I enjoyed doing was gags! When they'd have a picture they were going to start, anyone interested would come over to the soundstage and they'd have a little meeting and run through [the] storyboard and then [they] would say if anyone has any gags along that line, send 'em in. In one month I got three of those. I made more money sometimes with that than my [job]."

Even with such exciting progress and opportunities at Disney Studios throughout the 1930s, the world outside the perimeter of the company was crashing—literally. "One afternoon a short time after we moved in [in 1931], we were told to report to the new soundstage," said Jack Kinney. "Gunther 'Gunny' Lessing [then a lawyer for Disney], who had just returned from a trip to New York, was introduced by Walt as the principal speaker. He came on strong with a terribly sad story of conditions in New York—people going around with the seats of their pants worn out, and other distressing news of the Great Depression—ending up by passionately asking us to take a fifteen percent cut in salary.

"When you're young and ambitious, you bounce back from adversity," Kinney observed. "We all felt that by taking a fifteen percent cut, we had helped the studio survive a desperate period. We went back to work harder than ever."

Garner agreed, grateful to have work during the Depression. "It didn't feel that much to us, because we still just inked and inked! Many is the time we used to ink straight around the clock to keep the wolf away from the door, you know. We'd go to work at eight in the morning and work until eight the next morning sometimes."

WORKING WAGES

With the Great Depression in full force, work was hard to come by all across the nation. Having any sort of steady job was considered a success, but having a job at Walt Disney Studios during the 1930s was like winning the lottery. Disney Inkers averaged fifteen to eighteen dollars a week while, according to an Animators' union history, most other studios of the day paid their Inking staff twelve dollars a week. As Inkers, these young single women were considered to be "in the chips," for in the early 1930s this rate placed them well above seamstresses, textile workers, and nurses.

Inkers and Painters could easily afford a comfortable room or apartment. The Hollywood Studio Club reduced its rates during the Depression, offering a room and two meals a day for about $7.50 a week. Many of the women had roommates, with local rents averaging $18 to $25 per month. Buses, streetcars, and other affordable transportation were readily accessible with rates and

Hazel Sewell (right of cake) and the Ink & Paint artists from the Walt Disney Studios, celebrating Mickey and Minnie Mouse's fourth birthday, in October 1932.

transfers to Hyperion running about 5 cents a day. Carpooling was an option with gasoline at 10 cents a gallon. Grocery prices averaged 8 cents for a loaf of bread, around 23 cents for a gallon of milk, and about 12 cents for a pound of ground beef, though markets were not as readily accessible.

Due to the long hours of production, housing in close proximity to the studio flourished. Nearby neighbors frequently rented rooms to artists and staff who were new arrivals, while boardinghouses also offered hot cooked meals for the men who didn't, or couldn't, cook. Young Becky Dorner Fallberg, who later ran the Ink & Paint Department, grew up in the shadow of the studio. Fallberg's daughter Carla recalled the frugal sacrifice her mother's family made: "My grandfather put a notice on the bulletin board there for rooms to rent. There were three upstairs rooms they rented[,] while my grandfather was in a small room off of the living room, and my mother and my grandmother slept on a pull-out bed in the dining room. They had tenants in and out of there. Larry Lansburgh, Harry Tytle, and my dad all had rooms there."

SOCIAL SPORTS

In an effort to unify his troops even further, Walt initiated a studio newsletter, *The Mickey Mouse Melodeon*. In the capable and very social hands of Carolyn Schaefer, another of Walt's secretaries, this monthly "House Organ of the Disney Studios" went to press first in November 1932 and ran for several issues. The mimeographed newsletter kept the staff informed of landmark events.

One newsletter article, titled "Disney Cartoons Given Place in Art Exhibit," spoke of the Philadelphia Art Alliance galleries that were featuring Mickey Mouse and Silly Symphony artwork and declared Disney cartoons "A new type of American Art!" The rehearsal schedule for the studio's own Barnyard Band was regularly posted, as well as announcements on the baseball and bowling leagues. Each monthly newsletter also showcased Schaefer's love of gossip and, as Animator Jack Kinney noted, her "great knack for ferreting it out." Commenting on the social activities of most of the staff, Schaefer shared the studio scuttlebutt under the pen name of Clara Cluck.

The studio staff was youthful and athletic, and because they pretty much sat all day at their desks, Walt supported regular breaks of activity to release any pent-up energy. As Marcellite Garner recalled, "He was the big boss even if he was just a kid, but he was a lot of fun!" Every day at noon, there was always some sort of activity under way—baseball, football, volleyball, badminton, horseshoes, tennis, golf—and everyone participated. "Sports were a good way to get exercise, and everyone played, including Walt. . . . The girls played too," Kinney remembered. "We all pulled out our brown bags, ate swiftly, and adjourned to the vacant lot across the street for our daily softball game. In the early days the intramural teams were the Marrieds and the Singles, but later everybody was married, so we had to mix it up."

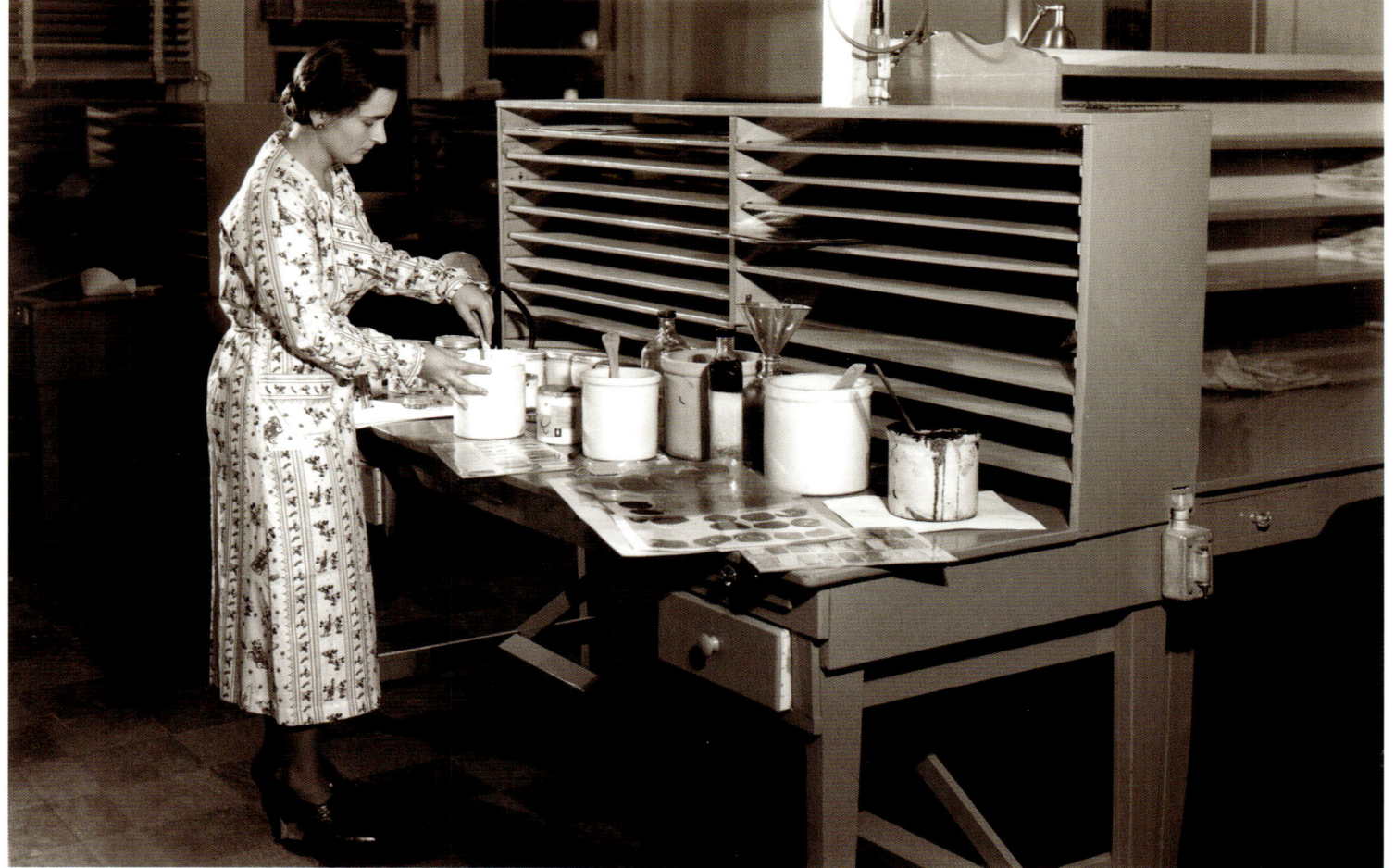

Painter Dot Powers helps herself to the black, white, and gray paints needed to complete the Mickey Mouse short films created at Disney Studios in 1931. Note: Her dress is made from Mickey & Minnie Mouse fabric.

PARTIES, HOLIDAYS & VIPS

Socialization was also encouraged within the studio, as it often ignited that sought-after creative spark. Parties, dances, and various contests were common occurrences throughout the studio. With the completion of each short, the Animators and staff would also celebrate by throwing the cels on the floor and sliding around on them! Informal parties marked production milestones. As Inker Marge Hudson recalled, "I've been to Walt's home. We all went swimming up there. Wonderful time. Hazel [Sewell] had a party for us [for] the finish of a picture, and we had such a good time. I'll never forget. We tiptoed into his bedroom, and they had twin washbowls."

With the staff size still fairly small, Walt made a point of celebrating the holidays in style. "It was always a thrill when Walt came by," said Ann Lloyd. "He didn't come often, but he always came around at Christmas with all these gifts. He felt the girls had been working very hard[,] so he brought a present for each of us." Ruthie Tompson added, "He came in holding this box and he says, 'Come on, girls, I got a grab bag for you all!'"

Inker Grace Godino remembered that "he brought compacts for the girls and he'd sit on the floor and give them out, and it was so cute because it even had the little card that had on it 'from Walt.' He was very nice to all of us; he was a sweet man." One Christmas when there was no work, Walt gave the women a week's vacation instead of laying them off.

Halloween parties in Ink & Paint were legendary and became a long-standing tradition in the department each October. Bridal and baby showers were regular occurrences among the young staff as well. The women of Ink & Paint painted baby names on the traditional studio gift: pink or blue ceramic potties featuring baby Mickey, Donald Duck, and pals. These treasures were kept at the department for the arrival of a new bundle and delivered to the new parents filled with a bouquet of flowers.

Birthdays were a highlight, particularly those of the Disney characters. Painter Grace Bailey started at the studio in 1932 as Mickey Mouse was celebrating his fourth birthday. To mark the occasion, cake and group photos were taken. "It was a small studio; everyone knew everyone and everyone called Walt 'Walt,' and he called everyone by their first name," Bailey said. "It was very informal. It was kind of a happy family[,] really. Everybody got along beautifully."

Occasionally, the day would be broken up with a visiting VIP. Celebrities often came through to see the wonders of Walt's magic factory. Hollywood celebrities, literary giants, world leaders—the guest registry at the studio read like a who's who. Film legends Charlie Chaplin, Mary Pickford, and Douglas Fairbanks; First Lady Eleanor Roosevelt; songwriter Cole Porter; and writers F. Scott Fitzgerald and H. G. Wells rank among some of the notables.

No tour of the studio was complete without visiting the feminine domain of Tracing & Painting. "One time, he [Walt] was bringing [British actor] George Arliss through the studio," recalled Godino. "And he was stopping at different desks, and we were not to have food because it would naturally get the celluloid dirty. But we had a gallon of milk that somebody had brought in. So we had the gallon of milk in one corridor and when we heard Walt was coming, they kept passing it on to the next one.

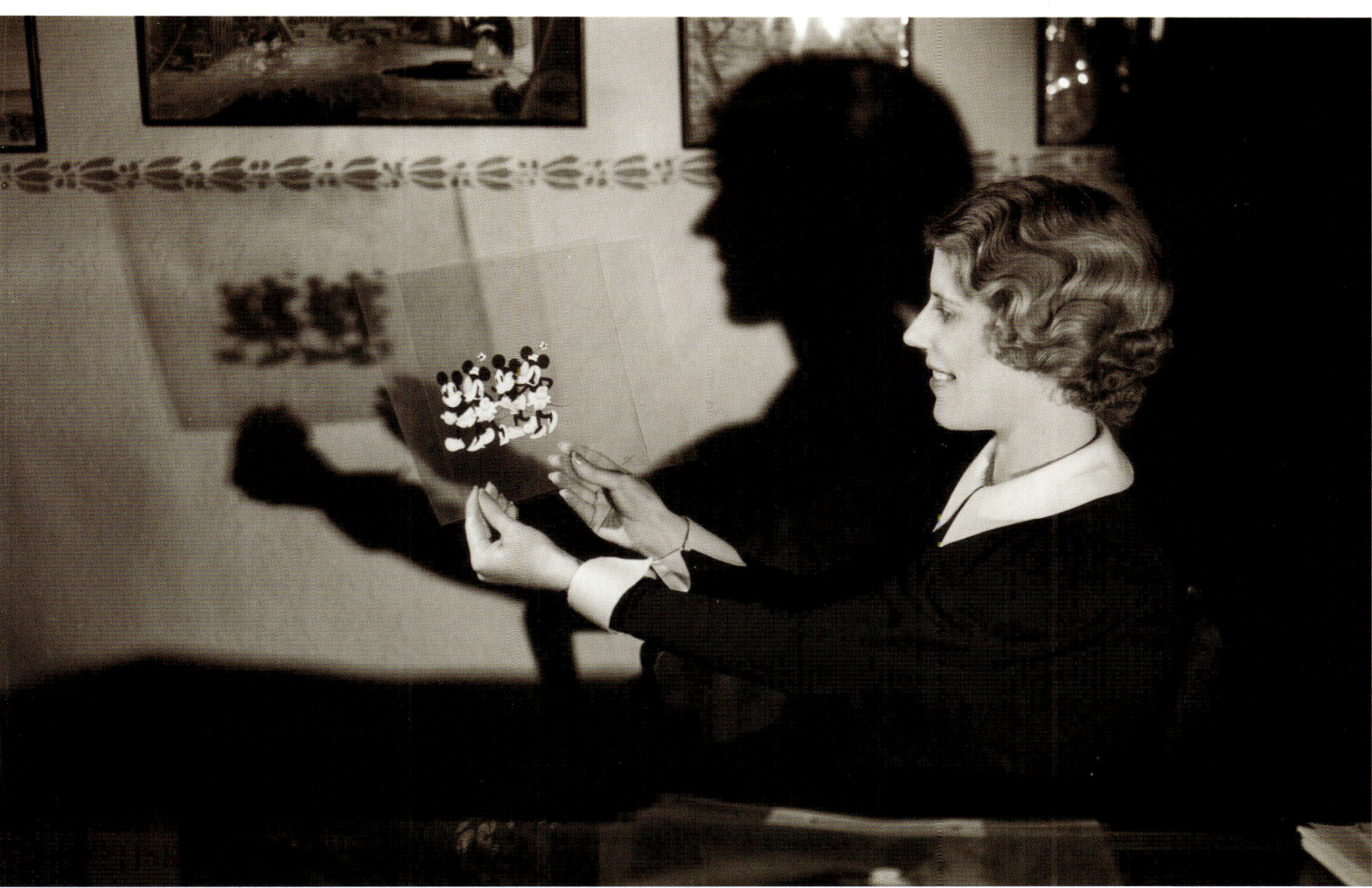

Hazel Sewell, department head of Ink & Paint, holds a set of cels from the Mickey and Minnie short *The Pet Store* (1933).

"So George Arliss," Godino continued, "as he came by, he says, 'My goodness, you Americans drink a lot of milk,' because every corridor had that same bottle of milk that was passed on down. That was kind of cute."

TECHNICOLOR TRIUMPHS

Recognizing the limitations of a black-and-white medium, Walt Disney was on the lookout for the next step in advancing animation. With various color technologies taking shape in the live-action world of cinema, the limitations for animation were still prevalent. Yet Walt recognized that advancing into color would be well worth the additional heavy costs, noting, "We think of animated cartoons as storybooks in motion. A storybook in color is a better book, so naturally a cartoon in color is a better cartoon."

Since the earliest days of hand-applied color to each frame, inventors sought more efficient applications and technologies to introduce vibrancy to the filmgoing experience. The illusory projection of images on a screen within a darkened theater required a different approach to color—intensity, values, pleasing palettes—than one might apply to flat canvases, paper, or other fixed mediums. A basic palette of four to six colors signaled audiences into specific moods and narrative settings.

By the early 1930s there were forty-two different colorization companies listed in a Hollywood film almanac developing well over 250 known methods of applying color to film. These various additive and subtractive processes ranged from tinting, prismatic approaches, embossment, dye methods, stenciling, and tone films.

> "*We could do many things with color that no other medium could do.*"
> —Walt Disney

EARLY COLOR

Walt Disney once wrote that early color processes "would add very little so far as comedy is concerned." Rather, "it is laughs and personality that count . . . a good, clever black-and-white cartoon should hold its own for some time to come." Yet, in the same manner that the advance of sound revolutionized the medium, the emotional appeal and narrative advancements of color brought the animated cartoon into an entirely new realm of sophistication.

Comedy was the domain of Mickey Mouse, but the tonal world of the Silly Symphonies provided a perfect canvas for visual experimentation. In early 1930, utilizing pre-tinted film stock, Walt and his teams incorporated color to convey mood and tone into two early shorts: *Night*, directed by Walt Disney in April 1930, which carried a blue tint throughout to denote a twilight mood, and *Frolicking Fish*, which featured a green tint to give an underwater feel to Norm Ferguson's fluid animation.

A preliminary two-color Technicolor process was utilized by Walter Lantz with his animated contribution to the short *King of Jazz*, released in August 1930. Animation was only a small section

Left: Tinted final frames from the early Silly Symphonies *Night* (1930); and (right) *Frolicking Fish* (1930).

of this theatrical live-action revue, but the integration of color was key. Color paints of the day were not designed to adhere to nitrate animation cels, and when the oil-based paints created by the Grumbacher company chipped off before the cels could be placed before the camera, the Technicolor process was ultimately limited to red and green dyes with a few additional hues mixed in.

After beginning a brand-new distribution contract with United Artists early in 1932, Disney had the capital to pursue a new level of quality. Responding to a demonstration of an early experimental two-color process, Walt wrote, "I am convinced that good color, not too hard on the eyes, would be of value to a cartoon subject." He also stated his concerns that technologies were not yet up to his standards: "All samples of color prints that I have seen to date would detract rather than add anything to a cartoon."

Recognizing the importance of color to advance the medium of animation, Disney later reflected, "There never was a time in our own work when we were not conscious that we needed color to achieve maximum entertainment in our pictures. For too long it is unavailable to films—then came Technicolor."

By early 1932, after nearly fifteen years developing various color processes, the Technicolor teams had established a standard necessary for the right qualitative method to reproduce true tones. Utilizing a three-strip approach that processed yellow, cyan, and magenta prints onto a black-and-white negative, Technicolor became the preferred method of achieving color in films. "Basically, we had perfected a way of marrying together negatives individually sensitive to red, green, and blue—by suitable combination of the proper proportions of these components, all shades of all colors can be reproduced," noted Herbert Kalmus, the longtime developer of this technology, which was akin to a lithographic process.

Believing that people who lived in a colorful world would no longer accept black-and-white films, Kalmus, along with his wife, Natalie, had long courted feature film producers to adapt to their technologies, with little response. Adding the expense of the Technicolor process was prohibitive to producers who were garnering very little in profits with rising production costs. Deciding on a different course, Kalmus invited Walt Disney to a screening of their latest process. "Dr. Kalmus needed color to get Technicolor started," Lillian Disney said while noting the high-stakes risk of color. "It was new. He was always interested in new things. Walt was willing to go along with him." Ecstatic with the results, Walt was said to have exclaimed, "At last! We can show a rainbow on the screen."

The latest production slated at Disney Studios was a Silly Symphony ode to nature entitled *Flowers and Trees*, which was in the early stages of production in black-and-white. This delightful tale features anthropomorphized trees in the forms of a dapper sapling and willowy sycamore who fall in love despite the interference of a craggy old oak. Writing to their new distributor, United Artists, Roy Disney explained their cautious plan: "We would like to have your reaction to the idea of producing this one to color, not with any thought of making any other Symphonies in color, but just to try out the idea on this particular subject."

As a backup, Roy agreed to complete the negative in black-and-white as a measure of insurance before proceeding with color. "I started on the greatest campaign of persuasion in my life," Walt Disney recalled. "There were plenty of our associates—including sales and financial—who thought I was crazy. Cartoons sold well in black-and-white, they argued. Why change?"

Quick yet careful color planning was assembled at the studio. Walt, Director Burt Gillett, and Hazel Sewell met to discuss the necessary steps for transition. In February 1932, Sewell and

Ink & Paint | 73

Left & right: Final frames from *Parade of the Award Nominees* (1932), featuring the first appearance in color for Mickey and Minnie Mouse.

her teams provided color tests to Technicolor, which were dyed and transferred to film, with Walt keeping a very careful eye on the process. "A black-and-white print looked as drab alongside *Flowers and Trees* as a gray day alongside a rainbow," he noted.

From March 3 to April 6, production was under way in black-and-white on the twenty-ninth Silly Symphony, *Flowers and Trees*. After all of the nearly ten thousand black-and-white cels were photographed, cameraman Bill Cottrell recalled, "They took all the [original] cels and carefully washed all the reverse sides," removing the black, gray, and white paint on the back and leaving the inked lines on the front of the cels. They "then repainted them in color on the back." Walt noted, "Some of the backgrounds [were] already painted in black-and-white. [We] went right over the same backgrounds and repainted them in color. It was a tempera type of paint we were using and you could paint right over them."

Sewell and her expanded team of approximately thirty-two Tracers and Painters crossed the threshold from function to artistry as they established the necessary methodologies to introduce a range of color to the animated form. Painter Grace Bailey, who had a couple of years of training at the Cleveland School of Art, was placed in charge of paint. When she started, they were still working in black-and-white. "Then we went into color in the Silly Symphonies," Bailey noted, "and then from there on, practically everything was in color." Sewell and Bailey worked with Walt, Gillett, and the background artists to determine approaches and palettes.

Sewell's department ran tests and developed color combinations to define each character and scene utilizing commercially manufactured paints. Bailey, who later ran the Ink & Paint Department, remembered some of their earliest challenges in transitioning to color. "Yes, it made it more complicated," she said. "And the colors were washed out, thin on the backgrounds and the characters, actually, too. They didn't have the brilliance or the definition [and] we had a limited range of colors."

Yet under their exploratory efforts, the flora and fauna of *Flowers and Trees* came to vivid life via brilliantly colored hues now carefully applied to the inked cels. The newly colorized cels then went before a Technicolor camera set up at a separate studio location on Seward Street with Ray Rennahan at the helm. Colors applied on the cel appeared very differently once through the Technicolor process and projected onto a screen. Color-transfer processing tests continued through April while Rennahan kept United Artists up to date, stating: "Work has been progressing slowly because of the necessity of 'feeling our way' with colored paints."

In light of this delay, Roy Disney requested pushing back to a September release. By early June, printing of the color had progressed, and Roy set up a screening at Disney Studios to demonstrate the results to United Artists' Joseph Schenck and master showman Sid Grauman. In an article from *Technicolor News & Views* explaining the significance of this screening, Grauman declared, "Walt, if you make *Flowers and Trees* in the Technicolor process, you've got a booking at the Chinese [his Hollywood movie palace]." Grauman also added, "The picture and Technicolor are made for each other!"

Roy later recalled, "Technicolor and ourselves put the rush on the completion, and the picture was finished just two days before Grauman's opening." On July 30, 1932, the premiere of *Flowers and Trees* marked the threshold of a colorful new world of animation artistry for Walt and the Tracing & Painting teams. This pivotal point for the women of the department ushered

Hyperion Heydays

in a new level of artistry and sophistication to animation, forever changing this art form. It also raised the bar on the caliber and talent of the Inkers and Painters joining the team.

After some initial skepticism from exhibitors, audiences quickly embraced this new world of color. In writing to his parents, Roy shared the exciting news: "Our color pictures, while costing a lot more money, promise to be a very good investment. They have met with very wonderful success, and in England they are doing a much better business on color pictures than on black-and-white."

For Sewell, this vivid experiment required some adjustment. "When they first went into color," recalled Sewell's granddaughter Nannette Latchford, "she didn't like it as much. She enjoyed the challenge of getting expressions and details out of the limited shades. Color made its own story." Audiences and critics embraced the change.

A British reviewer in *Close Up* magazine raved about Walt Disney's *Flowers and Trees*: "With the Silly Symphonies . . . colour [sic] brings out the lyricism which the music attempts to infuse. His films are now one step nearer as a child's picture book comes to life."

With the success of *Flowers and Trees*, the world of live action quickly responded to the advent of color. Pioneer Pictures rushed into production with the first live-action feature film to utilize the Technicolor three-strip process, *Becky Sharp*. In shaping this period costume drama, director Rouben Mamoulian enthusiastically declared, "We have always had pencils—now we have paints!"

MGM's notable Art Department director, Cedric Gibbons, declared: "We are indebted to color for the added pictorial 'lift' made possible by the naturalness on the screen." And Schenck of United Artists later declared, "Color is daily becoming more perfect. Perhaps the greatest strides in pictures will come through its use."

> "*Color was accepted at the outset as a novelty. . . . Audiences expect more than pure novelty.*"
> —**Walt Disney**

EXCLUSIVE COLOR

Before the premiere of *Flowers and Trees*, Walt signed an agreement securing exclusive use of Technicolor technologies for his cartoon productions for two years, giving Walt Disney Studios the advance on color development. "The cartoon was ideal for their experimentation," noted Walt of his arrangement with Technicolor. "They still didn't have enough equipment to handle a lot of people if they suddenly came in and wanted it. So they granted me that exclusivity for two years." This sent several leading animation houses—including that of Ub Iwerks, who had left Disney Studios in 1930—back to the inferior two-color process for film colorization. *Flowers and Trees* went on to garner Disney's first Oscar, the first-ever Academy Award presented for Animated Short Subjects.

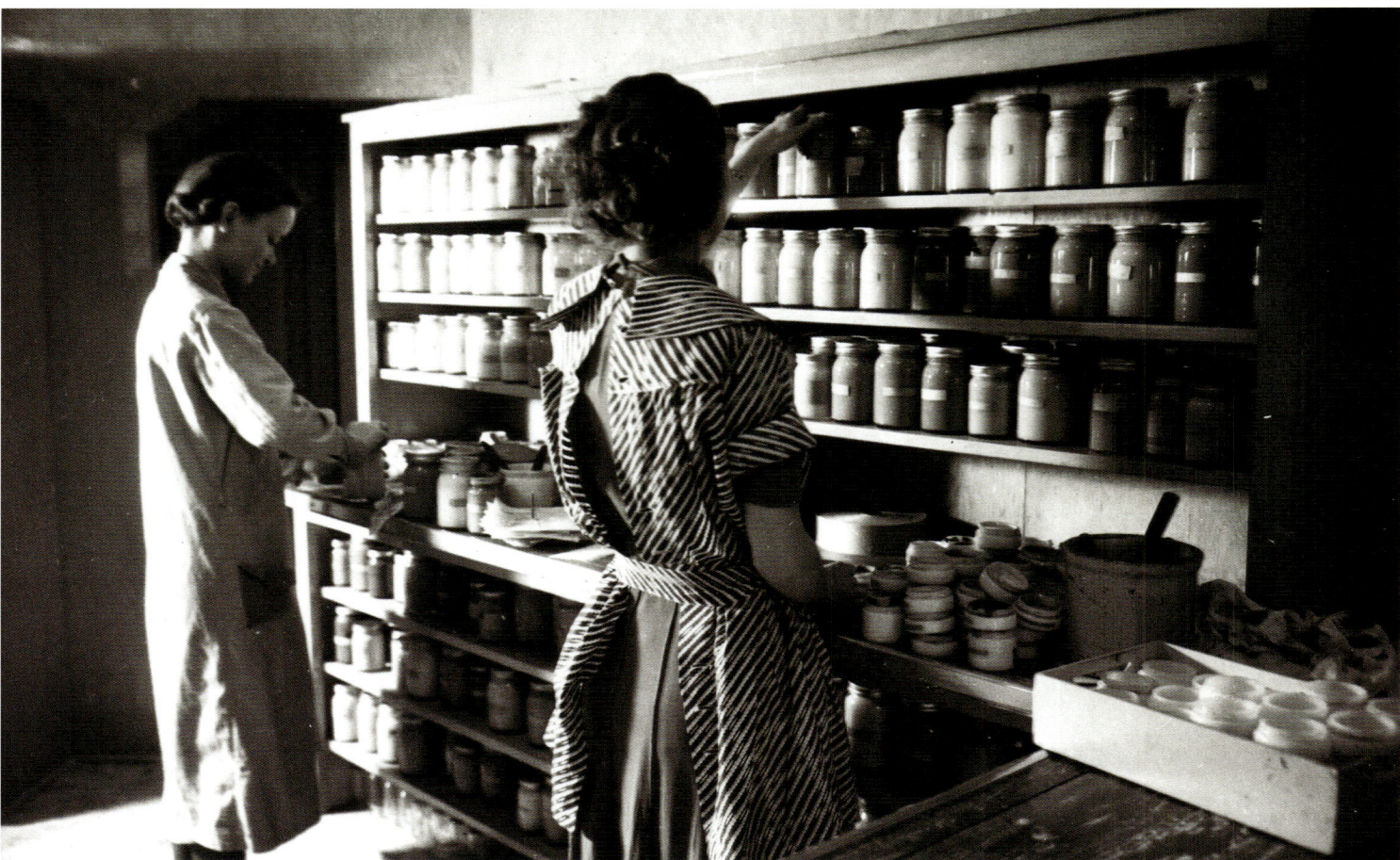

Pages 74/75: Cel setup from the Academy Award–winning short and first colorized animated film utilizing the three-strip Technicolor process, *Flowers and Trees* (1932).

This page: The early Hyperion studio color paint dispensary, circa 1933.

On November 18, 1932, the night of the fifth Academy Awards ceremony in the Fiesta Room of the Ambassador Hotel in Los Angeles, Mickey Mouse joined the ranks of color in *Parade of the Award Nominees*. This privately screened Disney short featured Mickey—wearing green shorts—and Minnie, leading a parade of caricatured nominees and Disney characters. Walt Disney also received a special award that night for the creation of Mickey Mouse.

Along with the exclusive Technicolor agreement, Natalie Kalmus, color director of Technicolor, was contracted to work with each of the Disney pictures to ensure the best color effects. In an address to the Academy of Motion Picture Arts and Sciences in 1935 introducing the concept of "Color Consciousness" to the motion picture industry, Kalmus wrote, "the principles of color, tone, and composition make painting a fine art. The same principles will make a colored motion picture a work of art."

Emphasizing color harmony, color appropriateness in specific situations, the link between color and emotions, and most importantly, a higher interest in the colorful world all around us, Kalmus's pioneering influences on the visual sense of how films are experienced through color are still applied today.

DISCERNING PALETTES

With color now established as the standard for Walt Disney's Silly Symphonies, the series became a proving ground to explore, expand, and define the medium of animation. The introduction of color now presented new challenges for the still-young studio. As Walt reflected, "Our problem is not merely to add color to a 'black-and-white' story, but to use color with wisdom and good judgment in order to strengthen the picture, not only artistically, but dramatically." Color now presented unlimited possibilities for expanding story and enriching characters and would play a key role in defining a new art form.

The size and scope of this challenge was clear, with a minimum of fifteen thousand drawings needed for a single reel of film, which consisted of approximately sixteen thousand frames. Every line of these drawings would be finely interpreted onto multiple layers of celluloid in ink. The application of color to each character or group of characters on specific layers could require anywhere from six to ten color combinations per layered frame. To surmount this challenge, a higher level of skill and artistry was required from one particular department within the animation process.

Hazel Sewell's department at Disney Studios now had a staff of thirty-five women with roles clearly delineated between the newly defined Inkers and Painters. Dot Smith, a former Painter, began overseeing the Final Checking Department, which reviewed all completed cels against backgrounds before scenes would move on to camera. Potential candidates were now screened for their artistic ability to work with color as well as line. "We didn't mix our paints in those days," recalled Smith, "but bought them ready-mixed." A limited palette of top colors was purchased from local paint representatives. The range of color was expanded with white paint to achieve the necessary shades for each film.

In the earliest days of animation, many studios utilized Grumbacher paints, but several problems persisted. In wet and cold weather, the paint would remain sticky, causing damage to cels while under the camera platen. And not only did the Grumbacher paints have a short shelf life, but in the 1930s, this

Inked cel from *Three Little Pigs* (1933), featuring the work of longtime Inker Evelyn Coats.

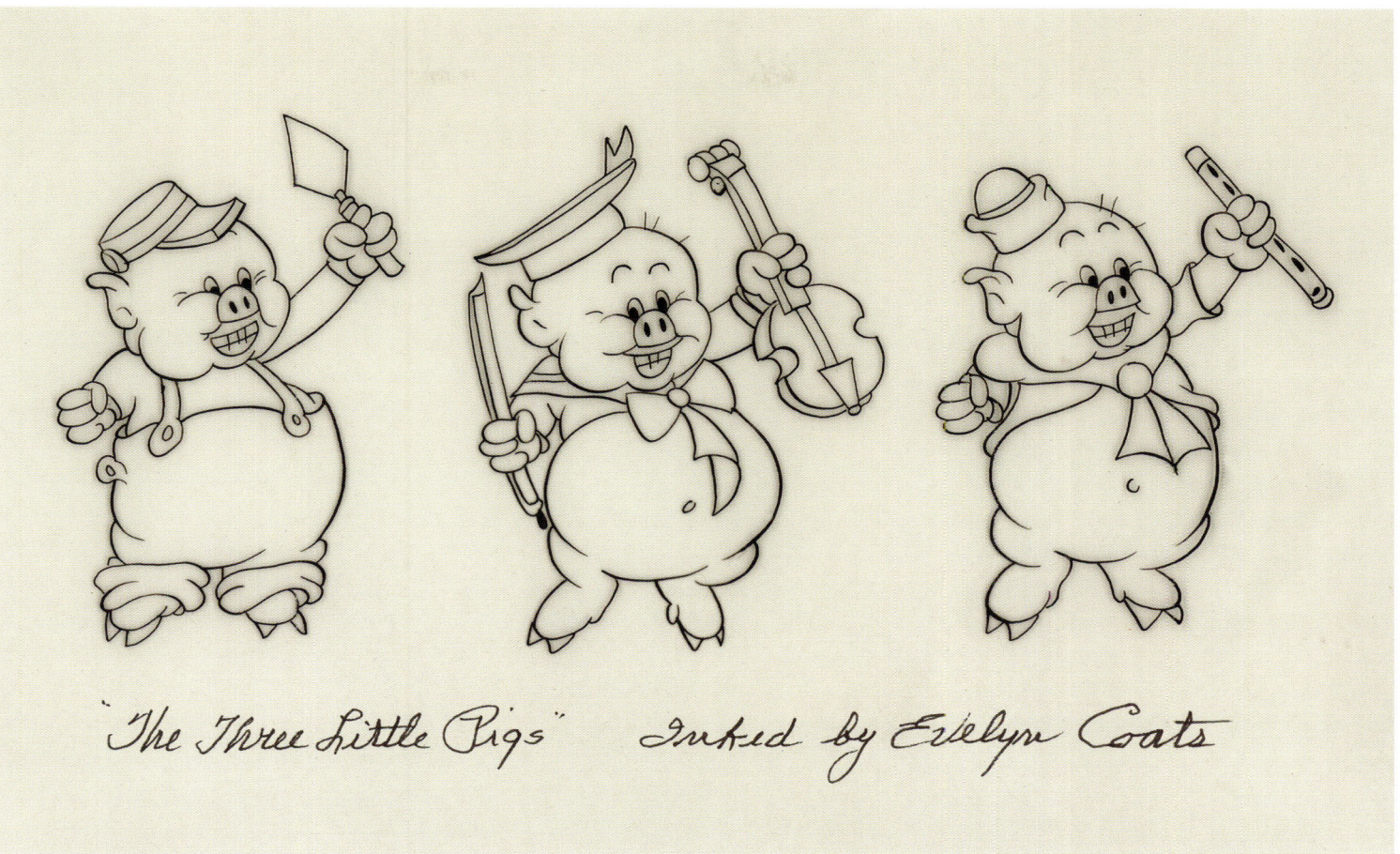

German-made material became more difficult to obtain. This gave Los Angeles–based paint manufacturer Edgar Wilkerson a window of opportunity. He established the Catalina Color Company in 1934, and it soon became the film industry's paint source. In addition to addressing temperature and material concerns for animation, Wilkerson eventually formulated a line of opaque tempera paints preblended for the necessary let-downs of each color.

"We needed different shades of all of those colors to compensate for one or more cels being placed on top of each other," said Martha Sigall, who painted at various studios in the 1930s. "This paint had to be especially suited to be used on nitrate cels. It came in all basic colors, in large sixteen-ounce jars. Our studio bought these colors and then added white to make as many as twenty shades of each basic color."

At Disney, production continued on the colorful Silly Symphonies. The fish in the vivid underwater adventures of the second color cartoon, *King Neptune*, took on a more believable quality than the fish that populated earlier black-and-white shorts. *Bugs in Love*, the last of the black-and-white Silly Symphonies, was released shortly afterward, followed by a retelling of "Hansel and Gretel" called *Babes in the Woods*. Then, just in time for the holidays, the colorful world of *Santa's Workshop* debuted.

By this time, the Animators were split into various teams, with a specific hierarchy focusing their efforts into areas such as story, gags, action, character design, animation, and cleanup. Ramped-up production slates with the colorful world of the Silly Symphonies and the black-and-white adventures of Mickey Mouse kept the Inking & Painting Department busy as the volume of cels to be completed per each production soared into the tens of thousands.

PIGS WITH PERSONALITY

By 1933, Depression-weary audiences were finding solace in the cinema. Mickey continued to delight theatergoers, and the introduction of color brought vibrancy to daily life. From an idea suggested by Lillian Disney and her sister, Hazel Sewell, it was a trio of portly pigs that elevated animation to new levels of artistic status. It took Walt over six months to persuade his teams to create a short based on the classic tale of three pigs. In an interoffice memo, Walt spelled out his vision:

> These little pig characters look as if they would work up very cute, and we should be able to develop quite a bit of personality in them. Might try to stress the angle of the little pig who worked the hardest, received the reward, or some little story that would teach a moral. This angle might be given some careful consideration, for things of this sort woven into a story give it depth and feeling. These little pigs . . . will be more like human characters.

Color could now play an integral part in defining character, expanding story, and inspiring humor. As Walt explained, "With sound came every kind of a gag you could do with sound, and after color, you would do it every way you could with color—like the wolf when he blew, he turned purple—all of those gags came with color." Color was a new "tool in the belt" of animation, and the novelty lingered for a while. "That was in that period . . . up to [19]35," Walt later recalled. "[You know], always putting rainbows in because you could do it."

Composer Frank Churchill was fast at work shaping the featured song that would populate this short. Story and direction were also under way, with two of the three pigs being voiced by women. Both Mary Moder, who voiced Fiddler Pig, and Dorothy

Production cel of the House of Straw from *Three Little Pigs* (1933).

Compton, who voiced Fifer Pig, would go on to provide voices for a number of the later Silly Symphony characters. Practical Pig was voiced by Pinto Colvig, and the Big Bad Wolf was voiced by Billy Bletcher. Running just under eight minutes, *Three Little Pigs* offered a new approach to characterization with personality. The team of forty Animators, Inbetweeners, and Cleanup Artists shaped the particular characters and action by studying real pigs for inspiration.

Utilizing a new cel material, Pyralin (nitrate) celluloid, inking took on refined levels of mastery. The tapered lines and curled forms of the portly heroes required a masterful discipline to achieve calligraphic quality in the figures of each character. Ninety shades and colors were used to liven up the world of *Three Little Pigs*, with paints purchased from local commercial paint companies. But the ordinary finishes presented a number of problems.

Grace Bailey and her Painters dealt with a wide range of challenges to meet their timetable of completed cels for camera. Streaking of the colors caused uneven opaqueness when cels were set against the camera lights. The colored paint would often crack once it dried, rendering it unsuitable for camera. Getting the paints to dry within a reasonable amount of time presented problems as well. They would appear to be dry, yet would often stick together. Halation on the celluloids destroyed color values by giving various colors a flat appearance. Applying certain colors in a thicker density helped, but introduced a new range of problems with uneven textures causing additional halation when under the Technicolor camera platen. Working through these problems, Sewell's Ink & Paint artists created three times the cel-level work for the 12,992 drawings provided by animation. These carefully inked and painted cels were systematically collected and photographed in correct sequence onto film before processing, edit, and distribution.

The May 27, 1933, release of *Three Little Pigs* was initially met with a lukewarm response. "It caused no excitement at its Radio City premiere," recalled Walt. "I was told that some exhibitors and even United Artists considered the *Pigs* a 'cheater' because it had only four characters in it." But the timing could not have been more perfect, with President Franklin Roosevelt's Hundred Days campaign in full swing to combat the suffocating grip of the Depression—now in its fourth year.

The picture was widely embraced by smaller neighborhood theaters. Audiences around the world were soon whistling "Who's Afraid of the Big Bad Wolf?," the delightful little tune composed by Frank Churchill with noted lyricist Ann Ronell, who was one of the earliest successful songwriters of Tin Pan Alley and Hollywood. This timely number grew to become an anthem of defiance to the public's view of their economic circumstances. Soon, box office receipts came rolling in with the studio's first musical hit, leaving Walt to declare, "Possibly more people have seen the *Pigs* than any other picture, long or short, ever made!"

The film's success signaled a triumph for color in animation and solidified the alliance with Technicolor. By 1935 the studio worked exclusively in the three-color strip process. "Whatever the reason for 'The Pigs' astonishing popularity, it was an important landmark in our growth," Walt noted. "It nailed our prestige way up there. It brought us honors and recognition all over the world and turned the attention of young artists and distinguished older artists to our medium as a worthwhile outlet for their talents."

Riding the wave of success, Walt worked to ensure the continuation of this new prominence. "We poured the money back into the business in a long-range expansion program pointing at feature-length production and the protection of our new prestige through constantly increasing quality. The Mickeys went Technicolor. We enlarged our training school and began a nationwide advertising campaign for young artists. The production costs on our Symphonies shot skyward until some of the little pictures approached the ridiculous figure of $100,000.

"But the quality was there," Walt stated, "and by 1935 even *Three Little Pigs* looked dated and a bit shabby in comparison with the newer Symphonies.... Our staff at this time numbered around three hundred. A greater degree of specialization was setting in."

WOMEN BEYOND INK & PAINT

By the mid-1930s, the cartoon medium was thriving with multiple studios in Hollywood, all of which featured talent that stemmed from Disney Studios. Charles Mintz now produced the Oswald series and Krazy Kat cartoons for Universal; Ub Iwerks's independent studio created Flip the Frog cartoons; and other studios, including Hugh Harman and Rudy Ising's Happy Harmonies series, Leon Schlesinger's Merry Melodies, and Paul Terry's Terry Toons, created overt attempts to match the template of Disney's hugely successful Silly Symphonies.

Animated films continued to be viewed as programmable "fillers" and add-ons by the movie theater chains, but the demand was increasing. Mary Ellen Bute pioneered experimental animation with visual explorations and music from 1934 to 1953. Her abstract shorts often played prior to the featured films in prestigious movie theaters, including Radio City Music Hall.

For a magazine article in 1935, Walt addressed the question of why there were no women Animators at the Disney Studios. Walt's

LILLIAN FRIEDMAN ASTOR & LA VERNE HARDING

Though growing in artistic sophistication, animation was still considered a lower form of entertainment, and women's roles had not progressed beyond inking and painting, with the exception of two women: Lillian Friedman Astor and La Verne Harding.

Astor began her career as an Inker at the Fleischer Studios in New York and worked her way up to Inbetweening with Edith Vernick. She then began assisting Animator Shamus Culhane, who recalled, "There was an uproar. The Animators didn't want any women in their department. My rebuttal was that talent, not sex, should be the deciding factor. She was so talented." Astor later animated on Popeye cartoons in 1933.

A quiet artist, Astor was the only woman Animator working alongside twenty-nine male artists. Her first animation work went uncredited, in an early Popeye cartoon ironically titled *Can You Take It*. She worked on various Betty Boop cartoons as well, but sadly, Astor was given credit for only six of the eleven films she animated on. Credits weren't the only disparaging circumstances for Astor. "Max gave Lillian a contract for a starting salary of thirty dollars a week," remembered Culhane. "This in contrast to our [male employees'] starting salaries of one hundred a week."

Astor's pioneering role proved challenging, with her work as an Animator lasting only five years. "[There were] particular stresses I was under when I quit," noted Astor in a later interview. "The [Fleischer] Studios had moved down to Florida, I was separated from my husband who was up in New York, I was persona non grata with the company because of my union activity, and I was really unhappy. . . . While I loved my work before, I had lost interest in it."

"There was no other studio that wanted to hire me, even though I had five years' experience as an Animator," Astor added. "I had several screen credits, but there was still a ban on women in the higher positions, so I said 'the hell with it,' and I went up and joined my husband and went into the business of producing babies."

La Verne Harding first animated on the later Walter Lantz productions of Oswald the Rabbit cartoons in 1934. "I had more the feeling of cuteness than goofiness," noted Harding. "I never got too many wild scenes, because my style was more the cute type. I worked better in a personality scene than a wild action thing." Ink & Paint artist Martha Sigall recalled, "She was like a goddess[,] because nobody else even got to be an Inbetweener." Assistant Animator Joan Orbison later said of Harding, "She was a very good Animator, and one of the first women to do so."

A strong artist, Harding often submitted her portfolio under the more masculine-sounding "Verne." She started as an Inker and in 1934 received her first on-screen credit as an Animator for the Oswald production of *Wolf! Wolf!* Early Animator Xenia DeMattia recalled, "I worked with her at Universal for Walter Lantz. I was in Ink & Paint[,] and then I became an assistant there. La Verne was considered [a] maverick. She was a great gal. I liked her a lot. But she didn't really encourage women to animate."

Recognizing the dearth of female Animators at the time, Harding noted, "I knew there were others, and if they were given the same chance, they'd be where I was."

response reflected a bit more enlightenment than the prevailing attitudes within the industry during that time: "Very frequently, they are better artists than men[,] but for some reason they lack the knack of getting smooth action into their drawings."

Walter Lantz offered further insight into this: "The business of animation is the most peculiar one in the world. I have known artists who could draw circles around any of us[,] but they couldn't earn their salt as Animators because they had no dramatic sense." These were fairly reasonable responses, considering society at large in the 1930s saw women in the workplace as invisible, relegated to completing menial tasks. Women who went in search of employment were seen as taking away paying jobs from men, whom society viewed as breadwinners.

For widows and single women, it was difficult to find proper employment to care for their families or themselves. Throughout the male-dominated animation industry, roles for women were growing but limited, as their capabilities were still generally overlooked. This view, however, was beginning to change at Disney Studios.

> **"** *I feel the female is the influential human. They influence the world.* **"**
> —**Walt Disney**

FEMININE OPINIONS

Very early on, Walt Disney recognized the importance of the female ticket-buying audience, stating, "Women are the best judges of anything we turn out. Their taste is very important. They are the theatergoers, they are the ones who drag the men in. If the women like it, to heck with the men." Inviting the opinions of his studio staff, Walt held regular preview screenings in the studio auditorium where he encouraged his entire staff to submit preview criticism of the various shorts once completed. Surveys

BIANCA MAJOLIE & GRACE HUNTINGTON

Feminine First

In April 1934, Walt received a letter from a former high school classmate, Bianca Majolie. An exchange student from Rome when she attended McKinley High a few years ahead of Walt, Majolie had been working in New York as an art director for the department store J.C. Penney. After several months of correspondence, a review of her artwork, and a lunch meeting, Walt offered her a job. On February 19, 1935, Majolie began work at the Walt Disney Studios as the first female artist in the studio's Story Department.

In an interview many years later, Majolie reflected on her workplace, noting, "In 1935 the studio's atmosphere was crammed and clammy. We worked in close quarters in an L-shaped old building with a front parking lot. My close coworkers were [gagman] Roy Williams [who later became known as the Big Mooseketeer in the *Mickey Mouse Club*] and Walt Kelly [originator of the comic strip *Pogo*]."

Majolie's delicate sensibilities widened the range of concept and development offerings within story meetings, but it wasn't always easy. Story meetings were often high-pressured and nerve-wracking, and the story men were not the most accommodating. "Being the only woman in the group," she observed, "I did not enjoy the story conferences, which called for action contributions of slapstick comedy gags, and [I] avoided them whenever possible."

After providing concept and development work for various shorts, Majolie's first truly artistic contribution was the thirteen-page script that developed into the story of *Elmer Elephant*, a little elephant that didn't quite fit in. This early 1936 short film reflected her own daily challenges as the only woman in a group of men.

Majolie's tenure at Disney yielded volumes of extraordinary concept and development work, but unfortunately, very little made its way to the screen. Beyond story direction on the 1937 jazz-flavored Silly Symphony *Woodland Café*, Majolie submitted proposals for three additional shorts in the series that were either never completed or dropped altogether. The imposing and isolating circumstances, which were exacerbated by the other male artists, made life difficult for Majolie.

"During my last years at Disney my sanity was saved by my evening ceramic classes with Glen Lukens at USC," Majolie remembered. "Glen was a great teacher, and for the first time in years I was able to complete a work of art without having it changed or torn apart."

On March 30, 1936, another female Story Artist was hired: Grace Huntington. A plucky fine artist, Huntington was also a licensed pilot. While recalling her interview with Walt, she noted his 1930s mind-set as well: "'In the first place,' he told me, 'it takes years to train a good Story man. Then if the Story man turns out to be a Story girl, the chances are ten to one that she will marry and leave the studio high and dry with all the money that had been spent on her training gone to waste as there will be nothing to show for it.'" She added that Walt "explained that he had women as Inkers, Painters, and Stenographers, but that their training period was relatively short.

"He would never consider hiring a woman as an Animator," Huntington continued, "because when she married she would be a total loss to the studio. However, if a girl could write, she could work at home after she married and her ideas *might* still be used by the studio."

Walt also related the realities Huntington would likely confront at the studio: "It is difficult for a woman to fit in this work. The men will resent you. They swear a lot. That is their relaxation. They have to relax in order to produce gags, and you can't interfere with that relaxation. If you are easily shocked or hurt, it is just going to be bad."

"Walt was right," she admitted. "It was going to be difficult to 'fit.' It was a big jump from my sheltered life to the business world full only of men. Not because the men resented me—they were nice to me—but I was strange and I knew I had to be one of them if I was going to 'stick.' I had a lot of lessons to learn. In a story meeting, I had to shout to be heard. I simply couldn't be shy.

"Then I had to lose any semblance of self-consciousness," Huntington said. "More than tell ideas, I had to act them out. A person can't be self-conscious and act out a screwy scene for Donald Duck." Hired to work on discovering story ideas and adapting books, Huntington contributed to a number of the Silly Symphonies and Mickey Mouse shorts.

Mary Flannigan holds court in her canteen cubby at the Hyperion studio with Walt Disney (striped shirt) and various Animators.

were issued, stating: "Your cooperation in answering these questions frankly may help us to become better craftsmen.—WALT."

Questions ranged from general thoughts on narrative problems to specific solutions that might help the story, including great concern on whether "any gag, action, or dialogue [were] likely to offend good taste." Mary Flannigan oversaw the distribution and tabulation of the results, which Walt and the directors regularly utilized to tighten and retool as needed. Over the years this practice elicited a number of strong improvements in the characters and stories of the department.

INTRODUCING THE FAB FIVE

By the mid-1930s, Walt Disney's shorts had redefined the film industry. Mickey Mouse, the cornerstone of the studio, grew in his distinctive role and level of sophistication. Walt's daughter Diane once offered a unique perspective on her father's approach to Mickey: "He did Mickey's voice for years, and as Mickey became more of a celebrity, there was a distinct change in his character and his behavior.

"You'll notice he was a little rascal; when you look at the early Mickey, he did in all these little films all these almost vulgar things," Diane continued. "But as he became more famous, as Dad said, there were a lot of things that he didn't think Mickey should do[,] because he was the emblem of the company. And so that's when they invented Donald Duck and Goofy to do all those things."

Mickey found his way into Technicolor with the 1935 short *The Band Concert*. "I used [color] when I started my first deal with RKO," said Walt, "so the first Mickey Mouse to be released under the new arrangement at RKO was in color." Mickey is the conductor of a ragtag orchestra performing a concert in the park, and trouble ensues when a wayward cyclone enters the scene.

Set to the score of Rossini's *William Tell* overture, Mickey's first public short in color was a hit. This new color short defined the look of Disney's heroic Mr. Mouse and launched such Mickey companions as Goofy, Clarabelle Cow, Horace Horsecollar, and even Donald Duck. With this new cast of characters, whose colors were applied by the women of Ink & Paint, the studio increased production of its shorts tenfold.

COLORFUL METHODS & WIDER PALETTES

The studio's expansion signaled growth and necessary refinements to the Inking & Painting Departments. Hazel Sewell's teams grew, with Betty Anne Guenther supervising the Inking unit and Margaret Walters overseeing Painting. With an ever-increasing slate of full-color films and a wider range of distinctive characters, the department's pace picked up drastically. New levels of mastery were required for each character that came down the ongoing pipeline of material, and the limits of the premixed paints utilized at the studio were soon realized.

"We didn't have many colors," noted Grace Bailey, who oversaw the Painters. Bailey took on the task of defining a wider palette of vivid tones that would bring Disney animation to life. Studio Painter Betty Kimball recalled, "Everything was so unscientific back then. We were just creating, and it was fun. I remember Grace had developed a new blue color. She tried to describe it to me. 'It's the same color as your dress, Betty. What color is your dress?' I had dyed my dress and I told her that the name on the package of dye was 'Sky Blue.' So she right there and then named the new blue after the color of my dress."

Bailey set new methods in place to aid in consistency and color options for each character. "We have color charts that we match the paints back to and they have to be rematched every so often because they fade, just sitting on the shelves," she said.

Hyperion Heydays

"So they must be constantly matched back to the original charts, the original colors."

Defining the colors of each character introduced a new step in the overall process of animation. Before a scene moved to Animation, it would now require a number of color-model sheets to be produced illustrating the specific color choices to define each portion of a character and the props of the film. Color callouts would become the term to define these choices.

Definitive color models were created for each and every character. Donald Duck's distinctive blue coat presented some problems, as Ruthie Tompson recalled: "In the old days when we were working on shorts, we were using nitrate cels, and they were washed. Some of the paints would dye the cels, like Donald Duck's blue would dye the cels." Tompson said this was "not so much [a problem] with Mickey's pants, and we could use Mickey's over again. But Donald Duck's blue, we couldn't, so we'd make things out of them. . . . We made birthday cards and get-well cards and stuff like that."

DEFINING THE HUMAN FORM

Production continued on the various shorts and Silly Symphonies, with the latest shorts, *The China Shop* and *The Goddess of Spring*, being released in January and November 1934, respectively. These shorts marked several early attempts by Walt to have his Animators explore the human form on-screen.

The lead china statues, which come to life after hours in *The China Shop*, marked advancement in defining the female form. Further attempts at animated movement unfolded as Hamilton ("Ham") Luske and Les Clark were called to animate a believable girl as Persephone, the Greek goddess of spring. Eric Larson acted out movements for Ham, and Les tried a different approach. "I used my sister, Marceil, for certain poses," Les stated. A Painter with the studio, Marceil Clark became one of the earliest live-action reference models. As Inker Marge Hudson noted of Marceil, "She was hot stuff."

Les continued, "I had to get some sort of human anatomy, but it came off miserable, I thought. I'm sure Walt was thinking ahead to Snow White. I had a hard time with the figure, not that I didn't know how to draw it, but to animate it."

While this early attempt to animate a graceful young girl came off for the most part as rubber-hosed movement, Pluto, king of the underworld, had enough character qualities to render his devilish form believable. The staging and dramatic development of *Goddess of Spring* marked a worthwhile exercise. The artists of Ink & Paint broke new ground with an expanded color range and visual effects conveying the flames of Pluto's underworld. But in truth, this short was an internal embarrassment, merely pointing out the long road ahead to achieve animated believability with the human form.

> " *Disney created a climate that enabled all of us to exist.* "
> —Chuck Jones

MORE SHORTS

In an article for her hometown Seattle newspaper, early Inker Rae Medby recounted her experiences working on the shorts for the studio:

> It's after midnight and my brain is still swimming with droopy St. Bernards [sic] and fuzzy kittens, which I've been painting through twelve hours today (ditto for yesterday), and my eyes are doing their darndest to shut up for the night. . . . Don't get the idea that Mr. Disney is some kind of Simon Legree making us work twelve hours a day. It's simply a case of having to get out his next picture[,] *More Kittens*, a sequel to *The Three Orphan Kittens*, sooner than expected.

As challenging as some days might have been, Medby reported, "It's all more fun than work for me." She particularly noted the special screenings held for the whole staff in the soundstage after the workday: "The other night we saw *The Country Cousin*, which I believe beats even the *Three Little Pigs*. It's the cutest thing I've seen in a long time. Having worked on the pictures of course make them a lot more interesting." Medby's sense was accurate, as *The Country Cousin* went on to win the Academy Award for Best Animated Short Film of 1936.

Well into the 1930s, theater houses began running double features to attract audiences. Disney as well as other cartoon houses began to feel the squeeze-out as valuable running times eliminated shorts from the billing. Walt saw the handwriting on the wall. "My costs kept going up and up, but the short subject was just filler on any program. And so I felt I had to diversify my business."

Final frame from Silly Symphony *The Goddess of Spring* (1934).

Page 83, top: Cel setup from *The Country Cousin* (1936).

Center: Cel pieces from *The Band Concert* (1935), Mickey Mouse's first full-color animated short.

Bottom left: Production cel piece from *Mickey's Service Station* (1935).

Bottom right: Inked cel from *The China Shop* (1934), inked by Evelyn Coats.

ASSEMBLY LINE APPROACH

> *"Of all the things I've done, the most vital is coordinating those who work with me and aiming their efforts at a certain goal."*
> — **Walt Disney**

As an industry, animation was still very young. In the early days, everyone—even the front office—participated in every aspect of production. Experienced Animators stepped directly into production, while newcomers began within the Camera or Inking and Painting groups to learn every aspect of animation. Ideas and basic stories were often developed in a loose, collaborative manner. "Every once in a while, Walt would throw a luncheon," recalled Dick Huemer. "We'd discuss the next story, sometimes presented by the author, and were invited to criticize or to add improvements. All this was stimulating and wonderful."

With more advanced sophistication to the characters and stories taking shape at Walt Disney's Studios, new processes were soon required at the turn of the decade. The intricate, complicated process of animation required thousands of hours of painstaking work. With production schedules, costs, and staff numbers increasing at Walt's Hyperion studio, it quickly became necessary to streamline the production process with a clear and carefully planned pipeline. Mere months after the Disney brothers first opened their studio, automotive industrialist Henry Ford realized his landmark vision as the ten millionth Model T rolled off the factory assembly line in Michigan. One of Walt Disney's heroes, Ford revolutionized the world with his sturdy Model T and development of an assembly-line approach to automotive production in an effort to reduce costs and increase efficiency. Leaders of other industries applied this approach to their own methods of production—and that included the Disney brothers.

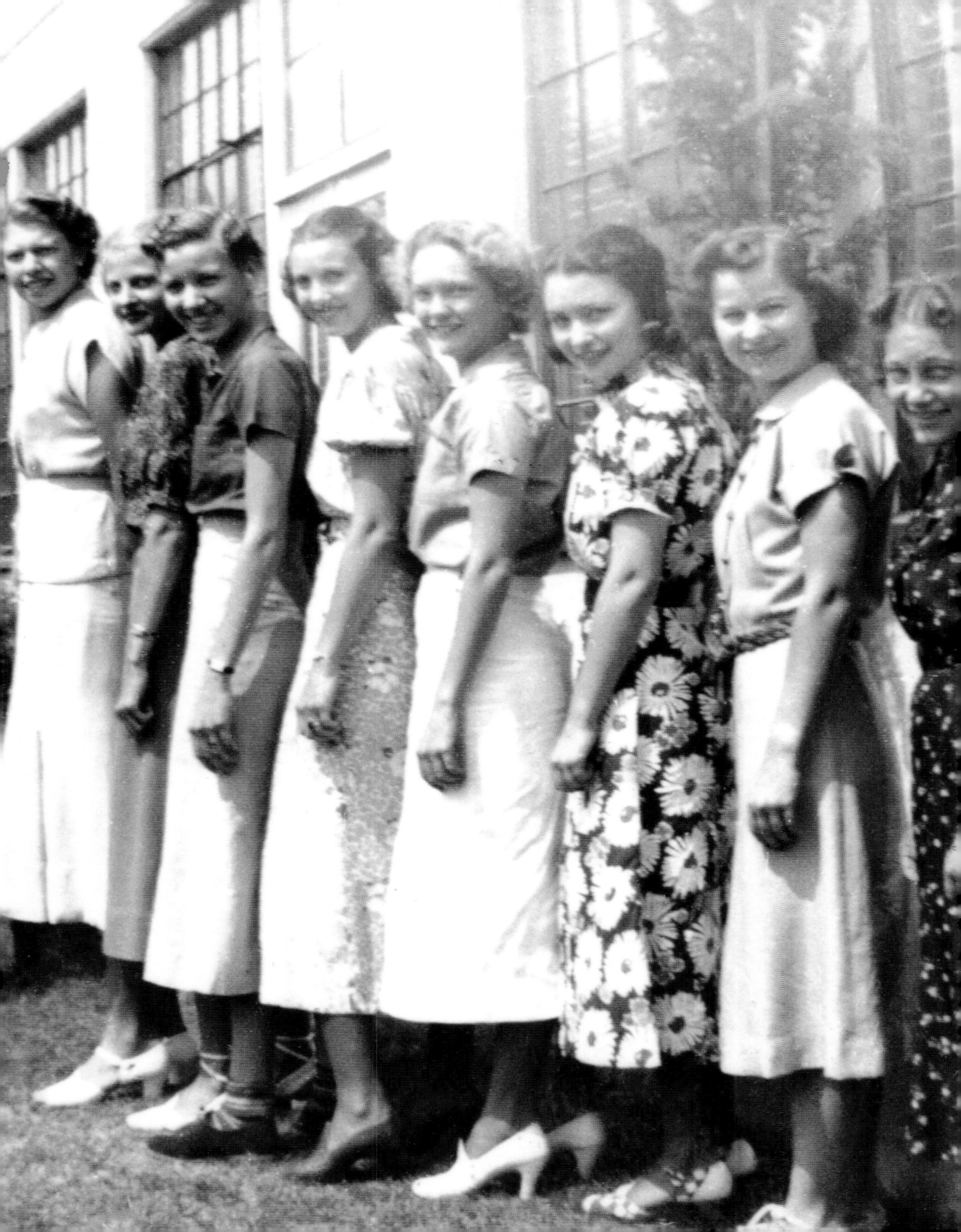

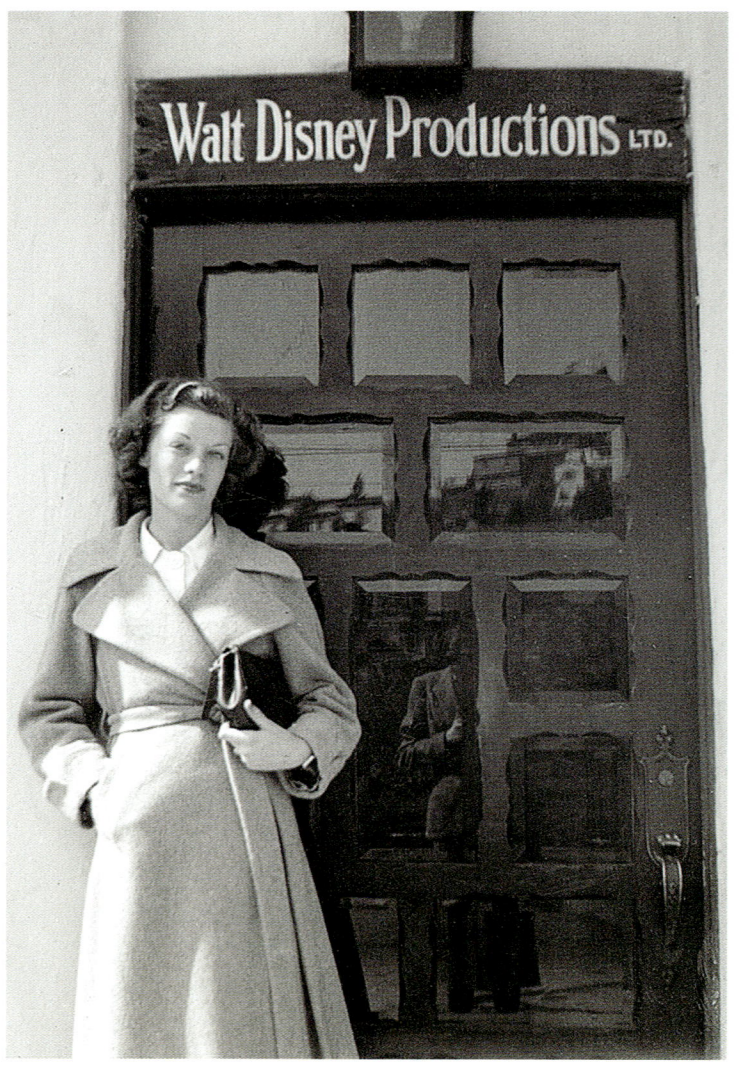
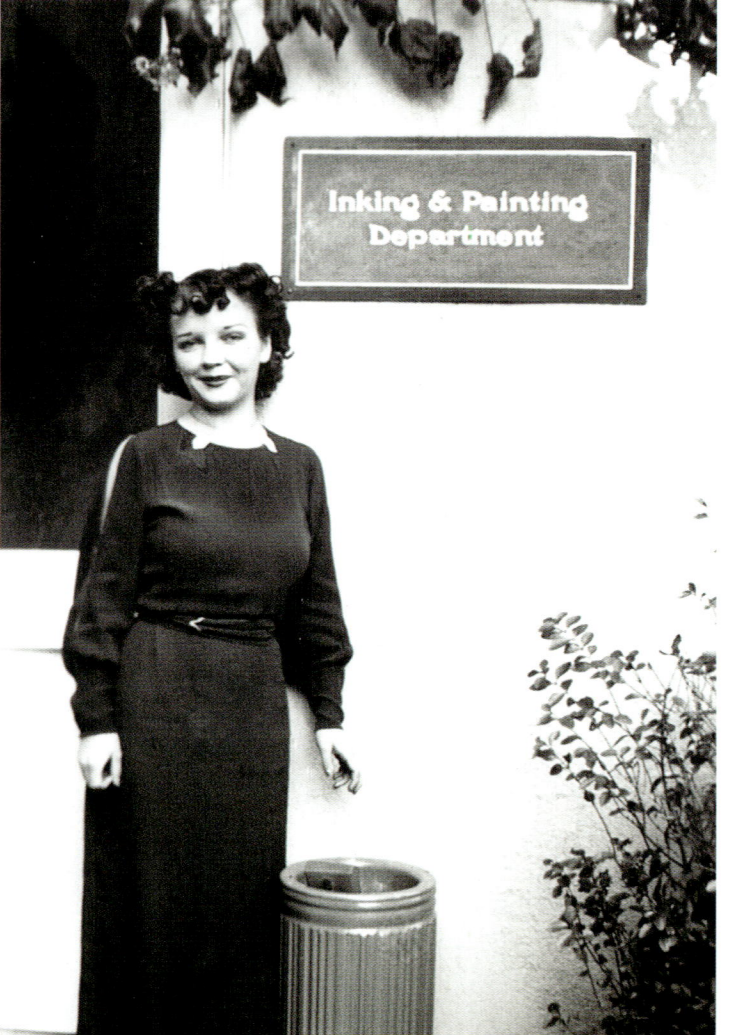

Page 85: Lineup of several Ink & Paint staffers: Kae Sumner (far left), at 6'2" tall, founded the Longfellow's Club for tall persons while working at Disney Studios. Betty Anne Guenther, Mimi Thornton, three unidentified Ink & Paint artists, with Geno Renshaw and Ingeborg Willy, who stood at 4' 10 1/2".

This page, left: Unidentified Ink & Paint artist at the entrance of Walt Disney Studios on Hyperion Avenue, 1936. Right: Ink & Paint artist June Brandon-Madson at the entrance to the Ink & Paint Department Building, 1936.

ATTENTION TO DETAIL

Experiencing the most expansive growth in Disney Studios' relatively short history, additions were made to the Animation Building in 1934 and 1937. With the volume and complexity of productions growing, a new Inking & Painting Building was added in 1935. The fresh crop of apprentice Animators were trained in a building across the street from the main structures along Hyperion Boulevard, and within the next two years, two apartment houses on Griffith Park Boulevard were housing offices, various production shops, and labs. By the latter half of the 1930s, with exponential growth and success, Disney's Hyperion studio was a thriving, bustling campus.

While other studios in town were somewhat utilitarian, "Walt Disney definitely took pride in the appearance of his studio," recounted Animator Dick Huemer. "We were all enthusiastic and had what we thought was a beautiful studio. This made you feel good. [He] made beautiful desks, nice furniture, landscaped the grounds. Walt always wanted nice surroundings." Painter and special effects artist Grace Godino recalled of Walt's attention to detail: "He always worried about if we sat so long and he always worried about being comfortable in the chairs. He'd have them bring in all these different types to fit it just right in our back so that we could sit at the animation board. He was really very fussy about that."

Efficiency experts were regularly brought in to structure the bourgeoning organization. Evolving from a freewheeling, all-hands-on-deck approach to a chain-of-command assembly-line process, the production method at Walt Disney Studios developed into a continuous flow of results. This efficiency came with a price, as it isolated the role of each department within focused areas of production, leading to a business of separate specialists rather than overall artists.

COOL & SECURE

Beating the heat at Hyperion studio occasionally presented challenges. On the hottest of days, Ink & Paint would have to shut down as the paint would smear from the artist's perspiration. George, the Good Humor ice cream vendor who regularly roamed the halls on warm days, sold Popsicles and cups of frozen treats to keep the staff cool. As the studio newsletter reported, George kept "an intricate credit system" for those who may not have had the five cents and "acted as a sort of frozen cupid by delivering prepaid sundries to surprised Secretaries and Inkers and Painters."

Heightened security measures were put into place as the studio became more renowned. June Patterson, a young Painter, took these efforts seriously. "It was one rainy night, and it was late—work hours were over, but it was dark. . . . and I was waiting for my ride. There was a man there who had to sign everybody in and sign everybody out. He said, 'June, you take over and don't let anybody in or out without having them sign.' So, I saw a man coming down the hall, and I was feeling very young and facetious, and I said, 'Sorry, you can't go in or out without signing here, please,' and he stopped and he just looked at me and

Ink & Paint | 87

Top: Historian Hans Perk's interior diagram
Bottom: Aerial photograph of the Hyperion studio Ink & Paint Building, constructed in 1935.

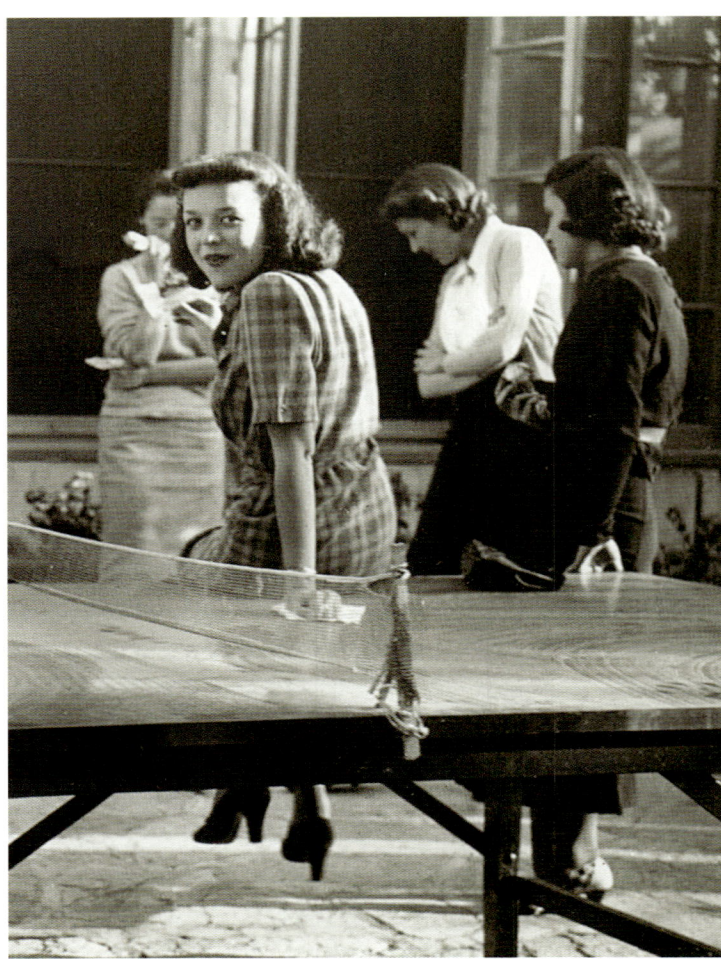

Left: Ink & Paint girls enjoy ice cream on a hot day in the Hyperion studio courtyard, circa mid-1930s.

Right: Kae Sumner purchases a cool treat from George, the ice cream man, at the Hyperion studio in the mid-1930s.

I couldn't see him very well because it was dark. He said, 'Who are you?' And I said, 'Well, my name's June Walker and I work in Ink & Paint, but that's not the point. . . .' I rattled on, and he kept looking at me—I just didn't recognize him. So he said okay [and] signed. The guy that left me in charge came back and said, 'You made Walt sign out?' I said, 'Well, you told me not to let anybody in or out. . . .'"

> " *More study was the only way to keep advancing.* "
> —Frank Thomas & Ollie Johnston

"MORE LIKE A SCHOOL"

In the earliest volume written about life behind the scenes at Disney Studios, Robert D. Feild describes Walt's approach to his designs: "He conceives the studio as a living organism, reaching out into the future, incapable of satisfaction with what already has been accomplished, forever watching for the opportunity to do something better." Walt summed up his methods: "Our studio had become more like a school than a business. As a result, our characters were beginning to act and behave in general like real persons." Life drawing and color theory were taught, animals were brought in for study, and classes were regularly on offer for all departments to improve the artist's skills and understanding of their roles.

To enrich and expand the skills of the current artists, Walt established a Development Board that brought a number of leading luminaries of the day to the studio. Lectures, screenings, and demonstrations were scheduled regularly and were usually open to all employees.

Leading artists and experts were brought to the studio specifically to enrich the work of the Inking & Painting artists. Noted American artist and educator Ruth Faison Shaw paid several visits to the studio conducting workshops for the artists of Ink & Paint. Shaw developed the techniques of finger painting and introduced these concepts into the US arts education. Shaw recognized its uses in therapy while working with soldiers returning from World War I and developed her work as a teacher for American and British children in Rome. Returning to the States, she opened the Shaw Finger Paint Studio and published books on the art of finger painting. Walt found her work interesting and encouraged her various demonstrations in the Paint Laboratory for the Ink & Paint staff as well as for the educational programs at the studio.

Author and widely known color authority Faber Birren was brought to the studio for a series of lectures on the psychology of color. Generally recognized as the leading authority on color in the day, Birren devoted his life to the study of color and its psychological application within industry. "I have gathered together all possible research, facts[,] and lore that have to do with the influence of hue on the mind and emotions of humans," Birren wrote to Mary Weiser of the studio Paint Lab. "I feel certain that the subject of color is an important one and that I could acquaint your various technicians with the vital elements of color appeal and color influence."

Studio staffer and Helen Deforest Ludwig (right) setting up Walt Disney Studios' first library.

Pages 91-95: Artwork created for various production phases from *Music Land* (1935).

Birren's studio lectures covered the history, science, effects, and uses of color. Delving into the relation of color to vision and the psychological reactions to color, Birren's presentations explored the symbolism and effects of color and lighting on audiences when seated in a motion picture theater: "Movies use film colors and with them attempt to give the appearance of surface colors, textures, materials, substantial things."

Color qualities and textures achieved with pigments and photographic processes opened up new techniques and visual suggestions for the Painters. As Birren noted to the artists of Ink & Paint, "Finally, you have millions of people to think about and not any one individual taste. It is this big feeling for color, this childish response that must be watched and capitalized. You can work with subtlety, with softness, but always with the idea that someplace you will hit a big peak. People have simple tastes. It is your job not to fail them, for as one man in [New York] said, the animation motion picture is the only universal art form we have today."

"BUY" THE BOOK

To alleviate stress and expand their horizons, Walt and Lillian headed to Europe along with Roy and Edna in the summer of 1935. "That was our first trip," recalled Edna. "We visited England and then France and Italy and Germany." While traveling, Walt collected books on a wide range of subjects—art, reference, fairy tales and children's stories—all related to improving the world of animation. Crates of books were sent back to Hyperion Avenue, and upon his return Walt established a studio library with the hiring of Helen DeForce Ludwig (later Hennesy) as the Walt Disney Studios' first librarian.

Ludwig was living in Pasadena with her parents, who watched her young baby while Ludwig attended USC to complete her degree in public library administration. At the loss of her father, Ludwig became the head of her family, and was financially responsible for her daughter and widowed mother when she sought work with Walt. Excited for her first day of work in July 1935, she wrote on her calendar, "Start work at Walt Disney Studio at 8:00." With complete authority, Ludwig set up and organized the resources on hand and expanded the library's content to meet the creative needs of the entire studio. Soon after, Mary Brown Salkind and Caroline Jackson were added to the library staff to handle story research needs. With the number of projects expanding, Inez Henderson and Elsie Jane Heid later rounded out the research staff to meet the demand for information. In 1938, Jane Clark and Carl Jenson joined the research staff to assist with story research as needed and to catalogue the mounting volume of studio artwork stored in the studio library.

Over time, resources including general subjects, rare and specialized volumes, magazines, periodicals, and an extensive news-clipping catalogue were added to the shelves for the various departments and specific productions under way. "Helen was very proud to have worked for Walt," noted her granddaughter Charlene Sundblad. "She took her librarian work seriously and would send off many 'notes' to those who did not either check the books out properly or return them in a timely manner. She would chase down all missing books[,] no matter who had them." Even when it was Walt Disney!

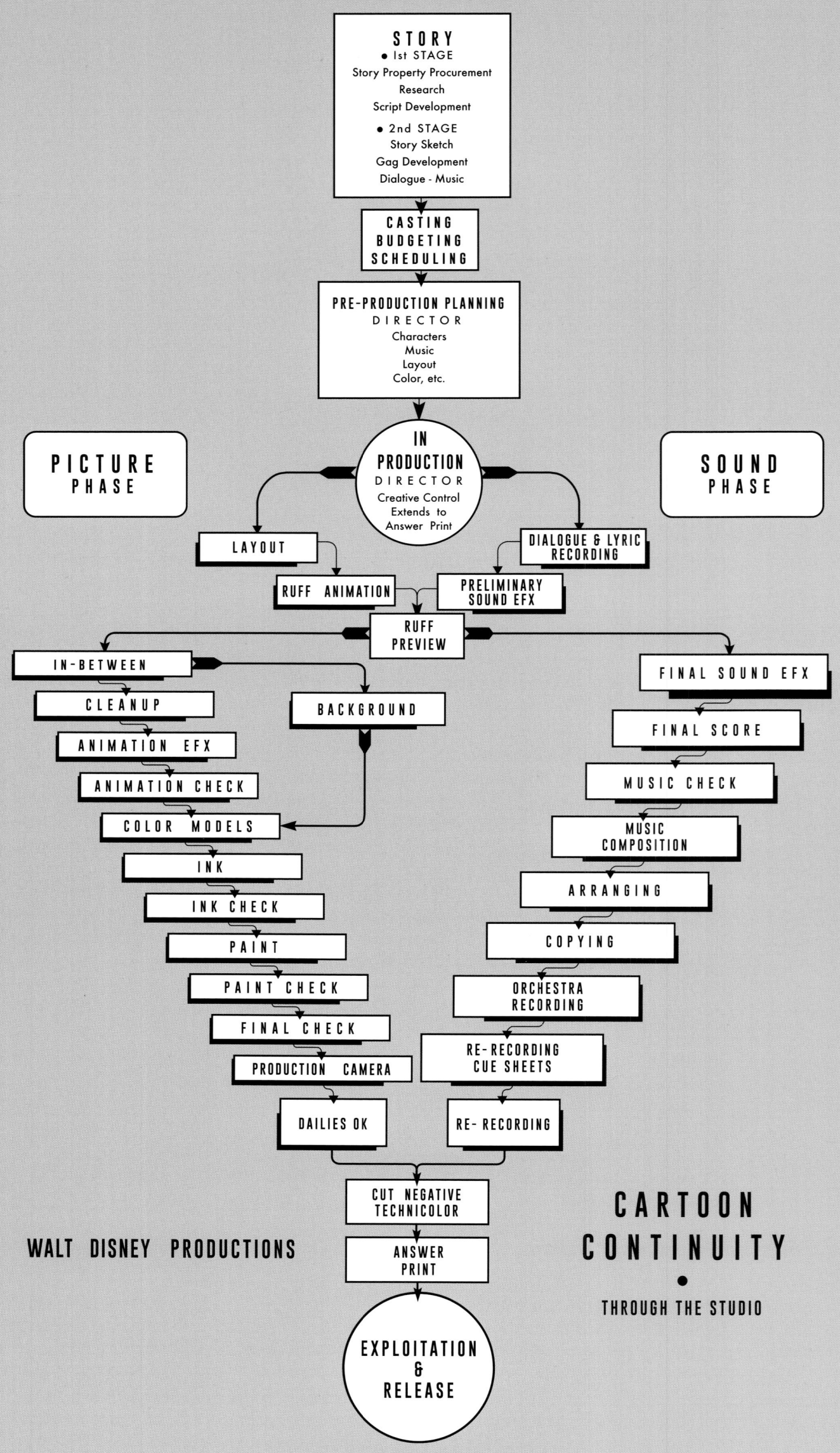

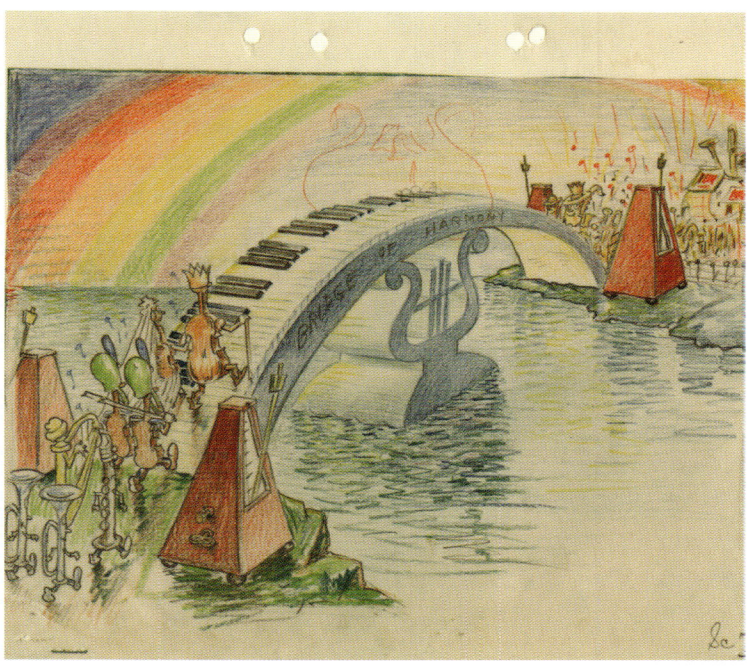

STORY

At the Walt Disney Studios, a story passed through various stages. A studio write-up noted, "The Story Department is responsible for the idea pattern of the picture. This department is fed by and co-operates [sic] closely with the Story Research Department, which[,] it may be said, starts the story on its way."

STORY RESEARCH

Story Researcher Mary Goodrich works with Librarian Diana March. The women of this department played a critical role in finding suitable stories and material to shape shorts and feature films from. Started by the pioneering work of Dorothy Ann Blank, the department explored every type of story, including fantasy, folklore, and legends from all nations, searching for basic story material suitable for the Disney animation medium. Gathering all available information and detail on various stories, the Story Research staff created a bibliography and exploration of various source material and adaptations for each possible story idea. These elements were then shaped into an early synopsis outlining the quality of story and characters. Department members shaped a suitable animation treatment and worked with writers and sketch artists to form an adaptation and continuity script. Once these elements were in place, the story could potentially become an active production.

STORYBOARD

In the Storyboard Department, the story line for a short was developed through a series of sketches that carried the overall action in a logical sequence. Walt always credited Webb Smith (others credited Ted Sears) with the notion of making drawings on separate pieces of paper and pinning them—in sequence—to a large bulletin board, stating, "We developed the storyboard technique as it is known today, wherein we really started laying out the story and the dialogue and the complete continuity on the storyboard." Any changes to the story could then be made by moving or replacing drawings. With this simple approach, all members concerned with production were able to see the span and plot of the entire film. Once the story was finalized, Marc Davis clarified, "Then those boards would be taken down to the dialogue stage, and you would have the voice artists . . . [reference] this with the director, and generally the top Animators."

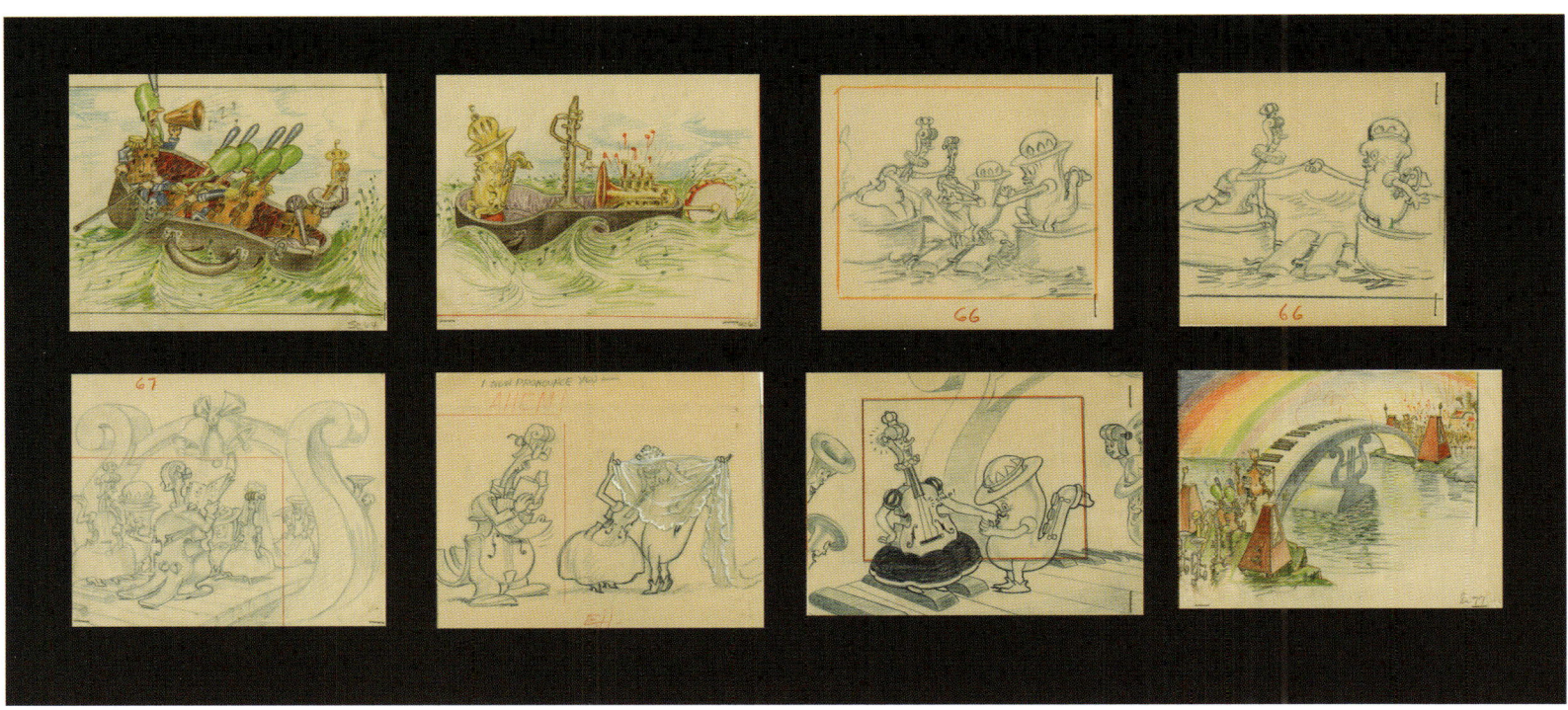

MUSIC/SOUND

With Animators roughing out a few of the principal scenes, the musical head and Sound Effects teams began working with suggestions regarding appropriate music and sound for the developing story. Spotting where to introduce possible songs throughout became a standard part of the story process, as the film's plot would advance through the use of songs and score.

SCENARIO/DIALOGUE

Once the overall story was worked through visually, the writers staffing the Dialogue Department worked on the written word to shape the action, direction, and spoken dialogue for each character. Once completed and approved, Talent Casting began to find the definitive voices for each character. The writers participated in each recording session, developing and adjusting dialogue, if needed, throughout each session.

LAYOUT

To stage the scenes, the plan of action was laid out in-line with the camera. The artists in this department also supplied the Animators with detailed instructions on the mechanics of their work. The finished scenario was broken down into scenes, which were are numbered and passed along to the Animators together with two sheets. One furnished the Animators with specific drawing instructions; the other, an exposure sheet, or X-sheet, was a breakdown chart of the music and sound effects in a scene, which the Animators used as a guide for drawing. This vital point of communication traveled with each scene to convey any specific instructions to each department throughout the entire production process.

BACKGROUND

Background artists developed and created the settings and scenery of the film. These artists created the world in which the figures live, move, and play out their scenarios. Background teams worked with the Color Model artists and supervising Director to ensure the proper color choices were made to create a cohesive, pleasing, and narratively appropriate palette for the overall story.

MODEL SHEETS & CHARACTER MODEL DEPARTMENT

In one of the larger departments, the most-skilled artists oversaw the characters and defined their form and movement so they would come alive on the screen. These artists did not concern themselves with color but focused on form and movement. To finalize the character from several rough design options and maintain consistency, model sheets were created. This strengthened the film's consistency and believability in each character. In addition to model sheets, the Character Model Department founded in the late 1930s provided three-dimensional sculptures, called maquettes, of the various characters. These maquettes were sculpted and shaped to support the artists' ability to capture the form of each character from various directions and angles.

ANIMATION FIELD GUIDE

A vital reference throughout the animation process relating various sized artwork to the final film frame.

PEG REGISTRATION

Since multiple artists would make contributions throughout the production process, the peg-registration system maintained a unified point of consistency for the characters' placement and action—every step of the way. Animation paper and cels were punched to keep uniformity locked between the animation drawings, the final cels, and the camera. In the early days of Disney, Ub Iwerks built a machine that is still utilized at the studio today.

- From *Plane Crazy* (1928) to *Who Killed Cock Robin?* (1935), a two-punch peg system was utilized, but from *Mickey's Garden* (1935) to *Cold Turkey* (1951) a five-punch system with three peg holes surrounded by two registration bars was used to ensure the proper alignment of all action and artwork. There were three small registration pegs on each animation desk that every sheet of animation paper would align with.
- The Acme peg system was widely used throughout the early animation industry. This system featured metal pegs equally spaced at four inches from center to center.

Ink & Paint | 93

CEL & PAPER SIZES

Size	Dimensions
6½ FIELD	CEL = 12½" x 16" PAPER = 12½" x 15½"
10 FIELD CEL & PAPER	19¼" x 25"
10 FIELD CEL & PAPER	20" x 25"
20 INCH CEL & PAPER	= 12½" x 20"
30 INCH CINE. CEL & PAPER	CEL = 12½" x 30" PAPER = 12½" x 31"
2 PAN	CEL = 12½" x 32" PAPER = 12½" x 31"
3 PAN	CEL = 12½" x 48" PAPER = 12½" x 50"
4 PAN	CEL & PAPER = 12½" x 64"

FINAL ANIMATION

With preliminary scene sketches approved, sequences were roughed out and then photographed with a 35 mm camera. As Bill Garity noted, "This footage can be viewed by the Animator with [a Moviola,] a sound-equipped device that gives him an idea of how the scene is going to look on the screen." Adjustments could be made to the sketches as needed. Once set, the lead Animator focused on the key poses or drawings. Assistant Animators completed the "extremes," frames that started and finished specific sections. As Eric Larson noted, Walt insisted the Assistants "make it stronger than it has been drawn," seeking bold, energetic work. The sequence of images between these segments of the action were then drawn by the Inbetweeners, and later, Cleanup Artists would clarify the final lines of each scene.

ANIMATION CHECK

Once the Animators' scenes passed through final cleanup animation and achieved Walt's approval, Checkers within the Animation Check group "walked" the characters through their scenes by carefully reviewing the X-sheets with the drawings for a completed scene. Flipping and comparing the drawings on pegs, the Checkers looked for a continuous flow to the animation, and any gaps in movement, distortions, or mistakes would be corrected.

COLOR MODEL DEPARTMENT

The artists within the Color Model Department remained involved throughout various steps of the production process. At this point, they established the "individuality" of the characters by the story teams and the film's Director to define the required colors, personality traits, and structural proportions. Several different color combinations for each character were created on cels for review.

INKING & PAINTING

Once Walt approved final scenes from a sweatbox screening, the final animation drawings were sent to the newly dubbed Inking & Painting Department. In this division, the final "by-hand" artistry was applied to each cel. Inkers skillfully redrew the animation drawings onto cels using watered-down paint. India ink had been utilized in the earliest days of animation. After the inked side dried, trained artists painted the opposite side with the specified colors mixed in the studio's Paint division. Once through each division, the work underwent a rigorous checking system.

SPECIAL EFFECTS

Various elements such as raindrops, flames, or cloud movements were drawn, then inked and painted on separate cels. Specific animation artists created these pieces and special teams of Ink & Paint artists would complete the detailed work. These would be integrated into the scenes before they headed to Camera. Ink & Paint artists who specialized in shadow painting also completed cels featuring the translucent shadows cast by various characters.

CAMERA

In this final stage, the combined visual elements were captured through the eye of the camera and forever recorded onto film. Meticulous movement, layers, and timing were all factored into the stop-motion photography in which each exposure was made separately. Various cameras were utilized to achieve specific scenes—the primary camera work was achieved through traditional animation platen setups, and special effects were accomplished via separate camera techniques based on the effect.

EDITING

Editor Shirley Gross preps footage at Disney Studios. All elements came together in the hands of the Editor for the final telling of the story. Sound, music, and picture were assembled to complete the final film. The Sound Department, Music Editor, and final Editor all worked in conjunction to complete the final picture.

ADMINISTRATION

The administrative staff fulfilled the various support matters that were part of Roy Disney's world, such as the contracts, bookkeeping, supplies, materials, training, communications, daily matters of studio personnel, and numerous other matters, including overseeing production and progress.

Ink & Paint | 95

 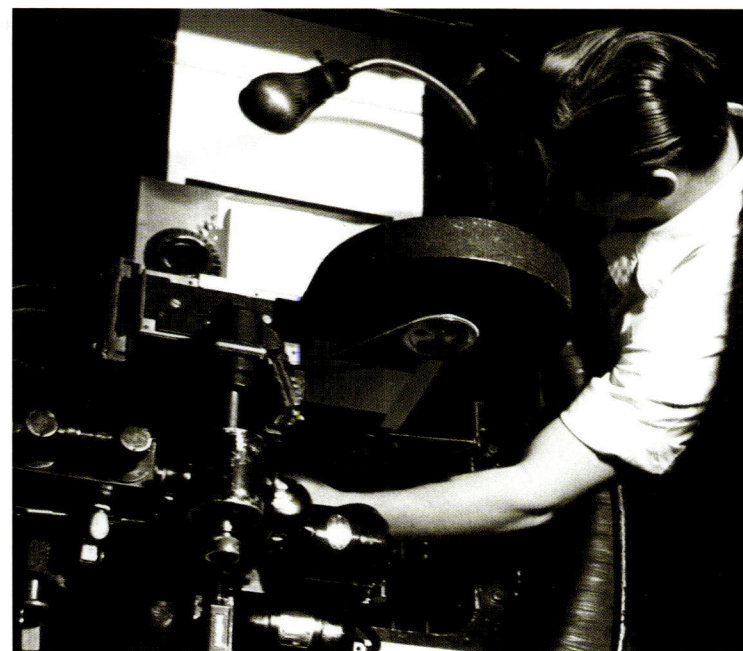

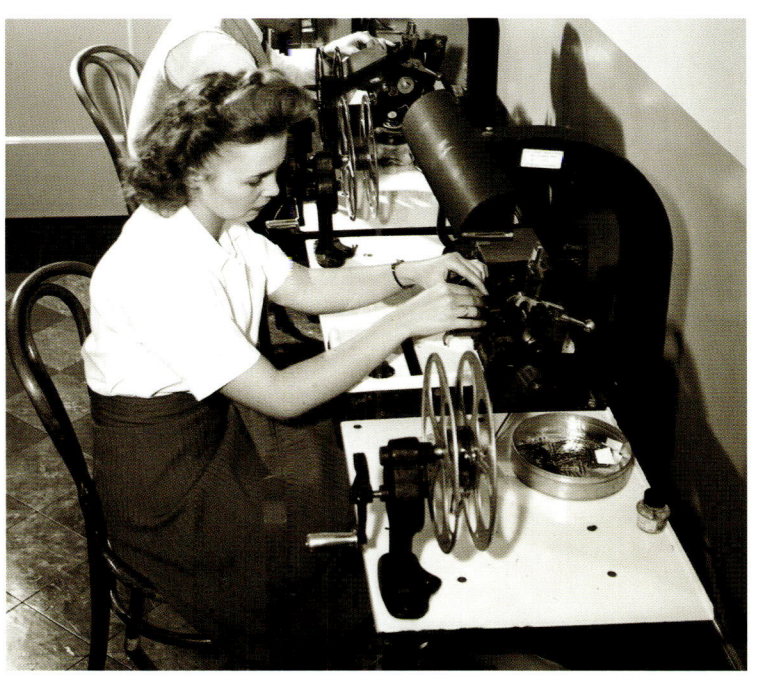

WORLD OF INK & PAINT

> *"We had learned how to use our tools and how to make our characters act convincingly. A greater degree of specialization was setting in."*
> — **Walt Disney**

Synonymous in function yet separate in form, the original Ink & Paint Department operated as one unit to bring depth and dimension to the Animators drawings. The responsibility for the lines, colors, and final forms the audience experienced on the screen was the department's ultimate artistic responsibility.

With the various studio expansions in the early 1930s, this growing group established their own domain in the original Hyperion building refreshed for their specific needs. Custom-built tables featuring thinly spaced shelves within arm's reach, lined the large-windowed walls, as the detailed work performed in this room was best accomplished with natural light. Large electrical fixtures overhead filled the room with warm tungsten light for overcast days and occasional late nights of working overtime on production deadlines.

"It was very small," remembered Grace Bailey of her beginnings at Walt Disney Studios. Hired by Hazel Sewell as a young Inker, Bailey had previously inked at Fleischer Studios in New York. "I think there were about 150 people in the entire studio[,] and in the Inking & Painting Department, I believe we had about sixteen or eighteen people." All the girls could paint, but not everyone could work with ink. In the very early 1930s, Marcellite Garner recalled, "We all started out as Painters[,] and after you learned that, then if you could ink, you went into Inking, but inking was something you really had to learn to do, and Walt demanded shaded lines in his inking[,] which made it even harder." Providing depth and dimension to each character, these shaded lines, as well as shadow painting, required girls to became specialists in specific details.

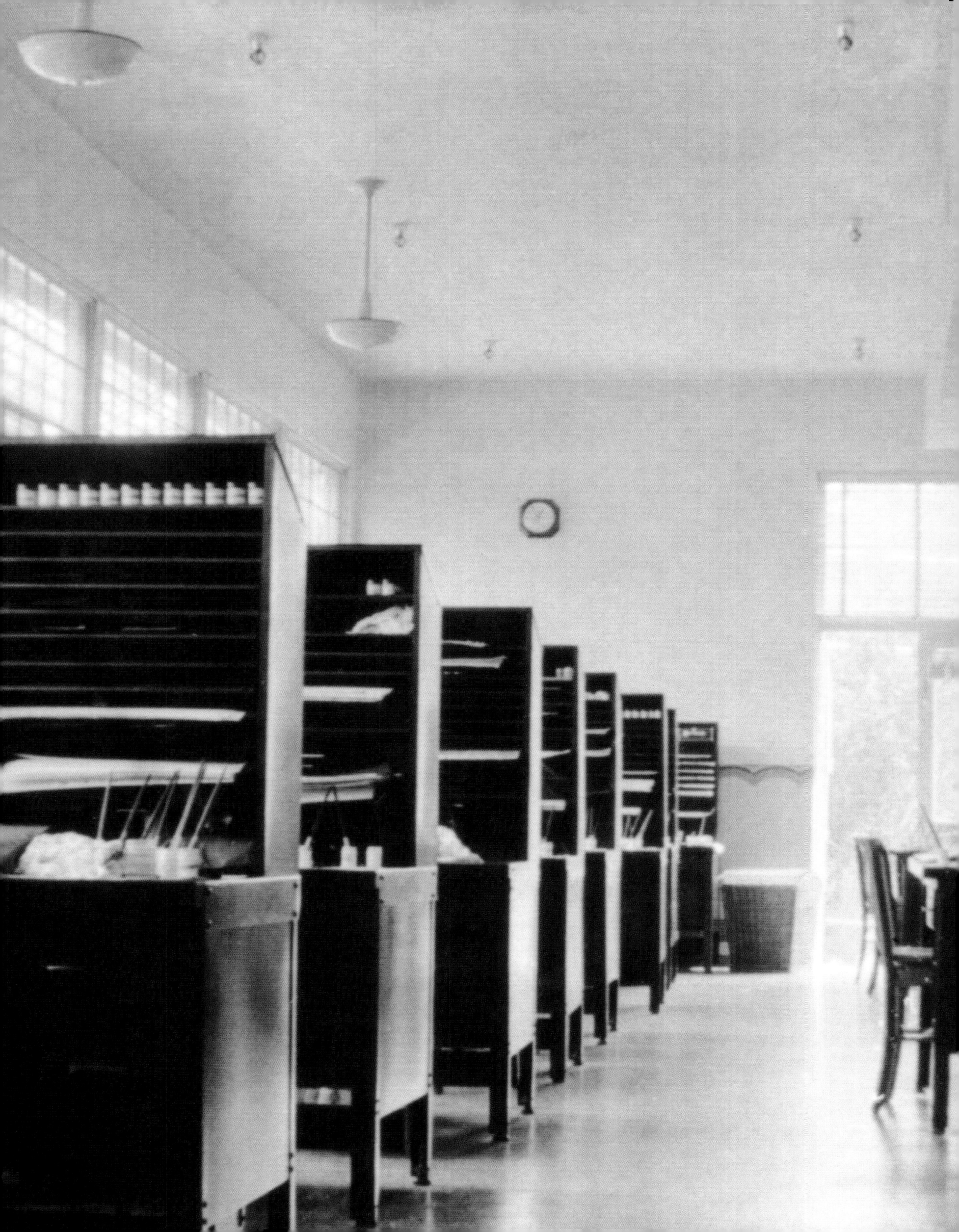

WALT DISNEY NEEDS GIRL ARTISTS NOW!

Steady, interesting jobs for girls, 18-30 with elementary art training. No cartoon experience needed; we'll train you, pay you while you learn.

Apply
DISNEY STUDIOS, ART DEPT.
Bring samples of your work.

TRYOUTS & TRAINING

"Girls not only have more patience and a finer sense for detail, line, and color—they have infinitely more patience to do a more finished type of work so necessary for this work on celluloids." So said a late 1920s studio write-up explaining the role of women as Inkers and Painters. The prevailing attitude of the 1930s was limited in its scope, and even more limited in its view on the pool of qualified women applicants. "For every woman applicant there seems [sic] to be ten men [just] as good if not better."

With the continuing growth of the studio in the 1930s, Hazel Sewell's Inking & Painting Department kept expanding as well and had turned into a well-oiled machine. By the mid-1930s, this now fully feminine stronghold was no longer a handful of "girls," but rather hundreds of artists efficiently handling any creative challenge that came down the pipeline. For many of the women in this era, working at Walt Disney Studios was a dream come true. As Evelyn Coats, an Inker, later recalled: "It was so exciting to be working for Walt Disney that I don't think anybody got bored about it. No way. I was so thrilled to have that job."

Under Sewell's leadership, the role women would play within Disney animation dramatically rose from "mere" tracing and filling in to a new level of artistry. The techniques developed and applied within the Inking & Painting Department required mastery never before seen or achieved in animation and marked the most advanced development in the animation art form of the 1930s. Their work transformed animation from black-and-white novelties into full-color works of art.

GIRL ARTISTS WANTED

In the early 1930s, internal references and local newspaper ads calling for qualified artists yielded a number of female artists responding as prospective candidates. A limited perspective from the young studio narrowed possible candidates by age: "[We're] seeking women between the ages of eighteen and thirty-five," studio documents stated. "Women over thirty-five have shown that their muscles start to stiffen and that they cannot master a pen and brush technique so well as younger girls." Of course, this mind-set of the times was quickly proven wrong and later dropped from studio requirements.

MOrningside 12131

WALT DISNEY PRODUCTIONS
MICKEY MOUSE SOUND CARTOONS
2719 HYPERION HOLLYWOOD

We have received your inquiry regarding a possible affiliation with this Studio.

All inking and painting of celluloids, and all tracing done in the Studio, is performed exclusively by a large staff of girls known as Inkers and Painters. This work, exacting in character, calls for great skill in the handling of pen and brush. This is the only department in the Disney Studio open to women artists.

Our needs are more than adequately met by local applicants. Therefore, please do not consider a trip to Hollywood for the purpose of finding employment in our Studio.

Thank you for the interest which prompted your inquiry.

Yours very truly,

WALT DISNEY PRODUCTIONS

George Drake
Head of Training Department

SILLY SYMPHONY
Sound Cartoons

Local inquiries sent by women who showed some level of promise received the following instructions:

> One must be well grounded in the use of pen and ink and also of water color [sic]. We ask the girls to call at the Studio, bringing with them samples of their work. From the applications and the work, Mrs. Sewell, in charge of the girls, picks members of our training school. At the class, which meets for three hours every day of the week except Saturday, the girls are taught to Ink & Paint on celluloid. This is a considerably more difficult medium than paper. The girls who prove the most proficient are offered positions when there are openings.

As reported in the *Ogden Standard Examiner* in May 1935, "Receiving an average of twenty applicants a week, with a considerable increase in that number during the summer vacation months, Disney is forced to reject most of the applicants. Only those showing genuine talent are given trials."

As the popularity of the Disney cartoons grew at the height of the Depression, letters, portfolios, and queries arrived from hopeful applicants all over the country, and a response from the home of Mickey Mouse became necessary. Initially, Walt's secretary, Dolores Voght, sent out this polite reply: "We do not accept

Page 97: Inking corridor after hours at Walt Disney's Hyperion studio.

Page 98, left: An early ad placed, seeking "Girl Artists" for Walt Disney Studios.

Right: An early rejection form letter issued to the many unqualified and out-of-state application requests received by the studio.

This page: Girls working on the Inking corridor of the Hyperion studio.

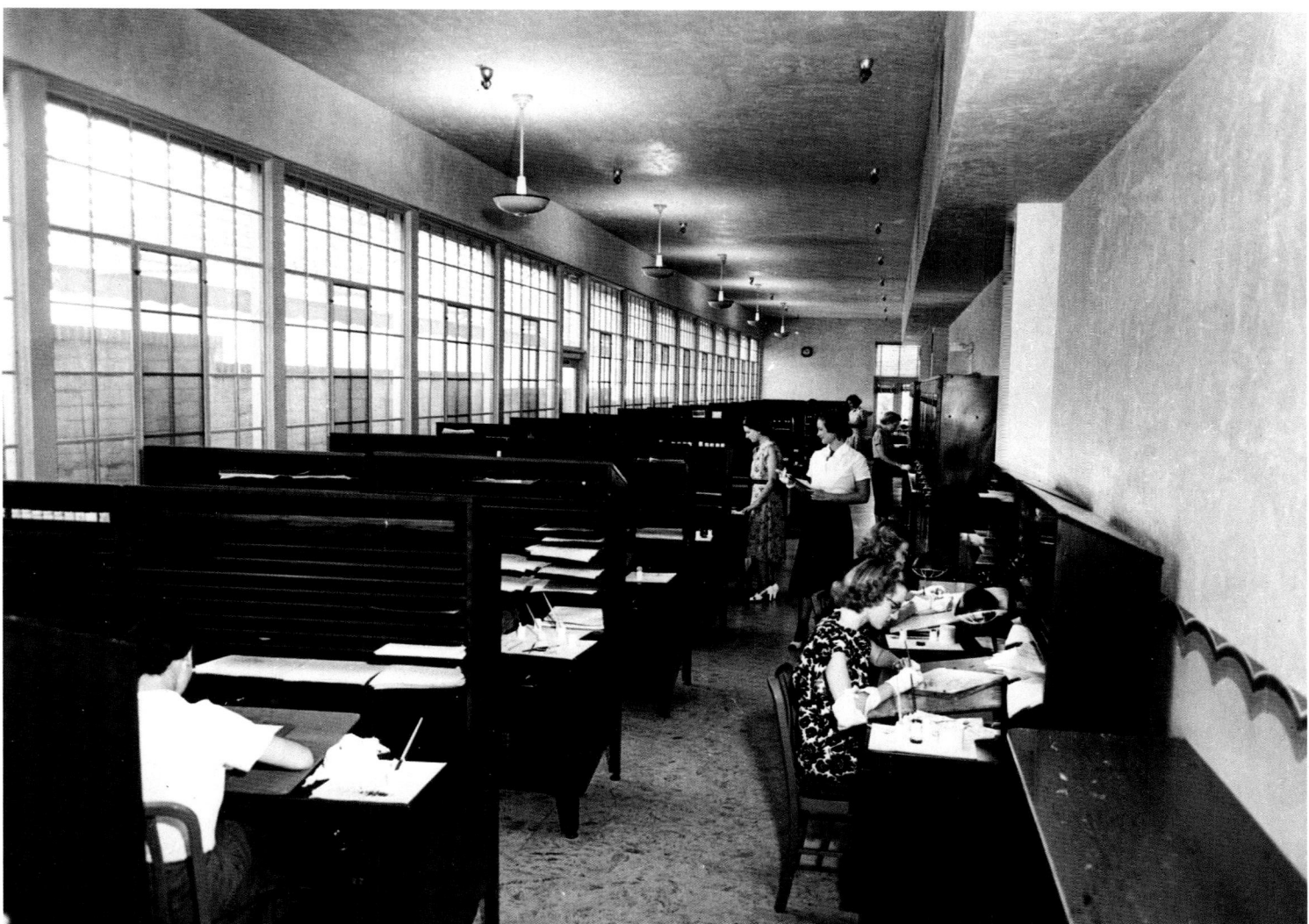

sample drawings and applications from those whose homes are in various distant parts of the country."

With the international success of Disney's Mickey Mouse and Silly Symphony shorts, the mounting volume of queries soon became the responsibility of the Development and Training Department. Generic letters with a curt but polite response were utilized to deter the volume of hopefuls eager to join the ranks at Disney Studios. Qualified portfolios were accepted only from those candidates who were already living in the Los Angeles area. Out-of-town queries were promptly discouraged: "It would not be advisable to come to Hollywood, as there are really very few openings in comparison with the number of girls who apply."

Generic letters based on presumed gender, proved somewhat helpful in managing the volume of queries received at the studio on a daily basis. Unfortunately, this industry-wide approach occasionally proved counterproductive. As a young artist, legendary Animator Marc Davis sent his portfolio to Disney for consideration. "Marc received a letter back, addressed to 'Miss Marcia Davis,'" chuckled Marc's wife, Alice. "It was from the man that was in charge of answering requests for a job who didn't know that the French spelling of 'Marc' was spelled with a 'c,' so he thought this was from a girl. The letter stated that Disney was not hiring women at the present time and they would let 'her' know if and when they decided to hire women because they liked 'her' portfolio very much.

"Marc was so angry," Alice continued. "He wadded the letter up and threw it in the wastepaper basket." Two years later, Marc applied at the studio in person. He was hired that day and went to work as an Assistant Animator to Grim Natwick. Surprised that a studio of that size would make such an error, Alice noted, "When he met the man who sent the letter to him, he understood why, because he was not the brightest person."

TUESDAY MORNINGS

Potential Inkers and Painters were seen at the studio every Tuesday morning between nine thirty and eleven thirty a.m. for training consideration. The studio's Personnel Department processed a constant flow of eager eighteen- to thirty-five-year-old portfolio-clutching candidates. Betty Kimball, a Painter, recalled her Tuesday morning interview: "I never went to art school, so I didn't really have much of a portfolio, but I had botanical prints that I did in my botany class."

As the complexity of the films grew, so did the screening of potential candidates. Eventually, all the women had some sort of an art background, whether through formal training or natural talent. A strong understanding of color and a sense of perspective, shape, and depth were required, and applicants were also considered based on their handwriting. "If she had a free style to her signature, ten to one she'd have a good pen and brush technique," noted Kimball.

Women with strong portfolios and evident talent for line work were in demand. Marge Hudson recalled, "I took my portfolio to Hazel [Sewell] and she flipped through it and she

practically just said, 'You're hired. Come to work on Monday.' Because I could do such good pen and ink." Marie Justice, who briefly worked at Ub Iwerks's studio before applying at Disney's, recounted her Disney interview process: "Mary Cleave [of the Ink & Paint Department] interviewed me in the morning, and then that night, she called and said to come to the studio the next day and meet with Grace Christianson, which I did[,] and that was it." Many years later, Justice and her coworker came across her application and noted that it read "Young, healthy looking girl." They took it as a good joke. "We figured that looked like I would be good for a lot of overtime!"

TRAINING CLASSES

In an effort to meet the growing sophistication and detail within the Silly Symphonies series, Hazel Sewell instituted training classes within each discipline to separate the talent from one division to another. On Tuesday evenings, regular classes were held with eight to ten apprentice attendees learning the various crafts of Inking & Painting.

In 1932, a young Grace Bailey came to the studio for a tryout. "A friend of mine said that they were asking for artists," she later recounted, "and I had just gotten out of high school, and I went over and showed some of my things and they said that they were a little bit too loose, that they were more interested in fine line work. So I went back to school and I took a lot of the line work and tried to improve. I was very shaky most of the time. I was shaky from fear more than the actual doing it.

"But I learned," said Bailey, "and so I came back with my other things and they said that I could come in on trial. So I came in for ten dollars a week, and I think they gave us three weeks and after the third week, they said that I was accepted and I was going to get sixteen dollars a week, so that was a big deal."

Betty Kimball later recalled, "First they had me work for a week for nothing while they were training me. They had a class that met from six to nine in the Inking & Painting Department, which then was just a little place that faced Hyperion [Avenue]. And I took a training course for four days. I flunked Inking completely.

"The celluloid is slippery and the hand just goes sliding all over it, and I couldn't do that at all," Kimball revealed. "So after one evening of trying to ink they had me painting the backs of the cels. Then on Thursday they said, 'Okay[,] you can come back and work Monday morning.'"

In the Depression era, people were desperately looking for work, and joining the ranks of the Disney Studios was quite a coup. The pressure to learn the delicate skill of inking was palpable. As Ann Lloyd recalled, "It's a wonder we learned to ink, we were so nervous; and it really takes a loose arm and relaxation to get this technique, and we were nervous wrecks all the time."

Ruthie Tompson experienced similar frustrations. "The first thing they put you in is Inking[,] because they want somebody with a little flair, which I didn't have," she said. "I went two nights a week. So, I tried to ink. . . . Those little pen points are so frail, and I went the wrong direction with them, and broke two or three [points]. . . . And the next night I went there and Marie Henderson . . . was the night teacher. I walked in and was getting ready to find my desk, and she comes to me and says, 'Honey, I think maybe we better put you in Painting.'"

INKING INTRO

Inking training incorporated basic calligraphic exercises. "Circles and circles and circles," said Tompson, who laughed about it. "Over and over again. Mine were always lopsided and I'd scratch the cel. Then they'd have you work on lines and tapering the

Ink & Paint | 101

Mid-1930s training cels. Final inked cels from studio short films were painted with available colors by Painting trainees.

ends. That was tough." Shapes, lines, and various techniques were drilled. "They kept telling us, 'Forget everything you've learned about writing[,] because this isn't writing,'" Eleanor Dahlen, an Inker, remembered. "Your hand is now a penholder. You don't use your fingers, you use your whole arm." Counterintuitively, a sure line required a delicate touch. Oftentimes the Supervisor "would walk by and they'd pull the pen out of your hand," noted Dahlen. "If you had it so tight that they couldn't get it, they'd say, 'That's wrong. Relax. You're just holding it.' It was a lot of training."

Some candidates showed a natural proclivity to inking right away. "My brother had answered an ad for Animators, but he didn't get the job, unfortunately," remembered Evelyn Coats. "He got home and said, 'They were hiring girls today. Why don't you go?' So of course I hotfooted it out there. Twelve of us were taken that day. Twelve gals. They were gonna start making these big films like *Snow White*[,] so they needed a lot of Inkers and Painters.

"I took some samples," Coats continued, "and it must have been that they needed Inkers, and so I guess from my samples that I took they figured I could do it. Some went into Painting. I'm glad I went into Inking. That was really a better job than the painting. I had to do a little practice at inking first, but not a whole lot. Later on the gals had to do a lot of inking. But I just did a little bit. And they decided that I could do it."

In January 1936, high school graduate and valedictorian Rae Medby made her way from Seattle to Hollywood, as her heart was set on painting Mickey Mouse. Living with relatives in California, Medby "lost no time getting out to Disney, [where I was] put in their Inking class. I soon learned there was much more to being an Inker than merely shoving a pen around. Training lasted five days a week, three hours a day for five months then.

"Since business was very, very slow," she continued, "they put me to work painting instead of inking." By early June 1936, with production beginning on *Snow White*, Medby was transferred to the Inking division, "where I'd hoped to stay for keeps." Her call to destiny was timely. A diary entry reads: "I was very, very lucky getting here just at the right time. I got in with the last group of girls to be trained. The classes have been disbanded and the only girls who get in nowadays are those with actual art training and previous inking experience."

Training classes continued to be offered throughout production on *Snow White*. As Betty Anne Guenther recounted, "When I came in 1937, the Depression was really still on and I was happy to get a job—or a chance at one." She further remembered that "there were two classes. . . . I came for about two months at night, for three nights a week, for about three hours in training and didn't get any money, but I was luckily hired as an Inker. In that way, they got really good Inkers because people worked really hard." Each week, the artists were introduced to inking techniques, various exercises, and scenes with progressive complexity, with constant emphasis on "swing, tapered lines, and smoothness."

The level of skill required was "premium," as Grace Bailey explained. "We weeded out the people who did the wobbly inking. Generally we gave them a pretty good length of time to learn[,] and then if it was hopeless, we'd explain it to them [that] when we hired them, that they were more or less on trial and it was a system that always seemed to work pretty well."

Once on the job, training still continued, Bailey added. "We used to say [it took] about a year for an Inker and about six months for a Painter. Inking is quite a skill the way we used to do it. Lines had to be tapered and you had to be exactly in the center of the pencil line. You couldn't wobble. Some of the girls couldn't smoke or drink coffee—it would make them shaky."

Animators Frank Thomas and Ollie Johnston wrote, "On Fridays, their ranks were thinned down. There were many tears and hysterics. But those who survived had real dedication and the sense of accomplishment that would go with weathering such an ordeal. The Supervisors still ruled them with a firm hand even after they were taken on, being stern and demanding in their criticism and exerting extreme pressure on everyone to do it faster and better."

> **DESIRED INKING QUALITIES**
>
> 1. **Accuracy to pencil drawing**
>
> 2. **Consistency of penline**
> Correct width of line as called for by color model
> Opaque line (not watery)
> Tapered ends of penlines
> Smooth connections when lines meet.
>
> 3. **Ability to improve on drawings**
> A feeling for the form being inked, remembering that it is usually three-dimensional

PAINTING PUPILS

Paint application classes were developed by Paint Supervisor Mary Weiser and her Assistant Supervisor, Jeannette Tonner. These sessions were usually held in the Paint Laboratory. "Introduction to Painting" included a brief tour of the Paint Lab followed by the setting of each girl at her own desk with preset tools. "I was living at home in Glendale [California]; that's when I applied and went for the evening class to learn how to paint," remembered Wilma Baker. "They had us painting on practice cels that weren't good for production."

An overview of equipment was offered. Brushes of several sizes were issued, with one brush designated for the exclusive use of applying black paint. The utmost care was to be given to each Painter's brushes, and they were never to be left soaking in water jars or lying around with dry paint on them. Eyedroppers and water bottles were provided to dilute paint that might be too thick, and stirrers were readily available to keep the paint properly mixed. Clean gloves were to be used and changed whenever necessary. Industrial wipes were provided to wipe brushes and stirrers, and soft lint-free cloths were utilized to clean fingerprints from the cels.

Each desk was set up as a personal paint lab where jars of white values and black were always present. All other paints were to be kept in titled order in separate areas based on the primary shade and various dark and light values required for each set.

The paint was to be maintained at a creamy consistency. If too thick, a thin layer of water was to be floated in on top and allowed to sink in. Paints were to be mixed in a figure-eight fashion to reduce bubbles. These were water-soluble paints, so care had to be taken, as too much water would lighten or change the value of the paint. As Baker noted, "They would give us a list of paints and have us start doing it—applying the paint so that it was smooth and not lumpy, because if the camera [platen] came down on the paint, [and] if it's too bumpy, that's going to make a terrible mark."

Skillful mastery of the brush in a loose and relaxed manner was required. Too light of a touch would cause thin areas and streaks; too heavy, and the brushstrokes would show. The skill of floating paint onto the cel was to keep paint between the brush and cel to ensure a smooth and even application. Accuracy of delivery was crucial and meant hitting the lines slowly and carefully, then increasing speed while filling in larger areas.

Due to the constant variety of work involved, mistakes occasionally occurred. Trainees were shown various corrective painting techniques, such as washing, peeling off, or cutting out sections—or the entire character—as well as painting on the top of the cel within the inked lines. Additionally, potential Painters were encouraged to experiment with different-sized brushes to find which was suitable to their own individual style of painting.

Later, Weiser ran the Paint Lab classes, which reviewed the methods and processes of mixing the ever-growing spectrum of colors created in the lab. Dot Smith oversaw Ink Checking classes and Katherine Kerwin ran Paint Checking classes in the Checking room whenever there was a need to train staff in these areas.

Hazel Sewell's teams formulated a criteria utilized in evaluating a Painter:

> **DESIRED PAINTING QUALITIES**
>
> 1. **Smooth opaque painting:**
> Uneven paint can cause "newton rings" in camera or streaks in the color.
>
> 2. **Accuracy in hitting the line:**
> If painting is sloppy, the Checker will have to spend time fixing-over the lines if they are extreme. Also it's necessary when painting "opaque for backlite [sic]" that the paint be exactly to the line (no light showing between the paint and the line). If the Painter is not accurate, someone will have to spend additional time correcting her work.
>
> 3. **Clean sets and unscratched [sic] cels:**
> Cels [that] are too badly scratched must be reshot, thereby causing a delay in production. Time is also wasted by having to paint the same cel a second time.
>
> 4. **Correct follow-through:**
> A good Painter makes few mistakes[,] because she looks through the drawings and other instructions [that] come with her set before beginning to paint.
>
> 5. **Organization:**
> Work is neat and turned-in in good order.
>
> 6. **Productivity:**
> A good Painter does not cause delays in production because of too many mistakes, inadequate speed, or sloppy work.
>
> Basically, a good Painter shows pride in her work, is cooperative, contributes her share to the product, and does not cause delays in the productions because of poor work habits.

Page 103, left: Eva Appel fills paint orders in the Hyperion studio Paint Lab, circa 1934.

Right: Expanded colors and early refrigeration for certain pigments in the studio's Paint Lab.

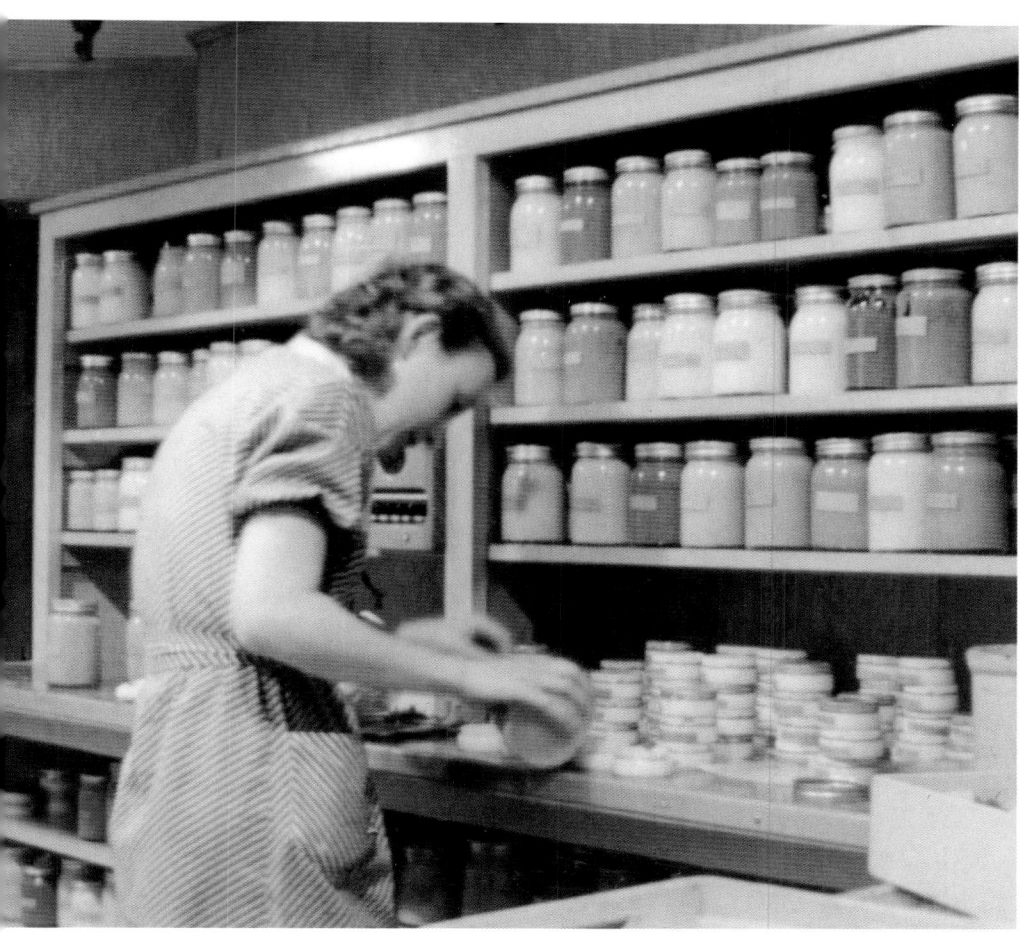

COLORFUL MASTERY

By 1935, Mickey Mouse was a worldwide phenomenon, the Silly Symphonies had broadened in range and sophistication, and color had been introduced to animation! Nearly fifty women now worked in the five specialized groups within the Inking & Painting Department—Paint Dispensary, Color Models, Inking, Painting, and Checking. Each group had Supervisors, and before scenes would leave each area, they passed through a rigorous review system in which multiple sets of keen eyes checked for possible mistakes or anomalies within the thousands of cels that would pass through this division. Despite the level of mastery achieved in each area of their work, the combined efforts of the Ink & Paint artists were intended to last only two or three weeks until the completed cels were photographed. The final projected film was always the goal, as Walt Disney continued to remind his Ink & Paint Department heads to limit "the fancy stuff."

EXPOSURE SHEETS

The unifying tools that ensured the ultimate synchronization of the developed story, music, and sound effects were the notations found in exposure, or X-sheets that accompanied each scene that came through Ink & Paint. As Studio Manager Bill Garity noted, "Basically, our film production is simply a mathematical process. Since film is standardized at sixteen frames to the foot and run by projection machines at twenty-four frames per second, it is possible to make these three elements separately and then accurately synchronize them."

By April 1935, a specific training curriculum had been developed for Assistant Animators and Inking classes in order to unify and streamline the exposure sheets. Because of the number of hands required to handle the artwork and materials throughout the production pipeline, the standardization of exposure sheets was critical. "Don't leave anything to the other person's imagination. . . . When placing notes on the exposure sheet, place them with the thought in mind that they are to guide someone with absolutely no conception of the effect to be obtained." A studio memo also reminded, "never let a scene lay idle—move it on to the next department."

In the fall of 1940, colored folders were introduced to flag various scenes: Red covers designated preference scenes, close-up scenes were enclosed in orange folders, multiplane scenes were indicated by green folders, and any scenes requiring wash-offs were housed in gray folders.

THE PAINT DISPENSARY

In the early days, Disney Studios utilized basic black-and-white paints manufactured by a local commercial interest. When Technicolor was introduced a decade later, the studio established a wide spectrum of color from premixed pigments to advance the medium of animation. "Walt loved incredible colors," recalled Color Model Supervisor and Layout Artist Sylvia Roemer. "That was inspiring for us all." In the earliest days of color animation, the Paint Dispensary carried approximately ninety colors for the artists to work with.

When Grace Bailey first started, the studio was still working in black-and-white. "Then practically everything was in color," she later recounted. "They didn't have the brilliance or the definition that they have had in [later] years." From their limited palette of color, the teams of the studio Paint Labs began formulating colors to expand the range of the Disney rainbow.

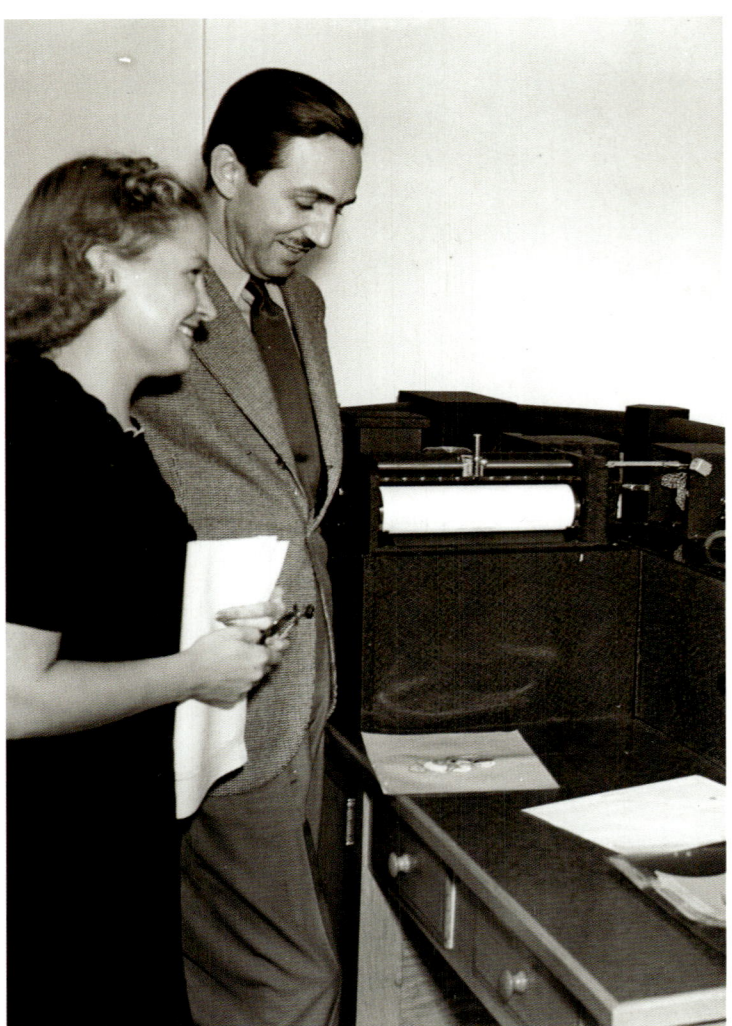

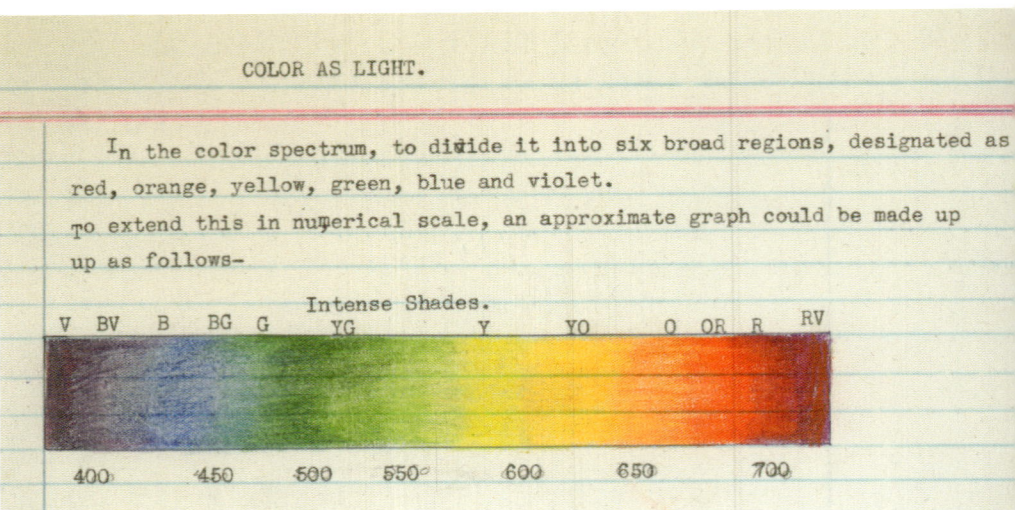

By 1934, thirty more colors had been added to the artists' palettes, and in 1935, over 150 colors were being utilized. Throughout the remainder of the 1930s, the range of colors doubled with each passing year, and in 1938, the Paint Lab featured over 1,500 colors.

Referencing the defined color charts of the day, the Color Model Supervisor advised the Paint Dispensary on which color combinations were selected for each character. Gouache paints consisting of pigment, a gum arabic binding agent, and water were mixed to achieve the overall opaque consistency necessary for animation. Heavier and denser than watercolor, gouache was water based, easier to work with, and more pliable to celluloid, and it dried considerably faster than oil-based paints.

One-kilogram batches of the specific colors of paint were mixed and matched to color charts and freshly made swatches as reference, then stored in large, clear sixteen- or seventeen-ounce jars. Lab technicians dispensed the ordered paints into one-, two-, and four-ounce opal cosmetic jars, which were distributed to the cel Painters based on their needs. The remaining paints in the Lab would often have to be refreshed. Fading, separating, and accelerated aging due to climate conditions were frequent problems with early pigments.

PROPER PIGMENTS

While in training, Painters received a full training in the various ingredients of paint. Paint Lab Supervisor Mary Weiser broke down the following elements that constitute the paint utilized at the studio:

> VEHICLE or BINDER—This is a fluid [that] acts as the carrier for the pigment and [that] oxidizes when exposed to air with the production of a hard elastic surface. Some vehicles dry from the cel on out to the surface. Our binder[,] which we have proved to be the most successful[,] dries from the surface on in!
>
> PIGMENT—a finely divided, insoluble colored powder, that when mixed with the media or binder, and ground through the paint mills many times to ensure fineness of texture, is sealed in pint or gallon jars and tested and eventually reaches your desks after the proper match is arrived at.
>
> As simple as this sounds, it's important to remember there were still a number of colored pigments regularly utilized with varying personalities, each presenting variables when applied on celluloid.

COLOR MATCHING

With an ever-increasing palette of color, the importance of color matching became quickly apparent to establish the consistency and believability of characters. Carefully re-creating the exact tone to be utilized across thousands of cels required a keen eye. "I was very good at matching colors," recalled Betty Kimball, "and so I started working almost immediately."

Paint matching presented challenges. If more paints needed to be mixed, there would occasionally be changes to pigments between batches. Previous jars were labeled as OLD and the fresh

Page 104, left: Mary Weiser and Walt Disney oversee installation of the studio's spectrophotometer.

Right, top: Excerpt from Mary Weiser's custom lab manual on color.

Right, bottom: Excerpt from Jeanette Tonner's experimentation log, developing the combination of colors and elements to distinctly convey rain for the production of *Pinocchio*. Jeanette's quest continued well beyond 250 separate experiments.

Feminine First

MARY WEISER: PAINT LAB

In January 1936, after several months in the new Inking & Painting Building on the Hyperion lot, Mary Weiser, an industrious Supervisor in the Color Model Department, filed a report reflecting on the previous year's production. Weiser accounted for the ongoing paint problems resulting from intermixing various commercial paint blends, stating, "Due to their unwise selection of pigments we ran into serious trouble."

Paints would not properly blend and often separated or streaked into other colors. As Weiser noted, "We discovered by a series of tests that we had not one red or orange that would not strike through in flesh tints and neutrals." Continuous problems occurred as "hours of the Painters' time were devoted to washing the cels and repainting work that had either been sent back from the camera because of stickiness or paint that refused to dry at all." Weiser focused on the costly toll: "Because of our inability to cope with these problems and lack of cooperation with the distributors of these paints, the actual paint cost in the past year has been enormous.

"A few pictures were criticized severely because of paint that had gone bad before it reached the camera," she added. "Hours of testing and mixing were put in to determine why this all was happening." Weiser's conclusions proclaimed that there was no reason Disney Studios couldn't create its own paints to meet the recurring problems with celluloid application.

After briefly traveling to New York for training and to meet with various vendors and supplies, Weiser took it upon herself to study paint chemistry and began spending her evenings researching the desired qualities for suitable materials. "Mixing colors—that was special. It took a chemist to make combinations, and of course the first woman that handled that was Mary Weiser," remembered Painter Ruthie Tompson. "I don't know whether she got formulas from paint companies, or how she did it, but she worked up formulas for mixing paints." Through extensive experimentation, Weiser began developing effective paint formulas ideally suited for use with celluloid.

Within the year, a new Paint Laboratory was installed in a small section of the south end of the first corridor. It was stocked with nearly seventy main families of colors and more than six hundred different shades. "They had big tubs full of pigment that had to be mixed," Tompson said. "They had these machines that mixed the paint a certain amount—just like you're making bread—they had the bottles of paint. It was a spectacular room. The paint goes from black to white and the different shades of gray all the way down, and it goes the same way with all the colors. It's a colorful room."

Weiser's methodical approach to color development and experimentation would meet the unique needs of the first and only animation studio to create its own paints. Within the first year of operation, the studio's Paint Lab soon made noteworthy news as it saved the studio $6,000 on white paint costs alone.

Under Weiser's lead, a small staff was assembled and the studio's paint was soon specially ground and mixed. Grinding the paints in the mills required from three to ten grinds to ensure the proper fineness of texture. The mills were washed and adjusted after each color was ground. A form of gouache, the opaque watercolor paint used by Disney was more finely ground than most. These colors or "selections" were not blended to the appearance of the pigment mixture, but rather to how the tone would reproduce on-screen as a result of the Technicolor process. As such, the painted cel would often appear odd in tone, but brilliant under the camera lights and ultimately on-screen.

Working from carefully typed note cards featuring the formula of the specific color, women in white lab coats mixed and blended the raw ingredients together into the desired finished product, determining the hue with pinpoint accuracy. Each production presented new challenges, as every new character required the development of its own distinctive set of colors. Weiser sought out pigments from around the world, including unique hues emanating from various floral, mineral, and vegetable sources to achieve this ever-expanding palette of choices. "Actually, there was more involved here than just artistic endeavor," recalled Frank Thomas and Ollie Johnston. "The transparent paint that produced the appealing filmy effect on the screen was made from the bile of an Asian ox, and was smelly and unpleasant to use."

Weiser developed training classes, assembled reference manuals for her team, and logged copious notebooks with methodical experiments in her quest to reach the optimum discoveries for each production. Her work resulted in two key patents for the development of techniques, which enhanced the dimensionality of Disney Animation. "This is very effective!" Walt Disney declared of Weiser's blend refinements, "I think we are on the right track."

Left: Measuring pigments in the Hyperion Paint Lab.

Right: Mixing elements for various pigments in the Hyperion Paint Lab.

mixtures were labeled as NEW. This would ensure consistency across scenes. Occasionally, some colors would brighten on the shelves as the pigments dispensed in the jar, making a stronger color and creating consistency problems over the course of production. Generally, jars of paint required re-milling to restore the color to its original tone. Color swatches for each new family of colors were carefully made and refreshed, as needed.

In 1936, a spectrophotometer was installed to ensure accuracy with the matching of color. This state-of-the-art machinery provided graphed records of paint match accuracy and consistency. "It records the disastrous effect of adding too much water," the women were instructed, "and will prove invaluable in checking the painting on the cels." These records were intended to track the consistency of the paint and the percentage of water the women were adding.

But scanning accurate sample matches proved problematic. "They brought a big machine in from Caltech," laughed Betty Kimball, recalling the spectrophotometer. "It was a machine that took up a whole room, a little room that they sort of partitioned off. They would have me match colors and then they would have the machine match the colors. And I did it better with my eye; it photographed better than what the machine did. So they moved the machine out and they moved me in with an assistant."

PROBLEMATIC PAINTS

Commercially produced paints presented continual problems for Disney Studios. Some paints had to be kept at certain temperatures in order to apply them effectively, while others were simply hard to apply. Colors quickly faded or took too long to dry. Paints wouldn't blend consistently, leaving streaks or uneven textures. Mildew, lumpiness, and streaking would occur. Often the paint could become fragile, cracking, chipping off, or separating completely. Shrinking might occur while drying, resulting in the paints pulling back from the intended edge and resulting in light leakage on camera.

Gum-based paints presented environmental challenges as well. Weather changes, room temperatures, and other external conditions had a lasting effect on the paints. If the relative humidity in the room were too high, the paint would remain sticky due to reabsorbed moisture. When the paint would finally dry, it would take on a shiny finish that would cause problems for the Camera Department. If the humidity was too low, the paint would dry too quickly and pop right off the cels.

The ever-changing humidity also presented difficulties with the shrinkage and expansion of the celluloid. The tiny pores within the cels that the paint bit into would shrink and loosen their hold on the paint if the humidity was too low or when the building needed to be heated. When too high, the humidity caused the paint to stick, delaying the time it would take to dry. To address the variable of the Southern California climate, longtime Disney Lab technician and Chemist, Steve McAvoy declared, "We made the paint a little wetter on dry days and a little drier on wet days."

STAYING COOL

The ability to control the atmospheric moisture was a key factor in effectively and efficiently creating the colorful cels for camera. Inker Mary Ellison recalled working in the non-air-conditioned rooms of the Hyperion site, where "the afternoons were particularly difficult. The inks as well as the paints were drying out way too fast to be usable."

In the very early days, the staff at the little Hyperion studio tried a number of solutions to moderate the temperature. As Grace Godino recalled, "There was the time that it was so hot and we didn't have any air-conditioning and so they brought in these big tubs of dry ice and we all got very ill. They had to close the studio down for the day because . . . they didn't know that the fumes were making everybody very sick!"

Open windows were often clogged with dust and debris, which would collect on the cels as they were drying. Studio Manager Bill Garity expressed continued concerns about this problem via interoffice memos, as the tiniest speck of dust would magnify into a giant boulder once projected on the screen. Electric fans were not a viable option as they would stir up dust, and early air-cooling systems were crude and consequently added to the dust and atmospheric debris problems rather than resolving the humidity concerns.

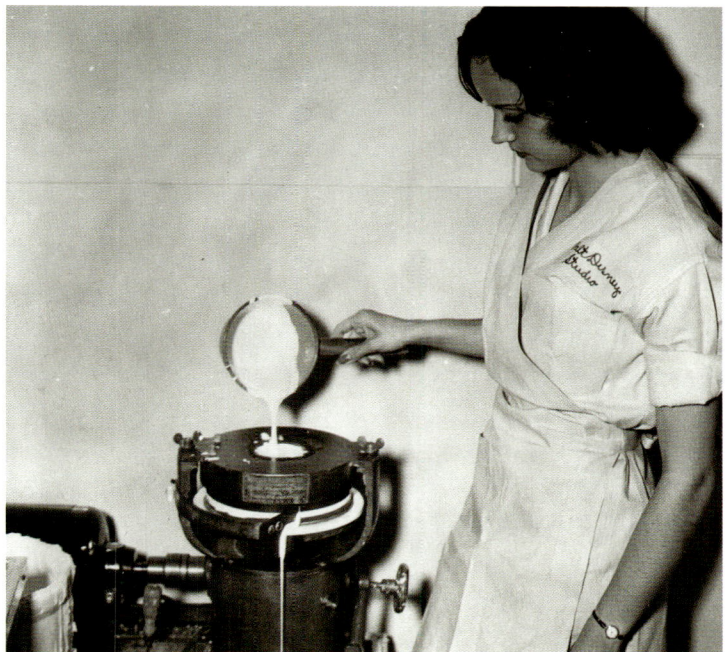

Left: Milling paints in the Hyperion Paint Lab.

Right: Matching cel colors at the Hyperion Paint Lab.

CREATIVE CHEMISTRY

As they advanced in the chemistry of color, the lady Chemists within the Paint Lab quickly moved beyond the manufacturing of paint. Some of their accomplishments included developing deodorizing solutions applied to various paints so the artists were not annoyed or distracted by odoriferous paints. The Paint Lab supported the overall studio by creating stamp-pad inks, glues, and adhesives for general office needs. They developed wallpaper remover for various remodeling efforts and glass cleaner designed for the needs of the Camera Department.

For the Sound and Music departments, the women of the Paint Lab created various colors of "blooping" ink, which was painted onto sound tracks to cover a joint or splice and remove extraneous noise. For Ink & Paint, the lab teams developed cel-cleaning solutions and briefly experimented with protective coatings for the cel setups. Most notably, in 1936, when such products were not widely available, the ladies of the lab developed their own hand lotion to combat the abrasive chafing that resulted from constant cel washing and brush cleaning. This effort was not to be overlooked, as the suppleness of the artists' hands ensured optimum artistry that was ultimately conveyed on-screen.

KEEPING IT "LEVEL"

To minimize production time and streamline the process, characters and elements on the page would be rendered on various levels of cels. If a character were bouncing a ball, only one arm might require movement, while the rest of the body might remain still. It was time- and cost-effective to isolate the moving portion of the character.

Explaining the process from a simplified black-and-white approach in 1933, Studio Manager Bill Garity explained:

> "When a number of characters are superimposed simultaneously on the background, 1, 2, 3, or 4 sheets of celluloid are used. In order to produce the same color value in the negative, five different shades of gray paint must be employed. The darkest shade is used on the top sheet and the lightest on the background. This is necessary because of transmission losses inherent to the celluloid. The thickness of the sheet is also a factor to be considered; and for that reason all sheets are carefully graded as to thickness and color, in order to minimize the painting problems and reduce density changes in the half-tones of the film."

Working with a standard of four levels of cels—and later, with the multiplane camera, up to seven levels—paint and inks had to be matched to accommodate the various levels. With each type of cel having a particular cast of color, adjustments or cel matches were made of each color necessary with a precise alignment of the color based on the level of cel as photographed under the camera.

CEL MATCHING

To keep the colors consistent across multiple cel levels, cel matching became a critical component of the Ink & Paint Department. This matrix of colors and cel levels was a constant challenge as the Paint Lab strove to achieve perfect matches. Each individual Inker and Painter had to be constantly aware of which level each cel would be recorded at. "Not all the girls were good at cel matches," noted Painter Ginni Mack. "But there was always a girl who could do cel matches really well. We had special lights to look at the matches under camera lights to see if it was a uniform match on camera. It was quite technical."

Even in the early days of black-and-white cartoons, "You don't notice it when you look at it," noted Betty Kimball, "but if you put several [cel] layers together, it changes the whites and grays." Kimball explained, "From the master paint shades, variations of each color are required for the different cel levels. The top cel—or the nearest to the camera—will photograph true to its own shade, but darkens under the various levels of celluloid[,] so elements on the lower level cels must be painted slightly brighter shades to uniformly match the colors on the top cel. "The shades were labeled," Kimball continued, "and came in number one, number two, and number three, whether it was on the first level of the cel or the second level or the third level[,] because you had to compensate for the color of the celluloid."

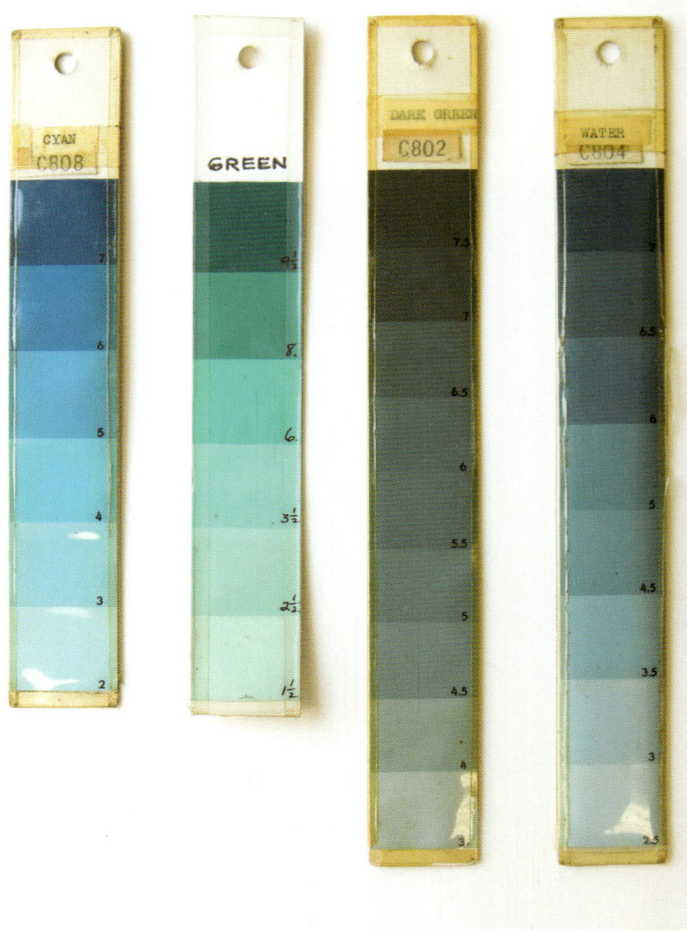

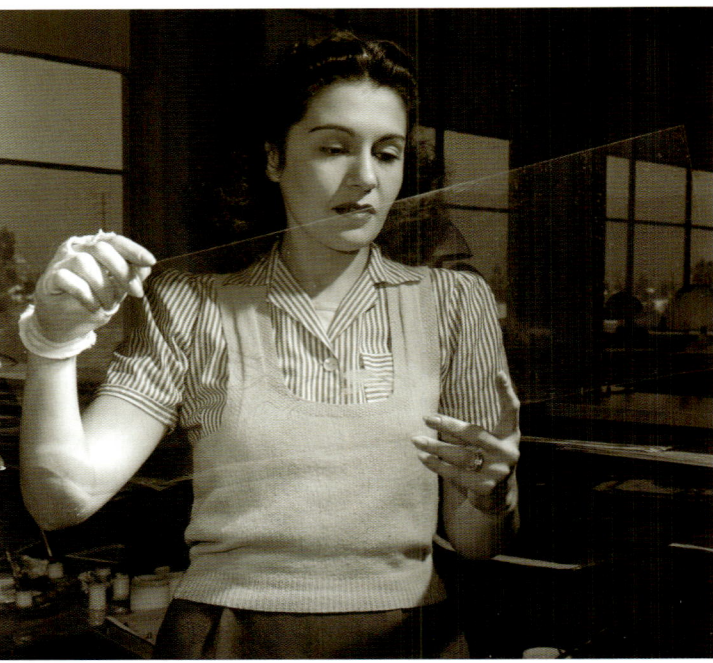

Left: Early studio examples of color "let-downs".

Right: Inker Lisa Beck examines a piece of celluloid.

"The Sorcerer's coat wouldn't be the same color if he walked into a dark room or had a bunch of stars twinkling over it," explained Dodie Roberts of the Paint Lab. Painter Ginni Mack recalled that, when creating the let-downs of each color, "You have to lighten that lower color to match the color on top." Generally, this was achieved by using white paint to create a range of let-downs from the primary shade.

The main action occurs on the second cel, or key cel, so the Color Model teams factored in the additional cel levels when designating the specific colors utilized on each level. This process was called "cel matching." Black was the only color that didn't change on any level. Whites and various shades of gray were numbered based on their levels. Thus, white subjects carried on the third cel would be painted with the number one gray, and white subjects on the fourth cel level would be painted with the number two gray.

With the introduction of color to animation, working on multiple layers of cels also presented its own set of challenges. Though appearing clear, various types of celluloid held casts of color—sometimes casting blue, yellow, or even pink. Ensuring a color's consistency all throughout a scene was critical. Without adjustments, the lower painted colors would shift and grow darker with each layer of cels added on top.

To contend with the added cel color, the ladies of the Paint Lab blended colors to compensate for the various levels of celluloid, mixing each shade a percentage or gradation lighter or darker. "We had to learn to mix the paint for [cel matching]," Mack explained. "If you have cels over a background, and one arm or one hand is down two cel levels[,] it had to be darkened or lightened accordingly. We had to be able to lighten or darken a color for cel levels, like Flesh Dark 1 for cel level 1, or Flesh Dark 2 for cel level 2. It was quite a process."

LET-DOWNS

Once a key color was developed, many gradations of that color had to be maintained to match the changing lighting, settings and moods of the film. These were referred to as paint "let-downs."

COLOR SYSTEMS

With the introduction of color, the standardized Munsell color system was implemented to identify the growing number of colors now created in the Paint Lab. Each basic set of paint families was given an alphanumeric Munsell-based code such as Y214 or R211 (with each let-down number designated from dark to light). "In the early years, paints were given numbers, not names," recalled Ruthie Tompson, "with the exception of a beigy-brown we called 'Roy.'" The girls named this special color after the well-liked man who cleaned their Paint Lab and washed the early nitrate cels and paint jars for reuse.

Additional values beyond the standard color families would be created when the color model stylist deemed a standard value either too dark or too light. These "special" values would be defined by names, and let-downs would be created.

Years later, the color codification was changed to follow a new method, the Plochere color system, with core color families given names such as Candy Red #1, 2, 3, etc. Once the transition occurred, the paints lined the shelves in alphabetical order, with base tones ranging from Acorn to Yellow and followed by the adjusted levels.

Colors were often named for those who inspired them. Dodie 6, a lush purple, was named for Dodie Roberts, who ran the labs in later years; Mist was the color of the Sorcerer's coat; and Dreiss, a yellow-green shade, was named for Retta Scott's sister, Supervisor Jane Dreiss. The naming of a color was quite an event and garnered high honors within the Paint Lab.

In training her staff, Mary Weiser developed a few basic guidelines for the colors mixed within the studio's laboratory:

Inked examples of Minnie and Mickey from separate short films, inked by Mary Ellison.

> **PERMANENT COLOR FOR CEL APPLICATION**
> 1. The surface of the cel does not have to be prepared with any abrasive before applying color.
> 2. Color does not crack, chip[,] or smear.
> 3. The color is easily removed after the cels have been photographed, leaving no residue or injuring cels in any way to prevent further use.
> 4. The color is not affected in any way from the time of application until the photography of the cells is completed.
> 5. This formula controls the behavior of the entire range of colors.
> 6. It also produces beautiful half tones and quarter tones of these colors and absolutely eliminates streakiness.
> 7. Colors dry in ten minutes[,] permitting further application without danger of colors running together.

With each passing character and production, the range of colors expanded, eventually reaching thousands of hues. "I loved to just sit and look at all those colors lined up in jars," said Dodie Roberts. As a result of this vibrant range of hues, the Paint Lab was often referred to as The Rainbow Room!

CELLULOID

The link between paper and screen, "cels," or celluloid sheets, were the primary "canvas" for the women of Ink & Paint. Without this clear sheet, it would have been necessary to draw a complete background for each frame of the film, hindering quality and economically impossible. These clear plastic sheets were often washed and reused, but there was a limited life to the vulnerable plastic. With the volume ranging from 10,000 to 15,000 or more cels utilized for each short, a constant and clean supply of these materials was vital and as standard to animation as paper.

In the earliest days, celluloid—with its base of cellulose nitrate, or Pyralin—was the primary material produced with a form suitably thin for animation. Highly flammable and heat sensitive, this material was problematic and susceptible to decomposition, yet with certain precautions and proper storage, nitrate-based cels were a stable and durable tool for the short-term application of animation. The cast sheeting was cured, given a special seasoning for twelve days at thirty-five degrees, lightly vaporized, and then seasoned for forty-eight more hours before the final polishing operation. The application of paint to celluloid for use in animation was fairly young, and numerous variables with the curing process added to the persistent problems the studio confronted with their cel stock.

Hazel Sewell's correspondence with the studio's primary celluloid vendor explained the overall production process: "Cast acetate is sprayed in a liquid form on a metal drum[,] and there may be some chemical reaction caused by the material coming in contact with the metal service of the drum which would tend to cause color changes.... Even extreme degrees of light or shade would effect a change in the color result." Batches of celluloid held a fairly consistent color throughout, but due to the nature of the raw materials, each batch could vary slightly in color. Problems with color matching and paint application arose when using cels from different batches.

Standard industry sizing for the Pyralin celluloid was 10 × 12½ inches, with larger sizes utilized for sliding cels or pan action. The staff oversaw the trimming, punching, and overall quality control of the celluloid stock. Cel material would arrive in large sheets completely backed with a thin tissue, which stayed with the cel throughout the inking process to protect the cel surface and artwork. The exclusive Disney peg registration system aligned the paper and celluloid utilized throughout the production pipeline. Once scenes were signed off by the Camera Department, the cels were collected for washing. After washing, the staff would sort the reusable cels from the scratched or dented discards. These employees also ensured that each corridor had ample cel supplies to work with.

A PROBLEMATIC CANVAS

From the earliest days of animation, ongoing problems with the celluloid material were revealed in the correspondence between the studio and their vendor: "We have inspected these sheets and find that, for the most part, the largest percentage have a fine, snow-like, flaky flaw in the celluloid; some have cutter marks not taken out by the polisher, and in every case there was something defective about each piece." Shipment delays, graining, and numerous other problems were prevalent. The stock might arrive in pristine shape, but a shift in the overall cel color to an amber tint would be unacceptable as paint had been mixed and measured to accommodate a well-established bluish tint. Cels that were too thin presented additional problems, such as splitting and warping with the application of paint and inks, while punched holes could easily tear and throw off registration.

With the hot California temperatures, having large quantities of celluloid stacked up was extremely hazardous as it would easily become combustible if not properly stored. With nitrate cels and film stock throughout the studio, smoking was absolutely forbidden in most areas at Hyperion. Shipment delays and sourcing the necessary volume of this precious material during frequent shortages, also presented persistent problems.

In September 1932, Hazel Sewell's teams received a few samples of a new celluloid-like material with an acetate base. Testing of the early samples of the acetate cels presented some unsuitability, as Sewell noted "distinct differences in what might be termed the 'seasoning,' as it did not hold to the peg-holes and tore very easily." But the far greater safety advantages with the acetate stock outweighed any other problems, including increased costs.

Eager to move forward with acetate, the studio let its nitrate stock run low and placed an order for 2,000 acetate sheets in late December 1932. But this order was quickly canceled: "It seems the Painting Department had made some tests which at first seemed satisfactory, but when we got into washing the cels, it was found there was quite a bit of shrinkage in them which threw them off 'register' and therefore made it inadvisable to use that type of material."

The studio went back to working with nitrate cels, but additional issues occurred with paints permanently staining or dying the plastic. Chemicals in the celluloid caused inconsistencies with specific colors from cel to cel. Still working with commercial paints, the burgeoning studio was frequently at the mercy of its suppliers. After years of ongoing issues, it was concluded there was very little that could be done to eliminate these problems if the studio continued to work with the commercial paints of the day. It quickly became apparent that new solutions needed to be found.

After all of the fuss over the quality of cels utilized in production, each finished cel was ironically short-lived. As Animator Bill Justice stated, "Cels were only expected to last long enough to be photographed. They were not made to be durable. In the early days of the studio, cels were cleaned to be reused. But since inking tended to scratch them, many cels were simply thrown away once the picture was completed. None of us considered them works of art." This lack of respect from the Animators continued as they were often seen sliding across the floor on painted cels at the end of each production.

Several types of cels were designated in the Animators' notes and would affect the action occurring on them. Sliding cels were utilized for moving action out, in, and across fields.

The type of movement would be indicated on the first and last animation drawing of a series. Hold cels were held for sixteen frames or more and usually marked with an H. These were generally placed on lower layers, but if other action occurred underneath, the held cel would be placed on top layers. There were also overlays, in which another action or effect appeared over an inanimate object or portion of the background created on a cel underneath.

To address persistent challenges with maintaining the proper detail when inking and painting characters that were tiny in size or far in the distance, the Wash-off Relief cel method was developed in the mid-1930s. An offshoot of the process developed by Merrill W. Seymour for use in photography, this method involved applying a photographic emulsion to one side of specific cels. Animator's drawings that had been created on a larger scale were photographically reduced and transferred onto the treated wash-off cel. These treated cels were then processed and integrated into production along with the regular cels. Painting the micro-sized imagery presented new challenges, but the ladies of Ink & Paint persisted. As experimentation continued with this technology, other elements that enhanced the drawings could also be reproduced, such as smudges and minor details.

J. Arthur Ball, a former technician at Technicolor, was brought on by Walt to help develop a number of techniques that were being developed along with Wash-off Relief in the studio's Process Laboratory. Among Ball's efforts was the creation of a "frosted" cel, featuring a textured surface that would "hold" pastels or waxed crayons to the cel. Once the desired image was complete, a sprayed solution of clear lacquer would "fix" the artwork onto the cel and smooth over the textured surface, and the cel could be woven back into production.

COLOR MODEL DEPARTMENT

With the introduction of color, the simplistic range of monochromatic shades utilized to define the characters and their worlds exploded with a seemingly infinite range of color. The

Page 110, left: Color model sheet for Jenny Wren character from *Who Killed Cock Robin?* (1935). Cheek highlights were conveyed with ovals featuring a different shade of color.

Right: Final frame featuring Cock Robin and Jenny Wren from *Who Killed Cock Robin?* (1935).

need for a new method of establishing consistency and communicating specific color direction became apparent, and one of the more creative and high-profile aspects of Ink & Paint was defined. Working closely with the Paint Lab and every other aspect of production, the Color Model Department's business was the world of color.

PREPRODUCTION

While a short film was still in the early stages of story development, the Color Model team would already be exploring the various palettes of colors for each character. In a feature article, Mary Lou Whitham explained her role as a Disney Color Model Supervisor:

> There are four of us in the studio[,] and it's our work to determine the color for the characters and moving properties of the pictures. Each picture is divided into sequences and scenes[,] and a color model is needed for each. We either interpret the mood desired by the director and his artists or we originate the model by working against the painted backgrounds.

As a later studio write-up noted, "Colors in our features are not chosen with the simple ease of merchandising a postcard. They are the result of much study and discussion." The Color Model Supervisor's role was pivotal in defining the final visual form and colors that appeared on-screen. Working together with Walt Disney, the Directors, and the heads of Backgrounds and Layout, Color Model Supervisors regularly participated in screenings and sweatbox sessions.

Ann Lloyd, a longtime Color Model Supervisor, noted, "You had to know every other aspect of the business to do your own work, and be creative about it. . . . We're like a liaison between all the departments."

"I was in the Color Model Department for a long time," said Grace Godino, a former Supervisor, "and we picked the colors that would go with the background and through the Animation Department." This small team of artists supervised the color development for various projects by pulling key images from the film and inking and painting anywhere from two to six possible color combinations on the cels to determine the tones for each character and key objects. The selected colors might be chosen as early as the story-development stage, but the lead Layout artist worked closely with the Color Model artists to make choices with careful consideration for the story, themes, and emotions within the scene. These samples were tested against the backgrounds, with props, and with the other characters to determine the final colors used for each scene. "From there they would devise the color models," recalled Ruthie Tompson. "There would be girls that would just make those models."

"Mary Weiser was in charge of it," remembered Betty Kimball of the procedures followed when the Color Model Department first began. "But she left it up to you if she figured you could do it. I never was supervised much." Because of Kimball's keen sense of color, she and an assistant later worked on developing special color-model sheets for difficult effects such as splashes or scenes that might require work with a sponge or drybrush.

PRODUCTION

The Color Model Department's role continued when production on a film began. After the Lead Animator and his crew finished a scene, it was first delivered to the Color Model Supervisor, who oversaw the approved sample color models. The overall value of each character's colors might change or shift from scene to scene depending on the story tone or action. The colors of each character had to work throughout the entire film, as well as relate to every other character they would be seen with.

The Color Model Supervisor also determined exactly what size line would be appropriate for the character, and whether various parts should be outlined with a fine or a broad line. This was a time-consuming procedure with multiple variations to consider. Each added color or detail within a character's design would also be determined or questioned by the Color Model Supervisor. As Frank Thomas and Ollie Johnston noted, "We were told, 'Each button costs ten thousand dollars!' and we became very selective in our decorative additions to the characters."

Most characters averaged between eighteen and twenty colors each, with some characters requiring as many as sixty separate tones. Once all aspects of a character were finally determined, a principle color-model sheet was created featuring a pencil drawing with color callouts: the numbers or descriptive names of the specific hues to be utilized. Ultimately each character would have multiple color models based on the lighting within various scenes, as the tones utilized for a character in the daylight would be dramatically different from those shown in the moonlight. Each chart specified the name and number of the paints for each aspect of the character and traveled with each set of drawings and cels as it progressed through the production process. The Inkers and Painters who would later complete the assigned scene referenced the color-model sheets tailored to that scene.

A tidy row of binders storing each character's color details lined the Color Model Department's offices. In the earliest days, sample cels were utilized; then, as the number of artists grew, mimeographed sheets with callouts were created and issued to the artists. The final model set up by the Supervisor was then sent to the Inking & Painting Department, where, by the late 1930s, 215 Inkers and Painters followed these color indications. These master references for the distinct line weight and color designations for each character are still utilized today.

TIMING

Finally, the Color Model Supervisor also determined the time it would take to fully ink and paint a cel featuring various characters or scenes. To calculate the average time, complexities were determined based on each character's size, detail, color palette, and environmental circumstance. This helped artists gauge the speed at which their work should flow. This notation was usually added to the specific character model sheet.

Once colors were chosen, the animation drawings and exposure sheets were carefully checked and then sent to Ink & Paint along with the necessary color-model sheets as reference.

> "*Those Inkers had to be really good; they weren't just tracing [the] Animator's drawings, they had to get the feeling of the Animator's pencil lines too.*"
>
> —Animator, Ward Kimball

Inked cel from *The Pied Piper* (1933) inked by Evelyn Coats.

INKING

After the Color Model Supervisor reviewed a scene and defined final colors, the scene would be passed on to the Inking Supervisor, who reviewed it for subject and complexity and then passed it out to her corridor Supervisors. The various supervisory roles were one level of advancement within the department. The Supervisor oversaw the administrative details and ensured the quality and progression of scenes through her department while keeping order in the room.

Fittingly called "blackening," inking in the early 1930s involved tracing the Animator's lines in black ink. But with the introduction of color, and as characters and scenarios became more sophisticated, the delicate line work would often be inked in a variety of colors. Generally, the colored ink was made from the same pigment as the paint, but thinned out to reach the necessary fluidity.

Working from a full set of final animation cleanup drawings for the given scene, the Inker would place an individual paper cleanup drawing onto her metal pegboard, locking the drawing into registration. A similarly punched piece of celluloid, the approximate size of the paper and about five one-thousandths of an inch thick, would then be placed over the drawing and aligned via the peg registration.

Thinned paints for inking were designated with a red dot on the order sheets sent to the Paint Lab. The ink jars were narrower and taller than the paint jars to differentiate the thinner ink formulations from the thicker paint.

A studio write-up declared, "At Disney's [sic], this precise work involved skillfully redrawing the animation, rather than simply tracing, which would lose the life and spontaneity imparted by the Animator in his pencil drawing." Animators Frank Thomas and Ollie Johnston offered insight into the fine art of Inking, writing, "It is one thing to say that the drawings were traced onto the celluloid, but quite another to do it. Anyone who has tried to draw on glass with a pen will recall that nothing might come out of the pen at all, except a long, fine scratch. You draw slowly, you draw fast, you make little strokes, you use sweeping lines, then suddenly, for no reason, Ggrbloob! A huge splatter of ink comes out all at once."

As Painter Ruthie Tompson keenly observed, "I don't know whether the Inkers get enough acclaim or not, but they are artists, all of them, and they have to be. . . . The Animators were always complaining for fear they wouldn't get all their action in, and they'd miss it by a squirt of hair or something like that. So the Inkers, the ones that could do it beautifully, were the ones that should get a little more praise!"

TOOLS & TECHNIQUES

Inkers wore cotton gloves, which allowed their hands to slide over the cels as they worked and eliminated fingerprints that might later show up on camera. Fresh gloves were utilized each day and frequently switched out as needed, and batiste cloth was used to clean cels as well. Girls initially took their gloves home to wash, but later, an industrial washer and dryer were installed in the Ink & Paint Building to ensure the girls had an ample supply of clean gloves.

Inker Marie Johnston explained, "We had to wear cotton gloves, and for the right hand that you hold the [pen or] paintbrush in, the thumb and index finger were cut out; your left hand had the full glove on it. I'm kind of ambidextrous, so if I find that I could get into a point easier with my left hand I was changing hands, but not gloves. The Supervisor came along behind me and was standing there watching me switching back and forth. Then she said, 'It's marvelous that you can do this, but you're getting fingerprints on the cels and that'll photograph.'

"Oh, my gosh! I was so embarrassed," Johnston added. "She said, 'No, don't be. Normally I wouldn't have to say that, because most people couldn't do that.' So then I had to remember that, if I was going to switch. Well, then I didn't switch that much, because it was a pain in the neck to have to change your gloves right in the middle."

A steady supply of Gillott pens with 290 nibs (the thinnest available) were on hand. The Inkers also utilized pointers to

Ink & Paint | 113

Left: Line width reference guide for Disney Studio Inkers.

Right: Standard ink pen utilized within Disney animation.

prevent the work from slipping. These were made by gently sharpening ebony chopsticks found in the Chinatown district which would not mar the fragile cels. Pegged boards were raked, or sloped, with light boards to clearly view the animation lines. "In Inking, they usually had them use the same pen point so their lines would be uniform," recalled Ginni Mack. "We [often] didn't have a regular line to follow, but it was very precise. Some pens were more flexible than others and gave a better shape to the line, instead of a rigid line. You also wanted the ends tapered."

With access to a variety of pen points ranging in width from fine to super heavy, each artist chose her own pen and points for the work ahead. A small half-round of wood with holes drilled out housed each Inker's pens. A different pen was used for every color. A properly loaded pen with the selected color carefully transferred opaque ink onto the transparent celluloid. For a scene requiring a number of colors, one color of ink at a time was applied across all cels in the scene and then set aside to dry.

LINES & FORM

Prior to the 1930s, characters were uniformly outlined with no dimension to the lines. Striving for a higher level of quality to their work, Hazel Sewell and her team quickly recognized that the ultimate responsibility for the line rested with their department. This required reapproaching the details and definitions of each character. Marcellite Garner revealed the early difference that began to set animation at Disney apart from others: "They [other studios] weren't too concerned about how the lines looked as long as they were thick enough. But they were pretty fussy at Disney's [sic] and it all showed up in the finished product."

As the artistry developed, Inkers had to accurately re-draw each character from cel to cel in ink while persistently retaining the thickness and length of each line. Since several Inkers might work on each scene, it was important to maintain the same thickness and length of each line between cel sets. Inker Joyce Carlson explained, "I had to watch the girl that was before me to ink the line, because there's a fine line, a medium line, and a heavy line, so you had to follow her lines so it runs smoothly. Otherwise, it'd jump. You had to match what the other girls were doing."

Rulers were utilized for lengths of straight lines and to measure consistent lengths on repetitive lines. The consistent

Left: Inked cels from *Ferdinand the Bull* (1938); and (right) *Goofy and Wilbur* (1939), inked by Mary Ellison.

lines necessary for each new character in the Disney canon were developed, practiced, and refined. "Pluto was easy to ink. He had nice, long lines," recalled Inker Yuba O'Brien. Virginia Fleener declared, "Goofy, he was my favorite!" Jeannie Keil, a left-hander who had to learn everything backwards, noted, "I hated Mickey Mouse because I couldn't do the ears in one stroke with my pen."

As characters and scenarios became more sophisticated, the delicate line work would often be inked in a full spectrum of colors. Evelyn Coats, a young Inker who later supervised the department, spoke about the intricacies of the job: "At some spots, like on the face for instance, you wouldn't want it to be black. You used the gray or something else that wouldn't show. That's why we used the colored line, because [the] face wouldn't look very good with the black line." Ginni Mack expanded on applying colored ink: "As you ended one color, you tapered at the point and then [entered] with the other color of ink. Then you had what they called 'sep' lines, which were separation lines[,] like when you had a different color of shading. Like on hair, they would use a different technique on hair."

The Inker's line work evolved to a level where all lines had unique accents, each of which had to land in the exact same place every time for the same character. Additionally, the established thinness and thickness of a character's form naturally varied once in movement. "It wasn't just a mechanical line," noted Betty Anne Guenther. "There was a lot more character in the inking. You had to 'shade' on the bottom of the feet, and the bottom of the tummy, at the lower [portion] to emphasize [and] give [the character] dimension that way. Also, the eyes had to be finer around than the rest of the character."

According to Inker Marie Johnston, "You have to figure it out ahead of time, when you first look at the thing, which line you're going to start with." Then, with one stroke, each line was applied with careful yet relaxed control. "You need to get the flow of the artist's drawing," said Johnston, adding that sometimes, "you have to ignore some of their lines." The consistency across each set of cels of each line width and taper points was critical, as any deviation would result in a pulsating line on-screen. Marveling at her colleagues' work, Paint Matcher Betty Kimball added, "I'll have to tell you the Inkers are geniuses. They followed the Animators' pencil lines and did it exactly where the pencil line was but made it a free line."

Working from the color-model guides, Inkers had to be able to judge exactly what stroke of motion would be appropriate for the character. Sweeping, fluid lines were mandatory. "You had to make a more artistic line," according to Marcellite Garner. "For instance, if you are going around a curve; part of it would be heavy and part of it would taper out to a thin line." With swift efficiency, lines were often masterfully shaped from thin to thick and back to thin again with a clean tapered end, always consistently matching from cel to cel.

Drawings were far more than "traced" or "transferred"; they were translated. Each pen stroke required interpreting the Animator's intent while keeping specific touches of individuality and style intact. Even the tiniest element, such as an eyelash or the trim of a jacket, required exactitude. "They would follow those pencil lines [and] get it right on the nose," Kimball noted, "because if it went [beyond the line] it would be magnified on a big screen. And it was on that celluloid that the pen would just go scooting every which way if you didn't have perfect control."

To achieve a sure line, many Inkers controlled their breathing between lines. Any jags, wiggles, flutters, or breaks to a line would be jarring once projected onto the screen. "You couldn't get a jiggle or sneeze or anything," recalled Inker Marge Hudson. If mistakes or anomalies occurred, they were carefully washed off and quickly redone to avoid costly delays. "You can't do your own thing or you'd really be in big trouble," said Guenther with a laugh. "There was a story about a gal who worked there before me [who] decided that Minnie Mouse's shoes didn't fit right, so she drew them to fit and was laid off for causing trouble, so I heard." This was likely told as a creative cautionary tale to ensure uniformity and avoid costly problems on the production line.

Depending on the complexity of the scene, it could take a good Inker two to three hours to complete a series of cels. Speed was vital, yet could also present problems. "I got too fast sometimes. I probably had a wiggle in the line," said Hudson. "What

Production cel piece from *The Band Concert* (1935), featuring speed lines visually exemplifying fast movement on screen.

is worse is when they gave us our first close-ups. They'd be talking to each other and [had] these great big faces and [heads], and hair. That was a thing where [wiggles] really showed up."

Spot-on accurate consistency was required for these demanding scenes, and it was a sign of having achieved mastery when an Inker was given such a scene. "I can remember when Hazel [Sewell] came by in person and said, 'Well, I guess you're ready for a close-up. Try this,'" Hudson remembered. "So I had a close-up scene and I was thrilled!"

IMPLYING SPEED & MOTION

Drybrush techniques were applied as "speed lines" to indicate fast motion within the action of a scene. If "drybrush" was designated within a scene, Inkers consulted specific instructions on timing and effect. A flat, dry brush without a point was utilized. The girls would often take an old brush and cut off the point. Different-sized brushes were utilized based on the area covered or intention of the technique. "You'd load your brush with thick paint," recalled Ginni Mack, "and with a fragment piece of cel on the side, you brushed with it until you got it just the way you wanted it, and they called it drybrush. You'd use a mask or what we sometimes called a 'frisket' line. It was a cel or cutout [placed] next to the character, and that would give you a sharp outline by the character[,] and you dry brushed out by evenly lifting your brush so it disappeared to nothing."

Drybrush techniques were not only for applying speed lines. They also indicated movement, texture, shading, and dimension. "The Inkers did the dry brushing mostly," recalled Mack. Brush inking was rarely utilized at Disney Studios, but other animation houses trained in and applied the method. Spatter techniques, shadow lines, and a number of other special effects techniques were also applied within the Inking Department as needed.

PURSUING "PREMIUM"

According to Rae Medby, "There was much more to being an Inker than merely shoving a pen around." Evelyn Coats agreed: "Inking was pretty hard to do, because you had to have a very steady hand and real fine line. It wasn't easy." To ensure her work was steady, "I didn't bowl, smoke, or drink," noted Jeannie Keil. "We were worried that our hands would shake."

It took work to join the ranks of the Inkers, Coats pointed out. "Not everybody made it, because if you got off of the pencil line, then you get a wiggle. And the Animators didn't like that. I don't blame them." It took over a year before one could be considered a competent Inker. "There were certain girls that were just phenomenal," recalled Lucile Williams. A clear classification began to take shape. "Premium" Inkers—artists who were more assured and quick with their work—would handle more challenging scenes and certain detailed effects.

With careful yet relaxed control, a premium Inker could whip through the final work of the drawing with an economy of movement and consistency. Depending on the complexity of the scene and colors, most girls averaged six to eight finished cels an hour, yet the volume of necessary artwork produced for a standard short numbered in the tens of thousands. As Inker Marie Johnston stated, "They believed in quality, not quantity, and I've never forgotten that. It wasn't just, 'Get it out.' It was very different from a lot of places."

PHYSICAL CHALLENGES

The physically focused control necessary to do the work also came with a downside. "Aching shoulders were part of the job, until you got used to it," recalled Carmen Sanderson of her early inking days with Disney. "And if your mind was on something else, it would show in your work!" Inker Evelyn Coats reflected on additional physical challenges: "I think it

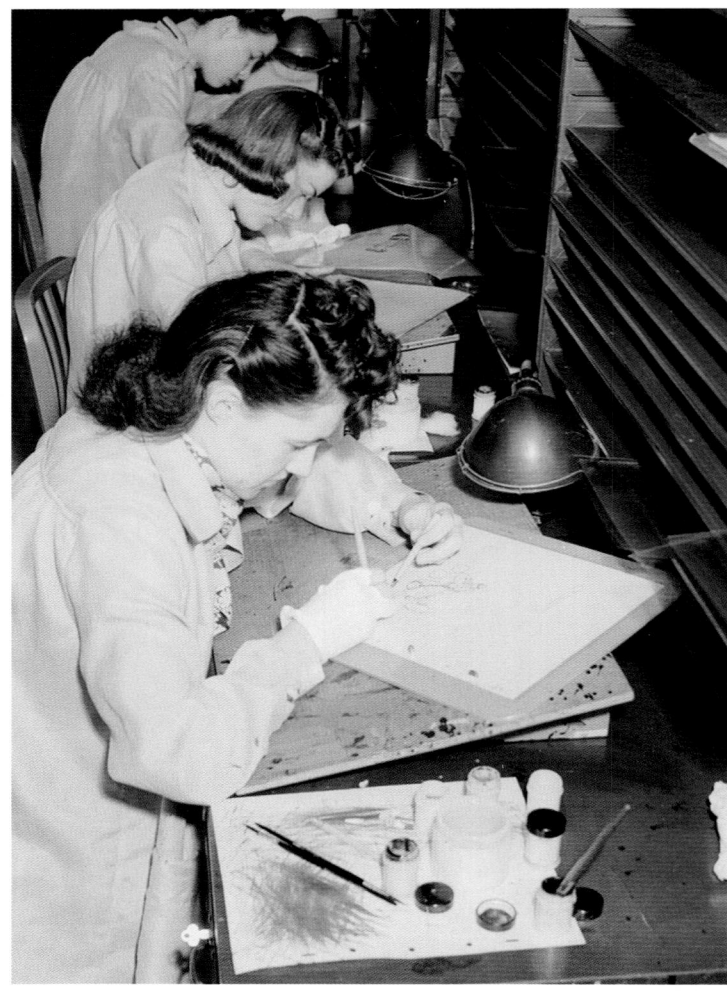

Left: Joan Shrimpton (front) inks an early Mickey Mouse cel, while Katherine Kuhlman inks a cel from *Little Hiawatha* (1937); and (right) Inker Kae Sumner.

was harder on your eyes than on your back. Actually it was hard on the eyes. You know, looking so long right at one spot."

Marie Johnston offered, "[Grace Bailey] would come around to your desk and say, 'I want you to stop and just look out in the distance, look out the window.' Because it's bad for your eyes, to keep going with that light under [the light boxes]. So they cared about you."

To achieve consistency in this fine detail, the best light possible was required. The Inkers' desks lined the large-windowed walls and were illuminated with tungsten and, later, fluorescent lights. This transition was lamented by Marge Hudson. "The only thing that bothered me was when they put in the new lighting that they have now everywhere, and that's hard on anybody's eyes anywhere," she observed. "And they did bother me. The fluorescent. Terrible. Bad for your eyes. But it had to be, of course[,] I suppose, true color. The sky had to be very blue when it was blue."

"You know, you didn't have to sit there just all day long without getting up," noted Coats. Mandatory breaks were taken each day, she explained. "You had lunch time and you had breaks." Leaving the pens for any amount of time required each point to be cleaned with water so it wouldn't lose its sharpness.

Timing guides were established for inking based on each character and their relative size. The cost of each element could be estimated based on this basic formula: a chipmunk that stood about two inches tall should take about two minutes to ink, while a nine-inch talking Snow White or Prince with detail would require over thirty-three minutes to fully ink.

INK CHECK

Once dried, the cels for a scene were stacked with the smallest cel numbers on top, along with the animation drawings stacked exactly the opposite with large drawing numbers on top. The exposure sheet and color-model sheets were placed on top. The scenes were passed on to an Ink Check Supervisor.

After setting all corresponding drawings and cels on pegs, these workers methodically checked each image for uniformity and completion. In an early lecture to the full Ink & Paint Department, Dot Smith, an Ink Check Supervisor, explained, "Each girl is given a complete scene to check by herself. She first counts the cels by the exposure sheet, [then] checks her hook-ups and cycles for color and action. The scene is then carefully checked [flipping each cel with preceding and following cels], for ink color, line quality, registration, held cels, animation jumps, drybrush, airbrush, shadows, and any other special effects used in the scene." If there were any corrections to be made, they were sent back to be re-inked. "It would never get by the checking," stated Grace Bailey.

Once corrections were made, the full scene was then checked with the background. For scenes involving pan backgrounds or sliding cels, a sliding-cel board was set up and moves were made according to the camera notes on the exposure sheet. Registration to the background, overlays, underlays, cutouts, and lengths of sliding cels were all checked against the background. Field charts were utilized to designate and ensure the proper field range was inked. Overall, Ink Check addressed any necessary adjustments, and if mistakes occurred, corrections were made before the sets were handed over to the Painting Supervisor.

A variety of paintbrushes utilized in various Disney productions.

> "*Painting ... takes patience, organization, and considerable skill.*"
> —Frank Thomas & Ollie Johnston

PAINTING

Once through Ink Check, the inked cels, along with the exposure sheet, color models and drawings, moved on to the Painting Department. Detailed records and tracking systems were maintained to chart the progress of the various scenes throughout the department. All scenes were entered into a log, with checks made for cels that might need to be sent to other departments, such as Background or Airbrush.

The Painting Supervisor, who also oversaw a number of administrative duties for the Painters, reviewed the content of each scene. Often reminded to "think like a Painter," the Supervisor and her assistant would mark up each scene utilizing clear, descriptive notations for each character and their color designation. The levels of each scene were broken down into sets comprising characters, effects, props or shadows. This division into sets allowed the scenes to move more quickly through the department. A thorough checking of the color models was made for any changes that would require new paints, and the estimated time to paint the set was noted. The sets were placed in a stack near the corridor Supervisor's desk, with the most difficult sets placed on top of the stack so that all sets within a scene would be finished at approximately the same time.

Once a Painter was ready for a new set, she had to select the scene that was directly at the top. "Sometimes people decided they would take the easy ones," remembered veteran Painter Wilma Baker. "One girl would dig through them and take the ones she wanted. That didn't last long." Sets that required special needs were given to the girls who were best qualified.

Animation drawings, and the "white card"—which came attached to the top of each set—would be carefully reviewed for any specific instructions. From these notations, Painters ordered any paints they required. "You'd make out a slip for the colors that you need to paint those cels[,] and you'd hand it to somebody from the Paint Lab," recalled Ruthie Tompson. "They'd come back with the little jars with the paint in them and you'd go from there." As they neared completion of their current set, Painters ordered the paints required for their next set, to avoid waiting for their paint order to arrive.

TOOLS & TECHNIQUES

Meticulously cleaned brushes and rows of tidy little pots of paint lined each Painter's desk. The numbers on the paint jars corresponded to those on the color-model sheet for the scene. Each Painter worked on sets averaging between ten to twelve inked cels and utilized whatever tools she preferred based on what each cel required. Standard size 6 through 9 sable brushes were the workhorses, along with a range of other brushes of various shapes and types of bristles. Fan, badger and detail round were also utilized to apply the paint, based on the techniques required for each scene.

"We had favorite brushes, and we used all sizes," noted Painter Ginni Mack. "Some of them were sable, and they were good brushes. But they were quite expensive. Somebody had to wear a brush out before we would replace a brush." Occasionally, when supplies were limited, the sable brushes were difficult to obtain. "We kept them locked in a drawer," said Mack.

"They brought you a jar of the color you ordered from the Paint Lab," Mack added. "The paint was usually too thick for painting, so we'd apply drops of water or sometimes an additive Emilio [Bianchi, the studio Chemist who began in 1939] made to combat bubbles or oiliness or other problems and [make] it so the paint was really smooth and free of bubbles." In fact, Bianchi developed a "de-bubbler" machine in the Paint Lab. An early high-powered blender of sorts, "it had a spinning piece of metal [that] spun around really fast to smooth the paint out as it was processed through," Mack recalled. "It would come out nice and smooth."

The right consistency was critical for effective paint application. "You got it pretty thin 'cause you wanted to float it on," Mack pointed out. "You put the paint in the area you want to paint and you kind of pushed it to the edge of the line, sometimes halfway over the line, and you didn't want any light to

come through. The ink lines were pretty opaque, but sometimes they were real thin, so you carefully brought the paint right to the edge. You could do a quick check for any light by holding it up to the light."

Initially, black was applied "on top," to the inked side of each cel throughout the set. "Tails, noses, eyes, puppy claws," Mack added. "Sometimes a kind Inker would fill these small areas in before the cels came to Painting." In an assembly-line fashion, paint was applied one color at a time to the back side of the inked cel set; then each cel was carefully placed into a tall stacking file to wait for it to dry, which usually took about three hours, before the Painter started on the next color.

"You had to judge painting something small to begin with—eyes, teeth, et cetera—and then move on to something large, because you could slip over the small thing," said Betty Kimball. "So you had to judge which color to put on first." Progressing across each cel set, the artists would determine the best approach, working from the smallest to the largest areas of color.

PAINTING MASTERY

As story lines and animation became more sophisticated, the seeming simplicity of applying color to cels in the proper areas became much more involved. The painting of each cel required its own mastery and discipline as the color itself became animated in the final film. "You were to get it to a mirror finish so when you turned the cel over, it's almost the same, front to back," said Ginni Mack. To achieve this, a number of stylized brush techniques for paint application and color consistency were required. With sure, single strokes, the paint was floated—not brushed—onto the cel, efficiently guiding the paint to achieve a smooth, even surface.

"If you dig in too much with your paintbrush," noted Marie Johnston, "those dig marks are a paler color and they'll show up."

The characters' movements determined style of paint application. Slow action required extreme care to ensure consistency from one cel to the next, particularly if the characters scarcely moved. Fast action was more forgiving, but still required careful follow-through. Different application was required between light and dark colors. Thinner light colors could be evenly floated on, while darker colors were smoothly brushed on, as the pigments required less water. With an even flow, the rounded edge of the smoothed paint was gently brought up to the inked lines, carefully meeting the finished edge of the adjoining color. Accuracy in hitting the line was key. Uniformly maintaining opaqueness was critical, as any light emanating through a color applied too thinly, or paint not meeting the inked line, resulted in costly delays.

Painting a large character required much more care in consistency, as the work would be enlarged four hundred times on the screen. Even the tiniest flaw or variation in the paint would be more than evident. This was also the case with close-ups. Just as the Inker's lines had to be rock-solid, any variation or inconsistency within the Painter's work across the entire scene would result in apparent jarring jumps or dropped forms on-screen.

With the matrix of cel layers necessary for any given scene, challenges were constant. Various aspects of characters, props, and scene elements on certain cels might not even make sense within the work each Painter completed. A floating arm, a random prop, or a disembodied head might constitute a series of cels. Often it was unclear exactly how their celluloid canvas would fit into the overall picture, yet each cel was vital. As Betty Kimball explained, "You usually had a whole scene but only one cel level to work on. Sometimes you'd only be doing something that moves[,] where something behind it moves slower and would be on a

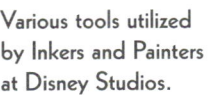

Various tools utilized by Inkers and Painters at Disney Studios.

Left: Final inked and painted cel element from *The Cookie Carnival* (1935); and (right) the back or painted side of final cel element, achieving a mirror image of the front.

different cel level."

In addition to the varying range of complexity and detail to the work that crossed each Painter's desk, some artists excelled at the specialty of visual effects: rain, water splashes, lightning flashes, or delicate foliage. Expert Painters in Special Effects had to keep track of the animated progress of a thousand specks of fairy dust or the highlighted spectral reflections on countless gurgling soap bubbles.

Once color was applied to the cel, it would be carefully shelved in large racks for drying before the next color could be applied. "You had to be very careful about that," recalled Marie Johnston. "We had shelves and we put [cels] with the paint side up, of course, and paper under it to let it dry. I can't remember how long it took. You had to keep things numbered. The numbers were in the corner, so you had to keep it in order so that when you did collect them all, to turn them in, they were the way they were supposed to be."

To keep the cels clean, the Painters, like the Inkers, wore cotton gloves with the thumb and forefinger cut out to better manage the brushes. "Mistakes were rarely made[,] as time was imperative," Johnston noted, but if they occurred, "you could wash it off with water and maybe cotton. We were able to clean [paint from] a cel up without hurting the ink line, which is on the back side. The paint was water-based. It had to have been, or we wouldn't have been able to clean it up."

Mack offered a quicker fix: "If you crossed over the line with the paint, you took a finger and pushed it back. We wore a full glove on the other hand, and when you pushed the paint back over the line, we wiped it on the back of our other glove." Speed was of the essence, and sometimes washing the paint off was too time-consuming. "You had to wipe it someplace[,] and that was the most convenient place," Mack laughed. "Even after they were washed, we had a lot of color left on the gloves from doing that."

Caring for the brushes once a scene was completed was a constant step in the process. "We had a paint cloth that we kept folded by our water," Mack remembered. "After you rinsed the paintbrush out, you turned it on the rag to get the excess water out[,] and that pointed the brush bristles as you turned it. You always wanted to keep the paint out as much as you could from the head of the brush 'cause it would dry and ruin the brush. We made sure we kept our brushes very clean and we didn't dip them too far into the paint."

LINES & FORM

Field lines indicated the visible area the camera covered. These line indications were critical, requiring constant vigilance to assure no jarring inconsistencies from cel to cel. Paint was extended smoothly about a quarter inch past the field lines to ensure the area was covered past the camera's range. It was imperative that Painters smoothly applied the paint to these endpoints rather than leaving ragged edges, which would be enlarged on-screen. Registered lines were repeatedly traced back to an original line, either on a background or another cel. Any variation in any of these lines would result in paint pops or other visually distracting anomalies.

Traceback lines on a master cel would be painted to another line on a cel beneath it. Tracebacks were utilized to repeat one area without movement for several cels while the rest of the character moved. Pegboard registration was critical when doing a traceback to ensure a proper and consistent match. Once each color was applied and fully dried, the cels were gathered into sets and returned to the Corridor Supervisor, who reassembled the sets into the correct scenes and advanced the collected scene on to Paint Check.

PAINT CHECK

"They had what they called "color checking," and what we did was check the colors to be sure that the Painters got the right orders," recalled Ruthie Tompson. "Because out of a five-hundred-cel scene, every four or five would be painted by a different girl, so the colors had to follow through, and so we'd flip the cels, and if they put blue in the wrong place, we'd have to take them back and have them redo them and fix them."

Katherine Kerwin oversaw the early development of Paint Check methods. Stressing a complete understanding of animation

Set of three cel elements and the final cel setup (bottom, right) from the early Silly Symphony *Lullaby Land* (1933).

techniques, Kerwin directed the process thoroughly, noting, "On the exposure sheet[,] when a group of numbers are called for over and over again, it is called a cycle. The first number of the cycle is circled in red. The last cel must be checked very carefully with the first as they will work together and a flash might easily occur if this is not watched."

If something within a scene suddenly came out of action, it was often accomplished with a cutout. A cutout had to exactly match the object on the cel. It was painted on celluloid, then lacquered on the back and cut out. The cutout would be laid on the camera platen, and the exposure sheet would indicate to the Camera Department when to place it and when to remove it within a scene.

Completed sets were reviewed for the slightest flaw within the paint and color: mismatched and incorrect shades of colors, any elements left off, incomplete shadows, or streaky paint. Larger painted areas required additional attention to ensure the color and thickness remained consistent for proper opacity. Unevenly mixed and applied paints, once photographed, resulted in "paint crawl"—an anomaly visible once the scene was projected onto the screen. Each of the irregularities would detract from the unifying artistry of Ink & Paint.

A rigid method was applied, as each scene was checked before it could progress to Final Check. Every number on the exposure sheet had to be accounted for. Hookups between scenes were checked, and each level of cels was checked for color consistency. A careful review of the overall condition of each cel had to be made. Cels would occasionally need to be made over due to dents in the celluloid from bending or mishandling. Stacking or shaking of a group of cels could result in scratches, and accurate replacements had to be created.

Sometimes a scene would be checked over a backlight as well as a front light to determine overall opaqueness and resolve any light leaks. If the paint were applied too thickly, it could come off onto another cel, often spoiling ink lines or black paint on the adjoining cel in camera. Any problematic cels were returned to the Painters for correction, and completed scenes were checked off and sent on to Final Check.

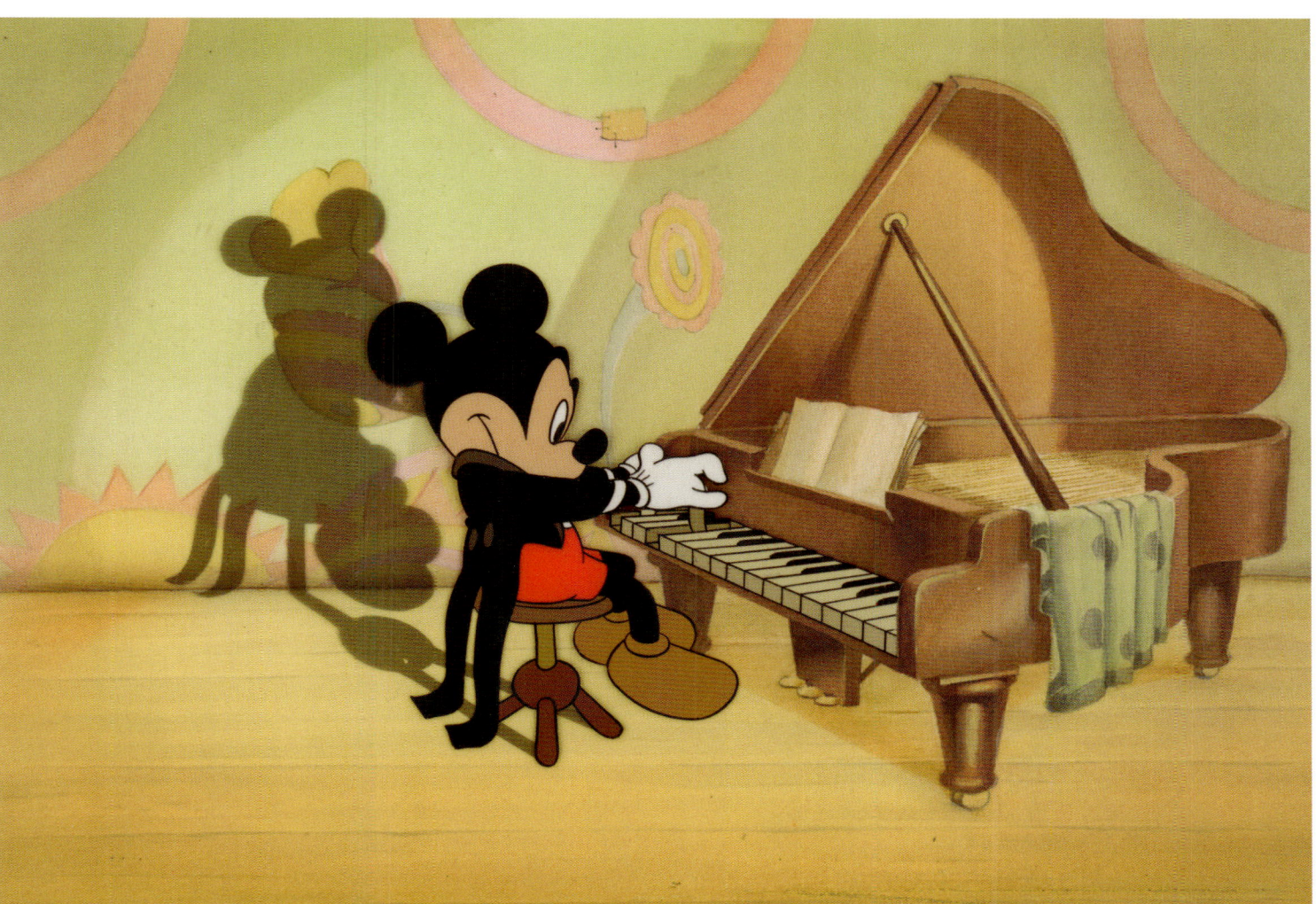

An example of shadow painting from the Mickey Mouse short *Orphan's Benefit* (1941).

EARLY PAINT & CEL PROBLEMS

Extensive drying time often caused delays, with cels sticking to each other or to the platen when in the camera. To help expedite the drying process, the women would often "cook" the cels by placing them under their lamps. Careful attention had to be paid to ensure too much heat didn't cause the delicate cels to bubble, rendering them unusable.

Betty Kimball explained, "You had problems with the paint not drying. That was because a medium was put in the paint so it would dry slower so you could finish painting and it wouldn't change color. Sometimes they put too much glycerin in and they would stick together. If it was a humid day in the Paint Lab, they had to use less glycerin, so [the] Paint Lab was sort of . . . a chemistry lab." If too little glycerin were used, the paint would crack, and removal of the paint required careful attention. Kimball recalled, "You either scratched it off . . . or used something like a swab. If you made a horrible mistake and had to wash the whole thing off, that would take repainting the whole thing beginning with the first level that you used."

Early commercial grades of paint wouldn't adhere properly to the nitrate cels. Streaking and separation occasionally occurred, and oftentimes remilling the paint would do the trick. Kerwin noted a few other problems at the time: "Once in a while we get a set [of cels] that has been painted with watery paint; as a result it is lighter than the work before and after, and when added to the rest of the scene [it] causes quite a flash on the screen."

SHADOW PAINTING

After a scene was painted, if it was required, the scene was turned over to the Shadow Painters. Working with transparent paint solutions mixed with black to achieve the required shade of gray, these special artists only painted the shadows within a sequence. Live-action films achieve this through set lighting or natural light. In early animation, these effects were primarily achieved with paints. Color added to the illusions of interiors, times of day, mood, and tone for the comedy or drama of a scene. The introduction of shadows added dimension to a character and depth to a scene.

To achieve an added dimension to Mickey Mouse, "They painted the shadows black and doubled [the exposure of the characters] in those days," said Painter Ruthie Tompson. Quite a bit was accomplished with the studio's paints, yet the tone of the painted subject would change depending on the amount of light placed on it. "That was before shadow paint," Wilma Baker explained further. "You would paint the shadow in black, but the X-sheet would indicate for Camera that the shadow effects were going to be exposed once; then the character would be exposed twice so it would appear lighter on the shadow effect and stronger on the character. As Shadow Painting developed, it was much cheaper than doing it with double exposure."

In early shadow experiments, consistency was an issue. The lack of evenness in the density caused flickering, but as the technique developed, the shadow paint ultimately became a specifically mixed blend that could be adjusted for darkness and density as needed. Later discoveries revealed that a weaker solution of shadow paint blended with various colors could be utilized to achieve certain effects.

Left: Painters and Airbrush artists utilized various shaped friskets to control the location of paint and to achieve desired visual effects.

Right: Walt Disney visits with a group of Ink & Paint artists within the studio's new Inking & Painting Building, circa 1935.

Initially, shadow solutions were made one pint at a time, which would last just under a week before it went bad. With later developments, a dozen pints could be created. As Mary Weiser noted, "the fact of the matter is that the paint improves with standing."

To simplify the approach to shadow paints and still achieve the desired sense of roundness or depth, Disney Special Effects artist Leonard Pickley introduced the shadow cel in *Fantasia*. "If it [were] a big shadow, occasionally the shadows would be painted on a different cel level," noted Wilma Baker, "but most shadows were applied on the same cel level as the characters. You learned the main method of doing these things, but there were always variables." Since a shadow cel was on its own separate cel level, light and exposure could be isolated and adjusted. Selected use of this approach eliminated issues that might occur when illuminating painted shadows on the primary cel.

AIRBRUSH

As style and the level of sophistication developed with the artwork, the Ink & Paint Department expanded in the mid-1930s to include a division for airbrushing and effects. Run by Barbara Wirth Baldwin at its height in the late 1930s and early 1940s, this group of twenty women and a few men capably handled the subtleties of the airbrush. "We had an Effects Department within the department, as part of Ink & Paint, [with] a group of girls that did airbrush work," recalled Baldwin.

Once the paint of a cel was dry, the airbrushing (applied by spray for cheek tones or puffy clouds) or dry brushing (applied by brush for speed lines, pixie dust, or smoke shading) specialists would finish up. Managing the subtle spray to add dimension and soften the harshness of flat color required skill and artistry, as these artists were often animating the movement of their work from cel to cel. The techniques also required precision application due to the variables of the spray or brushstrokes. Special stencils or friskets would also be developed as needed for specific characters and applied with airbrush, dry brush, stippling, or china marker.

Various cloud, underwater, and atmosphere effects, candle flames, reflections, and the special touches that make stars twinkle were achieved by this department. Smoke effects were examined, and studies were made of water dripping and light reflecting on various surfaces. Special care had to be given to the creation and handling of cels that were airbrushed. Overall, the work within this department brought careful touches of realism to each cel, which added to the believability of each character.

FINAL CHECK

From Paint Check, the completed scenes moved on to a Final Check Supervisor, who dispersed the scenes to several assistants. Ruthie Tompson recalled her days in Final Check: "The interesting part of checking was following the animation . . . and learning how they do their mechanics. That was really interesting to me . . . how they moved a character on the ground so his feet didn't slip, and all that kind of stuff.

"We weren't in cubbyholes like the Painters; we were in a . . . big room," she said. "There were about eight of us in the room, and we'd have complete scenes to work with. We were there to correct mistakes that were made, and if they were big ones that involved ten or twelve cels, we had to take them back to the Inkers or the Painters."

Scenes were processed based on priority. Checkers would place all elements of the entire scene on the pegs, along with backgrounds, to carefully check and recheck against the exposure sheet and review the overall scene. "We also had to do whatever the Animator's instructions were as far as the mechanics of the scene was concerned," mentioned Tompson. Wilma Baker, who later advanced into Checking, agreed. "We disassembled each scene[,] and if there needed to be any mechanics reworked, we'd do that, just like it would be worked on the camera when they shoot it."

A working knowledge of the various camera techniques and direction was required, as well as an understanding of the particular transitions—dissolves, fades, wipes—to ensure all cels were accurately completed to achieve the desired effect. An understanding of camera effects such as iris in, iris out, cross dissolves, and double-exposed shadows was critical. As Tompson added, "We did everything that the camera did except push the button. And we'd check to see that all the action was within the area, the visual area, so that we wouldn't see an unpainted background go sliding through by mistake."

Ink & Paint staff showing off their new smocks, hairnets, and visors.

Pages 124/125: Ink & Paint artists enjoyed Teatime twice a day at the studio. Occasionally, Hazel Sewell invited the girls to swim in Walt's pool at his Woking Way home to celebrate the completion of a short.

Completed scenes were finally reviewed for the slightest overall flaw within the line and color: missing cels, mismatched lines and colors, elements left off, jumps in animation. Tompson, Baker, and the other women of Final Check thoroughly reviewed thousands of cels and scenes. "It gets pretty well checked from beginning to end, from the painted cel to the scene," recalled Baker. Once checked, every cel was carefully cleaned to remove any fingerprints, and random dust or lint particles were taken out. After cleaning, the scene was sent on to the Camera Department for the final step in production.

CAMERA

In 1933, a standard Bell & Howell camera with a synchronous motor featuring a stop-motion mechanism was used for final photography of Walt Disney's animation. The camera could move in a variety of directions. Over the years, various camera's were utilized as technology advanced. Held in position by the registration pins, the cels were assembled and placed over the corresponding backgrounds. With an optical glass plate or platen operated by a compressed-air mechanism, the cels flattened against the background with adequate pressure to remove any wrinkles or curling of the celluloid.

The colors of the Disney paints were designed for the color temperature of lights set at 3,200-Kelvin illumination. The camera operator consulted the completed exposure sheet, which outlined any necessary instructions for the scene. Four layers of cels were always under the camera. If a scene required fewer than four cels, blank cels were added to preserve the photographic values of the background. Generally, an animated short subject running about six hundred feet of film required about one hundred hours to photograph. Effects shots and any necessary "tricks" increased the photography time. If any problems occurred within Camera, such as chipped or wet paint, the cels were rushed back to Ink & Paint for immediate correction. With deadlines looming, Ink & Paint girls were often stationed in the Camera rooms to touch up or make last-minute corrections as needed.

EVERYDAY INK & PAINT

Smocks were issued for the girls to wear over their street clothes after the fuzz from one girl's angora sweater adhered to the cels and couldn't be removed! The artists also wore gloves and occasionally hairnets and visors, to maintain cleanliness for their clothes, but primarily to protect the cels. Evelyn Coats recalled a few additional measures. "My hair was never real long, but if it was long they'd have to put it back so it wouldn't touch down on the cel."

While working in Color Models, Grace Godino, Patsy Oliver, and Ann Lloyd had different-colored smocks made. "We didn't like the white ones we had to wear[,] so we had our own made," declared Godino. "Each one had a different color, 'cause we figured Color Models should have color smocks. Mine was green."

CEL WASHING

Once successfully processed through Camera, the Animator's drawings were filed and saved, while the cels were collected and returned to the Cel Washing Department to be cleaned for reuse. This expensive material was difficult to get at times, and because of the costs, as many cels as possible were washed with mild soap and hot water for reuse. "When I came (to Disney), they didn't use the washed cels for production," recalled Betty Anne Guenther, "but they used them for training. If you got a washed cel that had the various characters—they got scratched on the surface and it was sort of hairy when your pen got in one of the scratches." With supplies difficult to obtain in the war years, this policy changed.

Wearing rubber boots and aprons, cel washers bent over big sinks. With perpetual steam rising from the hot water, the cels were gently washed and cleaned for additional use. All traces of the inked lines and paint were completely removed. "That was a regular job for somebody, to be continually washing cels," recalled Dick Huemer. "That wasn't too easy to do[,] either. The ink stuck to the cels. We had to use ammonia and one thing and another."

Once washed, the cels were placed on a board to dry. The cleaned cels would then be stacked with sheets of tissue paper as a manifold between them and then sent back to the department for reuse. Viable cels were reclaimed and reutilized never more than three times before being tossed for becoming too scratched, dinged, marred, stained, discolored, or shadowed from previous use. Additionally, as the celluloid aged, shrinkage occurred that prevented the cels from properly fitting over the registration pins.

TEATIMING

Walt Disney recognized the sedentary nature of the work involved in animation. In addition to the various sports played at lunchtime, Walt, a strong supporter of athletics, also instituted regular fifteen-minute morning and afternoon rest periods. A chance to break up the day, "Teatiming," gave the women an opportunity to move about, stretch their muscles, and rest their eyes.

At the Hyperion studio, in addition to lunchtime at noon, twice a day a uniformed maid set up large tables with teacups at the back of the room. Available only for the women, the maid would announce the designated teatimes of ten o'clock and three o'clock by ringing a bell, prompting the girls to stop what they were working on and step away for a break. Painter Wilma Baker recalled that on a long counter that ran across the back of the four corridors, "they would put all the cups and saucers out and pour the tea and then this girl would start at the back of the corridor and call, 'Teatime, teatime!' And boy, we were looking for that. We would mill around for maybe ten minutes and because it was one floor, we could go outside." In a long grassy space along the building, the girls would gossip, smoke, and generally rest outside in their own lawn setting. When pulling long days to meet production deadlines, the girls would occasionally nod off, and the maid would gently nudge the girls awake and send them back to work.

On Fridays during teatime, Lorna Doone cookies were usually served, with Mallomar cookies occasionally offered as a special treat when they were in season. "When I first went there to work, they had this teatime, and they served coffee, and I said, 'It's tea time, why do we serve coffee?'" recalled Painter, Ruthie Tompson. "Well, the Inkers have to have tea because coffee makes them have the shakes." Painters could have coffee.

Teatime breaks were also the designated time for a trip to the restroom, which often became the smokers' lounge. "Everybody would use it for a smoke room," remembered Marge Hudson. Inkers and Painters worked with highly flammable nitrate cels all day, so as Hudson recalled, "there wasn't even a match anywhere near that studio!" Since the Animators only worked with paper, Hudson lamented the fact that "men could smoke more than we could. I didn't think it was fair about the restroom. I used to go into the one in the hallway right outside the Inking Department rather than the other. I hated to come out and smell that way." As a result of the steadiness required in their work, Hudson and many of the women quit smoking.

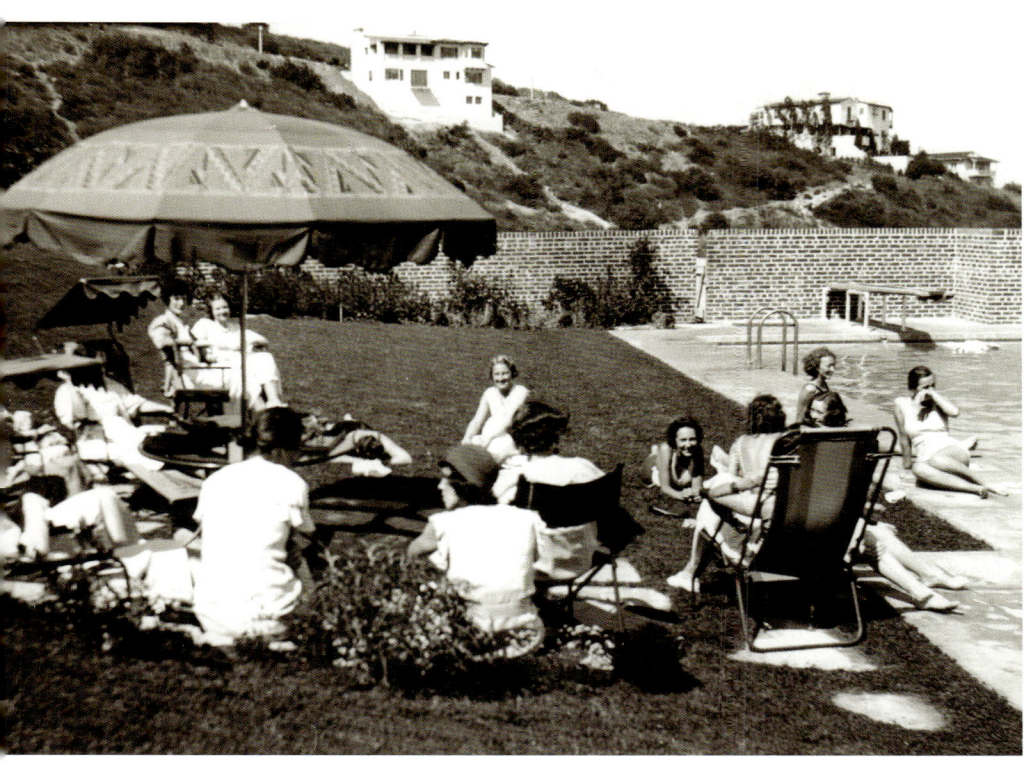
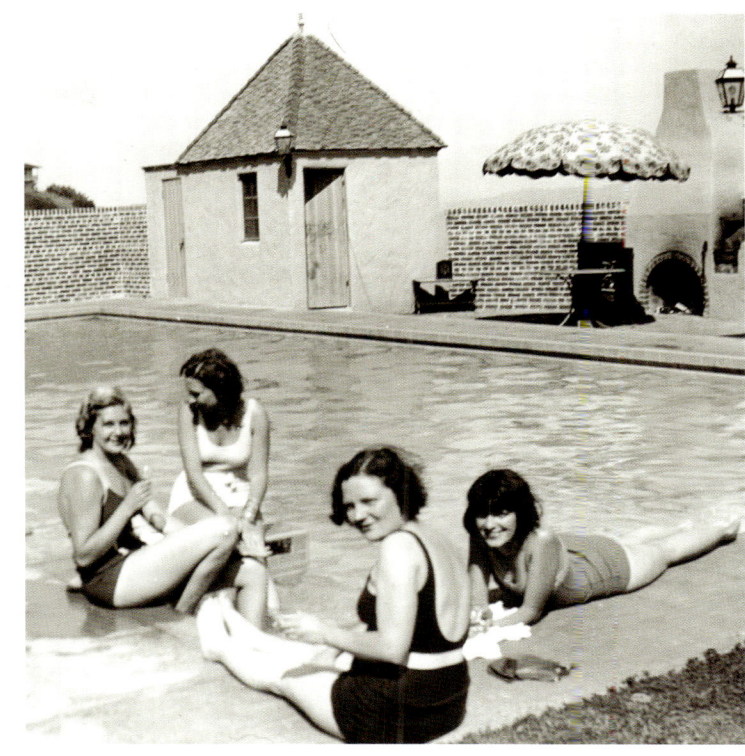

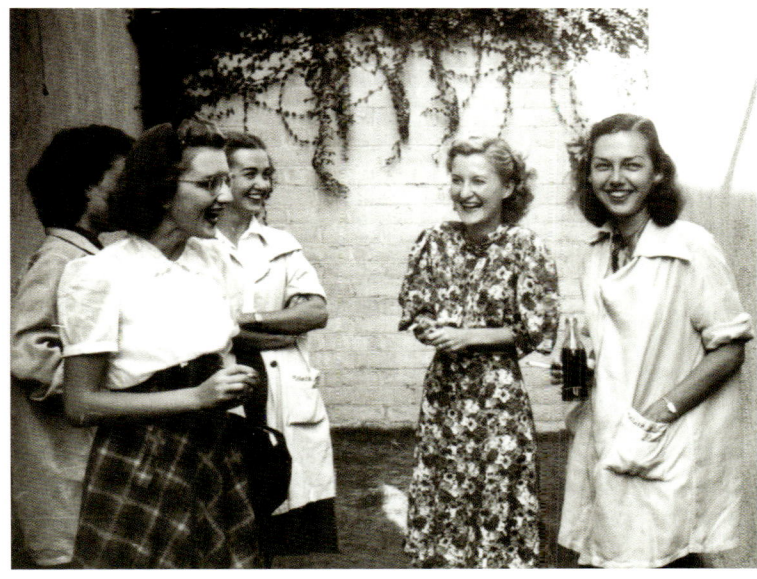

THE FAIREST ONE OF ALL

> *"We needed this new adventure, this kick in the pants, to jar loose some new enthusiasm and inspiration."*
> —**Walt Disney**

As early as 1933, Walt Disney explored the notion of a feature-length animated film. Having struck a distribution deal with Mary Pickford's company, United Artists, Walt Disney Studios was now aligned with one of the largest power holders in Hollywood. In addition to being America's sweetheart, Pickford also produced, directed, wrote, and starred in her own popular films. Pickford approached Walt with the idea of starring in a live-action/animated version of *Alice's Adventures in Wonderland,* but when Paramount Studios secured the rights for a feature film based on the popular Lewis Carroll tale, this project was quickly dashed.

Shortly thereafter, Disney collaborated with Fox and MGM Studios, creating animated segments for their live-action feature films, which seemed to add to Walt's intentions toward creating features. "We're pretty limited in making shorts," Walt told his staff. "We ought to go ahead to something else."

Sensing they had accomplished as much as they could in short subjects, Disney expressed concerns about "getting ourselves in a rut." A number of story concepts were considered and explored, including J. M. Barrie's *Peter Pan*, various fairy tales (including "Sleeping Beauty"), and folktales such as "Rip Van Winkle." "It was a long-planned thing," recalled Roy Disney. "We had a good stretch in that period from 1934 on. We were getting good distribution and making relatively good money." The time was right.

A FAIRY TALE FEATURE

Snow White and the Seven Dwarfs had been under exploration for a short subject film at the studio, but by then, a full-length production was clearly on the horizon. This traditional fairy tale with a prominent female lead held a strong resonance with Walt. "I once saw Marguerite Clark performing in it in Kansas City when I was a newsboy back in 1917. It was one of the first big feature pictures I'd ever seen. I just thought it was a perfect story."

But to translate this into an animated feature film was not going to be an easy task. As Lillian Disney summarized, "When Walt went into color with *Flowers and Trees*, Roy was scared, and so was I. It was the same way when he went into *Snow White*. People told him that the audience would be bored by a feature cartoon."

On the evening of October 30, 1934, a remarkable gathering of the Hyperion studio staff would change the course of history. Walt set his goal in motion on the studio's small recording stage with a three-hour telling of his vision for *Snow White*. "We were spellbound," recalled Ken Anderson, who worked in Layout and story at the time. "He didn't just tell the story; he acted out each character. He would *become* the Queen. He would *become* the dwarfs. He was an incredible actor, a born mime."

After three hours, the staff began to grasp Walt's vision. "When he got to the end he told us that was going to be our first feature," continued Anderson. "It was a shock to all of us because we knew how hard it was to do a cartoon short. He was doing something no other studio had ever attempted, but his excitement over *Snow White* inspired us all."

"We didn't know exactly where we were going," Walt Disney stated, "but we were on our way!" Animator Ollie Johnston, who was also present that electric evening, recalled, "It took guts to do what Walt did. The story is based on the idea that the Queen is going to murder this girl. That's one drawing killing another drawing. Walt convinced us that this could be done so that it would be believable, and we all believed him."

Recognizing the importance of getting this story right, Walt issued an interoffice memo to his personnel teams late in 1934:

> A thing we are sadly lacking in the Story Department is somebody who would be classed as a reader, capable of giving condensed versions of stories, which could be read in a few minutes. This person should also be capable of making adaptations to show the possibilities of stories for our use. Let's see if we can find someone to fill the spot. This person would have to be someone who knows showmanship angles, and would also have to know what we can do with a cartoon.

But 1935 would bring a number of delays while story points, the training of artists, and production methods were honed and developed.

Making this dream a reality required charting a new course for Roy as well, at least financially. As Edna Disney recalled, "That was something they'd never done before and, of course, they were all worried about that. When you do something different, and don't know how the public's going to take it, you're bound to get upset and worried. And then when it turns out all right, well, boy, you're really in the clouds."

Edna added that Walt's fortitude was something to behold as well. "[Walt] was always an optimist. [Roy] tried hard to be.

DOROTHY ANN BLANK

A year and a half after Walt proposed the creation of the position, Dorothy Ann Blank was hired on July 20, 1936, to develop stories for animation. The former journalist for *Redbook* and *College Humor* magazines joined Bianca Majolie and Grace Huntington in the Story Department. One of the earliest writers to get Walt's feature film idea under way, Blank was brought on board to provide "the woman's angle" to the forthcoming productions at Disney. Developing the earliest story treatments of *Snow White and the Seven Dwarfs*, she extracted key story points of the classic tale while highlighting the cinematic elements and forming solid character descriptions. Blank also defined script structures and wrote key dialogue for *Snow White*.

Occasionally, Blank also wrote stories for the studio newsletter, *The Bulletin*. She regularly participated in story conferences and contributed to a number of short films, as well as the early development of several later feature films.

Conducting extensive research into the worthiness of a story, Blank's talents defined what would soon become the Story Research Department. Her groundbreaking work determined the crucial foundational methods for exploring future story possibilities for Disney Studios and established many of the story research and early development processes that are still in place at the studio today.

An early exploration of telling *Snow White* in rhyming form brought Kathleen Millay, the sister of noted poet Edna St. Vincent Millay, to the studio. Millay's poetic expertise garnered a weekly pay rate that rivaled that of the key Animators (at one hundred dollars per week), but her specialty work lasted for only several weeks as the expanding range of comedic characters and dramatic direction changed the course of the story.

But he had the financing, so it was a little harder for him to be optimistic when he could see the payroll going up and up and up.... It wasn't that Roy never, ever wanted Walt not to do what he wanted to do. Never. He was always for Walt in everything he did."

A NEW HOME

By 1934, staff sizes had increased in various studio departments to meet the commitments to the shorts as well as in preparation for the large-scale needs for a production of a feature-length animated film. Later that fall, plans for a new building to house the Inking & Painting Department were under way, placing the Inkers and Painters in a facility properly suited to the artists' needs. By 1935 the building was complete and the team packed up

Page 127: Cel setup of Snow White from Snow White and the Seven Dwarfs *(1937).*

Final frame from the Academy Award-winning animated short *The Old Mill* (1937).

their old facility to move into the brand-new Inking & Painting Building. Four main corridors opened to large banks of windows providing natural light for the Inkers and Painters to complete and color the cels. Custom-built desks with thin stacker shelves were lined up side by side in rows of two along the windows throughout the new facility. A corridor of Inkers, separate rows for Painters, and rooms for Checking were at the ready. Hazel Sewell and her teams also set up a small department for paper punching, cel cutting, and cel washing.

As story development teams expanded the characters and world of *Snow White*, Mary Weiser's fully functioning laboratory began mixing custom paints within the Hyperion studio in 1936. Samples were sought for hundreds of distinctive pigments. Each was meticulously scrutinized for feasibility, and those that passed muster were mixed and dispensed to the Painters through a small counter accessed from the front main hallway.

The industrious efforts and scientific methods of the women in the studio's Paint Lab transformed the experience of animation by expanding the range of shades applied to *Snow White* far beyond what was commercially available at the time.

> *"We decided for features, the camera needed improvement too."*
>
> —**Walt Disney**

MULTIPLANE VIEWS

The year 1937 marked a dramatic turn in artistic efforts. The current Silly Symphony, *The Old Mill*, provided the opportunity to push the exploration of depth and dimension within the animated form even further with the advent of the multiplane camera. Animators Frank Thomas and Ollie Johnston later wrote about their first viewing of these new techniques, which were primarily the work of the Special Effects teams along with Ink & Paint. "Our eyes popped out when we saw all of *The Old Mill*'s magnificent innovations—things we had not even dreamed of and did not understand. We did not know how any of the effects were achieved or who had done what and how it was painted. Even the inked cels and backgrounds did not look like anything we had ever seen before. Unknown to us, Walt had hired color experts and engineers and had been experimenting with new ways of lighting and a multiplane camera and all sorts of things."

"Everything up to that time was in bright colors," remembered color matcher Betty Kimball, "but working on *The Old Mill*, they went into subdued grays and it was a serious picture. And that was when you could feel that a feature was coming on and you began hearing about it."

Recognized as one of the most important developments in the field of cartoon cinematography, Disney's multiplane camera took four years to develop and required a crew of four to eight operators. As a studio write-up explained: "It consists of moveable horizontal planes set underneath a Technicolor camera, also movable. A color background is placed on the lowest plane. On the next one above is placed a transparency with foreground scenery painted on it. Above these on the other planes are placed the transparencies (regulation cels) with characters on them. When

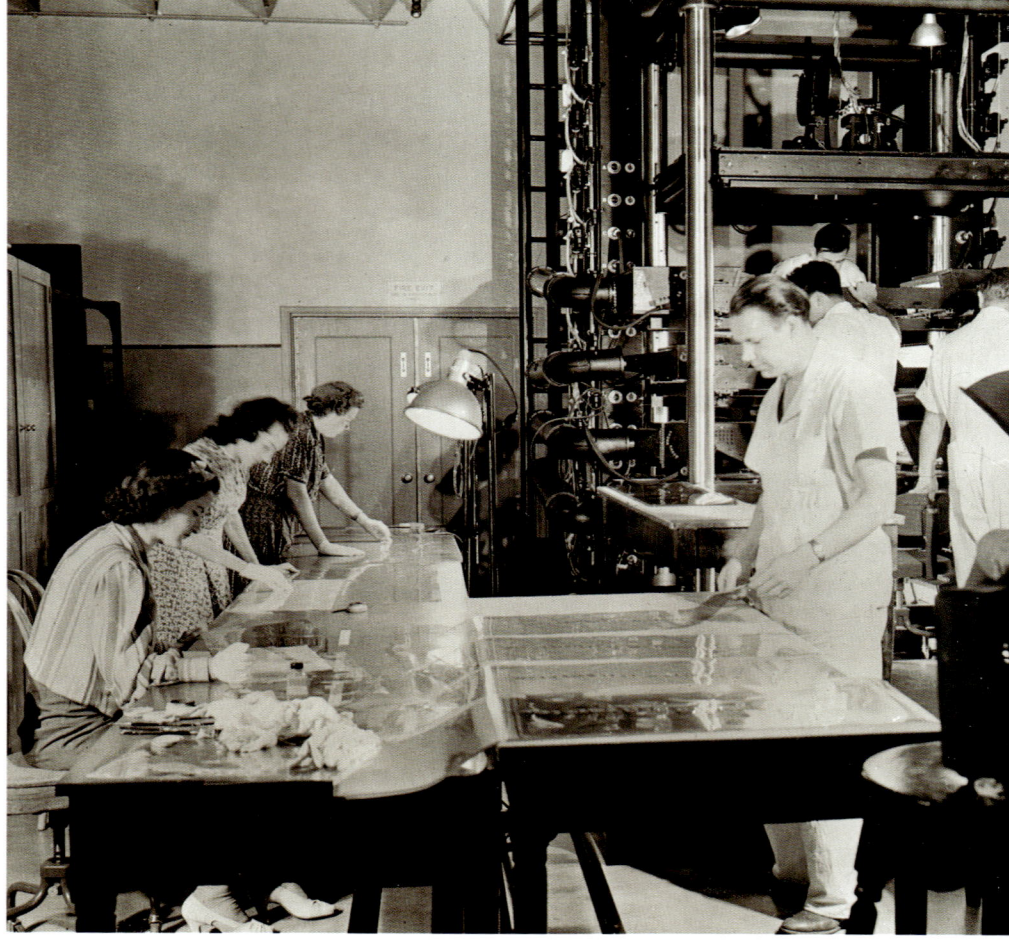

this whole unit is photographed, the space between the levels gives the same realistic effect to the scene that is, of an area of space between the player and the background."

This technical advancement was a time-consuming effect. A typical day's work with a standard, single-plane camera netted about 50 feet of film or approximately 1,200 pictures, yet with the multiplane camera, the same day's work netted about 10 feet of film or 240 pictures. Despite the costs, the results were visually staggering.

Several challenges with the multiplane camera directly related to Ink & Paint quickly became apparent. To achieve the camera's dimension via trucks and zooms, finding a sufficient light source was resolved with a combination of positionable lights and mirrors. But with this volume of reflective light, heat became problematic when it caused cels to curl up and paint to peel. To combat this issue, an internal cooling system was developed and installed. Further problems developed with flattening cels. Finally, a combination of compressed air pressure and a special type of glass proved fairly successful. Lines and aberrations developed across the backgrounds, and it was discovered that the direction in which certain types of cels were trimmed and cut from the block of celluloid resulted in lines. Once the cels were turned at right angles, tiny cut marks appeared as the light hit them. Thus cels had to be created at certain angles to avoid these aberrations. Layers of backgrounds and overlays were painted on plate glass in oil paints, and matching colors across various depths was achieved by adjusting the exposure and light across the multiple levels.

The realism and vitality now possible through Walt's latest technical advance provided a more realistic illusion of depth than in any previous system of photography to that point. These advances, debuted within the simple, eloquent short *The Old Mill*, garnered the studio an Academy Award for technical achievement and signaled the advent of a new level of sophistication necessary for feature length animation.

INTO PRODUCTION

Over three hundred staff members populated Disney Studios by early 1936 when *Snow White and the Seven Dwarfs* officially went into production, and by 1937, the size had doubled! A studio write-up noted, "Walt was beginning to be just a little irritated because there were too many people walking around that he couldn't call by name." New structures were introduced throughout the studio with even more defined production units in place.

Overseeing all production records and specific script details on *Snow White* was Production Secretary Bea Selck. In addition to her script supervisory and production duties on Disney's first feature-length animated film, Selck also held direct supervision over all the secretaries within the various directorial units throughout the studio. There were ten production secretaries at the studio, each assigned to a different director's unit. The equivalent to live-action Script Supervisors, the Unit Secretaries took notes during story conferences, often requiring—as a studio write-up acknowledged—"a sort of 'sixth sense' and a feeling for the sequence and story, knowing instinctively just what should be captured in written form—and what might possibly be recalled a few months later."

Throughout the course of production, Selck routed all information that went to the various departments—for example, notifying a Layout Artist or musician if a change had been made to the script or scene.

Ink & Paint | 131

Page 130, left: A studio stenographer taking notes in a story meeting at Walt Disney's Hyperion studio.

Right: Inkers and Painters touch up cels for the multiplane camera while in production, circa late 1930s.

This page: Diagram of the multiplane camera developed at Walt Disney Studios.

THE MULTIPLANE CAMERA

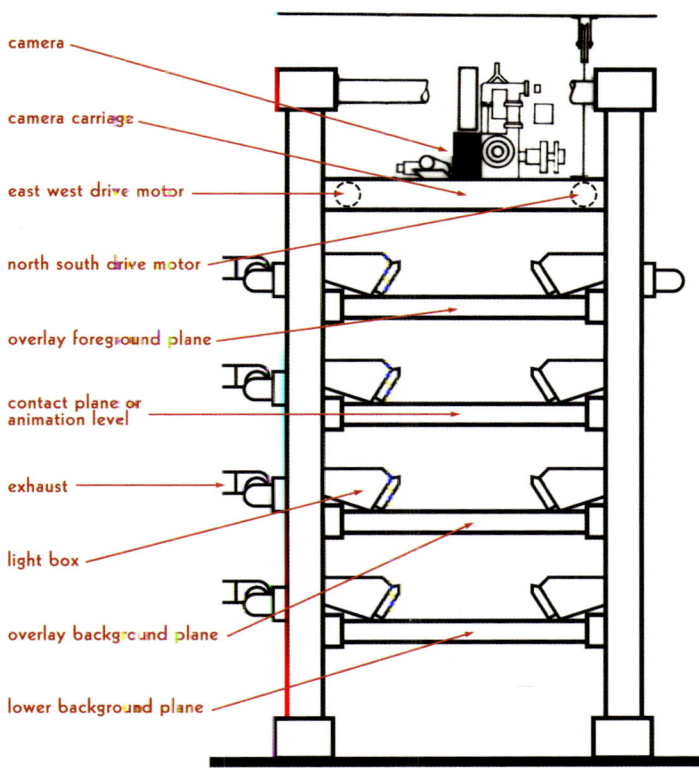

- camera
- camera carriage
- east west drive motor
- north south drive motor
- overlay foreground plane
- contact plane or animation level
- exhaust
- light box
- overlay background plane
- lower background plane

To ensure clear communication and continuity, Walt hired highly skilled Stenographers and assigned them to various departments to document all discussions, ideas, and creative developments in his production meetings. Stenographer/Stenotypist Esther Newell was added early on to the *Snow White* unit. Newell's role placed her in the meeting rooms as the eyes and ears documenting every comment and state of progress updates for the production of *Snow White*. Often the only woman in the room, Newell sat to the side with her precision stenotype (similar to that used by a court reporter), as the story meetings and sweatbox sessions proceeded. After extensive training to master the speed and accuracy necessary to record real-time conversations and notations, Newell became part of a pool of five women—stenotypists and "pencil people" or stenographers—that were on call at any time for any meetings. A studio write-up aptly described the role: "Taking notes at a story conference calls for psychic powers on the part of the secretary. When creative minds start popping thoughts back and forth, it's a case of get it now, or it's gone!"

Occasionally, misinterpretations occurred, as young Stenotypist Mary Campbell "Cam" Harding discovered. At a particular conference, Walt and the team of writers were exploring dialogue suggestions for a scenario with a bellboy character being unmercifully berated for making too many blunders in the line of duty. Ever the storyteller, Walt realistically addressed his team with a few suggestions: "You're fired! You've botched up things for the last time. Now, you're through!" In the middle of this demonstration, Harding entered quietly through the door. Upon hearing Walt's exclamations, Harding responded with a meek "Excuse me" and darted out the door. Animator Harry

NELBERT CHOUINARD

With a treatment under way on *Snow White*, Walt knew his artists needed to improve their skills to achieve the level of artistry he envisioned. But the increasing costs of the shorts in the Silly Symphony series kept a tight lid on the budget for training. Animator Marc Davis recalled Walt's earliest challenge: "He needed artists that could draw better than the guys he had. So he went down to [the] Otis Art Institute. He said, 'Look, I don't have the money now, but could I send down some of my men, like one night a week, for drawing lessons? I'll pay you when I can.'

"Otis turned him down," Davis related. "He went to Mr. [Edward A. 'Tink'] Adams. Mr. Adams was the head of a school that eventually became the Art Center [College of Design]. Adams turned him down. He went to Mrs. [Nelbert] Chouinard eventually, and she said, 'Mr. Disney, I admire very much what you do. You send your fellows down, and we'll worry about that when the time comes.'"

Born Nelbert Murphy, Chouinard was a stalwart Irish woman hailing from Montevideo, Minnesota, who had followed her passion for art with study at the Pratt Institute in New York. Following the tragic loss of her young husband, Horace, Chouinard made her way to Southern California, where she taught art at various schools, including Hollywood High School and the Otis Art Institute. In 1921 she started the Chouinard Art Institute. An early academic catalog explained Chouinard's mission: "The Chouinard art school was created to meet the necessity for an institution which should contribute basically to the development of our national art." Even at the height of the Depression, she managed to fund and construct a main building and campus setting on Grand View Street in Los Angeles.

Disney's artists made their way—often with Walt driving—to the Chouinard Art Institute for weekly classes in life drawing and the human form. As the studio grew in size and numbers, classes moved to the Disney lot and became a regular part of studio life. For classes in the soundstage, models were sent from the Southern California Models Club, a network of art school models run by Doris Harmon. A former model, Harmon often posed for the Disney artists or sent a select few, including Sandra Stark and Adrienne le Clerc, a twenty-two-year-old actress. "It was amazing to watch the reaction of artists and students," noted le Clerc, who later married Disney artist Bill Tytla. "They are completely indifferent when they walk into a studio and see a nude model. But as soon as she is in her clothes they become self-conscious, embarrassed, don't know what to say, and are afraid to look at her."

Page 132: Final production cel of the evil Queen from *Snow White and the Seven Dwarfs* (1938).

Final production cel featuring the corresponding windowpane overlay of the evil Queen cel (opposite).

Teitel (later Tytle) chased Harding halfway down the hall, calling her back so Walt and the staff could offer a complete explanation.

From Walt's 1936 story meeting notes discussing a dream sequence that was later excised from the film, it's clear he was aware of his audience. "I feel this sequence would be for the women," he said. "After all, 80 percent of our audience are women. If we get something they loved, it would help because there is a lot of slapstick stuff that women don't like so well. If your characters are cute, they'll like them. We don't cater to the child but to the child in the adult. What we all imagined as kids is what we'd like to see pictured."

When not documenting a story meeting, sweatbox sessions, or one of Don Graham's classes, the Stenographers were back at their desks, transcribing meeting notes or typing something for the front office. Walt would send down everything for transcription, from notes written on paper napkins to Dictaphone cylinders; there was always something to type up. This group of women often worked late into the evenings as they transcribed and typed out the extensive story-meeting notes. Once completed, the vital notes were handed over to the Mimeograph or "Ditto" Department for reproduction overnight and then distributed to the desks of participating artists by traffic boys early in the morning before their day began.

Stepping into the unknown in attempting to complete *Snow White and the Seven Dwarfs* by the year 1938, the Production Control Department scrambled to arrange a more efficient flow to the organization. With no further space available for construction, the studio began expanding into local apartment houses next to the Hyperion studio. Various departments set up shop in these units—right alongside the kitchen sinks, bathrooms, and pantry closets. Dorothy Ann Blank and the Story Department settled into their new home in these apartment units. Stenographer Jean Lowry was added to the Story Department, and Cam Harding was added to the Shorts Department.

A LARGER FIELD

With a wide cast of characters and a broad range of scenic locations, a new scope to convey the world of *Snow White* became necessary. With the existing field size the artists worked within, the number of characters appearing on-screen in a feature film would need to be drawn on such a tiny scale that detail would be impossible to render and ultimately lost. To meet this need, a "six and a half" field size became necessary, increasing drawing sizes by 20 percent.

To introduce this larger size, a complete and costly redesign, construction, and installation of animation boards, checking boards, inking and painting boards, sliding-cel boards, animation paper, and celluloid trim sizes became necessary. Even the camera systems needed to be adapted to shoot this upgraded field size. "Drawing was now a bit easier because the figures could be made larger," noted Animator Bill Justice.

Convincing various suppliers to accommodate this field size presented a number of challenges. In late August 1936, a studio staffer explained Walt's vision to their nitrate cel supplier: "We are at the present time pioneering and actually have in production a feature-length animation cartoon. We are definitely going to use on this feature a field size of $12\frac{1}{2} \times 15\frac{1}{2}$ instead of the present size field used on short product, which is $10 \times 12\frac{1}{2}$. We are building our organization to produce one of these features each year. We also intend to continue production of as many short subjects as possible. Now, when you consider that . . . this feature will be at least 6,000 feet long and that it will take an average of at least two pieces of celluloid to a frame of film, and that there are sixteen frames in a foot of film, you can readily figure that production would require 192,000 pieces." An earnest estimate.

With a well-established animation market, the supplier's sizing had been standardized for years, so accepting this request took some convincing. Cautiously recognizing a voluminous opportunity, the supplier offered a trimming solutions and a slightly thicker gauge of celluloid sheeting to work from.

VOICE, REFERENCE & MOVEMENT

Finding the right voice for Walt's first feature heroine represented quite a challenge. "I had one of the boys searching for voices," Walt recalled. Seeking a different quality, "away from everyday," Walt added, "we wanted someone who could sing too, because we were going to use a lot of songs." Unlike the shorts, Snow White would require a natural, ageless voice with the right blend of universal friendliness and innocence.

To audition his lead voice candidates, Walt developed a new approach, which later became an industry standard. "I didn't want to be thrown by looking at the person, because I only wanted their voice." Working with his talent scout, Walt

 Adriana Caselotti, the voice of Snow White.

Page 135: Final color model example (left) of the Seven Dwarfs, held by Painting Supervisor Grace Christianson (right), from the animated feature film *Snow White and the Seven Dwarfs* (1937).

explained his audition method: "The soundstage was right next to my office. We had a microphone there[,] and in my office, I had a big speaker. The person who was coming in to audition didn't know that I was listening. They were doing a little test in a microphone that let them relax.

"[The talent scout would then] call me, I'd leave whatever meeting I was in, I'd come into my office, turn on my speaker, and then this voice would come. And he'd pick up the phone and he'd say, 'What-d-ya think?'"

Over 150 young women auditioned for the role. Identified by only a number, each candidate sang and spoke while Walt listened via his speaker system. Auditions continued as production continued, until one day, the talent scout came in with a particular voice. "I listened to it and I said, that's perfect!" Walt declared. "I said, she sounds to me like a fourteen-year-old girl, but she was eighteen. But it was 'it.'"

The role of a lifetime went to young Adriana Caselotti, the daughter of a renowned vocal coach in town. Speaking and singing in a delicate upper range for Snow White was no easy task. "It's not my normal voice," Caselotti later admitted. "I had to push it up, to get that never-never land quality Mr. Disney was looking for." The lead role of a feature-length animated film surprisingly required only a few days of vocal work for young Caselotti. "All the dialogue and musical portions were done in a rather short period of time," she said. "Then there was a little dubbing to do after the animation was finished. But I always felt very much a part of the Disney family."

With dialogue recording and animation in progress, the Animators often required a visual reference for movement ideas. "The animation wasn't living up to what I wanted," Walt realized. "I had the problem of drawing a girl. It was quite a problem. You can make a good drawing of a girl, but to get all the shadings and all the things—the little arch of the nose and different things like that, and make it move and turn, and keep it simple enough that it can be duplicated—we went through quite a bit of experimenting to do that. I had to have something besides the artist's imagination. The artists sometimes can be bad actors and their timing can be wrong, so I decided to use models."

Story Department lead Dorothy Ann Blank served as the visual inspiration and reference for the evil Queen. Stage star Lucille La Verne provided the voice for both the evil Queen and Witch character, creating very different voices for each role. For the early shorts, the Inking & Painting Department had provided dozens of possible reference models, but to believably animate the young heroine of a feature-length story, it quickly became clear that a model with poise and a professional sense of movement would be required.

"I had to have a model," Walt recalled. "[Caselotti] wasn't a good enough actress to model, so I tried to find a girl to do the modeling for me that could add—could 'plus' things—that could pick up ideas that we wanted for the gestures and the movements and all of that. We found a little girl in a dancing school."

It was Marjorie Belcher Champion, the daughter of Hollywood's leading dance instructor, Ernest Belcher. She received the call to pose for the studio. "[Champion] was teaching with her father, so she came out and did what we call the pantomime for us on *Snow White*," Disney remembered.

"Hollywood was a pretty racy place, even in those days," said Champion. "My father would have never let me work anywhere because I was a young girl, but because he knew Mr. Disney, my father knew that I would be looked after."

Through improvisation and dance, Champion's movements served as a reference for the Animators throughout the production of the film. "They would often say, 'Well, now run through the forest the way you would see it,'" Champion recalled. "They had a clothesline lined up, and they had a bunch of ropes hanging from the clothesline, which represented the trees and branches that I had to push aside. But my action—that just came out of instinct, because I was not a trained actress."

With Champion's reference, the animation could begin. "[We] photographed her and let that be a guide for the artists," noted Walt. "They don't trace that, but they do get their timing, their movement, the flow of the dress, the gown—they get their inspiration from it." Betty Kimball provided fill-in live-action reference for Snow White if "Margie-Bell," as the Animators called her, wasn't available.

Despite overall staff growth, with over three challenging years of exploring story and character development from 1934 to 1937, the amount of artwork coming into the Ink & Paint Department decreased. "They laid off a lot of Inkers and Painters because the feature was starting and they kind of cut down on their shorts," recalled Kimball. "I remember I was laid off for a short while and then I went back and the Animators were all doing tests for the feature." After a lengthy ramp-up, the actual production of *Snow White and the Seven Dwarfs* was crammed into just over ten months. Studio staff grew to over a thousand, with a marked increase in the Inking & Painting Department.

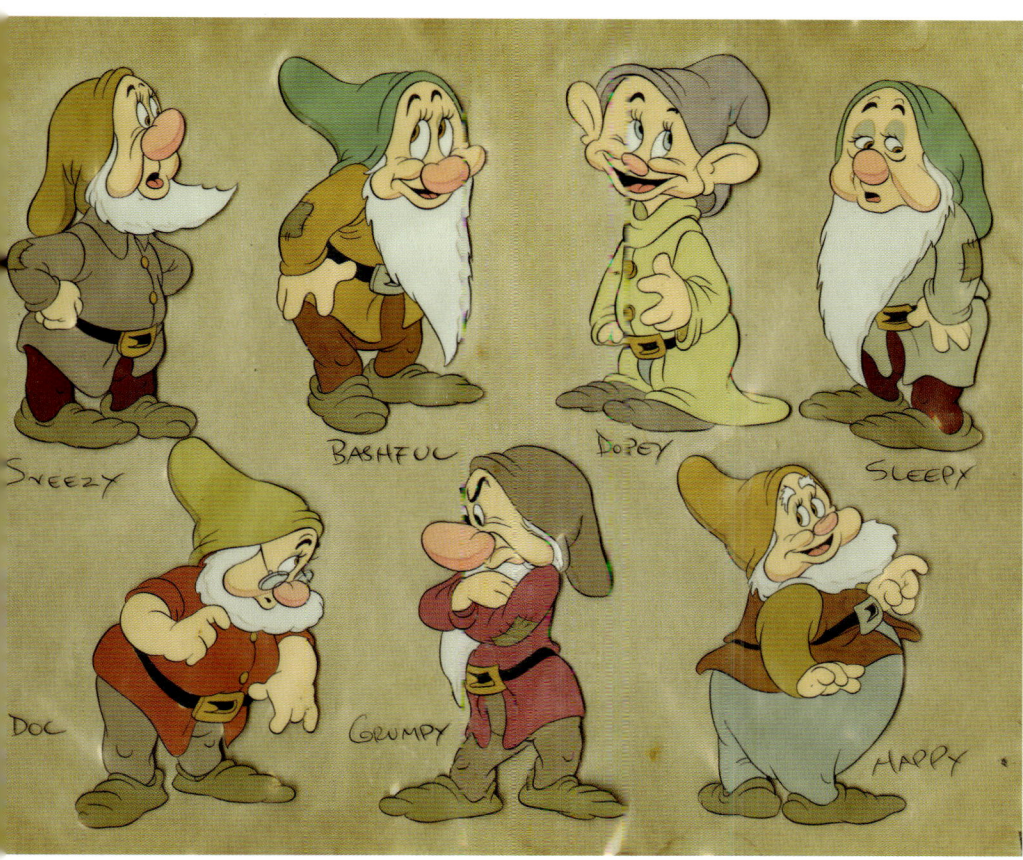

COLOR & STORY

Since the success of *Flowers and Trees*, the impact of color held a particular interest to Walt Disney. A vivid spectrum served a realistic function in many of the character shorts. But with a feature film, an ambitious use of color would advance his narrative. Speaking to his story teams about a particular Harman-Ising short he had recently seen, Walt noted, "They got colors everywhere and it looks cheap. A lot of people think that's what a cartoon should have. I think we are trying to achieve something different here." Walt and his teams quickly realized that the treatment of color in a nine-reel feature film would need to be completely different from the shorts. As Bill Garity recalled, "The bright hues of the short subjects were taboo. The audience might suffer eyestrain looking at such colors for an hour and a half. We had to select soft hues that were restful on the eyes and that harmonized with each other." Thus, *Snow White and the Seven Dwarfs* took on a sophisticated palette of subdued and subtle tones.

For a feature film, which offered a wider range of emotions, a wider palette of colors would help to build emotional reactions. Color would now be used to support story points, expand narrative, advance plot, and explain characters without the audience being conscious of it. Color could also assist in defining the identity of key props and forms within the narrative. As Disney artist John Hench later noted, "The shiny red apple given to Snow White by the wicked Witch is clearly identified by its color and form, and is an essential element in the story." From the 435 colors previously utilized, in 1936, the palette tripled to 1,500 paint shades as tests proceeded over many months to determine the final hues for the characters and backgrounds before production commenced.

Early color explorations and filter tests were conducted for the Technicolor process. Various combinations of color were created to explore the overall palette of the characters against the backgrounds. Set within limited animation, these tests were made to see how the colors reacted when filtered through the Technicolor printing process and how they would work with various combinations. Alternate color options and filter tests were being explored for each of the characters even as late as August 1937, less than four months before *Snow White and the Seven Dwarfs* was to premiere at the Carthay Circle Theatre.

In a December 1, 1936, story meeting, Walt expressed his views on the cinematic use of color: "We are not going after the comic supplements color. We have to strive for a certain depth and realism. . . . Inside the [Dwarfs'] house I see a very rich effect gotten by throwing the distance in shadows and subduing a lot of the background colors."

This realistic approach was also applied to the characters. Originally, the Dwarfs were colored with light-pinkish jerseys, but Painting Supervisor Dot Smith reasoned that a group of men living in the forest would logically sport darker tones. As a studio write-up detailed:

> Doc and Grumpy, the two most dominant characters among the dwarfs, wear a russet colored jerkin and a dull magenta one[,] respectively, in contrast to the gray and tan garments of the others. Doc wears the warm russet shade because he is a cheery individual, while the magenta definitely brands Grumpy as an irritable "wet blanket." Dopey, the slightly nit-wit [*sic*] member of the little band, wears a 'dopey' color scheme of saffron yellow doublet and grayed lavender cap.

As the featured star, Snow White was defined in lighter color values to allow her to stand out against the backgrounds and other characters. Separate colored ink lines were applied to define Snow White's eyelids, pupils, the eye itself, and her mouth as well, with some cels requiring up to twelve colors of ink. In an effort to bring further believability to his first feature-length

heroine, Walt insisted on finding more ways to expand her dimensionality. A more painterly approach was necessary for every aspect of this film, and the ladies of Ink & Paint met the call by adding elements to give Snow White further depth and visual substance to her form.

Unsatisfied with the flat, two-dimensional shape of the young heroine's raven hair, Painters instituted soft highlights to define her locks with a subtly lighter shade. To add definition to Snow White's face, Walt sought a way to add a believable blush to her cheeks. "We tried everything: airbrush, drybrush, even lipstick and rouge," recalled Ruthie Tompson, "which is probably why that legend started, but none of it worked." What grew into a charming publicity story of the feminine forces of Ink & Paint applying makeup to the cheeks of Snow White was, in actuality, an entirely different process. Exhausting every possible approach, the final answer was discovered in the summer of 1937 in the studio's newly established Paint Lab.

"HER CHEEKS AS ROSY . . ."

In July 1937, Mary Weiser of the Paint Department consulted with the National Bureau of Standards, seeking insights into working with transparent stains and dyes. When writing to a potential supplier, Weiser stated that her motives were to "[obtain] various decorative effects on the celluloids that we use in the making of our cartoons, [so] we are constantly experimenting in an effort to find new products and developments." On August 9, 1937, the solution was discovered: the shade of paint for Snow White's skin was applied as usual to the back of the cel, and then a light application of a transparent stain solution was strategically applied on the front of the cel. The stain absorbed into the porous plastic surface, giving the appearance of a gentle rouge-like blend. Red and orange dye combined with the powdered pigments of the Paint Lab to form the proper shade of pink. Carefully placed dots of this concentrated solution dissolved into a soft glow with no discernible edges, providing natural warmth to Snow White's cheeks.

To maintain this glow on Snow White's face consistently across hundreds of cels, this delicate solution required an exacting application to the front of the cels across the action of each scene. Essentially, the women were animating the color. Cotton dipped in a jar and applied at the end of charcoal sticks served as a swab to apply the solution. But the key was to know exactly how and where to apply the rouge-like effect. According to Ruthie Tompson, "Putting that rouge [solution] on, [well,] there weren't very many people that did it. We had one girl, her name was Helen Ogger. . . . She was an Inker, but she was the one. . . . Several of them tried to do the blush on the cheeks, and a couple of them were pretty good, but Helen was the outstanding one that did Snow White, and she did 'em on the close-ups on the Dwarfs and stuff like that."

Grace Godino added, "When they started it, the women knew how to do it because they knew where they put the rouge on their own faces. I remember doing it, but it took a little time."

This unique approach, or "the blend," was one of a number of advancements created within Ink & Paint. Weiser, the Painter who initiated the studio's original Paint Lab, developed and patented this as "a method to add depth and texture effects in animated cartoons." While rounding out facial features, such as the Dwarfs' noses, this technique was also utilized to give dimension or "depth of tone" to any number of forms. Either applied directly on the originally painted cel or on a separate registered overlay cel, the effect utilized opaque paints (slightly lighter or darker, based on the dimensional effect desired) applied in shade lines or washes with a brush, sponge, or tool in a stipple-like manner. This additional layer of shading also yielded a dimensional, fur-like appearance for various animal characters.

In a second patent, Weiser devised a tool to achieve The Blend. Essentially a waxy pencil, Weiser's patented device could produce smooth, uniform lines or an irregular blending, which resulted in pastel effects, feathering textures, stippling, and the staining effect that achieved the roundness and depth of Snow White's cheeks. The studio's Machine Shop created a metal mold to cast the various colored blend sticks created by the studio's Paint Lab team. The Blend was expanded and utilized by background and story artists. These techniques and tools heightened the level of artistry that Walt sought for his first animated feature film.

MAKEUP MYTHS

The looming mystique of the Ink & Paint Department perpetuated misinterpretations of the artistic work accomplished within its realm. Certain myths deepened when newspapers and magazines sought stories on *Snow White and the Seven Dwarfs*. Rather than delving into the artistry and color animation techniques developed by the artists of Inking & Painting, studio publicity teams fostered the simple yet charming story of: "applying real rouge and other assorted make-up [sic] directly to the cel. Walt conceded that it looked great but was concerned that they know exactly where to put it on each drawing."

Allaying his concerns regarding their feminine expertise in makeup application, one of the Inkers was purported to have replied, "Mr. Disney, what do you think we've been doing all our lives?" Perhaps it was intended as a cleverly cloaked admission of the women's animation skills, but sadly, this simplified story of the patented techniques and extensive methods these women achieved in animating color and expanding the artistry of *Snow White and the Seven Dwarfs* was naively perpetuated for decades.

FAIRY-TALE TEXTURES & TONES

The subtle detail applied with The Blend technique continued with the textures of the clothing as well. Walt was determined the characters' clothing would not be portrayed with flat colors. Again, Mary Weiser and her Paint Lab team refined paints for various effects such as a linen quality for Snow White's skirt and a woven sense for the Dwarfs' clothing. The Queen's collar was given a satin texture, while a velvet effect was added for her robe. The form of the evil Queen in *Snow White* was strongly influenced by the "ageless ice goddess" from Merian C. Cooper's 1935 film, *She*. The Queen was one of the more complex characters in the film. "They had just a few Queen Painters," recalled Frances Arriloa, a Painter with Harman-Ising Studios who was temporarily brought on to help complete *Snow White*.

Ink & Paint | **137**

Top, left: Final production cel of Snow White.

Top, right: Test cel exploring eyelash detail of Snow White, created by Inking Supervisor Margaret Trindade.

Bottom: Final production cel of Snow White and the wicked Witch.

138 | The Fairest One of All

The warm, vibrant colors of Snow White provided a sharp contrast to the wicked Queen's darker tones of unhealthy greens, blues, and blacks—the colors of decay. Defining the right tones for the pale Witch's face required a combination of mostly yellows grayed with a little violet and orange-red. According to lab notes, a rose color was mixed and first tried on the Witch, but it was considered too blue for the Witch's nose and later worked beautifully on the apple. "Cerise" was the color finally developed for the Witch's nose, which was essentially a "straight red with about one-eighth carmine."

Transparent paints were developed through exhaustive experimentation. Artist Mary Ellison and her corridor of Inkers re-inked several passes to achieve the precise movement of soapy bubbles when Dopey swallows the bar of soap. The paint was created with a weaker solution of the shadow paint, with diluted blue and green dye added for coloring. To create a dramatic difference from standard soap bubbles for the Queen's poisoned brew, three varying shades of blue-green, bright green, and yellow-green were used, giving a sinister quality to the transformative drink. Developing these transparent colors required a good deal of straining and refrigeration to maintain their translucent qualities.

"I learned how to paint with transparent paint, and I liked doing that," recalled Wilma Baker. "It was just called 'solution.' It looked like a milky gray, beigey liquid that they added paint color to. The main thing was about applying the paint consistently so they would match and it would look the same from one cel to the other." Utilized in place of double exposures, the transparent paint was also effective for various effects such as rain or water. As Baker explained, "We used it on splashes of water where they would paint on the edge in an opaque color, and then the middle part would be transparent paint, and [together] it would look like water."

The level of dedication demonstrated by the women of Ink & Paint might be best exemplified in the efforts of the Shadow Department. Building even further detail and belief into this feature effort, shadows were everywhere—cast from the brilliance of the sun to the dim illumination of candlelight. Special teams of Animators and Painters, including Betty Miskimen Walin, Muriel Gibbs, and Grace Godino, charted the lighting effects with intricate accuracy, plotting each shadow as realistically as possible to actual direction. When the Huntsman bends over Snow White to kill her, the shadow had to be cast precisely at the hour of three o'clock in the afternoon—the exact sort of detail that one shouldn't notice, but certainly would if it weren't precise.

"LIGHTS BURN AT DISNEY STUDIO"

The extensive details instituted within each scene came with a time- and labor-intensive cost. In the earliest days of production on *Snow White*, from one hundred to five hundred jars of paint were filled each day in the tiny Paint Lab. This number increased dramatically as production progressed. With the release date looming, the studio announced another staff increase, adding thirty-five girls to the Inking & Painting Department, as well as additional staff to the Background, Camera, and even the Cel Washing departments. This round of hiring marked the beginning of some of the longest careers in Disney animation. Betty Anne Guenther, Edna Smith, and Ann Lloyd arrived as Inkers and began their forty-plus-year careers with the studio.

"When the work got going real good on *Snow White*, it was really like a college campus," remembered Betty Kimball. "That was the period when all the romances started and the guys and the girls got together at dinner after work. You'd have a brief dinner across the street and then you would work until ten o'clock, and then you'd go to the Tam O'Shanter [a local Disney favorite restaurant] and gripe about what was wrong with the work. There were a lot of marriages during the *Snow White* time because the Inking & Painting Department kind of mingled with the rest of the place."

Nell Nevious and her roommates, Rae Medby and Claudia Sewell, worked with Inker Mary Ellison. The whole team worked on the Grumpy soap-scrubbing scene in the stultifying heat of summer. "It was particularly hot, and the cels stuck to my arms. So they made us redo all the bubbles," Ellison wrote. Between the heat and the need to redo such a detailed sequence, the artist's frustration was clear: "I'm *not* drawing bubbles!" With paints failing to dry in the heat, various dryers were brought in to eliminate the sticky paint issues, but they only created new problems with dust and debris on the cels.

In mid-August 1937, the headline "Lights Burn at Disney

Page 138, left: Final frame featuring detail from the Shadow Department heightening the dramatic effect of the looming huntsman.

Right: Final frame of Dopey spouting bubbles in the hand-washing sequence from *Snow White and the Seven Dwarfs* (1937).

This page: Color model sheet exploring the various tones and detail defining the evil Queen.

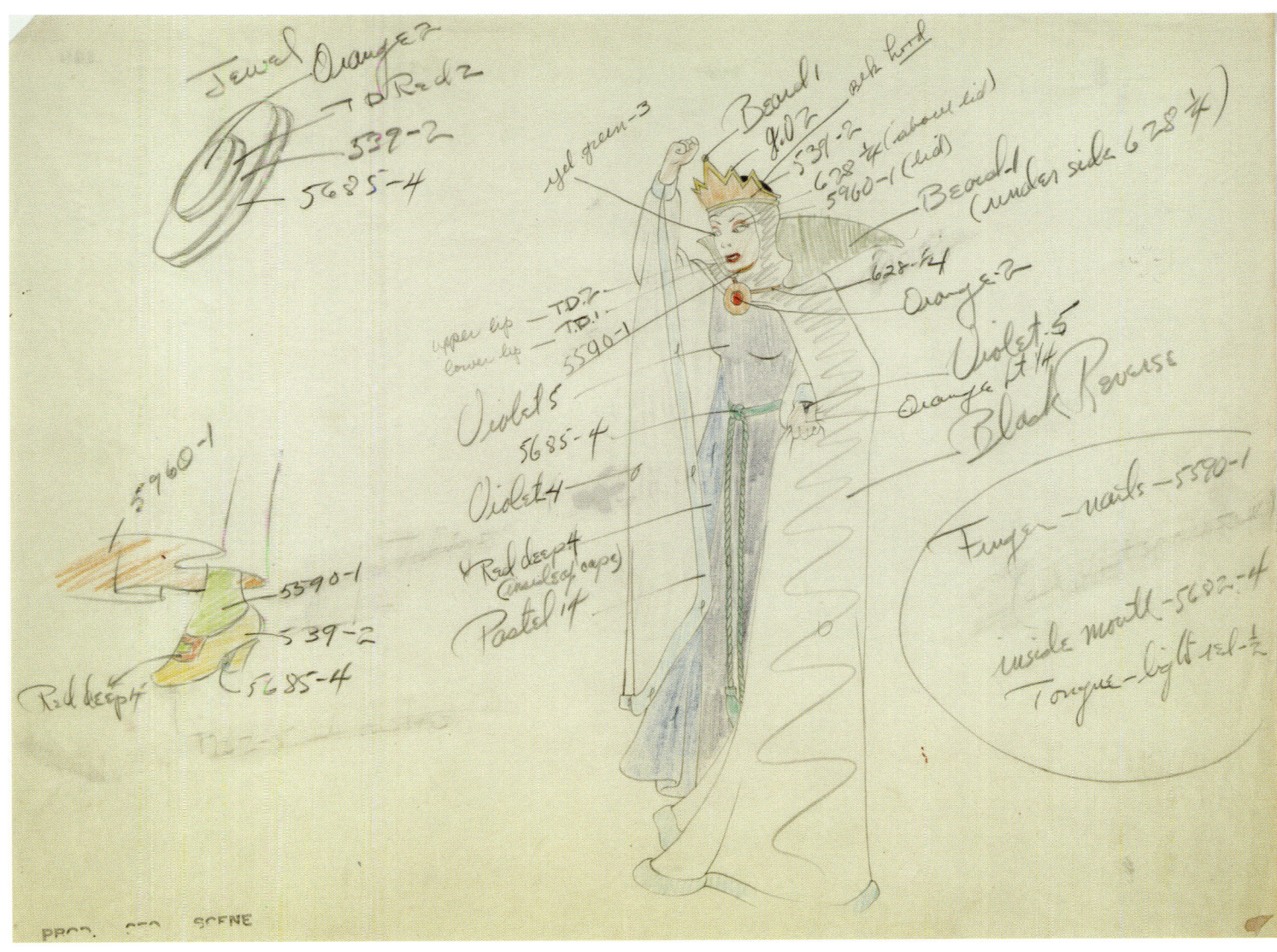

Studio" was printed in *The Bulletin*. The article read, "All employees will work Tuesday and Thursday nights from seven until ten o'clock." For the first time in the history of the Disney Studios, mandatory overtime measures were deemed necessary, though other studios frequently faced such problems.

"When I worked in production on *Snow White*," recalled Painter Wilma Baker, "it was really hectic because we were working overtime and I had never worked forty hours at a straight row, so it was tiring and I'd get headaches. I don't remember my back pain too much, but your shoulders, when you're leaning, everything strains." Grace Godino remembered, "We all knew that we were doing something that was special. You couldn't help but feel exhilarated working in all phases of *Snow White*. I remember one time sitting with a gal, we each got the whole set of Dwarfs doing something kind of fantastic and it was in the same scene, so we decided we'd have a race to see who could finish it [first].

"I forget what the bet was—buy lunch or something—but it was such fun because the Supervisors would go by and they'd see us working like mad painting these things," Godino continued. "We had paints set in a row[,] so I figured out the way that I could beat her[,] because she was doing the whole thing in order, and I took one color for the one Dwarf and finished one at a time and had all the colors right ready. I was going much faster than her all the way along, so I won the prize. . . . Of course, the Supervisors were thrilled." Godino also began

a long side-career as a voice artist. "They had me do the cackle of the old Witch. That was a wild cackle. Because the lady that was playing it didn't record her voice as loud as mine, so they used my cackle."

Production pressures continued right up to the last minute. "I was put on as a Paint Supervisor on the night shift," recalled Joan Orbison. "We worked all night, did two shifts." Up to 1,500 jars of paint a day were filled during the height of the production rush. "Everybody, the Painters, Inkers, everyone—they worked twenty-four hours," remembered Ruthie Tompson. "I was just doing the twelve-to-twelve [shift] on the finishing touches and that was quite a time."

Night work continued into the final months as the feature went into its third reel of color, and with the targeted deadline looming, additional inking and painting on *Snow White and the Seven Dwarfs* was farmed out to other studios when the production fell behind schedule. Thirty "Inkers and/or Painters" were hired for a four-week minimum from Harman-Ising Productions to meet the end date. "At that time, Harman-Ising was being disbanded to start the animation studio at MGM," according to Frances Arriola, a young Painter in her first animation job. "All of the men upstairs were moving to MGM and the women that were left went over to Disney's *[sic]*. We worked from seven in the morning until seven at night and Saturdays and Sundays. It was a blur. When I would get home at night it was dark and when I left in the morning it was dark. I would just fall into bed and

...they fashioned a coffin of glass and gold, and kept eternal vigil at her side...

keep painting in my sleep. And yet . . . I had fun because I met friends I still have and we used to go tearing off during the noon hour. We went to a place where we could get a waffle real fast and then we had teatime and that's all the time we would have."

"It was a fast-pasted process," Wilma Baker said, "and the production was hard work, but in those days, you were grateful for work and we made it a lot of fun. It was a tight-knit group of gals working together." The "gals" managed to keep spirits up with a bit of fun by sending gag drawings and pulling silly pranks. "We sure had lots of fun though. We needed laffs [sic]!" wrote Ellison. "Especially at deadline time!"

Meeting departmental footage quotas wasn't the only pressure. "Walt was a tough boss, but he could be very fair," recalled Checker Dot Smith. "Even when he got mad, he'd get over it if he thought the person was doing their best. Once, we had a showing in [the] sweatbox, and one of the scenes with the Dwarfs was supposed to be in shadow, but some of them were dark and some were light. It was a mistake in painting. Walt got sore at me. He said, 'You fix that!' Well, next time I thought I fixed it, but it was wrong again. This time he didn't yell at me—he knew I felt it was wrong and would correct it. It always amazed me that even under the pressure of getting *Snow White* out, he managed to keep his cool. He just seemed to know it would all come out right in the end."

In the final months, teams worked round the clock to push the final painted cels through Inking & Painting. "The roughest time I can remember was working overtime on *Snow White*," Smith noted. "We had a day crew and a night crew in the Ink & Paint Department. They even had Assistant Animators and Inbetweeners painting cels. This went on for about three months." The production teams were in uncharted territory concerning the time and materials required to complete a feature-length animated film. In September 1937, statistician Katherine Carlson Evans was hired to track the necessary raw materials and overall progress of each scene. By October, Evans determined the celluloid requirements needed to complete *Snow White* had increased to approximately one thousand sheets per day. In a desperate letter to the supplier, Hazel Sewell wrote, "It looks like this will continue for about two months, after which, of course, our requirements will be reduced considerably. However, we must have celluloid and lots of it immediately." In early November, further correspondence to the vendor sought "the most perfect celluloid possible," imploring, "You can cry on their shoulders—or any other way to get this stuff to us out here—but get it here!"

Working with existing cels was possible but problematic, as overuse of the celluloid caused expansion of the registration holes, thereby causing faulty registration. Roy Disney later recalled a scene that suffered from this problem: "[It was] at the end of the picture where the Prince walks down the path to the coffin where Snow White is lying asleep . . . except that she could be brought back by Love's First Kiss. As he [the Prince] walked down the path, he was shimmying and shaking quite a bit due to faulty registration under the camera. Walt said, 'If I hadn't been so damn tight they could have bought fresh celluloid where the holes weren't big and that wouldn't have happened.'" Fresh celluloid was the solution, but reproduction would delay the film's completion by three weeks at a six-figure cost. Roy concluded, "Let him shimmy!"

"As the date for the premiere of *Snow White* grew closer, we were running out of money and time," recalled Ken Anderson. "Everyone was putting in overtime to get the picture finished." Late on November 27, 1937, three weeks from the premiere, the last of the film's cels passed through Ink & Paint. Once the film was down to Camera for finishing, Inkers and Painters Katherine Kerwin and Evie Sherwood were on standby through the last nights. Prepared with a good book, the girls would pass the evenings talking or curled up asleep in the women's lounge

Page 140, left: Inked production cel featuring titles from *Snow White and the Seven Dwarfs*. Various languages would be inked by the Ink & Paint artists.

Right: Cel setup of Snow White in her funeral bier, conveying the dramatic lighting effects achieved by the studio's Airbrush artists which included Susan Eaton.

This page: *Snow White and the Seven Dwarfs* premiere at the Carthay Circle Theatre, December 21, 1937.

while the Camera Operators worked through the night. Kerwin laughed, "The camera guys would come in and give us a shake [to wake us up] to fix any cels that might need repair."

PREVIEWS & PREMIERES

Snow White was deemed "Disney's Folly" by critics prior to its release because the idea of a feature-length animated film was unthinkable. Even Walt's own staff challenged the feasibility of such a departure for animated cartoons. Questions were raised as to whether watching color animation for more than two reels would be dangerous to the eye. "You should have heard the howls of warning," recalled Walt. "It was prophesied that nobody would sit through a cartoon an hour and a half long."

Betty Kimball added, "They'd call the girls in for show[ing] us test reels to see what the reaction was." Grace Godino was among the women who were first to see the rough cut of the film. "We had to sit on the floor of the big soundstage, and we only saw it in black-and-white," Godino recounted. "The thrill, the excitement of that entire group sitting on the floor and knowing that it was going to be a hit. It was so new; that was the excitement of the whole thing that was worth every bit of work that we had ever spent . . . the hours and the air-conditioning going off and all the problems.

"In fact, a couple of weeks or so we weren't even paid," Godino added. "Walt came around and apologized and asked if we'd wait to get our paychecks because he was running so close. And it was all worthwhile because it was so exciting. We went back working, singing."

A preview screening of *Snow White and the Seven Dwarfs* was set up in a local theater in Pomona, California. Watching with an unsuspecting audience, a Stenotypist sat upstairs—with another downstairs—to note when the laughs came and ended. Dispatching secretaries to preview screenings of Walt Disney's feature animated films later became standard practice. After documenting the audience's comments and reactions to *Snow White*, Eloise "Toby" Tobelmann and her stenographer colleague had a couple of drinks at a local pub, then dashed back to the studio early the next morning to type up their notes for Walt and the team to review when they came in.

In the end, roughly 362,000 cels were produced for the final film. Within nearly a year of actual production involving 43,922:35 total hours, the Inking & Painting Department created 1,500 shades of paint, constituting nearly eighty-five gallons of color—enough to fully paint twenty-two cozy five-room bungalows similar to those that dotted the region around the burgeoning studio. The equivalent of 1.3 feet of footage was inked per girl per day, while 1.1 feet of footage per girl per day were painted. A total of 750 artists—including a staff that swelled to 66 Inkers, 178 Painters, 32 Animators, as well as various Layout, Story, and Special Effects artists, plus 36 Background artists and 103 Assistants—combined their talents into shaping over one million drawings made during the production of the final film.

With the Technicolor print arriving at the theater just a few hours before showtime, *Snow White and the Seven Dwarfs* premiered Tuesday, December 21, 1937, at the famous Carthay Circle Theatre in Los Angeles. "It was a wonderful turnout," recalled Lillian

Disney of the star-studded premiere. "[Walt] was nervous—but he had great confidence in it."

The toast of Hollywood stepped out for the premiere. Charlie Chaplin, Marlene Dietrich, and even the tiny titan Shirley Temple made their way into the theater for one of the most pivotal events in the history of cinema. The future of Walt Disney Studios hung in the balance for the next eighty-three minutes—either wiping out the tiny studio or forever changing the course of history. "They cried," declared Marge Champion, who attended sequestered in the back balcony of the theater for fear someone would recognize her inspiring features. "A cartoon made a tough Hollywood audience cry. This had never happened before!"

Indeed, history had been made. As the final credits rolled, the names of two women in addition to the lead female voice talent notably appeared on the screen: Dorothy Ann Blank for Story Adaptation and Hazel Sewell for Art Direction. It was a rarity in Hollywood.

Animator Wolfgang "Woolie" Reitherman later recalled, "The audience was so taken by the magic of what they [had] seen that they applauded after individual sequences. Just as though they were watching a stage play. I've never seen anything quite like it since." To the world, history had been made. To Walt it marked a new beginning. "I ran into Walt at the studio the next morning," remembered Reitherman. "Instead of talking about how he could now take a little rest after all the tensions he'd gone through during the four years it took to make *Snow White*, he began talking about the next animated feature and how he wanted to get started right away and all the new things we were going to do at the studio. There was only one Walt Disney."

The women of Inking & Painting received a week's paid vacation between Christmas and New Years while *Snow White* debuted, but were "now back at the old grind," as Inker Rae Medby wrote in a letter. Perfecting Walt's vision, production continued for the women of Ink & Paint. "In our first day back we had to work till ten p.m. on a retake of *Snow White*," Medby noted. "The picture is showing—premiered at the Carthay & made a big hit—but it seems that we'll be doing retakes for years and years."

Marjorie Belcher-Champion (center) and friends dance the night away at Walt's Field Day in June 1938, at the Narconian Resort.

WALT'S FIELD DAY

With the worldwide success of *Snow White and the Seven Dwarfs*, Walt organized a first-class event for his growing studio. Intended to be an all-at-once celebration to alleviate the pressures, pent-up energies, and accomplishment of this landmark feat, "Walt's Field Day" instead turned into an infamous night of excess.

The event announcement—playfully disguised as a preliminary story outline—circulated around the studio: "TYPE OF STORY: Walt is playing host at an old fashioned [sic] picnic—field—strawberry festival—quilting party—or name it and you can have it, combined with an informal dinner and even more informal dance." Setting the narrative tone, the memo continued, "All situations are to include humor (both subtle and broad), excitement, but no pathos."

Invitations went out and enthusiasm mounted. Walt stated in the official invitation: "Believe it or not, this is a day dedicated to the forgetting of sweatboxes, animation footage, and celluloids. It is my sincere wish that you enjoy yourself to the utmost, and that you will find the day one of complete pleasure and relaxation.—Walt!"

Walt's Field Day was set as a weekend event at the Norconian, a resort hotel about an hour outside of Hollywood frequented by many stars and studio elite. Built in 1929 near Lake Norconian, this swanky destination featured a golf course, hiking trails, an airfield, diving and swimming pavilion, horseback riding, and first-class dining. With all these activities, the final notice issued to attendees stated: "The Field Day is a party for adults only—Please do not bring any children."

"That was quite a party," remembered Katherine Kerwin. "People went up Friday night and came back Monday morning . . . in some cases." Inker Mary Ellison recalled, "I asked Paul [Allen] to be my date [and] we had a lot of fun." Gallantly fixing a flat tire on their way to the event, Ellison's date later became her husband. Ruthie Tompson noted, "They had a big pool, and . . . we all played games that you played at picnics and stuff like that." Athletic contests, golf tournaments, and swimming relays filled the day, and as Wilma Baker observed after her evening departure, "I guess they had some nighttime activities, too."

Following a large sit-down dinner, dancing and other "activities" carried on deep into the night. "Ward Kimball had his Huggajeedy 8 [band there]," said Tompson; however, "by the end of the . . . evening, something snapped." A raucous dance contest evolved into a conga line and a frenzied round of a Big Apple ring dance continued through the night. Tompson added, "I got a little tipsy. I know that Amby Paliwoda fell into the pool, and he had to be taken up and put to bed after that." Stories of the events and activities at this legendary party have long floated around, as the combination of men, women, pent-up energies, and a moonless night made for quite an affair. "It was about daylight when I got home," laughed Kerwin. "Oh, that was really a great party!"

> **"***The celluloids are not the original paintings by Walt Disney himself, but from the skilled fingers of the artists in his studio.***"**
>
> **—Eleanor Jewett,** *Chicago Tribune*

Four completed Courvoisier cel setups featuring production cel pieces against custom backgrounds created by the Cel Setup teams.

COURVOISIER GALLERY

Audiences of all ages were enthralled with *Snow White and the Seven Dwarfs* as its worldwide success continued. Cartoons were no longer lowbrow filler amusements between feature films; they were now featured works of moving art. Fully recognizing the level of artistry accomplished to create each individual cel, Walt Disney declared when holding a cel setup, "This picture moved. It's true it only represents one frame of a motion picture film, but delicate and intricate though it is, it came to life."

It was the visual artistry of *Snow White* that captured the eye of Guthrie Courvoisier, a leading fine art dealer in San Francisco. Searching for a new medium to infuse into the world of art, Courvoisier was drawn by the individual cel work of the Inking & Painting Department, leading him to pursue an exclusive representation arrangement. After several months of negotiations, Courvoisier reached an agreement with Disney Studios on July 19, 1938.

Under the guidance of Guthrie Courvoisier, the Ink & Paint artistry of the Disney animation cels was placed with exclusive dealers in forty-nine cities around the world. Courvoisier stirred up demand from the general public, art collectors, dealers, and major museums, noting: "They write a new chapter in the history of art's conquest over the drastic exactions of the machine."

As the official studio press response to these celluloid pieces was quick to point out, "Mr. Disney explained that the pictures selected from *Snow White* were really not his own creation—that in all his productions, his staff of eight hundred artists contribute as much as he." The Metropolitan Museum of Art in New York City accepted this explanation, "with the rejoinder that it neither cared nor knew who actually painted the picture, that it was a Disney just the same."

With the success of the *Snow White* cels, a new set of behind-the-scenes Disney masterpieces was to be offered featuring later productions. Of the thirty thousand paintings on celluloid required to make *Ferdinand the Bull*, one thousand select cels were released as well as five hundred animation drawings. A. J. Philpott, the art critic for the *Boston Globe* declared, "The artists of the Middle Ages, like Raphael and [Peter Paul] Rubens,

HELEN NERBOVIG: CEL SETUPS

Helen Nerbovig, a young Painter who crafted cel setups for Walt to send out as gifts, worked in the Character Model Department. A talented artist, Nerbovig was placed in charge of the division to develop and oversee the program. "Walt wanted every piece to be reminiscent of the film," recalled Nerbovig. "I would look at the film and decide how each setup was to be made, and I'd make the first one. Then everyone would follow my pattern." Nerbovig and her crew of twenty artists from the Inking & Painting Department assembled and prepared the artwork as the newly formed Cel Setup Department.

From the nearly half a million cels inked, painted, and photographed to make *Snow White*, several thousand of the choicest cels were selected. Some cels were trimmed to their edges, while others remained in full cel form. Hand-painted shadow details were added for depth, and a special coating was added to the reverse (paint) side to seal off the artwork. "Because there are so many more cels than backgrounds in a film," Nerbovig continued, "we didn't have enough original backgrounds to work with, but it would have been inconceivable to send out art that wasn't a finished picture. So when we ran out of backgrounds, we made our own."

Various materials and patterns were utilized to create uniquely individual settings for each piece. Special papers, intricately cut stencils, and even hand-rubbed wood veneer served as creative backgrounds, with each character cutout placed into a matted vignette. Original cel overlays, airbrush, and special effects were also applied to set off the cel segments. "Animation art was new to people," Nerbovig explained. "They weren't used to looking through layers of cel, and we were afraid they would find it distracting. We decided to carefully cut out the characters and glue them onto the backgrounds."

The materials and labor for each cel preparation proved too costly for the studio, and when Courvoisier renewed the contract for later films, Roy Disney mandated the artwork be prepared for sale by Courvoisier's staff. This resulted in dramatic changes to the art presentations. "When the studio transferred the making of setups to Courvoisier, little of what we had done went along," Nerbovig remembered. "A couple of the girls went up to San Francisco to work with them and get them started, but we were part of the studio and had access to its resources, including our own paint, and they were pretty much on their own." Without the studio's expertise, the overall look and presentation changed. The cels were laminated to ensure the safety of the nitrate material and to prevent the paint from flaking off. To certify the authenticity, an "original WDP" monogram was created and rubber-stamped onto the lower right corner of each print.

Entrance to the Courvoisier Galleries in San Francisco.

employed a great many assistants who could paint like the master, but never before in the history of art were eight hundred employed in the same work in one vast atelier. It took a master to mold these eight hundred persons so that they saw, and felt, and worked as he did. That proves him one of the greatest art masters of all time."

Gallery showings and exhibitions declared this art to be "alive, vital, functional art of today." Comparing the artistry of Disney animation cels to that of vintage glass paintings, the exhibition write-up further defined details:

> Because these are the paintings actually seen on the screen, Disney is extremely critical of the perfection attained in this department. The lines . . . must have a freedom and flow equal to that of the Animators to be accepted. It is no extraordinary thing to see a series of drawings discarded because they are a hair's breadth out of true perfection. . . . It is nevertheless another reason why the Walt Disney films have an excellence all their own.

Twenty-two museums purchased original artwork, including the Metropolitan Museum of Art and the Museum of Modern Art (both in New York); the Phillips Memorial Gallery (now known as the Phillips Collection) in Washington, DC; and even the Honolulu Academy of Arts (now called the Honolulu Museum of Art), as well as a number of renowned galleries and collections around the world. After successfully selling the original 6,700 *Snow White and the Seven Dwarfs* cel setups, Courvoisier expanded by including story sketches, backgrounds, and animation drawings, noting, "These men are skilled in drawing people and animals in every possible position."

Walt Disney and his mother, Flora Disney.

Perhaps due to the late-1930s prefeminist mind-set, Courvoisier made no mention of the women behind the colorfully inked and painted masterpieces that dominated the sales and started the program. The gender of the artists behind the animation drawings was noted, while the female artists behind the color remained anonymous.

For nearly seven years the art sold quite well, but with postwar economic struggles, the Courvoisier program closed in 1946. "You know," reflected Helen Nerbovig, "when I look back on what we did, I think it's kind of remarkable. We loved Walt, and we loved our films. Each piece of art we made was an expression of that pride and admiration. It was very special."

> *"Those boys [Walt & Roy] would have done everything in the world for their parents."*
> —Ruth Disney

FAMILY LIFE: A DEVASTATING LOSS

The financial success of the Disney Studios opened the opportunity for Roy and Walt to support their beloved parents. Elias and Flora lived near their only daughter in Portland, Oregon, but the brothers sought to bring them to California. Ruth Disney recalled, "Roy and Walt said, 'We want the folks to come down here, where the weather is better, and where we can keep an eye on them and they can watch their grandchildren grow up.' So Walt and Roy brought them down to Los Angeles and bought them a very nice little house in the valley, close to where Roy lived."

Diane Disney Miller remembered of her father, "He always had a great sense of responsibility for his family. He and Roy, both. They always took care of their sister . . . and his parents. They were very thrilled to be able to buy this home for their parents and to set them so nicely." The support of his mother remained vital to Walt as he once noted, "She was very proud of Roy and me and what we'd done. She'd go places and say her name was Mrs. Disney and they'd ask if she was any relation of the Disney boys and she'd say, 'Oh yes. My sons.'"

Settled into their Southern California residence, there were frequent summer weekend afternoons together in 1938 for Flora, Elias and the four Disney brothers. "They were very close." Roy E. Disney noted, "Walt and Roy and Herb and his wife and Ray would all show up on Sunday, particularly during the summer, and they would have these vicious croquet games . . . The day would usually wind up with barbecue of hamburgers and corn. It was very Midwestern."

As the winter months approached, Flora and Elias were having problems with the furnace in their new home. Flora even wrote to her daughter Ruth, explaining her concerns with the heating system in their new home. Walt and Roy sent over studio repairmen to address the problem, but sadly, they were not versed in heating systems. "One night," said Walt's trusted biographer, Bob Thomas, "Flora was asphyxiated from the gas leak, and, if he hadn't been rescued by the housekeeper the next morning, Elias would have died, too."

As Walt's daughter Diane remembered, "One of the greatest and I think only real tragedies in Dad's life was when his mother was killed. The little house that they bought them—it was the fault of the gas—the heating in the house." The loss was devastating for the family and particularly Walt, as Diane noted, "Oh, he loved his parents, dearly loved them." Lillian's niece Marjorie remembered, "Flora's frightful death was heartbreaking to Walt and Roy." Elias survived, but the loss of his wife and the physical damages of the fumes took a toll. "He was just lost without her," said Walt. "I never felt so sorry for anybody in my life as I did for Dad. He was really a lost person."

The family took constant care of Elias in his later years, but the loss of Flora remained difficult. Many years later, Walt's daughter Sharon recalled, "One morning I drove Daddy to work. I remember driving down Sunset Boulevard and asking Daddy where his mother was buried. All he said was, 'She's in Forest Lawn. And I don't want to talk about it.' Tears came into his eyes. Nothing more was said."

FEATURE FILM EXPANSION

> *"The two years between* Snow White *and* Pinocchio *were years of confusion, swift expansion, reorganization."*
> — **Walt Disney**

The phenomenal success of *Snow White and the Seven Dwarfs* proved to Walt, and the world, that there was indeed a place for feature-length animation. Newspapers soon announced the Walt Disney Studios was set for releasing one animated feature film a year. To meet this ambitious slate, expansion and growth soon overtook every aspect of the tiny studio, starting with the physical property. Walls came down, corridors were extended, additions were made, and doorways opened up in every direction. An initial attempt to redesign the Hyperion plant was developed, including a tunnel to permit expansion across the street, but it was quickly determined the disruption to production was too prohibitive. "At the time of *Snow White*'s release," recalled Walt, "our staff had grown to about six hundred. Having committed ourselves to a program of both features and shorts, it became necessary again to expand drastically. We needed a new studio and in a hurry."

On August 31, 1938, Walt and Roy made a deposit on a fifty-one-acre land parcel in Burbank. Previously owned by the Burbank Department of Water and Power, the barren plot of land was being utilized as a polo field. Walt noted, "Not only did we need more space and more buildings, but the increasing emphasis on the technical side of our craft demanded the most modern and specially designed type of buildings and equipment. An additional eight hundred people were added to our payrolls. "For more studio space," Walt said, "we were forced to lease a row of apartment houses adjoining the studio, and other temporary buildings were erected on the lot."

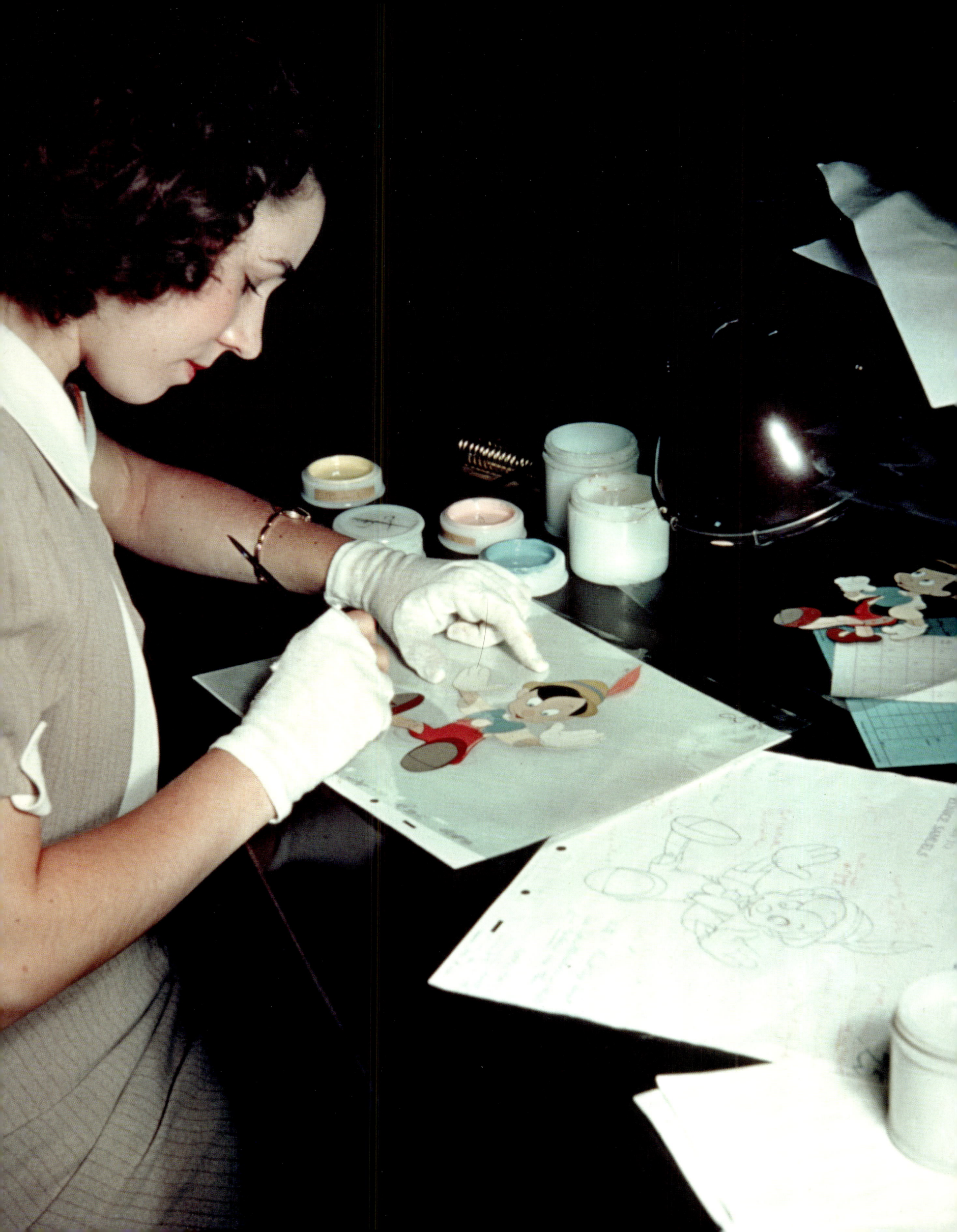

Page 147: Painting a production cel for Walt Disney's second feature-length animated film, *Pinocchio* (1940).

This page: The banner for the Walt Disney Studios' newsletter, *The Bulletin*.

Page 149, left: Final inked cel level; (center) painted color call-outs; and (right) the final printed page for *Grasshopper and the Ants* (1934) from the "Little Pigs Picnic and Other Stories" volume of the Heath Book series.

Early air-conditioning technologies were put into use at the Hyperion studio, and the *Film Daily* reported about it in a 1938 article, "Mickey Mouse Now Air-Conditioned." The system utilized a specially devised installation "whereby fresh outside air is drawn through Trane Cooling Coils, thus lessening its moisture content before it enters the building. A portion of this air is then mixed with the return air from the building and discharged from a cooling tower." This system helped to alleviate the issues with damage to the cels as a result of windows being opened in the Ink & Paint wing.

The main studio was now bustling, with several story ideas in development and production was as always proceeding on the usual slate of shorts. The next scheduled feature was a retelling of *Bambi*, Felix Salten's story of life in the forest. Space rented at 861 Seward Street in Hollywood housed the production team. They were plush headquarters compared to the local apartment complex housing the artists who were developing Carlo Collodi's story of a little wooden boy, *Pinocchio*. Story artist Jack Kinney recalled, "Those of us working on *Pinocchio* were ensconced in those old, beat-up apartment houses—strictly second-team in prestige. Dumb and happy, we went about it as though we knew what we were doing. We were virtually ignored while the push and pressure were being applied to the *Bambi* units."

THE BULLETIN

With entire divisions scattered across various off-site locations, a new studio newsletter was initiated to replace the various "overworked" bulletin boards throughout the studio and to keep the growing staff informed and updated. Very late in 1938, a new and official house organ entitled *The Bulletin* appeared at the Disney Studios. New issues of this legal-sized mimeographed multipaged newsletter became available every Tuesday and Friday morning. The growing Publicity Department, aided by the Mimeograph or "Ditto" Department, shaped this biweekly circular along with the early contributions of Dorothy Ann Blank, Mary Flannigan, Adeline Johnston, Jimmy Johnson, and Peggy Hughes at the main studio and Mary Old at Seward Street. Featured stories, studio announcements, caricatures, and newsy tidbits all kept the lines of communication open across the growing studio. *The Bulletin* even became the go-to source for all things social, including the schedule of the studio's amateur theater company (the Push Pin Players) and listings of want ads, as well as rooms for rent and juicy gossip.

Feminine and masculine dynamics of the day regularly played out across the pages of this newsletter. A poll was taken on what ten of the studio's most eligible bachelors were looking for in their "gals." *The Bulletin* noted: "If you're a career girl who's smart enough to know how to be a homebody type now and then, and if you're good company, it doesn't matter whether you are blonde, brunette, brownette, or red-headed [sic]." *The Bulletin*'s social pollsters proceeded to list the names of the "excellent cross section of the single masculinity rampant in the studio," but also noted the single dissenter who sought beauty over quality company, warning the female readers: "we feel it is only fair that the girls should know this."

Conversely, questionnaires among the girls surveyed "what the femmes think about everything from mice to men." Topics included "requirements for a good husband," listing the virtues, characteristics (humor rated highest), and appearance. "Extra's [sic] included: A man who doesn't tune in on the fights when Tony Martin is singing, doesn't eat crackers in bed, wipes the dishes and picks up all the cigar stubs after his poker parties! (P.S.—Breathes there a man . . . ?)."

When biographical content on the various male artists throughout the studio became a regular feature Effects Painter, Kae Sumner, launched the Femme Footnotes column, declaring, "From this beginning[,] we'll thrust forth what we hope will eventually become a page devoted to the studio girls. At least it'll acquaint the almighty men with the ways and wisdom of the 'weaker' sex." Sumner's column primarily shared details "dedicated to the inhabitants of the studios' most attractive island, [Inking & Painting]."

Other information in the biweekly included postings of classes and lectures, screenings of the latest films for learning purposes, details on staff relocations, production information, and ever-important reminders on fire hazards and the carelessness of smoking in the Inking & Painting Building. With the use of various solvents in the Paint Lab as well as the highly flammable nitrate cels still in use on the films, safety was critical, particularly with three feature films in production.

FINAL SILLYS & SHORTS

With story work under way on a variety of feature film concepts, the usual array of Mickey, Donald, and Pluto shorts came down the pipeline for the Ink & Paint Department, along

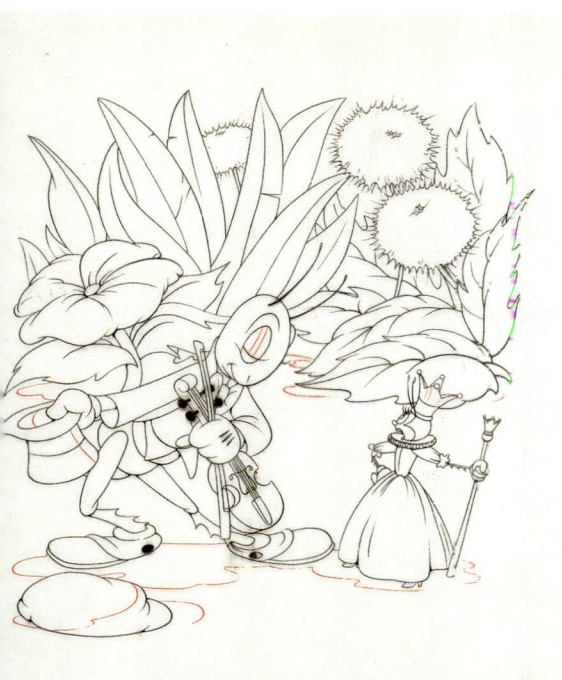 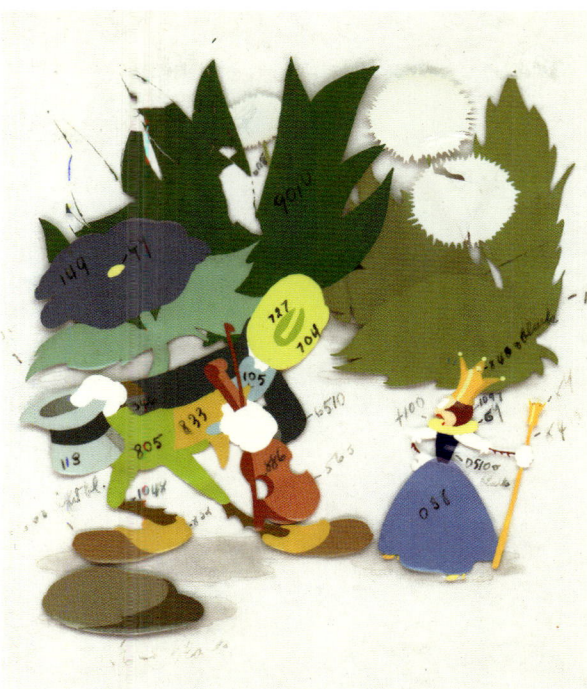

with the final Silly Symphony: 1939's color rendition of *The Ugly Duckling.* Animator Ken Anderson remembered, "The head of the Background Department [at the time] was certain that Walt hated two things: purple [he never used anything purple] and also, word was out that Walt didn't want any painting; he wanted tints. . . . Just put blue tints for the sky, and very soft tints [elsewhere], so that no matter where the little characters went, they were going to read." With *Ferdinand*, "It was a chance to make the picture fit the locale and fit the bull," noted Anderson. "We actually used paint colors, not just soft tints. It was a tremendous step forward in a different direction [from] the simply tinted background [that] had been prevalent up to that time."

By the late 1930s, Hollywood was also paying more attention to its animated content. The Motion Picture Production Code established what was later known as the Hays Code, named after its president, Will Hays. Spelling out what was acceptable moral content for audiences to view, the code began to realign and redefine the content emanating from Hollywood. The ominous reach of the Hays Code even meddled with one of Walt's feminine characters, Clarabelle Cow. Ink & Paint legend Martha Sigall, who occasionally did freelance work for Disney Studios over many decades, recalled, "In a 1930 cartoon by Disney, Clarabelle Cow only wore a 'smile and a cowbell.' No one objected to her udders showing. But, two years later, censors decreed that Clarabelle had to wear a skirt. And further, in 1939, she would have to wear even more and walk upright. So, she wore a dress."

THE HEATH READERS

Following successful early forays into publishing, Walt Disney expanded into further ventures. Though he never claimed to be an educator, he understood the impact of animation. "The cartoon is a good medium to stimulate interest," Walt said. "It is an ideal medium for teaching, and it has always been my hope that we could do something that way. But it would have to be of general interest, yet helpful in teaching. It should be used for opening people's minds and meeting their needs."

In the late 1930s, the Boston-based textbook publisher D. C. Heath and Company approached Walt Disney about producing books around the films and characters from the Disney stable. Seeing an opportunity to expand the role of the studio's characters, Walt agreed to a series of Disney Education Readers being created exclusively for schools. Carefully designed and sequenced by reading difficulty, the pedagogical series supported a range of classroom topics and themes.

Walt worked with Heath Publishing to line up a talented all-female roster of writers, librarians, and educators to ensure key educational benchmarks were met. The notable writers included professor of education and children's author Dorothy Baruch; poet and librarian Idella Purnell; prolific children's author Margaret Wise Brown (renowned for her classic, *Goodnight Moon*); notable elementary principal Dr. Florence Brumbaugh; children's textbook author Ardra Wavle; and writers Jean Ayer, Caroline Emerson, H. Marion Palmer, Robin Palmer, and Georgiana Browne.

In addition to original stories written by the noted array of female authors Walt selected, stories and characters from the studio's shorts and feature films were utilized. The artists of Disney's Ink & Paint Department created the artwork on two-piece nitrate cels. The top cel featured inked trap-lines (printing lines defining the image), and the bottom cel was painted as a color guide with the color callouts as a reference for the printer to create the mechanical screen tints to match. Key lines were inked in red, and Shadow Painters also contributed their artistry.

This approach to printing gave each illustration a brilliant three-dimensional appearance, and for the first time, characters on the page looked exactly as they did on-screen, with colors that were vividly true to the original animation. The books were published from 1939 to 1951 in sets of four. Heath also published a teacher's guide and several die-cut bookmarks. Clothbound and Smyth sewn, these easy readers were durably crafted to withstand decades of use as textbooks—and occasionally as home plate, if needed, for an impromptu game of baseball.

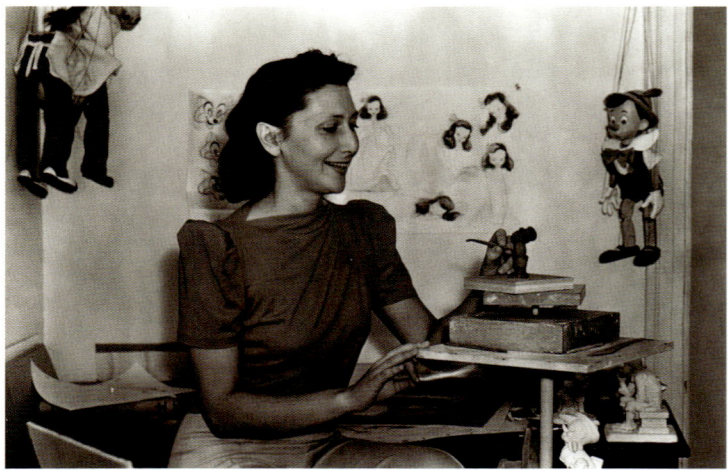
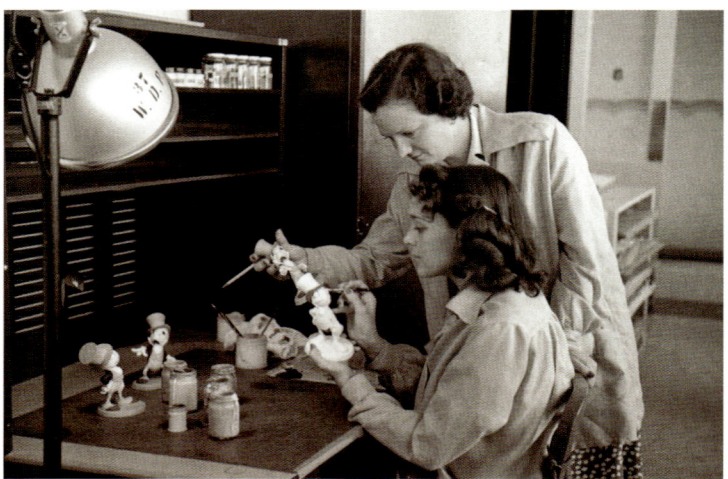
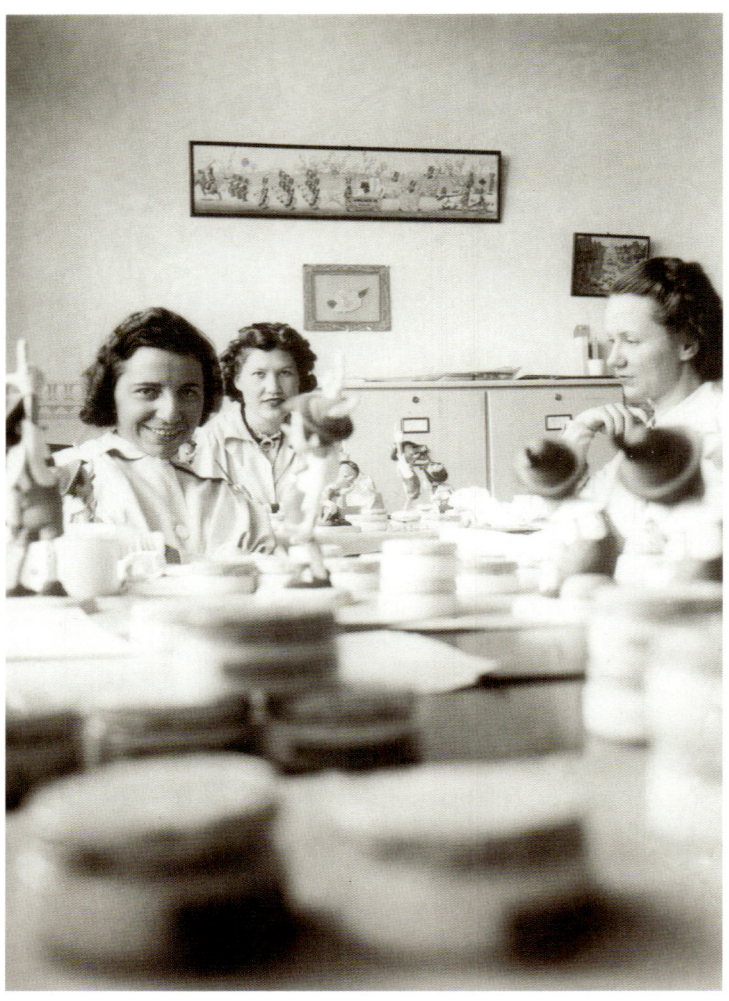

Top, left: Sculptor Shirley Soderstrom adds finishing touches to a Jiminy Cricket maquette.

Bottom, left: Inker Marie Henderson (standing) reviews various Jiminy Cricket maquettes painted by Ruthie Katerndahl (seated).

Right: Unidentified (left), Evelyn Coats (center), and another studio artist paint *Pinocchio* maquettes.

Page 151: A page from Inker Ingeborg Willy's scrapbook while working at Disney, featuring the studio's 1938 Christmas card with artwork by Tom Wood and fitting prose for the Ink & Paint Department.

MODEL CHARACTERS

Former story artist Joe Grant created and ran the Character Model Department, which was instituted after the success of *Snow White and the Seven Dwarfs*. From the two-dimensional drawings or model sheets that helped the artists to maintain uniformity with the characters, three-dimensional scale models of the characters and props were designed and sculpted. These small statuettes, or maquettes, offered the artists an understanding of the specific characters they would be animating and provided visual aid to further story and character development.

Seventeen artists ultimately constituted the department, including textile artist Elsa Libby and Austrian-Jewish artist Fini Rudiger, who fled to Cuba and then America when she felt threatened by the Nazi presence in Vienna. Rudiger started in the studio's Character Model Department in May 1939. Noted artist Mary Blair spent several months in this department. Another member of the department was Shirley Soderstrom. Her talents were spotted in early 1939 when a few members of the Disney Studios staff happened to visit the pottery center in Hollywood where she worked. The center featured her charming dimensional figurines. Within a very short time, Soderstrom was on her way to the studio, where she contributed to character designs on a number of later films.

Bob and Bill Jones oversaw the creation of three-dimensional models of specific characters, as Plasticine models were sculpted and then casts were made for plaster figures. Grant then brought in Helen Nerbovig to oversee Evelyn Coats and a number of girls from the Ink & Paint Department to paint the maquettes with the colors used in production. For the unique puppet movements of *Pinocchio*, Charles Cristadoro, who made puppets from wood, created a functional puppet in full costume that was painted by the women of Ink & Paint. This became an invaluable aid to the artists working on the early marionette sequences when *Pinocchio*'s movements were manipulated by strings.

INK & PAINT TRANSITIONS

The Ink & Paint Department soon reflected the burgeoning transition of the times as well. In May 1938, after completion and release of *Snow White and the Seven Dwarfs*, Hazel Sewell resigned her pioneering role as the studio's first head of Inking & Painting and the first woman in the animation industry to head a major division. In her eleven years at the studio, Sewell's groundbreaking tenure marked the most dramatic transformations within animation. "They were the first to do so many things," declared Sewell's granddaughter, Nannette Latchford. "There were no books or classes to attend. They just figured it out. She was fascinated by what they turned out, but her biggest pride was *Snow White*. She did it well and she loved it."

Over the years of working in close proximity to many of the men on the staff, Sewell had begun dating longtime studio coworker William "Bill" Cottrell. Cottrell had started at the small Hyperion studio in 1929 as a cameraman and worked his way to story man, sequence director, and later, an early WED (now Disney Imagineering) executive. With her marriage to Cottrell in 1938, Sewell remained on the periphery of the company's activities and continued to socialize with Walt and Lillian over the years. In submitting her resignation, Sewell pointed out

Ink & Paint | 151

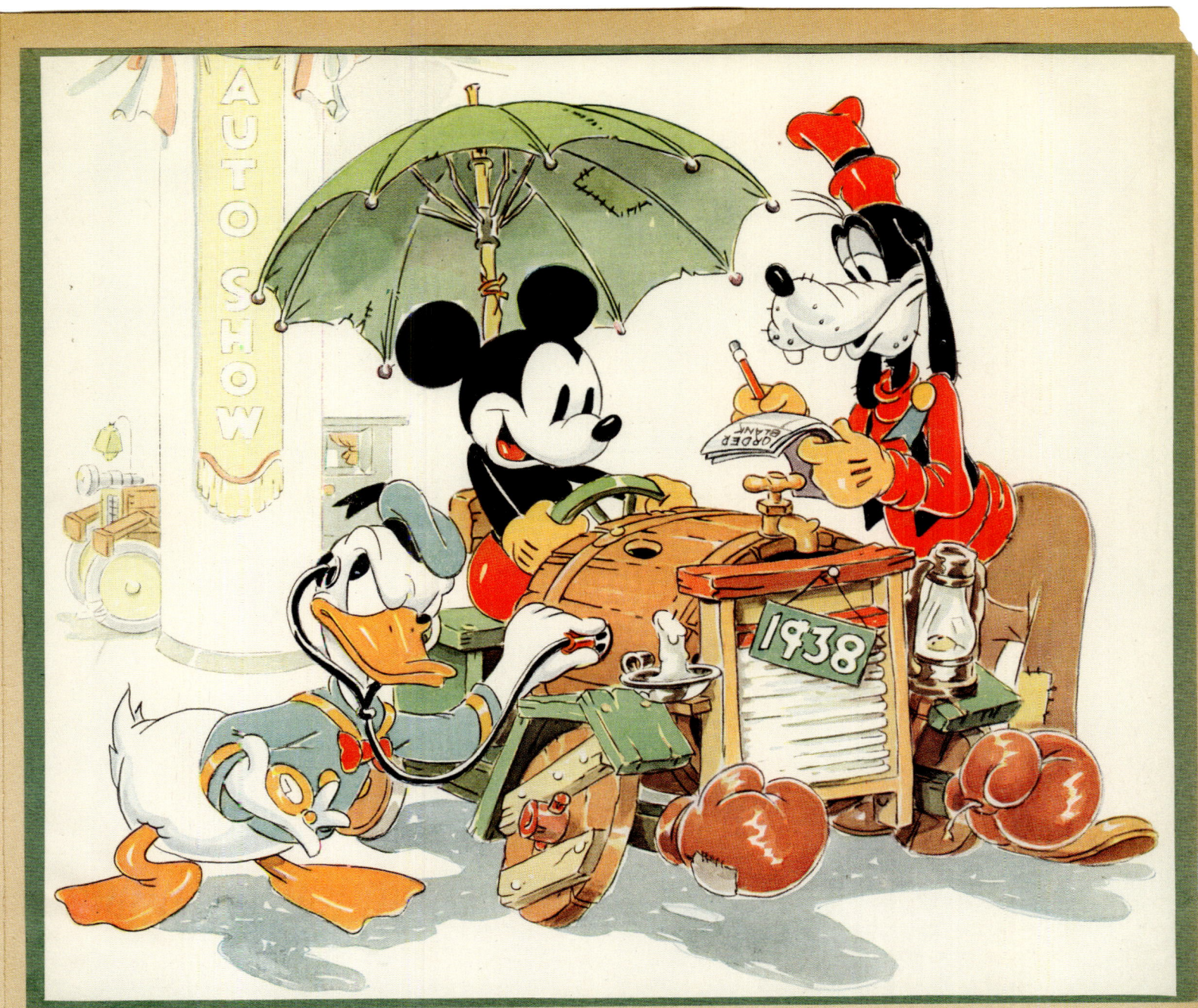

OLIVE PIPER'S ODE TO PAINTERS

When the earth's last Mickey is painted
And the scenes are checked, and okayed
When the last symphony's gone to the camera
And the last bonus check has been paid
And a score of feature-length pictures,
Beginning with lovely "Snow White"
Has changed the trend of all movies
And made a big hit overnight.....
We shall rest, and God knows we shall need it.
Then we'll retire at sixty-five....
And enjoy the Security Measure,
In case we are still alive!

KAE'S ODE TO INKERS

When the earth's last Mickey is inked
And if even we finish "Snow White"
By working both day and night...
We shall rest, and God knows we'll need it.
We'll lie down for an aeon or two
Till the "Master of all good comedies"
Shall put us to work anew!

Those who are good shall be wealthy $$$$
And sit in a golden chair...
And splash at a ten-acre cel
With pens...only an inker can bear.

Only the "Master" will praise us
And only the "Master" will blame.
No one shall work for money $ $ $
And no one shall work for fame!
But each for the joy of her "average"
And each in her separate star * * * *
Shall ink "The Mouse" as she sees it...
For the good of mice as they are.

her efforts in saving the company tens of thousands of dollars throughout her tenure. Though initially upset by Sewell's departure, Walt also understood the pressure and reality behind her decision, writing to her, "If I were in your place . . . I would probably do the same thing."

Marie Henderson, who briefly ran the Inking division, took over Sewell's position as head of Ink & Paint. But Inker Evelyn Coats recalled, "She didn't know that much about art, [so] Martharose Bode took over." Specifically, in August 1938, Bode, a talented Inker and one of Sewell's Supervisors, stepped in as head of Ink & Paint for eight months. With a staff of over two hundred girls throughout the various departments of the only female stronghold on studio grounds, Bode continued to sharpen the skills and artistic level of the Inking & Painting Department. Through Walt's newly initiated education program, Bode also offered training and lectures for her artists and expanded the technologies employed within the department.

With an escalated production slate, several staffers were hired for the Cel Washing Department. C. O. Peterson was declared department head, and his staff of workers kept the supply of animation cels trimmed and issued to the various departments. Occasionally, the production line experienced some gaps. Even with this downtime, the women were rarely laid off. Whenever production was slack, women often worked on the Courvoisier cel setups, updated color models and paint swatches, freshened paints, or worked on other projects.

The growing quality of talent within the ranks of the Inking & Painting Department presented an increased need for the Studio to provide opportunities for further creative contributions. "It is very important that the members of this Department feel a spirit of closeness and of being part of the Studio proper," noted a 1939 memo between Personnel staff. "The Story Department was always very happy to receive any suggestions they might have [and] the Comic Strip [Department] will probably derive actual, usable material from this group." Ink & Paint Personnel staffer Mary Cleave was "quite enthusiastic about allowing this medium of expression for members of that department."

Martharose Bode later stepped down to focus on several experimental applications with the *Bambi* team, and the leadership of Ink & Paint was split among three women: Dot Smith, a young Painting & Checking Supervisor, took over the Inking and Checking roles in April 1939; Grace Christianson assumed complete charge of the Painting and Color-Model functions; and Mary Weiser, the industrious Painter who had begun studying and mixing formulas for better paint application a few years earlier, became Supervisor of the Paint Lab.

Inking Supervisor Martharose Bode.

ladies of the lab, providing pertinent information on color and paint compounds, glossaries, and vendor listings defining sources for the various materials of the artists. Occasionally, Weiser and her team took the studio's company car to make field trips to local paint manufacturers.

A full program of research established by the Paint Lab expanded their responsibilities. Color development and expansion were a priority with extensive experimentation "auditioning" new pigments. "We endeavor to ascertain whether they give a better leveling out when applied with the brush and how they set on the cels," Weiser carefully wrote down in her lab journals. "A pigment is tested for fineness of grain by rubbing a sample between the thumb nails [sic]. Pigments should show an even grain. The covering of the paint is increased if it is finely ground."

Experiments with new white pigments were critical, as white, blended with the top colors, achieved the range of color via paint let-downs. But as one entry revealed, "This new type of white is excellent for straight painting—no bubbles and very good dispersion, but cannot be used as an extender with other colors—result in streaking and milky-ness [sic]. The new white reacts differently with various color families."

Additional research was also conducted on drying time and dust removal from cels. Electrostatic methods were employed in hopes of reducing dust, but the results remained unsatisfactory, as more information and time were required to explore this option.

LADIES OF THE LAB

With a flurry of films by this time, in progress to one degree or another, Mary Weiser's lab personnel expanded to include Jeanette Tonner, June Brandon, Margaret Selby, Margie Moorhouse, Katherine Whitlock, and secretary Hilde Thornton. These ladies worked to develop pioneering new applications for paints within animation while defining a wider palette of color for the various films under way at Disney Studios. Weiser and her team created extensive manuals and quick-reference notebooks for use by the

APPLICATION ADJUSTMENTS

In July 1938, Mary Weiser conducted a number of trials and experiments to refine processes and materials. A set of high-end paintbrushes was distributed among a few of the best Painters for a trial. After six weeks of use, the women's comments were compiled. Betty Durando noted of the No. 8 brush: "For a large brush, it can go in the most difficult corners. The bristles of this brush are more capable of undergoing punishment such

as we give them." Working with a smaller brush, Betty Bassett remarked, "It came to a beautiful point and seemed to retain it, regardless of how much paint was used."

In October 1938, Weiser conducted a number of training sessions to address the new application techniques for the original paints and color systems now in place at the studio. "Until recently, many of you had no idea that we actually manufactured our own paint," began Weiser. "The problem[,] then, that we are faced with, is that the present method of applying paint heavily, that is, floating it on with a maximum of water, is causing serious damage in the camera." When floating the paint, nearly an ounce of water might be added to a two-ounce jar of paint. The stirring and agitation that came along with adding water increased the likelihood of bubbles, which were highly undesirable and required additional agents to be added to prevent them from forming. However, these additional agents led to further problems.

A dry crust was forming on the paint jars, which was emblematic of how the paint dried: hardening on the top first, and then drying down into the cel. To all outward appearances, the paint seemed dry. Stacked and sent to checking, the cels still appeared to be completely set, but when the fifty-pound pressure of the camera platen was applied to each cel, "the moisture that was locked in, resulting from the heavy floating, is released." This excess moisture forced between the camera platen and the cel resulted in dark spots and halations, rather than the smooth, even opaqueness desired.

It was preferred to have the paint dry from the cel out to ensure the paint was completely set. To achieve this, several practices were put into place. Any water was to be applied with caution, and distilled water was given to all Painters to eliminate the hazard of impurities that might be introduced via tap water. New methods of paint distribution were implemented to reduce the need for overwatering or constant stirring. A completely new technique of paint application had to be mastered by the entire department. Referred to as "flattening," this method was essentially the placing of the paint on the cel. Later advancements to the Disney paint permitted a return to floating the paint, which then became the standard method of application.

In addition to lectures and demonstrations, Weiser developed rules for painting and conducted classes for the production teams of Painters, as well as trainees, in 1938. To highlight this comprehensive transition, Weiser formulated guidelines into a reference manual entitled *The Painter's Bible*. Mimeographed pages issued to each Painter spelled out the Ten Commandments of Painting:

THE PAINTER'S BIBLE

Rule 1—Thou shalt not add too much water.
(All of the studio's new colors required less water for successful painting and uniform results.)

Rule 2—Thou shalt not float paint on cel.
("Floating" the paint was believed to slow down the drying process, while the best results were believed to be obtained by "flattening" the paint out on the cel. This technique was to prevent stickiness, streaking, and minimized bubbles. Various colors required a combination to techniques for proper application and 'floating' the paint later became the standard method of application.)

Rule 3—Thou shalt honor thy fine sable-hair brushes.
(Reinforcing the quality care of their tools, brushes were never to be soaked and were to be kept out of the water jars. The girls were mandated to "religiously keep them scrupulously clean" as paint lodged between the hairs, especially the more potent or darker colors, would disastrously taint other pure or lighter colors.)

Rule 4—Thou shalt test all paint before adding water.
(Previously, when jars of paints could appear to be jelled or custardy, water was added, but with the new custom paints, the artists were encouraged to not do this as "chances are this was the nature of the paint.")

Rule 5—Thou shalt not add alcohol to black.
(The new formula for black did a better job of adhering to the ink lines and achieved a satiny-smooth finish. If it wasn't properly adhering, too much water had been added and a new batch of fresh paint was to be ordered.)

Rule 6—Thou shalt give special care to light values.
(Light colors were previously less problematic than darker tones, but heavy floating of the lighter, water-laden colors caused damage.

Rule 7—Thou shalt always paint the bright and vivid colors FIRST!
(Artists painted up to "just" the edge of the inking line with colors that followed, which eliminated retakes resulting from careless overlapping of the darker colors).

Rule 8—Thou shalt always place blank cels under thy work. Thou shalt not use small cels under multiplane cels.
(The careful handling of cels was crucial to prevent scratches).

Rule 9—Thou shalt not scrape cels outside the painted area.
(Scratched cels caused too many camera issues and were glaringly apparent on the screen, thus blotting any excess paint with a soft rag became the new standard. Special cleaning cloths were developed for polishing the finished cels).

Rule 10—Thou shalt always check your finished work before handing it in.
(Maintaining quality, Mary also urged, "Always keep your desk free from dust.")

154 | Feature Film Expansion

Left & right: Pinocchio and Jiminy Cricket production cel pieces inked by Marjorie Furnish.

> "*Pinocchio might have lacked* Snow White's *heart appeal, but technically and artistically it was superior.*"
>
> —Walt Disney

New staff was brought on to work in the lab, including Chemist Herbert Britt and Doris "Dodie" Roberts, who began in the Paint Lab in 1939 and quickly became one of the studio's best paint matchers. Once settled in their new laboratory, now featuring over two thousand colors and shades, a studio write-up declared, "The neat shelves are loaded with jars [that] look as though one had poured bits of the rainbow into them." Painters now received their required paints from lab girls who trundled up and down the corridors with double-decker carts, doling out the little jars of vibrant colors.

Development and early animation continued on *Bambi*, with a targeted release for Christmas of 1938, but after careful consideration, it became clear to Walt that the story of *Bambi* was something the studio teams were not quite ready to tell. *Snow White and the Seven Dwarfs* held a solid story with defined characters, but for *Bambi*, the studio's staff lacked the experience as storytellers and the maturity as artists required for this delicately complex scenario. *Pinocchio*, a straightforward fairy tale with a solid structure, was quickly moved up into production.

A LITTLE WOODEN BOY

"We all thought that *Snow White* was the biggest," reflected Animator Ken Anderson. "It never dawned on us that there was something else to do in life after *Snow White*."

The classic Carlo Collodi story told of a little wooden puppet on a quest to become a real boy. Two years were spent on creating Walt Disney's second foray into feature animation. Bianca Majolie, a native Italian, did a fresh translation of the story, keenly adapting it for the animation medium. Faith Rookus, a talented artist in her own right, quickly advanced from the Ink & Paint Department to become a story artist on *Pinocchio*. Rookus often explored story and character designs directly on celluloid, throughout development in 1938–39. It was within this two-year period that some of the greatest strides in animation, as well as women's roles within the studio, occurred.

Of the nearly four hundred women employed at Disney Studios by 1939, two hundred worked in Ink & Paint, bringing the division to its largest number. This expansion added Inkers Ellen Chrisney, Dorothy Esgate, and Margaret Trindade, who quickly established themselves as premium Inkers and Supervisors throughout their forty-five-plus-year careers at Disney.

Expanded shades of paint were developed within the Paint Laboratory to create the richest palette ever seen on-screen. New

Feminine First

RETTA SCOTT

The studio's long-standing alliance with the Chouinard Art Institute also provided insider access to a crop of new talent. And there was one young artist who was so outstanding that she was hired immediately upon completing her studies at Nelbert Chouinard's institute in March 1939: Retta Scott. Scott was the first credited female Animator at the Walt Disney Studios. She joined the Story Department ranks at the Seward Street site, aptly referred to as Termite Terrace. In her autobiography, Scott recalled, "The walls started curving in. In this old studio, the termites had done their work." A lanky girl who looked about fourteen years old, Scott could hold her own in the male-dominated world of animation. "She was assigned to animation, and [the person] who [got] to take her under his arm was me!" declared Don Lusk, who worked with Scott. "They assigned her to me, which got her indirectly to Eric [Larson], but no doubt about it, she knew how to draw." Lusk worked closely with Scott as she learned the ropes of animation.

As the rare woman in the male swarm of Animation, Scott's presence at the studio was newsworthy. A studio write-up noted, "The Animators had always hoped their pleasurable existence wouldn't be marred by the entrance of a mere girl into their working lives." The unofficial artwork that festooned the walls of the Animation Department was a bit racy and on hot summer days prior to air-conditioning, it was not uncommon for the guys to peel down to their shorts while they animated. On Scott's first day of work as a junior Animator, it was reported in a studio write-up that the men were "rocking with laughter" at the idea of a woman in their midst. Sneaking into the studio early, the men decorated her office with overly feminine touches including ruffled curtains and set "tidies" in her chair.

Many of the men vowed it was only a matter of time before she would leave, but instead, as one of Janet Martin's studio publicity write-ups from the late 1930s stated, "Retta was as open as the sea, as friendly as a puppy[;] she laughed at all their corny antics[,] and the fact that she had a turned-up nose and a cute figure and mighty pretty legs didn't harm the situation a bit." Influenced by her natural warmth and extraordinary talents, the Animators found themselves turning "motherly" towards her. They often went out of their way to help her if needed, although "Rett" often completed her work better and faster than many of the men.

On the production of *Bambi*, Lusk helped her with the animation timing on several key scenes. "She would draw [animals] in different positions . . . and I would just time it out for her. It would have to go to her for cleanup because it was all hers." Noted Scott, "My director, Eric Larson, gave me much encouragement and guidance. And as I only had been working on the dogs[,] Eric felt that I should clean them up myself where needed. I estimated that during that year I had drawn over 56,000 dogs for Bambi."

approaches to the application of the paint and pastels imbued the characters with a richer sense of lifelike roundness. Complex drybrush techniques and airbrush applications were developed to capture the heightened details and effects on celluloid. "We worked hard, [but] it was fun to work on," remembered June Patterson. "I almost ended up in the hospital; it was so hard. They were very fastidious; we had to have everything just right."

Pinocchio's tiny companion Jiminy Cricket presented a sizable challenge. To define his dapper form, as many as thirty-five different colors and shades were applied within the most complicated inking ever designed to that point. Twenty-two different lines were carefully inked in a myriad of colors, framing a complex color combination that made it challenging to achieve consistency throughout the film. Often it was necessary to show little Jiminy in relation to a normal-sized character, yet to enlarge the cricket would require the other character to be drawn correspondingly larger, and animation paper and celluloid weren't quite big enough.

Simply drawing the cricket larger was also explored, yet once he was reduced back down to his actual size, his eyeline would no longer match. To consistently maintain the detail of Jiminy Cricket no matter the size, careful application and checking of scene consistency were crucial.

ACHIEVING ETHEREAL

A natural sense of beauty was applied to the lifelike Blue Fairy. Originally envisioned as a blue-haired being in the Carlos Collodi story, the character was transformed by Disney's storytelling into an ethereal fair-haired being. A studio write-up announced, "[The Blue Fairy] comes to the screen as a blonde. Not because the Disney artists prefer blondes particularly, but because the lighter values of yellow suited her ethereal personality." To achieve these otherwordly qualities, she had to be colored in the right light values. If not done properly, she would appear washed out. Her diaphanous robes were achieved through various shades of light blue specially mixed for a distinctively gossamer blend. Voiced by popular actress Evelyn Venable with live-action reference by Marge Champion, the primary female in the world of Pinocchio required extra attention to achieve believability.

There wasn't too much to the Blue Fairy's action or any great length to her time on-screen. But with most of her scenes in close-up and her role holding direct impact on the story of little Pinocchio, it was critical to improve on the look and believability of the character. Department head Martharose Bode and Animator Jack Campbell set a meeting to instruct

156 | Feature Film Expansion

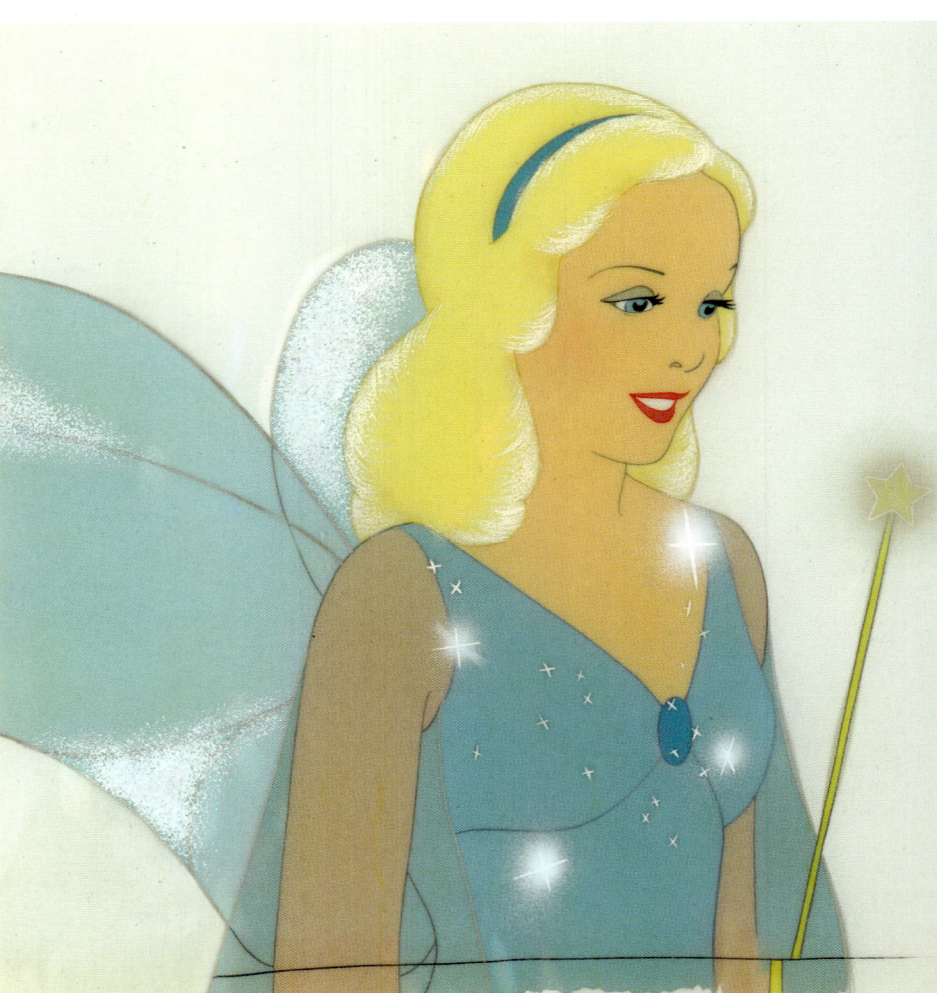
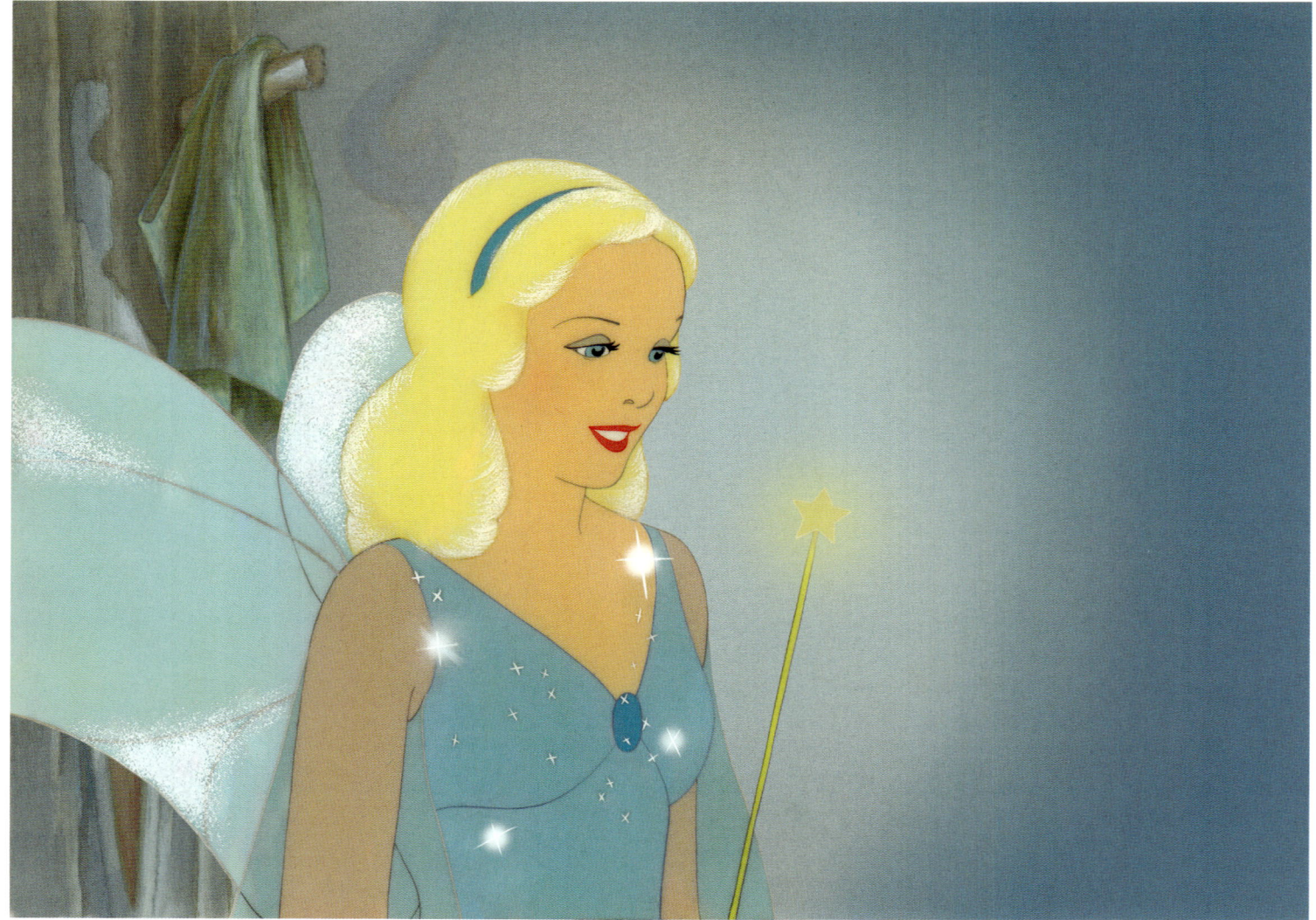

Page 156, top, left: Production cel inked by Marjorie Furnish; (top, right) painted and effects production cels; (bottom) and final production cel setup of the Blue Fairy.

This page: Paint Check on the Blue Fairy sequence for *Pinocchio* (1940).

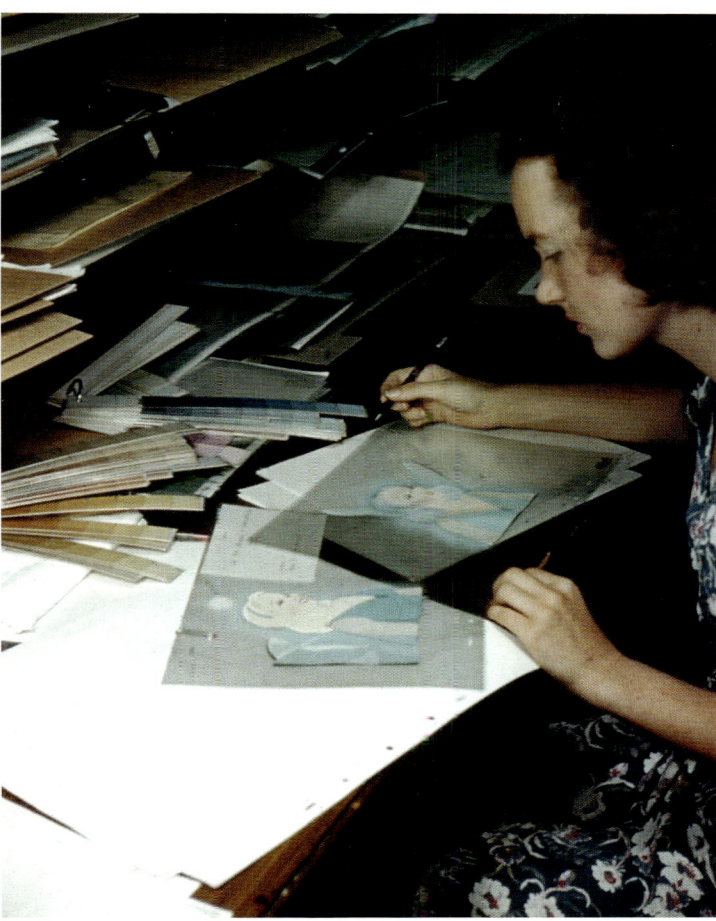

> ## Feminine First
>
> ## MARION WYLIE STIRRETT
>
>
>
> Helping to define the varied worlds of *Pinocchio* was the studio's first female background artist, Marion Wylie Stirrett. Trained as a fine artist at the University of Southern California and Art Center in Los Angeles. Stirrett joined Disney in the Painting Department in May 1939. With her natural talent, Stirrett swiftly advanced into the male-dominated Background Department where her quick wit served her well as she began defining the realms of a little wooden boy, prehistoric dinosaurs, and would-be sorcerers.
>
> A bright, cheery woman of intellect and artistry, Stirrett remained at the studio for a number of years, adding her talents to the backgrounds of several Disney animated classics, including *Pinocchio*, *Fantasia*, and *Bambi*. A studio press write-up noted, "We have another girl—Marian Sturrit [sic]. Beautiful, and a pretty girl figure. She's our only girl Background Painter." While working at Walt Disney Studios, Stirrett earned the same standard wage as her male background-painting colleagues while her husband, Lloyd, went through medical school. This critical department also added women to their ranks early on, including Yvonne Beryl Burchett, Dorothy Bachom, and Susan Eaton, who also did airbrush effects for backgrounds.

the Inking & Painting teams regarding the intricacies required to achieve the natural presence of the Blue Fairy.

Careful attention was given to the shape of her head. "There is no formula for drawing her head, as she is a straight character," noted Campbell. "In *Snow White* we had a formula[,] and it looked like it on the screen, too. In this case we are trying to keep [the Blue Fairy] as near as possible to the real thing." Detailed study was given to the front view oval of the fairy's head, as well as the profile and three-quarter turns. Her nose was slighted on purpose in an attempt to keep away from defining her outline unless she was in profile. "In three-quarter view, just use nostrils. [The] nose isn't important enough and is too hard to draw," advised Campbell.

As many as possible of the lines that defined the "outside" form of the character were eliminated to keep lines from jumping on-screen. The jawline was intentionally deleted and shading was utilized to define the lower frame of the face. Other lines that detailed her neck, sleeves, and waist were put to the inside of the character form, which added to her ethereal qualities. The women were cautioned against putting "cupid lips" on the Blue Fairy, and eyebrows were to be carefully applied in relation to the forehead.

"The attention is focused on the eyes of that character. That is a big point in the inking and painting," stated Campbell. "We are all familiar with the details—eyeball, eyelids, cornea, iris, pupils, etc. However, line drawings, as we know, is the toughest medium for expressions. We have to make every line count."

Through demonstration and lecture, the girls examined the functions of the various parts of the eye, ultimately striving to give each line more "wallop" than a simple outline. The artists defined the varying thickness between the upper and lower eyelids and how they varied when seen in profile, in movement, and straight on. The thickness and heavier weight of the upper lid was to be conveyed with a slightly beveled point, while the individual lines were rendered in separate shades of gray with flesh painted behind to achieve the right definition.

An extensive examination was made of the eye to establish a natural pupil. The artists explored how the whiteness varies within the eye when looking up or down; how the cornea travels to point out the direction the character is looking; and the different tones of the iris as it catches the light in various settings. Collectively, they determined that the highlight of the eye would be formed with a crescent shape so as not to pile up too much ink.

The detail defining the fairy's eyelashes was even more intricate: "They are not to be neglected," directed Campbell. "In most cases they start just inside [the] bevel edge of [the] upper lid. [Typically], we would curl them way up. This takes away realness and life likeness to the character. This character is straight and we cannot cartoon it." Studying reality helped the Inking & Painting artists make the necessary adjustments within their medium to convey the reality required throughout

BARBARA WIRTH BALDWIN: AIRBRUSH DEPARTMENT

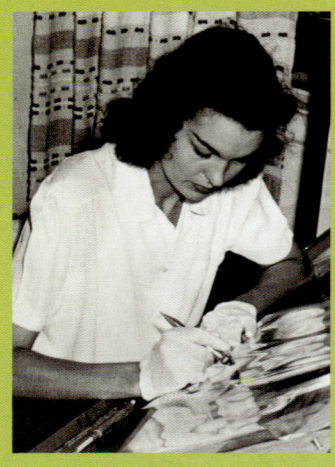

The greatest strides during the development of *Pinocchio* were made within the realm of Special Effects. Expanding the scope of his feature film projects, Walt Disney established a full Airbrush Department, and the first head of this division was a young artist by the name of Barbara Wirth Baldwin. "I had about twenty-five people that I was responsible for," recalled Baldwin. One of the earliest women to head a department at Disney Studios, Baldwin was also the first woman to transition into the Animation Department in the role of Special Effects. "I guess I was lucky because I just happened to have this certain skill that everybody didn't have, so I was made head of the Airbrush Department." According to Baldwin's sister, Mary Jane Frost, who was also an Inker at Disney, "That was kind of unheard of at that time, too. All the artists that I remember that really were big names in the business were all men."

Airbrush technology was developed in the late 1890s and gently introduced in the impressionist and art deco movements. By the 1930s, styles and techniques had developed and the airbrush had become a standard tool embraced by photo retouchers, illustrators, and advertisement agencies. Spraying on the paint lent a soft mist of color or texture to images, so it was an ideal tool to advance Disney animation, adding a further sense of blended realism or believable fantasy. "I didn't know beans about airbrush," Baldwin remembered, "but the weekend before I had the interview, I flew up to San Francisco and talked to my old teacher up there and he taught me about the airbrush. So, I came back and I got a job as head of the Airbrush Department." Starting in January 1938, Baldwin was the closest thing to a woman Animator at the studio at that time. Yet feathers were ruffled among the male artists, who felt it was not a suitable role for a woman. "I was in charge of the department. I didn't pay any attention to all these other people who were screaming about it," Baldwin laughed. "It was just kind of silly."

"My first job was with the multiplane camera," Baldwin recounted, "airbrushing clouds on the glass for the multiplane camera—and I was petrified, but I did it all right, I guess. It was all fun."

Baldwin set about building her team. "The gals in my department, I loved them all." Initially picked from the Ink & Paint Department, the women of Baldwin's team trained along with men in Animation and worked in alignment with the Special Effects Animators to create the realistic movement of dust and rain, the twinkling of stars, and other elements. "At one time," Baldwin recalled, "we had men in the department and . . . they [the Directors] got very picky about dandruff and stuff getting on the cels. So, we bought hairnets and decided all the men should wear hairnets. And some of the men in the department revolted," Baldwin recalled with a laugh. "They wouldn't wear hairnets."

Baldwin's unique pool of female and male artists included Emily Barbour, Ruberna Downs, Mary Ann De Pew, Grant Goddard, Marcia James, Mary Jardon, Marie Profetto, Mildred Rush, Vina Katrine Swartz, Ruth Thorbus, Beryl White, Betty Woodward, and young Dorothy Bachom, a left-handed artist they made a special airbrush for so she wouldn't smear the work as she painted. While several of the artists had an Inking & Painting background, many of the women who were added later were hired outright for their artistry with airbrush and were responsible for a wide range of the spectacular effects and beautiful scenes on the studio's productions. "We used to flip the cels when we airbrushed smoke and stuff . . . to make sure it was working," Barbara remembered. She laughingly recalled making a careful study of smoke: "[We] looked at it. Watched it. Smoked cigarettes."

Of her team's work in *Pinocchio*, Baldwin noted, "We did all the fishbowls, all those effects on the glass. The fishbowls were usually done with two layers of cels so they could put the fish in the middle." Cloud effects, candle flames, undersea effects, and even the unearthly glow of the Blue Fairy were only a few of the believable effects these women and men accomplished on celluloid.

the fairy's movement. As Campbell continued, "Take the front view. . . . [The lashes] are all the same height and [have the] same space between them. Going around to one side, they become foreshortened and [the] space between them goes smaller. Going still further around, they are very close together—almost massed. That is what we have to contend with. This is the toughest job—to show lashes."

To achieve the desired features of the lashes without filling in a mass area, Bode determined: "We almost have to carry them as separate eyelashes. We can put them close together to give the effect of mass. We have to use pointed ends." The excellence and believability achieved with the studio's feminine characters paid off. Hollywood makeup expert Max Factor kept special templates of Tinseltown's leading ladies on file, mapping the shape and tones of their makeup secrets. It was believed Factor also kept templates of Walt's early animated leading ladies, matching the right shades and tones to the characters' forms.

DETAILED ARTISTRY

For all the intricate details that went into creating *Pinocchio*, one of the most memorable scenes in this film was inadvertently shaped by circumstance. June Patterson had just signed on as a Painter in September 1938 when "I ruined a whole scene in *Pinocchio*," she declared, now able to laugh about it. She had been handed the scene of Stromboli's coach rambling along the road. "I painted on the [scene] and I was [being] so careful," said Patterson recalling the situation. "And when I took the scene up to the Supervisor I thought she was going to faint. . . . She looked at it and she didn't say anything. She just said, 'Go back to your desk.' That was the worst day of my life. I was brand new there and I went back to my desk and I thought, 'Oh, they're going to fire me, I know they're going to fire me!' I didn't know what I had done wrong yet.

"Finally," Patterson continued, "she came and she let me know I had painted the entire thing on the wrong side. They'd

Ink & Paint | 159

Top: Series of cel pieces featuring Figaro from *Pinocchio* (1940); (center) Inked cel of Cleo by Marjorie Furnish; and (bottom) final cel setup of Cleo.

already shot part of [the scene]. There was no way that they could fix it." Fortunately, after some quick thinking, a better, more dramatic solution presented itself in cleverly masking the error. "They put it in a rainstorm!" Patterson laughed. That memorable moment—and one of young Patterson's first scenes—made it into the final film.

The detailed artistry achieved in *Pinocchio* was not limited to the characters. Perhaps the greatest strides in animation were achieved in the rendering of water. Effects artists involved in aspects of the underwater sequences made a careful study of water, spending time at the beach photographing, filming, and sketching the surf. They later explored optimum color combinations and cultivated techniques to achieve realism in both the underwater and ocean-surface scenes. Rather than painting in the blue of the ocean, the outlines of the waves were inked onto cels; then sheets of blue paper were cut to match the shape of each wave. Ground and blended lead from blue and black mechanical pencils was painstakingly applied to the blue paper to give each wave the desired detail. The end result is the natural believability of the cresting ocean waves.

Achieving the fluid underwater movements of the feminine fish Cleo fell to the animated mastery of Don Lusk. Working along with Eric Larson, Lusk noted, "She [Cleo] was such a fun little character. Her underwater movement was like a ballet." Dorothy Castle Bronson, who worked in Inking effects and later as an Inbetweener, was a multifaceted artist who supervised the brush effects on Cleo and Figaro, as well as all inking-effect applications throughout *Pinocchio*.

With a tight schedule and ample overtime, nearly five hundred artists shaped well over three hundred thousand drawings and paintings utilized in the production of *Pinocchio*. Animator Jack Kinney later wrote, "Everybody flowered on *Pinocchio*. We decided to really make the best thing that had ever been made—learn from our past, which we did.... We exceeded everything—financially, economically, it could never be reproduced."

Feature Film Expansion

> *"In a profession that has been an unending voyage of discovery in the realms of color, sound and motion, Fantasia represents our most exciting adventure."*
> —**Walt Disney**

THE CONCERT FEATURE

Fantasia had been in development for some time. It began in 1937 as a Silly Symphony centered around Paul Dukas's musical work *The Sorcerer's Apprentice*, which was inspired by Goethe's poem "Der Zauberlehrling" ("The Apprentice Magician"). This story of an impetuous would-be magician became the genesis for a full-length animated feature film. The film, *Fantasia*, fused animation and classical music into a groundbreaking concert film under the musical direction of the legendary conductor Leopold Stokowski.

"At last," declared Walt, "we have found a way to use in our medium the great music of all times and the flood of new ideas which it inspires." Ultimately combining eight of the world's greatest symphonic works, *Fantasia* presented new challenges with merging color, action, and music. This blend of high arts seemed a natural evolution, for by the time this concert film was in full production, two cels from *Snow White and the Seven Dwarfs* were a permanent part of the fine-art collection of the Metropolitan Museum of Art in New York. But striving to establish a loftier approach to the blend of art and music, Walt knew the concepts and ideas required a delicate touch. He began a concerted effort to widen women's roles in Disney animation.

From the earliest notion of this musical adventure, the women of Ink & Paint were involved. Ruthie Tompson recalled, "They gave us the script for *Fantasia*. It probably wasn't complete, but they told us to read it and see what we'd think of it and if we'd come up with a different name for it.

"So we all took it home," Tompson continued. "Our families all read about it, and we all were thrilled with it, and made suggestions . . . and every one of us decided that we like *Fantasia* for the name. And so [Walt] kept it."

FEMALE FORCES

In February 1937, Bianca Majolie was assigned to bring a feminine sensibility and delicateness to *Fantasia*. Majolie's early concept pieces explored and reflected the subtleties of a true programmatic narrative inspired by music. With Sylvia Holland's deft handling of fantasy and Ethel Kulsar's skill at character drawing, Majolie began developing some imaginative story concepts for Walt's concert film.

Holland explored early concepts on Jean Sibelius's *Swan of Tuonela*, which was never realized. But when Walt needed sprites

Feature Film Expansion

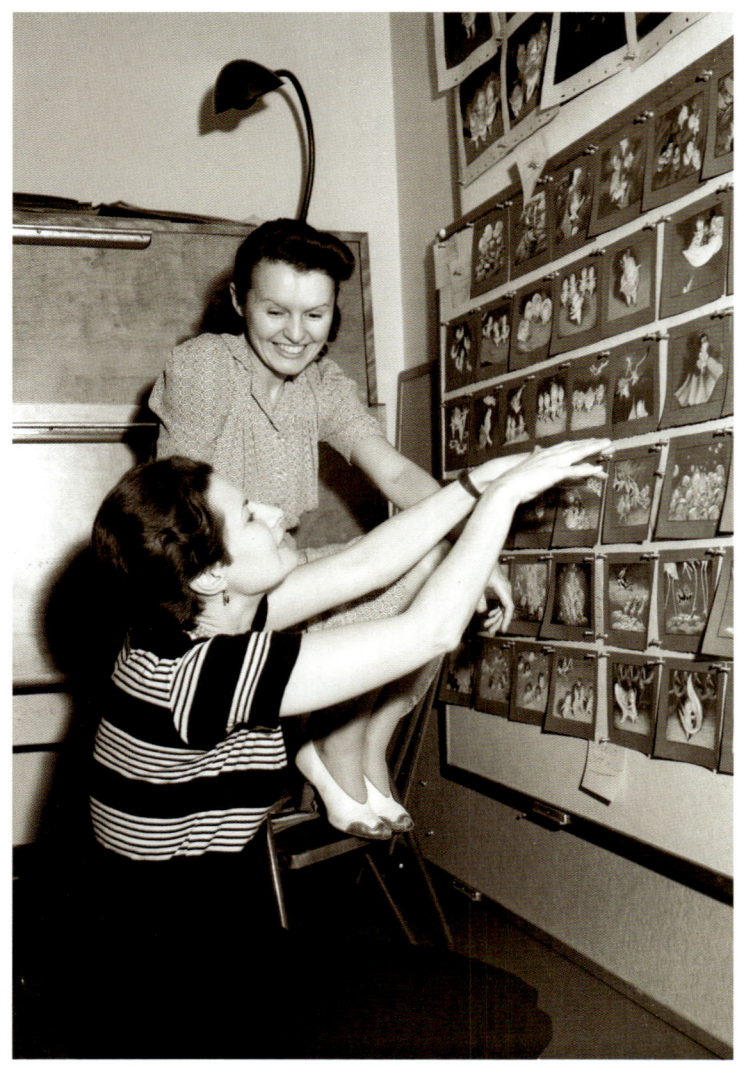

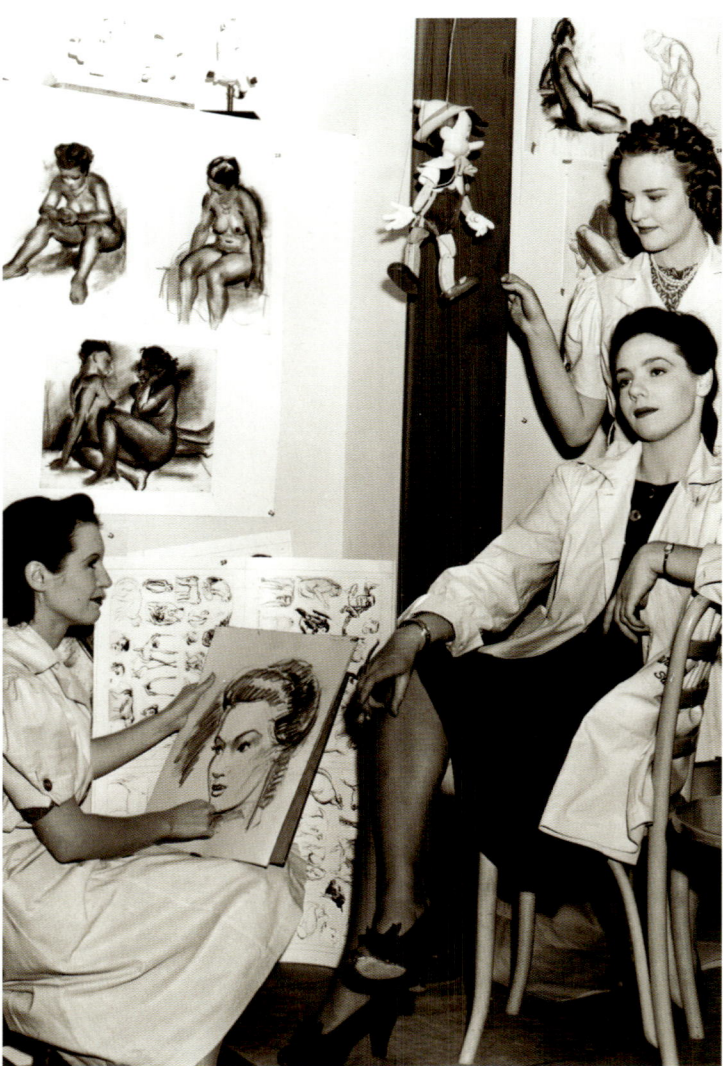

Pages 160/161: Concept artwork for The Nutcracker Suite sequence from *Fantasia* (1940).

This page, far left: Ethel Kulsar (seated) and Sylvia Holland (kneeling) work through their storyboards designed for the Baby Ballet sequence of Walt Disney's *Fantasia* (1940).

Right: Ethel Kulsar (left) sketches color Animator Mildred Rossi while the studio's first female Inbetweener, Viola Anderson, looks on.

and falling leaves for Tchaikovsky's *The Nutcracker Suite*, the men were not up to the challenge, and Holland handled the job masterfully. Disney described Holland as "a highly talented artist with a marvelous sense of decoration and color . . . who contributed immeasurably to the good taste and beauty of our pictures."

Story director Dick Huemer recalled, "I remember it was such fun because there were three girls [Majolie, Holland, and Kulsar] doing the storyboards and they would pick weeds in the outside lots and bring them in. They would use them for designs and for some of the little characters like the thistles. Very interesting. They were a very dedicated group."

Providing details and insights into the various subjects for this film was Mary Goodrich of the Story Research Department. Goodrich, noted for being the first female aviation journalist in the country, delved into such topics as prehistoric animals, Greek mythology, classical music, and even black magic. In addition to the details rooted out by Goodrich, Holland and Kulsar enlisted live-action models as well, referencing movement and tone for the final desired look and effect.

Conditions for this creative team were subpar. They were housed in the dilapidated apartment complex across the way from the Hyperion studio, according to Jack Kinney, who recalled the early days of development for *Fantasia*: "A few intrepid souls discovered that behind our apartment houses was a fenced-in backyard, overgrown with weeds and debris.

"This haven promised a perfect setting for staging and photographing live-action routines for the 'Dance of the Hours' sequence," Kinney added. "One of the secretaries, who had taken ballet lessons, was dressed in a lovely pink ballet costume, rehearsing to a portable, hand-wound phonograph playing a classical recording of Ponchielli's lovely theme, recorded by the Philadelphia Symphony Orchestra, conducted by Leopold Stokowski. From the weeds and debris of the sylvan glade, the melodic strains wafted through our open windows, quickly drawing the Story Department['s] curious inmates, who didn't mind offering suggestions to the perspiring artistic dance director. Ignoring us, she bravely continued her terpsichorean research until the sun set, when the valiant troupe packed and departed, as did the story crews."

A studio write-up noted, "Several girls of the Story Department started with the Disney organization as Inkers and Painters. Their skill with the brush and pen coupled with visualizing ability has landed them in the story sketching divisions. For one of the future feature productions, they are working on an entirely new technique—that of painting their sketches directly onto the celluloids." Taking early story ideas and visualizing them in color and context, the story sketches of these women—featuring females in many lead roles—found their way into the overall storyboard concepts. "[These] better artists would give us an idea of what it might look like in color and treatment," Dick Huemer observed. "And when this was done, we had the stuff on the boards with some nice colored things and played the [accompanying] record, and you could actually see *Fantasia* right up there."

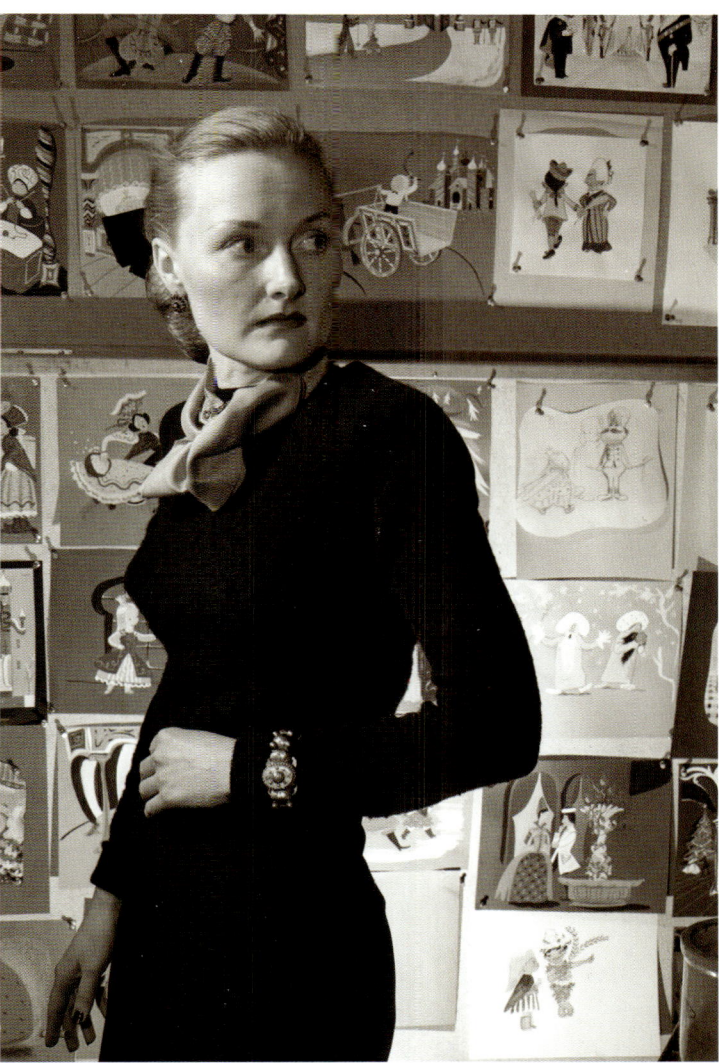

Studio story artist Peggy Johnstone.

Holland and Kulsar shepherded the "Waltz of the Flowers" sequence from *The Nutcracker Suite*. Majolie did preliminary work on the sugar plum fairies while Holland and Kulsar completed the sequence. "Miss Holland believes certain cartoon figures will become more natural in women artists' hands, [with] women in the audience preferring them that way," stated a revolutionary magazine story in 1940 entitled "Cartoons Given Feminine Touch by Women Artists." Holland's daughter Theo Halladay remembered seeing *Snow White* with her mother upon its release. "The one thing both Mother and I noticed was that when the Prince arrived on his horse, [it] was drawn clumsily, not accurately. She felt that if Disney was going to present realistic animation for the first time, it should be well done—better than that horse was."

After moving into the new Burbank studios, Halladay recalled her mother's actions when Walt came striding down the hall asking, "'Anybody know how to draw a horse?' I suppose he had been stung by others' criticism of the Prince's horse," noted Halladay. "She hurried out and walked along beside him, drawing a horse as she went. From then on she was teaching the men how to do it right." Holland taught the male Animators to define the form and movements of the slightly built centaurettes, the weighted horse bodies of the male centaurs, and the graceful movements of the mythical winged horses in flight. Sculptress Shirley Soderstrom of the Character Model Department formed the models for the centaurettes, various cherubic putti, Mother Pegasus and her offspring, unicorns, and jolly Bacchus, the Roman god of wine and celebration.

Feminine First

LUISA FIELD

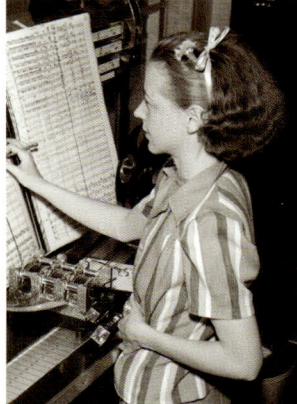

Advancing technology to achieve the optimum audio experience for Walt's concert film, Leopold Stokowski and the Philadelphia Orchestra recorded the music using a new system of sound recording and three-dimensional reproduction called Fantasound. Piecing together the musical foundation of the score was music editor Luisa Field, the first female Music Editor in Hollywood history.

Three aspects of the sound track had to be synchronized with the visual portion: dialogue, sound effects, and music. As Music Editor, Luisa took charge of the music portion, editing the scores for each classic work based on the early recordings, including the arrangement of Schubert's "Ave Maria," which featured lyrics specifically written for *Fantasia* by the noted American poet and novelist Rachel Field.

Once the music was addressed, Luisa worked closely with Steve Calling in cutting the final film. Final clearances and registrations of the music rested with Alma Fenter. As the studio's contact with the Hays Office, Fenter also oversaw the final synopsis approvals before animation could even be started. The work of all the musical talents was ultimately housed in the studio's newly established Music Library, run by Marcia Lees.

COLOR ANIMATORS & SKIRTED INBETWEENERS

Only after Walt Disney's approval did each scene make its way to animation. Dick Huemer explained, "The Animators had nothing to do with *Fantasia* until Walt had okayed the storyboards on the picture and a director was assigned to it." By late 1938, Disney had several women in training in Animation. Viola Anderson, the first "skirted" Inbetweener, and four other women worked alongside the lead Animators, completing the drawings between the lead Animators' takes on sequences throughout the film.

Handling some of the most visually challenging moments in *Fantasia* were Chouinard graduate Mildred Rossi and Marcia James, who both transferred from Ink & Paint into Animation and Effects in early 1940. Their Color Animation was employed to achieve the form of the devil, Chernabog, in the "Night on Bald Mountain" segment. These women also rendered and animated the creatures in "Rite of Spring," passing clouds in the "The Pastoral Symphony" sequence, and the tone-driven pastel forms within J. S. Bach's "Toccata and Fugue in D Minor" sequence.

With its fragile makeup and propensity to smear easily, pastel could not be utilized within animation. But to accomplish the desired subtlety and chalky feel of this medium, studio

164 | Feature Film Expansion

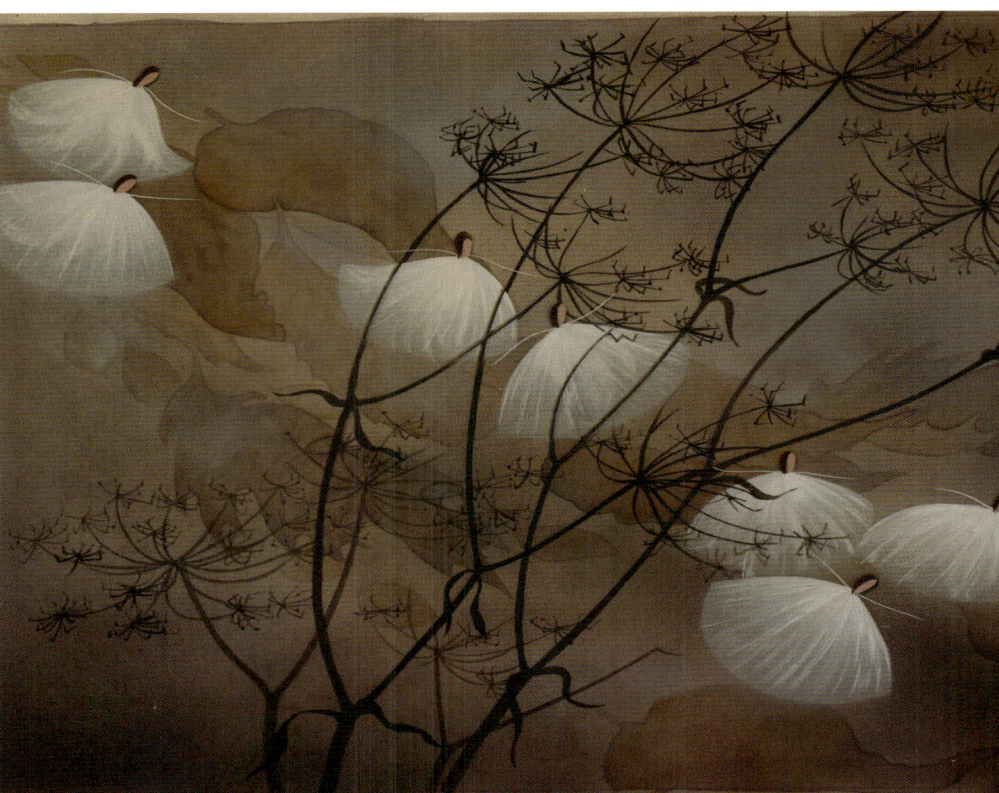

Left: Ethel Kulsar utilized nearby flora as inspiration for her Nutcracker Suite flower fairies.

Ethel Kulsar's final artwork for The Nutcracker Suite segment from *Fantasia* (1940).

Special Effects teams developed the "Pastel Effect," which was first applied on *Fantasia*. Working within this technique, the animated color and form achieved by these female artists provided drama and delicacy never before seen in animation.

In January 1939, a memo was issued to all personnel within the Inbetween Department as women began to breech the male-dominated domains of Animation: "Attention has been called to the rather gross language that is being used by some members of the Inbetween Department in the presence of some of our female employees. It has always been Walt's hope that the studio could be a place where girls can be employed without fear of embarrassment of humiliation. Your cooperation in this matter will be appreciated."

A FEMININE FEATURE

Providing movement and placement support to the overall production were a number of live-action reference models, including professional dancers Joyce Coles and Marjorie Belcher Champion (following her groundbreaking work on *Snow White*), Edith Jane, and Margaret Wesberg, as well as singer, actor, comedienne, and dancer Hattie Noel. Ballerinas Tatiana Riabouchinska and Irina Baranova also provided character and dance reference. Ink & Paint artist Grace Godino contributed comedic timing to various steps by stumbling around in oversized ballet slippers stuffed with cloth. With the help of these talented women, delicate fairies, blossoming flowers, shimmering snowflakes, and even pirouetting hippos en pointe all achieved anthropomorphic form.

Capturing audiences with mood and color was one of the more fascinating challenges with this concert feature. Never had color taken on such a vital role in animation as in *Fantasia*. Within the Ink & Paint Department, color was developed and various techniques were shaped to convey the tonal textures of the musical scores. Character color models were made in both warm and cool colors to explore the entire range of options. Detailed inking featured black-and-white lines of various widths, and painting choices involved over eight hundred colors along with a widening array of effects and techniques.

Color Model Supervisor Mary Lou Whitham explained, "In 'The Nutcracker Suite' segment, the highlights on the heads of the little mushroom dancers were rendered with airbrush. The heads of the Russian dancers were done with a stipple edge. The fish ballet sequence was done with transparent paint, plus drybrush highlights and pen line sparkles." When the intricacy of cascading snowflakes presented a daunting challenge for the Animators, once again, the Special Effects teams elicited the talents of the Ink & Paint artists. The women studied scientific diagrams of magnified snowflakes and replicated a series of individually unique crystal formations with white transparency paint and masterful inking on heavier celluloid material. These pieces were integrated into the three-dimensional live-action efforts developed by Herman Schultheis and the special effects team to achieve the effect of gently descending dancers.

The water in "The Sorcerer's Apprentice" portion was painted with transparent paints while the glow on Mickey, the apprentice, was rendered with airbrush. Betty Kimball noted that the development of special effects was a large part of the women's repertoire: "Working on special effects was really interesting. We did the special effects to make sparkles and the fairies dancing. We would do splashes by stippling on the top [of the cel] with a sponge to get foam. We figured out how to get a special effect by highlights.

"I thought painting on the other side of the cel was dull," Kimball admitted, "but figuring out how to get a sudden sparkle [was exciting]—you did it with extra paint on the top of the cel[,] and it really looks like a light goes on."

Pushing the envelope further, Disney expanded the

Ink & Paint | 165

Left: Final frame of Mildred Rossi's pastel Color Animation of Chernabog; and (right) a final cel setup from the Night on Bald Mountain sequence of *Fantasia* (1940).

complexity of color in *Fantasia*. Blend pencils were approved and created to define the delicate wings of the fairies in a range of colors from cerise to red violet. Careful combinations of orange and orchid, or yellow and blue, gave each featured wing an extensive palette. "Walt was so meticulous about the way it was done," recalled Marcellite Garner. "There was a scene where the hot bubbles in the mud are breaking. Each one of the bubbles was inked in five or six different colors. And it never showed in the picture, but you'd have maybe five shades of pink in one bubble, [plus] highlights and shaded lines and so forth. But Walt always said, 'They don't notice it while it's there, but if it wasn't there, they'd notice that it was different.' I suppose that's one of the things that made his cartoons better than others; he paid so much attention to details."

The musical tone poem of Bach's "Toccata and Fugue" introduced audiences to the suggestion of color and movement, with the "Fugue" portion requiring the most intricate multi-plane effects and exposures to that point. The delicate pastels of "The Nutcracker Suite" segment transported viewers to a veritable fairyland.

In direct contrast, the fiery reds, oranges, and yellows of Stravinsky's "Rite of Spring" segment blaze across the screen, only to be engulfed in a blue-green tidal wave. A murky gloom against ominous red skies sets the backdrop for a battle between prehistoric beasts. The gray-blue violet earthquake settles into the cool blue-green waters of a more peaceful world. Beethoven's "The Pastoral Symphony" sequence features brilliant rainbow hues of pink and green meadows populated by violet, blue, yellow, and chartreuse figures, in sharp contrast to the thin gray ghosts and dark witches set against the magenta and violet flames of unholy fires in "Night on Bald Mountain."

Spiritual hope is renewed as a gentle dawn draws back the dark of night with Schubert's "Ave Maria" segment of *Fantasia*. Less than one minute long, the visually stunning procession of the nuns required six multiplane camera operators and five Ink & Paint girls on hand to repair the paint, as it persistently chipped off during the shooting cycle of three-field sliding cels. This scene alone took more than three days and nights of continuous work to shoot.

Shadows required special applications as well as other special effects. "It was a translucent paint that someone had invented, and I thought it gave a solidity to the character," recalled Godino. A Painter on *Fantasia*, Godino oversaw "the fish that had those wonderful tails [with] the black lines that you could see through and see the colors so beautifully through it. And all the water scenes and the fire scenes—I worked on all of this." Godino continued, "We could capture things—for instance, the thistles that came down in 'The Dance of the Hours,' [well,] we worked on [that] for days and days to get that filmy effect. And you'd have to try to capture it from one cel to another so it wouldn't jerk and still look like it was that fluttery thing that just could fly off the page." Godino also handled "the water sequence [and] that huge wave [in] 'The Sorcerer's Apprentice.'" Despite this heavy load, Godino confessed that "we had fun!"

With all this extensive detail combined with the volume of content, even the most skilled of the Inkers and Painters had a number of issues develop with the material as it made its way through their department. Random summation notes submitted by Ink & Paint speak to the intricacy and detail sought throughout the effort: "Imagine the Ink Checker's surprise when she found an ostrich with three legs—all properly called for as tracebacks. Fancy painting three ordinary ostriches with pink ribbons on their heads when only the ballerina was supposed to have pink. Think of everyone concerned when it was ok'd *[sic]* for production, and someone not concerned discovered the error." For all of these issues, remarkably, there were no noted "battles" between Ink & Paint and Camera.

FANTASIA FANFARE

In addition to advancing steadily throughout the production side, women now held several important correlative positions at the studio. Janet Martin, head of Publicity, directed the flow of news releases from studio to newspapers and magazines across the country. "They had press books back then," noted legendary publicist Arlene Ludwig, "where all the head shots, production photos, copy—everything was contained in a large, glossy book and the exhibitors could choose whatever artwork they wanted." Publicity and marketing campaigns were still fairly new for most studios, but Disney's in-house creative teams wrote press releases and publicity stories and created all the necessary artwork for each film's launch.

Hired in January 1940, the studio's new promotion artist, Gyo Fujikawa, devised a variety of *Fantasia*-themed consumer products such as china, glassware, jewelry, and various textiles. Fujikawa also designed a number of *Fantasia* books, including the juvenile *Fantasia* reader, all of which were written by a young production writer from Minnesota, Roberta Lanouette.

With proper publicity measures in place by October 1940, the last touches of paint were made to the "Ave Maria" segment before the completed film was rushed off to New York for the premiere—literally, with hours to spare. *Fantasia* debuted at the Broadway Theater in New York in November 1940 and featured the largest contingent of credited female artists to date: Shirley Soderstrom, Ethel Kulsar, Bianca Majolie, and Sylvia Holland.

Introducing a new art form with his third feature-length animated film, Walt Disney noted, "A medium where color and motion are restricted only by the limits of imagination—the medium which is giving to the public *Fantasia*, that new kind of entertainment which has been described as 'seeing music and hearing pictures.'" Of *Fantasia*, Lillian Disney touted, "He was proud of it . . . because he had interpreted music in a way people could understand. He was very humble. He always liked what he had done."

With *Fantasia* completed, the Ink & Paint Department returned to work on various Mickey, Donald, and Pluto shorts, as well as preliminary animation tests on *Bambi* and the next overlapping feature assignment, *The Reluctant Dragon*.

OTHER STUDIOS

Animation work and releases were at an all-time high. Leontina Indelli pioneered animation in Italy, while a growing number of studios around Hollywood attempted to replicate Disney's success. Every studio featured artists trained at the Walt Disney Studios. Charles Mintz Studios set up in Hollywood and continued production on Oswald the Rabbit cartoons until Mintz was fired from Universal Studios and Walter Lantz took over production. Mintz's studio started the Scrappy cartoon series (created by Dick Huemer) and a series similar to Walt Disney's Silly Symphonies entitled Color Rhapsodies. With Mintz in poor health, his wife (and Walt's former distributor), Margaret Winkler Mintz, nursed him while assisting with studio operations. (The Mintz Studio operations were sold to Columbia Studios in 1939 and renamed Screen Gems Studios. Charles Mintz died in January 1940.)

In 1930, Ub Iwerks stepped out from Walt Disney to start his own studio with Pat Powers, creating such characters as Flip the Frog and a series about a young boy named Willie Whopper. Working in the inferior two-color Technicolor process, Iwerks's color animation continued with former Disney Supervisor Mary Tebb in charge of the Iwerks Ink & Paint staff. Artists put in a forty-four-hour workweek on a twelve-picture-a-year schedule without overtime. In 1936, distribution problems with Pat Powers forced Iwerks to close his studio. Both Tebb and Iwerks eventually returned to work at Disney Studios.

The Fleischer Studios were producing cartoons for Paramount Studios with their popular Popeye the Sailor Man series and Betty Boop cartoons featuring

Ink & Paint | 167

Pages 166/167: Colorful artistry illustrating a range of color and techniques featured within various final frames from *Fantasia* (1940).

This page, left: Dinnerware featuring the design of Consumer Products artist Gyo Fujikawa; and (right) Fujikawa working on designs for *Fantasia* (1940).

animation by one of the first female Animators, Lillian Friedman. Max Fleischer experimented in color and early dimensional processes, but their attempts were not as successful, and working conditions were rigid. Artists Claire Parker and Alexandre Alexeieff, who later married, developed an animation technique that brought engravings to life called "pinboard." This method was described by Parker in a later article as "a black-and-white technique somewhat analogous to the half-tone process." Parker and Alexeieff collaborated on a handful of cutting-edge short films. Their most noted film, *Night on Bald Mountain* (1933), is considered a groundbreaking example of experimental animation and provided inspiration for the ethereal ghostlike forms in Disney's take on Modest Mussorgsky's work in *Fantasia* (1940).

Former Disney artists Hugh Harman and Rudy Ising joined with Leon Schlesinger to create Looney Tunes cartoons, another direct attempt to take on Walt's successful Silly Symphonies, and a second series, Merrie Melodies. Auril Thompson, a young Minnesota art student who later worked at Disney Studios, began as a Painter with the Schlesinger unit for twelve dollars a week. "Because it was on the old Warner Bros. lot, it was really something," remarked Thompson. Inking & Painting were located on the upper floor where, according to Thompson, "there was absolutely no air-conditioning and nothing was insulated." Work was being conducted in less than desirable surroundings. "You could see through the floors," Thompson added. But employees made the best of the situation. "We used to write notes on the end of strings and let them down to the Animators on the floor below."

The Harman-Ising team parted with Schlesinger in 1933 and set up shop at MGM Studios. Having worked as an Inker and Painter at MGM in the mid-1930s, Xenia DeMattia recalled the glamour of studio life within what would later be deemed the Golden Era of Hollywood: "Oh, that was a glamorous studio! When we had to go to lunch, they had this great commissary. We had this long table; it was called the 'cartoon table.' Adjacent to that was the 'star's table.' And who sat at the 'star's table' at the very end, but Clark Gable and Spencer Tracy!" The parade of stars dining at the commissary continued, and DeMattia's lunchtime brushes with fame included contact with the likes of Judy Garland, Groucho Marx, and even Jimmy Stewart. "It was kind of fun," she recalled. "[At] no other studio that I worked in, even Universal, did you see that many stars."

A Painter at Harman-Ising in the early 1930s, Barbara Wirth Baldwin backed DeMattia's sentiments: "It was a fun place. I was fortunate because I was never put in a niche. I was allowed to learn a little bit about everything. I used to go to the library and do research for them. And when Harman-Ising closed, Hugh Harman gave me his Cord automobile with a chauffeur to drive me over to the Disney Studios to apply for a job!"

Disney was the only studio to create its own paint system. Other studios primarily utilized Grumbacher paints, but they came with a wide range of drawbacks. Problematic drying times and dramatic pigment separation were just two issues other studios contended with. "Sometimes we'd open a jar and the paint would be slimy and have a terrible odor," recalled Martha Sigall, who began painting at the Schlesinger Studios in 1936. To combat the drying-time issues, "we tried . . . using our little cornstarch bags to dust the cel. We made these bags by pouring a small amount of cornstarch on a paint rag and tying it with a rubber band." In 1938, Catalina Color Company opened its doors, and many studios changed their color systems to this premixed paint system.

Walt Disney enjoys playtime with his young daughters, Diane and Sharon, at their Woking Way home.

The Schlesinger Ink & Paint department was run by Frank Powers, who didn't encourage advancement. Sigall wrote about an exchange she had with Powers training herself to ink to earn more and move up: "'How long did it take you to do it?' [he asked on one particular assignment]. I told him and he responded with, 'No, you have to do it faster.' A few weeks later, I went to him again and told him that I was doing it faster. He gave me another excuse: 'I don't need another Inker at this time.' Another time, he told me I was too good a Painter and was needed in that position. I stopped asking him."

Jackie Ormes, a self-taught artist who created several successful comic strips and cartoon characters, breached more feminine barriers as the first African American female cartoonist, in 1937. Ormes's fashionable and professional characters, such as Torchy Brown, Candy the wisecracking housemaid, and later Patti Jo were not only humorous, but also expressed commentary on various societal issues, including race, current events, and environmental issues.

> "He was daddy. He was a man who went to work every morning and came home at night."
> —Diane Disney Miller

DISNEY FAMILY LIFE

The 1930s marked Walt Disney's transition into a family man. "Well, I guess we just decided it was time we had children," Lillian Disney recalled. But this proved to be a challenge. Two difficult miscarriages hit Walt and Lillian hard. "We were all very concerned about the miscarriages," Walt's niece Dorothy recalled. "You worried they might not be able to have their own child." Lillian's sister, Hazel Sewell, and Hazel's daughter, Marjorie, lived with Walt and Lillian at the time and cared for Lillian after both miscarriages. Marjorie later recalled, "It was very sad." While dangerous for Lillian, these losses also took a toll on Walt Disney. Irritable and driven, "I got to a point," Walt recalled, "where I couldn't talk on the telephone without crying." At his doctor's advice, Walt and Lillian left on a "gypsy jaunt" in the fall of 1931. "We had the time of our life," Walt remembered. "It was actually the first time we'd ever been on a true vacation since we were married."

Upon their return, Walt and Lillian began to build a new English Tudor-style home in the Los Feliz hills above the Hyperion studio. "I tried to set up my home as something apart," noted Walt. "There's hardly any evidence of the Mouse or anything around the place." They moved into their stately residence in 1933. The Disney home featured a large lawn overlooking the Hyperion studio with a swimming pool and pool house beyond on the lower terrace. Sunday afternoons were filled with festive gatherings including various staff and their families who enjoyed the pool along with barbecue cookouts.

In the summer of 1933, Lillian confirmed she was expecting again. Carefully cautious, Walt Disney wrote his mother, "Lilly is partial to a girl baby. She seems to feel that she could get more pleasure out of dressing up a little girl than a boy. Personally, I don't care—just as long as we're not disappointed again." On December 18, 1933, Diane Marie Disney was born.

Hazel and Marjorie moved out of the Woking Way home shortly after Diane was born. After suffering another miscarriage, Lillian's doctor advised against attempting to have another child, so Walt and Lillian made the decision to adopt. In January 1937, Sharon Mae Disney was quietly brought home at the tender age of two weeks old. "I would never let it be put in print," Lillian later stated. Born on December 31, 1936, Sharon completed the Disney family. When asked if Walt wanted a son, Lillian responded, "He always said he did but I think he liked girls best."

With two beautiful daughters, the Disney household was filled with the joys of children at last. Of her childhood, Diane Disney Miller recalled, "He [Walt] was a sort of person who, when you walked down the street, would have his arm draped around you, or he'd hold your hand. [He was a] very physically affectionate man." As a young father, Walt could always be counted on as the source of fun. "From the word go, Daddy was our playmate," Diane Disney Miller stated in an interview. "When Daddy came home at night[,] that was the fun time." Games of imagination and adventure were always under way between the doting father and his young daughters. His support and encouragement was equally evident. As Diane noted, "He would collect all my drawings and encourage me and make me think I was wonderful."

THE 1940s

1940
- FDR is elected to an unprecedented third term as United States president
- Notorious German concentration camp Auschwitz opens
- Bugs Bunny debuts in *A Wild Hare*
- Nylon stockings first appear on the market

1941
- M&M's candies are created
- Mount Rushmore is completed
- The Jeep is invented
- Pearl Harbor is attacked and the United States enters World War II

1942
- Anne Frank goes into hiding in Europe
- Japanese Americans are placed in internment camps
- The Manhattan Project begins
- The T-shirt is invented

1943
- Italy joins the Allies (after having sided with the Axis powers)
- The Warsaw Ghetto Uprising occurs in Poland
- The *Memphis Belle* crew completes its twenty-fifth combat mission
- Janis Joplin is born

1944
- Ballpoint pens go on sale
- D-day invasion to liberate Europe succeeds
- Hitler escapes assassination attempt
- The London Olympic Games are suspended due to the war

1945
- The first computer is built (ENIAC)
- The Germans Surrender and Hitler allegedly commits suicide
- The microwave oven is invented
- The United Nations is founded

1946
- Bikinis are introduced
- Dr. Spock's *The Common Sense Book of Baby and Child Care* is published
- Winston Churchill gives his "Iron Curtain" speech
- The Nuremberg Trials, which started in 1945, concluded

1947
- The US Supreme Court rules that women can serve on federal juries
- The Dead Sea Scrolls are discovered
- Polaroid cameras are invented
- Jackie Robinson starts for the Brooklyn Dodgers

1948
- The Big Bang Theory is formulated
- Mahatma Gandhi is assassinated
- The state of Israel is founded
- The Girls Rodeo Association is formed in San Angelo, Texas

1949
- Communists come to power in China
- The first nonstop flight around the world takes place
- George Orwell publishes his futuristic novel, *Nineteen Eighty-four*
- NATO is established

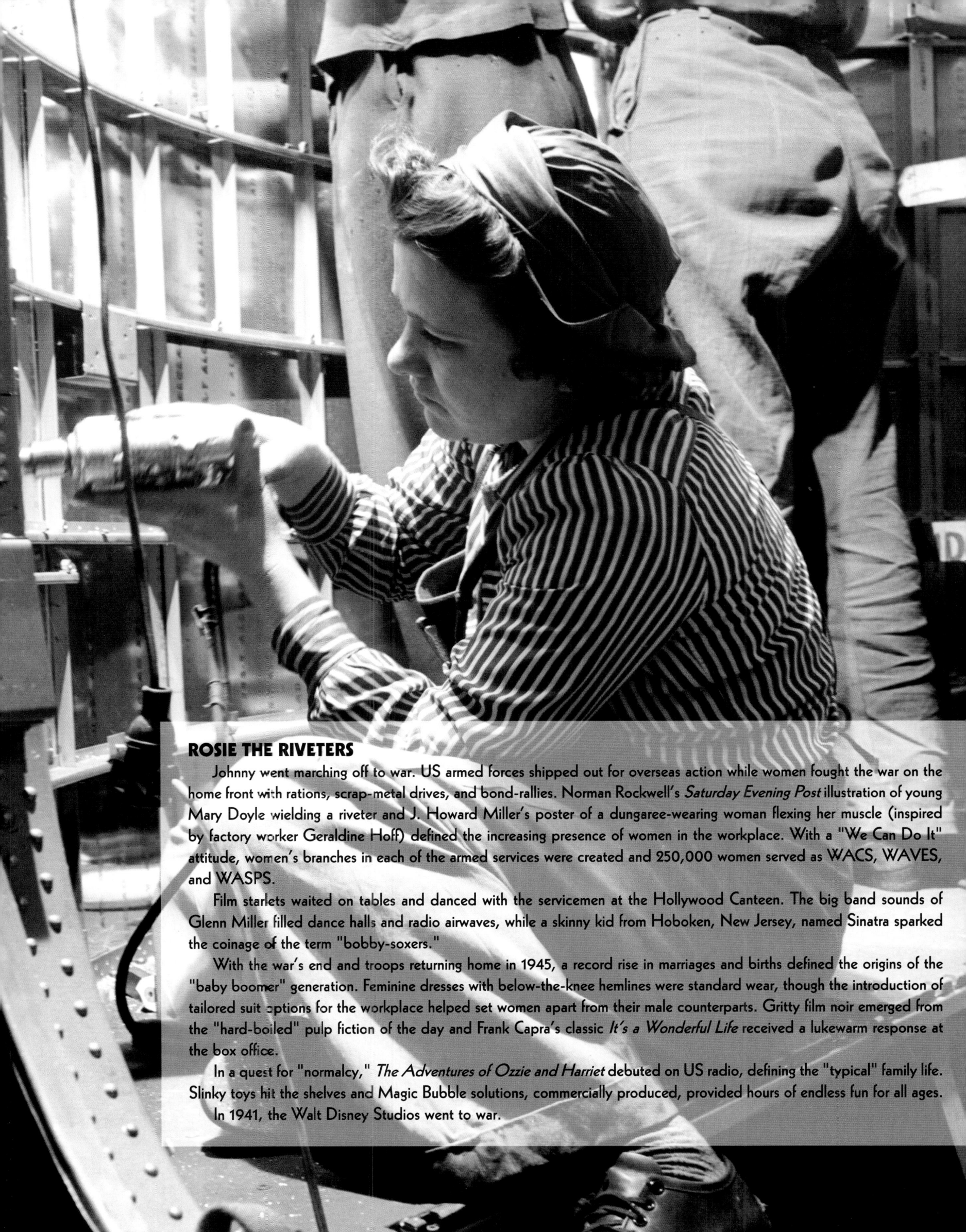

ROSIE THE RIVETERS

Johnny went marching off to war. US armed forces shipped out for overseas action while women fought the war on the home front with rations, scrap-metal drives, and bond-rallies. Norman Rockwell's *Saturday Evening Post* illustration of young Mary Doyle wielding a riveter and J. Howard Miller's poster of a dungaree-wearing woman flexing her muscle (inspired by factory worker Geraldine Hoff) defined the increasing presence of women in the workplace. With a "We Can Do It" attitude, women's branches in each of the armed services were created and 250,000 women served as WACS, WAVES, and WASPS.

Film starlets waited on tables and danced with the servicemen at the Hollywood Canteen. The big band sounds of Glenn Miller filled dance halls and radio airwaves, while a skinny kid from Hoboken, New Jersey, named Sinatra sparked the coinage of the term "bobby-soxers."

With the war's end and troops returning home in 1945, a record rise in marriages and births defined the origins of the "baby boomer" generation. Feminine dresses with below-the-knee hemlines were standard wear, though the introduction of tailored suit options for the workplace helped set women apart from their male counterparts. Gritty film noir emerged from the "hard-boiled" pulp fiction of the day and Frank Capra's classic *It's a Wonderful Life* received a lukewarm response at the box office.

In a quest for "normalcy," *The Adventures of Ozzie and Harriet* debuted on US radio, defining the "typical" family life. Slinky toys hit the shelves and Magic Bubble solutions, commercially produced, provided hours of endless fun for all ages.

In 1941, the Walt Disney Studios went to war.

BURBANK BEGINNINGS

> *"The first consideration was to provide a smooth and efficient production flow line—a sort of picture assembly line."*
> — **Walt Disney**

It was a new start. The spacious and landscaped grounds of the new studio in Burbank were like a sprawling college campus with towering buildings uniformly designed and lined in efficient succession stretching across the valley floor. Working with Walt, designer Kem Weber plotted a state-of-the-art studio designed for optimum function and contemporary form. A study was made of each department's needs, and for the first time in Hollywood's history, a new studio was built to fit those needs. Everything was purposefully laid out, strategically designed to match the evolving technological flow of animation production. Minimalist decor and stylish, functional furniture met each artist as they made the move into their new domain.

While still under construction, the studio announced the designs in a news release: "The new studio will be practically a complete twenty-one acre city. Paved streets, curbs, streetlights, storm drainage and sewage systems, and fire-fighting equipment are included in the setup *[sic]*. Among the buildings will be an 800-seat theater *[sic]*, restaurant, coffee shops, hospital, ample parking facilities, and shops capable of turning out a large part of the equipment needed for the maintenance of the studio." A wide array of amenities was available for Walt's employees: among them, dry-cleaning services, softball fields, a restaurant, a picnic area, barbers, and a snack bar with office delivery service. For the men, there was a members-only Penthouse Club, complete with a gymnasium, masseur, and sundeck for sunbathing; for the women of Ink & Paint, there was a "girls' cafeteria" complete with a private outer sundeck area.

A PRODUCTIVE PIPELINE

With a chance to properly align his departments into an efficient production pipeline, Walt envisioned producing a slate of eighteen to twenty shorts along with one animated feature film each year. An article in the *Journal of the Society of Motion Picture Engineers* explained the new layout that would enable him to meet this pace:

> One building was set aside for the complete creative function from beginning to end. This building is properly named the Animation Building, and in it are the Story Departments, Directors, Layout men, Animators, Assistant Animators, and Inbetweeners, the latter three doing the main part of the job, the absolute creation of the animated picture. Across the street from the Animation Building, and connected with it by an underground all-weather passage, is the Inking and Painting Building, from which branch the Paint Laboratory and the Process Laboratory, housing activities that are supplemental to the inking and painting process. From the Inking and Painting Building[,] the production flow line continues smoothly past a Checking unit into the Camera Building, and just beyond the Camera Building, in logical progression as to function, lies the Cutting Building, which represents the terminus of the process.

The workrooms faced north to get the most consistent natural light throughout the day, allowing the artists to work with the best possible light. Walt explained, "The importance of adequate light in any office building has always been appreciated, but in an office building which consists of over three hundred artists' studios, adequate lighting is doubly important. With this is mind," he added, "the rooms in the Animation Building and Inking and Painting Building were planned so that every artist was in an outside room."

MAKING THE MOVE

From December 26, 1939, through January 5, 1940, the general move took place. Marjorie Lusk, wife of Animator Don Lusk, oversaw the entire transition from the Hyperion studio to the Burbank campus. "It was one of the smoothest moves I've ever gone through," recalled her husband. "Friday afternoon, after lunch, we went to our rooms and put everything into packing boxes, and they were labeled according to where we were going to go." Even the disappearance of the exposure sheets for the latest production, *The Peculiar Penguin*, was quickly resolved when the alarmed Traffic Department earnestly scoured the empty halls of Hyperion and the crucial sheets were eventually found.

Settling into the spacious and state-of-the-art surroundings required a couple of weeks of adjustment, but by mid-January 1940, the ever-growing staff had transitioned into a new system of animation production—including the introduction of Unit Control Secretaries to track the access to each wing of the Animation building. From her central desk, each secretary would push a button to let each artist into his or her work area, as doors were now locked to control visitors. Designed for efficient communication, the studio-wide public address system—the back lot page—echoed across the campus' entire fifty-one-acre tract, which now included twenty-five buildings.

Pages 170/171: A young woman riveter works production assembly in the fuselage of a B-17F Flying Fortress bomber at Boeing Aircraft Plant, Seattle, December 1942.

Page 173: The new Walt Disney Studios' Burbank campus.

This page: Helen Nerbovig (on floor) and unidentified colleague unpack and settle into the new Walt Disney Burbank Studios.

While every other department made the initial move, the Hyperion Inking & Painting Building became a ghost town. The department was granted a week's vacation, having worked overtime since the previous August to complete the final inking and painting on *Pinocchio*. The Ink & Paint Department remained at Hyperion through May 1940, completing the work on *Fantasia* before finally making the move to Burbank on May 8th, 1940. *The Bulletin* heralded the event to the rest of the studio:

> Woe-be-gone looks to the faces of several Disney males who have been desolate since they moved to Burbank away from the glances of the Inking and Painting department will no doubt disappear when the entire unit moves into their new building. The new home of the girls, in addition to being completely air-conditioned, excellently lighted, and containing special lounge rooms, will have its own cafeteria, which will be operated solely for the benefit of the girls in this department. . . . Woolie Reitherman will just have to stay away—that's final!

"On the Friday night before we were moving," recalled Painter Wilma Baker, "we packed up our paintbrushes and anything we needed at our desks and went home and then came back to the new studio. That was really kind of exciting." Inker Grace Godino remembered, "I had to go in right at the very early stages, and after we'd been in these little tiny rabbit hutches, then we went into this big, big corridor[,] and I looked at all those shelves, completely empty—two or three large corridors.

"I said, 'What are you going to do with this? We'll never fill this. You'll never get enough Painters to fill this studio,'" Godino noted. "You could get lost, you'd have to have somebody put some little seeds so you could follow them around at

Ink & Paint | 175

Ink & Paint staff line up at the new Paint Desk to order their various ink and paint needs at the Burbank "studio."

the studio." Recalling her first impressions of the new Burbank location, Inker Jean Erwin reflected, "This place was desolate. Trees were just planted and the grass was just barely in. I was so homesick for some greenery, because this place was a real desert at that time."

Animator Jack Kinney marked the advancements of the staff's new home. "When the studio became more affluent, the screening rooms became posh mini-theaters, complete with air-condition, adjustable cushioned divans, and for once, enough ashtrays for the nervous butt-gobblers. But the basic function remained the same. . . . Someone once suggested that the new torture chambers should be renamed 'perspiration parlors,' but the name 'sweatbox' stuck."

While there was excitement about the improvements and possibilities, it was still a difficult transition. Evelyn Coats revealed, "It was kind of hard to think of going to a new place. We'd been there for so long and started there. It was so nostalgic, but anyway, it had to be done. Hyperion wasn't really great for a studio." For the Ink & Paint Department, their new facility presented the need for a number of adjustments to their process.

LARGER CORRIDORS

The Inking & Painting Building was formed in a similar fashion to the building at Hyperion, with four primary corridors built around garden courts to ensure optimum natural light. Yet it was three times larger than their facilities back at Hyperion. A studio write-up touted its size, noting that "the new department will comfortably accommodate four hundred girls. And at the rate the inking and painting technique is improving and becoming more complex, all four hundred desks should be occupied in due time." Inkers were upstairs for better light, while the Painters' corridors were downstairs.

At the far end of the main corridors ran a hallway, which led into added regions of the women's domain. The ground floor featured a state-of-the-art Paint Laboratory where all production paints were created and experiments with new colors and miscellaneous paint research took place. This new laboratory comprised three rooms, the first of which was lined with large metal pull-out bins filled with the vibrant powdered pigments. The middle room featured the paint mills for mixing the paint and processing materials for the production. Shelves were lined with the colorful array of jars filled with the various shades of paint, catalogued to over two thousand different colors. The third room, which had ventilation for the use of sprays and lacquers, featured a table in the middle for mixing the smaller let-downs of the various color values. A dumbwaiter system conveyed the various paints and materials between floors as needed. In addition to the actual working spaces where the inking and painting processes were carried out, the building also boasted supervisory offices and checking rooms where the production output was examined before being passed on to the Camera Building.

The second floor featured a secluded Tea Room with a number of tables and food service stations for the Ink & Paint staff. Just off the main room, a spacious sundeck behind the dining area featured umbrellas, chairs, and tables. Next to the Tea Room was a restroom with a full shower and fainting beds for the ladies if they felt sick.

Production problems the staff had encountered at the hodge-podge Hyperion studio would now be a thing of the past. All windows and doors were sealed and weather-stripped to keep dirt out, while drapes and carpeting were kept out of the Inking & Painting Department to avoid dust and lint. To manage climate and temperature issues, a state-of-the-art air-conditioning system—one of the very first on the West Coast—was designed for control over humidity to support the stabilization of paint formulas within the desert climate.

Yet even with these advanced facilities and the utilizing of the same materials, problems persisted—though they varied from corridor to corridor. Paints applied beautifully in corridors Nos. 112 and 113 might be rubbery in No. 114. Adjusting paint blends helped, but reactions would completely shift from week to week.

THE PAINT LABORATORY

Mary Weiser's staff settled into the new laboratory with twenty-two artists and technicians. Seventeen women worked in Matching, Dispensary and Mixing, and as the department's secretary. Five men were also part of the Ink & Paint Department—serving in the Paint Lab—including longtime lab staffer Steve McAvoy, who formulated, strained, and ground the paints along with Fred Wilson. John Gillam and Jack Vandagriff served as jar washers and general lab helpers, while Stuart Ferguson, who started in engineering, briefly served as the chemist at the time of the move.

In their new facilities, the Paint Lab team now provided the various types of paint, ink, transparent solutions, lacquer, blend

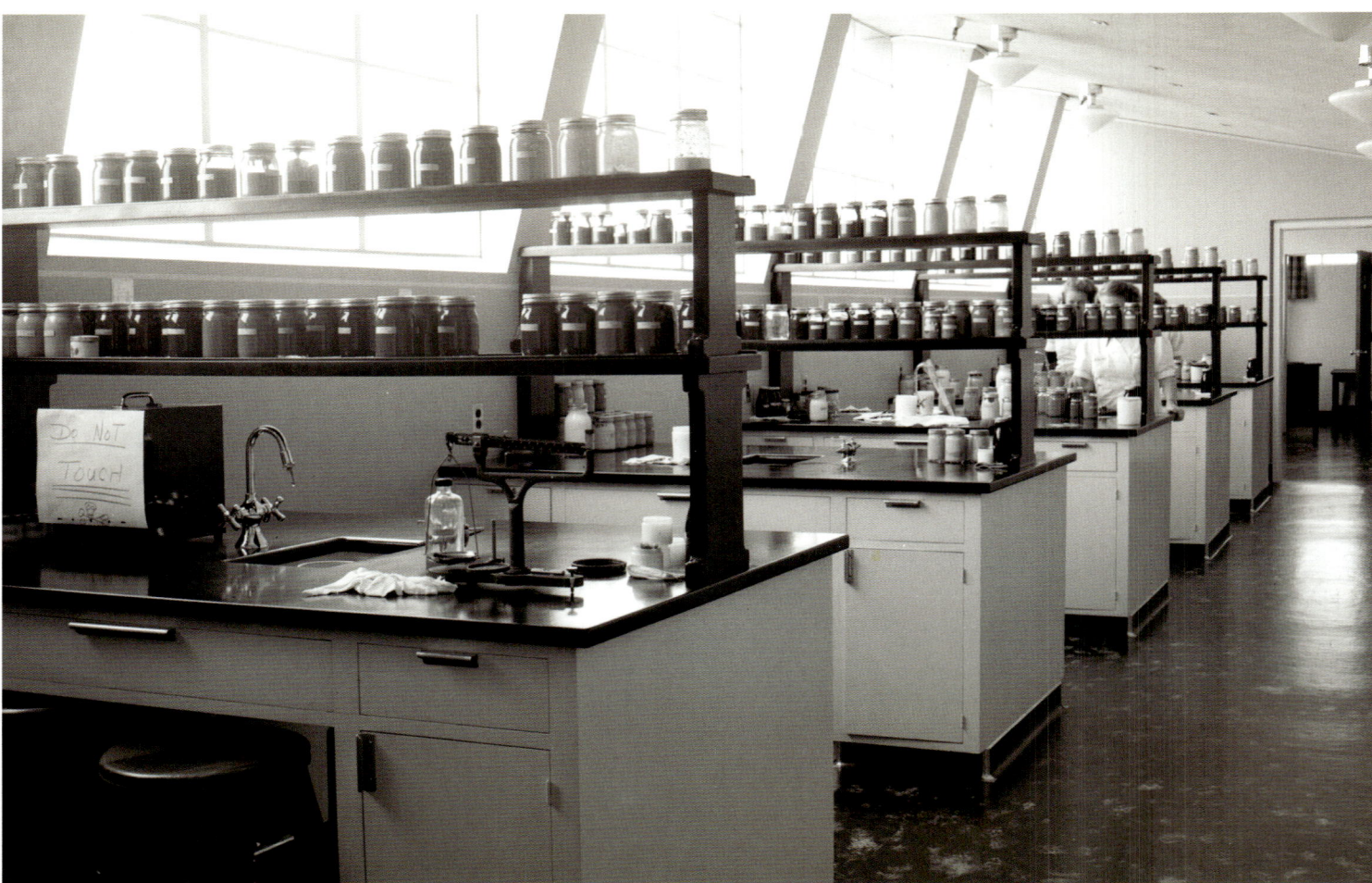

The new Paint Lab at the Walt Disney Studios, Burbank.

solutions, and blend pencils to the artists throughout the studio which, according to a studio press release included "Painters, Inkers, shadow girls, model girls, blend girls, Layout, Background, Checking, and miscellaneous departments."

Paint values and consistencies also varied according to department and purpose. Background paints were thicker and issued in tubes, while the thinner cel paints were distributed in one- and two-ounce glass jars. There were 127 families of color, which broke out to over 1,200 jars of opaque paint. Seventy jars of various "transparents" used for shadow painting and special effects required special care, including refrigeration and replacement into fresh jars every three hours. Fresh batches were created and replaced every morning, at teatime, after lunch, and at afternoon teatime, and also picked up at night. This necessary rotation required one woman to service the Shadow Department's stock on a full-time basis.

Women positioned at the control desk in the Dispensary received the paint orders, checked the paints, maintained the department's records, and were responsible for all servicing of standard paints. Wearing newly designed lab coats to help minimize dust and debris, lab women went through the new corridors with carts, picked up paint order slips, and then returned to the lab to fill them. They then delivered the orders, collected the jars when the Painters finished, and sent the jars for washing. Three hundred to one thousand jars were filled and delivered each standard day, and those numbers increased dramatically when things were extremely busy and there was a tight deadline. With the expanded studio, the delivery of paint took twice as long. Weiser even documented it: "The walking time alone from the Paint Lab to the four lower and four upper corridors, model rooms, Airbrush, Checking[,] etc., has lengthened the time considerably."

Weiser continued to explore new paints and options, but was cautious about existing commercial offerings. "It's amazing how many people feel that they have developed the most incredible paint in the world[,] and after a trial, we find it won't even flow or disperse well and countless other little factors." She further stated in her correspondence to a dealer while in early preparation on *Dumbo*, "Perhaps you are not aware of the fact that we manufacture our own paints. We like to feel that our own paint is unexcelled; however, we know that it would be folly to close our eyes to a new, more superior product." Yet the paint required for the quality of standards set by the studio needed to meet the following criteria:

1. "Are the paints equally suitable on nitrocellulose and cellulose acetate?"
2. "What is the average surface tension of this material?"
3. "Will the paints remain impervious to extreme changes in temperature and humidity?"
4. "Are the pigments organic?"
5. "Has the paint a gum- or water-soluble resin base?"

Becky Fallberg later recalled, "They used the same paint as long as I was there. This was the most wonderful paint; it was the finest paint. Everybody liked the Disney paint because it just flowed on the cel so easy."

Ink & Paint | 177

Left: The three ladies who ran the various Ink & Paint Departments: (left) Mary Weiser, Paint Lab; (center) Dot Smith, Painting; and (right) Grace Christianson, Inking.

Right: Photographic results of Mary Weiser's tropical sun and humidity test executed while on her honeymoon in Panama, 1940.

COST SAVINGS & FOREIGN WARS

In May 1940, just as the Ink & Paint Department arrived at the new studio, Roy Disney issued a series of memos instituting an effort to find cost savings throughout the studio. The advance of the war brewing in Europe cut off foreign royalties, and the new fantasy factory was feeling the pinch. Dot Smith from Inking responded, "We have talked to all our girls collectively about cutting down, and as soon as we are a little more settled and have more time, we are going to talk to each girl personally, telling them exactly what we're up against.

"It will create a closer feeling with the girls and get more work done when the girls feel they are personally helping to cut down expenses," she added. Keeping her experienced Inkers on the features, Smith also realigned her less experienced Inkers, or "chickadees," as she often referred to them, on the shorts to reduce costs. Assuring Roy of their support and efforts, Smith continued, "We have been thinking constantly of what we can do to help cut down on expenses, and you can certainly count on the Inking & Painting Department to cooperate in every matter we can to help you and Walt."

Grace Christianson, the head of the Painting Department, suggested the Directors and Layout Artists simplify the work required for each cel. "On the Shorts there sometimes is a tendency to put feature quality in them . . . fancy effects, too many props. . . . Too many colors are being called for, and insisted upon. Too much drybrush [sic] and other cel retouching demanded, and the animation of effects is becoming very complicated. This takes time in our department and it could be simplified. We have been doing quite a bit of cutting down on these things lately, however, and intend to do more."

Mary Weiser of the Paint Lab also expressed concerns over too much detail, stating, "the Production Department is getting so finicky on colors that they are increasing the Paint Lab's work by leaps and bounds . . . splitting color shades so fine that Technicolor does not register them and the work is lost." Even though the manufacturing of their own paints had been consistently saving the company nearly 60 percent of commercial costs for inferior paint that wouldn't properly stick to the cels, there was still a need for overall costs savings.

With the uncertainty of worldwide conditions ahead, problems arose in sourcing the watercolor pigments utilized by the studio's Background artists. "We are faced with the ultimate possibility of making our own transparent colors," noted Weiser in an interoffice memo. Resources from foreign manufacturers were soon in short supply, and rather than utilize available supplies that were "considerably inferior in quality," she added, "we feel that it is imperative to conduct some experiments in an attempt to duplicate the foreign colors." Lengthy discussions were held with Roy Disney, who welcomed the idea from an economic standpoint but urged caution in dealing with the Background artists who, as Weiser noted, "might be prejudiced against a paint made by our own organization."

In early December 1940, Weiser was working late at the lab on a Wednesday evening. The next day, however, she eloped, embarking on a honeymoon cruise in Panama. Now married, Weiser abruptly left the company and Dot Smith was placed in charge of the Paint Lab, with Jeanette Tonner stepping in as acting manager.

EMILIO BIANCHI

Emilio Bianchi, who worked in the Production Process Labs at the time of the move to Burbank, was officially brought into the Paint Lab in April 1941. "It was probably Ub [Iwerks] who got him to be in the Paint Lab," recalled Ruthie Tompson. As a young chemist, Bianchi had been working with Technicolor labs in London when his family fled to the United States at the outbreak of war. He was later recruited to work at Disney Studios and spent the remainder of his career redefining the paint formulas for better cel application. "He called them 'the girls,'" remembered Bianchi's son, Ed, "but to everyone, they were 'the girls.' He worked on improving the paint and on research to find better cels. They found that cels made of cellulose acetate were better[,] and used them for years."

Sylvia Holland's daughter, Theo Halladay, recalled working in the Paint Lab as a teenager. "There was a problem getting paint to stick on acetate cels, a problem that Emilio had heard about when he was part of a group touring through the studio. Being an enterprising sort, with some chemical experience and a great interest in paints, Emilio went to Walt and told him he could come up with a paint that would stick to a cel." According to Halladay, "Walt liked him and decided to take a chance on hiring him. Emilio did deliver on his promise. He succeeded in developing a paint that would stick to the surface of a cel."

Bianchi's formulas, mixtures of gouache paints, responded directly to changes in temperature and humidity, allowing the paint to retain just the right amount of moisture to permit expansion and contraction relative to climactic conditions. The consistency of Emilio's paints also addressed any possible paint mottling, which would reflect uneven blending of the multiple pigments mixed to achieve a particular color. All pigments were purchased in bulk, with over eighty colors for over one thousand different values all stored in jars or in formulas carefully documented in the lab files. Colors that might fade were avoided if possible, but if used, they were tested regularly to keep the shades consistent. When viewed through the cel, the vibrant colors appeared flat, but Bianchi's paints achieved the proper density to provide a controlled edge without creating ridges or uneven textures when dried.

Nitrate cels were still being reutilized on various "shorts" while the studio was adjusting to acetate cels. In a memo to Roy Disney from Ink & Paint, some of the problems with the cels were spelled out: "It seems that there are certain stains left on the nitrate cels that might be picked up by the camera." Acetate contributed an equal share of problems, according to those in the department. "There seems to be an objection to the acetate cels in that after they are washed," the memo continued, "they buckle and don't lay down flat. This would cause halations and jitter motion in the camera work. The material also warps out of shape. Of course, after a length of time, it would come back to its original shape and there would always be the problem of just when that would be. The [cellulose acetate] absorbs much more water than the nitrate celluloid. Another bad feature that has been found about acetate after being washed, is that it pits. It seems to leave particles like grit on the face of the sheet." Despite these daunting challenges, Emilio Bianchi's efforts redefined the colorful artistry of Disney animation.

DOWN THE DRAIN

In a small room positioned down a small walkway behind the Ink & Paint Department was the Cel Washing Department. The tiny windowed structure located near the nitrate vaults consisted of a large room lined with industrial sinks and hoses. Mr. C. O. Peterson oversaw three men who managed all celluloid concerns used by Inking & Painting, Background, Production, Camera, Airbrush and Special Effects, and the Courvoisier cel program.

Peterson explained the department's routine: "We punch all cels as they come in and deliver them to Inkers as ordered. Each morning we pick up all cels discarded by Inkers and separate the nitrate from acetate, pick out the defects that cannot be used for production[,] and put them away for return to factory. Cels that have been soiled[,] or on which the Inkers have made mistakes and discarded, are washed and returned to inking rooms. When a picture has been released, we bring the cels to Cel Wash Room and separate the spacers for reuse and sell the painted cels."

With the move to Burbank, a vendor was established for the washing of the cotton gloves and various wiping cloths utilized throughout the labs and corridors to ensure cleanliness and eliminate fingerprints on the cels. Gloves were also to be kept clean from dried paint, as stiffened gloves scratched the cels.

UP IN SMOKE

Once a production was completed, animation drawings, cels, and other materials were separated and sent to the basement of the Ink & Paint Building to what was affectionately referred to as the "Morgue." While the Animators' paper drawings could be studied and utilized by Animators for reference on future projects, only a few of the key cels were retained, as the cels created in Ink & Paint were always meant as a temporary bridge from paper to final film. The highly flammable nitrate content of celluloid added to the short shelf life of the colorful work of these artists.

"I worked down there for quite some time," recalled Grace Godino of her adventures in the Morgue, "and it was fun to work with the material, but it was [also] awful working down there. It was just dark, I mean, completely enclosed. But they had all those cels and they were very flammable. We lost a lot of those wonderful, wonderful cels because they had to throw them away.

"In fact, I was working in the Color Model Department for a number of years, too," Godino continued, "and we had a lot of those cels up there that we kept on file, and one day the fire department came and said, 'We're going to take all your cels.' We used them all the time for reference work, and oh, they were so beautiful. We said, 'Oh, you can't take them, we're working.' He said, 'Lady, I'm taking them. Do you want to come with me and

Left: Cel washing; and cleaning (right) at the Burbank "studios."

I'll show you why?' So, we followed them out and he took a group of cels and he put them in this big cement cavern and he threw a match in it and it went 'KAPOW!!!' . . . blew up in one minute."

THE INKER'S SHUFFLE

To work with the best possible natural light, the Inking staff was positioned on the second floor of the building. Once production in the new studio was under way, the staff quickly discovered the bounce to the floor as staff walked along the corridors. "An Inker would get a 'jog' in the line, if someone regularly walked by," noted Inker Carmen Sanderson. "So you walked without lifting your feet up. They called it the Inker's Shuffle." Ginni Mack laughed, "Yes, you glided. Everyone knew you had to glide with your feet when you were up on the Inking floors."

As a new studio guard, Johnny Polk had to quickly develop the finer points of this necessary choreography as he made his rounds through the Inking Department. "The first time he came into our corridor, everything stopped!" recalled Lucile Williams. "All the girls stopped and watched him. He had just learned to shuffle and had to go from one end of the corridor. He was so self-conscious and trying not to see the girls with their grinning faces. His face was pink!"

"It didn't matter with the Painters," noted Eleanor Dahlen, "but it definitely mattered with the Inkers, because when they're in the middle of a long line and they've got it going really good [and] then somebody walks by, and 'Oh! Now I've got a crook in there!' To fix it, "you would usually take it off a little bit, [and] hopefully there was a place where you could connect the line perfectly; and if you can't, then you take the whole thing off and do the line over." Thus the shuffle was critical, as time was always of the essence. This distinctive shuffle soon became second nature, as Ruthie Tompson noted. "You'd be at the market[,] and you could always spot a studio Inker by the way she shuffled."

STATISTICAL EFFICIENCIES

Working hours were changed throughout the Inking & Painting Department to a standard 8:30 a.m. to 5:30 p.m. workday, and by April 1941, new ratings, time cards, and quota systems were introduced. Efficiency experts were brought in to devise methods to reduce waste and increase productivity. A department handout clarified the new procedures: "Scenes delivered to the department are routed through the Statistical Division where representative breakdowns are made of similar type drawings."

Two to three drawings were pulled from each scene delivered to Inking, then timed by an average Inker with a stopwatch. The time it took to complete the inking required for an average cel was transposed into a point scale and notated on the key card attached to each scene. This time rating was also factored into each individual Inker's work.

Once the Supervisor handed out the scene, individual Inkers listed their timings on cards, indicating the "total amount of time consumed in completing scene from time of pickup to delivery to Supervisor." Inkers were now mandated to notify their Supervisor "that a new job is needed at least one half hour before running out of work. Painters must give notification one hour before new work is needed."

Young Inker Nancy Massie remembered a system at Disney called "the speed-up system. There were people who did nothing but time the Inkers; you had five minutes to ink a Mickey Mouse and a little longer for certain characters in *Fantasia*. And charts were made of where you stood above and below the average. One of the girls told us tricks to keep our speed up, like 'don't lift your head when you pick the paper and cels off the shelves

Left to right: Artists Ethel Kulsar, Mildred Rossi, Viola Anderson, Woolie Reitherman, Retta Scott, and Riley Thompson review production photos on the set of *The Reluctant Dragon* (1941).

Page 181: Various photographs of the studio's Paint Lab's colorized as storyboard inspiration for the Ink & Paint scenes from *The Reluctant Dragon* (1941).

in front of you.' It became a mechanical process of grabbing a paper drawing with your left hand and placing it on your board as your right hand grabbed a cel and put that down, while your left hand took the tissue paper [manifold] that protected the cels and [threw] it over your shoulder.

"Then your right hand would take the crow-quill pen that was stuck in an inkwell, and you'd ink the cel fast," Massie explained. "They had people who would come along and pick up the tissue papers on the floor behind you and fill your inkwells." This method seemed to work for the young employee who added, "I got to be second fastest. I was ambitious. I could ink twenty-five cels in an hour."

Time cards were collected at the end of the day and routed through the Statistical Department for ratings and notation in their statistical files. Every two weeks, the number of rated cels and total hours consumed were tabulated and recorded. An average of 8.8 cels per hour in Inking and 6.7 cels per hour in Painting was to be maintained. Each individual employee's speed average was then "combined with the rating of at least three Supervisors for quality, which includes judgment, attitude, adaptability, neatness, and general ability."

Five levels of classification, from "Poor" to "Excellent," were statistically calculated to determine the rating of each girl's speed and quality, which were then applied against the salary scale for Inking & Painting. At the end of each month, adjustment checks were issued on the level of quality and quantity completed by each woman.

As the procedural memo established, "Individuals falling consistently below average for a period of three months will be either eliminated from the department or reduced in salary in accordance with their earning capacity."

With larger staff and new efficiencies, Time Control mandated that rest periods be staggered across the various corridors, with three breaks falling between 9:45 and 10:15 a.m. and in the afternoon as well. Marie Justice remembered, "We had teatime in the morning and we could have coffee and coffee cakes. Then in the afternoon, they had teatime and they had tea cakes from Martino's [a local bakery]." Ginni Mack added, "They had little sweet rolls and muffins and things. Yes, the tea was free, but you had to pay for coffee."

LONG SHOT: INTERIOR INK & PAINT

Not all the Disney projects garnered high financial awards—at least not initially. To meet the shortfall of *Pinocchio*'s lagging box office and frozen foreign receipts, Walt Disney's latest return to the screen was a live-action anthology feature film entitled *The Reluctant Dragon*. This quickly produced and cost-effective film took audiences on a loosely threaded, behind-the-scenes tour of the new Walt Disney Studios.

Robert Benchley, a familiar Hollywood columnist and film presence of the 1930s and 1940s, played himself as a would-be pitchman making his way around the studio lot to meet with Walt Disney. For the first time, audiences would peek through a living window into the inner workings of the Disney Studios and get a

 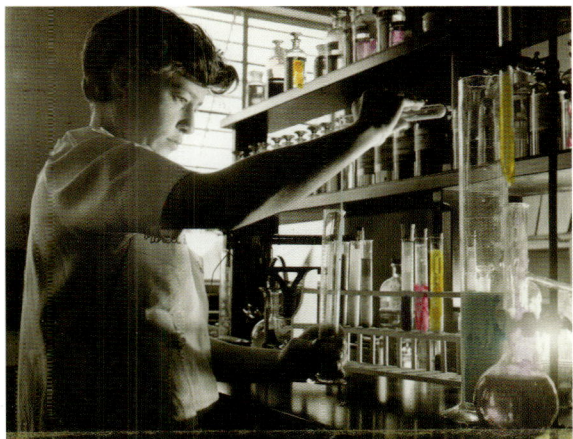
 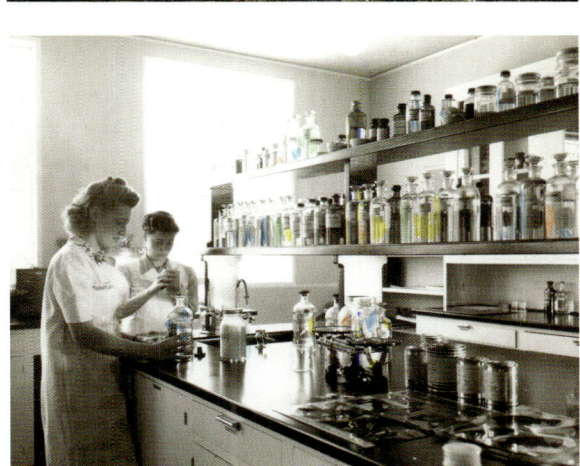

glimpse at how animated films were made. Along with the many other divisions of the studio, *The Reluctant Dragon* offered the first look into the world of Ink & Paint.

The first draft of the script appeared August 8, 1940, offering detailed insights into the entire inking, painting, and special effects processes of the female artists. The opening bustle and banter around the order counter of the Paint Lab involved the girls shouting out paint orders "in the crisp manner of lunchroom waitresses: 'One *Robin Hood* red and a dusky rose!' 'Mood indigo—number five!' 'Sink the pickle green and make it four blue Monday!'"

Stepping into an Inking corridor, Robert Benchley gasps, "Are all these pretty girls artists?" His first sight of the colorful jars of paint in The Rainbow Room causes Benchley to remark, "This reminds me of my aunt Effie's fruit cellar!" But the know-it-all traffic boy quickly corrects him: "The girls in our Paint Lab are all trained chemists." Somehow, this statement of female accomplishment was edited out in subsequent rewrites.

Filming within the actual Inking & Painting building was not practical, as it caused problems with lighting, added dust and distractions, and led to production delays. In October 1940, a spectacular re-creation of the Ink & Paint Department began to take form, spanning the eleven-thousand-square-foot area of the studio's soundstage. Many of the actual Ink & Paint staff stopped by to garner a peek at their staged workplace. While production on the film carried on across the lot, production work wrapped on *Fantasia* and continued on *Dumbo* and *Bambi* within the actual Ink & Paint Department.

Casting calls went out among the Ink & Paint legions at the studio to provide the background "atmosphere" and a few featured faces on their staged set. For publicity efforts, a photo shoot was announced, with "the 15 loveliest studio girls" appearing in their bathing suits. "Secret balloting by unnamed judges" was to take place, but perhaps due to the proclivities of the male population, "it is unlikely that time or place of shooting will be divulged."

Several key female artists from the studio were then cast as extras: Animators/Inbetweeners Mildred Rossi and Viola Anderson, sculptor Vera Yunger, and researcher Elsa Timner all appeared on-screen. Actress Frances Gifford played the recurring female who seems to be everywhere within the studio.

The film released on June 20, 1941. The mediocre box office results reflected the conflicted times as well as the disappointment of audiences and critics looking for a full-length Disney animated film.

DIVISIONAL DIVIDES

The new decade arrived with such promise. With a new studio at the highest level of staffing and talent, Walt's concert masterpiece, *Fantasia*, was just opening around the world, and a slate of exciting feature films were in the production line, including the stories of *Bambi* and the lovable elephant with big ears, *Dumbo*. A bright young artist started in the Color Model Department in 1940. Mary Blair, the wife of artist Lee Blair, found the work "interesting, but not enough to sidetrack my first ambition. So I quit in the summer of 1941," to paint at home.

The spacious new studio and deluxe surroundings in the middle of "nowhere" seemed to separate staff and countermand the camaraderie of the artists. As 1940 ended, a long series of pivotal events unfolded that forever altered the course of the Walt Disney Studios. The war in Europe took a turn for the worse as

Left: Phyllis Thompson poses for Don Graham's art classes for studio artists.

Right: Inker Rae Medby moved into Animation after completing the studio's training program in the early 1940s.

the Allies suffered a number of devastating setbacks. Hitler and his Axis powers advanced throughout Europe, Africa, and Asia, and refugees were fleeing their war-torn countries. From sweeping global events to internal conflicts, this period marked one of the most challenging times of Walt Disney's career.

TRAINING LADY ANIMATORS

By late 1940, Walt Disney Studios had reached a historic peak, with 1,023 employees—30 percent of whom were women. It was an unprecedented number in the animation world, as well as Hollywood, and an even more impressive ratio considering women constituted a mere 25 percent of the US workforce in the 1940s. Of the 308 women employed at the studio, 60 percent worked in Ink & Paint, and well over a hundred women were employed in a wide range of creative and administrative capacities throughout the studio.

With the new levels of artistry achieved in the studio's animation, and the growing advancements being made by women on his staff, Walt Disney launched a program to train key artists from Ink & Paint as Animators.

Viola Anderson and a handful of others had earlier breached the realms of Inbetweening, but now ten women, including Thelma Diefenderfer, Catherine Virginia Gleeson, Jean Holehan, Betty Smith, Beryl White, and Retta Davidson, were accepted in the first program and moved into Animation.

Along with this new program, the Ink & Paint Department was restructured once again. Grace Christianson and Dot Smith were assigned management of all feature films and special projects work, while Grace Bailey supervised the "shorts" footage. With an increase in the Shorts output, this division became the training ground for new Inkers and Painters as they developed their skills for feature film work. Just as a number of Ink & Paint girls had been trained within Special Effects Animation, training continued for the new legion of skirted Inbetweeners and Animators.

But turmoil was roiling, not just overseas but across the industry as well, and a number of disgruntled Animators began to take notice. "[Animator] Art Babbitt was at the studio and he was the one that started talking," recalled Grace Godino. "He would invite us [Inkers and Painters] out to lunch. . . . He meant well, I think, but he was really gung ho for this [labor] strike . . . and he was a powerful talker."

MOUNTING PRESSURES

Throughout Hollywood, unions were pressuring staff at the various studios. Working conditions, hours, and pay were all issues on the table. By February 1941, following several egregious strikes, employees at Schlesinger Studios, Universal, and the Screen Gems Studio had joined the Screen Cartoon Guild; a number of attempts at unionizing had been made at the Disney Studio as well. Jack Kinney recalled, "It was spring of 1941, and the Depression seemed to be over. Prosperity was just around the corner, and a lot of the people at Disney wanted to turn that corner. Arguments for and against [forming] the union echoed through the halls."

When union leaders threatened a strike at Warner Bros. Studio, pressure was also starting to mount at Disney. "We didn't like the way they got to the girls and scared them into thinking that they had to do this or that or something else," remembered Ruthie Tompson. Rumors began to fly and a level of unrest was becoming apparent. In a speech before his entire staff in February 1941, Walt Disney attempted to settle the developing unrest and quell concerns about the expansion of women's roles

within the studio. "Another ugly rumor is that we are trying to develop girls for animation to replace higher-priced men. This is the silliest thing I have ever heard of. We are not interested in low-priced help.

"We are interested in efficient help," he stated. "The girls are being trained for inbetweens for very good reasons. The first is, to make them more versatile, so that the peak loads of inbetweening and inking can be handled. Believe me when I say that the more versatile our organization is, the more beneficial it is to the employees, for it assures steady employment for the employee, as well as steady production turnover for the studio."

"The second reason," Walt continued, "is that the possibility of a war, let alone the peacetime conscription, may take many of our young men now employed, and especially many of the young applicants. I believe that if there is to be a business for these young men to come back to after the war, it must be maintained during the war. The girls can help here.

"Third, the girl artists have the right to expect the same chances for advancement as men, and I honestly believe that they may eventually contribute something to this business that men never would or could. In the present group that are training for inbetweens there are definite prospects; and a good example is to mention the work of Ethel Kulsar and Sylvia Holland on "The Nutcracker Suite" [segment of *Fantasia*], and little Retta Scott, of whom you will hear more when you see *Bambi*."

To advance these transitions and combat the mounting unrest, Janet Martin of the Publicity Department launched a series of articles lauding Walt's efforts in the advancement of women's roles within the Disney organization:

> Until a few months ago the work of animating characters in the Walt Disney Studios was purely a man's job. Today, there is a special art class made up of talented young women of the organization, who are receiving final training in the job of creating the whole gallery of Disney characters, of animating such interesting effects as smoke clouds, water, and other enchanting Disney phenomena. But animating is only the newest branch of the business of making cartoons [that] has been thrown open to women in this Hollywood cartoon "plant." In the vast and complex workshops which go to make up the Disney organization, women are holding important posts in Story and Character Development, Backgrounds, Layouts[,] and Cutting.

STAFF SUPPORT

By mid-March, divisions within the staff were growing. On March 24, 1941, Walt and Roy called their department heads together for a meeting to discuss the budgetary concerns and institute new hours of operation. The Ink & Paint Department heads, Dot Smith and Grace Christianson, sent a memo outlining their support to Walt and Roy:

> The meeting last night was wonderful! Of course we know you guys so well, and anything you say is O.K. *[sic]* by most all of us. Sorry we have to add "most all of us," but since all this union trouble there are undoubtedly a few, and we're sure very few, that are first rate "stinkers" in the plant. We appreciate very much the fact that you called us together last night to explain things to us. An employer doesn't usually do that, the employees are generally given a notice with their pay check *[sic]*, and that's all.
>
> We're sure the girls over here would be glad to take a cut to help lower expenses. So don't forget them if you need to cut further. . . . We thought of something else—how about the interest on the stock you so generously gave us. (this would ink and paint a 4 ft. scene) . . . and you could keep it to help keep the plant operating . . . maybe it can't be done . . . but it's all we can think of now. We're sure the boys can do as much work in 40 hours, because we've been operating on those hours since October, and our footage hasn't dropped a bit. . . . It's also a swell thing for us to be able to do something for you for a change—we think this should have happened long before this. In closing, if anyone gives you any back talk about this—just send them to us, we'll serve on the committee with boxing gloves!

Assuring the girls their suggestions were appreciated, but that they wouldn't have to resort to such measures, Roy quickly responded: "Thank you for your note. It is the feeling and the knowledge that we have so many people with us like you girls that gives a person courage to keep fighting and not lose faith in our fellowmen *[sic]*. . . . Many thanks again for your support. You're wonderful."

> **"** *I have never had the faintest idea where this business would drag me one year to the next. It's at the controls, not me!* **"**
>
> —**Walt Disney**

STUDIO STRIKE

The rosy possibilities for the female forces were now waning in the shadow of threatening unionization and a possible strike. After heated meetings and volleyed threats for several months, final meetings between Walt Disney Studios and the negotiating teams for the Screen Cartoonists Guild erupted and led to a complete standoff. With story and animation progressing on *Dumbo*, the studio was facing the process of completing *Bambi*, with most of the work now headed for Inking & Painting.

During the afternoon of May 27, 1941, Walt met with the Ink & Paint staff in the Tea Room. Flanked by Dot Smith and Grace Christianson, Walt addressed the Inkers and Painters. Phyllis Lambertson, an artist in the Airbrush Department, stated, "He started out by saying that he was calling the girls together to ask for their cooperation. He wanted to assure . . . [those] who wanted to come to work the following day across the picket line [that they] would have his complete backing; that he would support them and that their jobs would be safe." With the department behind on production, Smith and Christianson were in accord on their

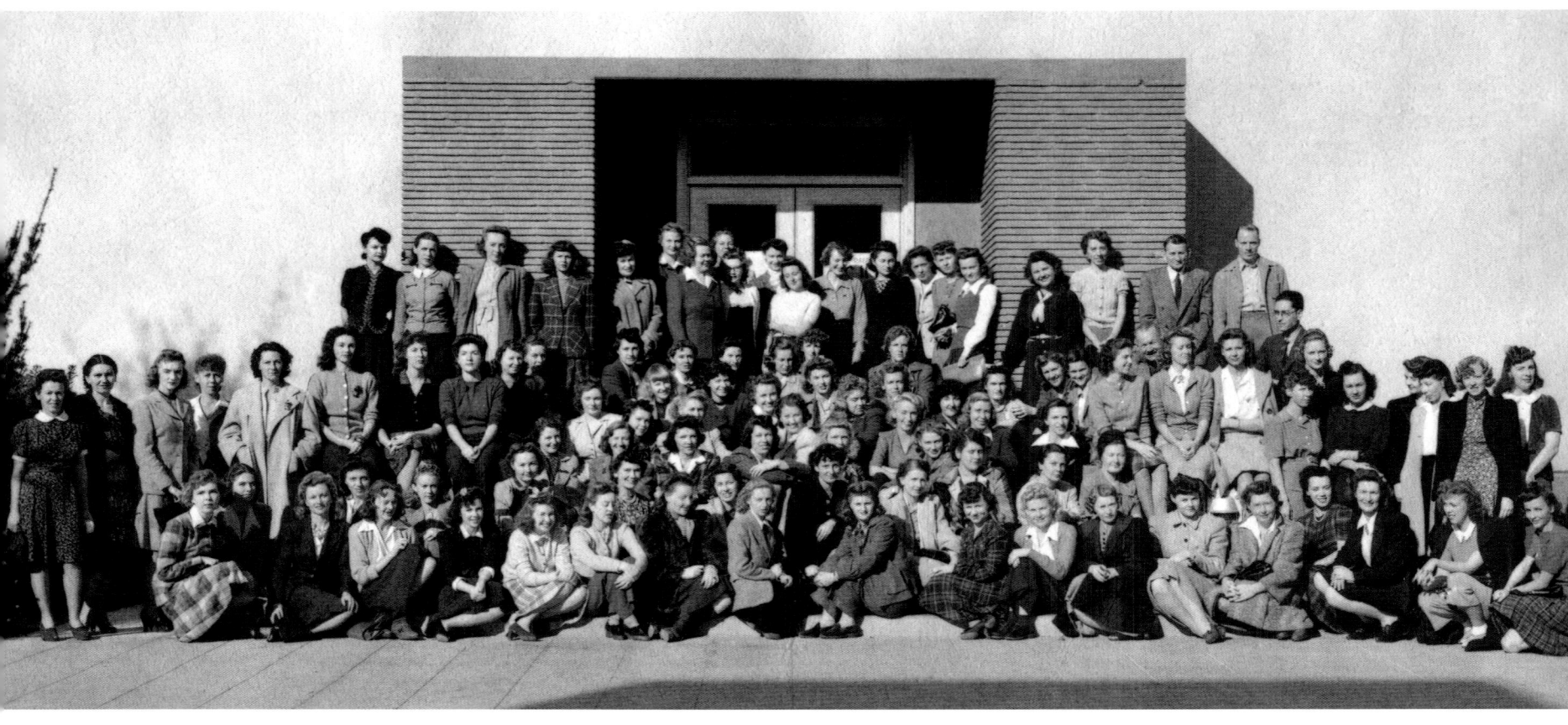

concerns and pleaded to their staff to do everything they could to help get the films out.

As the girls left the studio that evening, Lambertson, a vice president in the union that was striking, recalled seeing Smith. "She was standing in the driveway. . . . We all come out through the one door and couldn't help but pass her. She was . . . calling to each of the girls as they came by, saying, 'See you tomorrow. You will be here, won't you?'" As an officer in the union, Lambertson added, "Some of us, myself and others included who were obviously not going to be at work the following day, she said nothing to."

At six o'clock a.m. on the morning of May 29, 1941, picket lines formed at the main studio gate along Buena Vista Avenue. The *Los Angeles Times*' morning edition reported that "a crowd of several hundred strikers and sympathizers carrying wise-cracking cartoons appeared in front of the home of Mickey Mouse." For each employee, a personal choice had to be made—whether to cross the picket line or not. "Some did and some didn't," recalled Barbara Wirth Baldwin, who was a picket captain. "Like everything, people are divided." For Wilma Baker, "It was terrible. I was against the strike. My husband would drive me to work and we'd drive on the lot and I would get stares." Ruthie Tompson stated, "I wouldn't go [on strike] for love nor money, whether it was right or wrong."

"That strike was orchestrated by all the wrong people," remembered Grace Godino. "When the strike came, I belonged to Screen Actors Guild and Equity. And so, I was torn because I thought, 'If I cross a picket line what will that do to my SAG card and my Equity card?' So, I was sick. That night before, I couldn't figure out what to do because I was totally against the strike."

Unclear about her options, Godino deliberated. "Because of the SAG [membership] I thought, 'I better stay out and find out what's going on.' Well, I stayed out one day, and they put a notice in the front of the building there on Buena Vista. It said, 'Strikers may pick up their paychecks in such and such week outside the building.' I thought, 'Outside the building? This building that we worked so hard for?' And I said, 'To hell with anybody that's on the strike line, I'm going through.' So, I went in. Yes, and I didn't regret it."

"We were very young and very foolish," recalled Jean Erwin, who was among the Inkers and Painters who went out on strike. "We didn't know what we were doing. They'd come by and say, 'Call people "fink" when they go in, or "scab."'" Well, I wasn't going to call those words! We were very, very naive. Very, very naive."

"There were two very definite factions," explained Painter Mary Jane Frost. "There were those who were really behind the strike, and there were those who were very much against it; and it caused a lot of ill feeling and a lot of broken friendships at that time. It was a very divisive thing." For Marcellite Garner, it was a bitter experience "to be friends with someone one day and then the next day having them call you names because you go through a picket line to go to work." As Ruthie Tompson remembered, "Walt's niece was working there as a Painter and she had a friend who was also . . . an Inker and they shared an apartment. And so they'd get in the car and the niece would drive in, let the girl off in the picket line, and then she'd drive through the gate with her roommate yelling at her about the strike, calling her a 'strikebreaker' and all that stuff."

"I didn't go on strike," recalled Painter Joan Orbison, "because it wasn't that I didn't think that they should have a union. I thought that was a good idea, but it was the way they went about doing it that I didn't like. It just was distasteful. They'd yell at people. I know one of the secretaries was inside with a couple of the guys, they were office people, and this one Animator outside yelled at this gal, she wasn't particularly attractive, he said, 'Well, look at

Page 184: The Ink & Paint Department of the Walt Disney Studios in early 1941.

This page: Picket lines outside Walt Disney Studios, summer of 1941.

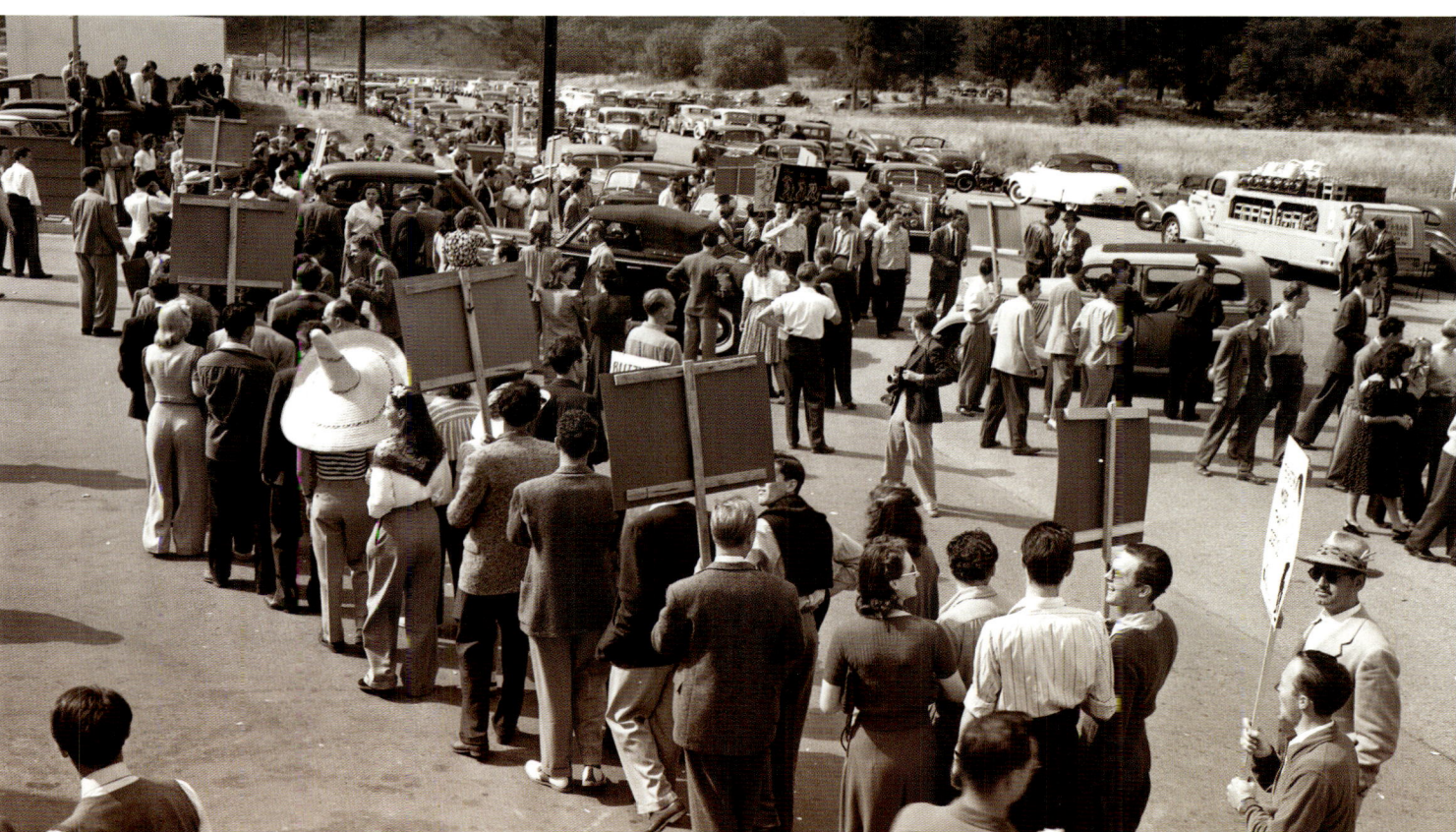

(whatever her name was), that's the closest she'll ever get to any . . .' Now, really. That had nothing to do with the animation part. And I wasn't too crazy about some of the guys."

"We picketed twenty-four hours a day," declared Barbara Wirth Baldwin, whose Airbrush staff "told me I brainwashed them because I took them out on strike." While inking at another studio, Martha Sigall wrote, "All members of the guild support[ed] them. Wherever a Disney film was showing, people were assigned to picket." *The Reluctant Dragon* opened at the height of the Animator's strike at Disney. Picketing strikers were present at the film's premiere and regularly marched at various theaters showing the feature.

While the weeks wore on, tensions mounted as threats and violence escalated. "I didn't come around to the studio much then," stated Edna Disney. "Roy didn't want me to drive over this way because he thought it was kind of rough." Indeed, simply going to work became treacherous. "They bumped my car," remembered Godino, "and they'd take keys and they'd scrape the paint off of my car as we were going through. . . . It became vicious after a while, it became very bad. And it was hard."

Tompson stated, "I remember one fella, he'd wear his heavy gloves and he'd be standing back there . . . and he'd be waiting for someone to start something so he could get into it." Director Jack Kinney recalled the turmoil that ensued as the strike ensued: "The strike became very bitter. Long friendships between 'ins' and 'outs' were destroyed. The hostility was brutal. Strikers let air out of tires or took screwdrivers and scratched the cars as they drove through the gate. There were fights, even some shots were fired. I was exempt from this treatment because, as a director, I wasn't eligible to join anyway. I had friends on the outside and on the inside."

Campsites were set up "across the street from the Disney "studio," on the property now occupied by St. Joseph's Hospital," recalled Sigall. "We set up a soup kitchen, and all of us contributed food and time for the strikers." Strikers and their families gathered for communal support. "We were out for nine weeks and it was a mixed bag," offered Baldwin. "I mean it was fun and it was horrible for people because some people lost their homes and everything. But it was worth it. All we wanted was our own union[,] and Disney wanted us to join the company union."

For others, "It wasn't the money," as Godino noted. "I felt it was wrong to do this. I had been treated so well at [Disney] that I saw no point. Why should I kick a person in the face that gave me this opportunity that I was so happy with and that I enjoyed and I was learning?"

Even amid this turmoil, production needed to continue with a slate of shorts and *Dumbo* in production, and *Bambi* on the horizon. The majority of the girls from Ink & Paint remained, but the volume of work was mounting. "We did *Dumbo* while the strike was on," said Inker Marie Justice, "and they did it in record time because the people that worked, worked hard. Long hours, but it was record time that they inked, painted, animated everything." Several former employees returned to support the department. "I helped on painting when the employees walked out," recalled Edna Disney. Inker Evelyn Coats, who had left several years earlier to raise her family, remembered, "I went back to work for them, which I was so happy to do. I just loved walking across that picket line.

"When I first worked at the studio, I never thought about a union," Coats added, "but [Art Babbitt] had to do that and then it all kind of changed. I thought it was wonderful I could do that."

While tempers flared outside the studio walls, Roy Disney worked behind the scenes to resolve the breach. "Finally Walt called us in," recalled Godino. "We went into the theater and he said he appreciated our loyalty and everything, but he said, 'I've held out myself as long as I can and I must admit that I can't go on any longer.' Because other unions were closing down, too.

Burbank Beginnings

Publicist Janet Martin and Mary Blair, on location in South America, 1941.

They were not getting food in, the electricians wouldn't come in, and . . . they didn't know what to do." Godino continued, "So, Walt says, . . . 'It's up to you, if you want to join.' He said why it won't go against anybody on the other side. So [I] think we had to join to keep him going. . . . That was our job, so we joined."

SETTLEMENTS & SACRIFICES

On July 28, after extensive negotiations, a deal was announced, but to financially meet the structured agreements, layoffs were the only solution. When the union complained, Roy ordered all studio production to shut down. After several weeks of arbitration, the studio reopened on September 21, 1941, and everyone went back to work.

"We paid our dues," noted Grace Godino, recalling their work lives before the strike. "We never had to punch a time clock before. It was on our honor. We just came in and sometimes we'd work longer, sometimes we'd work less. And that was pleasant." After the strike, Godino lamented, "I hated punching a time clock. That was hard." Marcellite Garner noted the difference. "When the union got in and these people came back to work in the studio, there wasn't the same feeling anymore. I think it destroyed something." Evelyn Coats agreed: "It was never quite the same."

To meet the new pay levels due to the unionization, dramatic restructuring and deep layoffs occurred in September 1941. The entire studio personnel was cut nearly in half, and a complete reorganization swept throughout the company. With the entire Airbrush Department laid off, any required airbrush work now fell to the Background Department, where Marion Wylie Stirrett, Mary Horn, Irene MacLean, and Marie Gerard worked. Each division realigned, and cuts within Ink & Paint deeply affected the department with nearly half of the corridors empty. "I worked at Walt Disney's [sic] in the Color Department," recalled Dorothy Jeakins, an Ink & Paint artist and Otis College of Art and Design scholarship student who came to Disney Studios with her friend Tyrus Wong and worked on *Pinocchio*, *Bambi*, and other films of the late 1930s and early 1940s. "We'd put our dimes together and laugh a little, share our meals. . . . We used to play Japanese card games on our lunch break at noon, in the garden, and talk." Following the layoff, these two friends and talented artists went on to work in live-action filmmaking. "Gradually, one assignment led to another" for Jeakins, who became the first person to win an Academy Award for Costume Design in 1948. Jeakins garnered three Oscars and multiple nominations throughout her career.

For many of the staff, time healed tensions and offered some perspective on the impact of these events. Godino reflected, "It worked out OK later. . . . I see the good that they've [unions] done. But at that time, they were people that were really trying to destroy portions of the industry." Jean Erwin noted, "It was a very emotional strike. Extremely emotional[,] and Walt was emotional about it[,] and he should have been. The older I get, I can see his view more. He wanted to put money back into the business. He was very farsighted, but we were very shortsighted." Mary Jane Frost succinctly offered, "I think that, too, was a turning point—probably the biggest turning point in the whole industry."

Walt and El Grupo arrive in Rio in 1941, including Hazel and Bill Cottrell, Ted Sears, Lilly and Walt, Norm Ferguson, and Frank Thomas.

> "*Inspirational sketches, styling, obtaining material on survey trips was started by this trip.*"
>
> —Mary Blair

SOUTH AMERICA BOUND

Late in 1940, Roy Disney was approached about the studio's help in bolstering US relations with Latin America. Roy explained, "As a national policy, the government [was] trying to foster better understanding and relationship and better business between our country and the South American countries." With a Nazi presence gaining strength in South America, Roy encouraged Walt to help the general cause of combating this by incorporating Latin American themes and elements into the studio's shorts.

Early in 1941, the women of the studio's Research Department assembled a wide variety of Latin American content for the Story Department to begin exploring visual possibilities. Hollywood's early homogenized efforts in live-action included what studio writer Bob Carr recalled as "dump[ing] into their pictures a mixture of junk [that] they call 'South American atmosphere.'" To understand and convey the distinct differences in culture and traditions throughout the different countries, it was suggested that Walt and a team of studio artists travel to South America to interpret and record their impressions of the various landscapes, people, and cultures. On August 17, Walt and a small band of artists departed, ultimately traveling to five different countries on behalf of the Good Neighbor Program to encourage a creative exchange between countries and to serve as ambassadors of goodwill.

Janet Martin served as Unit Publicist and deftly managed the floods of US press inquiries as well as the advance publicity and press coverage throughout their travels. Mary Blair, who had left the studio in June 1941, went to Walt and impulsively asked to return. Accompanying her husband, Lee Blair, Mary was the only female artist to travel with the South American team. Lillian Disney and her sister, Hazel Sewell Cottrell, accompanied their husbands on the trip but didn't serve in any official capacity. Throughout their travels, the group encountered some Nazi and labor opposition as the strike was being settled, but both potential problems were quickly swept away by the fans and fascination for Walt Disney and his artists.

Walt and "El Grupo" spent nearly three months traveling to various regions and cities in their study of Latin American countries in 1941. A studio write-up declared, "For years an ardent disciple of hemispheric solidarity and friendly relations, Disney was anxious to tap the reservoir of music, folklore, legends, scenes, characters, and themes of the Latin Republics." The studio artists returned home with hundreds of sketches and watercolors that captured the palette of the places, animals, vegetation, and people they saw during their travels. Mary Blair recalled of her South American experiences, "Everything was extremely interesting . . . I felt I found a place in the business."

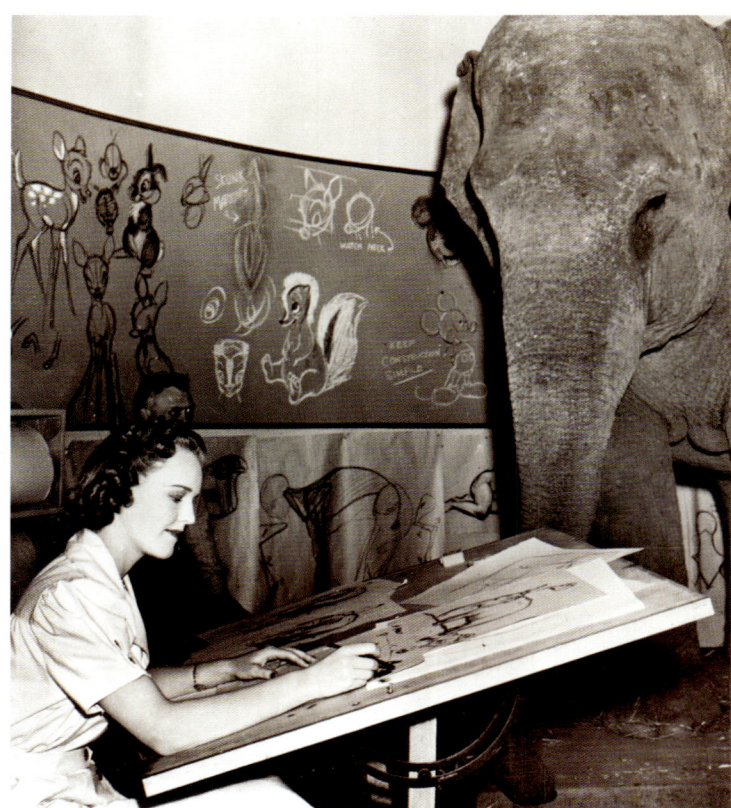

Left: Studio artist Viola Anderson; and (right) Retta Scott size up their model Mable the elephant in preparation for *The Reluctant Dragon* (1941) and their next animated feature film, *Dumbo* (1941).

A MAGIC FEATHER

With Hitler's advances throughout Europe, the studio's overseas finances were still frozen; Disney needed to release something quick to keep the studio open. "*Dumbo* was a rush production during the war," reflected Roy Disney, "[with a] shortage of manpower. It was done on a very close budget." Lead Animator Ward Kimball recalled, "I think the Disney cartoon reached its zenith with *Dumbo*. Walt was sure of what he wanted and this confidence was shared by the entire crew."

Story Artists Joe Grant and Dick Huemer developed *Dumbo* for the animated screen. The film was based on a scroll-formatted children's book by Helen Aberson and Harold Pearl. "It had the basic elements of the story: the little elephant who had big ears, was made fun of, learned to fly, and was redeemed," recalled Huemer. "Well, we took it from there, had a few story meetings, [and] then Joe Grant and I wrote it up a chapter at a time and submitted it to Walt. He used to come down and say, 'That's coming along good. We'll make it!'"

The original story of the little outcast elephant who finds his place in the world granted complete liberties for Walt and his staff. Development required only a handful of months—from January to June 1940. The following year brought a number of unforeseen challenges as the studio faced drastic financial and manpower limitations due to the war in Europe and the Animators' strike. As a result, the story of *Dumbo* had to be quickly produced in a cost-effective manner. With a lean production team of artists, Walt Disney's fourth animated film was completed in just over a year—a welcome contrast to the three or four years usually accorded an animated feature-length Disney film—at a fraction of the cost of his previous three feature films.

Working with a simple and airtight story, development moved quickly. Kimball recalled, "The first time I heard Walt outline the plot I knew that the picture had great simplicity and cartoon heart." The talented production team of *Dumbo* had such enthusiasm for the project that they worked overtime, putting out two or three times more animation per week than on any previous animated feature. With such contagious zeal, all concerned were eager to see the finished animation on the screen.

In one of her earliest roles at the studio, Mary Blair was assigned to explore the concept and development of the story. A talented fine artist, illustrator, and watercolorist from the Chouinard school, Blair described her role as "working with the writers and helping to create the ideas of the picture graphically right from its basic beginning." Her dark and moody watercolors explored the inner emotional reality of the mute little elephant with big ears.

Research for *Dumbo* took on a level of fun that was reflected in the film, as the artists got to visit each circus that came to town and make countless sketches of everything from tent pulleys to bareback riders; they even received permission to go on with the clowns for some firsthand experience! Kay Marshall, a caricaturist with the Animation unit, provided delightful inspirations; artist Phyllis Hurrell was brought on to develop story art; and with animals as her specialty, Animator Retta Scott was making complete studies of circus animals, particularly elephants!

Despite the fact that little *Dumbo* doesn't speak, tremendous thought and care was given to casting the human voices for this anthropomorphic tale. Verna Felton, one of only two women within the film's credits, was a renowned character actress who voiced a number of notable Disney characters. Felton provided the haughty voice of the stuffy matriarch elephant who snubs little Dumbo as well as the gentle voice of Dumbo's mother. In February 1941, Ink & Paint artist Marcellite Garner, the original voice of Minnie Mouse, expanded her voice-over repertoire by recording hiccups for Timothy Q. Mouse.

Left & right: Rare production cels from *Dumbo* (1941).

PACHYDERM PALETTES

"*Dumbo*, from the opening drawing, went straight through to the finish with very few things changed or altered," remembered Ward Kimball. Once scenes had progressed through Cleanup Animation, 250 Ink & Paint artists were progressing at a rapid clip with bringing the scenes for *Dumbo* to their colorful grandeur. While a simple production for other divisions, *Dumbo* presented some unique challenges for the talented teams of Ink & Paint.

One hundred fifty colors were used to bring *Dumbo* to the screen, a dramatic reduction from the extensive palette of shades utilized on the previous feature films. Each week, over one hundred bottles of premixed paints were applied to color the volume of cels processed through the department. Against the basic primary palette of red, yellow, and blue for the circus themes, the subject of elephants required an increased range of gray shades utilized throughout the film, even more than in the days of the early black-and-white films.

Color actively set the scene for the action within *Dumbo*. The bright clash of lightning highlights the brooding storm. Warm sunlight colors showcase the singing of the roustabouts, and in cool moonlight, *Dumbo*'s tender reunion unfolds with his mother, Mrs. Jumbo. Perhaps the most evident sequence where color plays a key role is the "Pink Elephants on Parade" scene. Polka dots, stripes, and even plaids in pinks, chartreuse, ochre, and puce form the surrealist nightmare of cavorting elephants. Each color was meticulously animated across the screen by the women of Ink & Paint.

With the large size of the elephants populating the screen, problems such as "paint crawl" became even more visible as paint occasionally shifted in color from one cel to the next due to a lack of even stirring of the paint. Emilio Bianchi made tremendous strides with his paints, but sediments settled and separated when not properly blended. The women were constantly reminded of the importance of continually stirring their paints. Dust perpetually presented a problem, especially with the larger, visible characters on the screen. Adjustments were still being made to the air-conditioning systems to minimize the presence of unwanted dust. Lab coats and gloves remained the standard uniform and first line of defense against offensive fibers and fingerprints on the cels.

With war at its full fury in Europe, supplies were at a minimum during the film's production. Still, the Cel Washing Department worked round the clock to keep a usable supply of cleaned cels available for the department. Previously, cels were washed and reutilized three times before tossing; now it became necessary to reutilize as many precious pieces of plastic as possible for as long as possible. Production continued on *Dumbo* with animated segments screened for studio staff review.

"At lunchtime, they were showing some of *Dumbo*," recalled Checker Ruthie Tompson. "It was the scene where the mama elephant is in jail and the baby elephant is swinging on her; she's singing him a lullaby. When I came out of the theater, I was whistling the tune, and Walt was walking by. He said, 'You like that tune?' I said, 'Yeah!' and he said, 'We'll keep it!'"

In May 1941, a rough assembly of *Dumbo* was screened for the studio. The "tough" studio audience laughed, cried, and even broke into spontaneous applause over *Dumbo*'s adventures. With three full-length productions already under their belt, the studio was settling into a familiar groove for the pace of creating these "longies." The crew deemed it the easiest feature production largely due to the simple designs and bright, basic colors, as well as no new technical effects to contend with.

Utilizing over three hundred miles of cels, 250 Inkers and Painters used an average of eight gallons and one hundred jars of paint each week to bring the big-hearted story of the little elephant to the screen, setting an all-time record for production speed with a mere six months of development and just over a year of actual production.

THE WAR YEARS

> *"We learned a great deal during the war years.... Things had to be made plain and quickly and exactly applicable to the men in the military services."*
> — Walt Disney

In late February 1941, with events in Europe, Africa, and Asia mounting and military preparedness measures advancing in the United States, Walt announced a studio-wide "Air Force, Army, Navy Insignia Designs" competition. As official requests came in, the efforts were widened to any and all staff. No payments were received, but the reward of pride in a design utilized in service to the country was priceless.

The studio began receiving hundreds of insignia requests from every faction of the military. An entire unit of Disney artists ultimately designed well over 1,200 insignia during the war featuring a wide range of original designs, as well as characters from the studio's familiar animated back lot. Dumbo, Bambi, and Donald Duck went to war featured on planes, tanks, trucks, and shoulder patches. Author John Baxter, writing on Disney's role during World War II, noted: "Request for female characters like Minnie and Daisy were rare, circumscribed by the limited role of women in the military as compared with men. And although many thousands of women served their country tirelessly during the war in various auxiliary military capacities that freed up like numbers of combat-eligible men for duty, there were very few insignia requests from all-female units. An especially notable exception was the Women Airforce Service Pilots, or WASPs, who ferried military aircraft to bases around the country and across the world, and proudly wore the now famous Gremlin 'Fifinella' insignia on their leather flying jackets."

The War Years

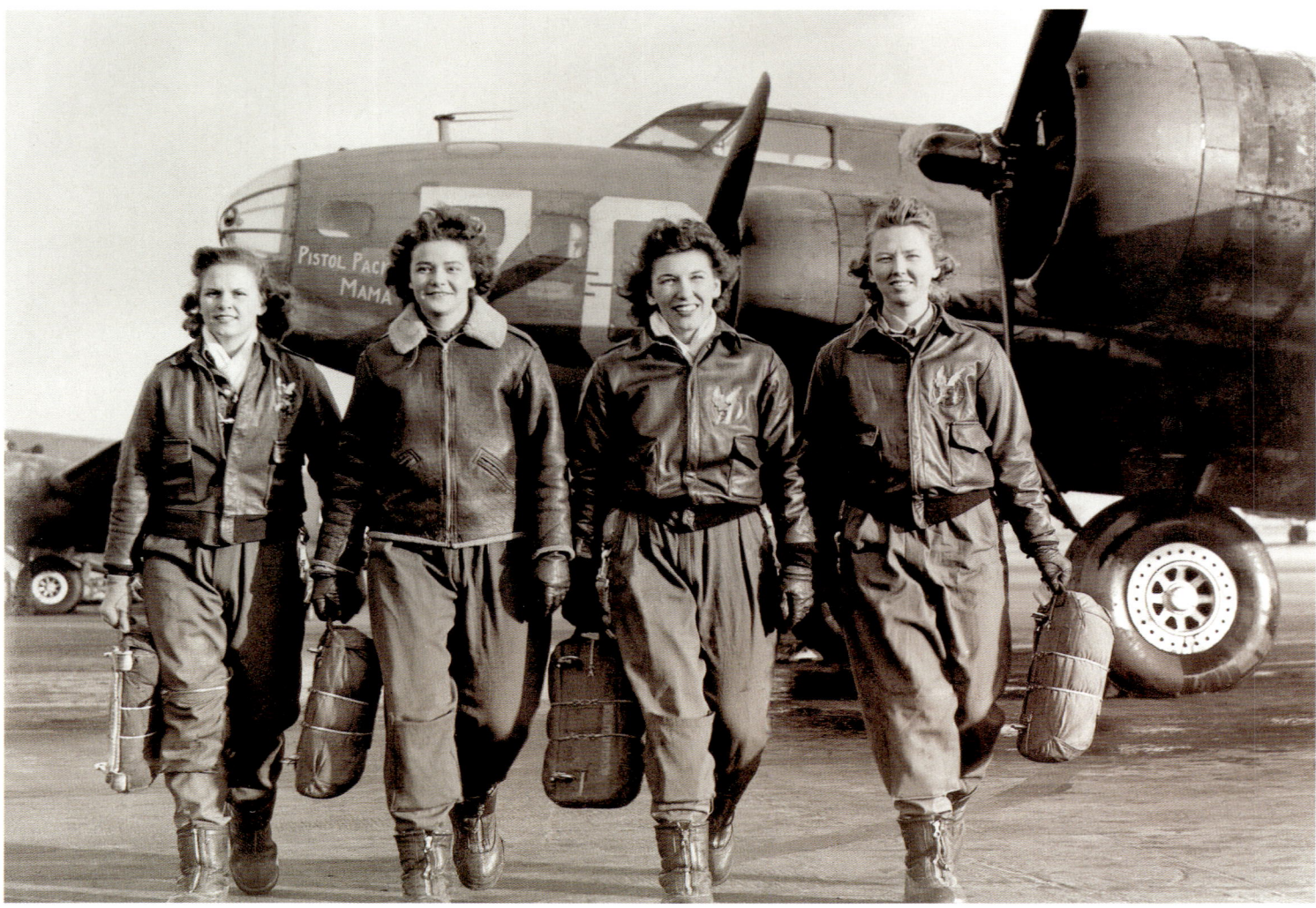

Page 191: The Fifinella insigne was created in 1943 for the 318 Women's Flying Training Detachment where many graduated into the Women Airforce Service Pilots (WASPs) branch of the service.

This page: Women Airforce Service Pilots (WASP) from the United States Air Force, at Lockbourne Army Air Field in 1943. (From left to right): Frances Green, Margaret (Peg) Kirchner, Ann Waldner, and Blanche Osborn, leaving their B-57 plane, Pistol Packin' Mama, carrying their parachutes and sporting Fifinella patches on their flight jackets.

In the spring of 1941, Walt began receiving queries from various divisions of the military regarding animation for training films. The Ink & Paint Department often consulted on a variety of production issues. In April 1941, Jeanette Tonner from the studio's Paint Lab made a number of suggestions for suppliers, sources, and solutions to the Marine Corps Photographic Division for their own animation efforts. These early queries was a harbinger of things to come for the women of Ink & Paint and the Walt Disney Studios.

Continuing to feel the pinch of current world events, the studio's working hours were changed and departments were restructured. Artists' supplies were already becoming difficult to secure due to the studio's National War Emergency Program and the war raging in Europe—and throughout the world. Many of the factories that produced the artists' supplies were transitioning to manufacturing war materials, and all supplies sourced from Europe were cut off. Animation paper, sable watercolor brushes, Gillott and Spencerian pen nibs, aluminum pushpins, and acetate were all back-ordered or became impossible to procure.

"The war had been going on, and when you saw the news you were concerned, but hoping that nothing was happening," recalled young newlywed Wilma Baker. "Then I realized it was getting closer." Animator Marc Davis agreed. "It was a very puzzling period, for all of us. Because there were these horrible things that we were hearing about: the Nazis on one side, and then on the other side [of the Pacific] was the Japanese war machine. So we were kind of in the middle, halfway between the two warring parties, actually."

By the fall of 1941, Jack Kinney recalled, "Many of the men and women at the studio enlisted. Others were drafted and still others were exempt because of age or dependents. The cartoon industry swung quickly into producing training films and soon the studio was dotted with uniforms of all kinds." Theo Halladay, who worked at the Paint Lab, remembered, "There were war preparations going on everywhere around us as well as in the studio."

With the world in turmoil and the studio's foreign assets frozen for the last few years, departmental layoffs were considered as a studio memo noted, "Within four weeks, it will be impossible to keep everyone busy." The memo tried to be encouraging but was grounded in reality: "The Inking & Painting Department over the period of the past two years has carried a very accurate record of output by each girl, and it is our intention to base layoffs on these records. With *Bambi* scheduled to be completed through Ink & Paint around mid-December, with layoffs pending." On November 27, 1941, with staffing cut, 50 percent of the Inking & Painting Building was closed to lower air-conditioning and maintenance costs.

"A DAY THAT WILL LIVE IN INFAMY"

On December 7, 1941, Walt Disney received word of the turning point of US involvement in the worldwide conflict. He recalled, "I was at home and we got word that they'd bombed Pearl Harbor. . . . It was on the radio. . . . Shortly after that I got a call from the studio manager and he had been called, in turn, by the police. He said, 'Walt, the [United States] Army is moving in on us.' . . . They

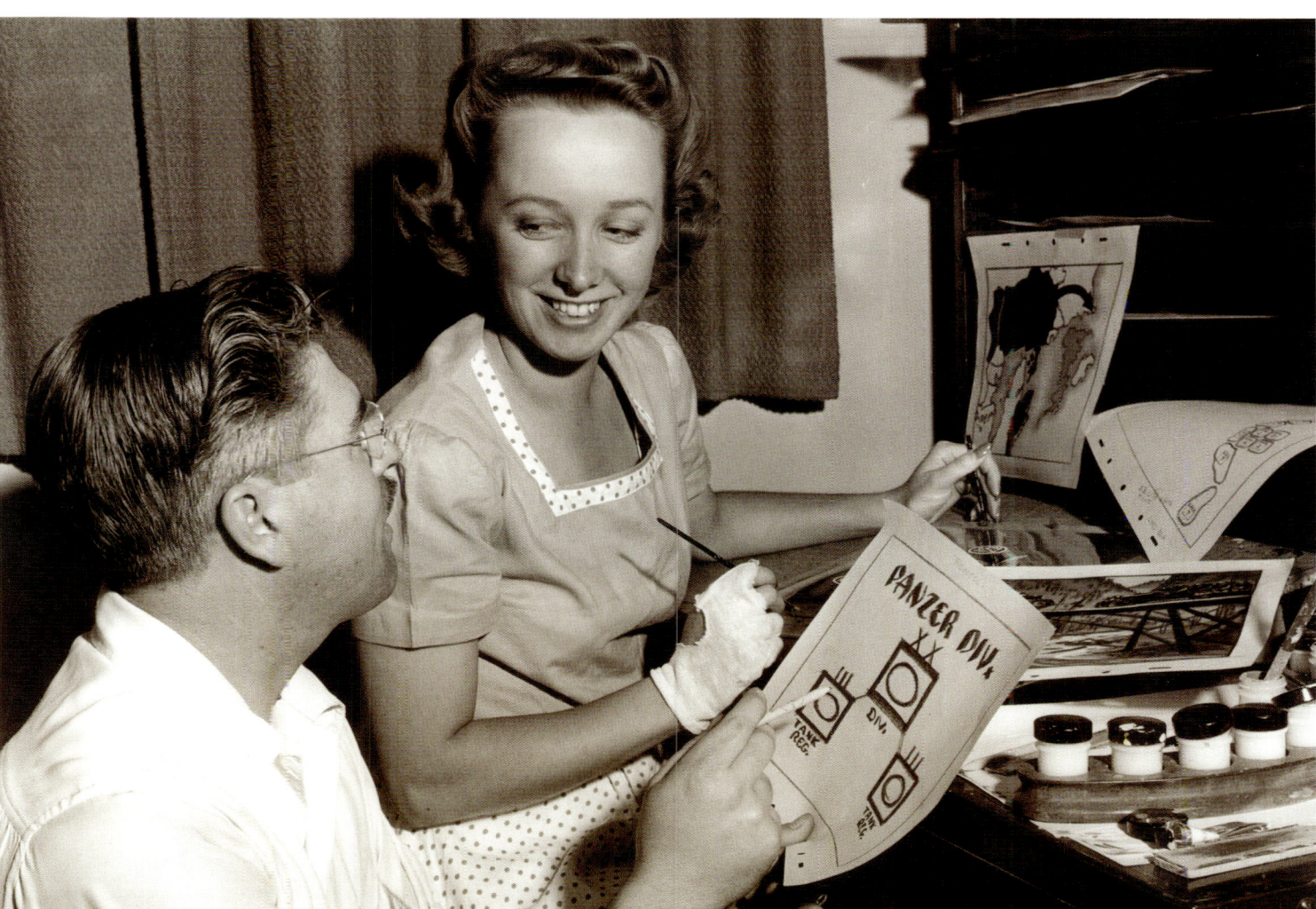

Rae Medby reviews a sequence of *Victory Through Air Power* (1943) with storyboard artist Dick Kelsey.

came up and said they wanted to move in, and [he] said, 'I'd have to call [Walt],' and [the army] said, 'Call him[,] but we're moving in anyway.' Five hundred troops moved in the studio."

With guards at every gate, soundstages commandeered, and ammunition stacked in the parking sheds, Walt Disney Studios became a military facility. "He was all for it," remarked studio nurse Hazel George. "During the war years, his number one concern was what the studio could do for the war effort." Walt Disney Studios was the only Hollywood studio to completely turn over its facilities to the military. For the first eight months, the studio served primarily as a supply depot, as Walt shelved a number of feature projects and turned to producing training and service productions.

In the days following Pearl Harbor, Bob Carr, director of the studio's Defense Film Division, reached out to the Academy of Motion Picture Arts and Sciences for reference materials from their War Film Library in an effort to explore approaches to the challenges ahead. The titles ordered to be screened at the studio included *Her Father's Daughter*, a one-reeler showcasing how women were being trained to replace men in English factories; *Welfare of the Workers*, reviewing the training of "a typical girl worker shifted to a new factory in the country"; and *Women in Defense*, issued from the Office for Emergency Management. Written by Eleanor Roosevelt and narrated by Katharine Hepburn, this short film noted that "two-thirds of the jobs in defense industries can be done by women today, and officials of the defense program are advocating more extensive job training for women and girls." These efforts—sexist by today's standards—widely shifted prevailing attitudes towards women and extolled their virtues in the workforce. The films' narratives indicated "finding women extraordinarily efficient," highlighted a woman's "constant care and alertness," and pointed out that "the nimble fingers of these workers are capable of turning out perfect workmanship on unbelievably fast machines."

AIR RAIDS, RATIONING & RELOCATIONS

On December 18, 1941, Walt issued a memo to all employees regarding air-raid precautions, stressing the importance of safety and remaining calm. "The joint was really jumping," wrote Animator Jack Kinney. "Rationing was in effect—for gas, meat, cigarettes, clothes, tires, butter[,] and booze. We all had ID cards that had to be carried at all times. Then there were air-raid drills. Wardens were assigned to go around and make sure we all pulled our blinds down tight so no light could come in while we waited for the 'all clear.' People didn't know what to think. We'd never been through anything like it. It was a jittery time—a scary time, really—especially for everyone along the coast."

"When I finished work on *Fantasia* they sent me to New York to work in the Merchandising Department," recalled Gyo Fujikawa, a Japanese American artist. "The war broke out after I moved here. My parents, my brother[,] and his wife were living in California. They were soon sent to an internment camp. I felt so guilty that I was free in New York and they were in camp. Walt Disney was wonderful to me. [He] came to the office where I

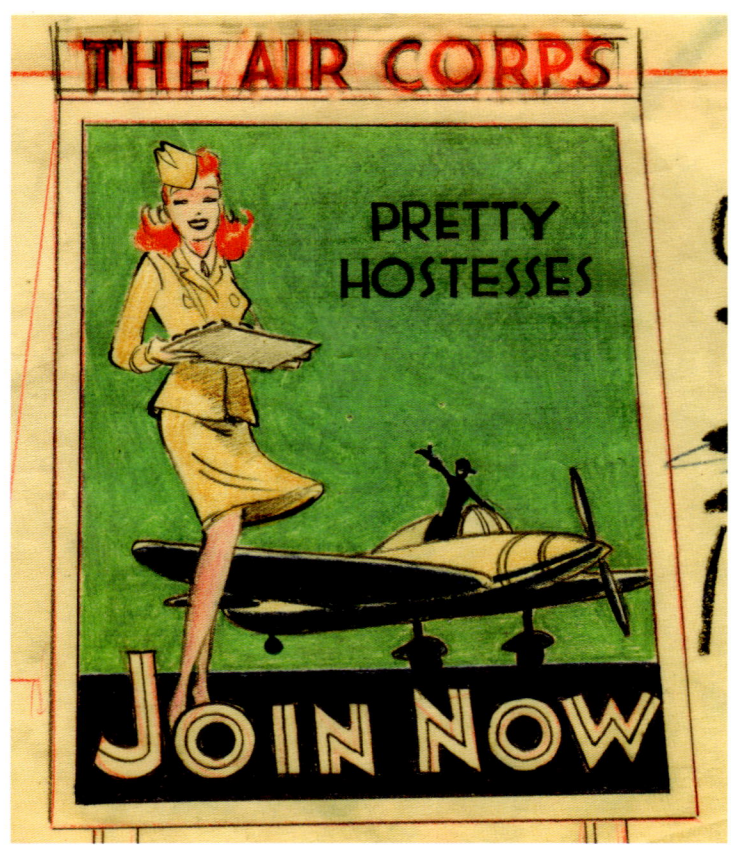 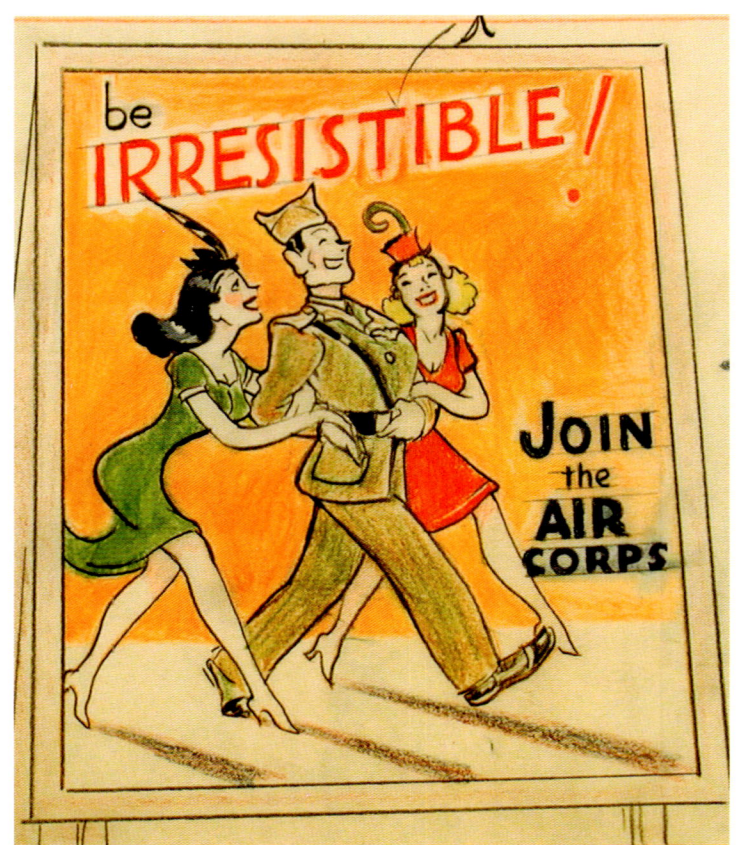

Left & right: Poster concepts for the Air Corps, created by studio artists for the war effort.

was working during the war. He came in to see me especially. He said, 'How are you doing? I've been worried about you.' I said, 'I'm doing okay. If people ask me what nationality I am I tell them the truth or give them big lies, like I'm half Chinese and half Japanese, or part Korean, part Chinese, and part Japanese.' He said, 'Why do you have to do that? For Christ sakes, you're an American citizen. Next time anybody asks you that, just tell them it's none of their business. Besides[,] you're an American citizen.' He was so right. From that time on I just told everybody I was an American citizen. But he was very concerned about the Japanese Americans that worked at the studio."

Fears and suspicions were rampant. Even with military presence on lot, studio personnel were encouraged to "be vigilant" of those around them. Talented artist and studio Inker Frances Goellert learned this lesson the hard way. In January 1942, her new husband, a German doctor, was convicted of using a Beverly Hills business to cover alleged Nazi espionage and sentenced to ten years in prison. Initially incarcerated as a suspected conspirator, Goellert was eventually exonerated of all charges, and she quickly divorced.

"WE'RE STILL HERE"

Through the turmoil of 1941, the Ink & Paint Department completed twenty-three short films, three feature films, and one Canadian defense film—a dramatic difference from what they experienced as 1942 began. With the studio quickly transitioned into a military setting, Dot Smith sent a memo to Walt in February 1942:

> Just a short letter to remind you that there is still an Ink & Paint Department on the lot. From the looks of all the pale, uninteresting engineers, the drooping police guards[,] and the special messenger boys chasing one another in and out of the building with their secret packages[,] the building is teeming with everything except Inkers and Painters.
>
> Mitch tells me Lockheed is to move into our two upstairs corridors[,] which means another drooping guard. They had better get a good-looking one outside in my hall or I'll raise hell. If I've got to look at the dope every time I go out my door he's got to at least be pretty! (He could probably say the same about me, but if he's just sitting there he can shut his eyes when I go by.)
>
> There is not much to say about the footage as the powers that be have changed the schedule so much lately all we can do is pray for work now-days—we aren't even fussy what picture it's on, just so it's work. There is positively no sense to the footage by weekly reports anymore. One week we'll put out 1386-05, and a few weeks later struggle to get 120-03 to Camera. Didn't intend to get on the subject of footage as you are probably tired of hearing about it, but I still say there ain't no justice!
>
> We only have 92 employees over here now (not counting my Lockheed boys, of course—wonder how they'd like to be called Dot Smith's Chickadees)? The payroll is down considerably compared with this time last year, and our 206 employees we had then.
>
> As you can see from the above I really had nothing important to say, but wanted you not to forget us as we're still here and working hard for our Alma Mater. Won't even end this by saying come to see us, but will say instead "Take it easy, and don't worry."

Smith later sent word to Walt updating the circumstances for her "chickadees" in Ink & Paint: "As you know, about 16 are working in the other building doing special inking and painting directly for the layout men (and good too). It has worked out very well so far, as they do tricky mechanical inking. We have lost 37 girls since the first of the year." Shortly thereafter, Smith and Grace Christianson brought back all available Inkers and Painters

Ink & Paint | 195

Inker Marcia Ashe's studio ID featuring creative embellishments, one of only a few known surviving examples of the mandatory ID badges worn by Disney employees during the war.

to work at the studio, including Gwen Corley, Marion Smith, Helen "Beanie" Ferrara, and Marcia Sinclair, but with the shortage of trained artists, they still weren't moving footage through the department fast enough to maintain the necessary schedules.

The studio sent out cards to women who studied at the local art schools in Los Angeles, seeking possible candidates. Ads were placed in local papers and radio spots recorded, announcing, "Do you want a career in art? Walt Disney needs young women who have had training in pen and ink work, now! A real opportunity for the girl who excels." Candidates were encouraged to bring samples of pen and ink, production illustration, line drawing, mechanical drawings, or drafting-board work. Those who qualified were quickly trained on the job. Additional solutions were initiated, including extending Ink & Paint to a forty-eight-hour, six-day week that added Saturdays to the schedule and immediately expanding the training program that put experienced Inkers and Painters to work in other departments. As production problems became more acute, the women of Ink & Paint stepped up and replaced the manpower the studio was losing to the draft.

ROSIE THE RIVETERS

Across the country, women stepped into the labor forces to keep industries moving. Dungarees and denim replaced dresses and heels as women, inspired by Norman Rockwell's "Rosie the Riveter," left their homes for factories in order to build aircraft, Jeeps, warships, and other materials to keep the war effort moving.

With the ever-increasing number of men leaving Disney Studios to prosecute the war, a full assessment was made and job classifications were adjusted. "The Studio will lose quite a few of its men to the armed forces," stated a memo issued in April 1942 from Janet Martin to Isabel Sheldon. "Should many more be called, it is not impossible that girls will be trained for jobs now held only by men. Walt's hardest job will be to replace Animators as, so far . . . the only exception was piquant blonde little Retta Scott, who animated one of the important sequences in Walt's forthcoming feature, *Bambi*." Corroborating the invisibility of feminine accomplishment, the memo continued, "Let's face it. Look at the dearth of fine women artists down thru history! But IF [sic] you're good, you're in demand."

ASSISTANT ANIMATORS

"When the war came along," recalled Joan Orbison, "most of the guys had to go, and so that's how the women got into the animation part." Jean Erwin recalled the response from within studio ranks: "So many of the girls came over to try out for Animation. I came over, and they had little tests. One of the tests was Donald falling over the cliff and bouncing up. Animation to me is a male art; it takes a lot of energy, I think. My Donald Duck fell over and floated up." Orbison remembered, "You can tell right now that I didn't have the energy and movement for animation. But there are women that did make excellent Animators."

"A talented young lady named Jeri Beaumont worked with me during 1944 and 1945," said Animator Bill Justice of his first female Assistant Animator. Young Mary Schuster moved into assisting on Ward Kimball's crew, while Janey Bryan, Ona Mae Chavers, Xenia DeMattia, and a number of women advanced to animate for the top Animators as well. "We became Inbetweeners and then got as far as Assistant, which was good," noted Orbison. "I like being an Assistant; a good Assistant is very important. You have to be able to draw, and some of the Animators are good on mechanics, but they don't draw as well, actually. . . . At Disney, the Animators used to just work in rough and then the Assistants would do the cleanup to make them look [right].

"They liked my work," Orbison added. "I worked with Clair Weeks. But he went back to India. So I was working with another Animator. I won't mention his name because he said I wasn't properly subservient to him." Unfortunately, this was a prevailing attitude among several of the men of the day.

In 1943 a number of talented artists from Ink & Paint made their way to Inbetween, including Marion Davis, Lula Drake-Jekel, Berta Jones, Lydia Gibson, Mary Kendall, Betty Sorenson, Sylvia Niday, and Leota Toombs. Many artists were also hired directly as Inbetweeners, including Phyllis Mooney, Gerry Goodwin, Lillian Evans, Garda Moulton, Joyce Gillies, and Virginia Hudson.

Noted film director Frank Capra set up production offices on the Disney Studios lot to complete his documentaries series entitled Why We Fight. Created as a direct response to Leni Riefenstahl's Nazi film *Triumph of the Will*, Capra's seven films were created to screen for soldiers the reasons for confronting the Axis and, later, to bolster public involvement in the war effort. Rae Medby was one of two women selected to work on this Academy Award-winning series, and by 1944, she was promoted to Assistant Animator.

With the United States now actively participating in the war overseas, more Inkers and Painters were trained and moved into the Animation Building. Jane Fowler's span of animation on the wartime training films and later feature films marked an extensive

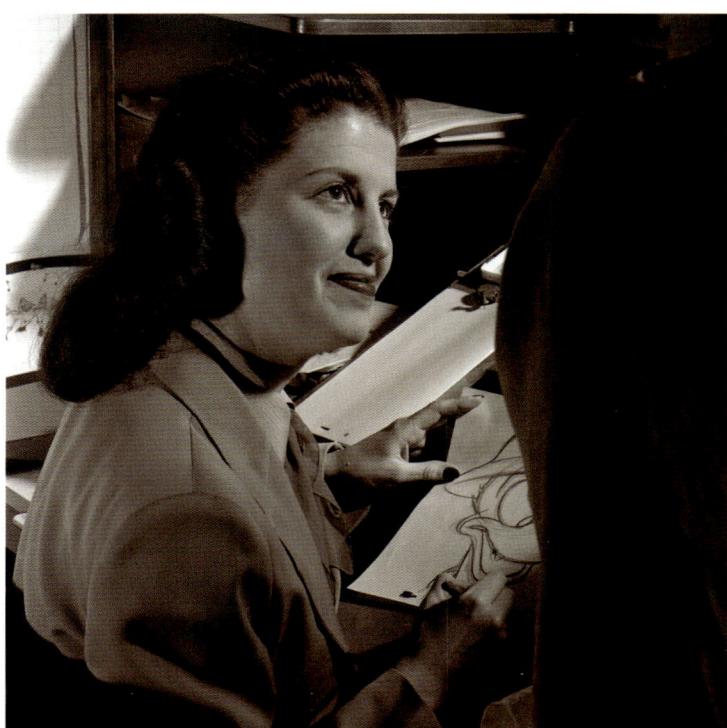

tenure in Animation at Disney Studios. Special Effects Animators Lydia Gibson, Charlot Manchester, Alice May Shaw, and Wanda Gunderson, meanwhile, moved into Character Animation along with Doris Holmes, Virginia Campbell, Mary Heydric, Evelyn Renfrew, and Kathryn Robertson. Fine artist Joy Hankins started in Cleanup and often showed her watercolors and oil paintings at various galleries. By March 1945, eighty-one women were working in the Animation Building; the majority were wielding pencils.

CAMERAWOMEN

"In those days," recalled Martha Sigall, "women weren't allowed in the Cameramen's Union." But with the lack of male personnel in wartime, unionized jobs within the Camera Department, Footage Control, and Scene Checking were now made available to the women of Ink & Paint at nearly twice the rate. "The studio wasn't that unionized yet, and yes, women were doing a man's work," recalled Wilma Baker. "That's one thing my former boss Katherine Kerwin did—she worked in Camera. It was a good job[,] and it sure paid a lot more than Ink & Paint."

Kerwin, Ruthie Tompson, and Mimi Thornton were given special allowances and worked in the Camera Department during the war, with Thornton later becoming the studio's first female camera operator, followed by Flavilla Hagin and Lois Jones. Kerwin added, "A lot of the camera fellas went to the wars, but there were about four of us from Ink & Paint that did this Checking function and it's practically the same as shooting—it's dry shooting—we just had to learn the photographic part of it. We couldn't join [the union], but . . . they gave us a work permit. . . . We made more money and we knew what we were doing."

BACKGROUND LADIES STEP FORWARD

With wartime measures in effect, the Background Department soon was staffed with talent that moved up from Ink & Paint.

Dorothy Bachom, Marie Gerard, Polly Chase, Georgia Skinner, and Kathlyn Jois Skinner all advanced through the studio during the war and used their talents to create the worlds that defined the extensive slate of shorts and training films.

Many talented women artists even stepped straight into the production forefront, including Barbara MacLean, Enid Smith, and Thelma Witmer, who were all hired directly into Backgrounds. Witmer's stunning work provided the setting for a number of the studio's shorts, and her artistry continued to define the worlds of Disney animation for many decades. Inker Betty Nissan later joined the department as the war neared its end, and Vera Gunvor Ohman was hired directly into Backgrounds to work on many of the postwar educational films.

LADY CUTTERS

Women dominated rare positions of power within the earliest days of Hollywood's live-action studios. But with animation's unique editorial needs, women were rarely found in such assignments during this period. Luisa Field's groundbreaking contributions to musical editing on *Fantasia* opened the door for women editors across all areas of production at Disney Studios. With US forces fully engaged in the war soon after Pearl Harbor, women stepped further into the editing field of animation. In 1942, Evelyn Kennedy began her lengthy career at Disney Studios, mastering music editing on later animated classics. Sally Forest and Margaret Godsel joined the ranks as apprentice cutters and within months worked their way up to being full Editors.

Ann Flannery and Margaret Jewell arrived in 1943 as negative cutters, along with Erma Horsley, a pioneering Editor whose career began in the early silent days of cinema. Horsley mastered her craft on a number of five-reelers and later films, including several featuring John Wayne. Gail Mickelson and Nelda Marshall were lead editors at Disney Studios. Marshall made international news in 1945, not so much for her editing talents, but for an annulled marriage to a decorated war hero who had married the glamorous female Disney editor, "forgetting" he had a wife and four children in Mississippi.

MILITARY MANEUVERS

In 1944, as the war was churning through its fifth year, Joyce Carlson was hired into the Traffic Department—a division of the Animation Department run by the husband-and-wife team of Ben and Violet Mosley. "We had traffic on four floors, and the Animators would need pencils, brushes, or coffee," recalled Carlson. "So we would run down and pick them up and take it to them in their room. You delivered things, ran errands, brought guests up to Walt's office. You'd also deliver the mail; I gave it right to the Animator, never the secretary . . . so I didn't last too long in Traffic . . . about six weeks." Fortunately, the Ink & Paint Department was hiring. Carlson was encouraged to submit examples of her skill, and Grace Bailey reviewed her work. "She was just taking Ink & Paint over, and I guess they decided I'd be good for inking," Carlson remarked. "They programmed me for two weeks practice, and after two weeks they put me on production

Assistant Animator Jeri Beaumont.

Ink & Paint | 197

Top & bottom: V-mail letter featuring a feathered Disney fellow drawn by Inker turned Animator Virginia Fleener.

BILL ANDERSON: MAN IN THE PAINTED FOREST

With a growing military presence on the lot, Bill Anderson was hired to oversee production on the various war projects in progress at the studio. "There were so many projects going on and it was a real problem," Anderson noted. "Each branch of the service was fighting to get their training and identification films [completed]. You had to be cleared to go into certain wings of the studio because of the various projects that they were handling." There was no letting up on these productions. "Walt had great enthusiasm and great patriotism," Anderson added. "Boy, if it was a project that he thought that we could do, that would help the national effort, [we were] going to do it!"

Late in 1942, problems began to develop within the Ink & Paint Department. To keep up with the studio production schedule, the Ink & Paint output required a 100 percent increase. Training was expanded and the department was authorized to work a six-day week. "We were very busy, doing *Three Caballeros*," recalled Grace Bailey. "They had three girls managing this department. One managed the Paint Lab, one managed the Inking Department, and the other the Painting Department." Without a cohesive Department Head to oversee the production flow throughout the various Ink & Paint divisions, conflicts quickly arose. Bailey explained, "The work began stacking up and Walt was displeased with the way it was being managed, so he sent Bill [Anderson] over to manage it."

Of his new role, Anderson noted, "The department just wasn't staffed to handle the work. The day I was to go over there, I met [Walt] and he said, 'Well, we've never had a man in that department before[,] so you're a first.'" According to Anderson, Walt added, "I want you to understand that these people have been with me since before *Snow White*. . . . They are very loyal people. . . . Work with them and they'll do you a good job!"

Listening to his staff and working with them to trim waste and find efficiencies, Anderson unified the division. "Of course, Bill didn't know anything about it at the time," remembered Bailey. "I was elected to help him, and I learned a lot from him. Excellent organizer, and all the girls loved him." In June 1943, with so many productions under way, an all-time high was reached in footage output. Within one month, the studio shipped nearly the same amount of footage they had issued in all of 1942. Walt issued a glowing studio-wide memo declaring, "We can proudly say that, at present, well over 90% has been a direct contribution to the war effort. This shows what can be done through the cooperation of management and employees and is very gratifying to all concerned!"

For the remainder of the war, Anderson ran the department with Bailey, Dot Smith, and Grace Christianson answering to him. Anderson remained in the department for just over a year. Then, "One day [Walt] said, 'I think we ought to get you up in the production end up here,'" Anderson remembered. Bailey was given the reins and with that, the Ink & Paint Department returned to the female domain it had long been.

Page 199, left & right: Final frames offering a look inside the feminine and masculine minds from one of the studio's military training films, *Reason and Emotion* (1943).

and we were doing a lot of the war insignias and the shorts for the training films.

"We had three corridors of Inkers upstairs and two or three corridors of Painters; and of course we had Final Checkers . . . where the Inkers were," Carlson added. Each corridor consisted of about twenty women, with Checkers, Supervisors, and Assistant Supervisors at the front of each corridor. Carlson later earned the nickname "Hot Shot" for her red hair, freckles, and superior inking.

Young Becky Fallberg started in 1942 as the telephone operator in the Ink & Paint Department. "We had to wear a badge all the time with our picture on it. Even to go from the Animation Building to the Commissary, you had to show your ID card. At that time they were making training films for the Navy, Army, and the Marine Corps. Lockheed was even there, first floor Animation. They were small units, [a] very small group of people that were working to make these training films."

With her quick talent, Fallberg soon moved up to Painting. "They had a Navy unit up on the third floor of the Animation Building, and of course we had to furnish the paint and the Painters, so they asked me if I'd like to try working with the Navy. I said, 'Sure.' They had maybe two desks to work at and then if there was anything big, they'd ship it over to the Ink & Paint Department. You had to be investigated and they had security at the entrance of every unit.

"It was hard to tell what I was working on because I think they wanted it that way," Fallberg observed. "They would give you cels to paint and you didn't know what they fit with. There wasn't really any complete character or a complete airplane or whatever—just bits and pieces." Secrecy was paramount, Fallberg remembered. "It was always hush-hush."

Leota "Lee" Toombs began her Disney career in 1943 as an Inker. "She was very good at drawing at a young age," recalled her daughter, legendary Imagineer Kim Irvine. "She was able to get a job at the Disney Studios in Burbank in the Ink & Paint Department when she was about eighteen. They realized she was very good at line work and they put her in as an Inbetweener." As one of the early women to rise to the ranks of Animation, Toombs broke ground with her trajectory in what had been a restrictive field. "I don't know how long she was in that department before she was assigned to work with my father [Harvey Toombs], who was a head Animator on *Victory Through Air Power*."

Rae Medby volunteered early to work with the military units. "I was the top Painter and she was the top Inker," declared June Patterson, who worked as a team with Medby. "We'd go on Sunday because there was no one there, and the guard would lock us in,

actually lock us in. Our only colors were grays, whites, and black—it was like a jigsaw puzzle." Medby also found time to train in identifying aircraft as a "skywatcher," or ground observer in the Aircraft Warning Service. A certified "teller," the young Painter underwent extensive training and volunteered countless hours tracking aerial activity as part of the studio observation post.

INKER TO ANIMATOR

In 1943, shortly after her new husband shipped out, costume design student Virginia Fleener began work at Disney Studios. "When my husband went overseas, I thought, 'I gotta do something'—I was going stir-crazy with worry." Friends saw ads placed in local papers seeking "girl artists" and suggested she answer the ad. "I took some samples of the control that I had with ink. At the time I didn't really know what Inkers were, I just wanted a job and I thought Disney would be great." Armed with innate talent, Fleener was hired without requiring training. "I met with Grace Bailey and Marie Justice [who] worked together with the Inkers and Painters. They both were so nice! They gave me cels and the inbetween stuff and they said start. So I did."

Living a distance from the studio, Fleener would pick up a number of employees along her route to qualify for a gasoline ration card. "I had four people, so there were five of us. They were a good bunch. Two worked as secretaries. One was a guy who worked in the music section, and the last one picked up—she was a cousin to Meredith Willson [the playwright]; she was also in the clerical section. When we came from the parking lot, we had to punch a time clock. You were given a card [ID] and you had to have your card to go past a security guard at the gate.

"In fact, one of the gals that we used to have lunch with, she married the guard. . . . There was a lot of that social thing going on," according to Fleener. Signing an extensive loyalty oath, recognizing the secrecy, restriction, and confidentiality of their work and its relation to "our national defense," every employee of the Walt Disney Studios was answerable to the military, the FBI, and the federal government. "We also had to join a union," recalled Fleener, "because they were doing government work."

Fleener went to work in the Inking Department, completing the various projects coming through. "We'd pick up our materials, just at the manager's desk. It was a long line, [and] you didn't work next to anyone. It was a single row. They didn't want any distractions. The [ink] pens were definitely different than anything you could buy in the store. They were quite flexible. You had to have the right touch. You had to be able to know how to make a curve. At the very beginning they might have shown me what to do, but I got into it very fast.

"They were really fussy in the Paint Department," she added. "The best materials came from Germany, and during the war years, they couldn't get some of the same materials. So things were done with black-and-white mainly—all black ink; I never saw colored ink. And since it was wartime, they were conserving on paper. There was rationing and paper was part of that. Cels during the war were [also] very hard to come by; that's why they had the [cel-washing] section."

With a heightened level of security, the women were often not given clear indication of what they were working on. "We felt it was all top secret," noted Fleener, particularly "if it was a training film. We were just given what was needed to be done and it would be put together elsewhere. I also worked just two people to a room to check and clean the cels before they went to photography.

"If there was a movie in process, you worked very hard," Fleener observed. "They really put you through the paces. If there was no particular movie at the moment, they let us do whatever we wanted to do. You'd finish your scene. I'd see the manager and she'd give you whatever she'd want you to do. They didn't put any pressure on you at all. They trusted you." Inkers

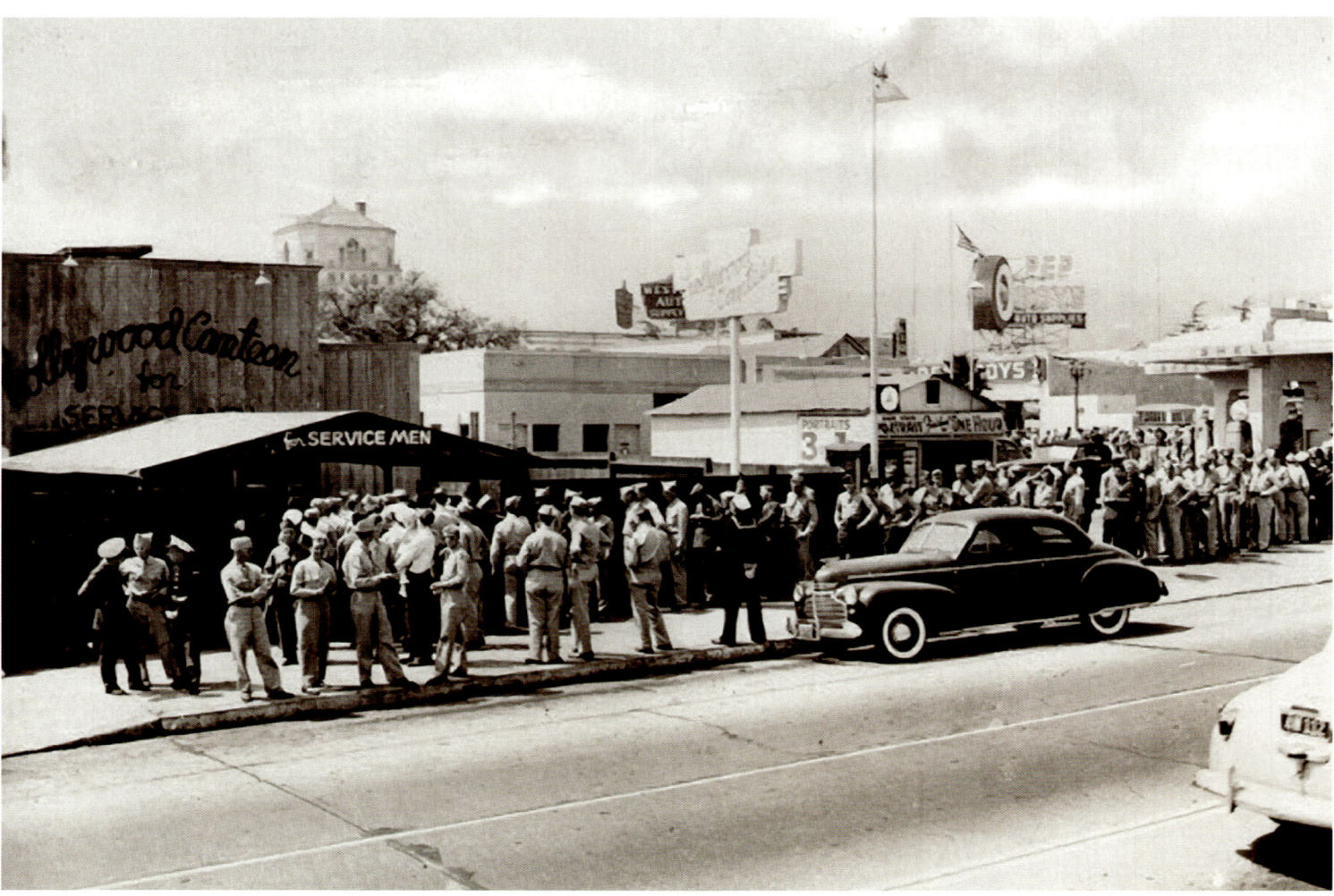

The 1942 opening of the Hollywood Canteen in Hollywood, California, where many of the studio's female staff volunteered to support the war effort.

and Painters continued to train to improve their work. "Another interesting thing they did," Fleener recalled, "[was] the first half hour of our hour lunch period, they would show films by other studios, to make us sort of critique so that we knew how not to do what they did wrong." This proved effective. As Fleener added, "You'd look at it and sometimes a line would go down further on the eyebrow or something, and then it jumps. Inking was quite precise."

After a handful of months, Fleener quickly transitioned from the ranks of Ink & Paint and moved into the first floor of the Animation Building. Briefly trained in cleanup and inbetweening, Fleener was one of two women working there among a large group of men. "I worked with Johnnie Bond[,] who was a real character. He was lots of fun to work with. I animated only if there was a job that was nonunionized. Mainly they were the training films. Animation was a little different, because you had to flip—put it between your fingers—and follow the lines from the light that shined up from beneath. No questions on what the lines were, it had to be perfect. The animation was as good as it was going to get."

Intermingling between floors was minimal. According to Fleener, "Military people were going through, not in our area, but having been up in Story or with Walt up on the third floor, [which] was the top of the ranks. I was on the first floor and sometimes I'd have to go up to the third floor for Story. But you didn't see too many of those people; they stayed up on the third floor." With military personnel positioned throughout the studio, even the Tea Room was commandeered. "We didn't have tea breaks. I don't remember a Tea Room at all," recalled Fleener. Lunches were usually brown-bagged and enjoyed with a group of girls under the shade of a tree on the lot or in the theater.

Some things didn't change. "Though there wasn't a dress code," Fleener remembered, "we always had to wear dresses; you didn't wear slacks then at that time."

MILITARY PRODUCTIONS

Animator Jack Kinney noted, "One of the military training experts told me that they experimented with two groups of soldiers—one group who read the usual written material for several weeks, and one group who viewed a training film just once. Those watching the pictures passed with a rating 20 percent higher than the readers." Thus, training and educational films starring Disney characters such as Mickey, Donald, and Goofy became the staple content coming through the production pipeline.

A wide range of productions was created at the studios during the war. These included the Academy Award-nominated *Victory Through Air Power*; *Maintenance and Operations for the Norden Bombsight*; the *Rules of the Nautical Road* series, which demonstrated how one ship should pass another; briefing films on landing preparations; and educational productions for screening in undeveloped countries and regions, such as *Food Will Win the War* and *The Winged Scourge*. Walt later recalled, "We produced . . . hundreds of films on such subjects as how to hate Hitler, the vulnerability of the Japanese Zeros, fighter tactics, bomber tactics, meteorology, briefing films on the hundreds of islands to be captured in the Pacific; and our series on simple sanitation with such alluring subjects as how to control

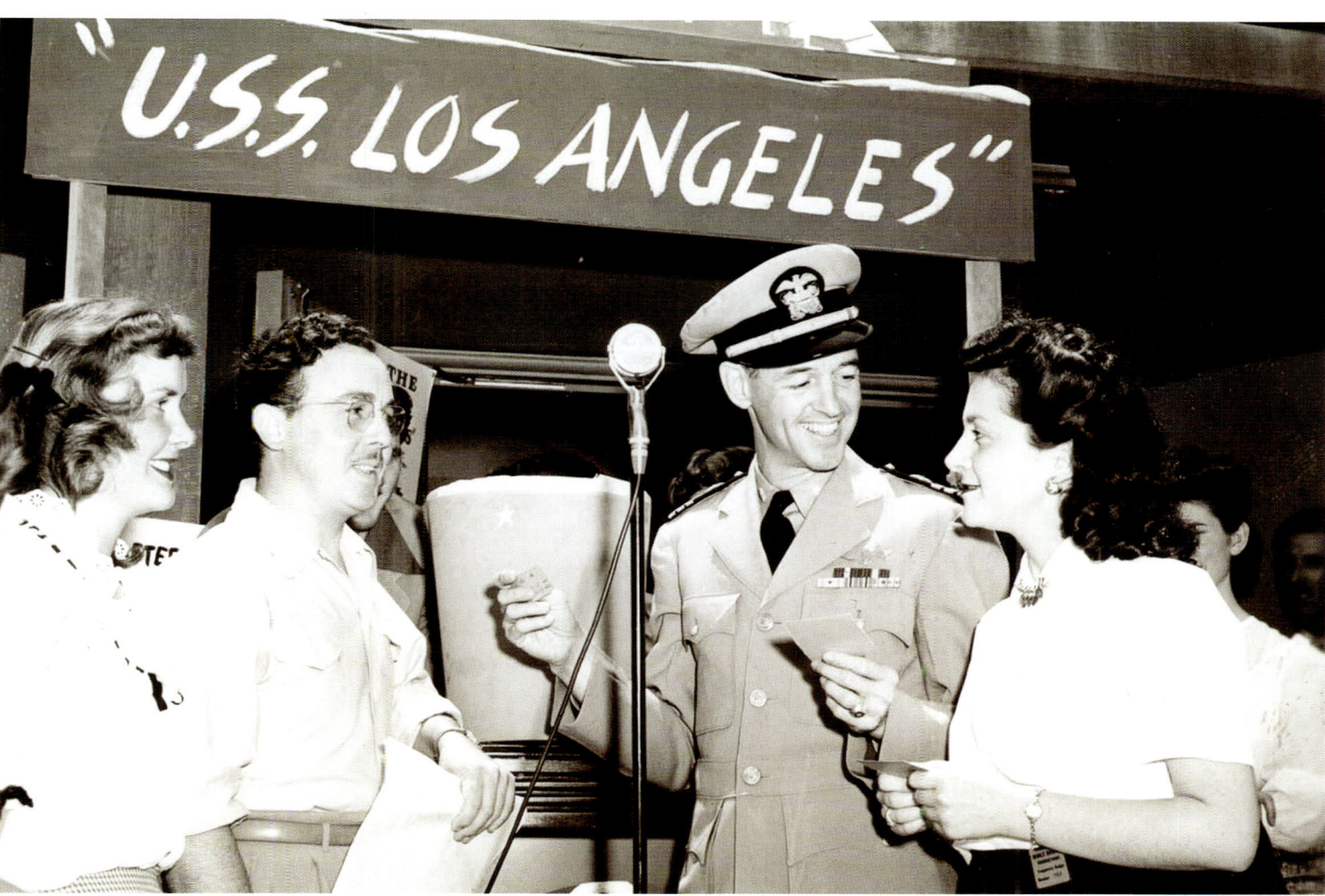

(Far right): Inker Marjorie Furnish helps out at a studio bond rally with Commander John Thach and studio personnel.

the malaria mosquito, how to avoid the hookworm, how to get rid of the body louse, how to build and where to locate a privy so as not to pollute the drinking water, and many more."

Women were now in every area of animation. Retta Scott was fully engaged in war work, doing preliminary story development and animation on such navy aviation training films as *Aerology*, which taught aspects of various weather conditions that wartime and civilian pilots might encounter. This animated training film took pilots inside thunder and lightning storms, fog, icing conditions, and other potential environmental circumstances after takeoff.

Scott also developed story aspects of *Victory Through Air Power* and *Chicken Little*, a film designed to combat false rumors during wartime. Bea Selck, who began on *Snow White* as the Music Room secretary, progressed further into animation at Disney. In addition to Assistant Directing on the short films featuring two new characters, Chip 'n' Dale (whom she named after an eighteenth-century furniture maker), Selck was also busy as Music Editor on *Victory Through Air Power*.

With teams of Inkers and Painters scattered into different roles around the studio, a smaller but sizable force of girls remained in the main Ink & Paint corridors to keep the studio shorts and feature films progressing through the pipeline. New problems arose as a result of the military subject matter now coming through. Ruthie Tompson, who rose to Scene Planning in the Camera Department, recalled, "During the war, we were doing ships and we were having trouble with the paint matching. We matched the color no problem, but the paint itself just would not dry. So they put it down to shoot it and they'd pick up the cel and they'd leave half of it on the background.

"So Emilio [Bianchi] went home and he took a bunch of his stuff with him," Tompson continued, "and he experimented at home and he painted the side of his house and let the sun shine on it to see if he could get something that would dry. He finally found a solution so that battleship gray color would dry."

Animator Bill Justice recalled the scramble to complete one of the critical scenes for a key training film: "Some sort of gunk had gotten on the cel and it wouldn't come off. Around three thousand dollars worth of effort was unusable. Then a young lady named Marie Foley, Supervisor in the Ink & Paint Department, spat on a tissue and cleaned the cel off perfectly. I told her she ought to bottle the stuff." Foley later entered Justice's life in a more profound way, as she eventually became Mrs. Justice.

SERVING BEYOND THE STUDIO

Wilma Baker recalled, "Many of the women of the studio went to Washington and worked there for the studio or for the government." A number of the women joined as regular navy personnel. "We were the first group of women to be recruited to join the navy," said Joan Orbison, who worked for the Art and Animation Unit in Washington, DC. "We were a photo science lab in the naval air station[, and] I was a story sketch and animation consultant on training films . . . to tell them where they could use animation to illustrate something, rather than live action." Traveling up and down the coast to various navy yards,

Orbison worked with a number of Animators from Disney who served with this unit, including Don Towsley and Lee Blair. Retta Davidson, one of the first studio-trained Animators, served for four years in Washington, DC, before finishing her military service in Hollywood.

Grace Godino went into the Army Air Corps and worked at Mines Fields near the Los Angeles coast, driving weapons and staff carriers. "I'd drive on all the posts. I'd smuggle some fellows that were on the post and they'd have dates and . . . want to get out for just a couple of hours. So, when I'd go out I'd put them under a bunch of mailbags and films and I'd say, 'Now, look, kids, I'll take you out, you can meet your gal for a couple of hours, but don't let me down because they'll slit my throat if you don't meet me in two hours right here.' Sure enough none of them let me down . . . but I was always nervous going through the gates." Godino knew the risks, "but some of those kids were shipping out overseas to be killed, and I thought I couldn't [say no]."

Marcia Ashe and many of the girls from the Walt Disney Studios Ink & Paint Department, along with other studio starlets, volunteered as hostesses at the Hollywood Canteen. Created by actress Bette Davis, the Hollywood Canteen was a social setting where servicemen could eat, drink, relax, and be entertained during their time off. Dinah Shore, Groucho Marx, and Marlene Dietrich were regular performers, and it wasn't unusual to see these glamorous stars tie on aprons to work in the kitchen, wipe off tables, and sweep the floors after a performance. After a brief training, women were teamed as junior and senior hostesses. The women were free to choose whom they danced with, but "scrupulous politeness at all times to all men in uniform is demanded."

Encouraged to mix and mingle, they were instructed, "Try to devote your attention to as many of the men present as possible, and do not spend all your time talking with one or two servicemen." Improper behavior was reported to the officer in charge, and hostesses were directed to "stop immediately, any serviceman who consciously or unconsciously begins to give information as to troop movements, boat departures, or other naval or military information." Above all, they were reminded, "The men are often very shy[,] and by approaching them and speaking to them first, you may be able to extend hospitality to a boy who otherwise would spend a lonely evening."

Nearly eighty studio employees performed in various "camp shows" for the military installations throughout Southern California. Complete with Ward Kimball's band, the Huggajeedy 8, dancers, singers, sketch artists, and comics performed in a number of these revues. A versatile entertainer, Godino recalled, "Sometimes we'd be in the middle of a show on a post somewhere, and there'd be a whistle, and that was our sign to just stop right onstage. We'd stop and certain detachments would get up. . . . They'd march out and they were off to war. We'd stand there, and tears would come in my eyes[,] and here we were doing a comedy. Those that weren't called, why[,] they'd sit there, too; they wouldn't say a word. It would take about maybe fifteen, twenty minutes until those guys would ship and then we'd start up on the scene again."

> "*There's something in* Bambi, *I think, that will last a long time.*"
> —**Walt Disney**

Final frame from Walt Disney's animated feature film *Bambi* (1942).

INTO THE FOREST

Back at the studio, work on *Bambi*, which had begun as early as 1936 at the Hyperion studio—though production carried on over the span of nearly six years—was proceeding. Many challenges cropped up on this production, including a number of difficulties with the story. But there was never pressure to rush completion, as Walt directed the artists to work at the story until it was right.

Producer Perce Pearce defined their biggest challenge in a story meeting: "We must capture a spirit of reality interpreted in fantasy. We must get poetry out of our pictorial side." The work of Chinese-born artist Tyrus Wong provided the key to poetically translating the reality of *Bambi*'s world. Walt recognized the impact of Wong's lyric simplicity: "I like that indefinite effect in the background—it's effective!"

Wong's style held a great influence throughout the film, especially within staging, backgrounds, and the color imagery emanating from Ink & Paint. But even bigger challenges came with the animal forms that would populate *Bambi*'s world. The charming animals of *Snow White* and *Pinocchio*—and even the centaurettes of *Fantasia*—had paws, arms, or even their entire bodies to express emotions with, but the four-legged anatomy of a deer presented problems. As Pearce recognized, "What we have to try to do is make the audience feel, for the duration of the picture, that these are real animals."

A VERITABLE ZOO

"I had to put my artists back in school to train them for this one picture," declared Walt Disney. "They had to learn animal anatomy and locomotion to a degree [that] you don't get in a formal art education." Rising to the challenge, Mary Blair, Retta Scott, and the artists also conducted regular treks to the Los Angeles Zoo and ventured out into the nearby fields to sketch and paint. "When I finally went into production," recalled Walt, "I just couldn't put every artist I had on it. So, I had to take a select team[,] and that cut the size of the staff down to the point that it took longer. But I think the end result was worth that."

So that the Animators could capture the realism and natural qualities of their young protagonist, game wardens from the state of Maine brought a pair of four-month-old fawns to the studio for the Animators to study. Aptly named Bambi and Faline, the two Virginia red deer lived in a pen outside the studio's Animation Building. Studio Animators spent hours sketching and photographing the deer as they grew to adulthood, making extensive study of the animals' movements, habits, tendencies, and lovable qualities.

Retta Scott drawing for her animated dogfight sequence in *Bambi* (1942).

Soon, Disney Studios was teeming with a variety of forest creatures for the artists to observe. In addition to the animal models, human models were also utilized, even though humans never actually appear in the film. To achieve believability as Thumper and *Bambi* skate across the wintery pond, skaters Donna Atwood and Jane Randolph glided on ice for the studio Animators. These filmed sessions brought detailed accuracy to the specific movements of the characters within one of the most memorable scenes in the film.

"SHE HAD A FEELING FOR POWER"

In an early 1940 story meeting, Walt spotted Retta Scott's story sketches featuring a meadow filled with deer. "This is swell stuff," declared Walt. Producer Perce Pearce informed Walt of Scott's inbetween work for Barnard Garbutt, to which Walt declared, "First girl Animator." Pearce added, "We call her the female Freddie Moore [another Disney Animator]."

With Scott's deft skill in rendering animals, *Bambi* was a perfect fit. Scott was given one of the more challenging sequences in the film to storyboard. "She was doing the dogs that were chasing *Bambi*," recalled Animator Don Lusk. "No doubt about it, she knew how to draw dogs." Scott wrote, "I developed the hunting dogs into vicious, snarling, really mean beasts. I spent weeks on the dogs and almost every day [instructor] Rico Lebrun came to my room to give me much advice and support. . . . I finished all three sequences[,] and they were ready for the layout men and the Animators. It was then that Animator Dave Hand and Walt felt that I should animate the dogs and the deer in these sequences." Legendary Animator Eric Larson remembered, "She worked and worked on it. This gal had a feeling for movement . . . she had a feeling for power."

In their book about the film, Frank Thomas and Ollie Johnston recalled being in awe of Scott:

A startling moment for us came when we saw Retta Scott's amazing sketches of the vicious dogs chasing Faline and keeping her cornered on a high ledge. We wondered who at the studio could have drawn this terrifying situation so convincingly and would have guessed that such virile drawings could have been done only by some burly man, probably with a bristling beard and the look of an eagle in his eye. We were amazed to find instead that they were done by a small, delicate, wonderfully cheerful young woman with twinkling eyes and a crown of blonde curls piled on top of her head. Retta was strong, had boundless energy, and drew powerful animals of all kinds from almost any perspective and in any action. No one could match her ability.

Color model sheet for Miss Bunny in *Bambi* (1942).

WHISTLING "INBETWEEN" THE FOREST

Adding an audible texture of reality to this artistic vision, the film's composers, Edward H. Plumb and Frank Churchill, integrated birdcalls into many sections of their woodland themes. To differentiate each bird's sound, professional voice artist and whistler Marion Darlington was enlisted to contribute to the film's sound track. Known as the "Bird Voice of the Movies," Darlington had worked on a number of the studio's earlier projects, but her biggest assignment came with *Bambi*, for which she filled an entire forest with birdcalls.

Inbetweener and later Assistant Animator Dorothy Castle Bronson caused quite a stir on her first day in Special Effects Animation during production on *Bambi*. It seems the other Animators lined her bosses' offices with doilies, tied-back curtains, throw rugs, frilly lampshades, and a mantel clock on the desk to announce Bronson's arrival. Despite this gentle hazing, Bronson's consistently strong work and her contributions as both a special effects artist and as an Inbetweener heightened the artistry of this forest adventure.

Over the years, more than one hundred artists, writers, and musicians shaped the animation of *Bambi* before each scene made its way to Ink & Paint. But as Thomas and Johnston later wrote, "When the animation on *Bambi* started filtering through the Ink & Paint Department, a new problem arose. The legs of the deer had to be strong and rigid for the animal to be convincing. The Assistants and Inbetweeners in the Animation Building had taken great care in practically tracing the legs during a scene of little movement, but now the Inkers found they could not copy these drawings accurately enough to avoid the jitters and wobbles." To solve the issue, the inking artists made the suggestion of doing the inbetweening directly onto the cel and eliminating the need for the drawings that were causing the problems. Thomas and Johnston concluded, "There were many days during the making of the picture that they regretted having made the offer, but the results were magnificent."

SHADES, TONES & DEPTH

Color came to the forefront in *Bambi*. To Walt Disney, color played as much of a role as any of his leading characters. Walt deemed color to be much more than a palette of bright tones to fill the screen, and so the psychological impact of various shades was studied and incorporated for emotional effect on the audience. Silhouetted forms in yellow-white transfer a sense of intense fear and a feeling of suspense when young Bambi and his parents race for their lives to escape Man's guns. Similarly, in the battle between Bambi and his rival for Faline's love, the brilliant midday light of

Production cel featuring Bambi and Thumper.

the forest transforms into ominous darker tones. Deep shadows highlighted by dull reds frame the two battling animals, while a terrified Faline stands out with spot-lit clarity.

Color experts keyed the characters to the forest world around them. Color Model Supervisor Mary Lou Whitham recalled the challenges they faced: "The charming [Felix] Salten classic considers animals as personalities. Here our problem is to find colors for the characters in the cool of the forest in spring, the meadow in dawn and in moonlight, the bleak cold of the long, barren winter, and the fierce red holocaust of the forest fire."

From late summer to early fall of 1938, the Paint Lab sought out new and exotic pigments to expand the palette of *Bambi*'s forest. Experiments were conducted on each tone to ensure feasibility, as the studio's lab notes reveal: "Tan 5—might be good for shades on clouds, light on leaves, shades on animals. Brown Tint—gives soft golden glow on most animal colors. Fails to show on darker values." Various dye tints were tested for the studio's patented Blend technique. Lab technicians experimented with water-green and water-brown dyes for the forest's pond and rain sequences. Creating color-model sheets required careful planning to work out the specifics of each character and the world they inhabited. The Background artists also referenced the color-model sheets created by Whitham and her team to ensure there were no conflicts with the colors of the characters playing against their backgrounds.

Marion Wylie Stirrett led the Background Department in translating the artistry of Tyrus Wong's delicate conceptual designs into the forested world of *Bambi*. As a fine artist, Stirrett introduced the use of oil-based paints to create the range of seasons within the forest. Early in the production, Stirrett and the other Background artists developed new painting techniques to achieve believable dappled sunlight effects that would ultimately be applied to over 450 background paintings. Animation had never before conveyed sunlight so vividly, cast through cool forest glades or reflecting off waterfalls cascading into limpid pools. Even the subtleties marked within a scene as the degree of light transitions from dawn to dusk came from years of experience. These were no longer just backgrounds, but a forest with actual depth and dimension. Once completed, the backgrounds made their way through a series of checks and rechecks in the Inking & Painting Department's Final Check.

"TWITTERPATED" TALK

An original term created by the studio's story teams, "twitterpated" described that springtime state of smitten infatuation: "Your head's in the clouds because your heart's in a whirl. . . . Brother, you're twitterpated!" During a conference on the famous sequence where the wise old owl enlightens Bambi and his friends about love, it seems a few of the male Animators protested the fact that the female characters took the initiative in the wooing. Walt began asking the men about their days of courting, and it was soon discovered that most of their wives had clinched the marriage deals.

During the course of production, it was more than the characters of *Bambi* who felt the potency of being "twitterpated," as Writers, Story artists, Directors, office personnel, and yes, Inkers

Ink & Paint | 207

Left: Cel featuring an experimental pigment application process exploring early cost-saving inking options; and (right) final film cel setup for *Bambi* (1942).

and Painters, fell in love in record numbers. As one of Janet Martin's clever studio write-ups noted, "The studio lawns were . . . full of twosomes, spending their non[-work] hours and recreation periods cozily under some tree." It seems that Walt himself was fine with romances forming at the studio, as he was quoted in Martin's studio release stating, "How could I be anything else but? After all, you know who the first fellow was, to marry a studio girl, don't you? Me!"

EXPERIMENTAL ACTIVITIES

The last department to move to Burbank, the Hyperion Process Lab continued to keep the productions of *Fantasia* and *Bambi* on track while the final plumbing and tank installations were being completed at the Burbank Process and Experimental Laboratory. Always searching for new techniques to improve quality and reduce costs, the studio developed a number of new experimental approaches over the long span of production on *Bambi*.

In the summer of 1940, as the Ink & Paint Department was about to begin work on the first cels for *Bambi*, J. Arthur Ball of the studio's Process Lab spent extensive time analyzing suitable acetate cel materials to replace the highly flammable nitrate cels utilized at the studio. Acetate cels had been available from various manufacturers for a handful of years, but continual halation and inconsistency problems—as well as "a price too great to permit its adoption"—prevented them from being used. But as manufacturers resolved various issues with static and construction inconsistencies, Ball determined, "There would appear to be no further occasion for the use of nitrate sheeting as soon as that which is already on hand is used up."

The Process Lab became the research and development hub of the studio, as an interoffice memo noted: "For the past two years we have been developing an entirely new formula, referred to as the Latex Paint, which has been sufficiently time-tested in production tests to warrant its recommendation." However, with war priorities, the introduction of the latex formula was postponed. Explorations in new techniques for paint application beyond the "orthodox brush" and airbrush were conducted.

New photographic methods took shape within the department, which directly affected the inking and painting processes. Refinements had been made in reducing the size of figures applied to cels, rendering one color per cel, which was effectively utilized with special effects such as water splashes, smoke, and ghosts in *Fantasia*.

On a suggestion by Ub Iwerks, Ball and his team explored a method of reproducing tracebacks, which occurred on 10 percent of all cels, for the Inking Department. This potentially improved approach to tracebacks could dramatically reduce line jitters on the screen. However, Ball pointed out, "because of the work being split between the two departments [Inking and the Process Lab], it can scarcely be considered economical except as it eliminates the redoing of scenes." This method was standard practice, however, by 1941.

Early explorations in substituting photographic copying for hand-inking were also conducted, but the yellowing and cracking of animation paper due to the continued flipping and handling

Concept artwork by Mary Blair for the South American films.

Page 210, top: Panchito and Jose Carioca cel pieces; and (bottom) painting a cel piece from *The Three Caballeros* (1945).

Page 211: Final frame from *The Three Caballeros* (1945).

of the pages proved problematic. Ball and his team worked with paper manufacturers and experimented with various paper stocks, but the preferred stocks were cost prohibitive. Though the desired intent wasn't achieved, these experiments raised the possibility of the use of colored pencils, which would not be picked up by the camera. Animators' notations and blue-sketch techniques came about as a result of these discoveries.

Ball and his teams also "developed a novel method of applying pigment under the control of a photographic process, working directly from the animation drawings." This very early precursor to Xerox technology, which revolutionized the animation industry over fifteen years later, was a method in which "a pencil drawing is sealed in between two cels. In this manner [which does not involve any photography], the inking procedure was to be entirely avoided and the artists' handiwork can go directly to the painting department."

Elizabeth Price, a young Painter assigned to the *Bambi* unit specifically to work on this experimental pigment application, often put in overtime on color-keying presentation cels for possible use. Martharose Bode, then head of Ink & Paint, also put in extensive overtime to determine a number of solutions to various inking and painting problems that arose during the course of production. These contributions did not go unnoticed by *Bambi*'s director, Dave Hand, who arranged for these ladies to receive raises for their exceptional work.

Expensive optical instruments, suitable paper stocks, and the development of chemical processes were required to explore transforming this experimental pigment possibility into a reality. With cost-cutting measures being implemented across the studio, Ball relayed the current challenges with this procedure to Walt in a memo: "The pencil line itself, at best, is wider than an ink line[,] and if there is further swelling of the line and loss of detail in the photographic process, the result can be very disappointing." Reporting to Walt on the status, Herb Lamb noted that the Process Lab's effort "still needs experimentation before practical adoption for elimination of inking." Costly and unstable, this early experimental process was quickly abandoned.

By January 1942, the last of the cel work on *Bambi* moved from the Ink & Paint Department to Camera. With 100,144 frames of film, a rough average of four images to a frame of film equated to approximately 400,576 inked and painted cels to bring the multiseason story of *Bambi* to life.

Once completed, Walt brought *Bambi* home to screen for his daughters, since Diane had read the book and loved the story. Afterward, Walt retold young Diane's emotional reaction: "She cried.... She said to me, 'Daddy, why did you have to kill *Bambi*'s mother?' And I said, 'Well, it was in the book, dear.' She said, 'There are plenty of things in the book that you changed. Why couldn't you have changed that?' She had me there."

> *"We made an honest effort to find out from them something of their culture, customs, music, color[,] and humor."*
> —**Walt Disney**

GOOD NEIGHBOR FILMS

Production began immediately as the traveling team of artists returned to Burbank. The colors, sights, and sounds of their south-of-the-border adventures filled the storyboards and strategy sessions in the sweatboxes as the artists translated their experiences into animation. Some of the most scenic spots in Brazil, Argentina, Chile, Peru, and Bolivia were explored in stylized form in both upcoming films, *Saludos Amigos* and *The Three Caballeros*.

An anthology approach composed of live-action segments with four animated episodes evolved into *Saludos Amigos*. Fan favorites such as Donald Duck and Goofy were featured along with a new raft of characters, including the fearless flier Pedro; a friendly llama; and a new fowl friend (joined by a second in *The Three Caballeros*). To differentiate these Latin feathered fellows from Donald, José Carioca and Panchito were each formed with colorful palettes reflecting their unique personalities.

Within the "Tico Tico" section that introduces José, the watercolor world of Brazil comes alive. From the tip of an artist's animated paintbrush, limpid waters of an imagined waterfall surge to the Latin samba. To achieve this expansive color palette, some Inkers worked with "four pens at once, tied by rubber bands," declared Inker Jeannie Keil. "I got twice as much done." Each brushstroke transformed into stylized settings for Donald and José, across thousands of cels masterfully painted by the women of Ink & Paint.

Once again these artists animated color as each scenic setting transitioned into the next via a watercolor blend. Watercolors were also introduced for the backgrounds, adding a distinctive quality to the vibrant world of *Saludos Amigos*. The Paint Lab chemists maintained a thousand compounded color formulas, with over two hundred used in *Saludos Amigos*, constituting over 150 gallons of paint.

Saludos Amigos marked the studio's first attempt at live-action Technicolor combined with animation. Challenges came with the combination of animation and live action. "One time they sent me up to work on *Three Caballeros* where they were putting animation with live action," recalled Inker turned Animator Virginia Fleener. "They'd never done it this way before so they knew each cel had to be traced around. I worked on that for over a month in a darkroom, tracing around. They [the three characters] were riding on a magic carpet. I was in a room all alone and I had to follow the outline that was to go on the rug. I don't know how they did it—what they did after that, but they seemed to be satisfied with it.

MARY BLAIR

After Walt and "El Grupo" returned from their travels to South America, development began on a number of film concepts. A studio write-up noted, "Disney declares that the wealth of material gathered from the trip is enough to supply him with backgrounds for many more films." One of the more notable developments from this travel experience was the brilliant artistry of young Mary Blair. The experiences and lasting impressions of her South American travels fed Blair's art and transformed her style. Watercolor and gouache turned into vibrant and colorful worlds under Blair's brush as she explored color, tone, staging, costuming, and settings for characters and scenes perfectly suited for Walt Disney's animated South American stories.

Further, her impact on Walt Disney and his animated films was unique, as legendary Animator Marc Davis stated: "People would say, 'don't ever use purple or lavender, Walt hates that.' Mary Blair used color like nobody's ever seen, and whatever she did, whatever magic she had, it hit Walt. From that point in, she used lavender and purple, but she made them work, with this wonderful sense of color and a very unique sense of design. . . . Walt was so intrigued with the work that came out of this woman. What he saw in Mary was something he wanted to inject into his pictures, but the rest of his staff was not up to the point of understanding what it was that she was doing."

Blair's best friend (and Marc's wife), Alice Davis noted, "Mary was the dearest, sweetest, kindest friend and person I've ever known in my life. She never realized how great she was. She had an unsureness of herself at times that I could never understand[,] when she should have been so sure of herself more than anyone, because of her talents and abilities."

"I had three jobs," Blair once recalled. "Raising children, keeping house, and doing my artwork." This sentiment was echoed by many women within the studio, but Blair's life was far from typical. As early as the mid-1940s, she juggled family and career as she regularly traveled from her home and studio in Long Island, New York, to California for studio meetings decades before the concept of a "frequent flier" became the norm. The artist described her roles as "working with the writers and helping to create the ideas of the picture graphically right from . . . its very beginning."

Throughout the numerous films Blair worked on, her influence is evident, though perhaps not as prominent as Walt would have liked. For *Saludos Amigos* and *The Three Caballeros*, Blair's was the only female name in the credits, for "Art Supervision," with many of her studies serving as visual bridges between segments within these vivid travelogues.

"It was just a matter of putting the animation outline on the actual carpet," Fleener noted. "It was the first time they'd used animation with an actual photograph of an actual carpet. It wasn't unionized work, so there I went to do it. Unfortunately, I never got a chance to see the final work go through Camera."

Striving to improve the blend of live action and animation, filmmakers explored the technique of rear-projection in *The Three Caballeros*. To accomplish this, an intricate combination of set pieces and cel overlays was utilized. Animator Ken Anderson explained the approach: "The animation was done first, and projected on the screen behind [actress] Aurora Miranda. She had to stand a certain distance in front of the screen, or the lights would wash out the rear projection." Optical experts created special quartz lenses to permit the maximum amount of light from the projected image. A translucent fourteen-by-twenty-foot plastic screen was erected with the projector on one side, set fifty feet away and on the opposite side; the Technicolor camera was set twenty-five feet away. The live-action dancers then performed on a stage set up in front of the projected animated characters. Anderson noted, "This rear-projection method had too many limitations for Walt, and he continually pushed for better methods."

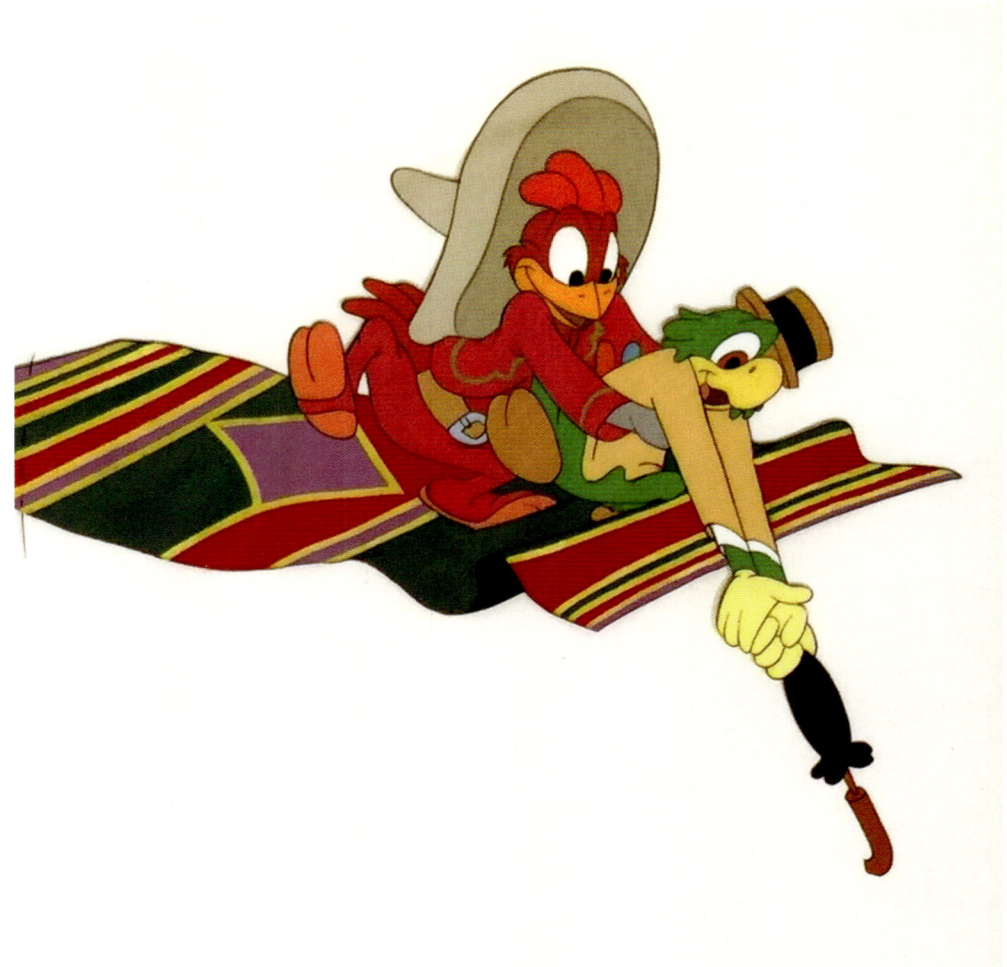

A RETURN TO PEACE

By 1945, with the end of the war on the horizon, a number of transitions were under way at the studio as well. After two years of working her way to animating on training films, Virginia Fleener, like many other female staffers, left the studio when her husband returned from war. In March, C. O. Peterson, the man who had worked since 1933 as a cel washer, was released due to the discontinuation of the cel wash function at the studio. "When I arrived in 1945, they did away with the washing," recalled Ink & Paint artist Carmen Sanderson. "They started just throwing the cels away."

Beginning her career at Disney in the summer of 1945, longtime Ink & Paint Department Secretary Edle Bakke stated, "I remember they were just kind of mopping things up from the army being there . . . [and] by September they were out." Animator Marc Davis recalled, "By the time the war was over, Walt was getting pretty tired of all these people sleeping in his offices here and there, but the work that he did saved the studio's existence."

"VJ [Victory over Japan] Day arrived at last!" noted Bill Justice. "The studio began returning to normal as people came back from the military. As quickly as possible we got out of making training films and back into entertainment." But by the end of the war, the studio was deeply in debt, having lost millions of dollars producing training content for the military at a much higher cost than what the government compensated. Miles of original Disney material had been produced, but with no opportunity to repurpose or reutilize any of it, Walt and Roy had to quickly diversify to keep the studio going.

When asked about low points for Walt and Roy, Edna Disney replied, "I would say it was partly during the strike and partly during wartime because they had a lot of war contracts that they spent more money on than they received. That was kind of hard on them. . . . It took a little while and then they began to pick up. And from then on they really have done very well."

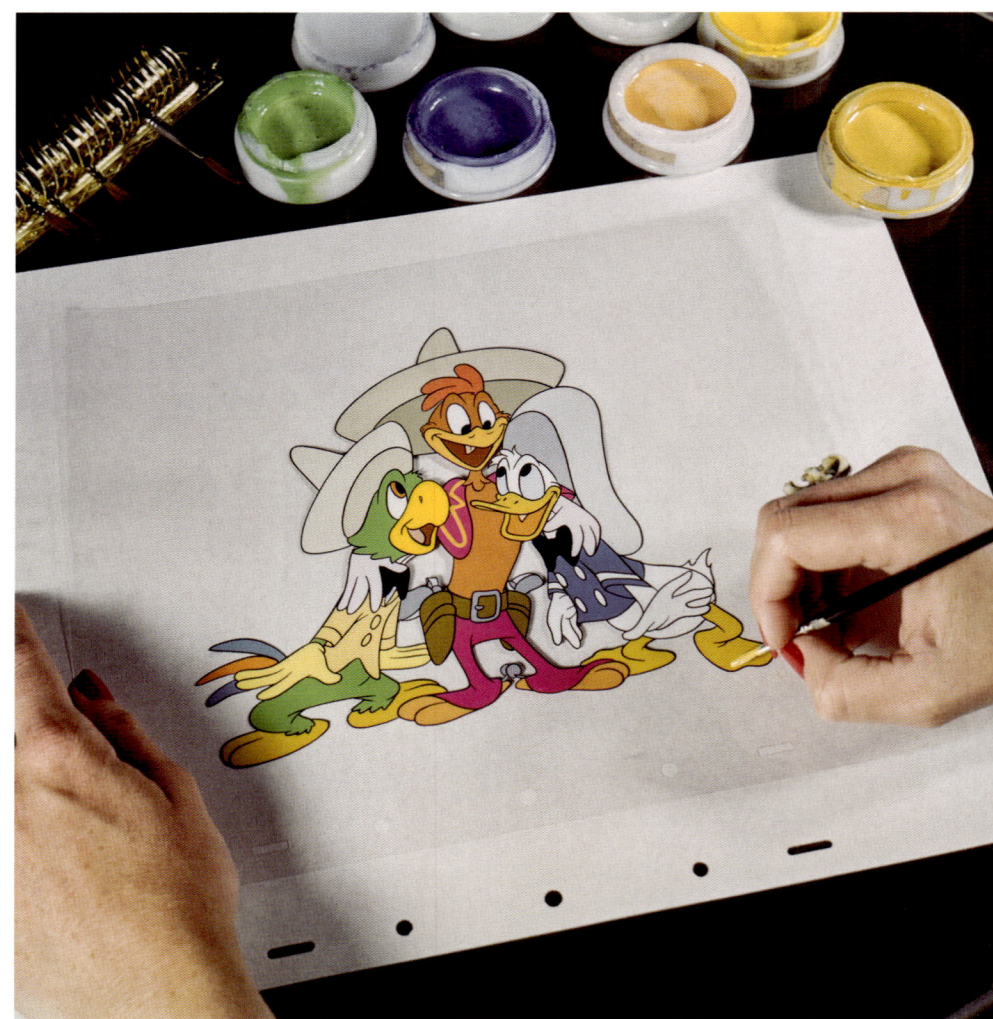

REBUILDING

> *"Coming out of the war, during which we had been deprived of so much through rationing and the absence of the men, made us grateful for our current circumstances. Even the young widows never complained."*
> — Lucile Williams

Roy Disney often referred to the first half of the 1940s as the "lost years." Entering the latter half of the decade, Roy recalled, "We were like a bear coming out of hibernation; we were skinny and gaunt and we had no fat on our bones." When the last of the military forces finally departed from the studio lot, the second half of the 1940s presented new challenges with getting back to the business of producing animation. Once again, the studio found itself in a state of rebuilding.

A new Inker in 1945, Lucile Williams, defined her colleagues and the tone of the time: "The Ink & Paint girls were lovely, sweet people. As young artists we were all fun-loving with a laissez-faire attitude." Williams came to Disney after her sister vouched for her. "Edle [Bakke] had begun working for the studio right after graduation only a few months before I started. She was secretary to Grace Bailey, head of Ink & Paint[,] and in her 'good graces.' I was originally hired to be Edle's helper, and while working the switchboard, I practiced inking and developed enough skill to be assigned to the corridor."

"When I started," recalled Williams' sister, Edle Bakke, "some of the girls who were in Checking weren't that happy because they had been running the Camera Department during the war." The women Bakke remembered were Katherine Kerwin, Mimi Thornton, and Ruthie Tompson. "We were in a whole different time," she reflected. "There wasn't that much advancement because there weren't that many positions for women, so women were expected to go back and take their old places and the men were supposed to have the good jobs."

A RETURN TO NORMAL

Wilma Baker added, "They all liked it and they hated to give it up when the fellas came back, but that's what was expected in those days." Katherine Kerwin, Mimi Thornton, and Ruthie Tompson returned to supervisory roles in Ink & Paint when the studio cameramen returned from war.

Young Carmen Sanderson began at Disney as one of the few girls in Studio Traffic. "You run errands and deliveries, and there weren't too many girls at that time in that department 'cause that was 1945. You dressed up in those days, high-heel shoes, hose, and all that." Making deliveries between the Animation and Inking & Painting buildings, young Carmen became fascinated by the working going on over at Ink & Paint. "People don't realize that this was an opportunity for women when there really weren't many opportunities for women—particularly in the 1940s," Sanderson reflected.

Perhaps the surest sign of a return to a "new normal" for the world of Ink & Paint was the restoration of the Tea Room, which was now back in operation and viewed as the welcome oasis for the women on break. Running this all-female domain was Vera Lelean, a lively and spirited British woman. During the war, Vera survived the bombing of the London Post Office where she worked, then later found work manufacturing bullets in a munitions factory for the war effort. The young Lelean and her small daughter, Moyra, later immigrated to Los Angeles to start a new life. In need of a job, Lelean met Bakke and Williams' mother through a friend at their church. "It just happened that the lady who was running the tea shop was leaving," recalled Williams. "Grace Bailey interviewed Lelean and hired her on the spot."

It was the right fit. "Vera was very proper," recalled Williams. "She ran the Tea Room strictly according to protocol." Then a new Painter at the studio, Norma Swank recalled Lelean's deep English accent and devilish sense of humor. "When Grace Bailey reprimanded her for not having enough tea cakes for everyone, the next day, there were tea cakes everywhere—even on the light fixtures!"

"The Inkers and Painters were all women at this time, and the Tea Room was for us," Williams noted. "News of happy events such as engagements and weddings were shared among us there." The secluded deck above the Paint Lab provided a bright outdoor respite as well. "We used to do our sunbathing up there," Bakke giggled. Williams chimed in, "We'd loosen our blouses and sit out on the porch." Bakke continued, "That was before they had the back lot. So it was quite private. There was a little resting lounge opposite the Tea Room and some girls would get very tired, or they'd get headaches, and they'd go there." Norma Swank added, "They had big couches in there and a lot of the girls would take naps during breaks or lie down if they had 'the curse' to get rid of cramps."

Men were discouraged from and rarely found in the Tea Room, as their Penthouse Club digs reopened as well. "Rarely would a man venture into the 'Nunnery,'" continued Williams. "When any of the fellows from Animation had a consultation with our Supervisors, they would go to the office, but didn't set foot in the Tea Room or onto our corridor. Likewise, the girls were discouraged from going over to the Animation Building on breaks. Fraternizing with the artists was highly frowned upon."

Grace Godino chimed in that "the fellows would sneak over . . . [but then] one time they finally stopped the boys from coming over." With the reopening of the Tea Room, the confines of the feminine domain had to be clarified with an "IMPORTANT NOTICE" sent around the studio from the director of Labor Relations, stating: "The recess privileges of the Inking & Painting Department and coffee service during the designated recess periods are FOR INKERS AND PAINTERS ONLY. These privileges are given to Inkers and Painters because of the tedious nature of their work. Other Disney employees not engaged in Inking and Painting will hereafter be denied this service during the recess period. Please cooperate."

Grace Godino, however, recalled Roy Disney frequenting the Tea Room, "because he used to get doughnuts. He'd sit with us and we'd enjoy having tea. Finally he said, 'I'm not coming anymore.' Vera, the tea lady[,] said, 'Roy[,] you can come over. I'll fix you a cup of tea.' And he said, 'No, if my men can't come over, I'm not coming.'"

MULTIPLE LANGUAGES

Foreign markets began to open following the war, and Walt Disney's animated films were in demand again. One studio write-up mentioned, "[There's] a cosmopolitan sound to the talk heard on stages, offices, the studio commissary[,] and everywhere that employees gather." To meet the growing demands of renewed worldwide audiences, prints had to be properly dubbed and transferred into a number of languages, each potentially requiring modifications to the animation, title sequences, and, in some cases, characters for each film on the Disney slate. Which, in turn, meant additional work for Ink & Paint.

Title cards, credits, and notable adjustments to character lip movements had to be created for each language. Eight various languages covered the European regions, almost double that figure would be sought for East Asia, and nearly ten times that number would be required for the vast population of India. The South American films were carefully studied for language, as these titles enjoyed a wide release all throughout Latin America before North American audiences were introduced to these films. Scrupulous localization for each global region was made to ensure audiences were not offended or confused.

ANIMATED LADIES

Rebuilding his animation talent pool once again after the war, Walt Disney returned to the well of Ink & Paint. Berta "Bea" Tamargo came to the studio in 1946 as an Inker, and her talent for drawing was soon discovered. Quickly promoted to Assistant Animator, Tamargo worked on a number of the postwar educational productions and on feature-length animation as well.

Born in Havana, Cuba, and raised in Miami, Tamargo trained as a violinist while still a child. But when her interest in art grew, Tamargo later traded her violin bow in for a paintbrush. When she was a young adult, her family moved to Los Angeles, where she was hired to work in the studio's Ink & Paint Department. Tamargo later assisted and animated on *Cinderella*, *Alice in Wonderland*, and *Peter Pan*, and she became a US citizen

Page 213: Dancing to a lunchtime jam session outside of the Burbank studio's Animation Building, with a female bass player.

Page 215: Teatime on the Burbank sundeck; relaxing in the Ink & Paint Tea Room lounge; braiding each other's hair outside the Inking & Painting Building and tea-timing in the ladies Tea Room.

Ink & Paint | 215

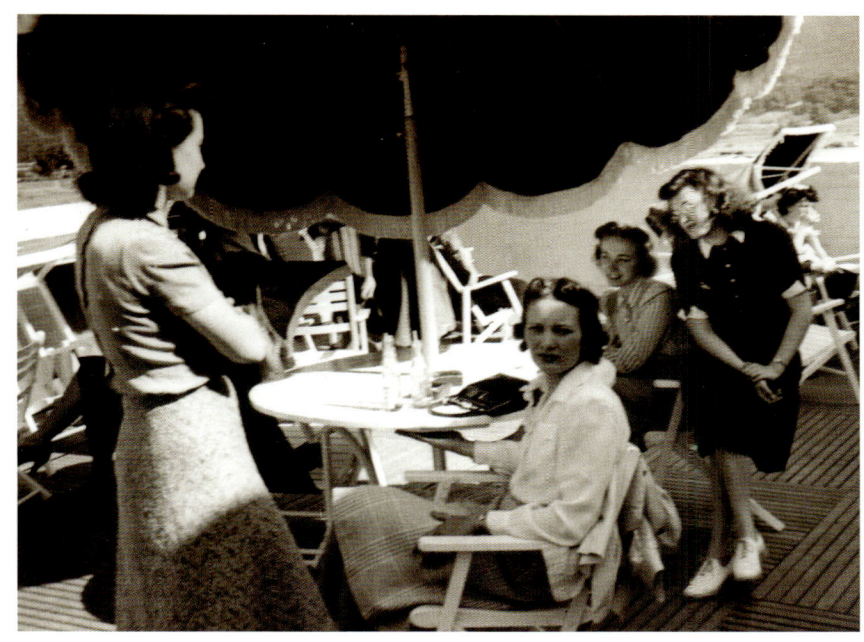
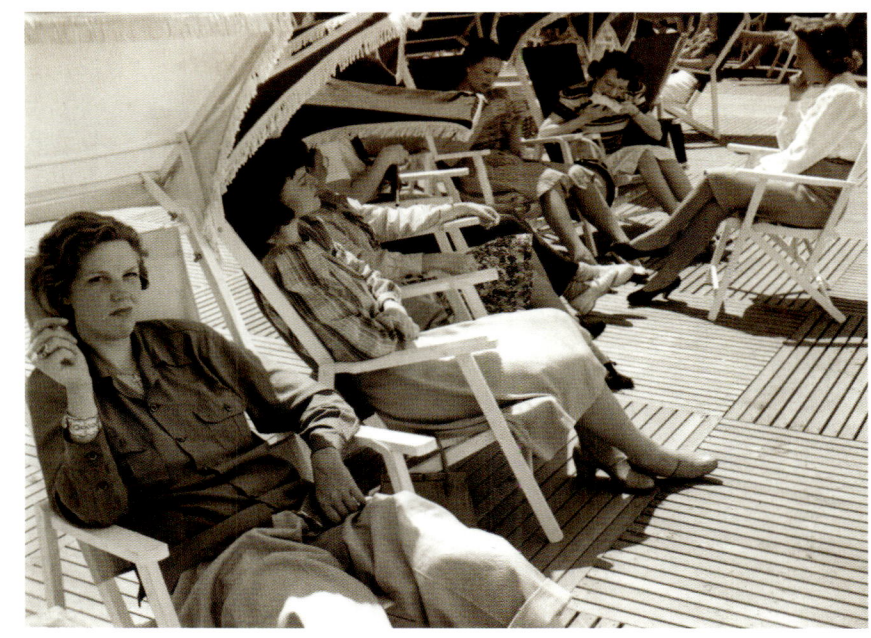
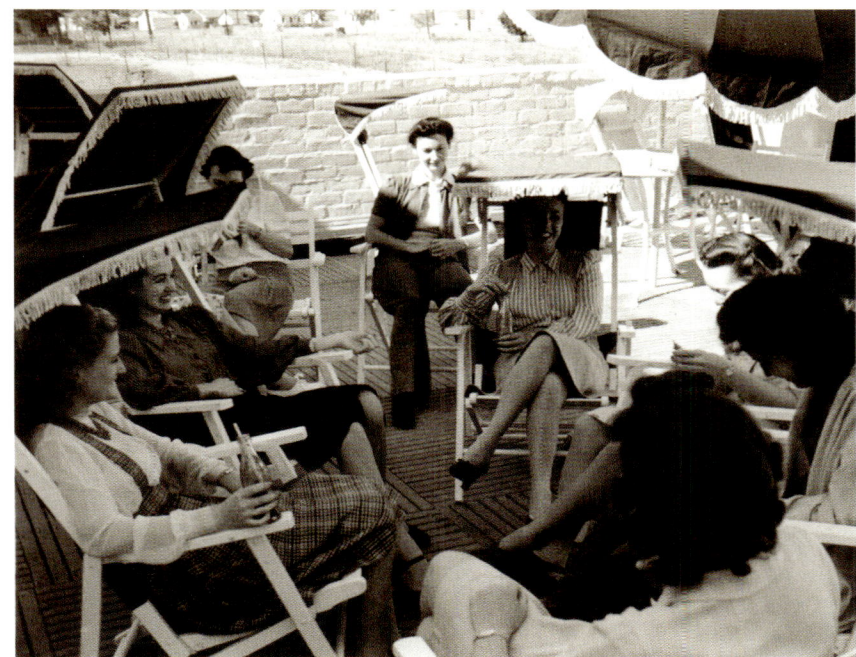
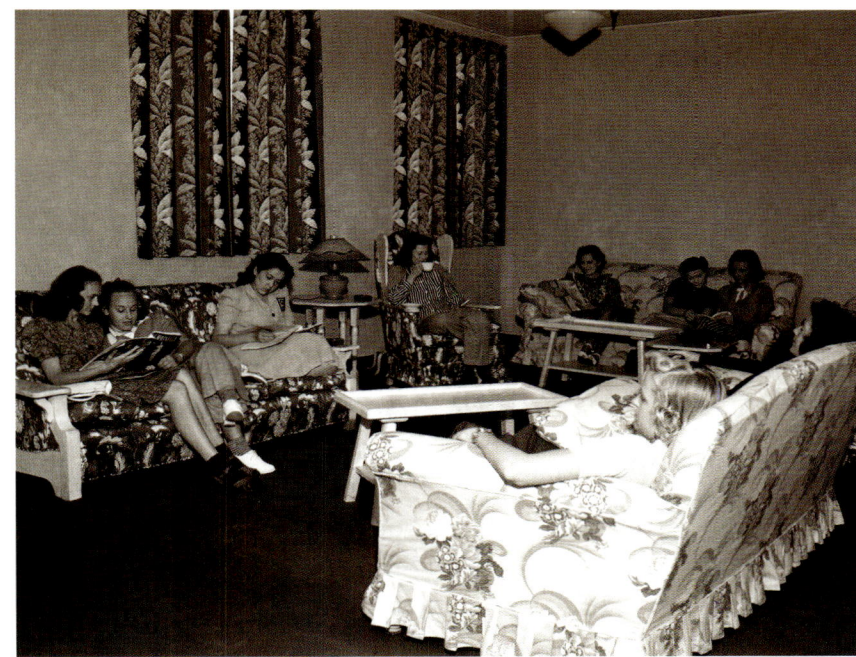

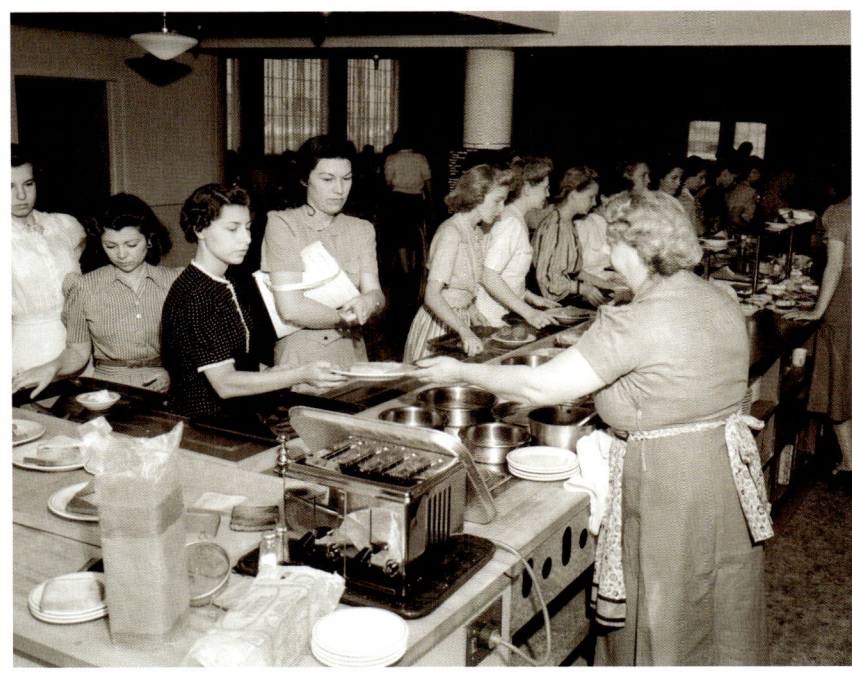

Assistant Animators (left) Bea Tamargo and (right) Velon Sewell.

while working in Animation on the later Disney feature *Lady and the Tramp*.

Tamargo's background and language skills became a proven asset to the studio as well. On numerous occasions she would be called upon to act as interpreter and translator for distinguished Spanish-speaking guests visiting the studio and to dub lines for cartoon productions with Latin American backgrounds. She also occasionally assisted with live-action reference on various characters and would often be found taking a busman's holiday to the beach, where she would paint and sketch in watercolors.

Another postwar addition was Velon Sewell. An early studio biography described Sewell as a "reserved and sophisticated Assistant Animator." An exceptionally talented artist who also studied drafting at Caltech and Production Illustration at Pasadena College, Sewell was hired at Disney Studios in 1947 and stepped into an Assistant Animation role after two weeks of working as an Inbetweener. She later moved into Animation, creatively animating a number of sequences for the later "package" feature *So Dear to My Heart* and contributing early work on *Cinderella*.

An avid aviator, Sewell flew light training planes and would often fly to Big Bear, just east of Los Angeles, for breakfast. In a studio biography, Sewell listed her hobbies as "shooting .22 caliber rifles in the desert, playing in the snow, flying, [and] candlelight and milk at midnight." Her genuine and adventurous personality made her a strong presence among the Animators. Several of the men even presented Sewell with a kitten named Figueroa.

Grace Stanzell and Margaret Ann Thiele came to Disney Studios at the end of the war as well, and both were hired straight into Inbetweening before becoming Assistant Animators by 1946. Additional Inbetweeners stepping into the animation ranks from their initial roles in Ink & Paint included Lila Beckton, Beverly Leffingwell, Carol Coor Pender, Elizabeth Kowal, Etta Parks, Carmen Singer, Gerry Goodwin, and Phyllis Mooney. Women were now a regular presence within the Animation Building.

> "*We came out of the war period, we had about three or four lost years in there.*"
>
> —Roy Disney

POSTWAR PRODUCTIONS

While rebuilding the studio talent and teams for the new global markets, *Make Mine Music* provided an economical solution in returning to animated entertainment. The *New York Times* agreed: "*Make Mine Music* is Walt Disney's latest and most fantastic cartoon-musical, a veritable vaudeville show, three-ring circus, and grand opera thrown together into one Technicolor masterpiece." Broadway lyricist and Hollywood musical screenwriter Dorcas Cochran explored preliminary musical and uncredited story

Final film frame featuring extensive dry-brush techniques from *Make Mine Music* (1946).

concepts. Several of the ten narrative segments in this anthology marked fresh new color techniques in animation.

In addition, the up-tempo surrealist musical landscapes of Benny Goodman's "After You've Gone," and "All the Cats Join In," featuring stylized caricatures of jitterbugging teens in a delightfully Salvador Dalí-esque jukebox dream world of disappearing and reappearing lines.

The tender tale of loneliness and yearning in the "Without You" segment is literally a moving watercolor painting. A kaleidoscope of natural scenery is visually conveyed through a rain-drenched window. Artists utilized an experimental wash technique dubbed "Water Color Luminosity" in which lines were literally washed away in pure, transparent color. Walt was looking for a "translucent, poetic tone, a moody shifting of colors and forms in various lights—all reflecting and underlining the tone colors of the music and the meaning of the lyrics." This "love letter in landscape" was designed to contrast with the rosy glow of love conveyed in the "Two Silhouettes" portion. Dinah Shore's interpretation of the title song features the animated "Ballade Ballet" of Tania Riabouchinska and David Lichine, silhouetted against stylized impressionistic backgrounds and floral effects cast by cupids. "A perfect dream set to a theme."

Groundbreaking story artist Sylvia Holland had been laid off in 1941, "but was invited back within a year at Walt's request," recalled her daughter, Theo Halladay. "She stayed another two years. During that time she worked on several parts of the musical collections of short subjects, including *Make Mine Music* and *Melody Time*. She was in charge of [the surrealist jazz interpretation of] *The Flight of the Bumblebee* [the "Bumble Boogie" segment in *Melody Time*] and did all the original storyboards for that.

"One memory," added her daughter, "is of a beautiful dragonfly sequence. She also worked with Ethel Kulsar as her Assistant and Background Artist on a feature which was never finished, *Adventures in a Perambulator*, also known as *Baby Ballet*." Halladay recalled of her mother, "She was full of admiration for the good work of other artists, and indeed for the overall quality and good manners shown throughout the studio."

In addition to these anthology projects, production on various shorts featuring a wide array of staple characters. New trainees cut their teeth in the Shorts corridors working on any number of characters continued. Ginni Mack, a new Painter in June 1946, later recalled, "Most of the shorts involved pretty fast action. If it's real fast action, it doesn't have to be as accurate, but they wanted us to learn the best way possible for future projects. After you worked in the Shorts corridor for a while, [well,] then you graduated into the feature productions and you had to be really good."

Each girl became familiar with each classic character. "Goofy was always fun to do!" Mack noted. "Pluto was the easiest character as he only had black and his main body color. Most of the time you put the black areas—his nose or ears—on the top of the cel with the ink. It gave it a velvety black look rather than a shiny black look."

Left and right: Marsha Ashe's inked cupid utilized in the final frame from the opening and closing scenes for the Two Silhouettes sequence in *Make Mine Music* (1946).

Page 219, top row: Various final frames from *Make Mine Music* (1946).

Second row, left: Dry-brush techniques applied to Casey at the Bat; and (right) dry-brush techniques and exaggerated form utilized in the All the Cats Join In sequence.

Third row: Final frames from Without You.

Fourth row, left: Final frame from The Whale Who Wanted to Sing at the Met; and (right) final frame from the Johnny Fedora and Alice Bluebonnet segment.

THE COUNTRY CLUB

During the war, military regulations governed the top salary rates for Inkers and Painters, but as the studio transitioned back into regular production, new measures were sought for maintaining artists of the right caliber. In a 1946 interoffice memo, Grace Bailey spelled out the department's staffing realities: "At the present time, we have ninety-five Inkers, of which only twenty-five have been here over one year, and of these twenty-five, only fourteen have been here over two years. Taking into consideration the fact that it takes a year and a half to train a good Inker, we can see the price abnormal turnover is costing us."

With such a high turnover, Bailey urged raising the top salary to attract more stable employees, ensuring a consistent quality of productions at a lower cost. "By raising the maximum on a merit basis," she continued, "those of outstanding ability would be paid for their contributions. There would be an incentive to excel and to work. It must be known to the girl that there is a future for those who are willing to make a career out of the work; that we are willing to pay for those who excel in both quality and quantity." As Bailey noted, these efforts were intended to establish "a real difference between the producer and the girl who merely wanted to work at Disney's [sic] until she settled down to raise a family."

To meet the pace of production, quotas were reinitiated and merit increases were tied to a rating system recording individual performances. "There were certain girls that were just phenomenal," noted Edle Bakke. "Ann Gale, she was fast—one of the best [Inkers] and could put out the most footage in a day. I had to keep track of those things. We had the old-fashioned adding machines. You had to make sure that was all done in the morning, and how many feet they were going to do in a day, and when it was going to be turned over. Then [they] would see how much progress had been made and if they needed more. If it was a big feature, then they started thinking that we're just going to have to hire some more people to make this work."

"They had what they called an 'Average List,'" remembered Ginni Mack. "It was our average for the week of how many cels we had painted. They put it up on the bulletin board in our room at the front, next to the office. Whoever painted the most was at the top—it was like getting a gold star. If you were at or near the top, you always got picked to go to the dailies; that's when they show the story that's going to be made. Everyone had work at their desk they had to get out, but we were fast, [so] we weren't going to hold up the scene.

"I was at the top of the list, I earned my way to go to dailies," Mack said, "when they show what's being made and get your opinion on it, and it was like a reward to [participate in] what they called Audience Reaction Indication, or ARIs."

As Jean Erwin noted, "It was good for the bookkeepers, but it wasn't for the girls, and it caused a lot of tension. It was quite unfair, because, if you know anything about production, you could get a cel with forty-seven colors on it, or you get some black mask. There's no way to have a policy on all that. We spent so much of our time not on production but on bookkeeping."

Joyce Carlson agreed with Erwin. "If you were given [scenes with] mud and water, that went so quickly you'd be on top of the average. I was always close to the bottom because they gave me mostly the main characters. Some of the figures had twelve colors, and you had to change your pen points and mix your colors, and that took a little time. I was worried about being below the average, but my Supervisor said, 'Don't worry about the average. Just do it right.'"

To maintain their quotas or to get an edge above the others, many of the girls found ways to beat the system. "People came in at odd hours and painted so they could get ahead one half a point on their average," recalled Erwin.

Additional methods were explored to improve quality while speeding up the work. "They brought in an efficiency expert and everything went screwy," laughed Mack. "It just didn't work at all. They would tell you everything to do, but nothing was any better." Short-term hiring of extra Inkers and Painters frequently occurred to meet the demands of various productions processing through the department, Ginni Mack recalled. "I remember one girl who had been working independently, and when she got to Disney, she was bowled over; she couldn't believe the opulence, and the supplies, and the first class, high class, everything.

"She said," according to Mack, "'Could I possibly get a steady job here? When you go to the other studios, they don't provide you with the pens and ink. This is fabulous.'" Indeed, many of the ladies who worked at other studios couldn't wait to get back to Disney. "I used to hear from [women] that came from other studios," noted Carmen Sanderson, that "they used to call it [Disney] the Country Club—the people were better dressed, [and] talent-wise . . . the cream of the crop."

Left: Title frame from the educational short *The Story of Menstruation* (1946).

Right: Typical local newspaper ad seeking female artists at Disney Studios in the mid-1940s.

> "We didn't come out of the war smelling like a rose, but we had acquired a wonderful education, and a determination to diversify our entertainment product."
>
> —Walt Disney

EDUCATIONAL FILMS

During the war, the studio continued working with the US government's Office of Inter-American Affairs, creating a series of instructional films with an entertaining appeal for distribution throughout the Americas. In addition to the ten health films and four literacy shorts completed, the studio's creative teams developed adult educational productions with lessons in Spanish language and reading skills. To test run the program, Walt sought out educational consultant Dr. Mildred Wiese to develop and oversee a literacy program in 1944. Despite a favorable launch, the program was short-lived due to various governmental interventions.

Expanding upon the studio's experiences after the war, Walt established a division focused solely on films that trained and informed as well as kept the production studio going while the world economy was still recovering. "Education films will never replace the teacher," noted Walt. "The three R's [reading, 'riting, 'rithmetic] are basic, but their advancement by means of the motion picture screen will give more people in this world an opportunity to learn. Pictures can make both teaching and learning a pleasure. And educators agree that when a student has begun to learn and like it, half their problem is solved."

A number of additional educational projects were produced through corporate sponsorship. Working with Kotex Corporation, *The Story of Menstruation* clinically explored the female reproductive system for educational purposes. "The man [directing] it was Ed Benedict," recalled Theo Halladay. "He was embarrassed about having to work on that feature and tended to look as if he was hiding his face." Sylvia Holland completed extensive concept artwork for this film, and even though minimal animation was involved, a variety of effects from drybrush to line work were applied within the Ink & Paint Department. A commentary of the times, the film's narrative assured viewers that there is "nothing strange nor mysterious about menstruation" as it is "nature's eternal plan for passing on the gift of life" and "like any mother, she quietly manages so much of our living . . . without our ever realizing there's a woman at work."

The esoteric efforts of the Educational Unit broke new ground as a number of similar titles came through the Ink & Paint pipeline from the mid-1940s well into the 1960s. A vast array of subjects and styles were experimented with, as familiar characters gently taught. The I'm No Fool series featured

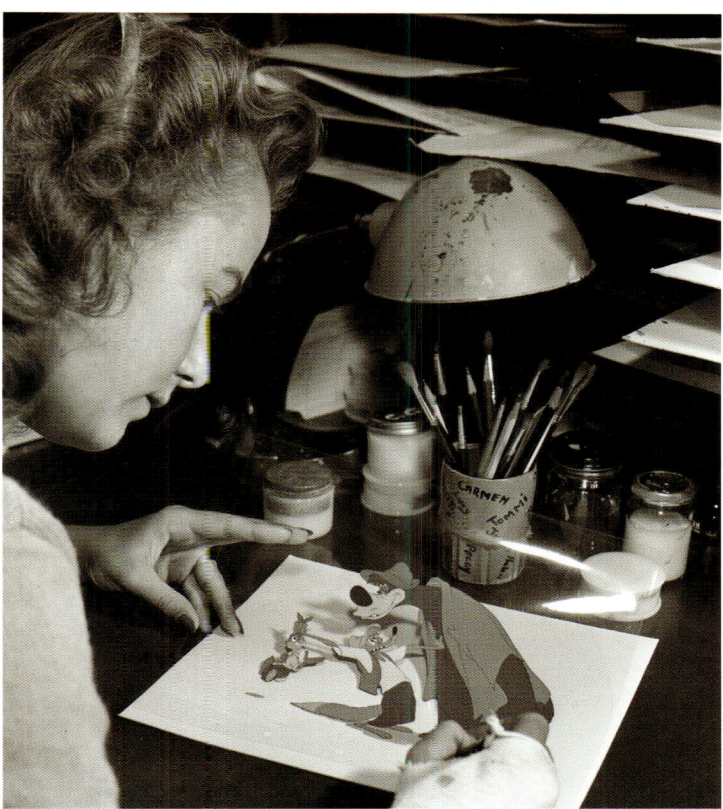
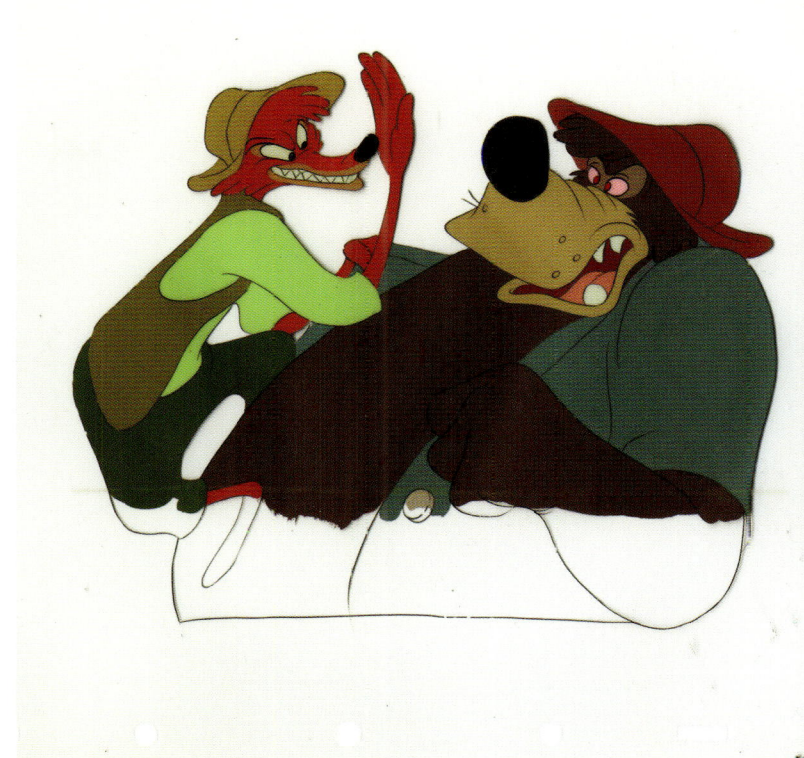

Left: Unidentified artist painting a cel from *Song of the South* (1946); and (right) a production cel from the film.

everyone's favorite conscience, Jiminy Cricket, while Donald Duck starred in several films, including *How to Have an Accident at Home* (1956), *How to Have an Accident at Work* (1959), and the popular stylized lesson in numbers, *Donald in Mathmagic Land* (1959).

While working in the Color Model Department of Ink & Paint after the war, Becky Fallberg also worked on a number of training and educational films with legendary Animator Les Clark. "That was fun because my Supervisor, Virginia Fontanella, and I were [in] the Ink & Paint Department. She was the color model and she painted, and I did all the different kinds of checking processes and I painted." As a filmmaker, Walt never intended to become a teacher, but he clearly grew comfortable with the role, recognizing, "We have always tried to be guided by the basic idea that, in the discovery of knowledge, there is great entertainment—as, conversely, in all good entertainment, there is always some grain of wisdom, humanity, or enlightenment to be gained."

UNCLE REMUS & BRER RABBIT

Walt's return to feature-length films also marked his first foray into producing a true musical drama: *Song of the South*. Disney's interpretation of Joel Chandler Harris's fables of anthropomorphized animals and their storyteller marked a return to combining live action and animation, signaling the beginning of a new era in motion pictures. As Walt stated, "I always felt that Uncle Remus should be played by a living person." Bill Anderson explained Walt's choice: "He did *Song of the South* strictly because it was a small amount of animation."

Striving for a distinct style, Walt positioned his first postwar production based on the work of one artist. "It was inspired to a great degree by Mary Blair," recalled Ken Anderson. In October 1944, Walt sent the artist on a ten-day trek to Atlanta and its surrounding rural settings. Blair's pastels, sketches, and paintings inspired the tone and visual palette of the film. "She came back with all kinds of paintings of the red earth and stylized drawings of peach trees and things like that," noted Anderson, "which we tried to use in the picture." Marc Davis agreed that "Mary Blair brought in a sense of modern art that was very lacking in the films up to the time she began to do this."

"Walt wanted to find the proper way to have humans and animals and cartoon characters work together to make us feel like they are in one world," noted Anderson. Learning from the live-action approach taken from previous films, including *The Three Caballeros* and *Make Mine Music*, Anderson and his team met the challenge by combining careful preplanning between the live-action Director and animation Director. "There was more interaction than on previous films, and we all worked together to make it really amount to something," said Anderson, who directed the animation. "It started a whole trend for the films that followed."

For the purposes of creating a believable world, "a huge 150-foot cyclorama, which looked like a painted cartoon background, was built at the Goldwyn Studios," pointed out Anderson. "The positions where Uncle Remus looked were predetermined by placing concealed sticks, which indicated the cartoon character. These sticks were covered later by the addition of an overlaid painted cel. The character animation was also done later with the Animators working with frame blow-ups of the live-action film." After the animation was carefully planned, the live-action work was completed first.

With the technical methods resolved to bring animation and live action together, the challenge then came in creating a believable, dramatic integration of live players and cartoon characters. "Color," as Walt maintained, "must amplify emotional response without being intrusive." Music, makeup,

Top left & right: Final frames exemplifying surrealistic styles from the Bumble Boogie segment of *Melody Time* (1948).

Bottom left & right: Final frames featuring the conceptual work and color styling of Mary Blair in the "Once Upon a Wintertime" sequence from *Melody Time* (1948).

costuming, lighting texture, and composition all played key roles in achieving this advanced combination of forms.

Registration and the adjusted field size of the cels demanded adaptations. With most of the film in black-and-white, the Technicolor inserts vividly showcased a renewed expanse to the studio's Paint Lab. Painter Carmen Sanderson recalled, "My first big production was *Song of the South*. I just took to it like a duck takes to water, and I was on production after the third day of training." Nearly two years of production was required for both the live-action and animated sequences. For one ten-minute sequence, over thirty-five thousand drawings were completed, with easily four times that number of cels created featuring detailed lines and vibrant hues to define the world of *Song of the South*.

Just as it seemed the studio was getting back into production, another devastating blow came in the form of a pending strike. Facing increased wage demands and mounting production costs, Walt and Roy had no choice but to cut their entire studio staff in half. "In August 1946, they had a huge layoff, and they wiped out animation," recalled Sanderson. As a fairly new Painter, Sanderson thought she'd be included, but her sharp talents were too valuable. The *Los Angeles Times* reported, "Layoff of 450 employees of Walt Disney Productions took place yesterday at close of the working day. Threat of a strike, however, was temporarily averted as the result of a meeting between labor and employees representatives with management." Meetings continued. according to the article, "to see if an answer to all troubles can be worked out satisfactory to both sides." It was a hard hit at such a critical time, and Sanderson stated, "I don't think it was ever the same after that layoff."

ANIMATED ANTHOLOGIES

With a bare-bones staff, a series of anthology films helped keep the studio afloat postwar. One, 1947's *Fun and Fancy Free*, featured Walt's telling of the classic English legend about the adventurous combination of a poor farmer, magical beans, an enchanted harp, and a giant's castle. Luana Patten appeared in the live-action portions, and Anita Gordon provided the siren song from the Enchanted Harp. Popular songstress Dinah Shore narrated the story of Bongo the freewheeling circus bear. Secretaries Eva Jane Sinclair, Marie Dasnoit, Toby Tobelmann, and Ruth Wright kept production for each segment of the film on track.

After two years of production, *Melody Time* premiered in 1948. Color abounds in the whimsical "Once Upon a Wintertime" segment, which was inspired by Mary Blair's distinctive style. But it's the surreal world of "Bumble Boogie," featuring the music of the Andrews Sisters, that pushed boundaries, once again, on style, design, color, and tone. "My first voice-over work was in *Melody Time*," recalled longtime Ink & Paint artist Norma Swank. "I was part of the angry crowd yelling 'kill the ump' in Casey. I could read music and sing pretty well, so soon I landed the Chip 'n' Dale films." Voicing the various chipmunks, Norma recalled, "they gave me a script and you acted, but they'd speed the record up so you could never identify who it was."

WHAT'S IN A NAME?

The animated sections within the live-action feature film *So Dear to My Heart* (1949) brought reflective memories alive through the vivid color explorations of concept artist Mary Blair once again. This film also marked a major transition within the color system of the Disney Studios' Paint Lab. Since 1932, the designation

Production cel element featuring Katrina Van Tassel from the Legend of Sleepy Hollow section of *The Adventures of Ichabod and Mr. Toad* (1949).

of required colors utilized within Ink & Paint had referenced the Munsell color system to identify the growing volume of colors created for the various films. Over the course of several months in 1948 following the completion of production on *Melody Time*, the Paint Lab transitioned their color system codification from the initial/numeric based Munsell method to a color-named specification aligned with the newly developed Plochere color system.

Created and introduced by interior designer Gladys Plochere and her contractor husband, Gustave, in 1948, this approach to color organization was based on Nobel Prize–winning Dr. Wilhelm Ostwald's research recognizing the psychological sensation of color. They also applied the theories and research of Robert Ridgeway's standards-and-naming methods, as well as the work of leading color expert Faber Birren (who, as noted, had lectured on color theory at Disney's Hyperion locale a decade earlier).

Following the war, many familiar pigments were no longer available. Colors could be mixed in a number of ways to find comparable matches with new materials, but with time a critical factor in the production process, quickly arriving at the right shade was vital. With Plochere's method, a range of 1,248 colors could be mixed from nine basic colors, along with black-and-white. From each of these colors, a series of let-downs would then be created, gradually reducing the tint from darker to lighter by adding increments of white paint.

Perhaps the most vital part of this transition was Plochere's simple, yet practical approach of providing a traditionally descriptive name, which instantly "brought to mind a mental image of the color," according to the Plochere method. This named solution would ensure color accuracy when defining, cataloguing, displaying, and referencing the ever-growing array of colors and values within Disney animation.

Thousands of shades were milled, labeled, and realigned. "It was quite a deal," recalled Edle Bakke, the Ink & Paint Department secretary at the time. "This involved Grace Christianson, who was head of Color Models, Color Specialist Mary Tebb, and, of course, Grace Bailey. Paint Lab Chemist Emilio Bianchi and Karen Johnson, who also worked in the lab, were involved and they were all huddled around talking about the change."

Once the Paint Lab was converted, color models for *So Dear to My Heart* were the first to be created following this transition. "All of the Supervisors in Painting were notified of the new system and they in turn informed the girls within the corridors," Bakke added.

Each top color of the new Disney color system was given a name. A numeric reference indicated the specific let-down level of that particular color (Blue Violet 2, Lemon 3, Saddle 4, and so on). While this transition proved a daunting task considering the thousands of various color values created within The Rainbow Room, this name classification ultimately simplified and aided in the accuracy of color reference for both the Paint Lab as well as the artists. These basic color principles are still utilized today. "It was an easier system," recalled Inker and Painter Ginni Mack. "You had less confusion with names than with a series of numbers."

A HECTIC PACE

The Adventures of Ichabod and Mr. Toad debuted October 5, 1949, featuring the delightful narration of Basil Rathbone and musical talents of Bing Crosby, but the feature female character in either segment was the alluring—and nonspeaking—Katrina Van Tassel. Mary Blair marks the only feminine presence on the films credits, and three uncredited production Secretaries, Marie Dasnoit, Dessie Flynn, and Eva Jane Sinclair, ensured the film's production progressed smoothly.

Though funds and talent were short, the pace and volume of production within the few years following the war built up to one of the busiest times at the studio. "I remember one time we were running fourteen pictures through here at once," noted Grace Bailey. "Many of them short subjects, not features. That was a little hectic. But it was fun." Norma Swank still remembers the necessary efforts to complete these films on time. "You'd get a backlog with the Animators and we'd wait and wait and wait for them to send scenes through and when it finally came, it was like a landslide. We'd work all night and stagger out about seven o'clock in the morning. That would happen for days. As long as work was coming in you just got it out!"

The postwar years also marked a time of new progress. As Frank Thomas and Ollie Johnston wrote of the time, "The concentration was on better ways to achieve the same result that once had cost so much in time and effort. Since no records were kept in that era when procedures changed with each scene, gradually people forgot how things had been done. Before long, the equipment that once produced the great effects—the drum that

224 | Rebuilding

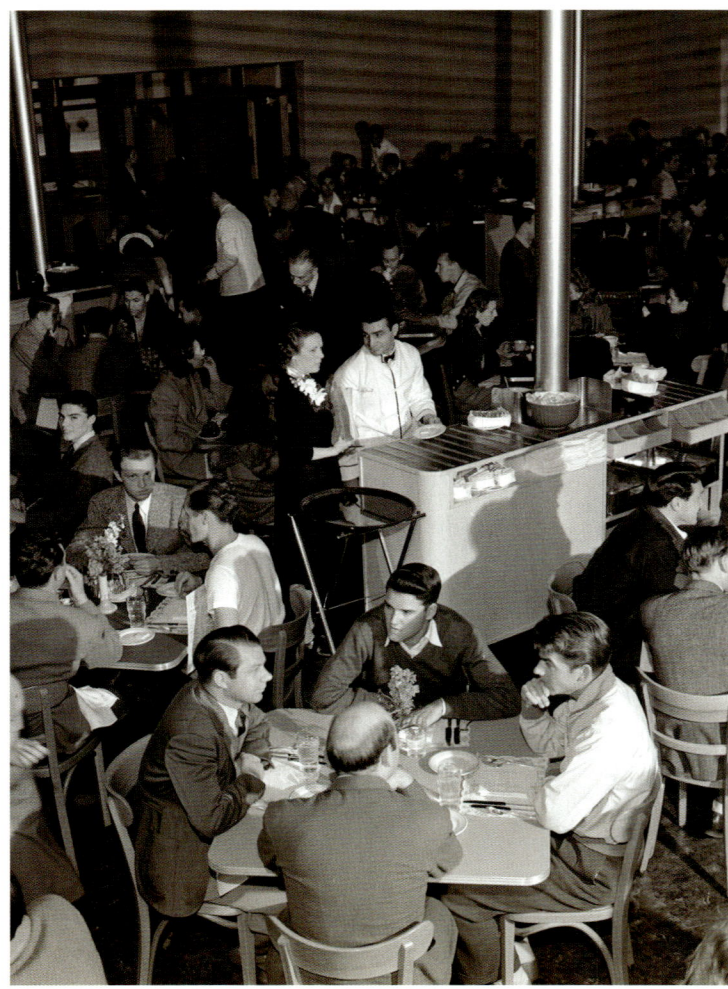

Left: The bustling Burbank studio cafeteria.

Right: Artwork from the studio issued handbook, *The Ropes*.

had cleared the frosted cels, the mechanism that had processed wash-off relief cels, the inventions that had held detailed work together under the camera—was all rusting on the back lot."

CAMPUS COMMUNICATIONS

With so many employees on lot, Studio Personnel issued a small handbook to new hires entitled *The Ropes at Disney*, orienting staff to the ways of the Disney organization. "This is a 'no-necktie, sweaters, and slacks' organization. 'Business Informality' is an accepted Disney policy which has done much to maintain a friendly relationship between Company and employee," the booklet stated. The general info within this charming booklet was designed to "tip you off as to 'what goes' . . . and what doesn't," including the reminder of various "Forbidden Fruits" such as wasting time or materials, among other things. Payday, or the "Day of the Eagle," was on Thursdays, and the military presence on the lot introduced the "new and necessary institution" of the ID badge. As Ward Kimball noted, "It was a handbook for new employees on what to do when they [came] to work here. This was the time when we were hiring a lot of outside help. . . . The war complicated things [and] we had to bring in people we wouldn't ordinarily hire. The new employee was supposed to take it in good humor."

Studio employees were represented by thirty-three different unions in the early 1940s, and many of the union attributes were temporarily suspended while Disney Studios supported the war effort. In the aftermath, many of the men returned back to their roles at the studio. *The Bulletin* newsletter from Hyperion continued delivering the studio news into early 1941, but with the strike, the outbreak of the war, and production demands, the newsletter was suspended and the studio reverted back to bulletin boards conspicuously placed within each of the buildings. Selective Services maintained an office on lot until shortly after the war to assist personnel with any draft concerns, and during the war, visitors were not permitted to tour the studio grounds or progress beyond the cafeteria.

To acquaint new employees and potential clients with the studio's efforts in the postwar era, the studio produced a fresh continuity flow chart, laying out each step within the animation production process. Despite this effort, the cloak of mystery around the Ink & Paint Department's accomplishments was still prevalent when the chart went to print without including the Checking Department. Ink & Paint director Bill Anderson fired off a memo with a thorough description of the role and importance of this highly skilled aspect of Ink & Paint, but the chart had already gone to press and remained incomplete, adding to the perpetual invisibility of the department's contributions.

> "*All the girls had a quirky sense of humor. . . . We especially loved to make fun of the Animators.*"
> —Lucile Williams

(From left): Dick Lucas, Becky Fallberg, Lois Cleworth, and Rae Medby watch a lunch-hour baseball game at the Burbank studio in 1945.

1940s STUDIO LIFE

The primary watering hole for the young staff was the main studio cafeteria, called the Commissary, or the Studio Restaurant—a lively gathering spot often dotted with various Disney celebrities dining among the staff. Manager Victor Bronnais stated, "The first thing Walt did was to insist that everything be the best. Not fancy, mind you, but fine and good and durable. It was because of Walt that chili beans and more fruit salads and fruit juices appeared on our menu; these are favorites of his. And about the first thing he insisted on was that the restaurant carry a super-excellent line of hamburgers!"

Many of the studio bachelors were regulars, catching three squares a day, as Bronnais noted. "Their favorite waitress becomes practically like their mother, scolding them if they don't eat well, telling them what they should have for breakfast instead of asking them, and generally treating their charges to a good bit of maternal bullying." The manager's take-out service permitted the busy working Disney wives to purchase at cost the various dishes and desserts available each day. "I imagine some of the husbands are quite thankful for such a service," observed Bronnais with a smile.

Effervescent Mary Flannigan held court in her coffee shop in the Animation Building. Though the tiny place seated only about twenty people, it was quite a step up from Flannigan's cozy Hyperion cubbyhole with snacks sold on the honor system. "You could get Cokes, milk shakes, coffee," recalled Sound Effects legend Jimmy Macdonald. Her bright spirit kept the Animators' pencils moving with deliveries to their offices throughout the day, but even good-natured Flannigan had to place a "mild complaint" in *The Bulletin*, as reported: "[Mary] feels that a great many knives, forks and spoons are scattered around the rooms of the Animation Building. Mary would also be grateful if the gang would refrain from using her glasses and crockery for Ink & Paint pots. This little practice is quite ruinous, as it is almost impossible to remove the stains."

Flannigan ran a tight ship, though Macdonald recalled that Walt ensured service was open to all forms of hungry beasts: "Walt came in for a cup of coffee [once] and sat at the counter and right behind him," Macdonald recalled, "a dog [that Disney didn't see] had wandered in. Came through the gate. . . . Possibly [drawn by] the smell of food cooking, this maverick dog wandered in just behind Walt. Then he noticed the dog and Mary said, 'I'll have to call the guard, I don't know where this dog came from.' Walt said, 'Oh, he's probably hungry. Give him a hamburger.'" Flannigan gave the dog a hamburger. Walt enjoyed his coffee, then put his dollar down to leave. Flannigan returned Walt's change. "Walt," according to Macdonald, "looks at this and yells, 'What kind of a price are you charging for coffee, Mary?' She said, 'The coffee's only a dime, Walt, but the dog was your guest, and that was fifty cents for the hamburger.' He paid the forty cents, chuckled, and left."

The Tam O'Shanter restaurant was still a regular haunt for Walt and his staff, while Riverside Drive in Toluca Lake, a short drive west of the studio—and known as "restaurant row"—offered additional options in the 1940s. One of the standard lunch spots for many of the staff was Alphonse's. Owned by Alphonse Sorrentino, who made all of the sauces and ravioli fresh each day, the establishment was a darkly

Left: Norma Swank and (right) Eve Fletcher inspect the highly detailed eggs painted by the Inkers for the studio's annual Easter Eggzibit.

Right: Artists Jeannie Keil and Phyllis Hurrell challenge a team of coworkers with a round of Ping-Pong outside the studio cafeteria.

paneled venue that had a grand fireplace, red leather booths, and stained-glass windows. It was a favorite dining spot of movie stars and locals. Studio artists with house accounts never had to wait for their regular tables, nor did they receive bills following their meals.

Many of the Ink & Paint girls brown-bagged it, often finding shady spots on the manicured lawns of the studio lot. Theo Halladay spent many lunches with her mother, Sylvia Holland. "Often we carried our own lunch to save money and ate it on the banks of the Los Angeles River, which flowed right by the studio," she said. For others, the lunch hour meant a chance for more active options off-site. Some of the girls would dash to the Griffith Observatory to watch the planetarium show, or go horseback riding at the nearby Equestrian Center. "In the summer, we often went swimming during the lunch hour at the Pickwick Pool, just down the street on Riverside Drive," recalled Lucile Williams. "We would swim frantically and save our sandwiches to eat later during our afternoon tea break [and] then return just in time to punch the clock and avoid getting our paychecks docked. Rushing back to our desks, we would still have a steady hand, and damp hair, when we returned from our lunchtime swim."

Production pressures could be channeled into many sporting activities around the studio campus. Ink & Paint women held Ping-Pong rallies on the cafeteria terrace, Cutting Department employees could be found tossing film cans back and forth in a precursor to the Frisbee fad of the 1950s, and Animators either teamed up for volleyball or softball in the nearby fields or could be found improving their golf games at the studio putting green.

HOLIDAYS & HAPPENINGS

Though the corridors of Ink & Paint were quiet as a library during work hours, the lively buzzing and "girl talk" at teatime and lunch hours also extended after-hours, away from the studio. "Most of the girls were close friends, sharing weekend activities like picnics and family get-togethers," remembered Lucile Williams. "There were four sets of sisters in Ink & Paint: my sister Edle [Bakke] and I; the West Corridor Supervisor Betty Anne Guenther and her sister, Velma, who worked in that corridor; Buf Nerbovig and her sister Helen; and two Southern gals, Edna and Marion Smith, one of whom was the East Corridor Supervisor. There were no pranks to speak of. There was no swearing, backbiting, or meanness among the girls, either. They were really just a wonderful group of women."

With the frequent number of interdepartmental relationships blossoming into engagements, weddings, and eventually births, showers and celebrations were regularly taking place. Retirement parties and farewell gatherings also happened. The women often lined the main counter of the Paint Lab with potluck spreads and gathered together to celebrate the various milestones of those in the department. Wrap parties were frequent events around the lot, as production teams would mark the completion of their work and the eventual release of a film.

"It was like a college campus," observed Ginni Mack. "[We] had a football field, and we played touch football and baseball at lunch and had Ping-Pong and archery. They had square dancing, and on certain days they'd have a thing they called 'Flicker Flashbacks' in the theater where they [screened] old comedies like Laurel and Hardy and Charlie Chaplin. They'd show those at noon and you could just go in and watch them if you wanted."

Left: Walt participates in a Disney Studios publicity photo shoot.

Right: Personnel relaxing on the campus lawns of the Burbank studios.

The walls of the Studio Library served as a gallery where many pieces by the Ink & Paint artists would be displayed. "I had many of my paintings there," remembered Grace Godino. "They were for sale and we made some sales. . . . That was kind of fun!" Ink & Paint art shows were also held in the art room of the schoolhouse where caricatures, ceramics, watercolors, and fine art works by the ladies were featured. "These ladies were artists," noted department Secretary Bakke. "Once in a while someone would bring in a painting or a sculpture piece and you'd be so surprised to see this beautiful work."

"We usually got holidays off," Mack added, "and if it was a holiday that was a festive day, that we didn't get as a holiday, they'd have a special lunch out on the lawn." Annual holiday happenings were a regular part of life within the department, as Williams recalled. "Around Easter time, the Inkers would begin making replicas of Fabergé eggs, beautifully hand-painted and ornately decorated. They were artistically exquisite and comparable to the real thing in design. We put them on display in the Studio Library for everyone to enjoy."

The traditional "Easter Eggzibit" ran in the days preceding the holiday, and only real eggs were permitted for display. The best egg creation received an Oscar made of a gold-plated egg. Studio employees voted for their favorite egg, with each vote raising funds to purchase holiday dinners for needy families of the surrounding San Fernando Valley.

The Halloween parties Ink & Paint personnel arranged were legendary. Months of planning and preparation went into the occasion, as each of the corridors competed for best costumes. "Halloween was the big event of the year for dressing up and having a lot of fun," Williams recalled. "One year, my corridor went all out as [zombies]. It was pretty gruesome. We had great fun going into Hollywood to buy burlap, masks, and costume accessories. We entered the Tea Room in costume, crawling and limping to the cries of horror from the other girls."

The Christmas holidays brought celebration, with decorations custom painted on the Ink & Paint Department windows. "When I first started," recalled Becky Fallberg, "they did have [studio] Christmas parties and then it got out of hand and then . . . we had them in Ink & Paint, which was separate and apart from the Animation Building. We had our own building away from the rest[,] so at Christmastime everybody brought food potluck and there were some musicians in the Animation Department that came over and they brought their instruments and played and we sang Christmas carols." For Williams, "The company Christmas party in the Studio Theater was an important event for my family. [We] enjoyed taking our girls to see Mickey, watch cartoons and the latest animated features, meet Santa, and receive Christmas goodies."

THE MATCH FACTORY

A 1941 article by Janet Martin, the studio's lead publicist, quoted Walt on one of his biggest challenges of the times, as he noted that women's salaries "would be higher if more girls didn't work a couple of years, marry[,] and quit." Employers in general lamented this pattern for many working girls in the 1940s, as any training investment would inevitably walk out the door.

Still, as the writer pointed out about the studio, "Romance opportunities are about the same as at a co-ed [sic] university." This was a reflection of the times, as the standard mind-set of

the day held that the only viable purpose for a women attending college was to obtain her "Mrs." degree. After the war, interdepartmental marriages were a frequent occurrence at the studio. As Martin also pointed out, "Many of the girls have married Disney employees and stayed on." It was a progressive notion at that time.

Mixing and mingling between the sexes was a given at the studio; as Wilma Baker observed, "These things just happen." Weekly dances spontaneously broke out in front of the Animation Building as male and female employees would dance away their pent-up energies. The sounds of the Disney Gadget Band, or The Firehouse Five Plus Two, frequently spilled out from one of the soundstages.

One of the more popular pastimes for the Animators was termed "gull watching," referencing the 1948 Disney True-Life Adventure documentary *Seal Island*. Assistant Animator Joan Orbison recalled the daily gathering of "barkers" that occurred: "On the way from the Commissary to the Animation Building, there was a walk along there[,] and [a] whole bunch of the guys, the Animators, who would sit out there on the lawn and everybody'd that'd go by they'd tear them to pieces, with gossip. Somebody said that women can be catty, but men can put you on the skids." This strategic *Seal Island* at the corner of Mickey Avenue and Dopey Drive also provided the perfect perch for watching the parade of Ink & Paint girls on their way to the studio cafeteria.

The hermetically sealed and predominantly feminine domain of the Ink & Paint Department provided an ideal target-rich environment for the Animators. Despite the relationships that blossomed, the segregation between men and women was palpable. Several clever monikers developed over time, renaming the Ink & Paint Department as the "Nunnery," with the Animation Building becoming known as the "Monastery." Other names for Ink & Paint included the "Henhouse," the "Convent," and "Tehachapi," referencing the location of a regional women's prison.

Interoffice matchmaking was always being conducted, particularly in the Ink & Paint Department. "Over the holidays in 1949," recalled Lucile Williams, "one of the girls from the department, Helen Nerbovig, invited me to a party to introduce me to an Air Force buddy of her husband's, Bob. His name was Bill Bosché. . . . It added up to a very positive reaction." Just two years later, Lucile and Bill were married. "On my last day at work, Betty Anne said, 'Well, so Helen's matchmaking worked!' Happily, it certainly did," laughed Lucile. Bill later worked closely with Walt Disney as an artist and Imagineer.

Animators were the most appealing choice, and the Ink & Paint Department served as a convenient dating pool. Courting on company time occasionally occurred as drawings designed to woo an Animator's targeted recipient frequently appeared on women's desks or were sent via interoffice mail and hand-delivered by the Traffic Department. Popular and talented Rae Medby had numerous suitors, despite her multiple wartime pen pals and a somewhat steady guy. She frequently received dinner invites and carefully crafted warnings against the various "wolves" via animation paper or interoffice memos.

Underneath the two buildings, a tunnel was built to safely move animation materials between departments without subjecting them to the outdoor elements. Deep in the lower levels, near

The special baby shower gift from the studio, a potty painted by the artists of Ink & Paint.

the Morgue, the tunnel linking the departments became a popular trysting place. Grace Godino recalled, "I had to work down in the Morgue . . . and I got claustrophobia because you were so far underground. But then we found out that it was a great place because . . . if you ever wanted to meet anybody, you'd meet them underground. It was great!" Romance was not forbidden, but "just not on company time," remarked Lucile Williams. This direct link between the buildings was a frequent conduit for amorous meetings. "Sometimes, some girls would sneak over there," Williams laughed, "but I didn't want to snitch on the girls."

WAR WIDOWS, BLUSHING BRIDES & BABY BOOMS

The war redefined the lives of women. The widened professional options many females managed during the war broke barriers and expanded opportunities. The 1940s saw one of the largest increases in marriage rates, with women marrying at a much younger age as men shipped overseas. Hollywood set the tone for women's roles during the war with such popular films as *Mrs. Miniver* and *Since You Went Away*, in which dutiful wives steadfastly kept the home fires burning until their men came marching home. Following the war, movie studios found new material exploring the harsh realities during and after the conflict. Movies like 1946's *Best Years of Our Lives* took a defining look at the struggles for both men and women as fighting heroes returned home.

The number of marriages and births at Disney Studios increased as well. With the military presence on the lot, men were a strong presence, and a number of romances blossomed. Once their sweethearts returned from war, though, many of the women left the studio to marry. "When I first started there," recalled Edle Bakke, "and really through most of the 1950s, the majority of women would retire to be homemakers. That was the way of life." Animator Virginia Fleener summed up why so many women left the studio to start a family when their husbands returned from overseas: "It's what you did."

Many women, however, had no choice but to find work, as sadly, a number of men did not return. "There were a number of [widowed] girls," Bakke recalled. "Phyllis Pickles, a lovely, beautiful girl, [well,] she was a single mother [who] had a baby girl, and

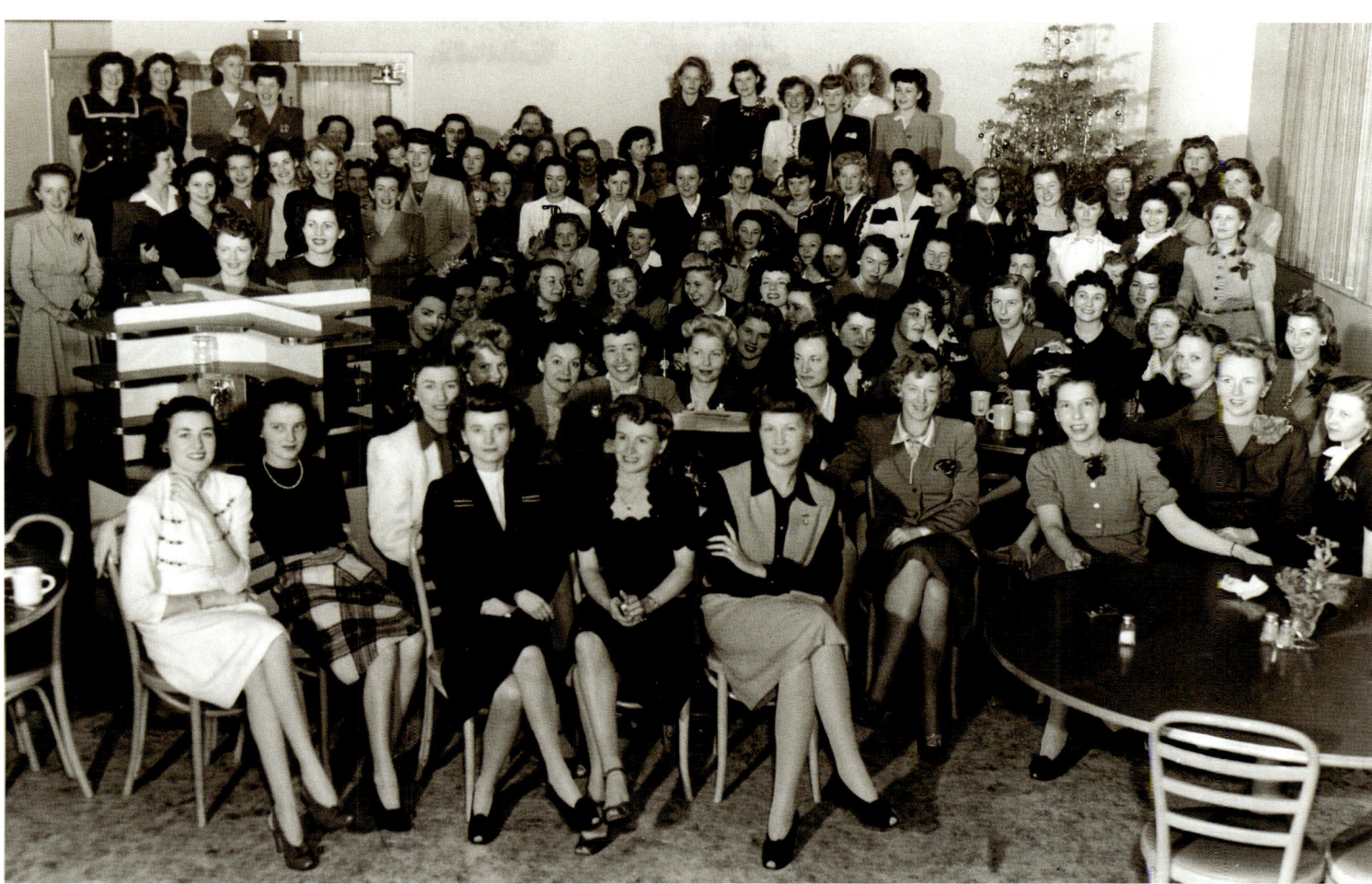

Studio Inking & Painting staff gather for a holiday lunch in the new Burbank Tea Room.

she lived with her parents because her husband was killed at the beginning of the war." Wilma Baker, who left the studio in the poststrike layoffs, married her high school sweetheart. When she was pregnant with her first child, Baker's husband was subject to the draft, and after he enlisted in the army, he was shipped off to war. Living with her mother and brother, she gave birth to a son while her husband was overseas. When he was lost in the Battle of the Bulge, she recalled, "I got myself together, called the studio, and asked Grace Bailey if I could come back to work; she said, 'Yes!'" Returning to the studio to support her infant son—who sadly never knew his father—Baker remembered, "I wasn't in a very good state. I was working, but . . . it was another world that you just get through."

For a generation raised through the Depression and the uncertainty of the war years, the promise of peace presented a fresh outlook for many of the returning staff, who quickly coupled off. The postwar years saw an increase in marriages and births nationwide, as many returning veterans were eager to settle down and start families. Thanks to the G.I. Bill, men bought their first homes and pursued higher education. Many of the former studio men returned to see about resuming their roles. When a strapping young editor returned from the Navy to visit old friends at the studio, "that's when I met him," recalled Baker of her second husband, Ted. "I consider myself lucky," Baker declared. "I've always felt that it was wonderful to be a part of that time of the studio. It was a special place."

One of the more interesting gauges of the marital status of the studio staff might have been the one Victor Bronnais of the cafeteria was tracking. He noted that the requests for cooking tips were "piling in" from the various Disney brides, "with interdepartment marriages occurring continually."

Despite the flurry of activity, the Ink & Paint women remained close, raising their families together even after they left the studio. Rae Medby and Yuba O'Brien met at the studio and remained lifelong best friends. Both ladies met their husbands at the studio and raised their children together. Yuba's son Kelan recalled, "We were known as Disney Babies and my brothers and I were raised with Rae's kids like one big family—we still are."

Even the studio's cats, Vera and Cora, carried on a race to see who would have kittens first. Employees were watching. Vera won. *The Bulletin* announced in 1941, "She and her four children are receiving company on the live-action stage. The kids are up for adoption. Anyone wanting one can see officer Riley Thompson, whose ward Vera is."

D-I-V-O-R-C-E

While marriages increased postwar, the later years of the 1940s also saw a dramatic spike in divorce rates. By 1946, nearly one-half of all marriages ended in divorce as many soldiers returned from war incapacitated physically and emotionally. Families felt the strain, with many unable to cope with such dramatic changes. Ending a marriage was not easy in the late 1940s as the presence of adultery or cruelty had to be proven, yet divorce became more prevalent among young couples than ever before in history. Many women who had sought work while their husbands were away enjoyed their newfound independence, which caused friction when their husbands returned from war. For some women, the single life was preferred and for the first time among young adults,

Left: June Brandon-Madson (left) and friend, strolling along the cafeteria courtyard at the Burbank studios.

Right: Gathering for a screening at the Burbank studio theater.

marriage became an option, rather than inevitable. Times were indeed changing.

Remaining anonymous, one of the women of Ink & Paint made her way back to the department after a long day in court in the late 1940s. Of her experience standing before the judge who would grant her divorce, she recalled, "I never thought I would have some man that had nothing to do with my life—that I never knew—be telling me what I could or couldn't do. That was the most horrible experience of my life."

CELEBRITY SIGHTINGS

The new studio facilities hosted a number of celebrities, high-ranking officials, and noted individuals at this point who were either visiting for the day or working on various productions. The lively studio commissary was often quite a star-studded showcase. Sylvia Holland's daughter remembered, "We might have lunch together in the studio restaurant. Mother might point out a Disney celebrity as they came and went from lunch." Walt enjoyed touring visiting VIPs around his state-of-the-art animation facilities, where Ink & Paint was a regular highlight. Painter Marie Justice recalled one particular tour. "He [Walt] stopped at my desk [with his guests] and pulled out a cel and they discussed it, and then he put it back in on top of another wet cel and he was so embarrassed. I just said as long as he did it, it was all right." "When Walt wasn't able to take time out from his schedule, they used to call me to take people around on tours," Norma Swank noted. "I remember Ginger Rogers, who was so tiny, and baseball legend Stan Musial. The girls in Camera were so jealous—they loved baseball."

"Whenever anybody came to visit, we were supposed to keep our noses clean and not scare people," recalled Ruthie Tompson, who explained the origins of this unwritten rule. "One time he [Walt] brought Cary Grant in, and of course the girls would just go gaga. He went in the Inking corridor with Grant and everybody craned their necks over the tops of their desks . . . they all stood up and everybody sighed. Walt went through the routine of talking to the Supervisor, which is what he usually did . . . and then he went out, and about ten minutes later the phone rang, and he gave that Supervisor [a] what-for so loud over the phone that we could all hear it. Thereafter, whenever he'd bring anybody in, we'd stay in our seats and mind our own business."

Excitement increased on the studio lot with every celebrity, but the extended stay of one notable caused quite a stir: Salvador Dalí. "I remember [Walt] bringing him through the studio," noted Grace Godino. "At first, they didn't mention that they were planning a picture together." The preeminent surrealist spent a brief tenure at the Disney Studios laying the groundwork for an experimental short, *Destino*—a project that was set aside at the time and finally completed over fifty years later. Carmen Sanderson often spotted Dalí in the cafeteria or roaming the lot: "You couldn't miss him. He was quite a character."

Godino remembered his work: "He'd be doing these things and he'd throw everything in the trash that he didn't like and everybody'd go at night and they'd swipe all the [trash] and then they framed them! Unfortunately, I didn't get one."

Getting back to the business of production following the war, private tours of the Walt Disney Studios were reestablished for visiting guests and VIPs. As film audiences had been given a peek inside the workings of the studio in *The Reluctant Dragon*, a

Studio nurse and songwriter Hazel (Gil) George.

fascination with the animation process inside the world of Walt Disney grew, particularly after the war. Tour guide Patricia Best escorted potential corporate clients, VIPs, and other employee guests through the various departments across the lot. Working from a prepared script, she and other guides were well versed in details on the various steps in the animation pipeline as well as fun facts about the latest films in production. The guides were encouraged to offer a particular point of interest: "As an aside, you might ask the members of your tour what they think would be the hardest color to make.... If no one comes up with the answer, tell them, it's the color of water."

"We had tourist groups that sometimes came through and they'd occasionally ask questions," noted Ginni Mack, who was often brought in to demonstrate or model the painting process for guests who included such Disney celebrities as Richard Todd, Bing Crosby and sons, Kathryn Beaumont, and the child stars of *Song of the South* (Luanna Patten and Bobby Driscoll). The list of notables who came through for photo ops also included Walt. "I often had my picture taken with him," Mack recalled. "So he knew who I was. When we were there taking pictures, we got to know each other a little. He wasn't pretentious at all, he was really down to earth. I guess I looked a little nervous initially, so to put me at ease he said, 'Just look at my ears and pretend I'm Clark Gable!'"

HOBBIES & SCOTCH MIST

Of the many interests Walt explored throughout his life, one of the more unique hobbies he enjoyed was a love of miniatures. After seeing an exhibition of miniature re-creations of various interiors carefully formed by Narcissa Niblack Thorne, Walt quickly became fascinated with tiny forms. When his love of trains emerged, Walt was able to combine these to interests by collecting and creating small worlds for his trains to traverse through. One of the more intricate miniatures that Walt crafted was a small potbellied stove for the caboose of his small-scale railroad.

Once fully formed, Walt sent these stoves over to the Ink & Paint Department for Peggy Raven, one of the department's Painters, to put the finishing touches to. Paying her separately for her work, Walt was delighted with the results. "I had a few made up: one was bronze, another black, and I even made a gold one. Then we made more and started painting them in motifs that fitted the period at the turn of the century." Each of the 5½-inch-tall stoves featured a unique design and color pattern. Walt had nearly one hundred of his miniature stoves made, and he began giving these out as gifts.

With plans to shape a touring exhibition of his collection entitled Disneylandia, Walt's collection inspired ideas for his later theme park. Over the years, a number of his miniature creations were colored by the artists of Ink & Paint. "My hobby is a lifesaver," Walt noted. "When I work with these small objects, I become so absorbed that the cares of the studio fade away . . . at least for a time."

Another of Walt's lifesavers was the regular traction treatments he received from notable studio nurse Hazel George. With her quick wit and pull-no-punches honesty, George was

a level-headed force with her finger on the pulse of the studio.

Perhaps the one person at the studio that Walt could actually talk to, George quickly became his friend and trusted confidant. "We went in the back room for him to go into traction and have the compresses," recalled George. "He would be strung up in this halter. He was not supposed to talk." With his favorite drink at the ready, the mixture of a Scotch Mist and traction lent itself to lively conversation. "He told me one time, 'You know, my greatest weakness is that I'm a lousy judge of people.' He thought that I had good judgment in that area." Trained as a psychiatric nurse, George leveled with Walt and he appreciated it. "He knew all the time that I had his best interest at heart in every possible way."

George recalled an insightful example of Walt's generosity. "Walt of course came from humble beginnings. I feel that he never forgot that fact, even after his many successes. Walt always liked 'snappy' clothes—he was always beautifully dressed. Perhaps it was because he had so little when he was young. One day, he noticed that my nephew was about the same size he was. My nephew came from a family [that] was not wealthy by any means, but he was a wonderful kid. Well, it wasn't long after that Walt began to bring in bags of his older clothing, most of it still like new, for my nephew. Times were tougher then, and this was a really generous gesture. I feel that [Walt] was really motivated by love, and this gesture certainly demonstrated that fact clearly."

With her keen people-sense and close association with Walt, George offers probably the sharpest sense of his view of the feminine gender. "I think Walt was more at ease with women than he was with men, I really do. I think that he was one of those unusual men who feel more identification and camaraderie with women. He wouldn't even have a male dog. All of his dogs were female."

OTHER STUDIOS

In 1941 a private personnel service prepared an "occupational brief" entitled *Motion Picture Cartooning*. Distributed to various colleges on the West Coast, this pamphlet was designed to aid potential graduates in their various career choices. This layman's overview of the animation industry paints a bleak image of the potential, yet notes a partial sense of progression at Disney Studios: "Practically all women employed today in the animation industry are in the Inking and Painting Department of the cartoon studio. In most studios there is a very slight chance for promotion from this department." The brief goes on to note, "Walt Disney points out . . . that future opportunities for women are more promising since the cartoon is moving toward the aesthetic type of presentation[,] which requires delicate, feminine handling." Warner Bros. featured animator Jean Blanchard and identical twin sisters Marilyn and Madilyn Wood as Inbetweeners in the 1940s.

For a woman in the 1940s, job options were minimal and the circumstances were not always rewarding. Coming to Walt Disney Studios from working at a lawyer's office, Edle Bakke recalled that her boss "only permitted me to have one piece of paper at a time to do my typing on[,] so I could never make a mistake. He was a pill, so when I went to Disney's, [sic] it was like heaven!"

During the war, legendary Ink & Paint artist Betty Brenon applied her talents to military training films at Disney before returning to Schlesinger Studios, where she ran the department and played "lots of five-cent showdown poker games." Later overseeing color at "Fort Roach," the First Motion Picture Unit, Brenon noted, "I felt I was doing my bit for the war effort." A Color Supervisor at Jay Ward Studios, Brenon later ran her own color service for many years.

Animation was an important part of the war effort in the United States as well as overseas. One of the foremost women to create animated films in Great Britain was Joy Batchelor, who cofounded Halas and Batchelor Animation, Ltd., in 1940. Working alongside her husband, John Halas, Batchelor produced animated training and propaganda films during the war. Later, they continued to produce educational, documentary, and experimental films for nearly fifty years, becoming the most influential producers of animated films in the United Kingdom.

The colorful animated characters of Walt Disney Studios played a significant role in the life of a future MGM Assistant Animator, Dina Babbitt. A young Czechoslovakian art student during the war, Dina was deported to the concentration camp Auschwitz with her mother. To cheer the children confined there, Dina used smuggled materials and bravely painted Walt Disney's Snow White and each of the Seven Dwarfs in the children's barracks, risking potentially dire consequences if caught. A week later, when a Nazi guard came to find her, she recalled, "I thought any minute I would be dead." Like so many others, she could have been sent to the gas chambers, but instead, when it was discovered that she was the artist, she was called before Dr. Jósef Mengele, the "Angel of Death."

"He asked," Dina recalled, "'Can you get the colors right?'" Declaring she could, Dina told Mengele she would paint only if her mother were spared. Releasing her mother from termination, Mengele ordered Dina to paint portraits for him of the various "gypsies" in the camp to accurately convey their skin coloration, as well as the numerous "medical experiments" he performed on those imprisoned. For six weeks, she painted portraits of eleven Romani men, women, and children, engaging in conversations with her subjects while painting to add some level of humanity into the horrors of their reality. "He told me to paint exactly what I saw," Dina stated. "But I also painted what was going on inside them."

Her Romani subjects were sent to the gas chambers. Together Dina and her mother survived a death march and two more camps before their liberation in May 1945. They moved to Paris, where Dina later met her husband, former Disney Animator and *Snow White* Artist Art Babbitt. After their marriage, the Babbitts moved to Hollywood, where Dina later worked within various animation studios as an Assistant Animator.

DISNEY FAMILY LIFE

The 1940s marked a time of tremendous family enjoyment for the Disneys. When Lillian's oldest sister, Grace, lost her husband in the early 1940s, Grace came to live at the Woking Way home and helped with raising the girls. "Dad insisted," noted Diane. As a father, Walt had a strong presence in his daughter's lives. "He always told stories," Diane recalled. "At the dinner table he would tell the story of whatever he was working on. That was his forum." Sharon recalled that, when she was a young child, her father was "very understanding, but he was stern. When he said no, he meant it. . . . He didn't spank. All he had to do was raise that eyebrow. And you knew. That was all there was to it. He trusted us."

"He was an all-day worker," recalled Sharon. "He didn't slow down at all. But he wanted his sleep at night and he was always in bed by ten o'clock." Despite Walt's long hours, Lillian noted, "Although he is one of the busiest men in Hollywood, he has never neglected his family for business. When the girls were young he would take as much time over a childish problem as he would over a studio crisis."

Sharon was her father's constant companion. "I enjoyed being with him and I was always game to go anyplace with him." Sharon continued, "We'd spend every Saturday and Sunday at the studio, very happily. We thought it was great fun." While Walt worked or roamed the studio, Diane and Sharon would "ride bicycles, come up and play in his office, [and] run the typewriters," recalled Sharon. "We weren't raised with the idea that this is a great man who was doing things that no one else has ever done," she noted. "He was Daddy."

Throughout the 1940s Walt Disney experienced the joys and pains of fatherhood as his daughters grew. "My daughters reached an age where they fell in love with horses," Walt said, "and their dad didn't count for much except to pay for the horses and things. For a while I was feeling rather frustrated. I'd say to the kids, 'Come on. Let's go somewhere,' and they'd say, 'No, Daddy, we've got to stay home,' or 'There's a prom on.'" Despite this general teenaged distance, Walt remained deeply involved in his daughters' lives. As Diane recalled, "He came to every father-daughter event on the calendar."

Page 233: Several women of Disney Animation in 1948, including Becky Fallberg (far left), Retta Davidson (2nd from left), Marie Gerard (wearing a white shirt front, center), Lois Cleworth (behind Marie), Sally Holmes (far right), and several unidentified ladies of Animation.

THE 1950s

1950
- The first modern credit card is introduced
- The first successful organ transplant is performed
- The Korean War begins
- Sen. Joseph McCarthy begins a communist witch hunt

1951
- Color TV is introduced
- The United Nations headquarters open in New York
- J. D. Salinger's *The Catcher in the Rye* is published
- The soap opera *Search for Tomorrow* debuts on television

1952
- Automobile seat belts are introduced
- The polio vaccine is created
- Princess Elizabeth becomes queen at age 25
- J. Edgar Hoover denies Charlie Chaplin reentry to United States

1953
- Pilot Jackie Cochran becomes the first woman to break the sound barrier
- The first *Playboy* magazine is published
- Sir Edmund Hillary and Tenzing Norgay climb Mt. Everest
- Jerrie Cobb is the first US woman to undergo astronaut testing

1954
- Jonas Salk's polio vaccine is given to children in a massive trial
- The first report stating cigarettes cause cancer is released
- Roger Bannister breaks the four-minute mile
- Segregation is ruled illegal in the United States

1955
- James Dean dies in a car accident
- Rosa Parks is arrested and the Montgomery bus boycott begins
- Ray Kroc opens his first McDonald's
- *The Guinness Book of World Records* is published

1956
- Elvis Presley appears on *The Ed Sullivan Show*
- Grace Kelly marries Prince Rainier III of Monaco
- The TV remote control is invented
- Velcro is introduced

1957
- Dr. Seuss publishes *The Cat in the Hat*
- The Soviet satellite *Sputnik* launches the Space Age
- Wham-O introduces the first Frisbee
- The Brooklyn Dodgers move to Los Angeles

1958
- Fourteen-year-old Bobby Fischer becomes a chess grandmaster
- Hula-Hoops become a craze
- NASA is founded
- The peace symbol is created

1959
- Fidel Castro becomes dictator of Cuba
- *The Sound of Music* opens on Broadway
- The Dalai Lama flees Tibet and is given asylum in India
- The Barbie doll debuts at the New York Toy Fair

FADS & BABY BOOMERS

Patti Page's hit song "Tennessee Waltz" topped the charts until a quiet Memphis truck driver named Elvis Presley fused the sounds of gospel/blues guitarist and singer Sister Rosetta Tharpe, turning the world's ear on its side. Disc jockey Alan Freed coined the phrase "rock and roll."

The introduction of frozen TV dinners altered lifestyles as Nielsen families dined while watching weekly episodes of *I Love Lucy* and *Queen for a Day* on television. Jimmy Stewart and his invisible "friend" in *Harvey* kept people flocking to the silver screen for a time, while Marilyn Monroe brought sexuality to the forefront.

"Cats" were defined by the "threads" they wore and if they knew how to "dig it." Motorcycles and souped-up hot rods were usual modes of transportation, especially if you were cruising for "chicks" in poodle skirts and saddle shoes. Screen heartthrobs James Dean and Marlon Brando made leather jackets, T-shirts, and Levi's a fashion statement.

McCarthyism and the Red Scare increased the paranoia and fear of communism. When the nation's First Lady, Mamie Eisenhower, defined her role as the "First Housewife," major home appliances and furnishings featuring her favorite shade of pink flooded the market. *Ladies' Home Journal* and *Good Housekeeping* were the leading women's magazines; both extolled the virtues of being "a good wife."

Feature-length animation returned to Disney, and in 1955 Disneyland redefined popular culture.

ANIMATING CLASSICS

> *"Fantasy, if it's really convincing, can't become dated, for the simple reason that it represents a flight into a dimension that lies beyond the reach of time."*
> — Walt Disney

"We were in a hell of a fix," Roy Disney stated of the late 1940s. "[With a] tight payroll on our hands, you don't worry about yourself, you worry about your commitments, your involvements." The studio was at a turning point. Rebuilding the artistry and talent of the studio staff through years of commercials, corporate productions, educational films, anthology films, and shorts, but to keep this progressing, it took time, talent, and money, which were all in short supply.

Finances were tight. With the studio still in debt from the war and overseas receipts indefinitely frozen, the studio could not continue without a significant financial success. Walt Disney knew that, to keep the studio alive, they needed a miracle. Believing in the talents of his artists, who were now seasoned storytellers, Walt sought out the trusted story form of fairy tales to re-create the success of *Snow White and the Seven Dwarfs*.

Various fairy tales that studio artists explored before the war were dusted off, and development artwork was reexplored on a number of titles. Walt knew his next animated film had to be something that audiences of the day could identify with. "I'm just corny enough," Walt noted, "I want to be hit right here in the heart." Once again, a female protagonist was called upon to save Disney animation, and production quickly began on the story of a young girl who overcame difficult circumstances through hard work, moxie, and a little bit of magic.

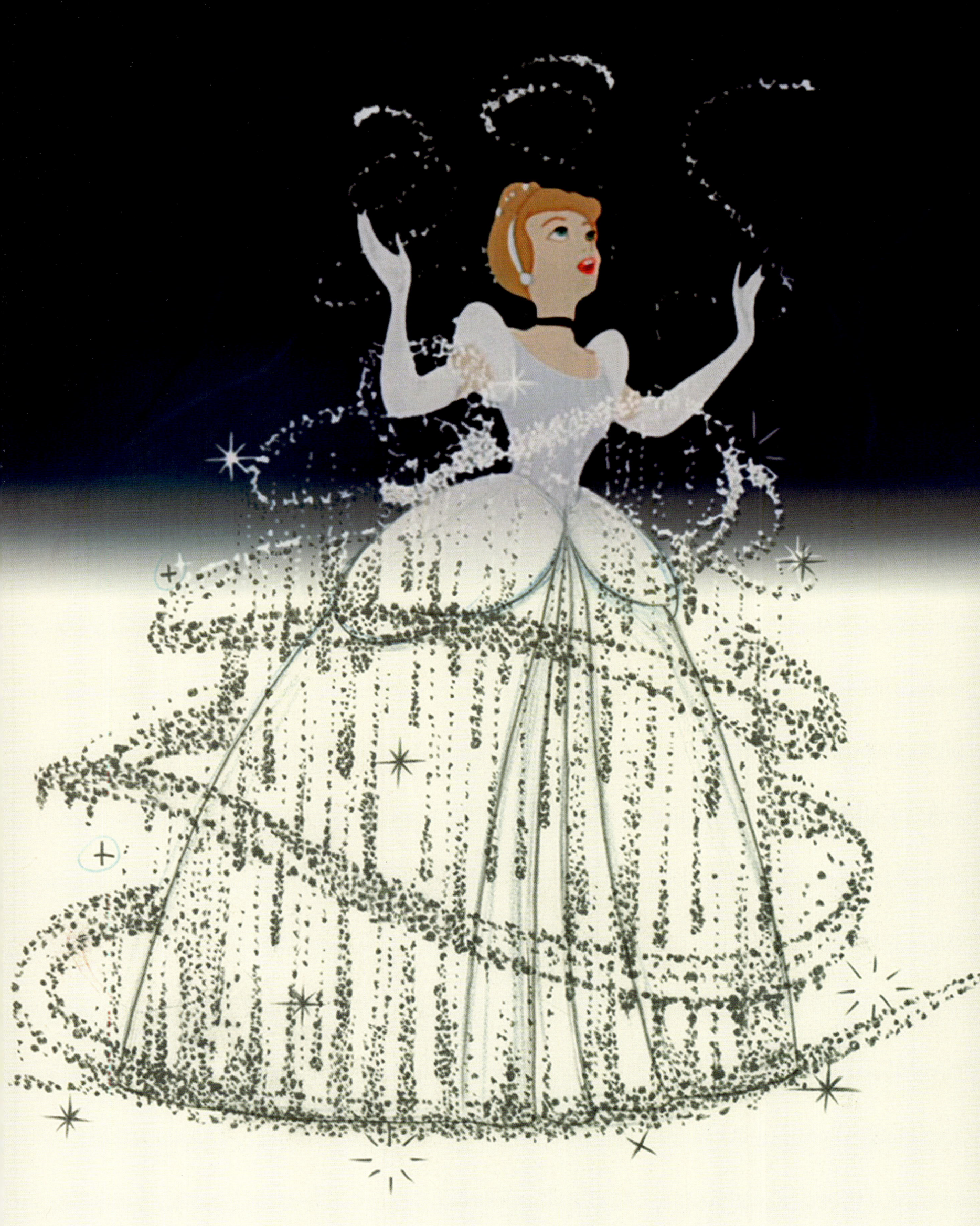

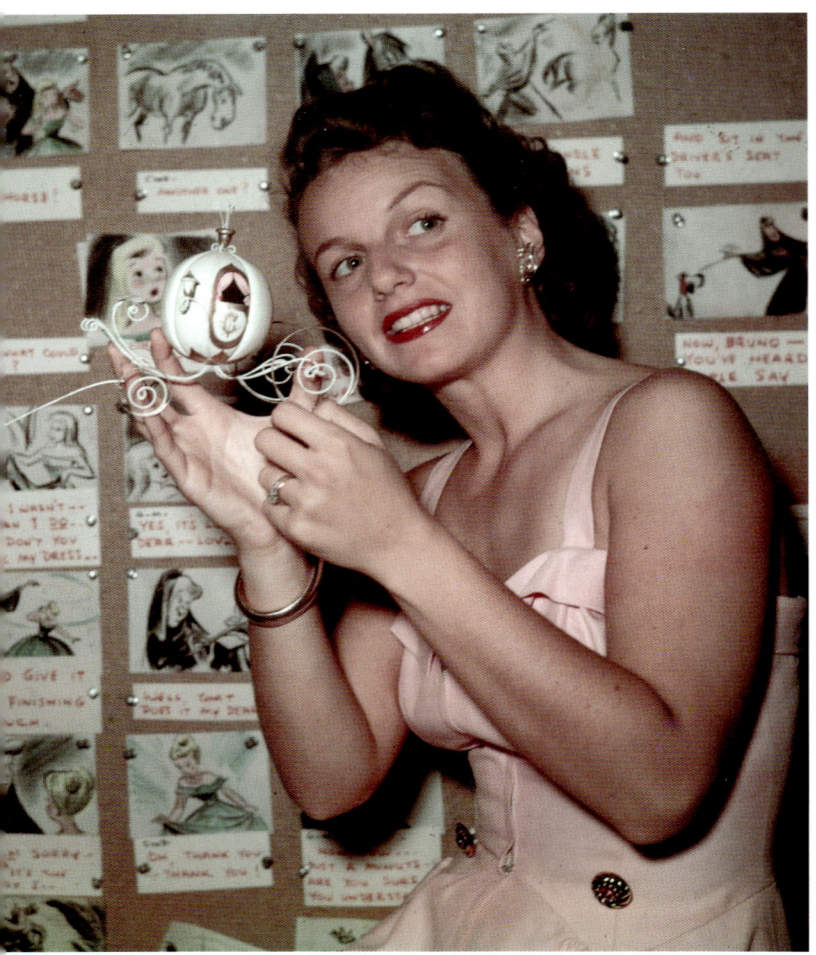
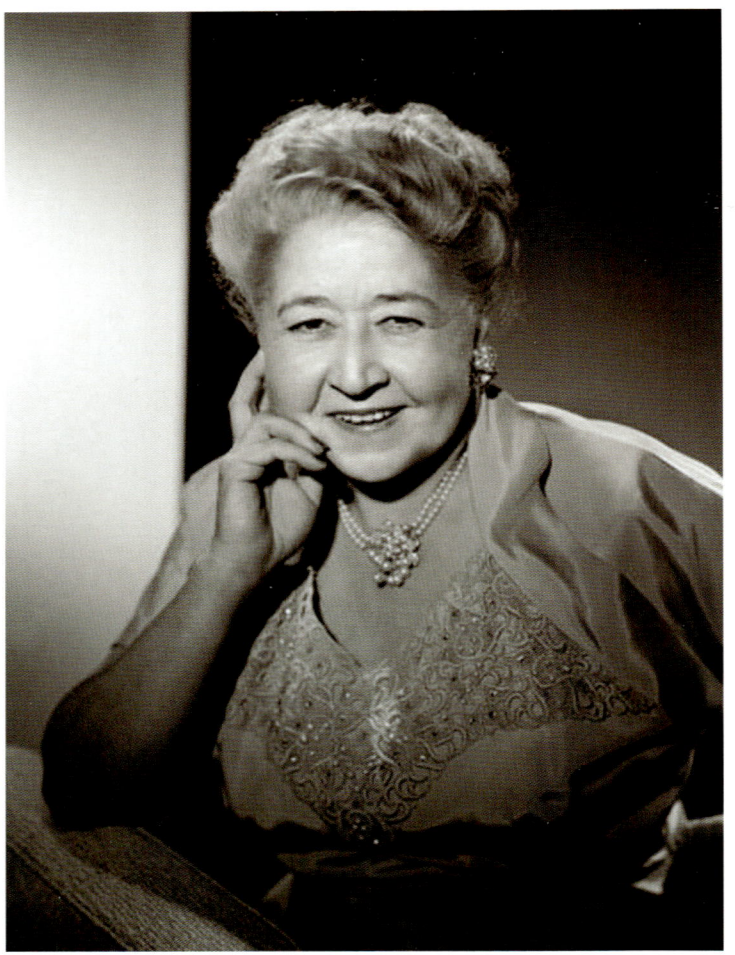

Pages 234/235: Trying out the latest fad, the Hula Hoop in 1958.

Page 237: Animation and effects layer transitioned to the final inked and painted frame from Walt Disney's *Cinderella* (1950).

This page, left: The voice of Walt Disney's Cinderella, Ilene Woods.

This page, right: Legendary voice artist Verna Felton, voice of many classic Disney characters including the Fairy Godmother from *Cinderella* (1950).

Page 239, top row: Various production cels of the Fairy Godmother, a pair of lady mice, and a royal footman presenting the glass slipper.

Center row, left: Mary Blair concept artwork of Cinderella's enchanted coach and the corresponding final film frame.

Bottom row: Production cels of Cinderella and her feathered friends and a final film frame of the *Cinderella* "Sing Sweet Nightingale" harmony sequence.

IF THE SLIPPER FITS

"Literary versions of old fairy tales are usually thin and briefly told," declared Walt. "They must be expanded and embellished to meet the requirements of theater playing time, and the common enjoyment of all members of moviegoing families." The entire studio relied on *Cinderella* to succeed. It was make or break. "My formula," Walt stated simply: "People always like to root for Cinderella and the Prince. You pull for Cinderella. You feel for Cinderella." Animator Dick Huemer recalled, "I remember Walt saying, 'This is it. We're in a bad way. If this picture doesn't make money, we're going to be finished. The studio's going to be kaput!' The staff was cut way down."

Returning to feature form, a number of production practices were put back into place. For live-action reference, a young dancer named Helene Stanley was brought in to assist the Animators in their visualizations. The entire film was shot in live action, and the footage of Stanley's movements was used to guide the overall layouts, action, movement, and editing. "Helene Stanley was quite capable [and] we used her many times," stated Marc Davis, the "ladies' man" of animation, known for his creative takes on female characters. "It was a matter of movement. We couldn't have found anybody any better than she to do the things that we asked her to do."

Veteran Animator Eric Larson agreed. "She understood the medium like few people did and was a great inspiration to the Animators in creating a convincingly lifelike girl."

Finding the voice of the lead character was a bit of a challenge, however. Selected from over three hundred candidates was twenty-year-old Ilene Woods, who had just arrived in Hollywood. Songwriting friends Mack David and Jerry Livingston had Woods cut a demo of several early songs written for the film to present to Walt Disney. Upon hearing her recording, Walt gave her the lead role. "I know Walt had been listening to a lot of girls," the singer reflected. "I was totally surprised when I got a call several days later saying Walt Disney wanted to meet me.

"He heard something in [my] voice that sounded like Cinderella," she added. Her first impressions of Walt were lasting: "I saw him sitting behind a desk; he always had kind of a quizzical look, like he was questioning everything about life, and I love that in him. He was a really, really fine gentleman."

From Betty Lou Gerson's opening narration, Disney's tale of the little Cinder Girl cast a spell on audiences worldwide. The great actress Eleanor Audley, cast as the evil stepmother, Lady Tremaine, recalled her various vocal assignments at Disney as the best part of her career: "It was challenging, a bit grueling, but overall most satisfying." Comic relief came in the form of the simple stepsisters, who were voiced by Lucille Bliss (Anastasia) and Rhoda Williams (Drizella). The distinctive voice work of Verna Felton helped to define Cinderella's benevolent wish-fulfiller, the Fairy Godmother.

The visual inspiration for Cinderella's Fairy Godmother was literally and figuratively found in the form of Mary Alice O'Connor, the wife of artist Ken O'Connor. Mary Alice's husband designed this magical character's physical appearance by featuring the same swept-up hairstyle and gentle spirit possessed by his wife, who inspired volunteerism throughout the Burbank community.

The directors had to look only as far as the Ink & Paint Department to round out their voice talents. "Because of my theatrical experience during the war," recalled Lucile Williams,

Ink & Paint | 239

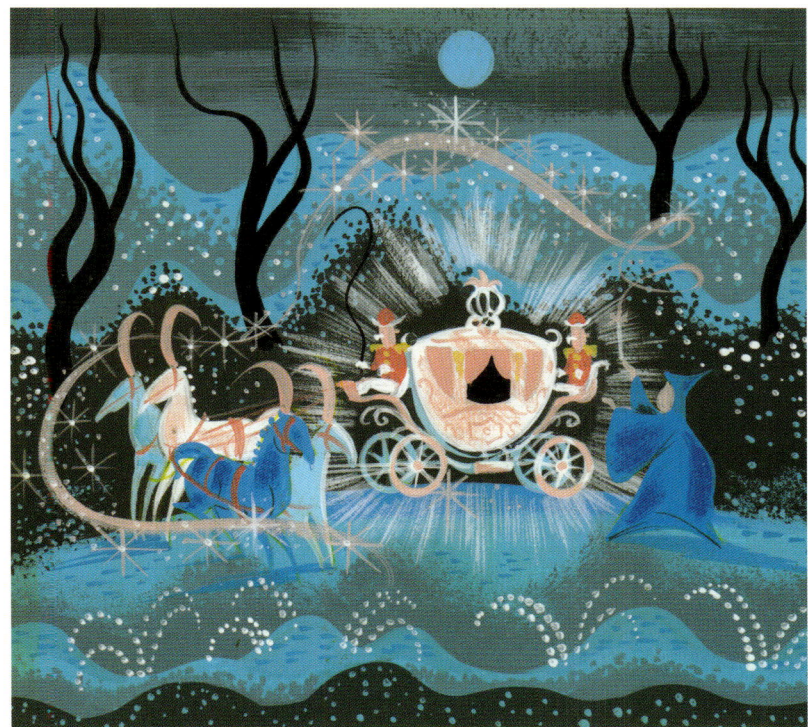

"I was occasionally called to the stage [to] do female voices on shorts and singing on some of the features such as *Cinderella* [as Perla, a mouse] and *Alice in Wonderland* [as a flower]. It was always exciting to do this double duty, spending the day on the stage with the director and crew, for which I'd received a modest sum in addition to my regular salary as an Inker. The other girls would look up as I glided down the corridor toward the exit when Betty Anne called my name and announced, 'Miss Williams, you're wanted on Stage 2.'"

Voice actresses Helen Seibert and June Sullivan also provided voices for the mice. Mary Schuster, working with Ward Kimball's unit, assisted on the animation sequences of Lucifer the cat, voiced by legendary voice talent June Foray.

One of the more magical sequences of the picture took form while recording "Oh, Sing Sweet Nightingale." Woods, the voice of *Cinderella*, recalled, "Walt came in and listened to the song at the end of the day, and he sat there very quiet for about five minutes and everybody thought, 'Oh, he doesn't like it.' And he said, 'I see a soap bubble coming up and I see Cinderella's face coming and I hear another harmony voice. And then I see another bubble coming up and I hear another voice singing harmony.'"

The technique of overdubbing had just been invented and developed by legendary guitarist Les Paul. A blending of this audible technology with animation had never been attempted before. Woods noted, "He [Disney] said, 'We can do it. I know we can do it!' That's the way he was. When he said something could be done, nobody questioned it."

Once the song was recorded, Ub Iwerks worked on drawing the bubbles for this memorable moment: "We spent two weeks timing the shots for that sequence, then two weeks to shoot," he said. The layered intricacy—visually and audibly—marked another level of magic in Disney animation. The Inkers worked with multiple colors of ink, rendering countless perfectly spherical forms, dimensionally highlighted to enclose the multiple floating Cinderellas among several layers of cels. Each frame was perfectly synchronized to blend and match the audio layers of Ilene Woods's voice, overdubbed in three-part harmony. "We spent more time on that one scene than on one of the early shorts," recalled Iwerks. It was movie magic.

Mary Blair received credit for Art Direction, and though several women had transferred from Ink & Paint to work within Backgrounds and Layout over the earlier decade, for the first time, a woman—Thelma Witmer—received credit for her work on backgrounds for *Cinderella*. Opening in February 1950, *Cinderella* went on to become one of the highest-grossing films for that year, as another of Walt's feminine fairy tales ushered in the studio's next golden era and ensured the continuation of feature-length animation.

WONDERLAND TO NEVER LAND

From Walt's earliest Alice Comedies with a live-action girl in an animated world, Lewis Carroll's charming nonsensical story had always been on Walt's short list for animated features. In 1946, writing in the *American Weekly*, Walt declared, "No story in English literature has intrigued me more than Lewis Carroll's *Alice in*

Pages 240/241: Cel setup of the Tea Party scene in *Alice in Wonderland* (1951).

Page 241, bottom: Production cels featuring a dizzying parade of marching cards inked and painted with painstaking precision, in addition to the Queen of Hearts.

Ink & Paint | 241

Feminine Firsts

CHECKING & CAMERA

Ruthie Tompson

Mimi Thornton

Katherine Kerwin

The employee with the longest history with Walt and Roy, Ruthie Tompson, progressed through an extensive career lasting over six decades at Walt Disney Studios. From a childhood extra to Painter, Tompson continued to rise through the studio ranks. One of the first women to break down barriers within Hollywood, the studio veteran recalled, "I went into Animation Checking and became in charge of Scene Planning, which is doing all the mechanics. After I got into Scene Planning, that was the part where I felt like I was really a part of the institution, because I was helping the Animators and I was helping the Background Painters."

In 1952, having worked her way into Animation Checking and Scene Planning, Tompson was invited to join the International Photographers Union, Local 559 of the IATSE, becoming one of the first three women to be admitted into the Hollywood Camera union, along with Disney Ink & Paint artists Mimi Thornton and Katherine Kerwin. A young Animator at the time named Floyd Norman later recalled, "I had to learn how to calculate pan moves and other camera mechanics. Should we tyro Animators find ourselves stumped, we could always trek down to Scene Planning on the first floor of the Animation Building. There, we received help from the amazing Ruthie Tompson who ran the department." Added Norman, "I've often said, Ruthie was our computer before computers were invented. Whatever the technical problem, Ruthie could usually solve it."

Wonderland." It seemed a logical choice for animation, but this particular adventure presented a number of challenges.

With a multitude of characters across the combination of two stories, choices had to be made. As Walt noted of Alice and the inhabitants of Wonderland, "They had to seem round, not flat. They had to be made mobile by the illusory processes of animation. They had to be seen in a lifelike flow of action from various angles." Minimizing detail saved time while the use of color was expanded to convey the Technicolor vibrancy of Wonderland. It was a world perfectly suited for the distinctive palette of Mary Blair.

The Paint Lab staffed up for the wider range of hues to bring Alice's fantasy to life. The Color Model Department explored twice the usual number of color options to define each whimsical character. Writing to an old acquaintance, longtime Supervisor Mary Tebb defined her role this way: "Another girl and myself do this work. It is called a color model because it is just that. A model . . . to know just what inks and paints to use on a given scene. Every moving thing and all action has to have a color. Action is very fast; drybrush effects add to this—it will zip across the screen." Tebb's patient description speaks to the mystique around the work of the Ink & Paint Department as she gently added, "I hope all this isn't too confusing. It is a very difficult business to explain to a layman."

The quest for character voices once again involved the women of Ink & Paint. The Story Department teams issued a memo to Ink & Paint seeking suggestions for voices of the inhabitants of Wonderland. Interesting nominations were made: a popular star of the day, Constance Collier, was proposed for the role of the screwball Queen of Hearts, while manic comic Danny Kaye was a candidate for the nervous and excitable White Rabbit. But Walt went in a different direction. The voice for young Alice went to talented ten-year-old Kathryn Beaumont, who also provided the critical live-action reference that would define Alice's movements. "Kathryn Beaumont—she was fine. You couldn't have found anybody better for the parts that she played!" said Marc Davis, the Animator of Alice.

CHALKBOARDS & SOUNDSTAGES

Placed under one of the earliest long-term contracts with Walt Disney, Kathryn Beaumont ended up enjoying her lengthy time on the studio's lot. "Walt was very accessible," she recalled. "As a child, I felt very comfortable with him because . . . he was used to dealing with children, so he was comfortable with me and made me feel that same way." Since she was a minor, the actress's care on set was in the hands of Dorothy Mullen, an educator hired by the studio (who oversaw the school needs of the various child actors working on lot). "I was only permitted to be on set for so many hours a day," Beaumont remembered. "Dorothy carried a notebook and would carefully mark every minute I was on set. She would quietly go up to the Directors

Production cel of the White Rabbit from *Alice in Wonderland* (1951).

JUNE FORAY

This legendary voice talent made regular voice-over appearances at every major animation and live-action studio in Hollywood. Renowned for her work as Rocky the flying squirrel, Foray also voiced every female character for the *Rocky and Bullwinkle Show*, including Natasha Fatale and Nell Fenwick. Foray's other legendary characters include Cindy Lou Who from *The Grinch Who Stole Christmas* and Granny, the feisty owner of Tweety and Sylvester. For Walt Disney, Foray was the voice of Lucifer the cat in *Cinderella*, Lambert's mother in *Lambert the Sheepish Lion*, a mermaid in *Peter Pan* and Witch Hazel in Donald Duck's short *Trick or Treat*. Later, she was the voice of Pinocchio for various television spots, Undersea Gal in *Tim Burton's The Nightmare Before Christmas*, Grammi Gummi on *Disney's Adventures of the Gummi Bears,* and Grandmother Fa in *Mulan*. Legendary Animator Chuck Jones once declared, "June Foray is not the female Mel Blanc, Mel Blanc was the male June Foray."

and say, 'You have Miss Beaumont for twenty more minutes.' She was quite stringent about that, and the studio was so supportive of my schooling."

Mullen, a credentialed teacher working under the Board of Education of Los Angeles, found her studio years to be flexible enough for her to return to the education field after raising her two daughters. "A regular day would be three hours of schooling and four hours UBL, or 'under bright lights,'" Beaumont noted. "Our classroom was set next to the Accounting Department in the small building closest to the soundstages. If we were needed, they would call the accounting office and someone would run over and knock on the door and give us a message. 'The Animators called and they want to show you their next scene.' Dorothy would bring me over when I had recess and the Animators always wanted to share what they were working on. It was quite a wonderful education."

Mullen worked with the other child actors on their various studio workdays as well. "She kept track of assignments and materials for Bobby Driscoll, Paul Collins, and the other children as they were on set," Beaumont said. "Dorothy also took me down to the Board of Education every year, for the annual tests to determine my matriculation to the next grade level. Everyone respected Dorothy at the studio. She was a very lovely person."

"MORE TALENT UNDER ONE ROOF"

Creating the wonders of Wonderland was a prodigious task for the women of Ink & Paint. One of the more colorful and detailed accomplishments in *Alice* was painting the Queen of Hearts's army of playing-card soldiers. "Those cards were the pits!" Carmen Sanderson declared. But she admitted that the arduous detail work involved was quickly forgotten when she saw the final film. "You didn't always think of yourself as an artist until the big payoff of actually seeing the film."

In a letter to a friend, Color Model artist Mary Tebb described the exhausting pace of production: "We are just finishing our latest feature picture[,] *Alice in Wonderland*[,] to be released I believe in August. We are also making a picture for the Kleenex people—*How to Catch a Cold*—really, how not to, of course. It will no doubt be shown in the public schools. Our next feature will be *Peter Pan*!"

Tebb continued expressing the excitement of the time in the letter. "Even after many years working in the business I'm still one of the most enthusiastic. I do not believe anyone can fully appreciate the work done here or what Walt has done to advance this type of art until they have been through the studio. As someone has said, they didn't know any place in the world where there was more talent under one roof."

After two years and a cost of over $2 million, *Alice in Wonderland* was readied for debut in July 1951. In a studio write-up featuring the production progress on *Alice*, Walt reflects, "Perhaps it's not the greatest picture we'll ever make, for I hope never to stop improving our product. But up to now, *Alice* is our top. There were no problems of technique to solve, no 'bugs' to work out. We knew where we were [going every] single minute of the time, and I think we got there."

Walt Disney's following feature, based on J. M. Barrie's classic story of a boy who wouldn't grow up, represented the most intense concentration of talent within the studio's history. While women constituted nearly half the studio talent, no recognition

of their contributions was recorded in the various articles celebrating the film's release.

In addition to Kathryn Beaumont's subsequent portrayal of Wendy in Disney's *Peter Pan*, the actress also provided reference for the tiny sprite Tinker Bell, who was modeled after Ink & Paint artist Ginni Mack with supplemental reference work contributed by actress Margaret Kerry. For Beaumont, her role as live-action reference model was a bit more challenging. "We had lots of acrobatics," she noted. "I had to fall down that hole after the White Rabbit, and they had a most complicated invention for that [film]. For *Peter Pan*, there were flying sequences. Animators had not dealt with the problem of weightlessness and movement in the air, so they had to simulate that. We were attached to a wire and harness, and then [we] floated back and forth across the stage while we were being filmed."

Beaumont added, "Creating the movement for Tinker Bell placed me in a number of funny circumstances as well with giant scissors and keyholes." Knowing the importance of strong visual reference, Assistant Animator Berta "Bea" Tamargo also briefly stepped away from her animation desk to provide live-action reference for the character Tiger Lily. After thirteen years of development and three years of production, *Peter Pan* debuted in February 1953 to worldwide box-office success.

"DISNEY GIRLS" & WORKING MOTHERS

"We referred to each other as 'Disney girls,'" noted Ginni Mack. These self-proclaimed "girls" of Ink & Paint found lifelong kinships, sharing their personal joys and sorrows. "It seemed all of us had a lot in common even though we came from different backgrounds," commented Phyllis Craig, a Painter at Disney in the 1950s. "If you lasted as an Inker or a Painter, you seemed to assimilate this sameness. We all became social friends. When someone new came to work there, you could almost say, 'she's going to make it, and she isn't.' The girls all had a feeling of camaraderie. It was a privilege to be working at Disney. There was never any negativity that I knew of. But then I wasn't in management," Craig said with a laugh.

With ramped-up productions in full operation, several of the "girls" who left to raise their families became the first of a new breed of working mothers who returned to work with their children now in school. "[Grace Bailey] was the one who hired me back," noted Marge Hudson, who returned to the studio in 1956. "I said, 'Grace, you think they'd rehire an old staggering mother with four kids?' She said, 'Sure, we need help!'" Hudson was delighted to return. "I did quite a few different things: I inked and painted models—they piled me high with models! I was only at the studio for about a year, but I loved it. There were several of the girls that were still there, but it wasn't the same."

Others continued applying their artistry a bit more conveniently at home while raising their families. "In the fifties," Lucile Williams said, "there was an inking service that would hire you to work at home. In those days there was no 'day care.' I had even tried it, but for me it was too difficult to manage family and children, plus work to earn extra money, because of the level of concentration and scheduling required."

Ink & Paint | 245

GRACE BAILEY: AT THE HELM

Throughout the 1950s the Ink & Paint Department held over two hundred artists, with Grace Bailey taking the helm over the entire division in 1954. "She was tall, slender . . . and very striking," remembered Ginni Mack. "She had a way about her and she was really respected [with] a certain sort of fear. Grace could hire and fire, everybody knew that. She had this 'thing' you felt [and] you wanted to know if she was in the room, so you wouldn't misbehave."

A stylish dresser, Bailey wore a charm bracelet loaded with a number of little figurines. "It jingled . . . made a lot of noise," laughed Mack. "She wore that bracelet, probably, so we'd know when she came in the room!" In addition to her jangling accessory, the girls of Ink & Paint had a method to mark her presence: "She was there, all the time, so we had a 'password,'" smiled Mack. "The ladies would say, MYRTLE! And that meant she was in the room." Bailey's assistant, Edle Bakke, recalled, "She had her plan every morning after she came in—who she was going to visit, and what she was checking on. All her lieutenants, Supervisors that ran each one of the corridors[,] had specific duties—what they had to perform, by the day, by the week—and we had all kinds of stats to see done. I would do whatever correspondence there would be about new decisions and orders that would come from the Story Department."

As Department Heads, Grace Bailey, Mary Tebb, and Grace Christanson regularly attended sweatbox story meetings to track story updates and decisions that pertained to Ink & Paint. "They were in color correction, and there were always problems," said Bakke. "The colors would come out and they'd say it's not working right and we're going to have to redo it, and [they'd] go back and repaint or reink lots of things. Grace did it diplomatically and she was wonderful to me."

Bakke was the Secretary, Stenographer, and Switchboard Operator for the entire Ink & Paint Department in the early 1950s. "We could communicate between all the corridors and get outside lines. You'd keep all the messages for Grace and keep all the books—we had cabinets with history on all the girls and everything that was pertinent to who was working in the section," Bakke remembered. "She was extremely diplomatic and she tried not to hurt the girls' feelings when she knew she had to reprimand them—or fire them, if they were consistently late, [or] if they made too many errors on the cels, and such."

Under Bailey's direction, the staggering staff numbers met the production demands. Space was at a premium and the desks of Inkers and Painters were stacked three deep. "The Inking & Painting Department occupied every room in this building even down clear to the Camera Department. [In] all those cutters' rooms, we had the Final Checkers. . . . We used to have about ten people in the Paint Lab. We do everything about the same way we always did as far as dividing the work," noted Bailey. "Putting the work through here by people and by department, we maintain the same channels."

Bakke added, "The different scenes would come in, and then the most difficult scenes were given to certain Inkers." They were the premium girls!" chimed in Lucile Williams. "Gracie Robinson, she was a premium Inker. She was in my corridor, one of the lefties, so we [sat] back to back." Even with the expanded staff, production always seemed to bottleneck for Ink & Paint, yet deadlines were always met. Bailey acknowledged, "The closer we get to the deadline, we have to go into overtime generally. As does the Animation Department."

Pages 244/245: Alice & Wendy voice talent Kathryn Beaumont and various production cel pieces featuring characters from Walt Disney's productions *Alice in Wonderland* (1951) and *Peter Pan* (1953).

Page 247: Production cel of Captain Hook from Walt Disney's *Peter Pan* (1953).

DRUMMING IN THE MUSIC ROOM

Story meetings took place in what was called the "Music Room," a holdover from the Hyperion studio days where meetings were held in the one main room, which held a piano. In the mid-1950s Edle Bakke was the Secretary for Director Jack Kinney's unit. "I got the job, because Jack Kinney fell in love with his secretary, so I was able to do more and he was relaxed with me because I knew his wife." A year later, Bakke joined Ward Kimball's unit, working on his "Man in Space" project. "Week after week world-renowned rocket scientists such as Wernher von Braun, Willie Ley[,] and Heinz Haber would get together," recalled Bakke. "I was assigned to take notes in shorthand on subjects such as weightlessness, centrifugal force, rocket stages[,] and orbital trajectories. . . . I was very busy."

"I was part of the unit[,] so I worked with the boys everyday," Bakke noted. Usually the only woman in the room, Bakke's role was versatile. "I did everything," she remarked. "I'd work with the crew of Animators and they had their specialties. When we had story meetings, the Animators would bring up their scenes and work through the sequences. Walt did come down a lot for those meetings." Regularly taking notes for each of these meetings, Bakke had a firsthand view of Walt's creative process. "He'd get everybody so up about what was going on in those meetings. He'd talk about . . . 'In 1990, we'll have helicopters on our roofs and we'll have monorails.' . . . All of a sudden you'd see in your mind's eye all of these things. Then he'd say . . . 'All right, you go figure out how this is done.' And then he'd leave."

One day, the story men set up a screen and informed Bakke that she would have to take her meeting notes from behind the panel. "I guess they felt Walt would feel more free to speak if it seemed I wasn't in the room." This hidden perch required a bit more discernment to her note-taking, especially if the meeting wasn't going well. "You just waited till you heard what was happening. If it wasn't going right, the first clue was Walt drumming his fingers on the table. Boy! When that started, oh gosh! The Animator would be shaking!"

Walt Disney films an opening segment for the television series *Disneyland*, circa 1958.

INBETWEENER TO ANIMATOR

"I'd studied stage design in high school," recalled Animator Xenia DeMattia. "When I went looking for jobs, they didn't have any women stage design artists. . . . This was the Depression." So, DeMattia began her career working at several smaller animation houses, and later noted, "They didn't have any girls Assistants then; they were always in Ink & Paint." DeMattia started as an Inbetweener and was eventually hired as an Assistant Animator at Disney Studios in 1950.

"I was working for an Animator," DeMattia recounted, "and we were two in a room, an Animator and an Assistant. I noticed other Animators were having a lot of changes, so we didn't have anything to do while they were making changes. We were waiting for more work to come to us [and] I thought, 'Gee, if you get this much help, I can even animate.' So, I made up a little short story and I animated it and inbetweened it, and they were very nice at Disney's [sic] about shooting tests, so they shot it for me and I got the test back and I showed it to my Animator and he got kind of worried.

"He was a real nice guy but he didn't have too much self-confidence, I guess, and he got kind of upset a little bit," said DeMattia. "So, I went to our Director and showed it to him and he liked it a lot, so he gave me some animation on the next film, which was *Paul Bunyan*. I got a few scenes on *Paul Bunyan* . . . that was the first . . . but at Disney's you had to have a lot of footage to get screen credit. It's different now."

When DeMattia began animating, it took a while for some men to warm up to the idea of a female Animator. "In the early days, some of the guys were just dead set against a woman in animation, but others were more open about it and encouraged me. So there were both kinds of men," DeMattia noted.

"I had a feel for action and I enjoyed it." Working with other woman Animators as they came in, "I encouraged them, because some of them just didn't have the feel for action that most men had, so that was kind of hard. They could draw, [and] some were actually better in layout than they were in animation."

> *"Instead of considering TV a rival, when I saw it, I said . . . I want to be part of it."*
>
> —**Walt Disney**

TELEVISION HORIZONS

From his first foray into this new entertainment medium, Walt Disney recognized the possibilities: "Television and the changes it has brought about in the motion picture industry have provided an exciting new stimulus to our creative efforts." Creating

The Mouseketeers from the *Mickey Mouse Club* television show. Mouseketeer Bonni Lou Kern later painted in the studio's Ink & Paint Department.

the very first televised holiday special, *One Hour in Wonderland*, which aired Christmas Day 1950, Walt featured his latest animated heroine, Alice. The following year, on *The Walt Disney Christmas Show*, Kathryn Beaumont made her second television appearance as Wendy in order to promote the forthcoming production of *Peter Pan*. "It was such fun for a little kid," recalled Beaumont, "because here it was summertime and we were on vacation from school, but we got to pretend it was Christmas!"

Asked to produce a weekly anthology series, Walt felt the timing was perfect, as a series provided the perfect forum to support other ventures he was exploring. "The Disneyland Story" debuted October 27, 1954, with Walt himself as host. Television was a family ritual in the Disney home, just as it was in households across the country. "On Sunday night we would eat in front of the TV," noted Lillian Disney. "He wanted my reaction on the show. Every time I would take a mouthful he would look over and say, 'You're not looking. You're not looking.'"

"SEE YOU REAL SOON"

Mickey Mouse Club, which began airing in 1955, was not initially associated with the studio's animation efforts, but it later boasted ties to the Ink & Paint Department. Mouseketeer Bonnie Lynn Fields from the show's 1957–58 season served as an Ink & Paint girl on Walt's various *Wonderful World of Color* introductions that took place on a set depicting Ink & Paint.

Ink & Paint secretary Edle Bakke worked on the early television and live-action film ventures, including *Mickey Mouse Club*. "I trained and became the first Script Supervisor at the studio. I threw up practically every day for a year when I first started, it was so much pressure," laughed Bakke. Usually the only woman on set (other than cast or hair/makeup/wardrobe), Bakke shouldered responsibilities that were critical to the continuity and believability of the program. "You couldn't fake it as a Supervisor because it's there on film," she noted. Decades before instant playback, she often had to speak up and stand her ground if continuity wasn't matching. "At the time, you didn't have access to the clips automatically . . . so it meant you had to stop production and go and look at things," she remarked.

Bakke recalled that many men were indignant with having a woman on set—especially a "girl" whose role was to correct their work. "I had one girl that I was very good friends with; I became the first Script Supervisor and she was the second," Bakke remembered. "We would get together and talk about so many things we didn't understand how to handle diplomatically." Venting about their daily circumstances formed a bond, but as the only women on set—and often together—they were the frequent subjects of gossip circulated by their male colleagues. Bakke later laughed about the unfounded gossip.

This breakthrough television show featuring a merry band of Mouseketeers often featured serials written by longtime screenwriter Lillie Hayward. With a keen sense for adaptation and a reputation as a quick writer, Hayward wrote extensively for the show's *Spin and Marty* serial and later wrote the screenplays for *Tonka* (1958), *The Shaggy Dog* (1959), and *Toby Tyler* (1960). *Mickey Mouse Club* also advanced the career of another groundbreaking woman at Disney, Harriet Burns. As a young artist, Burns briefly

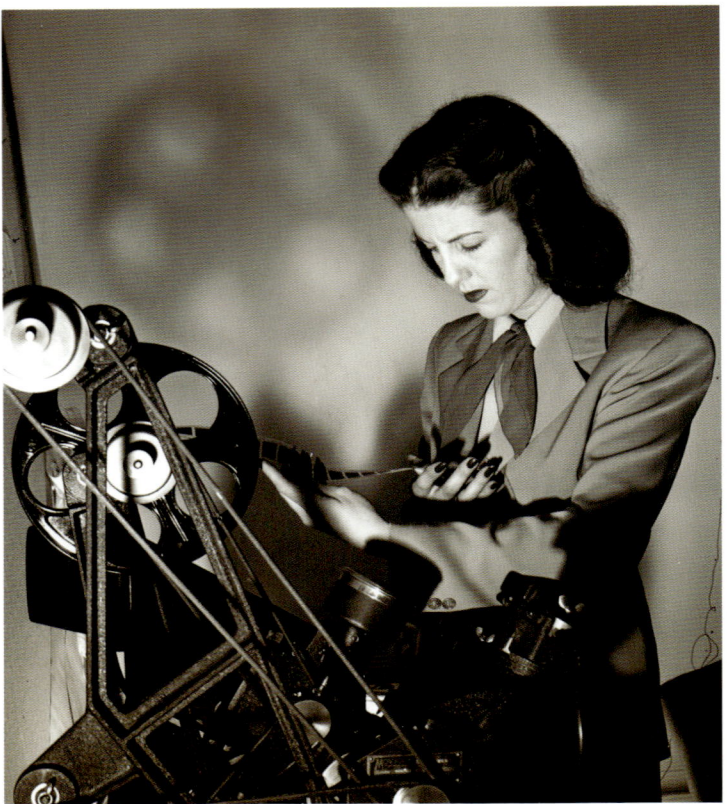

Left: Assistant Animator Mary Schuster with Ward Kimball and Julius Svendsen on the *Toot, Whistle, Plunk and Boom* (1953) production team.

Right: Music Editor and Songwriter Wanda Elvin Sykes.

worked for a Los Angeles company creating props and displays for Las Vegas casinos and various seasonal Santa villages. When the company filed for bankruptcy, Burns and her assistant, Jim, were both hired to work with Bruce Bushman, the *Mickey Mouse Club* art director. "TV was new," stated Burns, "and no one was sure of anything. I worked with Bruce and had a wonderful time with the background paint. This was an animation factory with Ink & Paint. We were really oddballs."

WOMEN OF NOTE

The talents of Walt Disney's staff often expanded far beyond their daily roles. With a wide slate of animated and live-action films, along with the faster production pace and volume of creative content necessary for television, talents of all kinds were tapped across the studio.

Hazel George, the studio nurse and Walt's trusted confidant, was also a gifted songwriter. Writing under the pseudonym "Gil" George, she wrote lyrics for many of the songs featured within Disney films such as *Perri*, *Westward Ho the Wagons!*, *The Light in the Forest*, and the theme for *Old Yeller*. She also frequently contributed to various Disney television shows such as *Zorro* and the original *Mickey Mouse Club*, writing the song for the "Talent Roundup Day" segment, the *Corky and White Shadow* serial, and many of Jimmie Dodd's noted "Doddism" ditties such as "Beauty Is as Beauty Does," "Safety First," "Good Samaritan," and "Everything Is Fun."

"I really felt that Walt's greatest talent was recognizing the potential in others," George once observed. "He really sought to bring out the best in people, whether they were artists, story people, or accountants. He encouraged me to write lyrics for music at the studio, as he knew that I wasn't really using my college degree in literature as a nurse. So I did, and he loved my writing. Walt was a special man."

George also deserves credit for coining the title of one of Walt's True-Life Adventures documentaries. "I titled *The Living Desert*," she revealed. The documentary's original name was *The Desert Story*, and George offhandedly suggested her title while Walt was on a phone call. She recalled, "[Walt] said, 'My god, that's it!' Then a little later he said, 'How did you think of that?' And I said, 'I got it out of the Bible. . . . It says, 'the living water. . . .' I just changed it a little. Besides, I was born in Arizona, I know a thing or six about the desert. That's a living thing, believe me.'"

Cowriter of over ninety songs for various Disney productions, George collaborated with a number of composers and writers, including her longtime companion, Academy Award–winning composer Paul Smith; George Bruns; and many others, including another studio employee who regularly contributed to various projects, Wanda Elvin Sykes.

With a degree in music from the University of Southern California (USC), Sykes arrived at Disney Studios in 1942 to fulfill a variety of jobs in the Music Department. Her sharp mind and expertise on a wide range of subjects quickly landed her a promotion to the Research Department, where she soon rose to become Director of this vital division. Sykes and her team covered detailed research needs for animation, live-action film production, music, short subjects, and television.

An accomplished pianist, arranger, and music teacher, Sykes applied her musical talents to a number of projects at the studio, including songs and material for various television productions. As was common in the day, Sykes utilized a masculine nom de plume, writing under the name "Sam" Sykes and is credited with collaborating with "Gil" (Hazel) George on lyrics for such toe-tappers as "Oom-Pah-Pah," "Open Your Eyes," and "Up in the Mountains." She also wrote the music for "Safety First."

A number of additional female musicians either wrote for or made appearances within early Disney television. Ruth Carrell, the wife and collaborator of lead Mouseketeer Jimmie Dodd, wrote or

Left: Folk duo Frances Archer and Beverly Gile, the first artists signed to the Disneyland label as Archer and Gile.

Right: Becky Fallberg takes a stroll on the Disney studio lot.

collaborated on a number of songs utilized on *Mickey Mouse Club* and served as a surrogate parent along with her husband to the young Mouseketeers at their various appearances. Frances Jeffords cowrote several of Annette Funicello's popular *Mickey Mouse Club* songs, including "How Will I Know My Love?" Frances Archer and Beverly Gile were folk-music pioneers Walt discovered at a party in Palm Springs. As a duo, Archer and Gile made several appearances on *Mickey Mouse Club* and released recordings on Golden Records. Later, they were the first recordings artists with the first LP to bear the Disneyland label. *A Child's Garden of Verses* featured music by Gwyn Conger. "I did a lot of different voices and singing for the various children's records," recalled Ink & Paint artist Norma Swank. "One time, I had to sing in Portuguese. We did it phonetically and it must have worked[,] because they used it!"

STOPPING BY THE SET

With various productions happening on the studio lot, many of the Ink & Paint girls would dash over to the soundstages to watch filming. Many cast members were equally fascinated with the animation production process and wandered into the Ink & Paint Department, as Marge Hudson recalled: "They were filming [*Davy Crockett*]—the big tall guys, Fess Parker and Buddy Ebsen. I'd be in [painting doing] some models, [and] I was alone on this particular day, and . . . they wanted to know all about what I was doing and why. They were so cute."

Often the Ink & Paint teams were called upon for their thoughts on various development choices. With production on the new series *Zorro* under way on the back lot, the name of their new star, Armand Catalano—whose stage name was Guy Williams—was at issue. As there were concerns about confusing his stage name with other screen actors of the day, questionnaires went around seeking suggested name options.

Despite these efforts, Guy Williams kept his stage name.

"We could go to the back lot on our coffee breaks," laughed Phyllis Craig, "and watch them filming a movie or TV show. We could go into the Music Department and watch them recording. Everything was there and it was a wonderful place to be." Personalities and celebrities passing by were all part of a day's work. With *20,000 Leagues Under the Sea* in production on the studio lot, Carmen Sanderson recalled, "We would see James Mason and Kirk Douglas when they were filming on the set, you'd see Kirk around all the time, it was fun. . . . He wasn't shy."

COMMERCIAL VENTURES

With the need for funds to fulfill his vision of Disneyland, Walt saw an opportunity to gain quick revenue in the form of commercials. Applying the same knowledge and approach he'd used for the training and educational films, which kept the studio open in the late 1940s, Walt established a Commercial Unit in the mid-1950s and placed a women in charge. Phyllis Hurrell, a former studio Painter and Animation artist, oversaw the complete direction of this groundbreaking film unit.

At a time when women's roles within the workplace of other industries were primarily relegated to secretaries and schoolteachers, Hurrell ran every aspect of this production division. The wife of the legendary photographer George Hurrell, and Walt's niece, Hurrell managed production of over 250 commercials, many of which aired during the shows that Walt was producing for ABC, including *Mickey Mouse Club*, *Zorro*, and *Walt Disney Presents*.

Animator Paul Carlson later recalled, "In 1956 I went to work for Phyllis Hurrell. She was in charge of the Disney Commercial Division. [Her] assistant was her cousin, Sharon Disney, Walt Disney's daughter. Sharon Disney and I had an office together. We were in the H-wing of the Animation Building that was developing rides for Disneyland, so Walt would come and stand

252 | Animating Classics

Left: Director of the Disney Television Commercial division, Phyllis Hurrell.

Right: Television production cel piece from Ipana toothpaste commercial produced by Phyllis Hurrell's TV Commercial division.

in the door frame visiting Sharon; he'd bring her in and take her home. I got to meet him there.

"We did the lead-ins for *Walt Disney Presents* . . . when Tinker Bell came up and introduces the four lands," Carlson continued. "We did different commercials and . . . there were so darn many of them. We did a lot of peanut butter commercials with Tinker Bell. We also did a Bucky Beaver commercial for Ipana toothpaste . . . American Motors. . . . we did 'Fresh Up' Freddie for 7 Up. He was an Aracuan bird that we designed. Sharon and I pasted up the model sheet. 7 Up bought twenty-six commercials at one hundred thousand dollars apiece. They were all one-minute commercials. That was $2.5 million dollars. That was a good deal."

Floyd Norman, who was a young Animator starting out at Disney Studios at that time, later recalled, "The Commercial Unit was extremely successful and provided a much needed revenue stream when the Walt Disney Studio truly needed it."

Once the concepts were confirmed and animated, the cel work for these commercials was added to the production pipeline at the Ink & Paint Department. "[When] Disney went into TV cartooning, it was a whole different way of doing things, making it for small screen," said Phyllis Craig. "At first we were doing them in black-and-white because there weren't that many color screens. We'd use a magic eye [a device that reduces color to a tonal range] to see how the black-and-white would match with color footage and vice versa. When we need to revive some of the studio's old footage to use in the Disney TV show, we had to look at it through the magic eye to make sure there wouldn't be a dramatic change in the tonal values between the old material and the new animation. It was a whole new world that started and it was really fun."

Joanna Romersa also contributed to this new world of animation. As her family's primary breadwinner when her then-husband quit his job, Romersa took on freelance work with an independent animation inking service to make ends meet. "I was actually working for Auril [Thompson] when I was at Disney[,] and Auril taught me to brush ink," recalled Romersa. This thicker, less detailed [sic] and faster approach to line work had long been applied to television work at other studios. "So when the commercials came in at Disney's [sic]," Romersa added, "I taught them how to brush ink and that was kind of a kick."

LIVE-ACTION EFFECTS

With foreign box-office receipts from the studio's animated films still frozen in Europe after the war's end, Walt began producing live-action films in England to utilize those funds. A departure from animation, live action offered shorter production commitments, was cheaper to produce, and garnered a faster return on investment. Production teams ramped up, and live-action films quickly became a standard part of the Walt Disney Studios' slate.

As the style and sophistication of the various live-action titles expanded, the animation teams were called upon to contribute to the special effects required to achieve the magic of motion pictures. For Walt Disney's 1954 live-action film of the Jules Verne adventure *20,000 Leagues Under the Sea*, the talents of the animation teams added to the underwater fantasy created by the live-action teams. "I did artwork for a coral reef in a process shot," noted Ub Iwerks. Animator Marc Davis designed the deep-sea divers' gear. Exotic fish swimming past Captain Nemo were brought to life by the Inkers and Painters, but didn't appear in the final scene. The women of Ink & Paint later implemented inked effects to simulate the electrified charge thrown to cast off a band of marauding cannibals.

Eventually, various elements for live-action films became a frequent part of the materials that came through the department's pipeline. A film might require any number of visual effects, from drenching downpours, lightning strikes, or alien rays, and all were supported with the artistry of Ink & Paint.

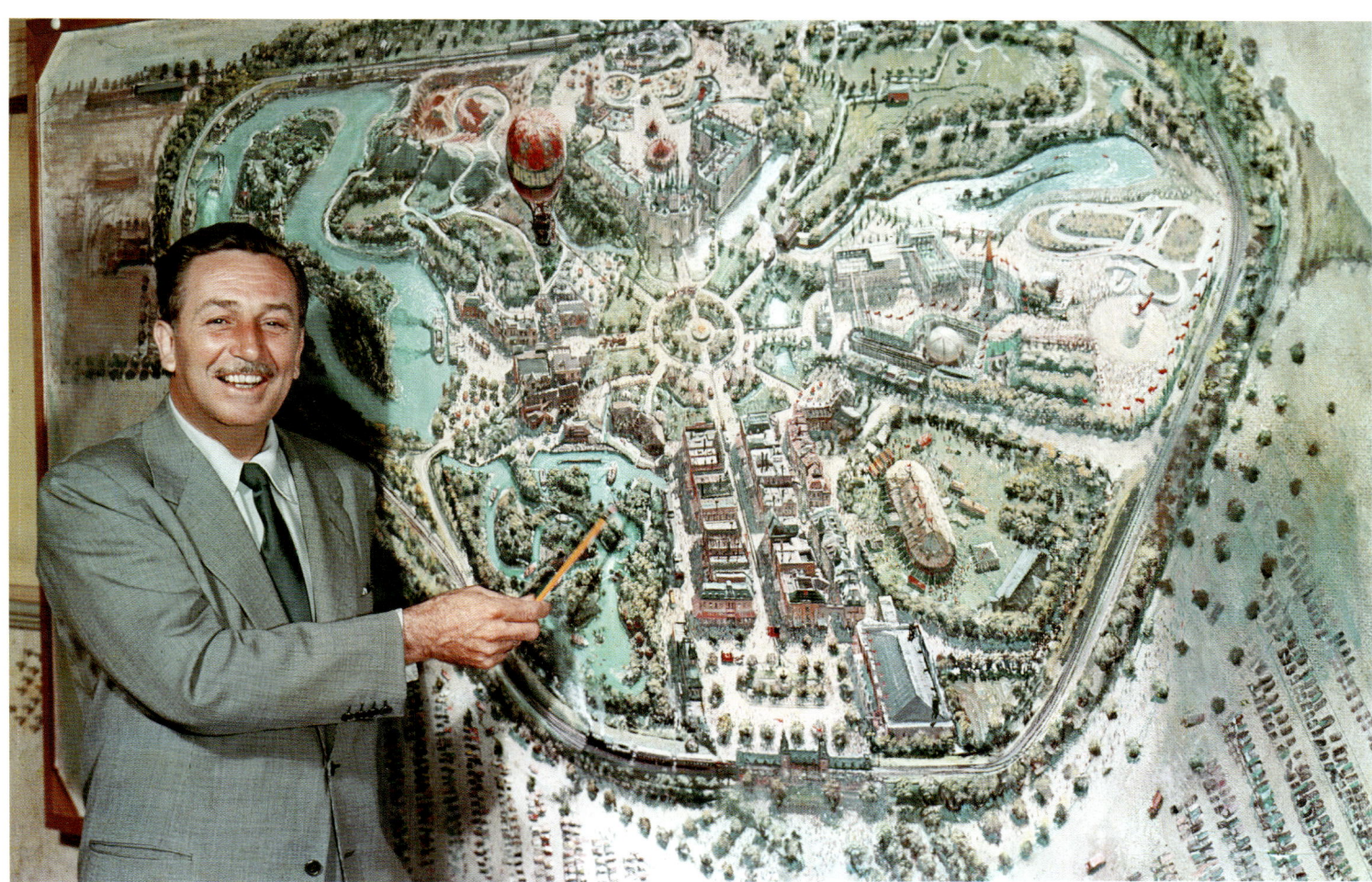

Walt Disney announces his plans for a theme park called Disneyland.

> "*It all started from a daddy with two daughters wondering where he could take them where he could have a little fun with them. . . . That's how Disneyland started.*"
>
> —**Walt Disney**

GOLDEN RINGS & SUNDAY AFTERNOONS

With two young daughters and a major studio to run, Sunday was "Daddy's Day" at the Disney home. "They used to love to go with me," recalled Walt of his weekly ritual, "and [those were] some of the most happiest days of my life." Walt's older daughter, Diane Disney Miller, recalled, "At Griffith Park . . . there was a beautiful carousel. [Sharon and I would] ride the carousel over and over and over. There was some apparatus that had rings sticking out from a slot, and you'd grab a ring as you went by. If you got the gold ring, you got a free ride. One day I kept getting that gold ring and I felt so clever and I got all those free rides. Years later, I asked Dad, 'How'd I keep getting that gold ring?' 'Oh, I gave the kid a few dollars and he kept putting in the gold rings where you could get them.'"

While his daughters enjoyed their rides, Walt sat on a particular bench, envisioning a safe, clean place where families could enjoy entertainment and experiences together. "I guess now," Diane reflected, "he was really analyzing just what we were enjoying and why." This place later became Disneyland. To realize his vision, Walt established a separate company, WED, utilizing Walt's initials, to quietly begin the planning and design work of his theme park.

Hazel George, the studio nurse, was one of the first employees to support Walt's idea of building his "Mickey Mouse Park" across the street from the Disney Studios. Organizing the Disneyland Boosters and Backers Club, George raised contributions from the studio employees for Walt's park project. The overwhelming support that Hazel initiated convinced a skeptical Roy Disney to finally back the idea. "When they started Disneyland," remembered Edna Disney, "I think Walt wanted to start some small park here someplace. And Roy didn't get too interested in it at first. But Walt kept plugging away at it . . . and it got to the point where Roy said, 'Oh, we can't do that—we should do it in a bigger way.' It just grew, and they picked out this place in Anaheim and gosh, before I knew it . . . it was happening."

Recalling the experiences of his youth, much of Disneyland's Main Street was designed with his hometown of Marceline in mind. A fellow Marcelinian, Ink & Paint Supervisor Jean Erwin, reflecting on Walt's inspiration for Disneyland, said, "Yes, definitely, there were so many things that he took right from Marceline. Like the bandstand . . . and the Fourth of July fireworks, and of course, the Santa Fe [railroad]." Walt's vision of his animated classics coming to life served as inspiration, as he noted, "In Fantasyland, those classic stories of childhood have become actual

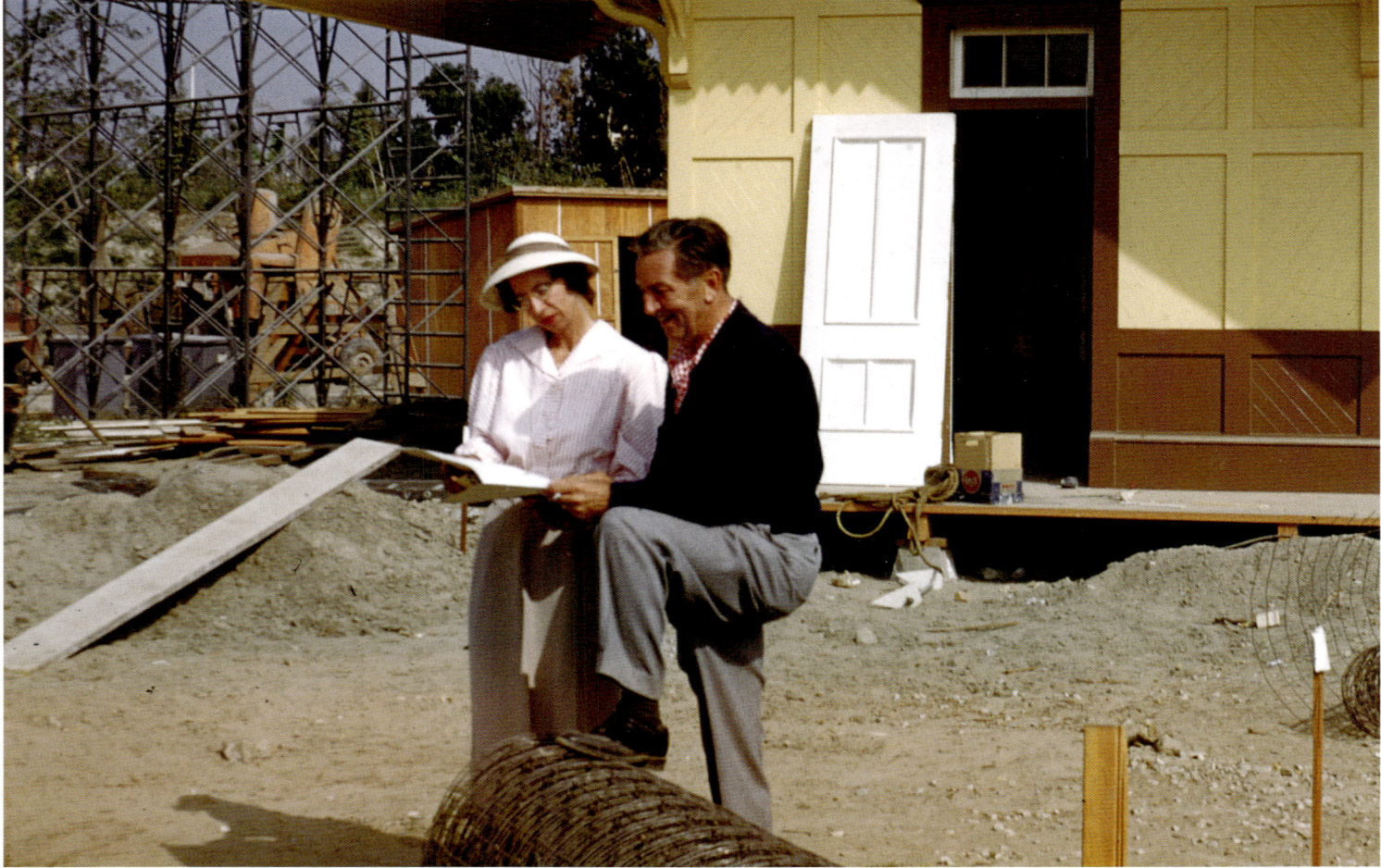

Renowned Landscape Architect Ruth Shellhorn and Walt Disney review her designs on-site for Disneyland.

realities for you to participate in." From the original colors and forms of the animated films, to the craftsmanship and artistry of the WED designers, audiences could now step into their favorite animated classics and discover new worlds in "the happiest kingdom of them all."

Story and the impact of color were key considerations within the design of the new family park. To create a unifying approach to the five differing lands of the Disneyland park, Walt Disney sought out noted landscape architect Ruth Shellhorn. "I wasn't too sure I wanted to do it," Shellhorn stated. Creating atmospheric transitions from Main Street, U.S.A., into the central hub and out to the various lands, Shellhorn's design integrated vegetation and architectural features that produced a cohesive world. Of her experience, Shellhorn recalled she felt no discrimination as a woman. "If you go at it as a person, you're not a woman or a man. It doesn't make a difference. You have a problem to solve. So you cooperate and you work on that problem."

One of the first employees at WED, Harriet Burns pioneered an entirely new form of artistry. "I was a Painter for the Mouseketeers set at the time. Walt loved to do models and told me that when I wasn't shooting, I could work on this new park he was building." Burns and her colleagues, Wathel Rogers and Fred Joerger, worked in the newly defined Model Shop. "We worked on everything from the model up to the attraction at Disneyland. I worked on films as well," Burns recalled. Designing everything from the *Pinocchio*-inspired models in Storybook Land to recreating a scale model of the Matterhorn, Harriet creatively contributed to such legendary Imagineering efforts as Sleeping Beauty Castle, New Orleans Square, the Haunted Mansion, and the first Audio-Animatronics attraction, The Enchanted Tiki Room. The studio bio written for this petite wife and mother noted that she worked "padded shoulder to shoulder with men of the model shop, wielding saws, lathes[,] and sanders. She was still the best-dressed employee in the department." As Burns explained, "It was the 1950s. I wore color-coordinated dresses, high heels[,] and gloves to work. Girls didn't wear slacks back then, although I carried a pair in a little sack, just in case I had to climb into high places."

Calling on artists from within his Animation Department, Walt also found a number of key artists and designers from within the Ink & Paint Department. Leota "Lee" Toombs, a former Disney Inker and Inbetweener, was asked to come back to work in 1962 for Walt's new venture. "Chuck Romero recognized her talents," noted Toombs's daughter and Imagineer Kim Irvine. "He felt she would work perfectly within Walt's recently created new division called WED Enterprises. At that time it was very small. . . . Only four or five women in the Model Shop, they really were the ones that painted, feathered, and detailed not only all of the scale models, but they worked on everything." Animator and Imagineer Bill Justice later wrote, "My years as an Imagineer introduced me to the capable ladies in the Model Shop. They were fine artists and bailed me out on several occasions."

The Ink & Paint Lab mixed paints utilized for planning the earliest models. As Steve McAvoy II recalled of his father's work, "When they started doing work at the studio for some of the attractions, one of them was the horses for the carousel. My father would take paint down from the Lab and work on the color schemes for the horses." Beyond the regular production needs, there were always various activities happening around the studio. "When they were building Disneyland," Joanna Romersa

Left: Legendary Imagineer Harriet Burns.

Right: Leota Toombs prepares characters for the Pirates of the Caribbean attraction at Disneyland.

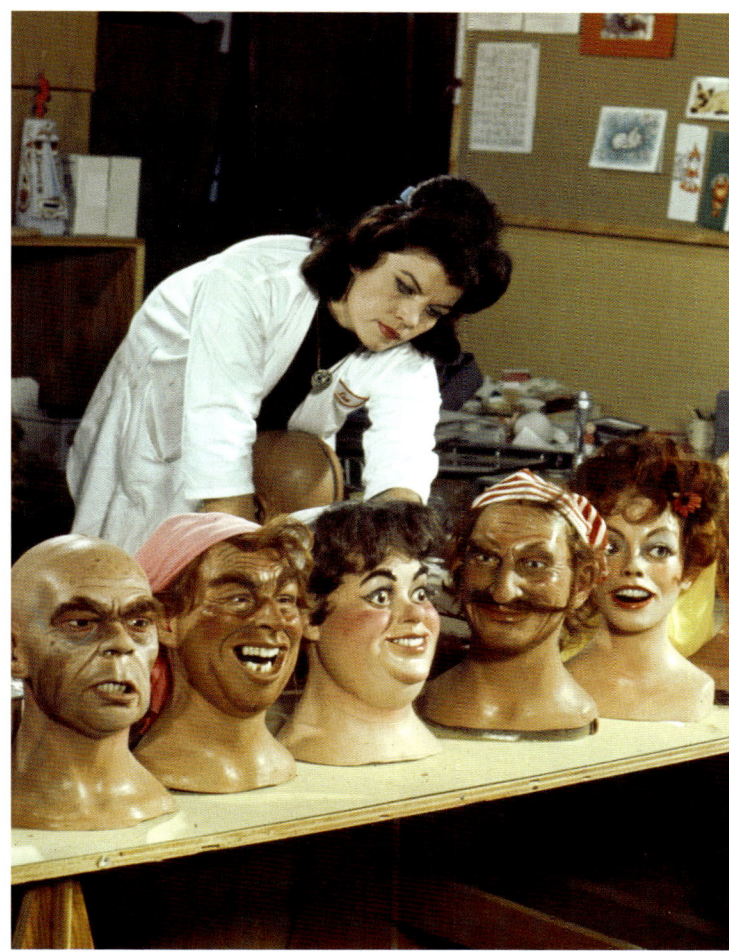

stated, "they had the Mr. Toad ride on the back lot, set up like a cheap carnival, and as Ink & Paint girls, we'd walk through and the things would flop down[,] and who could have imagined a Disneyland from that ride, but they did. I was there on opening day!"

Disneyland was ushered in with a preview day for studio employees, their families, and invited guests, on Sunday, July 17, 1955. "Oh[,] the crunch," recalled Burns. "There was just this mob of people and it felt like 110 degrees. The asphalt was melting, every woman wore heels and my heels would sink into the asphalt. It was a miserable hot day." Despite this heated "soft" opening, Disneyland opened to record crowds and defined an entirely new form of popular entertainment.

As Disneyland flourished over the years, key women continued to contribute to many of the landmark attractions. When development began on the Haunted Mansion, designer Yale Gracey asked Toombs if she would pose for the fortune-teller within the crystal ball. "Mom said it sounded like fun," recalled her daughter, Kim Irvine. "Blaine [Gibson] made a life mask of her face and Yale, Wathel [Rogers] and the rest of the team filmed her, crazy makeup and all. I still remember when she wore it home that night!" Though Toombs' likeness is forever enshrined as Madame Leota, her incantation was dubbed by Disney voice legend Eleanor Audley. "Then they created the 'Little Leota' bride at the end of the ride," Irvine said. "Since that figure is small, they wanted a high voice, so they kept Mom's voice because she sounded like a little girl." In a fitting manner, Irvine was asked to provide the life mask for a new incantation utilized in the *Tim Burton's The Nightmare Before Christmas* overlay for the Haunted Mansion. "They discovered that our life masks are so similar they can just project her face on my head and they match perfectly! Mom would have liked that!"

Joyce Carlson, whose artistic talent quickly established her as a strong Inker, worked on many of the classic features through the mid-1950s. Carlson moved to WED Enterprises in 1962 and began working on attractions for Disneyland and the 1964–65 New York World's Fair. Enjoying the process, Carlson later stated, "I love the magic, the pixie dust that's flying around here. . . . It's very rewarding to see the smiles on the guests' faces and to know that I helped put them there."

"Glendra Von Kessel, who was nicknamed 'The Baroness[,]' was such an interesting and wonderful soul," noted Irvine. Beginning life as Glendra Bernice O'Mara, 'The Baroness' married Johannes Von Kessel, a consulting engineer from Germany. A flamboyant personality and skilled Painter, she was commissioned by Lillian Disney to create the mirrored motif for the opening of the Parfumerie at Disneyland. Her later contributions included the Haunted Mansion and Tropical Serenade in Walt Disney World. As Grace Godino recalled of her fellow Painter from Ink & Paint, "Glendra 'The Baroness' Von Kessel painted some beautiful things on glass for Disneyland."

Launching the Disney Ambassador program, Walt chose a woman to represent his park on a global basis. Miss Disneyland Tencennial, Julie Reihm, was selected as the first such representative of the Disneyland park. "My purpose was to share the joy, hope and happiness of Disneyland to communities around the world," Reihm noted. "Working with Walt was a super learning experience. His creative genius often came with a boy-like excitement of discovery." Reihm's professionalism launched and defined this unique ambassadorship, which still continues today.

Upper left and center: Dorothea Redmond conceptual artwork including: Main Street restaurant concept, and the Plaza Inn (1965).

Upper Right: Dorothea Redmond.

Lower left: Former studio Inker and early Imagineer, Joyce Carlson.

Lower right: Early Imagineer Peggy Van Pelt makes adjustments to a miniature scenic layout.

Ink & Paint | 257

Longtime studio Painter and early WED Artist Glendra Von Kessel working on her glass paintings for the Disneyland Parfumerie.

Walt sought out the design work of the film industry's first female production designer, Dorothea Redmond, to provide interior designs for his New Orleans Square expansion in 1966. Her work on such legendary films as *Gone With the Wind* and longtime collaboration with Alfred Hitchcock garnered her a world-class reputation. Redmond's designs included a private residence for Walt and his family in the space above the Pirates of the Caribbean attraction, which was being developed. Redmond later designed major portions of Walt Disney World's Fantasyland and the mosaic murals throughout. Interior designer Tania Norris worked closely with Redmond to bring her designs to life.

Designer Alice Estes Davis, the wife of Animator Marc Davis, was called to design the costumes for three of the World's Fair attractions. Davis's effective understanding of animation principals led to her continued work for Walt Disney as the groundbreaking designer of costumes for the Audio-Animatronics characters that populated many of the early Disneyland attractions. Davis is most notably celebrated for her work on the international array of dolls in it's a small world, and later, the animatronic figures of the Pirates of the Caribbean. Aptly summing up her pioneering theme-park costuming projects, Davis remarked, "I went from sweet little children to dirty old men!"

Artist Maggie Elliott began in the model shop and quickly rose through the ranks to become the first woman senior vice president of Walt Disney Imagineering. Concept designer Karen Armitage developed the interior art direction for many of the parks, shops, restaurants, and theatrical show pavilions. Artist and creative advisor Peggy Van Pelt developed design and training methodologies that challenged and expanded the Imagineers' creativity, often asking her staff, "Where are you most happy in a project's life cycle?" Her foundational work in creativity led to standard approaches still utilized at the parks worldwide.

SELLING CELS

With the closure of the Cel Washing Department, once cels were finalized through Camera, they were thrown away, as they were no longer needed. But when the gates of Disneyland opened in the summer of 1955, a solution was found. Ken Peterson of the Animation Department undertook the task of marketing the celluloid artistry. Designing lithograph backgrounds and matting for the art, Peterson retrieved the cels from being trashed and selected cels suitable for sale. Official cels were placed within a windowed envelope and sealed with a golden metallic emblem claiming: "This is an original hand-painted celluloid drawing actually used in a Walt Disney Production."

In September 1955, the Art Corner opened in the futuristic world of Tomorrowland. The Parisian big-top canopy setting seemed better suited for Fantasyland, but for many park visitors, it was the mecca for all things animation. Initially, the cels were sold at the Disneyland Emporium for $1.50 to $3—a dramatic difference from the artwork that had once hung in the Metropolitan Museum.

After the Art Corner closed in 1966, cels continued to be sold at the Emporium on Main Street as well as at Tinker Bell Toy Shoppe situated in Fantasyland. Sadly, no instructions were included regarding the care of these celluloid treasures, and over time, many of the vulnerable cels were subjected to exposure or heat and were lost.

WIDE-SCREEN HORIZONS

> *"Of all of our inventions for mass communication, pictures still speak the most universally understood language."*
> — **Walt Disney**

Just as color had been part of cinema since the beginning, so too had wide screen presentation. As early as 1897, documentarian Enoch J. Rector captured a boxing match between "Gentleman Jim" Corbett and Bob Fitzsimmons utilizing Eastman film stock with only five perforations per frame. Running true to the event's real-time length, the Corbett-Fitzsimmons fight originally ran over one hundred minutes, making it the first feature-length film and longest-running film ever released at that point.

Shot at a 1:65 ratio to record the range of the boxing ring within the mise-en-scène, this unique aspect ratio was defined as a security method to prevent piracy, as the film could only be projected via a specifically gauged "Veriscope" system. Though a groundbreaking view of moving pictures, the provocative subject matter stirred controversy within Victorian audiences. Live boxing matches were considered unsuitable events for respectable ladies, yet this wide screen interpretation of two fighting men stripped down to boxing shorts was deemed a perfectly "proper" way for women to view such an event.

By the early 1950s, television had presented a strong rivalry to motion pictures. Now, news and entertainment could be experienced from the comforts of home. With the growing number of households with televisions encroaching on box-office receipts, Hollywood filmmakers stepped up their artistic and technological game by giving audiences a reason to return to movie theaters. Technicolor epics told on horizontal vistas in glamorous settings featuring air conditioning and advanced sound systems rivaled the limitations of television. Walt Disney recognized these artistic possibilities for animation.

Wide-screen Horizons

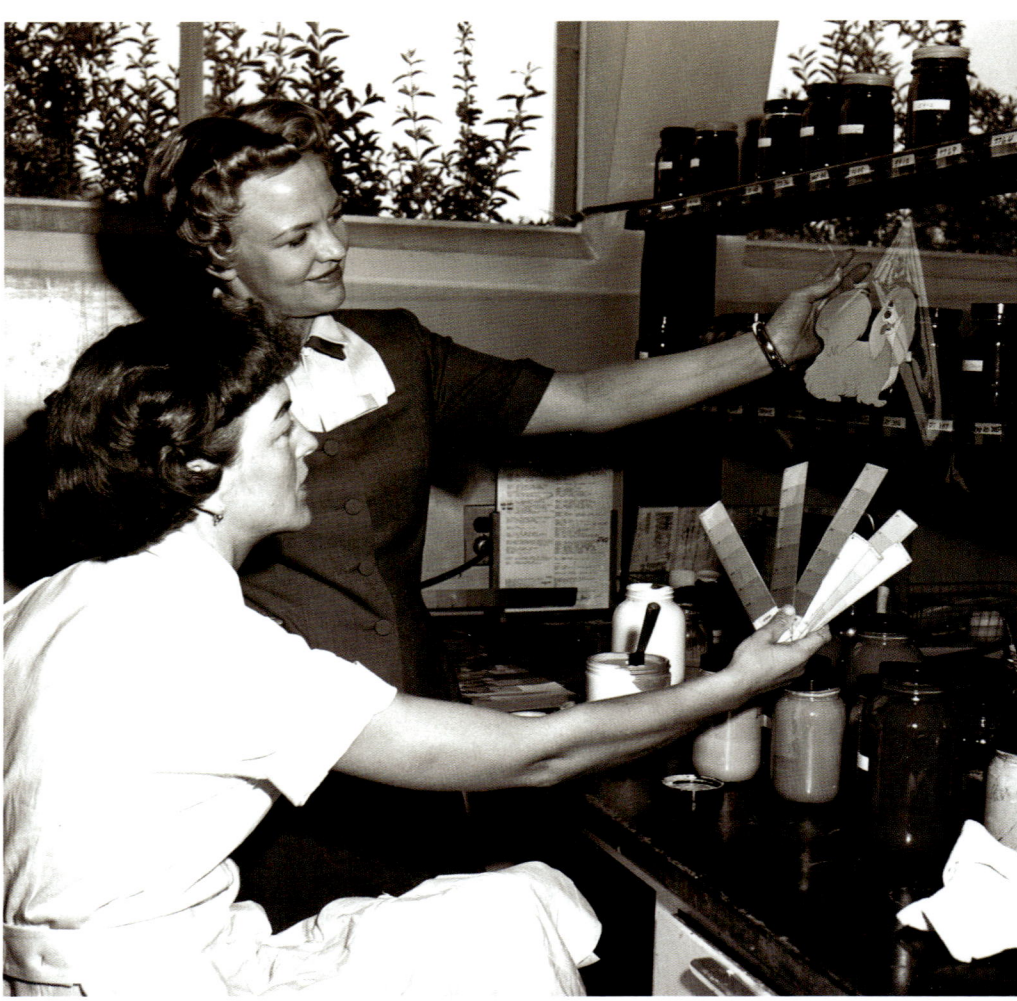

ADVENTURES IN TECHNOLOGY

The first animated cartoon filmed in 3-D, and the first in a proposed series of educational shorts entitled Adventures in Music, Walt's 1953 short *Melody* was designed to explore the principles of music. The recurring character, Professor Owl, holds his lessons from within a stylized classroom, introducing the basic concepts behind sound and melody. This whimsical short film marked Walt Disney's entr'acte into the technological race to lure audiences back into theaters by utilizing three-dimensional technology.

A technique dating back to early photography and stereoscopic cameras, the first stereo cinematic camera was developed in 1915. Preliminary experimentations happened in 1915 and the early 1920s, but 3-D was deemed a novelty. Setting latent for years, 3-D technology enjoyed a comeback in the 1950s as the film industry combatted the impact of television. "*Melody* was done in 3-D," stated Animator Ward Kimball. "We broke it down into five levels of depth. It was startling and it had a very surrealistic look because of this depth."

The added illusion of depth through the use of two synchronized cameras provided a dual perspective that suggested dimension when viewed through special glasses. While attention was given to color choices to avoid eyestrain, it was business as usual for the Ink & Paint teams as the 3-D effect was achieved in postproduction. Following its theatrical run, *Melody* made its way to Disneyland's Fantasyland Theater where entertained audiences viewed it along with the Donald Duck and Chip 'n' Dale short *Working for Peanuts* as part of the *3D Jamboree*. However, a number of problems—particularly with animation, as the two-dimensional characters appeared "cutout" and on different planes—prompted the decline of this technology in the late 1950s.

The second Adventures in Music series short and the first animated work completed in the new format of CinemaScope, *Toot, Whistle, Plunk and Boom* broke artistic and technological ground. This Academy Award–winning short presented a number of challenges for the artists now working in the 4:3 wide-screen format. Larger fields required longer celluloid sheets, creating the need for new production furniture to complete this film. "They were ninety-inch cels," remembered Becky Fallberg of her time working on *Toot, Whistle, Plunk and Boom*. "They had to have the desks [and] make the shelves longer." Carmen Sanderson added, "As we were inking or painting a cel, we would roll it up, and sometimes two girls would hold the cel."

With nearly double the size to the standard field, production costs and time increased. To compensate for these extra concerns, graphically stylized limited animation was utilized. A technique in use since the beginning of animation, this minimal approach limited action to basic movements of various elements. Color also played a vital role, with the short featuring bold palettes set within imaginative settings, all of which defined the mid-century sensibilities of the 1950s.

A PET PROJECT

The first animated feature film made in CinemaScope, *Lady and the Tramp* was based on "Happy Dan, the Whistling Dog," a story by Ward Greene about the romantic adventures between a refined cocker spaniel and a stray mutt. One of Walt's "pet projects," *Lady and the Tramp* had been in development as far back as 1937.

Page 259: Production cel piece of Professor Owl, from the first wide-screen animated short, *Toot, Whistle, Plunk and Boom* (1953).

Left: Production cel pieces of Lady and Tramp.

Right: Popular singer/songwriter Peggy Lee views a painted cel of Peg with an Ink & Paint Colorist.

Ink & Paint | **261**

Left: Production cels of Peg; and (right) Si and Am from *Lady and the Tramp* (1955), characters voiced by the film's songwriter, the legendary Peggy Lee.

Inspired by a puppy concealed in a hatbox that Walt gave to Lillian in 1925 as a peace offering following a forgotten dinner date, this dog's-eye view of the world required realistic and believable animals. The lengthy development aided the final film. "We were free to develop the story as we saw fit, which is not the case when you work on a classic," Walt acknowledged.

"As the characters came to life and the scenes took shape," Disney continued, "we were able to alter, embellish, eliminate, and change to improve the material." Studies of a wide range of breeds were being conducted while the vocal ensemble came together. Veteran radio actress Barbara Luddy voiced Lady. Disney voice-favorite Verna Felton played Aunt Sarah, and her own cocker spaniel, Blondie, was the model for the film's feminine canine lead. It seems even the reference model for the male lead, Tramp, was actually a female dog rescued from the local pound.

One of the film's strengths is the musical appeal, with five original songs written for the film by legendary jazz vocalist and Grammy Award–winning songwriters Peggy Lee and Sonny Burke. "I was hired primarily as a songwriter," Lee said. "We did little demos from which the artists could work. It came as a pleasant surprise when Walt asked me to sing and do the voices as well." Several of these timeless tunes were sung by Lee, who also provided character voices for the female human, Darling; both of Aunt Sarah's antagonistic Siamese cats, Si and Am; and the pound's canine torch singer and show-stealing pup, Peg, for whom she became the namesake.

This character was originally called Mame because she sported bangs similar to Mamie Eisenhower, the First Lady at that time. "Disney was such a thoughtful man," said Lee. "He didn't want in any way to offend the First Lady. He asked me if I would like to have the dog named after me[,] and I said I would love it!" It was a perfect fit, and Lead Animator Eric Larson noted, "Peggy Lee inspired the personality of Peg the most. She had a deep affinity for this character, which she expressed in her singing."

Legendary Music Editor Evelyn Kennedy received her first animation credit with *Lady and the Tramp*. Kennedy began as a stenotypist for the navy, working on the lot at Disney Studios on many of the training films. "I got interested in film cutting, and so many men were being drafted in those days that I was given a chance." With her music background, she made her way to Music Editor. "There's . . . an enormous amount of pressure that often surrounds a Music Editor's job," noted Kennedy. "There always seems to be a deadline! But . . . the virtues far outweigh the drawbacks."

Midway through production on *Lady and the Tramp*, CinemaScope was developed and a number of theaters were now retooled for the wide-screen aspect ratio. With the studio's production system now fitted to accommodate the CinemaScope format, *Lady and the Tramp* was essentially created twice—once in 4:3 and again in the 2.55:1 aspect ratio. The production department requiring the largest adjustments to this new screen size was Layout. With nearly three times the field to fill, artists had to redefine their compositional approach to assure no dull spots or color clashes occurred. Separate X-sheets defined the direction for each format while entirely new backgrounds were created to convey the wide-screen world. Backgrounds were to be created by Mary Blair, but she left the studio to pursue children's book illustrations. Claude Coats, husband to early Inker Evelyn Coats,

262 | Wide-screen Horizons

Left: Inked cel of Briar Rose from Walt Disney's *Sleeping Beauty* (1959).

Right: Inked cel of Flora the good fairy. A paper clip from Walt's story meeting notes illustrates size reference.

worked with Thelma Witmer, Barbara Begg, and other artists to shape the wide-screen backgrounds that defined the world of *Lady and the Tramp*.

While all of these adjustments added to the sense of realism, they also impacted the audience's ability to connect with the characters. The artistry of Ink & Paint stepped to the forefront as color served to distinctively define each character on this wider visual plane. Though seemingly simple when projected on-screen, the complexities and details of setting and mood within *Lady and the Tramp* were established through a blend of color and lighting carefully harmonized with the colors and tones of each character and their actions. Mastering these visual techniques on *Lady* paved the way for Walt's next wide-screen animated adventure.

CHUCK JONES: CEL WASHER

In 1953, a seasoned Animator by the name of Chuck Jones came to Disney Studios and briefly worked with Ward Kimball's unit on *Sleeping Beauty*. Beginning his career in the world of Ink & Paint, Jones wrote: "I found in 1931 an occupation that was ideal: cel(luloid) washing. I was discovered by Ub Iwerks, who had just started his own studio after leaving Walt Disney. I washed cels for *Flip the Frog* with distinction and alacrity and began my long climb to mediocrity by becoming successively a Cel Painter, a Cel Inker, and eventually an Inbetweener, now called an Assistant Animator, from which lofty post I was immediately fired."

"In the same year," Jones continued, "after brief sorties with Charles Mintz and Walt Lantz, neither of whom wanted Cel Washers inbetweening, I returned to the Iwerks studio, where I was unrecognized but my work unfortunately was. And I was fired again, this time by Ub's secretary, Dorothy Webster, a sociology graduate from the University of Oregon (who later, in 1935, became my wife, probably on the wan supposition that a good cel washer might also be a good dishwasher)."

While his tenure at Disney lasted only a handful of months, Chuck Jones always spoke highly of Walt. "Disney's *[sic]* was to animation what [D. W.] Griffith was to live action. Almost all the tools were discovered at Disney's. They were the only ones who had the money, and who could and did take the time to experiment."

BRIAR ROSE

Taking nearly a decade to complete—and turning out to be the most expensive of any animated feature created up to that point—*Sleeping Beauty* was the last of the great fairy tales produced under Walt Disney's watchful eye. Though this legendary interpretation was not embraced at the time, *Sleeping Beauty* has since been recognized as Walt Disney's masterpiece. Inspired by the extraordinary color styling of Mary Blair, Eyvind Earle had completed background work on the short *The Little House*, *Peter Pan*, and *Lady and the Tramp*, proving he was ready to create distinctively stylized work on a feature film. "I knew the secret of doing color schemes in all different variations," Earle stated, "so that the storyboard as a whole made a very colorful exciting picture by itself."

Many challenges and delays arose among the other artists in determining the final look of *Sleeping Beauty*. With his stylistic designs detailed to the state of embroidery, some of the Animators felt their characters would be lost in such ornate backgrounds. Strongly siding with Earle, Walt Disney stepped in to

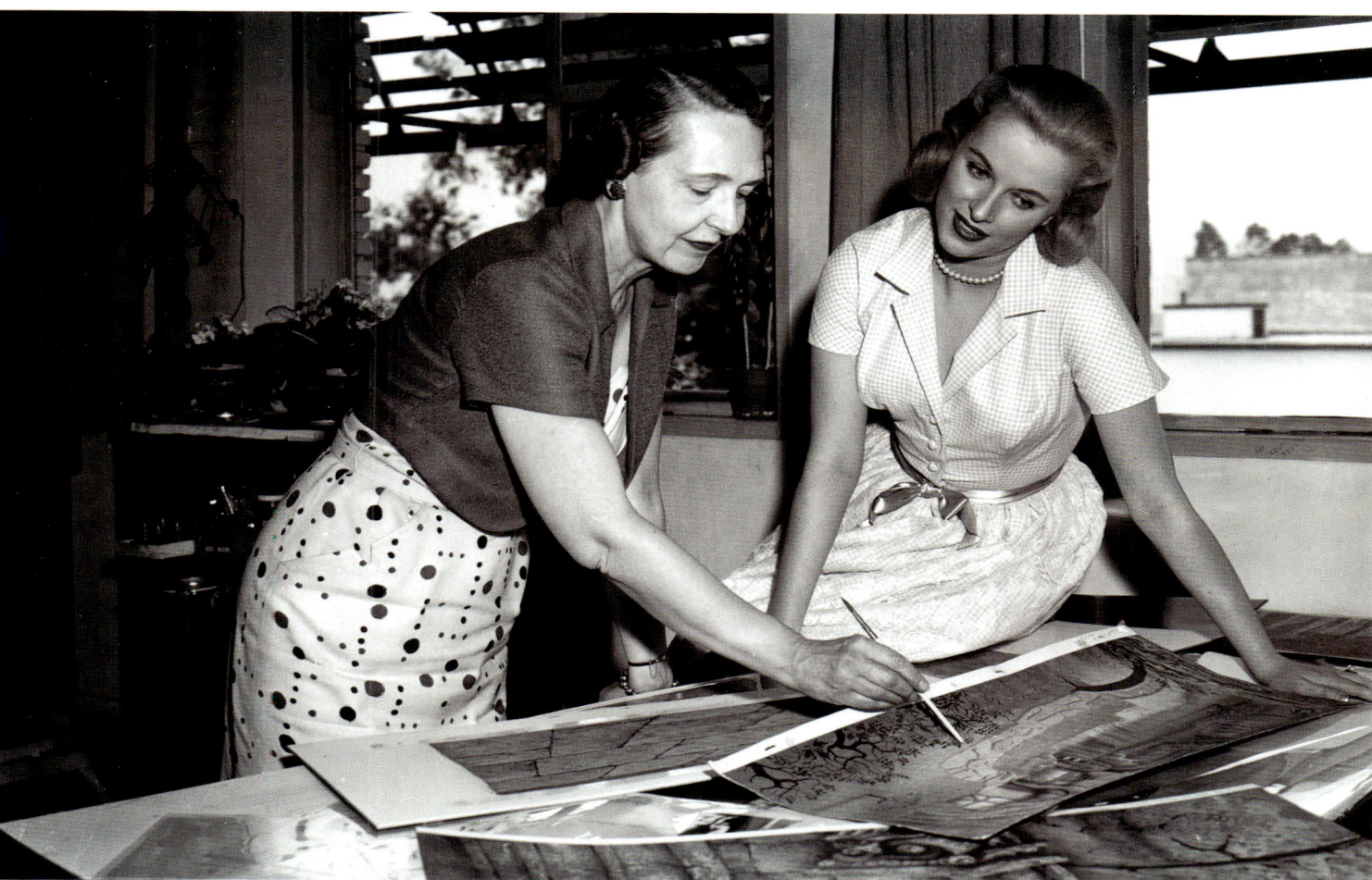

Background artist Thelma Witmer reviews her work with Princess Aurora's voice artist and opera legend Mary Costa.

quell the controversies. His response was simple. "For years and years I have been hiring artists like Mary Blair to design the styling of a feature, and by the time the picture is finished, there is hardly a trace of the original styling left. This time Eyvind Earle is styling *Sleeping Beauty* and that's the way it's going to be!"

With access to the finest collection of art books from the studio librarians and researchers, Earle drew on multiple inspirations to redefine a period style with landscapes, backgrounds, color, and detail akin to Botticelli or Fra Angelico. Incorporating Arabic, Persian, and Asian influences, Earle later equated his experiences on this film to putting himself through art school.

The challenge of defining the look and style of Walt's next leading lady was handed to Marc Davis. Live-action reference work was under way with the talents of Helene Stanley, who provided grace and inspiration for the movement of the young princess. The right flow to Aurora's form was also supported by the design efforts of Davis's former student from Chouinard Art Institute, Alice Estes. In the late 1940s, Alice was not permitted to study animation because she was a girl, but Mrs. Chouinard personally arranged for her to attend Davis's animation classes as his Teacher's Assistant while studying Costume Design.

Several years later, Davis called Alice and asked her to create a full costume with the proper look, cut, and weight to provide the fluid movement of Aurora's dress. "I took Helene Stanley's measurements and fitted her with a rough muslin pattern, then applied that to the final material," stated Alice. "Marc was concerned with the weight so the skirt would cling slightly. Marc was very pleased with it and I didn't have to change anything. What I learned in his animation class helped me more in costume design and understanding the human figure than anything I learned in my costume studies." Later becoming Marc's wife, Alice Davis had an effective understanding of animation principals that led to her continued work for Walt Disney as the groundbreaking designer of costumes for Audio-Animatronics characters at WED.

Searching for three years to find the perfect voice for his fairy-tale princess, Walt nearly shut down production on his epic telling of *Sleeping Beauty* before finding young Mary Costa. "Walt chose me because my voice was a pure voice; singing was my most personal way of expressing myself," recalled Costa. "He told me, 'When you get in front of that microphone, use all the colors of your vocal palette and paint with your voice.' I shall never forget that." Mary's legendary vocal performance brought life to one of the most beloved princesses within Walt Disney animation.

In creating one of the most powerful Disney villains, Marc Davis defined the ultimate "mistress of all evil." Maleficent was designed with a linear Gothic style, and the detailed form and color instantly signal her menacing presence. Jane Fowler, who started as an Inker in 1943, quickly moved into Character Animation during the war. She worked as an Assistant Animator at the studio through the late 1950s, including a tenure assisting on Maleficent, in addition to performing additional live-action reference work for the character. The evil fairy was voiced by Eleanor Audley, who provided additional model reference; Audley's performance also proved inspirational for Marc Davis in shaping this misunderstood villain.

"Working with her was just great. She was a very wonderful, wonderful lady, and a very fine actress," he said. "There's a lot of the facial look that I have put into Maleficent that really is Eleanor Audley. . . . Her look was just right." Regarding her vocal performance, Audley later stated, "I tried to do a lot of

RETTA DAVIDSON

Of his experience as a young Animator starting at the Disney Studios on *Sleeping Beauty*, Floyd Norman recalled, "[It was] an Animation Department filled with women. *Sleeping Beauty* was the feature film currently in production and the animation in this Disney movie required a high level of drawing ability and meticulous attention to detail. It seems women were particularly adept at doing this job.

"One of the many women I met and had the pleasure of working for was Retta Davidson," Norman remembered. "She worked as an Assistant Animator for a dozen or so Animators. Good Assistants were highly sought after, and Retta was always in demand. I never heard Retta express any desire to become an Animator. Being a key Assistant Animator was a tough enough job and Retta seemed to find satisfaction in that assignment."

As a longtime friend of Davidson's, Norman remembers this feminine force of animation. "If I could use one word to describe Retta Davidson, I think it would be 'chipper.' She was an upbeat and very funny lady. Retta always had a joke or funny story to tell, and could keep us kids entertained for hours. Retta was a little older than most of us young upstarts at the studio. She often seemed like our den mother when we worked for her." Tough and demanding when it came to work, according to Norman, "Retta could also be sweet and gentle as a mom when necessary. When she was pregnant, she worked up until the last moment because she knew she only had to go across the street to St. Joseph's Hospital to have her baby."

contrasting to be both sweet and nasty at the same time." The guardians of the young princess came in the form of three spinster fairies whose combined temperaments embody the perfect archetype of a maternal caretaker. Flora, the self-appointed leader, was voiced by Verna Felton; Fauna, the sweet-natured nurse, was voiced by Barbara Jo Allen; and the voice of the ardent little fairy, Merryweather, was provided by Barbara Luddy. Their stylized, distinctively colored triangular forms unify the trio while separating them from the realistic lead characters.

FEMININE PROMINENCE

Throughout the 1950s, women were a strong presence within the Animation Building. "There were a fair number of female Assistant Animators assigned to the film," observed Floyd Norman. "You would find three or four young women doing beautiful cleanup animation under directing Animator Marc Davis [who] was grateful to have women such as Mary Anderson, Fran Marr, and Doris Collins assisting him as he animated Briar Rose.

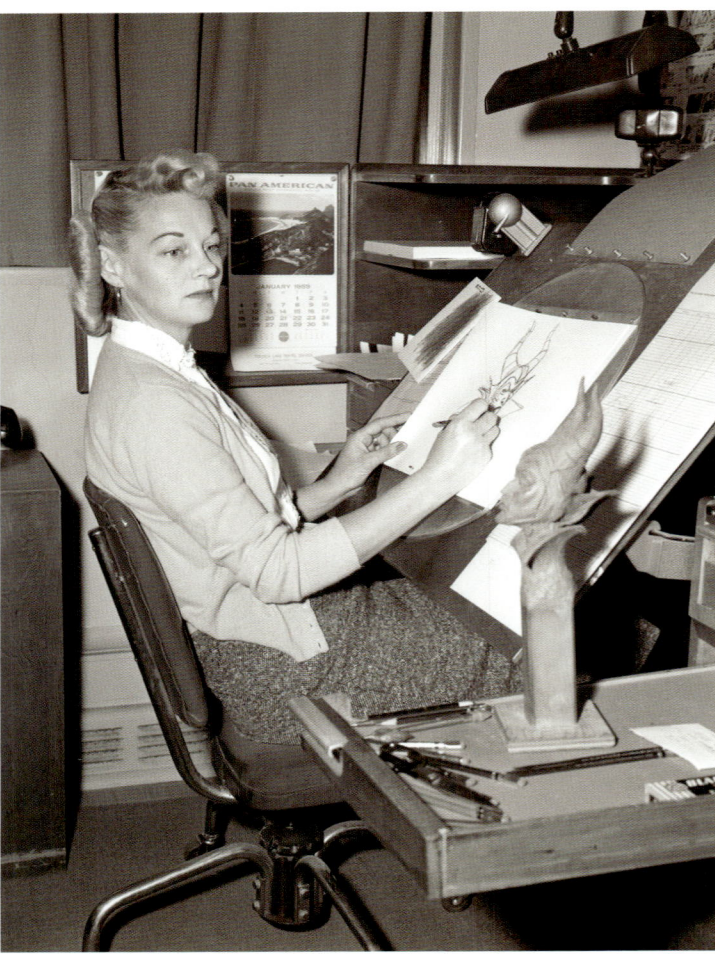

Assistant Animator Jane Fowler works on a scene featuring Maleficent. Jane also provided live-action reference for the film's evil fairy.

There were so many [women] that I can't even recall [all] their names: Lois Blomquist, Elizabeth Case Zwicker, Eva Schneider, Bea Tamargo, Jane Baer, and Sylvia Fry Mattinson to name a few."

Their contributions were vital. "*Sleeping Beauty* had been the most intricate and detailed film we had ever done," noted Norman. "It was an animated motion picture perfectly suited to the unique sensibilities inherent in most women artists with their ability to focus on intricate detail. Male artists," he added, "frustrated with drawings where the weight of an eyelash was considered important, often deferred to the skill and patience of their female colleagues. I hope this is not sounding sexist, but the women were just darn good at doing this job."

Fine artist Zwicker was a single mother who answered an ad in the *Los Angeles Times* and went to work for Walt Disney Studios as an animation artist. "We called her 'Big Liz' because she was an attractive, statuesque blonde," Norman recalled. "I can still see her in her cool cape, sandals, and dark eye makeup. As you can imagine, Zwicker didn't take guff from any man on the Disney staff." Zwicker was part of the emerging counterculture of the 1950s. Clever, worldly, and outspoken, she had classical art training that served her well as a Disney Animator. She made extensive studies of birds and quickly mastered the winged characters of *Sleeping Beauty*. From there she moved on to other characters and thrived within Disney animation.

When production was finally completed on *Sleeping Beauty*, Zwicker was laid off in the "Black Sunday" mass layoff and never pursued animation again. Though not as well known as other female Animators, Zwicker is perhaps more renowned for her post-Disney accomplishments. A painter, illustrator, and muralist, the artist made her way to San Francisco and followed

Left: Legendary actress Eleanor Audley provides the voice as well as additional live-action reference for Maleficent; and (right) production cel of Maleficent from Walt Disney's *Sleeping Beauty* (1959).

her passion for politics and women's rights. She became a poet and began doing poetry readings in the coffeehouses of the late 1950s. Thrown out of the famous City Lights bookstore when the owner didn't want to hear any of her "women's poetry," Zwicker quickly became known as the "Mother of the Beat Generation."

"There were relatively very few women in the animation process industry-wide, except for Ink & Paint," recalled Animator Jane Baer (then Takamoto). "On *Sleeping Beauty*, they needed some fresh talent, so my timing couldn't have been better." As a top student at Art Center College studying commercial illustration, Baer was amply qualified. "There must have been eight or ten women hired along with a bunch of young guys; there was Diane Keaner, Sheila Rae Brown, Sylvia Mattinson, Kimi Tashima, Peggy Higashida. Johnny Bond supervised our early days of training. It was a testing period to see if we were up to snuff.

"Johnny was great! He had nicknames for everybody. He couldn't pronounce Takamoto, so he called me 'Jane Tomato.' He was quite a character," she said. Practice scenes featuring Donald Duck and some of the main characters were issued to test their skills and whether they could accomplish accurate inbetweens. "We were in a training area in the studio and they had lots of other training options," Baer recalled. "We had night classes you could attend if you wanted to—sculpture classes and things like that. There was so much creative energy in that studio[,] and that training led us on to other things later."

Upon passing the preliminary training with Johnny Bond, a candidate was hired. "We were all in the Animation Building," recalled Baer. "They put the girls in one area and the guys elsewhere; it was still a bit of a backward time in the 1950s. It was a wonderful time. We were in D-wing, the same wing of the studio with Marc Davis, Milt Kahl, Frank [Thomas], and Ollie [Johnston].

"When I think of the talent going through there . . ." Baer said before she paused. "But we were so young, we didn't fully appreciate how fortunate we girls were—just to be in the company of such esteemed Animators was pretty incredible. Frank Thomas was another who encouraged me." As a young Assistant Animator on *Sleeping Beauty*, Baer worked with Thomas on the legendary birthday cake scene. "It was to be a disaster with icing going everywhere. Frank let me animate the birthday candles sliding off the cake. I was so proud."

This pride was well deserved as Burny Mattinson noted of his time on *Sleeping Beauty* as an Assistant Animator where he met his wife, Sylvia. "It was hard to break through the ranks," Burny declared. "No one could move—man or woman—because of the 'nine-old-men' [Walt's Lead Animators from the 1930s to the 1970s]. The highest you could get was to be one of their assistants. It was frustrating, but that's how it was."

INKING MASTERY

As an eager young Animator, Floyd Norman made a point of immersing himself into the entire world of Disney animation. "I remember my visits to Walt Disney's Ink & Paint Department back in the day and seeing Steve McAvoy, Katherine Kerwin, and the boss, Grace Bailey, going over color swatches," Norman recalled. "Walt's Ink & Paint Department was often one of the

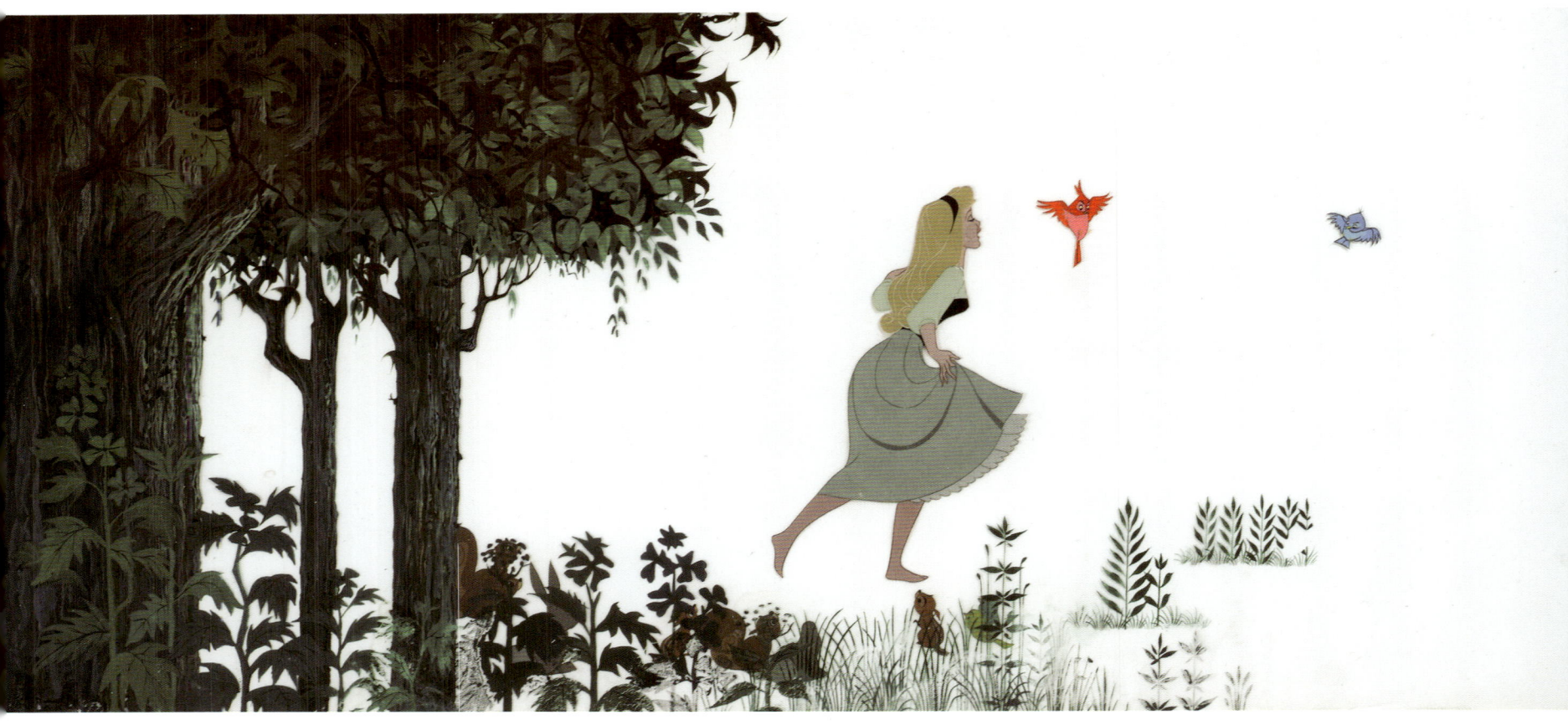

Pages 266/267: Wide-screen production cel pieces from *Sleeping Beauty* (1959).

happiest places I visited on the studio campus. The work accomplished there was legendary." Inker Phyllis Craig agreed: "The hand inking was fantastic. It often took longer to ink a cel than it did to paint it. King Stefan and King Hubert had about sixteen colors of ink, so you'd have sixteen ink jars lined up in front of you and everybody's ink lines had to match. Everybody's ink line had to have the same tapered feeling to it. It was really an art form. I had to agree with Grace Bailey when she said, 'You just don't learn to ink, it's something you have to really work at.'"

Working as an Inker on *Sleeping Beauty*, Joanna Romersa recalled, "When you're first starting to learn how to ink, [it's] frustrating. I don't know how many times I almost quit." Frustrated with inking minimal segments on *Lady and the Tramp*, Romersa wanted to do more but recalled the advice of her Inking Supervisor: "Jeannie Keil said, 'Learn this and you'll have a job for the rest of your life.' Little did I know it was so true." Romersa later became an Assistant Animator, and always credited the importance of her start as an Inker.

Young Annie Guenther arrived in Los Angeles and quickly earned her way into Disney animation. "They started me on a 'Fresh up' Freddie TV commercial, and it took me six months to get on to *Sleeping Beauty* because we had to learn how to ink. Margaret Trindade trained me. She was very patient. She trained all of us. We made wobbly lines[,] so she showed us how to breathe and she showed us how to shuffle our feet when walking through the department, so we never bent our knees." Quickly transitioning into feature work on *Sleeping Beauty*, Guenther inked on several iconic scenes. "I was working on the fairies in the 'Pink, Blue' battle, but you had to watch the script because you don't want to go 'pink' where it's 'blue'—you had to concentrate. Every scene was marked A, B, and C, which meant action. Well, I forgot to see where the action was and I put the action on the wrong side. I got down to the bottom and knew I made a mistake. I thought, 'I'm going to get fired!'

"So the girls told me to go to Betty Anne Guenther and get a 'cel stretcher'!" Annie (Guenther) recounted. "Now, you know if they stretch a cel, they're going to stretch a character and they can't stretch a cel anyhow. Betty Ann looked at me and said, 'Who sent you over here for a cel stretcher?' I said, 'Eve Fletcher.' Well, they set me up for a joke and Betty Anne went along with it, but I was so young I didn't know any better. Betty Anne set me straight and I stayed late re-inking the scene; I was not going to leave that job."

Inker Lee Guttman's work on *Sleeping Beauty* highlights an incredible life. When she was six years old and living in Germany, her father took her to the movies and a Disney animated cartoon appeared before the film. When it was over, she turned to her father and said, "One day I want to work for Walt Disney." As Hitler rose to power, Guttman's family escaped, barely, with Guttman wrapped up in a coat and pretending to sleep so the Gestapo would not question her. At eighteen, living in London when the war broke out, Guttman dropped out of art school to fight Hitler and joined the Royal Air Force, working in cryptology and translations at a top secret level. The war bride of an American dentist, Guttman moved with her husband to the United States and they eventually came to Hollywood where she quickly made her way into animation. Working as an Inker on *Sleeping Beauty* fulfilled the promise she made to herself years earlier.

One of the legendary Inkers of the Walt Disney Studios was Maria Fenyvesi. A young refugee from Budapest, Fenyvesi escaped the Hungarian revolution of 1956. After months of displacement at Camp Kilner in New York, a local church sponsored Fenyvesi and her family to relocate to Los Angeles. Trained as an engineering draftsperson, Fenyvesi first created

Ink & Paint | 267

Right: Production cel pieces from *Sleeping Beauty* (1959) with enlargements. A paper clip from Walt's story meeting notes illustrates size reference.

Pages 268/269: Cel setups from various scenes within Walt Disney's *Sleeping Beauty* (1959).

maps. "You had to learn to do beautiful writing for the maps," she said with a chuckle. "I did not speak any English [at the time] and I had a policy—the first time anyone asked a question, I would say yes. The second time they asked a question, I would say no." When Fenyvesi applied at Disney Studios, the interviewer noticed her handwriting, and fortunately, the first question they asked was, "Are you an artist?" Following her policy, Fenyvesi had the right answer. Placed into training with Inking Supervisor Margaret Trindade, the Hungarian refugee worked to develop her skills and became one of the most masterful Inkers at Disney Studios. "Margaret Trindade was great," Fenyvesi offered. "I was lucky because she helped me, taking her own time and staying late. She gave so much to every single person. She was so dedicated. No one could copy what she did." Stepping into production on *Sleeping Beauty*, Fenyvesi handled the masterful close-up inking of Maleficent, which required a steady, consistent hand.

Production on *Sleeping Beauty* lasted over six years. "There wasn't overtime then," noted Inker Eleanor Dahlen. "In the fifties, we made the film eight hours a day until it was done. That's the way it was. They worked until they finished the film and then they brought it out. Not like later where we worked to meet a deadline."

Yet despite its incredible artistry and considerable cost, *Sleeping Beauty* was a box-office disappointment. Following production, a massive layoff reduced the production staff of nearly six hundred to under one hundred. "I would venture to guess women would have probably played a larger role in Disney animation had it not been for the *Sleeping Beauty* layoffs in late 1959," observed Floyd Norman. Assistant Animators Nancy Stapp, Bea Tamargo, and Liz Case Zwicker were let go, with Tamargo and Zwicker both leaving the business entirely. For Inker Eleanor Dahlen, it was a difficult departure: "I was devastated. It was horrible. My first layoff. With production, it's old hat. Everybody got laid off in the Ink & Paint Department until there was another production. You get used to it or you get in another business."

Technological change was on the horizon, and it would forever change the approach to animation. *Sleeping Beauty* was the last of Disney's hand-inked animated feature films. After the Inking Department had been largely eliminated, "Grace [Bailey] asked if I wanted to transfer over to Painting," Joyce Carlson recalled, "and I told her it just wasn't my cup of tea. But one thing about inking is you [could] always get a job on the outside in the ink-and-paint services, because studios would all call for the former Disney Ink & Paint girls." Bailey personally made phone calls to the other animation studios in town to place her talented Inkers. 'She was wonderful," noted Maria Fenyvesi. "She found me work at Filmation Studios[,] where it was very different. Disney was so quality oriented." Animator Jane Baer recognized the masterful inking of *Sleeping Beauty*: "Oh, they were amazing, those Inkers. The meticulous detail in the eyes of the character and every curl on the princess, it was just something else, never to be repeated with the arrival of Xerox."

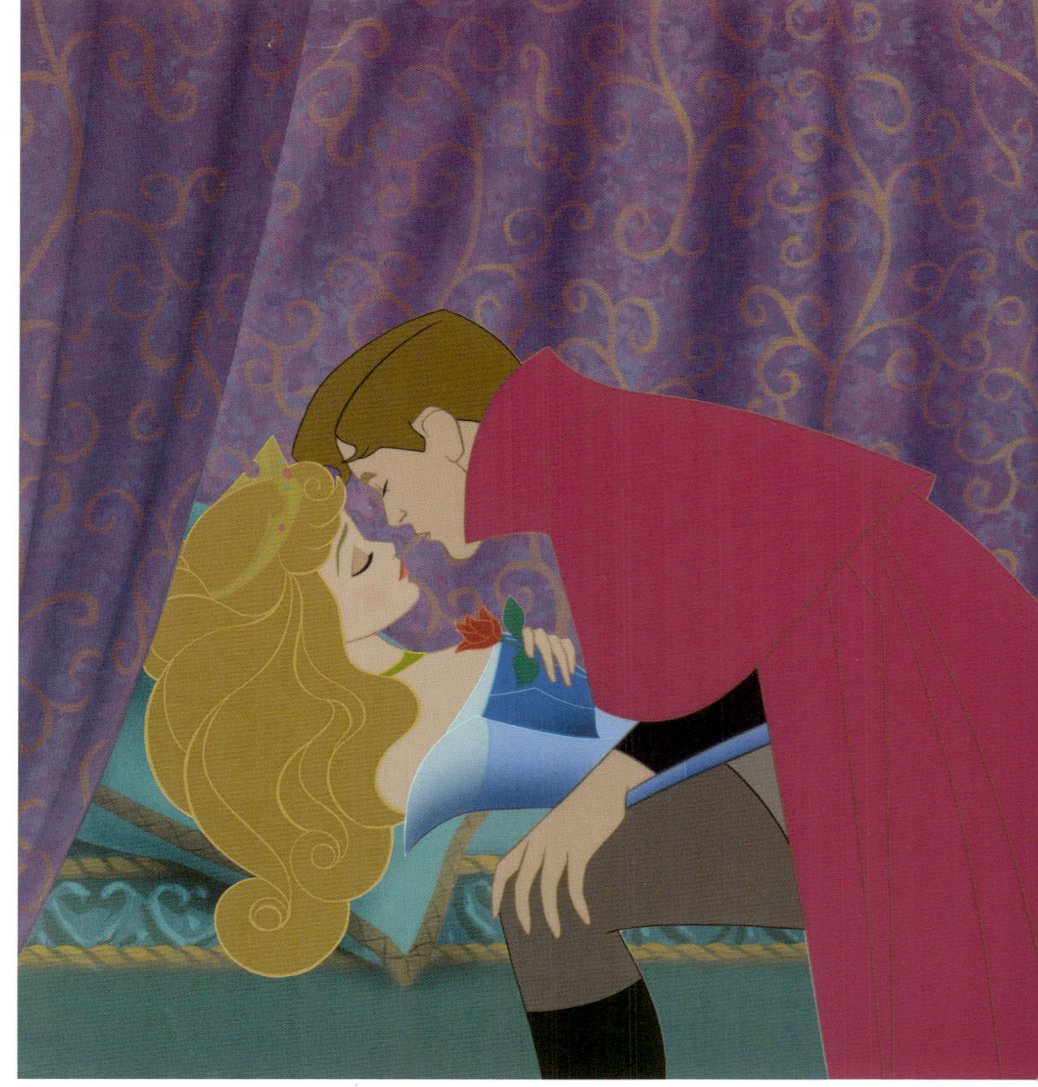

Ink & Paint | 269

XEROGRAPHIC BEGINNINGS

> "I think [Walt] believed in himself and he believed in what he was doing and . . . when he wanted to try something I think he gave it lots of thought."
> — Edna Disney

On October 22, 1938, in a makeshift laboratory in Queens, New York, Chester Carlson, a patent attorney with a passion for chemistry and graphic arts, developed the first graphically reproduced image. Carlson struggled with the lack of carbon copies for various patent specifications he processed. Photographic reproduction was costly, and retyping and proof reading documents for errors was time consuming. His curious mind began developing a cost-effective method of quickly duplicating documents.

Initially working from a makeshift laboratory in his home kitchen, much to his wife's chagrin, Carlson unlocked the basic principles of what he initially called "electrophotography," a dry process of direct duplication. "I knew that I had a very big idea by the tail," Carlson recounted, "but could I tame it?" Hiring Otto Kornei, a young physicist, Carlson set up a small lab in Astoria with his meager savings. In a small rented room above a bar, xerography was invented.

Finding a proper investor took time. "The years went by," Carlson recalled, "and several times I decided to drop the idea completely. But . . . I was thoroughly convinced that the invention was too promising to be dormant."

In 1947, Haloid, a small photo-paper company, made an agreement with Chester Carlson and the development of a xerographic machine was under way. Carlson's description of "electrophotography" was deemed too cumbersome, and a classical language professor from Ohio State was approached to redefine the moniker. Combining the Greek words for "dry" and "writing," the term "xerography" was coined. The first viable copier, "Model A" Xerox emerged in 1949. But it would be nearly ten years before the tiny company began to see commercial success with their dry duplication process.

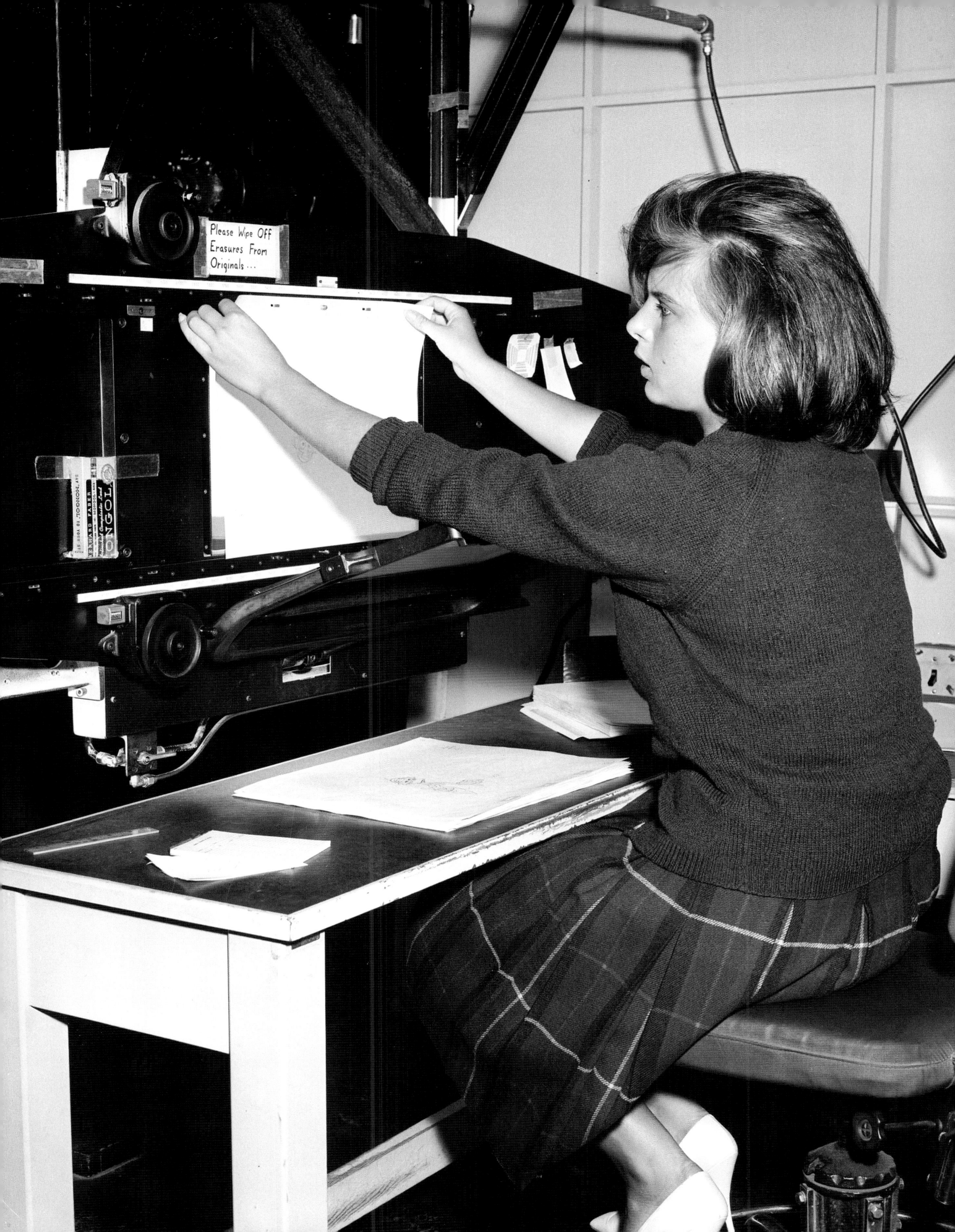

REINVENTING THE INKING PROCESS

"It really began as a chance conversation between Roy Disney and my dad [Ub]," recalled Don Iwerks, who worked with his father on the adaptation of Xerox technology for animation in the later 1950s. "They happened to be talking one day and Roy was commenting to my dad that he was gonna have to tell Walt that they were probably going to have to get out of doing animation work." The studio had already cut back on producing shorts as they were not returning profits, and the live-action films the studio was producing were turning a higher profit with a faster return on their production investment. The feature animated films required years to develop and hundreds of artists to produce, and *Sleeping Beauty* was already shaping into the most expensive animated production at that time. "Of course, my dad was not pleased to hear [this news] but understood what Roy was saying," noted Don.

"Some live-action ads were done [at Disney] with a Xerox line," noted Walt's jack-of-all-trades artist Ken Anderson. Phyllis Hurrell's advertising teams had first utilized this new process to achieve a proper visual framing effect. "They just had a great heavy line around them, a Xerox line," recalled Anderson. "It wasn't much, just a clue you could use Xerox. We had to have it adapted to a cel [for animation], so Ub came into it."

Contemplating where money could be saved in the animation process, Don recalled his father's approach: "Around that time, Xerox brought onto the market a desktop copier. He got to thinking maybe that might work for the inking process." With his mechanical genius, Don's father "was given the freedom to investigate anything he wanted if it might help the company." Purchasing a standard Xerox copier, Ub "made a few paper drawings and transferred them onto cels, and he could see that maybe this had some possibilities. He went down to the Camera Department and borrowed a scene, which was still all on paper, and brought them back to his lab and then copied them all [onto cels]. And then took the cels over to Ink & Paint and asked the girls if they would paint them for him, which they did. He then went back to Camera to have them photographed. He was very pleased with the result. After dailies one afternoon, he said to Walt that he had a test he'd like to show him. He ran it and explained to Walt how this was achieved."

Roy and Walt saw the inked writing-on-the-wall regarding costs. A number of earlier methods had been explored before the war to directly transfer the Animators' drawings to the screen, yet continuous dark lines failed to meet Disney's artistic standards. Ken Anderson explained, "It was known that when the line around the human's face was drawn, it would be drawn in the color of the paint that that face was going to be painted. And the only place there were any ink lines were in the black areas like the eyelashes or around the eyes. The whole quest was to try to prove that this was really a photograph. We don't want to disturb people by making them think that anybody sat there and drew it."

Hanna-Barbera had earlier announced the application of Xerox as a cost-saving approach to its television animation, and this could perhaps provide a solution to the Disney Studios' rising feature animation costs. "Roy and Walt had not made any decisions, but it appeared that this would have possibilities," noted Don. While Walt may have needed some convincing, others were sold. "The Animators, [well,] there were a number of them that really liked the fact that it was their drawing," Don added. "By making a direct copy of the drawing, there was nobody inking it. You got what the artist drew, exactly. It was after Walt agreed that maybe this was the answer to the problem [that] my dad then went to Xerox."

Traveling back to Xerox's East Coast headquarters, Ub met with their engineers and discussed his approach. "Each of these machines were [designed as] stand-alone and on wheels so you could move them around if you wanted to," Don recalled. "He was looking at the process of the Xerox machine, how each function works, from the scanning part of it to getting the powder onto the plate to get the transfer, to getting the powder fixed to the paper so you can't smear it anymore. They literally laid that all out and figured out how Disney could do those processes separately from having it inside one machine."

Designs were created, laying out the machinery rooms in one of the corridors to achieve optimum flow and to define the operator roles necessary to create an entirely new approach to this cutting-edge production method. Bill Brazner, head of the studio Machine Shop, came on board. Don recalled his contributions: "(As) Designer and Chief Engineer who did all the work with my Dad on the design of all of the pieces . . . (Bill) spent several months making drawings, and we spent at least six months before we were operational." Brazner remained as Xerox Foreman until his retirement in 1991.

Page 271: Christal Klinge applies animation artwork to registration pins on the outside platen of the studio's Xerox camera.

This page: Ub Iwerks demonstrates his Xerox camera adaptation for Walt Disney animation.

Patti Pounds prepares to fuse the charged platen artwork to celluloid in the Xerox process room.

DISAPPEARING INK

Shepherding the transitions into this new technology was a formidable task for Grace Bailey's teams: "Oh yes, we suffered through all the birth pains of that," she recalled. "It was a difficult changeover because no one had ever done this before[,] actually, with the kind of cameras we had." Phyllis Craig's initial reaction to this technological transition was common. "When it first came in . . . I didn't think it would work. The Inkers, of course, were very upset about it. So were the Painters[,] because they didn't like painting to the Xerox line. They were used to painting to a really clear and concise inked line." Don Iwerks noted, "There was a concern that there was going to be a great layoff, that they wouldn't need the Inkers anymore, [but] the plan was to train the Inkers to operate the equipment."

Eleanor Dahlen was the first Inker asked to make the transition into the new Xerox Department. "I was there for one day and I was so upset about them not wanting me to ink." Having worked so hard to refine her skills as one of the top Inkers, Dahlen was quickly dismayed by not being able to utilize her artistic skills. She turned the position down. Craig voiced her staff's widespread frustrations: "Even though we did production line work in animation, they felt that working on the Xerox was factory work."

Once training was started, Walt decided to test the applicable usage of this technology with the current film in production. "It was right near the end of *Sleeping Beauty* where the scenes were shot," Iwerks remembered. Dahlen recalled the scene. "It was the shot of the whole procession of the people across the bridge [walking] up into the castle that was xeroxed. It was a long shot, so it wasn't close enough so you could see the difference."

Iwerks concurred. "A large crowd scene, which had a lot of heads and people—that's an ideal one to work on because of the time it takes to draw every one of these complex cels." The scene melded perfectly into the final film, and the fate of the Inking Department was sealed; only a handful of Inkers would be kept on, and the rest would be woven into Xerox teams or other areas of artistry and production. "None of them were fired," noted Ken Anderson. "None."

For the once higher-ranking Inkers of the studio, their role and artistry were now obsolete. Carmen Sanderson recalled the frustration: "No one was happy. No one knew where they were going to go or what they were going to do and that was it." Phyllis Craig noted the transitions: "At first it was scary because of the layoff. Disney then offered to put the Inkers on the Xerox crew or the few that had painted could, horrors forbid, go back to Painting. A few of them went to WED." Others, including Eleanor Dahlen, later moved on to Animation Checking and other departments.

PART OF THE PROCESS

To gain the skill sets required for the new technology, the Xerox team became a muddled combination of artists and technicians. "They hired people from Lockheed, who were used to doing factory work," recalled Phyllis Craig. "Finally, in order to make job stability, they had to say to some of the Painters, 'Look, we're not giving you a choice. You have to go into Xerox.' So they would have them in Xerox for a while and then put them back in Painting. Then another group would go."

XEROX CAMERA

Spanning the size of three small rooms, it took five people to run artwork through the entire process, with two operators on the camera in its prime.

The camera can enlarge, shrink, rotate, and relocate images, though everything done with this camera is a 1:1 reproduction—essentially, a direct duplicate of what is placed in front of it.

The concept behind Xerox photocopiers involves the charging of a plate, drum, or belt, which is covered with a toner or photoreceptive material. This toner loses its charge once it is exposed to light. As the original work is brightly illuminated and reflected onto this charged surface, the exposed areas lose their electronic charge. The powdered carbon toner clings to the unexposed or dark areas. The toner is vapor fused which solidifies the toner onto the blank paper or surface, and a copy or cel is complete.

ROOM ONE

Outside Platen Area: The Animator's artwork is placed on the outside platen. The work is referenced via the standardized Disney registration pegs. Sharon Price (left) confers with Betty Anne Guenther (right).

ROOM TWO

Darkroom: Everything takes place in the dark, just as in a regular photographic darkroom.
Xerographic plates are two-sided, made of aluminum and selenium. Printing takes place on the selenium side.

Each plate is run through the charger twice and is given a positive electrical charge. The charged plates are placed on the inside platen of the camera, which also has the registration pegs, as DeDe Faber operates. The camera's lens is located within the wall that separates the first two rooms. The platen is closed and the exposure is set (for around nine seconds on average). The exposure can be adjusted: a higher exposure gives a lighter, thinner line, and a lower exposure gives a fatter, thicker line. When the Animators and Inbetweeners work together, occasionally their pencil weight is different, causing differences in their lines. If a line is too light or too dark against the others, the Xerox camera operator can compensate with exposures to even out the work to a uniform style.

The exposed plate then goes into the cascader bin, which is filled with developer—a combination of tiny glass beads and toner. For every six camera exposures, a scoop of toner is added to the cascader bin. The cascader bin rocks back and forth to evenly attach the toner to the positively charged image on the plate. Where the electrical current picks up the line form, the toner sticks to the plate.

The plates are sent out via the conveyer belt to the final room, as Bill Brazner demonstrates. Conveyer belts were built to ease the flow into an assembly-line approach for the employees operating the camera.

ROOM THREE

With regular cotton, excess toner is wiped away from the image to remove excess lines and to give the image a cleaner quality, as Claire Ryker demonstrates.

If Animators don't want something in a scene (specific lines, images, etc.), they take a blue pencil and mark through it with an X (blue pencil is not picked up in this form of Xerox technology). If an Animator doesn't like a foot drawn on a particular character, for example, it can be blue-penciled out and the rest of the scene can be processed. On a separate set of animation papers, the Animator draws the preferred or corrected foot, which can then be "fused" back into the scene via the Xerox process.

The plate's images are then transferred onto clear acetate cels on the transfer table. Here, the toner is still in powder form and the lines can easily be wiped off.

The acetate cel is placed into the fuser, where it is pressured sealed with a trichloroethylene vapor fuse, as Lisa Takako Poitevint demonstrates. Once this process is completed, the lines on the cel are fixed to the top of the cel and can be touched without smudging or smearing.

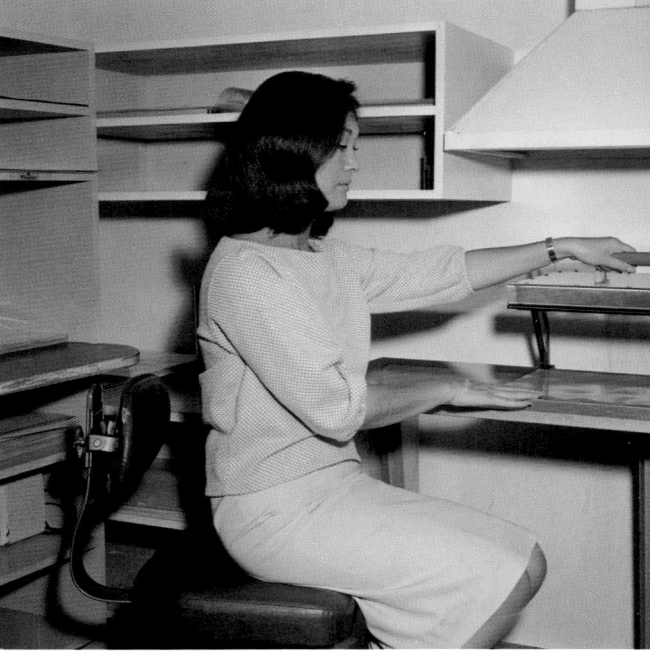

The plates are brushed off in the vacuum, which has been lovingly named the Monster, and the plates are sent back into the darkroom via the second return conveyer belt. A microphone is placed between each room for communication between operators.

All drawings are numbered, and the cels are numbered accordingly as well. Once completed, the finished cel is transported to the Painting Department between cardboard panels to protect the delicate cels.

Ink & Paint | 275

WALT DISNEY PRODUCTIONS
XEROX® PRODUCTION PATH
1961-1990

- STORY & PRE-PRODUCTION
- RUFF PENCIL TEST
 SCENE PLANNING
 TEST CAMERA
- CLEANUP PENCIL TEST
 SCENE PLANNING
 TEST CAMERA
- EFX WEDGE TESTING
- ANIMATION CHECK
- COLOR MODELS
- PAINT LAB
- XEROX MARKUP
- XEROX
- XEROX CHECK
- PAINT MARKUP
- PAINTING
- PAINT CHECK
- FINAL CHECK
- CEL SERVICE
- PRODUCTION CAMERA

Every step of the process was designed to facilitate the needs of each department along the pipeline. Defining the production staff of the Xerox process took time as skilled Painters and Inkers now had to work side by side with nonartists in a crew context. Carmen Sanderson discussed the various roles. "I used to do the Markup for the cameras and I was the Assistant [Camera] in Xerox. There were two people inside the camera, and then we had a crew—a girl that sat on the platen and then a girl where the plate came out. She would clean it and put it on the transfer table and a girl transfers the image to the cel and then one would fuse [the toner to] the cel and then you rotated."

The Xerox method required additional changes to the production process. In the previous method, inking and painting instructions would often be written on the cleanup drawings. "Inkers knew not to transfer these instructions onto the cel," Sanderson stated. But now, with Xerox directly transferring the artist's drawings to the cel, the process had to change. "Scenes would come from Animation Check," Sanderson recalled, "and you'd put a number on the drawing and then mark the corresponding cel. I would mark them starting with the highest number, or the end of the set, so when it was completed, it would stack up in numeric sequence for Xerox Check." The Animators used blue pencils to make notes on their drawing, because the tones would not show up on the Xerox process. "Later on we transferred to stickers," Sanderson added.

Despite the transitional challenges, the Xerox method added new efficiencies to the overall process. "Before, when scenes arrived in Inking," Sanderson noticed, "they were broken down in sets and each girl had to match their set with who their scene followed to make sure the inking and line work matched across the entire scene. In Xerox, now the entire scene was brought over from Animation Check to Xerox Markup and could be processed through the Xerox process all together at the same time."

The same Cameraman and one key Assistant (Camera) stayed with the Xerox camera, while the crew would rotate, every week moving to another camera. "Once the process had been proven," noted Don Iwerks, "it was just straightforward with making it operate. My dad's directions on what he wanted and how he'd want it done . . . it worked right away."

TIGHT TEAMWORK

Working in such close quarters presented problems. "We had such a mixture of people and there was constant bickering at first," laughed Carmen Sanderson. "You had to 'feel' them out personality-wise, because you're working as a team. If there were people that didn't get along, then I would have to make sure that those two would never work together, because there were clashes. It would happen after [Lockheed] came in. I'm not saying Disney people were perfect, it was just a different tone [and] it took a while to get things organized."

DeDe Faber was one of the leading Xerox Camera Operators. Bertha "Bert" Wilson was hired in 1958, launching a nearly thirty-five-year career in Xerox processing. Once the crews were established and running, one Xerox camera and crew was capable of printing far more cels than individual Inkers could produce. Legendary Animation Inker Martha Sigall recalled the impact of

Becky Fallberg and Inker Edna Smith enter the studio Theater.

this invention and new process: "I was told that this machine was able to turn out one thousand cels a day instead of the [approximately] fifty done by an Inker."

For all the efficiencies Xerox offered, it was limited to one color. The few remaining Inkers were busy inking detailed areas such as lips or eyes, colored lines as needed, and any separation lines that might be required. The careful removal of the excess toner required skill, with "the goal being to wipe as close to the image without touching the line with the cotton wipe," noted Gretchen Albrecht. "This had to be done quickly and accurately[,] as that position set the pace for the back room." The other roles involved in the Xerox process didn't require a background in art or artistic skills. "After a couple of years," noted Phyllis Craig, "everyone got used to it and it just became another part of the process."

INTO PRODUCTION

Throughout most of 1958, three Xerox machines were installed and ultimately available for production within the Inking & Painting Building. An entire corridor of camera and process rooms was reconstructed, and the production crews fell under the domain of Grace Bailey. in February 1959, Dick Pfahler updated Bill Anderson on the status of the Xerox expansion in a studio memo: "Machine No. 1 is a completely versatile unit, capable of making trucks, enlargements and reductions. This is the most used one of the three installations and is currently being operated 16 hours a day. No. 2 machine is a one to one operation, which is capable only of making direct transfers. This machine is now operating 8 hours per day. No. 3 Xerox machine is designed to

Katherine Kerwin and Mimi Thornton stroll the studio lot (1954).

make Xerox transfers from motion picture film exposed in test camera or motion picture film exposed elsewhere under special conditions. No. 3 Xerox is still in a development stage with the possibility of being a key part in a technique whereby live persons or other solid objects can be reproduced as line drawings, painted, and photographed to appear to be cartoon. Xerox No. 3 is used sporadically as specific scenes or tests suited to the equipment are available."

Don Iwerks explained the No. 3 camera's unique setup: "The idea was that live images captured on film could be transferred to the Xerox plates and then onto cels." Unfortunately, this camera was not utilized much, since the lines tended to project wider onto the platens than did direct copies of drawings with the other cameras.

The versatility and speed this technology was capable of marked a new advent in the animation process. With production demands growing, the Ink & Paint staff warmed to the possibilities, and a fourth camera was soon in the works. Under Bailey's direction, the light well of the north Xerox corridor was enclosed and her Xerox teams expanded with a new camera installed in time to meet the ramped-up production on the studio's next feature-length animated films.

1950s STUDIO LIFE

The start of each day at the studio was regimented by the studio time clock. Inker Joanna Romersa recalled, "We'd have to clock in and man, we'd run like crazy 'cause if you were late even by five minutes, they'd dock you." For some, maintaining this timeliness took a bit more effort. From her rented room and bath in Hollywood, dedicated Inker Annie Guenther frequently arrived early to work at the Burbank studio. "Walt Disney caught me at the lot one morning," laughed Guenther. "He said[,] 'I see you here when the sun is coming up. What time do you get to work?' I said eight-thirty, and he said, 'Well[,] it's only six thirty.' I said, 'Mr. Disney, I don't have a car. I have to hitchhike!' I wasn't afraid to do that then. Most of the people knew me, so they'd pick me up."

The 1950s marked one of the most productive times for Walt Disney Studios. Television, live-action films, and the development of Disneyland placed even higher demands on Walt's time. "Walt was a busy man, but he would come by once in a while," recalled Inker Eleanor Dahlen. "He was a sweetheart!" Joyce Carlson agreed. "Oh, Walt was very warm and friendly. He used to come over and it was such a pleasure to see him in the halls." Particularly proud of his state-of-the-art Paint Lab, Walt continued to tour and accompany VIPs through the department.

The industrial refrigerator in the Paint Lab stored an impressive array of specialized pigments, and during one particular tour, while standing before the impressively large refrigerator, Walt expounded with an extensive explanation of its vital function and purpose. With a grand flourish, "he opened the door to find . . . sandwiches, fruit, cartons of milk, leftover lunches, and random doggie bags," laughed Carmen Sanderson. "Anything but pigments!" Apparently Walt had not been in the Paint Lab in a while, and the temperature-sensitive pigments were by then stored elsewhere.

INK & PAINT PETS

A "cute blond" in the Ink & Paint Department was known for having an unusual pet. "Flo Brandt came to Long Beach, California, from Minnesota to find work in 1941 within [animation] industries during [World War II]," recalled her best friend, Ellenetta Longworth, sister to Alice Estes Davis. "Flo was a sweet, talented, pretty girl who had a great zest for life and a great passion for art." After driving a truck in the Long Beach Naval Shipyard during the war, Brandt married and moved to Los Angeles, where she found work at the Walt Disney Studios in the Ink & Paint Department, fulfilling her artistic passion.

Since she had a natural connection with animals, someone gave Brandt a baby skunk whose name was Petunia. Marie Justice later recalled the time "when Flo brought her skunk to work, she was sneaking him around the corridors . . . so Grace [Bailey] wouldn't see her." Bill Justice added, "The strange pet aroused the curiosity of her coworkers, so one day she fixed a shoe box with several airholes and brought the skunk to work. The box was placed discreetly under her desk so 'The Madam' [her Supervisor] wouldn't know.

"At teatime," Bill noted, "Flo took her pet into the grass outside to play. The entire department thought they had a secret. But about four o'clock the phone rang. It was Walt. 'Would Flo bring her skunk to his office so he could see it?'" A few minutes later, the phone rang again. Walt's request to view Flo's unique pet was quickly rescinded once he learned the animal had not had its odiferous proclivities altered.

Unusual pets were part of the fun at the studio. Many of the staff kept horses at the nearby Equestrian Center and often spent their lunch hours riding the nearby trails. The Ink & Paint

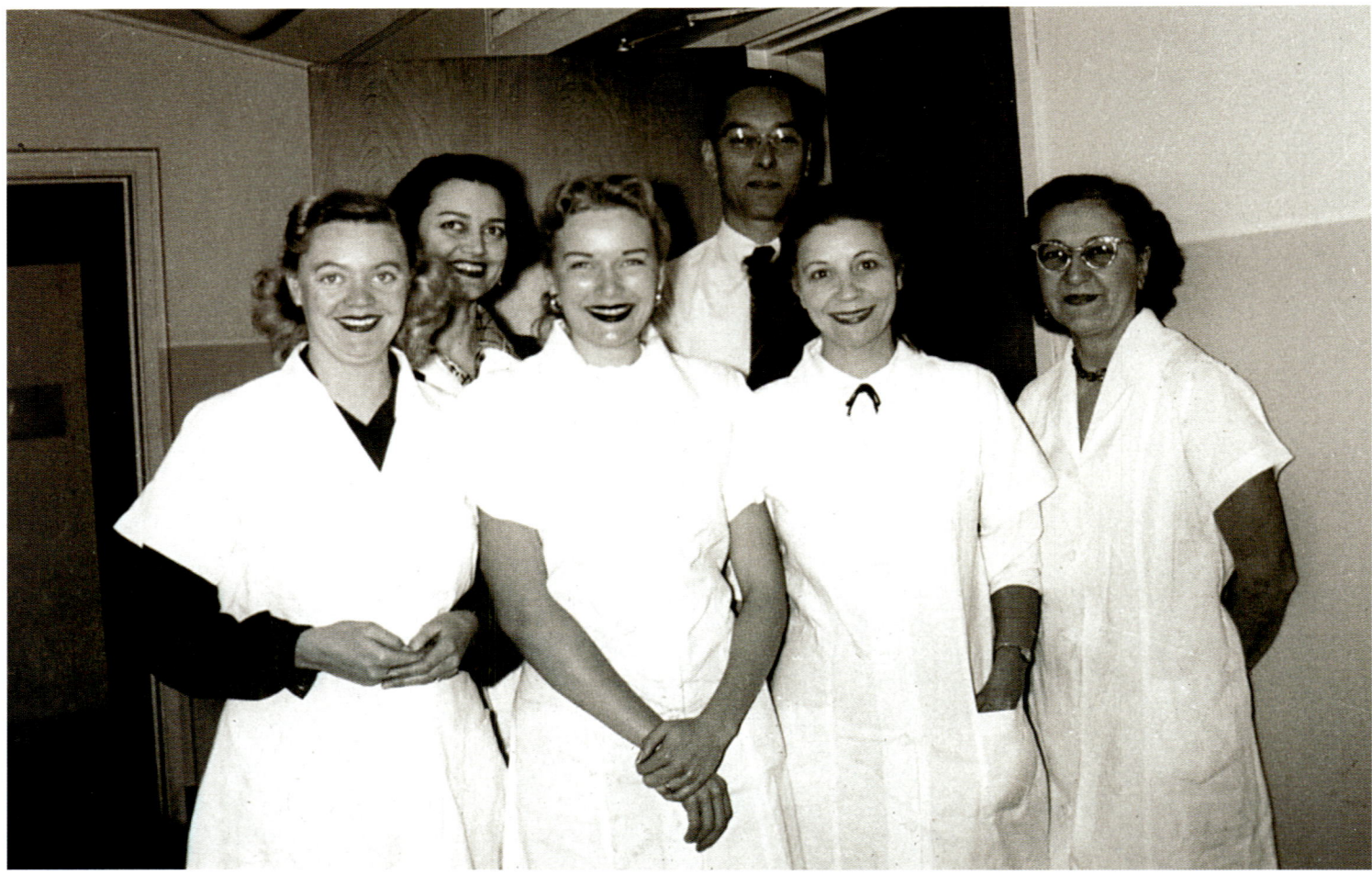

Members of the Paint Lab, left to right (unidentified), Helen Green (back), Ginni Mack, Emelio Bianchi (back), Karen Johnson, (unidentified).

Department kept a careful eye on the studio cats, and a small community of squirrels established permanent residency on the lot thanks to staff who kept bags of peanuts stashed at their desks for noontime feeding. This steady source of food virtually tamed the studio squirrels as they scampered about uninhibited by their human keepers. They were almost as lively as the squirrels in Walt's 1957 live-action take on Felix Salten's book *Perri*, or the squirrels of Snow White's forest. Years earlier, the Shadow Department adopted a pet turtle, Toby, and bedecked its shell with paint. Unfortunately, perhaps as a reflection of its department's role, the elusive turtle broke free from its domain and disappeared into the shadows.

ANTICS & ACHIEVEMENTS

Grace Bailey took over as the head of Ink & Paint in 1954, and ran a tight ship. Discipline and efficiency were the standard within the corridors of Bailey's domain. "It was very quiet, extremely quiet," laughed Eleanor Dahlen. For Ruthie Tompson, the silence was often deafening: "I would occasionally drop my brushes just to hear some noise."

The latest fad of the transistor radio offered portable music and information wherever they were wanted. Radios began to appear in the corridors—with headphones, of course. Dahlen remembered, "If you had a radio that couldn't do [headphones], you could bring it in and they would send it down to the Machine Shop. The studio was like a whole city and they would modify it for you."

Personalities often dictated the seating arrangements in the corridors, as Carmen Sanderson recalled. "Marie [Justice] was the Assistant Supervisor in the room I worked in[,] and we sat three across in those funny tin desks. We didn't have anything to entertain us but ourselves and we'd get real noisy and loud, and poor little Jeanie Young was like a little bird, and she'd stand out in the hall and yell 'QUIET,' so we'd get a little bit louder. The poor thing would change our seats!" Despite this constant changing, Carmen, a bubbly pint-sized brunette, was always quick to make friends. "You'd get friendly with your partners and then, within a month or two, you'd change." The moves continued for Sanderson until finally, "I ended up sitting right in front of the Supervisor so that she could keep her eyes on me."

Occasional commotion happened to break up the day. "One time, two of the girls were dancing in the corridor in our room," said Sanderson. "They were doing the tango and as they turned, there's the head of the department—the doors had glass—and they didn't know what to do, so they just turned around and continued tangoing down the corridor."

Random dancing wasn't the only extracurricular activity found in the department corridors. "Glendra 'the Baroness' Von Kessel, a marvelous Painter, brought her fencing outfit in," laughed Grace Godino when she related what would happen next. "And Glendra and I used to fence in the corridors. We learned the whole thing—falconer's style fencing."

Brazen, spontaneous behavior occurred at times, but within the department corridors, it was frequently placed in check. "There was this new gal who worked at the studio," recalled Sanderson. "She was giving a party and she invited Walt to go. Well, his secretary called Grace [Bailey] and then Grace called the girl." After Bailey issued a swift lecture on workplace decorum to the innocent new hire, Sanderson recalled, "[Walt] probably would have gone—if he actually got the invitation."

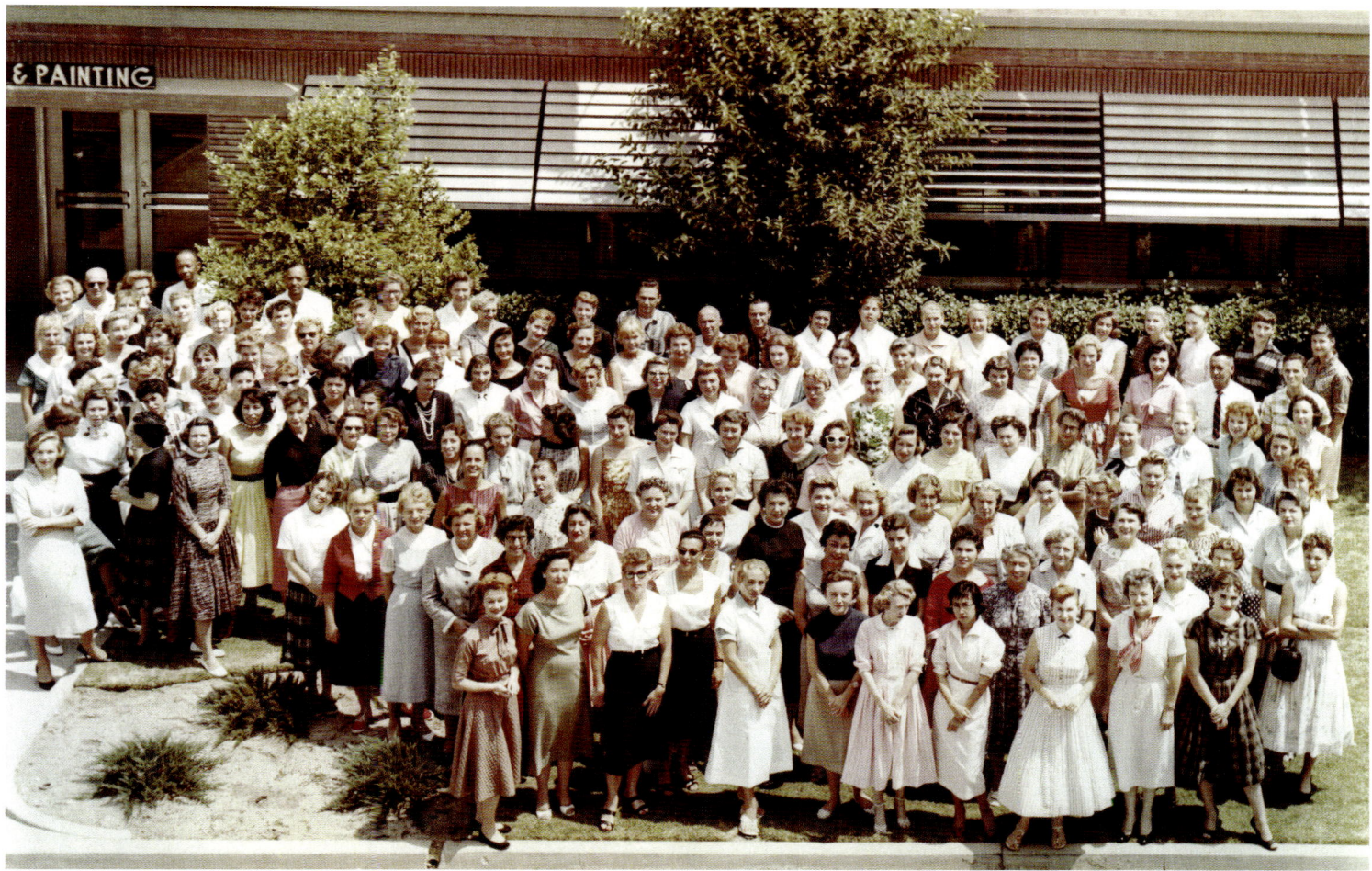

The Walt Disney Studios Ink & Paint Department, circa late 1950s.

Another time, at a fund-raising dance for uniforms to suit the studio's baseball team, Sanderson happened to be seated next to the head of the studio. "I was with my date who worked at the studio, and at the table next to us was Walt. They played a rumba[,] and I heard that Walt loved South America and that he liked to dance, so I moved over and said[,] 'Can I have this dance?' And he said 'yes.'" While sailing over the dance floor, Walt asked Sanderson, "'Where do you work?' I said[,] 'Walt Disney Studios.' And he said[,] 'No, what department?' I thought, 'Oh[,] Carmen, you're going to be fired!' Over the next few days, every time the phone rang, I thought[,] 'Grace is going to call me in.'"

Carmen's fears were quickly allayed when a large envelope addressed to her arrived through Studio Traffic. In it was a glossy photo of Walt signed, "To Buster, best wishes, Walt." "I don't know where he got 'Buster' and I thought it was someone playing a joke, but many years later I told Diane [Disney Miller] the story and she laughed, saying, 'It wouldn't surprise me if he did!'"

The spacious parking areas at the studio provided the perfect place for new drivers to practice. "I bought my first car and I didn't know how to drive," related Sanderson. "Flo Brandt would take me in the lot and taught me how to turn on the ignition and the shifting . . . back and forth, back and forth . . . until I finally did learn to drive." Ink & Paint girls weren't the only ones training on the lot. "One day, we were working overtime on Saturdays," recalled Becky Fallberg, "and I went out to the front gate for a walk and I saw a car going around and around and I asked the guard, 'Gee, there's a car over there; looks like they're learning how to drive,' and he said, 'Yeah, Walt's teaching his daughter Diane how to drive.'"

Traveling with friends to Europe in July 1956, Disney artist Marian "Pat" Paxton was onboard the *Andrea Doria* ocean liner, which collided with the MS *Stockholm* off the coast of Nantucket, Massachusetts, on the ship's return. Surviving one of the worst maritime disasters in US waters with only her evening gown, life jacket, and camera, Paxton even lost her shoes as she scrambled across to the starboard side of the listing ship. Paxton and several other passengers began singing while waiting to be lifted into lifeboats. As Paxton noted, "I didn't want to show panic." Later rescued by the cargo ship *Cape Ann*, Paxton declared, "It's something you'll never forget."

During the Korean War, forty-seven members of the Ink & Paint staff pooled their resources to become the collective sponsors for a young Korean orphan. The ten-year-old boy, Kim Sun Jun, had lost both his parents in the war. Pledging fifteen dollars a month, the girls regularly exchanged correspondence and photos with the boy and his siblings. The department also sent clothing and gifts for the family over several years as they kept track of his education and gave this young child a better life.

TUNNEL VISION & DATING POOLS

Even with all of the projects coming through the department, the women of Ink & Paint were fairly isolated, having little or no interaction with the rest of the production divisions. As Phyllis Craig noted, "The only people who worked with and met other departments were Color Key [Color Model artists] and Grace Bailey, who was head of the entire Ink & Paint Department. So even the Supervisors of Ink & Paint really had no direct contact

Marc Davis' renowned painting, which hung behind the bar at the favored Burbank dining establishment, Alphonse's.

with any of the Animation people. In fact, most of the Painters had no idea of how anything else worked. The girls were pretty much tunnel-visioned [since] we were not really allowed to mix with the Animation people."

Though the work was secluded, there were always ways to fraternize with the male employees. "We'd get a talking-to from the boss: 'You're not supposed to fraternize with the Animators,'" laughed Inker Joyce Carlson. "But we'd go over and see what they were working on. We'd have fun doing that." The forbidden quality was reason enough to try. "Girls were sneaking over to Animation all the time," chuckled Ginni Mack. "I had broken up with the scientist I was going to marry," recalled Joanna Romersa of her interoffice dating. "I saw Tony Romersa [a studio artist], who was a big tall Italian [who] was absolutely gorgeous. I used to go over and talk to Tony and was told that he could come to visit me in my building, but I could not go to visit him in his. And that's the way it was."

Two months later, Joanna adhered to the standards of the day: "I got married very young. In those days you didn't go to bed with anybody unless you were married. I was an Inker at Disney on *Lady and the Tramp*. When we got married, they gave us a big shower and I remember Ducky Nash [the voice of Donald Duck] gave me a cracker holder with crackers in it and he made the 'C' into a 'Q' so it was 'Quackers.'" After marrying fellow Animator Gus Jekel, Lula Drake Jekel worked on call, animating on every feature in the 1950s. "As a married woman," noted her daughter Lynn, "she wouldn't work full time, to help the women who weren't married and needed a paycheck."

Beyond the workday, at lunchtime or after hours, there were ample opportunities for socializing throughout the studio. Jane Baer recalled, "Sometimes the studio felt more like a college campus than a place where we worked. In that sense, Walt encouraged a lot of creative freedom." Often Walt would be seen in the midst of the noontime commotion. As voice talent Kathryn Beaumont recalled, "Oh yes, Walt was always around. He would come down at lunchtime and go to the line at the large studio cafeteria. He would sit with whomever, where there was a free space at the table. The fact that he was so accessible just made it a very pleasant place." Joanna Romersa agreed. "Working at Disney's [sic] was just great. I met a lot of people," she said, "and a lot of those people, I still know. It really was a good beginning for me."

Ink & Paint

Legendary Animator Tissa David.

THE USUAL HAUNTS

Studio staff frequented their usual local establishments for lunches and to quench their noontime "thirst." Of her tenure as an Assistant Animator on *Sleeping Beauty*, Jane Baer recalled, "One time, the Story Department—which was all guys at that time—went out and had a martini lunch and came back and they were feeling pretty good and came into our room laughing and telling jokes and just being a little bit silly.

"[Later], several management guys came down and chewed them out and then we got yelled at for encouraging them, and we had nothing to do with it, but we were treated like it was our fault," Baer said, bemused. "It was just typical 1950s. That's just the way it was and we accepted it. Isn't that odd?"

Disney talent was often spotted at local restaurants during the lunch hour or for frequent dinners. Alphonse's continued to be a favorite locale. Evelyn Coats recalled spotting Roy and Edna Disney having dinner from across the restaurant one evening. As Evelyn and her family were seated, drinks arrived at their table compliments of Mr. Disney. "That was sweet of him," Coats noted. Animator Marc Davis noted, "At Alphonse's restaurant, we used to go over practically every day and have a drink and something to eat." Marc's association with Alphonse's went beyond his usual lunches. One of his original paintings, featuring four females cleverly attired as favored cocktails, was displayed prominently behind the bar. As a newlywed, Marc and his beloved bride, Alice, had just purchased their first home and were in dire need of furniture. Marc bartered this original painting for a set of four captain's chairs and a table from the owner of Alphonse's. For decades, Davis's artistry was an iconic part of this legendary watering hole.

OTHER STUDIOS

With the advent of acetate cels in the late 1950s, animation studios throughout the industry quickly made the celluloid transition. Premanufactured paint systems were utilized at other studios as well. Spectracolor created an acrylic paint that was better suited for the acetate cel creating competition for Cartoon Colour, which later provided its own "cel-vinyl" paint system. By the 1950s, United Productions of America, or UPA, Studios had risen to prominence. Founded in the 1940s by a number of former Disney Animators—including John Hubley, who left following the 1941 strike and layoffs—UPA established the distinctive mid-century style utilizing limited animation. Of her experience working as an Assistant Animator for UPA Studios in the late 1950s, Joan Orbison recalled, "It was a small studio, but I liked it. I enjoyed working on *Mr. Magoo*. We used to turn him around as much as we could, facing his back[,] because he talked so much [and] we had to animate all that."

With a number of other animation houses in town, many of the artists found work elsewhere between productions. "I did bounce to other studios," recalled Disney stalwart Grace Godino in a later interview. "During the slow periods, I worked briefly for Walter Lantz and for Hanna-Barbera and UPA, but what they call the 'Parent Studio' was Disney. I always came back to Disney and [later] I was happy to retire from Disney."

A growing number of televisions were found in households, and commercials were a staple business for many animation studios. Inker and Special Effects artist Gini Swift recalled the early days working at Screen Gems in the 1950s: "When we started out tackling commercials, we did an awful lot of black-and-white at Screen Gems and we'd ink in gray. I learned from an old fellow in the industry to be able to look at color and read it in black-and-white. I could tell what shades of gray that various colors would come out in . . . it was just a knack that I was so lucky to be able to do."

Halina Bielinska became the first Polish Animator, Reiko Okuyama became the first female Animator in Japan, and young Animator Therese "Tissa" David emigrated from Hungary. She survived the daily bombings of the 1944 siege of Budapest. "We were starving," David recalled, having learned "how small and how great people can be." Co-owner of an animation studio, in 1950 she escaped the Communist takeover and settled in Paris. A year later she became the second woman to direct an animated feature film, *Bonjour Paris!* In 1955, David went to work at UPA as an Assistant Animator to Grim Natwick. "In America," she noted, "animation is a jealously guarded men's field. So girls should be Assistants, Inkers, Painters—not Animators." Yet she animated an extensive array of commercials, television, and feature film work. Dedicated to her field, David remarked, "You can only have one love if you want to be an Animator."

DISNEY FAMILY LIFE

Walt Disney lived in a world of women. He was comfortable there. In a women's magazine of the day, Lillian Disney offered a bit of insight into her world-famous husband: "Being married to Walt Disney is never dull. I maintain that Walt's imagination flies so high he naturally sees a little farther than the rest of us.

Walt, Diane, and Sharon Disney enjoy sodas and ice cream together at their Holmby Hills home soda fountain.

Walt may be a genius[,] but any genius, especially Walt Disney, is wild-eyed and needs a practical family to watch over him. . . . I wouldn't have missed one minute of the twenty-seven years I have been married to Walt Disney."

Recalling a European summer vacation, Lillian continued, "Walt is always telling people how henpecked he is. Last summer, appearances seemed to support him when he took five women to Europe with him: me, our two daughters—Diane and Sharon—a school friend of Diane's, and our niece. But it was all his own idea, and he loved it." The women of Walt Disney's family clearly knew their lone male member quite well. In her 1957 book, *The Story of Walt Disney*, Diane Disney Miller noted about her father: "He likes to pretend that he's victimized at home because he's the only male in residence. When he gets that far, we know that Dad is secretly enjoying his household, with a lot of women fussing over him. He's very sentimental."

As wives dealing with the dynamics of brothers, the two Mrs. Disneys continued to be close. "The Disneys' disposition—that's what we always kidded about, Lilly and I," laughed Edna Disney about her husband and Walt. "They could flare up very easily, both of them[,] and maybe hurt each other for a few minutes and then they're always sorry and apologize. . . . They can flare up easily, but they get over it quickly. It's good, you know. They don't hold grudges."

When not at the studio, the Disney family often made their way down to their desert home at Smoke Tree Ranch in Palm Springs, California. There, Walt would relax, but the work of the studio was always on his mind, and Lillian recalled he would act out various scenes he was envisioning: "Always—to the sky, the birds, to anything. He was always making gestures—talking . . . laughing and acting out something he was working on."

In a rare interview, Lillian reflected on her marriage to Walt: "I am flattered to say that, after twenty-seven years he seems to want me around as much as when we were first married. He is actually hurt if I don't go along with him on a business trip. And he spends as much time and thought on a present as though he were still courting me." As an anniversary gift for each other, Walt and Lillian designed and built a spacious new home in Holmby Hills, though Lillian noted, "When we built this house he had that train in mind." In addition to the space for his one-eighth-scale live-steam railroad, Walt had a small barn built as reminiscent of the Disney family barn in Marceline, Missouri. Endless hours were spent building model trains and miniatures in the little red barn, which became his workshop and "happy place." Lillian noted of Walt's railroad hobby, "To be truthful, the girls and I don't share Walt's unbounded enthusiasm for the train. Actually I owe that train a debt of gratitude. It is a wonderful hobby for him. . . . It has been a fine diversion and safety valve for his nervous energy, for when he leaves the studio he can't just lock the door and forget it."

For the girls, a playroom and a fully functioning soda fountain were incorporated into the design of the Holmby Hills house, where, as Walt noted, "the girls can entertain their friends without disturbing the rest of the household." With parties and friends a regular scene at the Disney household, Walt mused that he was "supplying the whole neighborhood with sodas at

Left: Walt and Lillian on vacation in Europe.

Right: Walt and his pet poodle, Dee-Dee (short for Duchess Disney), raid the icebox.

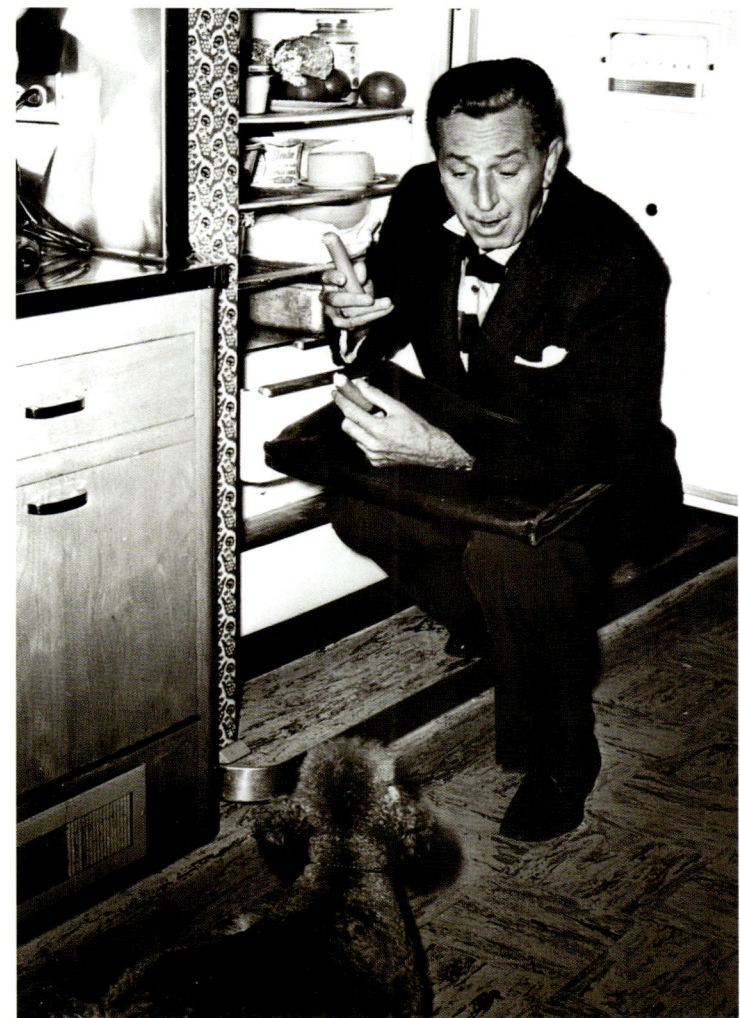

my expense." This was a small price to pay for a father's peace of mind in knowing his daughters were safely home. It was one of Walt's favorite features as well. "He'd experiment," Sharon recalled, "by making these weird concoctions that nobody, including myself, would eat. He once tried to make a champagne soda. It was the most awful thing. He couldn't get anybody to taste it, and he agreed it was pretty bad."

EXPANDING THE FAMILY

Family dinners occurred every night, prepared by the family cook, Thelma Howard, who joined the Disney household in 1951. Diane described Howard as "housekeeper, cook, sometime nanny, and wonder woman." A quick-witted presence who loved football and the color pink, Howard played a mean game of gin rummy and was an excellent cook. "Dinner hour would usually be about seven thirty, which is late by most standards," recalled Diane. "We always had dinner with him [Walt]." On Howard's day off, the family would pack up and drive to the Tam O'Shanter near Glendale or Hollywood's famed Brown Derby restaurant. Walt's dietetic tendencies were simple. Canned beans and frankfurters were always kept in stock at the Disney household. "He ruins every suit he owns," recalled Lillian, "by coming through the kitchen when he gets home at night and filling his pockets with bologna and hot dogs for our French poodle, Dee-Dee."

In 1951, Diane left for college, attending the University of Southern California. While there, she met a handsome football player named Ronald Miller. "[When] I first arrived at the house for a date," he laughed, "I could tell that both Walt and Lilly were sizing me up." Ron easily made the grade. As Diane stated, "My parents liked Ron the minute they met him." They were married in a tiny church in Santa Barbara in 1954. "I think Dad relished every role he played in his life, and being father of the bride was a very important, tender one," Diane reflected. "Dad brought me up to the altar where Ron was standing, and I heard a sniffle. I turned, and he turned and looked at me. I felt him squeeze my hand." In the late 1950s Walt and Lillian became grandparents, and in May 1959, the Disney family expanded once again with Sharon's marriage to Robert Brown.

Having worked for the family for many years, Thelma Howard, or "Foo Foo," as she was affectionately called, raised not only Walt and Lillian's children, but had a strong hand in raising their grandchildren as well. "Foo Foo was a dynamite lady and we were all drawn to her. My grandfather had an incredible rapport with her," recalled Walt and Lillian's grandson Chris Miller. "They seemed to share everything, from a sense of humor to their notions about what was happening with the kids and what was best for them. Foo Foo was, in many ways, kind of a teacher to us." Regularly gifting Foo Foo with a few shares of Disney stock, Walt would tell her, "Now, don't you spend this. Hang on to it." When Howard passed in 1994, she was a multimillionaire and left the bulk of her fortune to fund scholarships and grants for underprivileged children.

THE 1960s

1960
- Lunch counter sit-in occurs at Woolworth's in Greensboro, North Carolina
- Alfred Hitchcock's *Psycho* changes filmgoing forever
- The first televised presidential debates occur
- The birth-control pill is approved by the FDA

1961
- The Bay of Pigs invasion occurs
- The Berlin Wall is built
- Freedom Riders challenge segregation on interstate buses
- The Peace Corps is founded

1962
- Andy Warhol exhibits his *Campbell's Soup Cans*
- The first James Bond film premieres
- Marilyn Monroe is found dead
- Rachel Carson's book *Silent Spring* is published

1963
- President John F. Kennedy is assassinated
- The first *Doctor Who* episode airs
- Russian cosmonaut, Valentina Tereshkova, becomes the first woman in space
- Martin Luther King Jr. makes his "I Have a Dream" speech

1964
- Muhammad Ali becomes world heavyweight champion
- The Civil Rights Act passes in the United States, barring employment discrimination
- The G.I. Joe action figure debuts
- Nelson Mandela is sentenced to life in prison

1965
- The Watts Riots occur in Los Angeles
- The miniskirt first appears
- The Rolling Stones' hit song "Satisfaction" is released
- The United States sends troops to Vietnam

1966
- The Dance Theatre of Harlem debuts
- Indira Gandhi is elected prime minister of India
- The *Star Trek* TV series first airs
- The first Kwanzaa is celebrated

1967
- The first human heart transplant is performed
- Thurgood Marshall becomes the first African American Supreme Court justice
- The first Super Bowl is played
- Muriel Siebert becomes the first woman with a seat on the New York Stock Exchange

1968
- Martin Luther King Jr. and Robert F. Kennedy are assassinated
- The EEOC rules sex-segregated help-wanted ads in newspapers illegal
- Yale University admits women for the first time
- *Planet of the Apes* is released in theaters

1969
- Neil Armstrong becomes the first man on the moon
- The Woodstock rock festival occurs
- *Sesame Street* first airs
- California is the first state to adopt a "no-fault" divorce law

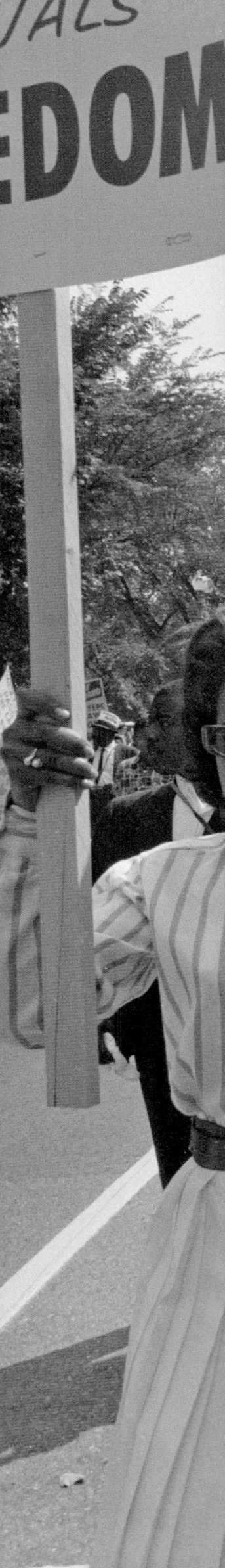

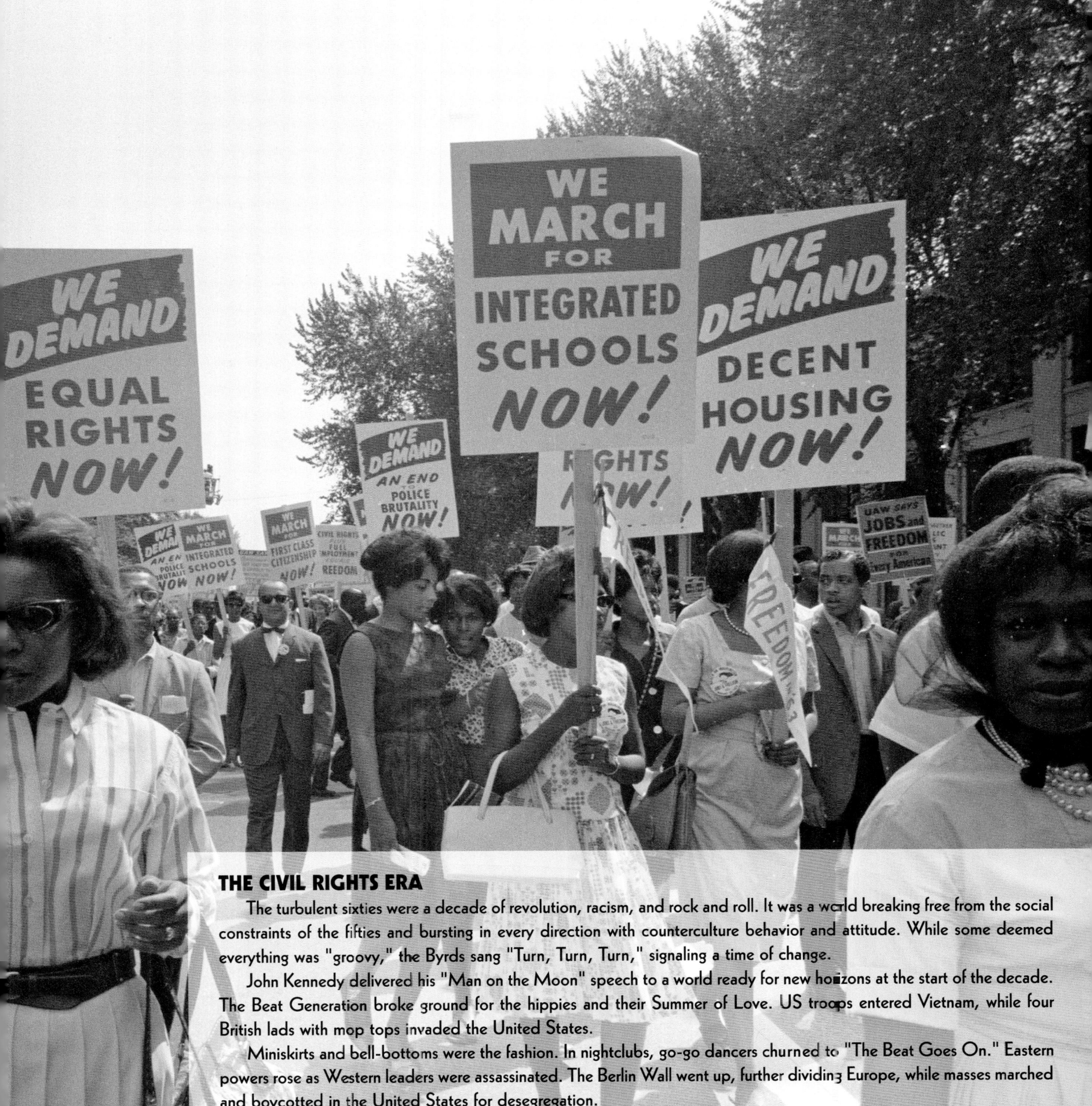

THE CIVIL RIGHTS ERA

The turbulent sixties were a decade of revolution, racism, and rock and roll. It was a world breaking free from the social constraints of the fifties and bursting in every direction with counterculture behavior and attitude. While some deemed everything was "groovy," the Byrds sang "Turn, Turn, Turn," signaling a time of change.

John Kennedy delivered his "Man on the Moon" speech to a world ready for new horizons at the start of the decade. The Beat Generation broke ground for the hippies and their Summer of Love. US troops entered Vietnam, while four British lads with mop tops invaded the United States.

Miniskirts and bell-bottoms were the fashion. In nightclubs, go-go dancers churned to "The Beat Goes On." Eastern powers rose as Western leaders were assassinated. The Berlin Wall went up, further dividing Europe, while masses marched and boycotted in the United States for desegregation.

The best-selling book *The Feminine Mystique* challenged societally imposed roles on middle-class American housewives, and NOW, the National Organization for Women, was founded. Congress passed the Equal Pay Act, while a woman disguised as a man finished in the top third of the male-only Boston Marathon, declaring: "I was running to change the way people think."

In 1966, Walt Disney passed. Disney Animation carried on.

TRIUMPHS & LOSS

"I do not like to repeat successes, I like to go on to other things."
— **Walt Disney**

The sixties marked a time of technical transitions, tremendous triumph and devastating loss for the Disney Studios. The lavish 70 mm production of *Sleeping Beauty* was considered ahead of its time. A jeweled-toned palette set within the stylized tapestry-esque quality of this lavish feature-length production established a new zenith for animation. Yet, despite its wide-screen splendor, ticket-buying audiences of the day didn't warm to Disney's animated masterpiece.

Walt's attention was spread thin overseeing Disneyland, television production, and a number of other projects on the horizon. Time and money were tight and the future of animation production at Disney Studios reached a critical point. "In these extraordinary days," Walt acknowledged, "we realize fully that the public is shopping more than ever for its box office fare. It's no secret that we were sticking just about every nickel we had on the chance that people would really be interested in something totally new and unique in the field of entertainment."

Expanding the realm of live action provided creative entertainment options with a crucial cost efficiency and swifter returns. "When they started going into the live action [films]," observed Grace Bailey, "they slowed down on making animation pictures. It got to be pretty expensive, and I believe that Walt and Roy felt that it tied up too much money too long, and they [could] make several live-action pictures for the price of one animation picture." The art form that built the Walt Disney Studios took a backseat to other endeavors. Animator Floyd Norman recalled that during the post–*Sleeping Beauty* era, "We truly needed to come back strong."

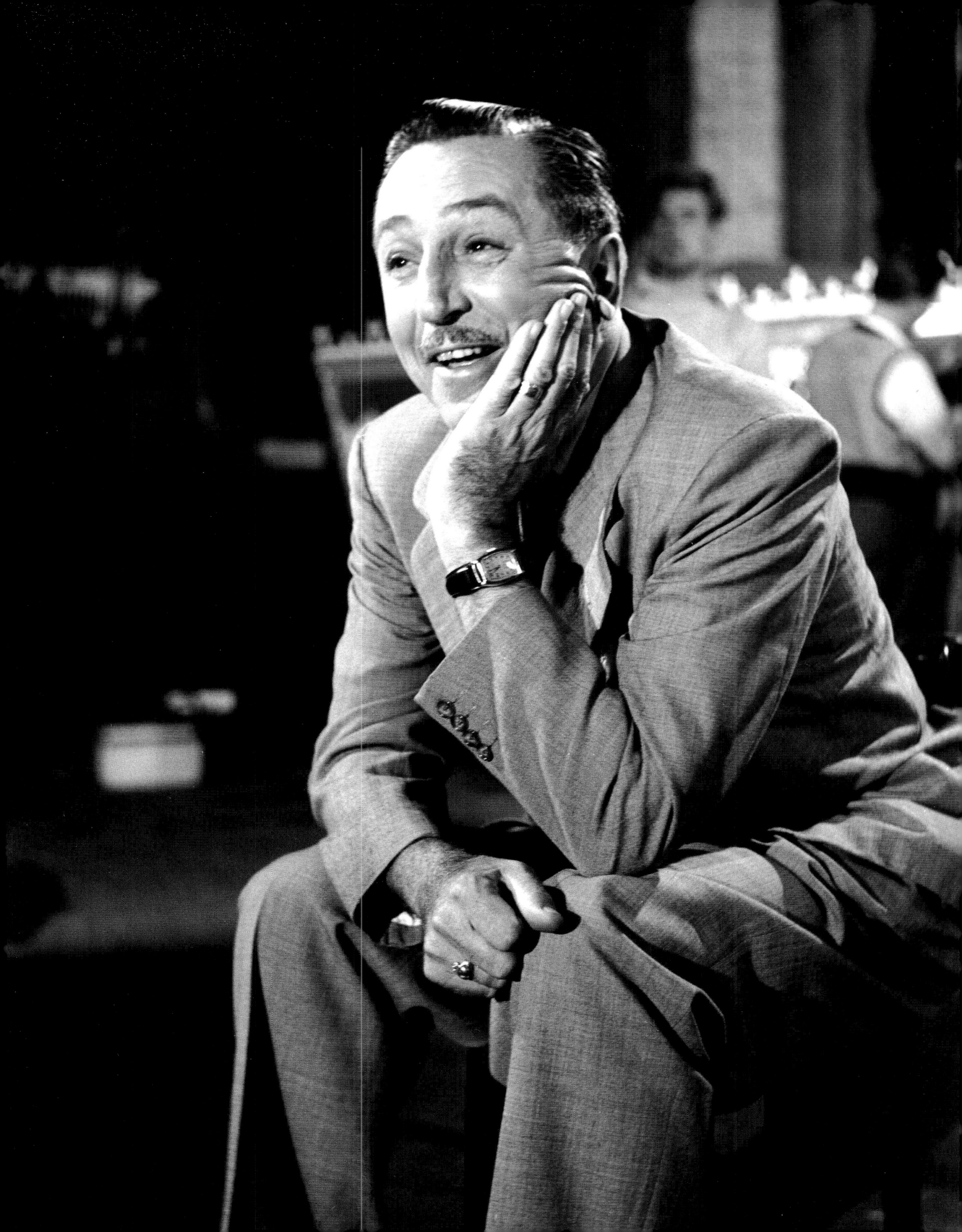

GOLIATH II

In order to test the methods, materials, and most importantly, the audience's sensibilities towards the new Xerox technology, Walt and his teams quickly placed an animated short into production. *Goliath II* was the first Disney cartoon to make full use of xerography. With an original story by Bill Peet, this landmark short told the tale of a tiny elephant named Goliath who struggles to find his place in the world alongside his larger-than-life father. Several favored Disney voices were featured, including the familiar Barbara Jo Allen and the beloved Verna Felton. The studio's key creative teams were engaged in the project as well, with Thelma Witmer contributing to the soft, stylized backgrounds.

The new production flow instituted with the integration of Xerox required new attention to the animation process. The direct usage of the Animators' drawings called for a heightened level of accuracy and steadiness in the final lines of Cleanup Animation. Animation Check teams had responsibilities added to their role as well. Once a scene was checked and approved, it was off for Color Model development and Paint Lab evaluation. But from there, each scene proceeded through the newly established Xerox pipeline steps. In Xerox Markup, notations were made on the original animation drawings with blue pencils that wouldn't read when photographed. Next the drawings moved on to Xerox Processing and ultimately Xerox Check, where the cels were compared to the matching drawings to ensure everything was ready for Painting.

XEROX CHECK

With Xerox technology integrated into production, a new level of checking was introduced to the production line: Xerox Check. Xerox Checkers reassembled each scene to review the overall cel lineup to the original drawing. Discarding the original tissue paper that accompanied each cel throughout the Xerox process, Checkers would compare the image on the drawing. Carefully removing any unnecessary lines, Checkers inspected the quality of ink-separation lines and registration lines according to cel colors indicated on the color-model sheets.

Airbrush, drybrush, or any specialized inking required for the scene would be checked and processed at this point, while Xerox Checkers utilized final backgrounds for registration checking of the characters, Special Effects, and any working mechanics on the cels. Xerox Checkers replaced the backing tissue with a heavier tissue manifold to protect the cels as they advanced to painting.

Goliath II was quietly released in theaters along with the live-action feature film *Toby Tyler* on January 21, 1960, with no mention of the implementation of Xerox. Walt's emphasis on story won out, and audiences responded favorably. Technology served the narrative, and the advent of Xerox was affirmed when *Goliath II* received an Academy Award nomination for Best Animated Short, effectively green-lighting the next feature-length animated film on the boards, *One Hundred and One Dalmatians*.

SEEING SPOTS

"The idea came from a novel by Dodie Smith," Walt remembered. "She's a good writer [with] a very good story line. She had a lot of things in the book [that] I loved, but we couldn't do everything."

Smith's imaginative book of Dalmatian dogs in danger from the diabolical dognapping villain Cruella De Vil provided the perfect feature-length "tail" for the studio to road test the new technology of Xerox.

"We had moved from a European fairy tale to a more contemporary story with a totally different sensibility," recalled Animator Floyd Norman. "It was fresh, it was bright, and it was lean and mean; we did it in half the time and it was made with half the staff employed for *Sleeping Beauty*." As Animator Marc Davis noted, "This was the first time we saw our own drawings in a picture, literally. It meant a great deal to us, as Animators, and as artists, too."

With 101 distinctively spotted dogs throughout the entire feature film, the use of Xerox was perfectly suited to this concept. Hand-inking would have been virtually impossible, as Pongo, one of the four-legged leads, sported seventy-two spots, while Perdita had sixty-eight and each of the ninety-nine pups featured thirty-two. All together, there are exactly 6,469,952 spots appearing throughout the 113,760 frames of the final film. Grace Bailey offered insight into ways in which the Xerox process facilitated the animation: "We had what appeared to be 101 actual drawings of the dogs with a title over this. Well, the Animators drew one little section with maybe four or five dogs on it and we just repositioned that little section all on one cel and saved all that drawing. Otherwise, it would have taken hours and hours to draw them all."

Even with the advance of Xerox technology, Margaret Trindade often spoke of the hurdles created by the distinctive spot patterns for specific puppy characters. Her cousin Antonio Barreto Jr. remembered, "Every time they moved, the spots would elongate, squash[,] or stretch and the ladies would go 'nuts!' There are 101 of these dogs and they all have different spot patterns. She couldn't sleep at night because all she'd see was white with

Pages 284/285: Civil Rights march on Washington, D.C., August 1963.

Page 287: Walt Disney, circa 1960s.

Page 288: Final film frame from the first Disney Xerox production, Goliath II (1960).

This page, left: Legendary character actress Mary Wickes provides live-action reference for the dognapping villainess Cruella De Vil; and (right) early Marc Davis Xerox cel exploration of Cruella, painted to explore color concepts for One Hundred and One Dalmatians (1961).

black spots. It seems everyone was having the same problem. The ladies would frequently need to step away for a while because it was nothing but spots."

The film's femme fatale, Cruella De Vil, was animated by Marc Davis; his tour de force efforts resulted in one of the most memorable animated characters of all time. The inspiration for this canine-thieving baddie came from several different ladies: the legendary character actress Mary Wickes, who also provided live-action reference for Davis and the Directors; a volatile fashion designer who was a former work colleague of his wife, Alice; and screen legend Tallulah Bankhead. The final inspiration was the voice talents of Betty Lou Gerson. "Betty Lou has one of those great voices that give you something to work with and which makes animating easy," noted Marc Davis. "Her voice led us in the proper direction and helped us develop the character." Even some of Gerson's distinctive physical attributes reside in Cruella. "I loved doing Cruella," chortled Davis. "She was erratic, eccentric, and violent[,] and there were no restrictions of trying to keep her innocent and believable." Cruella's colors clued audiences in on her evil tendencies. Red accents against the black or white garments highlight the extremes in her actions and nature. Reflecting on the impact of her color-coding, Davis acknowledged, "I think this is right for the way we made films," noting, "She never changed costume, except when she was in bed—that was the only time."

Perdita, the female dog lead, was voiced by actress Cate Bauer. Actress Lisa Davis voiced the ever-joyous Anita, a warmhearted character designed with an emphasis on intelligence and personality. Nanny, the down-to-earth caretaker of the Radcliff household, was voiced by Martha Wentworth.

Sitting next to the large story room in Woolie Reitherman's 2-C production offices was Betty Gossin, production secretary for One Hundred and One Dalmatians. Background artist Thelma Witmer was the sole woman on the production side noted in the credits. But despite this single credit on the screen, women held the strongest presence within the halls of the Animation building since the war years. "By the 1960s, women were finally moving into Disney's once all-male Layout Department and working alongside the men," noted Animator Floyd Norman.

"Talented Layout Artists such as Sylvia Roemer and Sammie June Lanham began creating layouts for One Hundred and One Dalmatians and The Sword in the Stone," Norman continued. "Veteran Animation Assistants Retta Davidson, Grace Stanzell, Sylvia Niday, and Charlotte Huffine were eventually joined by newbies Joan Drake and Kimi Tashima. Times were changing, and their male superiors did not as easily intimidate this new generation of young women."

PROGRESSING THROUGH THE RANKS

"I really didn't feel there was any discrimination when I was there," noted Sylvia Roemer, "and I didn't feel like I was being put there because I was a woman. You just had to have the talent and be able to contribute something." Starting as a Painter, Roemer quickly progressed to Inking and Color Models. "I was very fond of color," she remarked. "I can carry a color like some people can carry a note!" The artist's talents continued to propel her forward. "It was a very interesting job being the Supervisor of the Color Model Department; you had quite a bit of leeway in what you could do as far as designing the colors," she said. "We made so many more new colors because some of the things were

290 | Transition: Triumphs & Loss

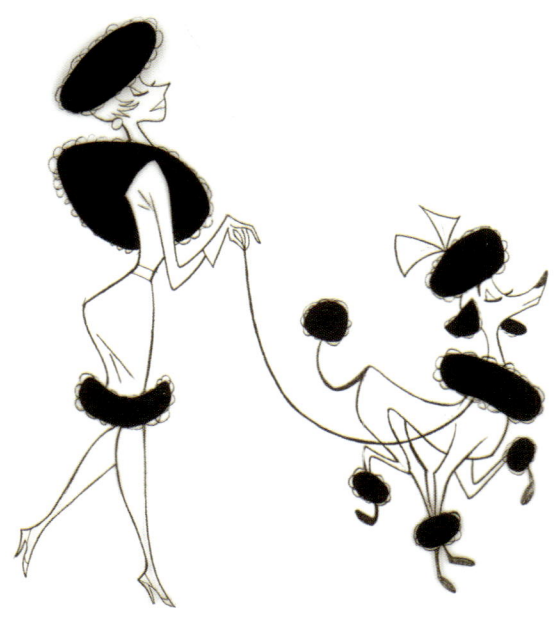
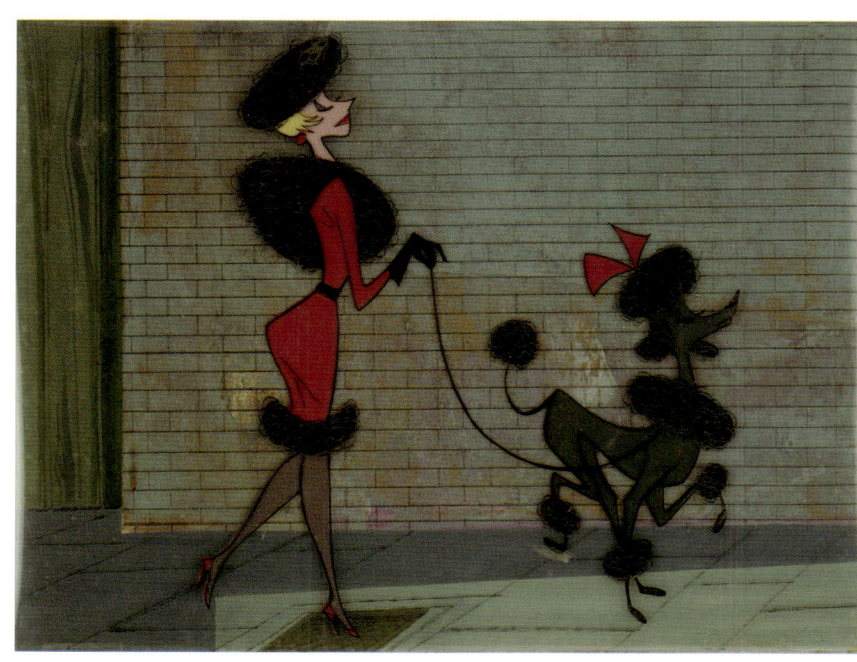

Page 290: Complete image elements from the Xerox process. (Top left): painted background; (top right) Xerox background overlay; (center left and right) painted cel elements and Xerox cel overlay; (bottom left) effects Xerox overlay; (bottom right) final frame composite.

so subtle. We were always calling the Paint Lab and saying, 'I've got a new color for you to make.'"

Roemer's career continued to advance. "Then the director asked me if I'd like to go over to Layout," she recounted. "They were going to ink the layouts, drawings, [and] backgrounds so you get a nice clean line. That [drawing] was xeroxed and put over a painted version on [illustration] board. So, because I had inking experience, that's how I got into Layout[,] because we were drawing fairly detailed drawings of the backgrounds. We'd get what we called the Blue Sketch, which showed the extremes in the action." Blue Sketch artists accomplished their work with blue pencils to designate exactly how the animated character interacts with the environment. "You'd work it so they wouldn't walk into a table," Roemer continued, "and we'd fit the scene to match the background of the scene beforehand and what might be coming up afterward. There would be frustrating things—just the difference of a little line can change an expression so much, but artists are sensitive people and it was like going to school every day. You learned from all the clever people there."

TECHNOLOGY & COLOR

The Xerox conversion brought a new dynamic to the Ink & Paint Department. Male Camera Operators and shift bosses were working alongside women in the Xerox corridors. For the Painters, the scratchy, hard outline produced via the Xerox process was sometimes less defined than its hand-inked predecessor. It could be difficult to discern the line's edge, and careful attention was required with paint application to achieve a true opaqueness on the final cels. However, the heavy, stylistic Xerox lines served the vibrant color styling of Walt Peregoy.

Given free rein to work with this new approach, Peregoy defined one of the most distinctive visual experiences in the studio's history. "Conventional approaches just won't work and my work has been anything but conventional," Peregoy quipped. "It's not 'warm' or 'cool.' It's really what I feel." The stylized backgrounds for *One Hundred and One Dalmatians* were produced from layout drawings. Utilizing a variety of techniques, including xeroxed cel overlays against painted backgrounds, Peregoy focused on staging and color for each scene. "I would approach color freely—painting behind the Xerox overlay. This gives the work a free, almost watercolor quality. [Thus,] color styling serves the sequence and the animation."

Becky Fallberg noted this advance. "Then they started doing a lot of things with Xerox camera . . . xeroxing the layout onto the background board. That was all traced by hand before. The layout was xeroxed onto a pan cel and then they would lay that right over the painting. Before they did that, they made a light xerox copy, printed lightly on the background board itself, so that gave you something to paint to.

"They really make two copies of the layout," she remembered. "One was on a board—light[ly,] and one was the dark color for the overlay cel. They call it [an] overlay." Peregoy's use of the overlay method in creating backgrounds marked a new application for Xerox and signified a new approach to defining animated worlds, as he later noted. "None of my backgrounds take away from the beauty of the animation."

A voluminous exercise in artistic logistics, this cinematic canine caper required over eight hundred gallons of custom paint mixed within the studio's Paint Lab, forming over a thousand different shades—enough paint to cover the exteriors of 135 average homes. As 1961's top box office winner, *One Hundred and One Dalmatians* ushered in a new era of Disney animation. The successful integration of Xerox technology was perhaps the most critical innovation in the world of animation since the art form began. Frank Thomas and Ollie Johnston wrote: "There was very little delicacy in the result, and a light line was apt to drop out entirely, but the Animator's drawing was there, strong and irrevocable in the blackest of lines. In fact, this heavy, black line put us right back into the 1920s, before the refinements of inking had begun."

OF SWORDS & STONES

Walt Disney's take on T. H. White's classic, *The Sword in the Stone*, was the second animated feature utilizing Xerox technology. Martha Wentworth vividly voiced Madam Mim, the zany shape-shifting crone who matches her magical wits with Merlin. In true transformational fashion, Wentworth provided the additional female voices of Granny Squirrel and one of the scullery maids.

The Sword in the Stone also marked the animated feature film debut of music by Richard and Robert Sherman. During the course of three years in production, the Sherman Brothers concocted a clever canon of wizardly words into memorable songs for the film, establishing their prominent place within Walt Disney's world of animation. "It was our first animated feature," recalled Robert. "We didn't know too much about how pictures were made." For Richard, "The principal lady I worked with was Evelyn Kennedy. She was a very key player in all the Disney films. Evelyn was one of 'Walt's people,' and these people were brilliant."

The quiet force behind Disney music from 1955's *Lady and the Tramp* to 1981's *The Fox and the Hound*, Evelyn Kennedy was involved in all facets of the studio's music for films as well as television, and she oversaw the work of several other studio music editors. "My God, the work she did!" remarked Richard Sherman. "I was fascinated by how the voices were finally synced-up to picture. So many times the spoken dialogue and animation was slightly out of sync, but she would make it work. Evelyn was a whiz at what she did and was very respected by everybody."

This legendary Music Editor became a musical mentor for Richard Sherman. "She was a bit older than me, so I was kind of like 'the kid' wandering around, but I was so interested in how she did it. She never let anybody into her editing room where she worked with the Moviola—switching and pushing the film around to make it work." Kennedy's mutual respect for Richard was evident. He noted, "She had a little sign that said, 'Nobody can enter except Richard Sherman.' I was the one guy she would let come in. I was not supposed to talk, so I would just stand there and watch how she worked and see how she did it. I was fascinated by it. . . . It was 'lessons' for me. I was learning so much in those days."

Taking the young songwriters under her wing, Kennedy patiently oriented them through the scoring process of animated films. "We learned that one must preestablish thematic lines within

292 | Transition: Triumphs & Loss

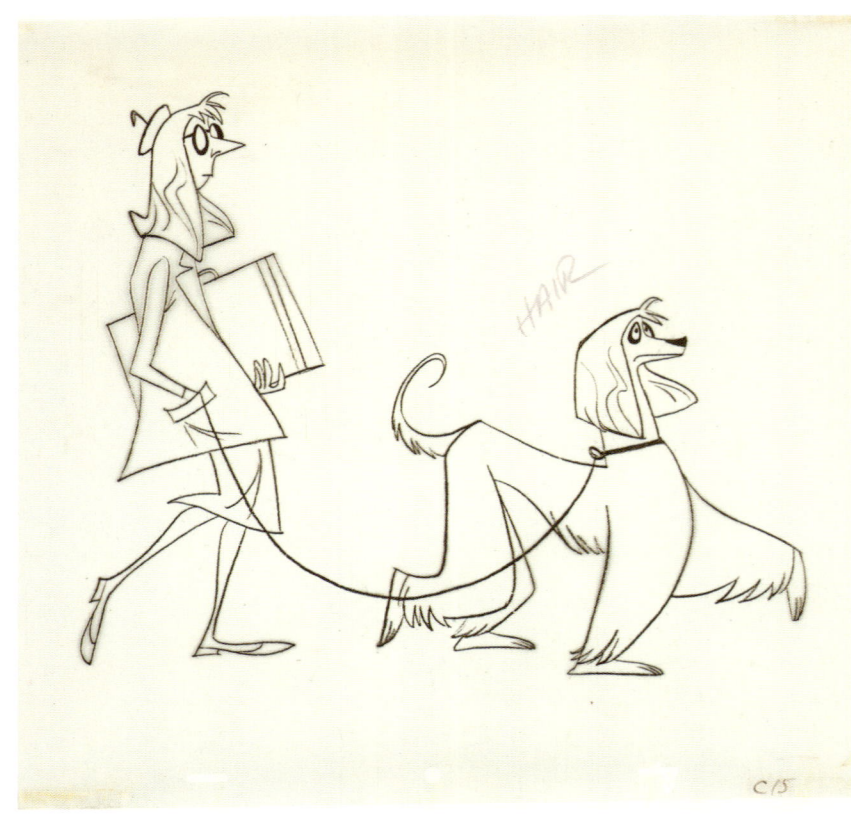

Ink & Paint | 293

a musical film so that melodies of the songs are utilized within backgrounds as well as foreground as they are sung," Richard noted.

"Evelyn made it work, particularly with background scores; many times something had to be cut and she would make it look seamless when she was through with it," the songwriter said. "It would always sound beautiful[,] like the way it was supposed to have been." Of their early scoring sessions, Richard recalled, "She was also the one who marked every session. You listen to the tracks of the takes and she'd have the number on it—'Take Number Six, Take Number Seven'—so she could figure out what they were going to use. She oversaw sweetening [of] tracks and was a total pro."

The credits for *The Sword in the Stone* featured the first Layout Department credit for Sylvia Roemer. After beginning her animation career in Ink & Paint, Roemer's talents ensured her transition into Layout and Backgrounds, where she continued to work for more than two decades.

CREATING CAL ARTS

Nearly thirty years after Walt Disney came to her for help training his artists, Nelbert Chouinard came to Walt asking for his help. She was now an elderly woman in her late eighties, in poor physical health, and on the brink of closing the Chouinard Art Institute due to financial problems. Walt sent his accountants to review her situation.

"They found that somebody had stolen over twenty thousand dollars," stated Marc Davis, who taught animation at the school. "To see this woman whom he respected was in one helluva shape. Walt always said she had been wonderful to him. So he began to figure out what to do for her." From the Disney Foundation, investments were made and measures taken to ensure the security of Chouinard and the school. "Walt took care of her so she would be financially well off as long as she lived," Davis added. "The studio contributed equipment to the school and Walt sent one of his WED architects to fix up the school['s] buildings."

Envisioning a utopian campus where the arts were central to an advanced educational curriculum, Walt Disney molded Mrs. Chouinard's Art Institute into a unified "community of the arts" where young artists of every discipline could work, learn, and foster their training under the guidance of "current masters" of the arts.

A 1961 merger of the Chouinard Art Institute and the Los Angeles Conservatory of Music formed the California Institute of the Arts. Today, CalArts continues to train the top Animators in the world with a majority of female students studying this unique art form. "[Walt] was always interested in CalArts [*sic*]," recalled Edna Disney. "He got a lot of his artists from Chouinard, and I think it grew out of that."

WORLD'S FAIR ADVENTURES

An international spotlight was soon to be focused on Flushing Meadows, New York, for the 1964 New York World's Fair. In the grand tradition of national exhibitions, leaders of industry from around the world exhibited their wares and advancements on a global stage. With various corporate sponsorships, the artists

| 294 | Transition: Triumphs & Loss

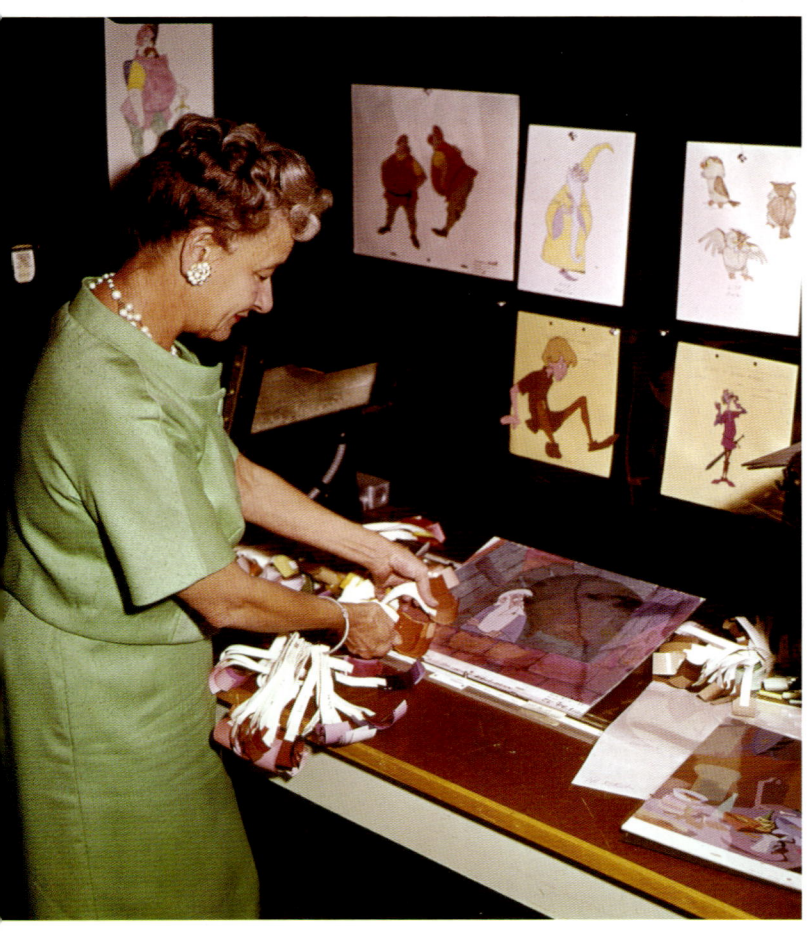

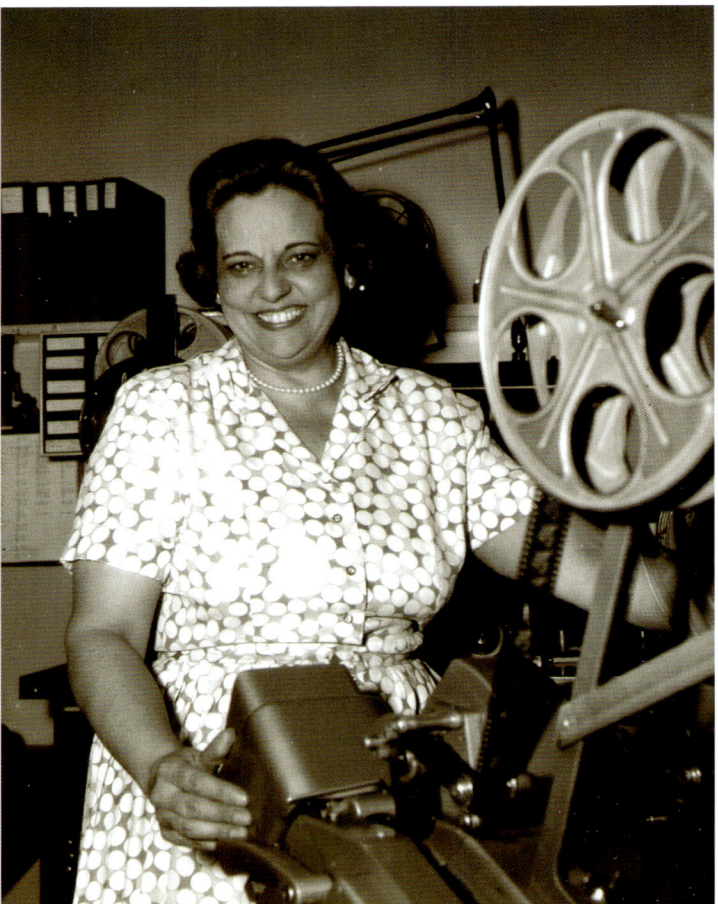

Page 292, top: Xeroxed line cel overlay with painted cel piece from *One Hundred and One Dalmatians* (1961).

Page 292, bottom: A Xerographic cel demonstrates the reduction capabilities of the Xerox process.

Page 293, top & bottom: Production cel pieces of Madam Mim and Merlin from *The Sword in the Stone* (1963).

This page, left: Color Model Supervisor Mary Tebb reviews color swatches for *The Sword in the Stone* (1963).

Right: Renowned Music Editor Evelyn Kennedy.

of WED developed four different attractions, which presented new opportunities for a number of extraordinary women. Designing and fabricating these attractions in less than a year, their combined efforts resulted in some of the most beloved attractions of all time.

Celebrating the children of the world, it's a small world was designed by Marc Davis as an international boat tour of music and magic. Walt Disney brought Mary Blair in to work with Marc on the art direction and sets. It was a fortuitous transition for Blair, as her distinctive art direction and color treatments on Small World set the tone for this iconic world tour. "She wasn't always happy with how her artwork got translated to animation," Joyce Carlson recalled of Blair, "but she was happy with the finished product of Small World."

As a former Ink & Paint artist, Carlson was brought on to work directly with Blair, fashioning the props and environments for each country. The World's Fair attractions opened a welcome opportunity for Carlson after the end of Inking due to the advent of Xerox. Carlson created and painted the various toys and props for it's a small world. "Mary would let us put our ideas together, she'd pick things we'd do and put them in the show. It was something I was looking for like when I was in Ink & Paint—something creative." Carlson also developed and created the sets for the General Electric show, Carousel of Progress.

For Alice Davis, designing the costumes for both it's a small world and the Carousel of Progress was one of the greatest opportunities imaginable. With only a handful of months to design, source, and manufacture the costumes, Walt Disney gave a clear directive. As Alice recalled, "He told me, 'I want you to use the best materials you can find.' Walt always insisted, 'If you give people the best, they'll always come back for more, [and] if you cheat them, they won't come back.'" Working to accurately portray the detail of the costume creations for each country, Alice took Walt's advice to heart as she designed and tailored over three hundred costumes for "the world's greatest doll collection."

Publicist Arlene Ludwig got her start at Disney Publicity with the World's Fair. "I just loved every moment of that," Ludwig stated. Working with the studio staff and various VIPs, Ludwig was regularly on site. "It was a very, very thrilling experience."

In support of her teams, Blair spoke with Walt about bringing the artists who created the attractions to New York to experience the fair firsthand. "We got to go to New York for ten days. It was great," said Carlson. "Walt gave us each three hundred dollars cash spending money. Boy, that was quite a bit in 1964!" Walt valued the experiences and observations of his traveling staff. As Carlson noted, "We had to write up what we thought of the ride and if we had any ideas for them. Walt would read those folders when we brought them back home." Traveling to the World's Fair with her husband, Bill Bosché, Inker Lucile Williams Bosché recalled, "We were on the company plane. Walt sat with us and he asked Bill, 'Well, were you two a studio romance like Lilly and I were?'" Bill said, 'Oh, yes!' And Walt turned to me and said, 'Well, I hope you don't have to turn over your paycheck as Lilly did for me, [so] that we could build the studio.'"

THE WOMAN WHO SAID NO TO WALT

"The book had been sitting around our house for a long time," recalled Diane Disney Miller of *Mary Poppins*. "I read it as a child." Hearing Diane giggling over the stories of the magical nanny, Walt read her copy in the early 1940s and later assigned his

Legendary Costume Designer Alice Davis makes final adjustments to her dolls for it's a small world.

studio story analysts and writers Inez Cocke and Peggy Connell to explore the feasibilies of bringing this children's classic to the screen. Connell's structural breakdowns as well as character and story analysis were key to translating *Mary Poppins* to cinematic life, but it would take over twenty years to make this masterpiece a reality. "It was P. L. Travers," noted Diane of this delay. "It was getting her approval to do it."

It seems Travers was not a fan of animation and quite vocal in her dislike of Walt's treatment of fairy tales. Through correspondence and visits with Roy Disney, Travers was stalwart in her resolve, yet Walt was equally determined. While in production on a live-action film in London, Walt paid her a visit. "She enjoyed male company. No doubt she warmed to Walt Disney immediately," recalled author Brian Sibley, who knew Travers in her later years. "He clearly worked his charm on Mrs. Travers, because by the time the meeting had come to an end, she was prepared to discuss how the film might be made . . . as a live-action film."

"We didn't even know P. L. Travers was a woman," recalled legendary Songwriter Richard Sherman. "Walt handed us the book of *Mary Poppins* and said[,] 'I want you to read this and tell me what you think.' We never talked about who it was until the day he said, 'You gotta meet this lady now, she's a little difficult, but we gotta get this thing done, so get her to say yes!'" laughed Richard as he reflected on working with the recalcitrant Pamela Travers.

Reviewing casting choices for his magical nanny, it was Walt's secretary Tommie Wilck who suggested Julie Andrews for the lead and sent Walt to see her performance in *Camelot* on Broadway. Winning the role, Andrews recalled her first encounter with Travers: "I knew that she was tough, I had met her in London and we did correspond." Finally approving of Andrews, Travers stated: "Yes, yes, you'll do. You're too pretty, of course, but you've got the nose for it."

Casting continued as the screenplay and music were under way. Sherman noted, "We were doing a number in a hurry . . . trying to get Glynis Johns for the Mother role[,] and we had to write a song for her to sing. We decided we'd have her be a suffragette and she'd be singing their marching song. We had to create something overnight practically. On the second floor of the Animation Building, there was the Disney Research Library—the Researchers, they were marvelous!" Longtime Librarian and Researcher Caroline Jackson, as well as Mary Jean Kenney, provided detailed insights and materials to support the filmmakers. "All you had to do is call up and ask these gals 'anything on suffragettes, or chimney sweeps?'" Sherman noted, "and they'd come up with a pile of books, articles[,] and things to keep you going! We didn't have the Internet—you couldn't just look it up like you do now. You'd have to have somebody research it and they were the perfect resource people to go to! They were very, very vital to all of the people who were working on productions."

With the film's lead still in London, Painter Grace Godino was called in to help with production. "I did a looping for Julie Andrews in *Mary Poppins*. She was in England at the time[,] and so the Sherman brothers wanted some looping done on some of the scenes [where] she was going to sing this little Cockney type thing." Godino's versatile voicing served the purpose.

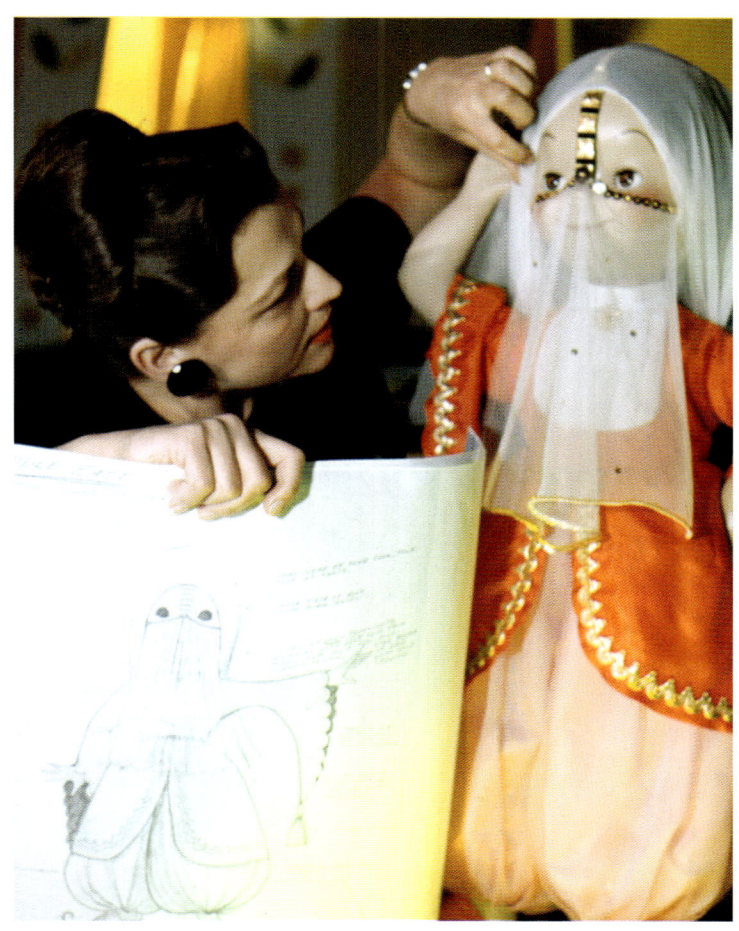

> "*We decided to try something that would employ about every trick we had learned in the making of films.*"
>
> —**Walt Disney**

AN ANIMATED INSPIRATION

Proceeding forward with the live-action screenplay, Richard Sherman recalled how one of the most unforgettable animated sequences came about. "It was like a bombshell! I was in the middle of singing a song Bob and I had just finished called 'Jolly Holiday.' We came to a section of the song where a quartet of waiters was going to come out and sing, 'Order what you will, there'll be no bill. It's complimentary.' [Then Walt] said, 'Hold it. Waiters always remind me of penguins. I think we should have penguins as the waiters. . . . We'll animated the penguins.' Bob and I were dumbfounded. Walt said, 'All the principal players will be live action, and everything else will be animation. It'll work!'"

But when P. L. Travers arrived at the Burbank studios to discover that the story under way was not quite what she agreed to for "her Mary," she insisted that animation was out of the question. As preproduction continued, Walt persisted with his vision of incorporating animation, guiding his teams at Disney

296 | Transition: Triumphs & Loss

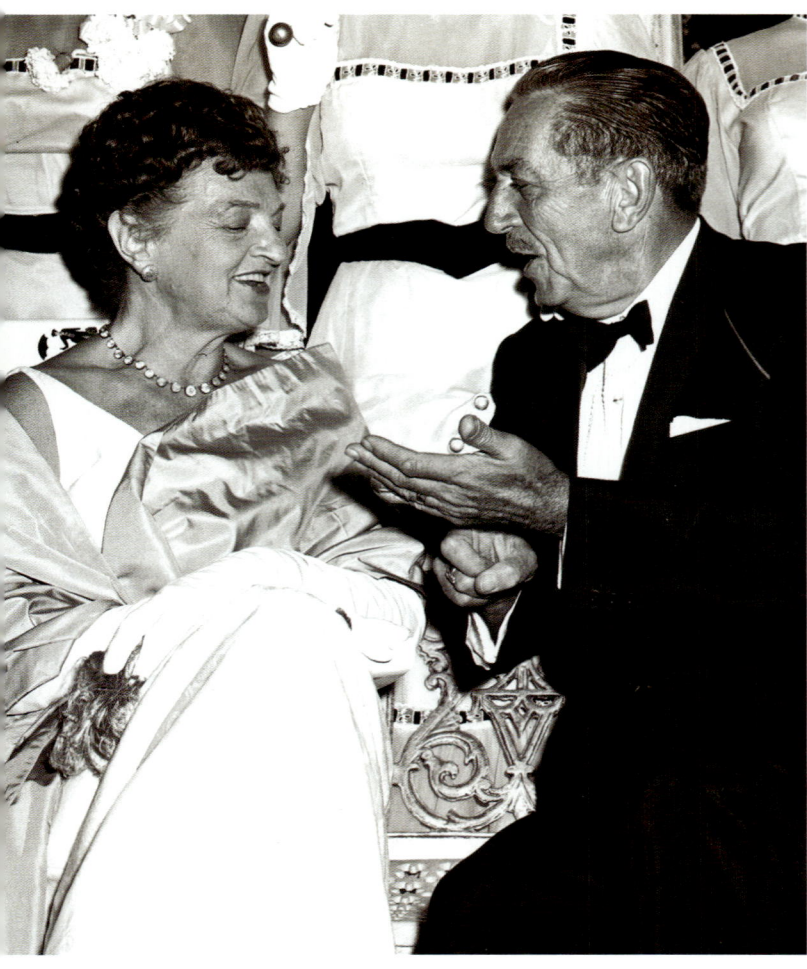

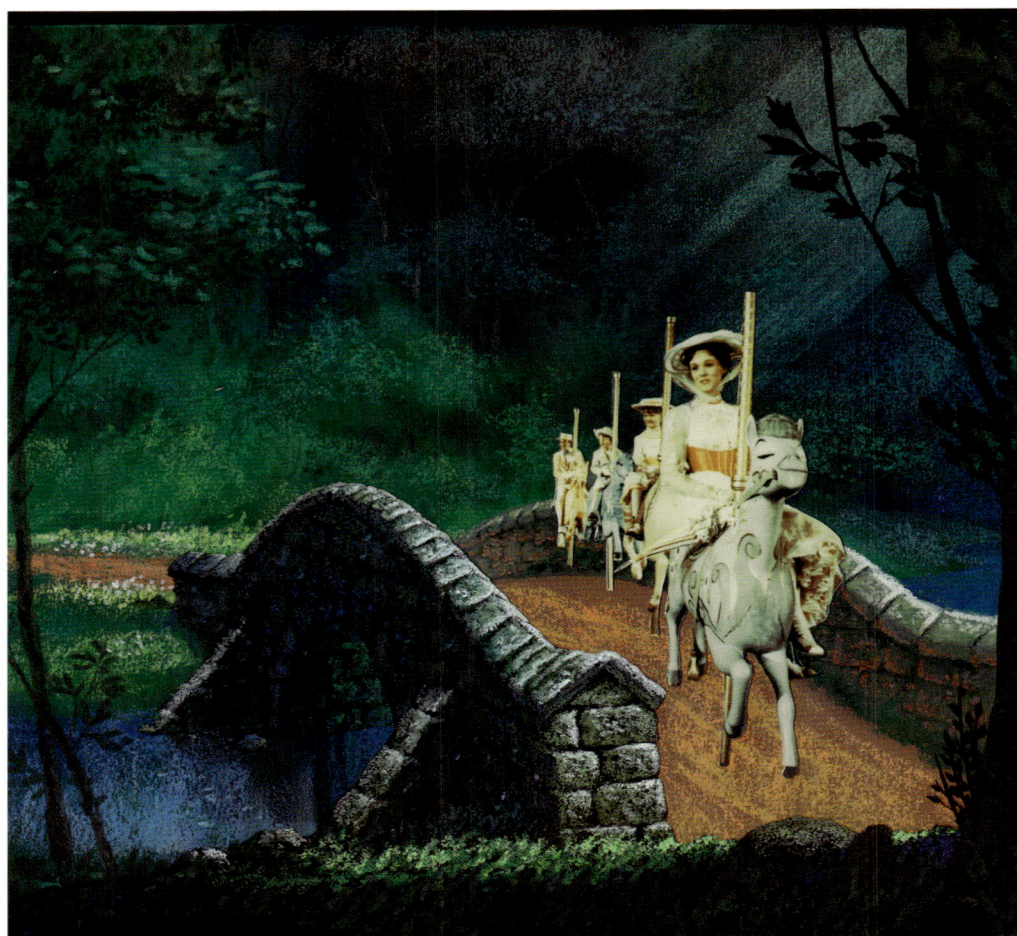

Left: Mary Poppins author Pamela Travers and Walt Disney at the film's 1964 premiere.

Right: Final film frame featuring live-action cast within the animated world of *Mary Poppins* (1964).

Studios into forming one of the most vividly colorful and magical sequences every captured on film.

With the advent of the sodium vapor process, production on the animated portions presented new territory for the cast. Working on a blackened soundstage, it was a challenge for the cast to image the colorfully animated world they would eventually be playing in. "Because the special effects were filled in later," recalled Karen Dotrice, who portrayed Jane Banks, "we had these large, sweaty Prop guys in braces dancing about with cutout horses and penguins to show us what was going on. They both tried hard not to cuss in front of us children." Richard added, "Walt loved women and was very respectful of them. He wouldn't allow anybody to tell an off-color story if a woman was in the room. He was conscious of the fact that ladies should be respected."

Though the concept of live action and animation wasn't new, the sodium vapor process required additional care to achieve a believable blend. The timing and intricacies required long days for capturing the live action accurately to integrate with animation. "There were so many retakes of the 'Supercalifragilistic' scene," Dotrice remembered, "that we got sick of the toffee apples we were supposed to be eating. So the Prop guys would let us order whatever flavor we wanted for the next day's shoot."

PAINTING *POPPINS*

Through Walt's vision, the colorful world of character Bert's pastel pictures came to life within the corridors of Ink & Paint. "It was a remarkable department that they had," Richard Sherman declared. "Without the ladies of Ink & Paint, we wouldn't have color pictures. They would work tirelessly and brilliantly—they were incredible!"

As production expanded, color lines were soon required of the Xerox process. Once again, Ub Iwerks worked to develop the tools and materials to work with color lines, though limitations were still prevalent as only one color was possible at a time. "They had colors. [The] Effects Department [utilized] a lot of different colors, [such as] brown and red and orange for flames," Becky Fallberg explained. "If they didn't have colors, then they would ink them. Say they wanted to put white on [a cel. They'd] Xerox the whole scene with white and then they'd come back and they'd put another color on the same cel. And maybe if you had fireworks . . . you're going to have to make up quite a few repeat jobs [with different colors]. Sometimes, it would build up the toner . . . on the cel and it wouldn't take any more. There were a lot of technical problems to work out."

Troubleshooting with any number of story or logistical challenges was a large part of the department's regular responsibilities, and such was the case with *Mary Poppins*. "We used to get those long, long background boards, coming to the Xerox department," recalled Becky Fallberg. "Well, you had to have a long narrow room to get them under the fuser[,] because they would only shoot a section at a time and then you move it [across the scene] and it has to register so that it doesn't [wipe] off."

WALT'S GREATEST ACHIEVEMENT

Working at the New York office, Arlene Ludwig stepped into various publicity efforts with publicizing *Mary Poppins* and the world of Walt Disney animation. Ludwig recalled, "Back then it was

Production cel piece of the Pearly Band from *Mary Poppins* (1964).

such a family operation. Our Art Department—the Art Director and the Copywriter—they did everything in house, they created the campaigns. I don't even know if the Producers got final approvals[,] because the producers were also in-house producers. They rotated from one movie to another movie. . . . Everybody was employed by Disney."

With publicity campaigns, packaging, and promotion in place, Walt Disney's greatest achievement was poised for its debut. Hollywood glitterati came out as Grauman's Chinese Theatre featured a star-studded event. "Yes, the premiere was a grand night," said Richard Sherman. "That was my very first world premiere and it was amazing. I could barely sit while they were running the film. When the film was over, there was cheering and applause and it was a much-deserved tribute to Walt. He did all the magical things he was famous for in one picture." Yet even at the *Poppins* premiere, Sherman recalled how animation still presented problems for P. L. Travers, "As we were leaving the theater, Mrs. Travers approached Walt and insisted that they start over, beginning with removing the entire animated sequence. To which Walt replied, 'Pamela, the ship has sailed.'"

1960s STUDIO LIFE

Dress codes were still strongly enforced. "Wearing slacks? No. Definitely not at Disney, it just wasn't done," laughed Eleanor Dahlen. Carmen Sanderson recalled, "Grace Bailey was pretty strict and we were not allowed to wear pants—maybe on Saturdays when we worked overtime—but otherwise they did have the dress code. I remember the gal in our department that wore miniskirts. . . . She had been a model part-time; she was tall, slim, had the boots and the miniskirt. I kept telling her, 'Don't wear miniskirts,' and she played Ping-Pong all the time but without a slip. I guess somebody made a comment and she was called in. Well, she was so upset, but those were the rules. Grace wanted the Ink & Paint gals to look decent."

"They still had all kinds of names for us," laughed Ginni Mack. "We were called 'Stinker and Fainters.'" Parties and celebrations continued, and the legend of the "Tunnel of Love" that connected the Animation and Ink & Paint buildings was still intact. "But that wasn't just what the tunnel was about," Carmen Sanderson noted. "The telephone operators and switchboards were downstairs, too."

Creative talents among the studio staff branched out to the dramatic arts as the Disney Players mounted several stage productions in the studio theater. Auditions were open to all studio employees, and a wide array of theatrical fare was mounted. Delightful productions of *The Whole Darn Shootin' Match* and *The Best Laid Plans* hit the boards where studio employees stepped into the spotlight.

Far from community theater, the casts featured talented amateurs alongside box-office stars particularly in the Disney Players' 1963 production of the 1956 Broadway play *The Happiest Millionaire*, which featured Brian Keith as Anthony Biddle. The production was such a success, Walt purchased the film rights, and the Sherman Brothers' musical adaptation later became one of the studio's last live-action film productions to be overseen by Walt.

As the studio marked its fourth decade, many of the longtime employees now had children reaching high school. The studio served as a source of summer jobs for many of the

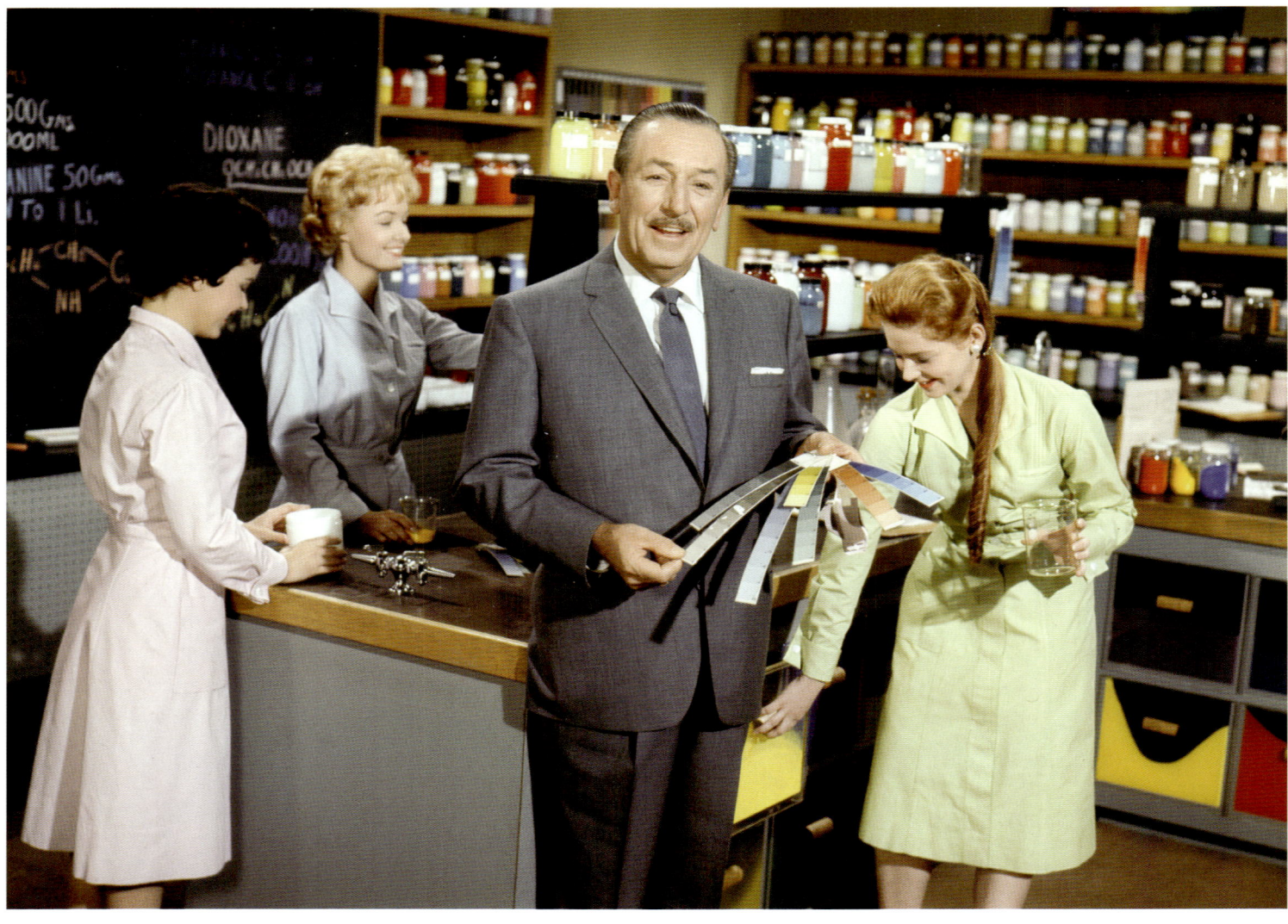

Recreating the Ink & Paint Department on a soundstage, Walt Disney features Ink & Paint artists (including former Mouseketeer, Bonnie Lynn Field—right) in an opening sequence for *An Adventure in Color/Mathmagic Land* (1961).

second-generation staffers. "I did work at the studio for several summers," remembered Peggy Luske-Finefrock, daughter of Director Ham Luske. "I was sixteen that first summer. I worked in the steno pool because I could type. When one of the secretaries would take a vacation, I would fill in. I remember being in Roy Disney's office for a week. I felt very special being there. It was a busy place and an awesome environment to work in. Several studio people's daughters worked there at the Disney Studio various summers. I felt that it was like one big family."

Joan-Patricia O'Connor, daughter of Animator Ken O'Connor, agreed, "We affectionately referred to ourselves as 'Disney Brats,' but it was such a special part of our childhood." Steve McAvoy II, the son of Painter Mary ("Scotty") McAvoy and longtime lab Chemist Steve McAvoy Sr., grew up on the lot. "I took my first step at the corner of the Commissary at the original Animation Building, test drove the first Autopia cars for Walt on the backlot, and was present on the opening day of Disneyland. I worked part-time during the early 1960s for the Walt Disney Music Company." One particular second-generation employee of the Disney family became a steady worker in various roles across the lot. "I knew he [Walt] was keeping track of me," Walt's daughter Sharon recalled. "Not where I was, but he knew if I was late. And he called personnel every so often to find out if I was goofing off or not. During the two years I worked there, he was very proud that every morning I arrived on time and never left until the end of the day."

MALE BONDING

The men of the Ink & Paint Department were a tight-knit group within this feminine stronghold. Master chemist Emilio Bianchi, a quiet, patient man, enjoyed working with the women but often aligned with a number of men, assisting in Special Effects and the Process Lab. He also sought time with Ub Iwerks and Eustace Lycett. "He knew Walt Disney real well," recalled Bianchi's son Ed. "He'd go up to the Sweatbox and Walt would be running the dailies in the morning of the things they shot the day before." Bianchi's paints were the favored blends of the Inkers and Painters. "They were hardworking women," noted Ed Bianchi. "They asked my father to become the manager of the Ink & Paint Department and he took the job, but less than a year later he came home one day and said he thought he was going to have a heart attack, it was too much pressure. He went back to his work supervising the Paint Lab and that was the end of that."

Longtime Lab Technician and Chemist Steve McAvoy was an equally personable presence. "My father was a wonderful man," recalled his son, Steve McAvoy II. "He got along with all of the ladies very well." Working his way up from Jar Washer to Chemist, the elder McAvoy was one of the leading experts in paint applications for animation and a constant presence in the department. "He was also a man in a woman's world," noted his son. "That's probably why my father went out of the department so much.... He wanted the companionship of other men. He would go out on the backstreet and talk to the guys working on the back lot."

Xerox production teams including Robyn Roberts (left), and Janet Zoll (right) in the Finishing room.

Of the other department men, the younger McAvoy remembered, "Ray Owens and Carlos Guice [Lab Technicians/Jar Washers] were always good to me when I was around as a kid!" Joyce Carlson acknowledged another gentleman of the department: "We had one fella, Lloyd Winegardner, who punched the cels." Winegardner trimmed and punched cels and paper to the numerous specialized sizes as needed for each department and production. A tremendous lover of movies and always ready with the latest gossip, he was affectionately known as "Lloydie" to the girls of Ink & Paint.

The company of men could also be found in the long-standing Penthouse Club. This male-only answer to the ladies-only Tea Room provided the men refuge from the pressures of production. When the studio first opened, the Penthouse Club was a members-only club with fees assessed, which only the higher-paid male staff could afford. "We would be glad to allow any fellow who is decent and respectable to belong to it," Walt announced. "However, at the start we had to allow those men who carry the main responsibilities of the studio the first chance to join. After giving those men their chance, we then threw it open to the whole group."

Artist Harper Goff noted of this masculine domain, "I was invited to go up to the Penthouse Club where they had their own cook and people had special diets and you could exercise up there." In addition to a small dining area, other amenities included a bar, a full gym, and a barbershop, as well as a masseur and steam baths. The rooftop patio included tables and umbrellas, but the most popular activity was nude sunbathing. This ritual eventually ended when the hospital across the street added a four-story wing and the nuns who worked there complained.

OTHER STUDIOS

Across the industry, trying to find work after the Xerox transition was challenging. Private inking services continued as television animation and most of the other studios were still hand-inking. Joanna Romersa experienced the limitations of other studios: "Women were primarily ink and paint. That's all[,] folks, no mistake about it." While some of the skilled and trained Inkers made the transition into Inbetweening and Assistant Animation work, the industry-wide workplace dynamics made it difficult. "Not many [women] got into animation because it was too tough," Joanna added. "There were some wonderful men, but I have to tell you, most of those men made our lives miserable. They were just awful. They would give you the worst stuff to animate . . . the hardest. . . . They used to call it the 'Under Water Ballet Scenes.' It's hard, because until you get the good stuff [to animate] people don't recognize you as a good Animator, even though you can make busy stuff look good. If it was complicated, they gave it to the newer people[,] and a lot of women just couldn't deal with it. . . . At Hanna-Barbera when I was assisting [animating], they just made it too hard on you. The [man] in charge of animation was the worst chauvinist I have ever met in my life. . . . He hated women, he really did." Romersa was also subjected to blatant sexual harassment: "[He] used to love to give massages . . . then it was over the shoulder and then [grabbing]. One day I had enough of this and I just screamed as loud as I could, . . . 'Get your hands off my boobs!' And he never touched me again."

Often given impossible deadlines, Romersa would stay up all night to complete the scenes given her. "I was very tenacious. I'd taken a shower, did my makeup, went into the studio, and turned in the work and smiled. They'd give me another one and then I'd work all day . . . just to prove that I could do it." Often typecast with the scenes given to her, Romersa stayed with it. "I always did women and feminine characters well. But I very quickly learned how to draw Superman."

"Speaking of chauvinists," recalled Animator Joan Orbison of her time at Hanna-Barbera, "[there] was a chaser, a real womanizer, always draping himself over all the gals[,] and this guy came up and said, 'Well, you got a pretty good place here. . . . Have you got an Assistant?' I said, yes. He said, 'Well, where is she?' In other words, I had to have a woman Assistant; a man would never want to be [my Assistant]. As a matter of fact, I had several men Assistants."

Freelancing for various studios or independent ink-and-paint services such as Marion O'Callahan's Ink & Paint Studio provided a flexible option for many working mothers. After leaving Disney to raise her children, Rae Medby later worked at Hanna-Barbera, where she could take work home to complete. At her inking desk in a corner of her kitchen, "she would stay up all hours of the night—that's when she did her best work," recalled her son Kelly. "She would be doing raindrops or wind or some tedious little thing and all of a sudden the cat would circle around and bite her. Mom had forgotten to feed the cat."

After raising her family, Disney-trained Inker Eleanor Dahlen took work at Hanna-Barbera. "When I came back, the Inkers had never been trained. It wasn't Disney quality. Even after a break of a number of years, I was faster than anyone there because there wasn't a quota anymore and I was used to working on a quota.

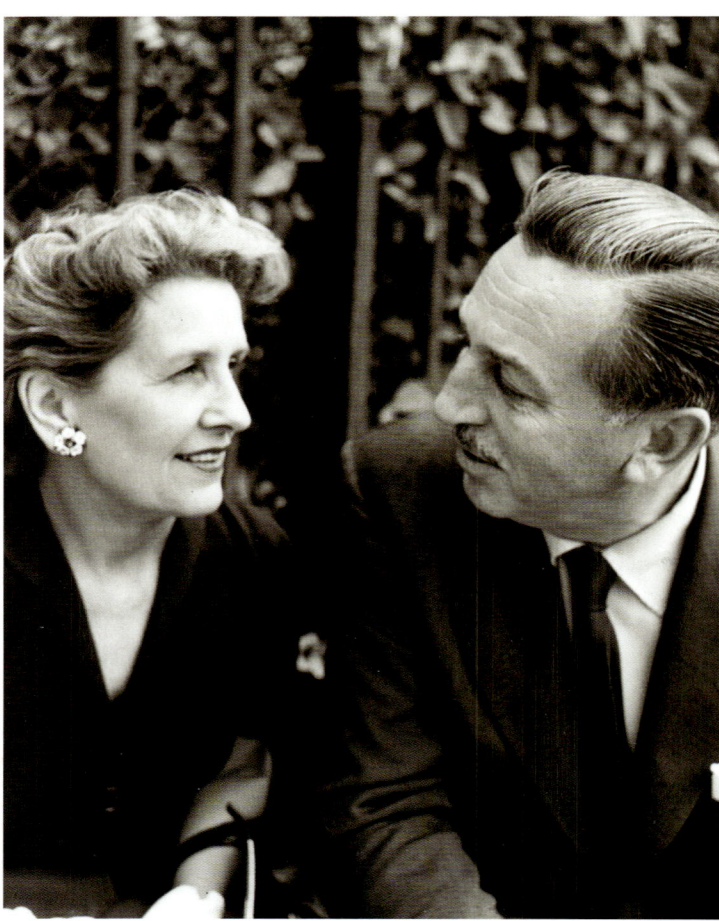

Lillian and Walt in a quiet moment together.

We'd be inking eye blinks all day long and I was sitting next to a girl who would be so irritated[,] and she would hear three swishes before she'd get one cel done, and she'd say[, 'Would] you slow down?' and I'd say[,] 'I can't.' You get a rhythm going and you have to keep going. I have to work at my speed. It's a flow. A rhythm. Otherwise it absolutely shows up in the work!"

Storyboard artist and Animator Shirley Silvey drew extensively for classic television of the day. Ruth Kissane apprenticed at Disney Studios as an Inbetweener in the mid-1950s, and her career as a rare woman Animator expanded in the 1960s in television animation, features, and documentaries. "I loved her," recalled Mary Jane Frost of her longtime friend. "She went on and became one of the top Animators." Within her thirty-year career as an elite Animator, Kissane worked at all the major studios, codirected an animated feature, and received the Festival de Cannes and Winsor McCay awards for her work in animation.

KEEPING WALT ON TRACK

"In those days, my God, there were lots of women—everywhere," observed legendary songwriter Richard Sherman. "I was very much involved in so many projects with Walt [Disney] and the women that worked at the studio, [and] they were integral—a major part of the studio." Women had long held creative and supervisory roles in animation, and this was the case in live-action films as well. Times and attitudes were changing. "I never thought of them as ladies—they were talent," noted Sherman. "You worked with guys and with gals and they were just the people that did these things. There was no separation in that regard."

For the Sherman Brothers' many interactions with Walt during productions, one woman's role was vital: "Walt's Secretary, Tommie Wilck, she was the brains behind all of it," recalled Richard Sherman. "She kept him going from one job to the next—keeping notes on what he did and where he was going to be.... She was so great; and Dolores Voght[,] his other secretary—two people who worked round the clock for him. It was just amazing how he functioned beautifully because of the women around him, and he was always highly respectful of these women."

Walt referred to Wilck as his "Secretary of the Exterior" and Voght as "Secretary of the Interior." A strong persona who was one of the few who could stand up to Walt, Wilck recalled her days of working for the boss. "He was awfully good to me, and we really did have a lot of fun together. I got mad at him and he got mad at me, but it was seldom personal. He was a tremendous idea man. He knew how to spark other people with his ideas."

Keeping Walt Disney on track was more than a full-time job for these ladies. As Wilck noted, "We gave him every day a little slip of paper the night before telling him what his appointments were for the day[,] and then he had a card on his desk telling what his appointments were for the week [and] the rest of the year."

Wilck described a typical day at the studio for Walt Disney: "Usually when he first came on the lot he'd go out and check the stages. He started out in Room Twelve at nine thirty [a.m.] looking at ... a rerecorded track. This particular day he had lunch with Merle Oberon and [another guest]. Hedda Hopper would come in about once a year to have lunch with him. He would prowl after lunch, usually. Go out to the stages. And about two o'clock then he might come back here and have a meeting until four. Dailies were always run at four o'clock when they were shooting anything.

"And he would go to the dailies and then he would come back here," she added. "He'd usually take care of his phone calls then—four thirty and five.... At five I'd call Hazel George." Tommie mixed Walt's regular Scotch Mist at the end of the day, noting, "I would put ice and water in it and then float the Scotch on top and not give him very much of it."

DISNEY FAMILY LIFE

After nearly forty years together, and their daughters grown and married, Walt and Lillian continued to enjoy each other's company in the quiet comfort of their Holmby Hills home. "He was my whole life, too," Lillian Disney stated. "We wanted each other's presence. I would read. He would read scripts. I would want to see the news on TV and he wanted to be outside on the patio, so he put a television outside." Sunday nights, Walt and Lillian could be found dining together while watching the *Wonderful World of Color*.

Walt and Lillian continued to travel, enjoying weekends at their desert home at Smoke Tree Ranch. As grandparents, the Disneys hosted their growing brood of grandchildren on frequent adventures. The final trip Walt enjoyed with his entire family was a cruise through British Columbia in the summer of 1966. Diane Disney Miller remembered this cruise fondly. "We had all my children from Chris down to little two-year-old Ronnie as well as Sharon, her husband Bob, and their little baby, Victoria, who was about six months old. It was an idyllic trip."

Newspaper artwork reflecting the world's reaction to Walt Disney's passing, December 15, 1966.

> "*Everyone knew him or felt they knew him, and his presence was felt everywhere.*"
> —Peggy Finefrock, stenographer

SAYING GOOD-BYE

As Walt's daughter Diane recalled, "That summer . . . he didn't know he was ill at that time. I didn't sense that at all." But by October, things had changed. "He had what he thought was an old polo injury," Miller continued, "but in X-rays, they saw a lump in his lung. That was the first sign." Walt's beloved wife Lillian reflected, "I think he told the doctors what to do like he told everyone else. He hated illness."

"The last time I saw him was when he was quite ill," remembered Grace Godino, "and he was walking across the lot and I was with Grace Bailey. Walt was walking toward St. Joseph's and he said, 'Hello, girls,' to both of us and then he said, 'Good-bye, girls.' And walked on and he went to St. Joseph's and he died, so, it was a memory that stays with me because it was just sweet." Inker Marge Hudson agreed. "Everyone was just depressed. They knew he was sick[,] but we didn't know how sick. I understand he had a room at the hospital and that he could see the Animators leaving early. . . . Sounds like him, just keeping an eye on things." Margaret Trindade often recalled how hundreds of studio staff lined the parking lot facing St. Joseph's Hospital where Walt could see them in early December and singing "Happy Birthday" to him. That was the last time many of the staff saw him. As Miller remembered, "From his first knowing . . . I remember six weeks, then he was gone."

On December 15, 1966, the studio employees were given the news. "We were working and it came through," recalled Carmen Sanderson. "We were just told [he passed]. Everyone was pretty upset. . . . They said the studio was closed. Everyone was shocked." For longtime employee Ruthie Tompson, it was "a horrible shock. I went home and my mother was sitting there with a long face, and my young cousin was just back from Vietnam. . . . Not a peep out of either of 'em. We were all sick. Real sick." Roy issued a statement later that day: "His entertainment was an international language," the elder Disney wrote. "He built a unique organization. A team of creative people that he was justifiably proud of." Expressing Walt's unique dedication to the impact of entertainment, Roy ended with this assurance: "All the plans for the future that Walt had begun—will continue to move ahead. That is the way Walt wanted it to be."

TALL TREES

Just as the civil rights movement of the 1960s marked a necessary transition for the world at large, life at the studio endured dramatic changes as well. A zenith was reached for Walt Disney with the success of *Mary Poppins*. A well-trained staff, seasoned talent, and the expansion of technology brought the Walt Disney Studios to a new level as a leader in redefining the entertainment industry. Yet with Walt's unexpected passing, industry watchers felt that the stability of the company was rocked. It was Walt's older brother Roy Disney, the financial mastermind behind Walt's visions, who stepped in to helm the studio. In a 1967 company report, Roy eased fears: "Sometimes I think we all get too close to the proverbial forest to see the trees we have been growing. We have a lot of very tall trees that Walt planted over the years. And in the years to come, these trees will keep right on growing and maturing all over the world. Our company, and Walt's name . . . is a name that is good—more than good—anywhere in the world. So never sell yourselves, or the company, short."

Though Walt Disney World was still years away from completion, Roy stepped in to spearhead the progress. Various leaders of industry were also keen to participate in the showcase envisioned for their technologies and products exploring the "world of tomorrow." As Roy recalled, "Disney World" was easily the most exciting idea everyone wanted to discuss." By 1967, legislation was signed into law by the governor of Florida to establish the legal foundations necessary to build one of Walt's greatest visions.

INTO THE JUNGLE

The last animated feature in which Walt Disney personally oversaw, *The Jungle Book*, marked a pivotal point in animation history. Without the presence of Walt Disney at the helm, the world wondered if Disney animation could continue. "It was always 'that is how Walt would want it,'" noted Publicist Arlene Ludwig. "We always felt[, 'We've] got to make this one right.' But with Walt, we felt that way on everything that was done."

Production continued on the Disney take on Rudyard Kipling's classic book. "They were advertising for a Background Painter[,] and the union called me because they knew I was a pretty good Painter," recalled former Inker Annie Guenther. "They gave me a test on a *Lady and the Tramp* background and said, 'We've had a lot of people coming through, [but] take this home and make a duplicate of it.' So I did. I painted my heart out—shadow for shadow—and I took it back to Disney. I thought I'd never get the job."

Guenther's artwork was reviewed by Woolie Reitherman, Ken Anderson, Eric Larson, and Don Griffith. "Three weeks later, I got a call at ten o'clock at night," remembered Guenther. "It was Don Duckwall calling. Out of the two thousand people that applied, I got the job." Under the direction of Al Dempster, Guenther became the next female artist to join the ranks of the legendary Background Department. She recalled working with Thelma Witmer, the first woman to receive film credit for her backgrounds. "She had been there forever. They named a paint color after her. Red—Witmer Red."

Learning the ropes from her colleagues, Guenther noted, "I didn't have much experience, so I did touch-up work on *Jungle Book*. I learned to badger-brush better and I had to learn all about clouds—cumulus, cirrus. They told me that whatever I paint, I had to have research in front of me for accuracy. Al Dempster said, 'Don't ever let me catch you without research.' The Research Librarians did all the research and would bring it to me to use for each film." Witmer, Guenther, and the Background team collaborated with Effects Animators to bring the lush world of Kipling's stories to life. Glistening streams bathed in shimmering moonlight marked a newly stylized environment, which heightened the drama and delight of the animated Indian jungles.

Many of the various production departments now featured staff with over twenty years of Disney experience who had helped to develop and advance the art of animation. With the overall Ink & Paint staff now down to about seventy, the six departments each featured specialization in their functions: Animation Check, Color Models, Paint Lab, Xerox, Painting, and Final Check. Ruthie Tompson and Katherine Kerwin covered Animation Check, where each of the four women of the department had over twenty years of Disney experience. Since the Xerox process had been introduced, Ub Iwerks had continually expanded and developed the capabilities of the process. With four machines in operation utilizing twelve-and-a-half-by-sixteen-inch sheets of acetate cels, a staff of twenty-eight operators (plus the Xerox Checkers) could produce sixty cels in one hour, which would have taken forty hours when inked by hand.

Disney voice legend Verna Felton was featured as one of the elephants, and young Darlene Carr provided the haunting vocals of the village girl who lures young Mowgli back to the Man village with her siren's song. Again, Sylvia Roemer on layout, Thelma Witmer in Backgrounds, and Evelyn Kennedy as Music Editor are the feminine presence on the film's credits. Once the credits rolled, the fans and critics responded alike. As *Time* magazine noted, "The reasons for its success lie in Disney's own unfettered animal spirits, his ability to be childlike without being childish. . . . It is the happiest possible way to remember Walt Disney."

Ink & Paint | 303

Above: Cel setup from Walt Disney's classic *The Jungle Book* (1967).

Bottom, right and left: Product on cels of the Girl and Mowgli from *The Jungle Book* (1967).

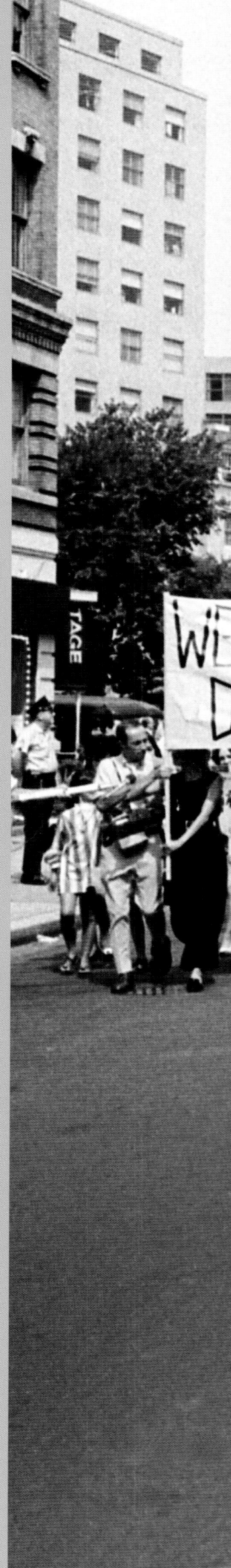

THE 1970s

1970
- The Beatles break up
- Computer floppy disks are first introduced
- The Kent State shootings occur
- Diane Crump becomes the first female jockey in the Kentucky Derby

1971
- Greenpeace is founded
- VCRs are introduced
- Jim Morrison of the Doors dies
- *Ms.* magazine is first published as a sample insert in *New York Magazine*

1972
- Terrorists attack at the Munich Olympic Games, killing the Israeli fencing team
- Pocket calculators are introduced
- The Watergate break-in occurs and the scandal begins
- Representative Shirley Chisholm runs for the Democratic presidential nomination

1973
- *Roe v. Wade* legalizes abortion in the United States
- The first handheld mobile phone is created
- The United States pulls out of Vietnam
- Women can now serve on juries in all fifty states

1974
- Russian dancer Mikhail Baryshnikov defects to the United States
- President Richard Nixon resigns
- Congress prohibits housing discrimination against women
- The Equal Credit Opportunity Act permits women to obtain credit cards

1975
- Arthur Ashe becomes the first African American man to win Wimbledon
- Former Teamsters Union leader Jimmy Hoffa goes missing
- Microsoft is founded
- *Saturday Night Live* debuts

1976
- Sarah Caldwell is the first woman to conduct the New York Metropolitan Opera
- Steve Jobs and Steve Wozniak form the Apple Computer Company
- The first class of women is inducted into the United States Naval Academy
- The Concorde begins commercial flights

1977
- Elvis Presley is found dead
- The landmark miniseries *Roots* airs
- *Star Wars*, the first of the landmark film series, is released
- Patricia Harris is the first female African American cabinet member

1978
- The first test-tube baby is born
- John Paul II becomes Pope
- The Jonestown massacre occurs
- The Pregnancy Discrimination Act is passed

1979
- Iran takes American hostages in Tehran
- Margaret Thatcher is the first female prime minister of Great Britain
- Mother Teresa is awarded the Nobel Peace Prize
- Sony introduces the Walkman

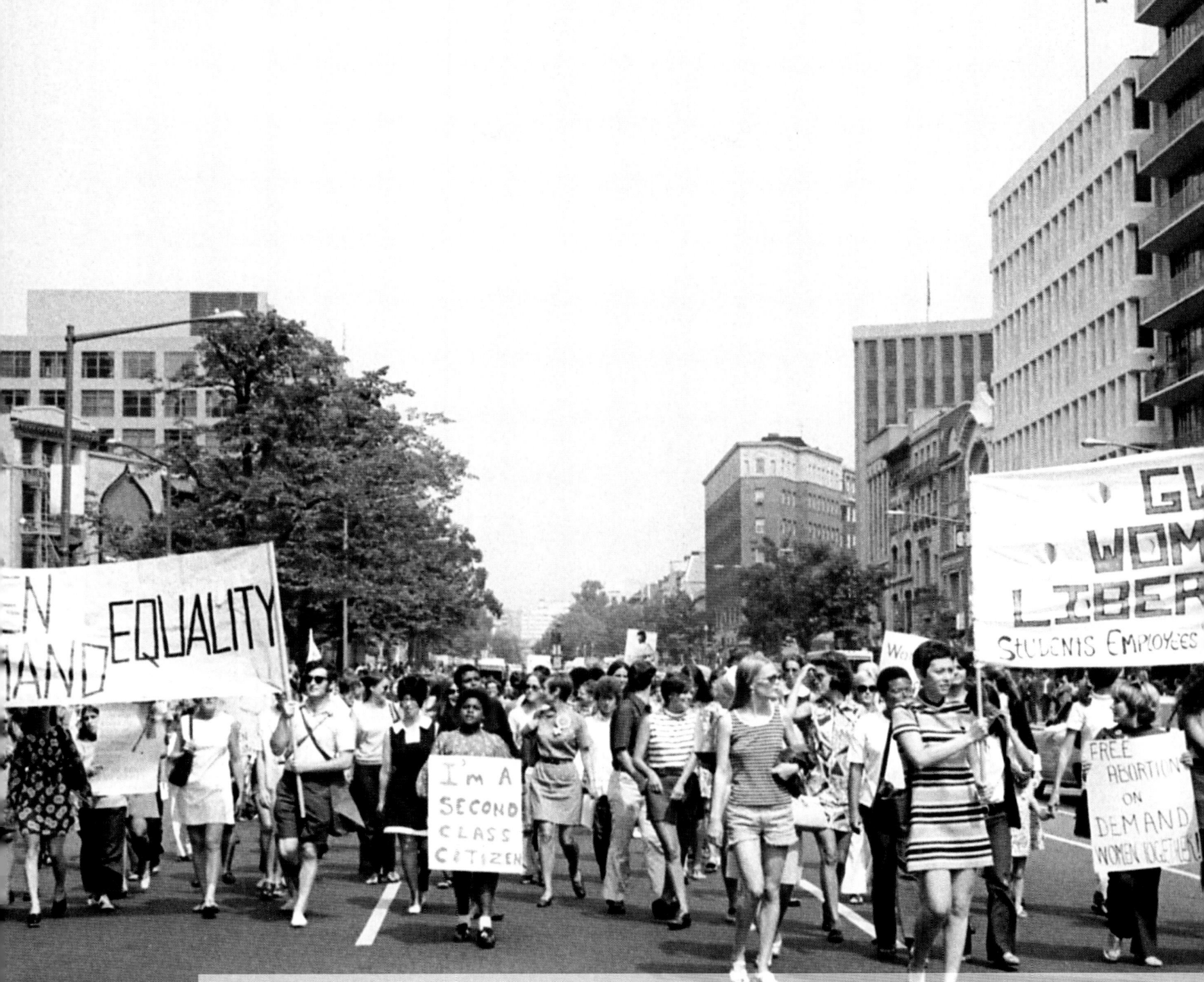

THE FEMINIST MOVEMENT

Despite its origins as a cigarette slogan, "You've come a long way, baby!" became the declaration of this era's women's movement. The first issue of *Ms.* magazine hit the newsstand, and its editor, Gloria Steinem, became an icon for modern feminists. Women constituted nearly half of the workforce, with both parents working in almost 70 percent of families. The phrase "sexual harassment" entered office vernacular, and for the first time in US history, with the passage of the Pregnancy Discrimination Act, employment discrimination against women who were or might eventually become pregnant was legally banned.

Gender superiority was challenged on a tennis court in the "Battle of the Sexes" between an aging tennis pro, Bobby Riggs, and one of the top-ranked women players, Billie Jean King. The camped-up event resonated for generations of women when King won handily. Women officially ran in the Boston Marathon for the first time, with Nina Kuscsik registering the fastest time. The first perfect scores in any Summer Olympics athletic competition were recorded by Romanian gymnast Nadia Comăneci in 1976.

Disco was king, and nightclubs were "Stayin' Alive" with ABBA's "Dancing Queen," while newly adopted no-fault divorce laws brought about the highest divorce rates since the late 1940s.

In 1971, Walt Disney World Resort opened in Florida as Disney Animation nearly closed down.

TRANSITIONS & TRAINING

> *"As long as we keep growing, the future will keep opening up."*
> — **Walt Disney**

The 1970s marked a time of transition for women. Within general industries, women's presence in the workplace had expanded to the widest point in history. Over 30 million feminine forces comprised nearly 40 percent of the overall US workforce, and throughout the decade, women made their largest gains, but the glass ceiling loomed large as their positions were still narrowed to very traditional and limited roles. Record numbers of women entered colleges and universities seeking long-term careers. Most schools adapted to their presence by introducing areas of formal study, such as women's history and civil rights. Ivy League schools, which traditionally kept their doors closed to half the population, began permitting women into their hallowed halls by 1977.

Transition was prevalent at the Walt Disney Productions as well. New leadership signaled a shift in the company's direction. Theme-park expansion and business diversification stepped into the forefront while the Animation studio navigated the course of change. Long-reigning senior Animators were retiring, and the rising costs of animation left the remaining artists grappling for their positions within the company. Without Walt Disney at the helm, many feared animation would cease to exist.

The first animated films without Walt's guidance or development were created within this decade. In addition to achieving critical and box-office success, these films proved the tenor of the studio's storytellers and solidified the art form. Women continued to climb through the ranks of animation in the 1970s, and at Disney Studios, their numbers would expand even further with a new generation of Animators.

FANCY FELINES

Full production was under way on the final animated film that Walt Disney had nurtured into development. Another anthropomorphic adventure, *The Aristocats* was the twentieth full-length animated feature and the first film completely produced following Walt Disney's passing. Duchess, the feline heroine, featured the voice talent of Eva Gabor, with Liz English as little Marie. The legendary Hermione Baddeley voiced the feline fancier Madame Bonfamille, while classic character actress Nancy Kulp neighed the dialogue for the carriage horse Frou Frou, with popular comedienne-actress Ruth Buzzi stepping in as Frou Frou's singing voice.

Ink & Paint artist Grace Godino was brought in for live-action reference work as Madame Bonfamille. "They took a dancing sequence with me dancing . . . in Victorian clothes," recalled Godino of her work with director Woolie Reitherman. "And they brought a real cat[,] and then the cat wouldn't stay still long enough. So [Reitherman] got an artificial cat for me to pet and they got such a kick out of it!"

Once again, music editor Evelyn Kennedy worked on the five songs featured in this feline-centric film; three of them were penned by the legendary Sherman Brothers and Terry Gilkyson. Working with a noted range of composers, Kennedy maintained the integrity of each song by deftly editing music cues. Songwriter Richard Sherman noted, "It was always a joy to work with Evelyn. Many times they didn't want to have a certain scene go as long, so she'd have to make the music work against the picture exactly the way it should be, and she always amazed the composers. She was a Music Editor of first rank."

Sylvia Roemer's layouts helped to define the world of this family of French felines, envisioning turn-of-the-century Paris and the French countryside from a cat's point of view. Once the animation drawings of *Aristocats* reached Ink & Paint, it was business as usual. The featured felines in this animated film wore simple collars, so painting proceeded faster as there were no detailed costumes to fill in. Though, just as with the characters of *Dumbo* or *The Jungle Book*, the department had to keep a close eye on the opacity as the unclothed form of each feline presented large areas requiring the proper application of paint.

With the film opening strong at the box office in December 1970, it seemed everybody wanted to "be a cat!" Animation resumed under the leadership of Woolie Reitherman, but with rising production costs and without Walt at the helm, the question of whether animation would even continue remained on everyone's minds.

BUBBLES & BEDKNOBS

"We were looking at two book properties that Walt bought," recalled Songwriter Richard Sherman. "*Bedknobs and Broomsticks* was written from the book series by Mary Norton, and we were waiting for [P. L.] Travers to give the okay to go ahead with *Poppins*." Several years after Walt passed, this magical classic was brought into production. "We came back to the studio and filmed this wonderful picture," stated Sherman, "and we got marvelous Angela Lansbury." Lansbury stepped into the lead role of amateur witch Eglantine Price at a precarious time. "It's a very rare and unique place, Disney," recalled Lansbury. "Walt Disney had a very high standard of conditions for his workers. [It was] like a lovely country club."

Keeping the live-action elements in line with the animation needs was Script Supervisor Lois Thurman, who had gotten her start on Disney's live-action film *Tonka* (1958). Thurman supervised a number of Alfred Hitchcock's films, including *The Birds* (1963) and *Torn Curtain* (1966), before returning to Disney with *Bedknobs and Broomsticks*. Working again with live-action integrated into an animated world, the Ink & Paint Department dropped down to a core group of twenty-five girls. Defining the underwater world of the "beautiful briny seas" off the isle of Naboombu involved an assorted array of colorful sea creatures, but the most daunting effort came in the animated underwater effects. "Bubbles!" Carmen Sanderson moaned. "I was so tired of those bubbles!" Countless multicolored bubbles floated across the screen, carefully matched to final film photostats.

In addition to the stream of animation for the film, special visual effects were a large portion of the work coming through Ink & Paint. As Supervisor Becky Fallberg recalled, "For *Bedknobs and Broomsticks*, I made masks[,] which are black things to block out the wires where they had live action and they wanted to give them the appearance of floating in the air." The department's mask work added to the believability of Eglantine's "substitutiary locomotion" spell, which brought countless suits of armor to animated life.

Disney's latest blend of animation and live action was a box-office success, and went on to win an Academy Award for Best Visual Effects, but the celebration was short. Two months after *Bedknobs and Broomsticks* opened, CEO Roy O. Disney, an original founder and Walt's older brother, passed.

FINDING SHERWOOD FOREST

With the reigns of the company in the hands of a team including Card Walker, Donn Tatum, and Walt Disney's son-in-law Ron Miller, animation continued, but as Animator Ken Anderson recalled, "We were without Walt." Determining their next animated effort, Anderson led the early story development. "I had always been close enough to him to make this sort of thing . . . so the feeling was [that *Robin Hood*] did come from Walt." Placing the classic tale into an anthropomorphic world was a logical step. "What is an animal that would be best suited for [the character Robin Hood] but a wily fox," mused Anderson. "I started making drawings and Woolie [Reitherman] got all excited about it. . . . Finally we got into production."

Noted Background Artist Annie Guenther helped define the film's world. "Oh, was she a good Background Painter," declared Guenther's friend and co-Inker, Eleanor Dahlen. Guenther fondly recalled this production: "I had a beautiful office on the second floor in Animation with Sylvia Roemer. She was in Layout and I worked closely with the Layout teams. In Backgrounds, the colors were established, but working with the forests and characters in *Robin Hood* was a fun film!"

The Disney telling of this classic tale presented a number of challenges for the Ink & Paint Department. While the film

Pages 304/305: Women marching for equality as part of the Feminist Movement of the 1970s.

Page 307: New studio Animators. Front row: John Musker, Brad Bird, Jerry Rees. Middle row: Heidi Guedel, Linda Miller, Emily Jiuliano. Back row: Jeff Varab, Gary Goldman, Chuck Harvey.

Ink & Paint | 309

Top: Longtime Ink & Paint artist Grace Godino (left) serves as live-action reference for Madame Bonfamille, with final production cel (right) from *The Aristocats* (1970).

Bottom: Cherie Miller paints a production cel of Maid Marian (left) from *Robin Hood* (1973), with final production cel overlay (right) for the film.

Inking Supervisor Edna Smith with Gretchen Albrecht, and Dodie Roberts in the studio Paint Lab, circa mid-1970s.

was in production, Grace Bailey shared, "This *Robin Hood* picture we're making is extremely difficult for us because there are so many characters and they are all in costume[, and] not only one costume, but several, so it's very slow painting." In addition to the extensive detail, the range of colors grew. "After we started the picture, we had a meeting with Woolie Reitherman and the Background/Layout people and tried to simplify by eliminating certain areas—for instance[,] a yoke, [by] painting it the same color as the rest of the shirt—but there are a great many characters, colors[,] and areas to paint."

"Learning to paint on *Robin Hood* was fabulous!" exclaimed Gretchen Albrecht, a young Painter on her first Disney film. "I loved painting the characters. I couldn't believe a job like this existed. Jean Erwin was our trainer. She was very systematic and emphasized accuracy and efficiency. Cels were to be placed in your shelves in a certain way so if you were out, anybody could sit down at your desk and know exactly where you were at with the work and be able to finish your set. Jean encouraged us to start walking faster; making your bed faster . . . to do everything you did faster in preparation for being a fast Painter, but to paint slowly while learning. This approach kept it all moving. It was just a methodology to maintain production consistency. The whole Ink & Paint Department worked like that. It was just a well-oiled machine."

Over 100,000 painted cels conveyed the characters of *Robin Hood* throughout 1,200 scenes across eight hundred painted backgrounds that defined Sherwood Forest. With the volume of qualitative work required within the final months and even weeks of production, instilling the importance of speed was paramount for the young recruits. As Albrecht recalled of her first Painting partner and former Inker, Gracie Robinson, "She always said, 'Accuracy is good, but at the end of the day you had better be fast.' Consequently, the jars of paint in our lab were covered with paint on the outside of the jar as well as the inside."

Stepping into the ranks of Inking & Painting in the mid-1970s had a lasting impact on Albrecht, who would later run the department. "Many people who had started at the studio in the 1930s and 1940s were still working in Ink & Paint," Albrecht noted, "and this was a great opportunity for those of us who were just starting our careers to learn from and be inspired by people who had worked on the classic films of the past. They gave us a sense of continuity and responsibility to carry on the Disney standards of quality in Ink & Paint."

MAGNIFICENT "MYRTLE"

The processes and procedures were nothing new, but as Grace Bailey reflected while working on *Robin Hood*, "Each [film] that comes along, we think this is the hardest we've done." From a department that once boasted over two hundred artists occupying every inch of the Ink & Paint Building, Bailey had to hire several people back to the department to bring her total staff count to just under sixty artists. "We used to have about ten people in the Paint Lab, now we have three," she reflected. The emphasis of the Disney Studios' live-action slate of films over the preceding two decades had dramatically affected animation production, but as Bailey noted, "There seems to be more interest now in animation and they're planning more features."

While in production on *Robin Hood*, Bailey provided a sense

Left: A visual development cel of Christopher Robin and Pooh from *Winnie the Pooh and the Honey Tree* (1966); and (right) a final production cel of Tigger from *Winnie the Pooh and the Blustery Day* (1968).

of her department's critical role: "We've consolidated; we've moved people in rooms together as the crew got smaller, but the pattern still follows, we do everything about the same way we always did as far as dividing the work, putting the work through here by people and by department, we maintain the same channels. [The] main pressure comes on towards the closer we get to the deadline when we have to go into overtime generally. As does the Animation Department. I try to take on more experienced people to avoid overtime[,] and I have just hired back quite a few in Ink & Paint Xerox recently[,] because we have several Xerox cameras. We have three of them going now. But the Xerox has more footage going through there than goes through the Inking and Painting Departments, because they do so much work for the Animators—for test purposes—and we do it on paper as well as cels."

Robin Hood marked the final film for Grace Bailey after a forty-year career with Disney's Inking & Painting Department. The legendary leader of Ink & Paint retired in 1972. Her impact lasted throughout the course of the department's history, as many of the ladies who took over the reigns were girls Bailey had personally trained. "Grace was a wonderful woman," noted Ron Miller. "She was a great Supervisor of all those talented people in Ink & Paint." After enjoying a number of years in Florida, Bailey peacefully passed in August 1983. One of Bailey's protégés, Ginni Mack, recalled, "When she died, the [staff] planted three little myrtle trees outside her office window." It was a loving tribute to the woman the girls coded as "Myrtle" to track her presence in the corridors. "Everyone knew about the 'Myrtle' password," Mack fondly remembered, "and she probably did, too."

TIGGERS & TRANSITIONS

The departure of Grace Bailey marked the end of an era, as the defined roles and structure of the department changed when forty-year Ink & Paint veteran Valentine Vreeland stepped into the head role. With a core group of twenty-four Inkers and Painters, the third of the A. A. Milne stories of a certain silly old bear went into production for the short film *Winnie the Pooh and Tigger Too*. The introduction of a distinctively orange-colored bundle of bouncy-flouncy fun required extensive use of the highly developed drybrush techniques to permit the coil-tailed character Tigger to spring onto the screen.

With live-action production on the rise, various special-effects needs came through the pipeline as well. The science fiction adventure *Escape to Witch Mountain* featured the work of Inkers and Painters to convey the telekinetic powers of the child extraterrestrials Tia and Tony. "The department would fluctuate from its core [group] of twenty-four up to around 140," noted Gretchen Albrecht, "depending on what was happening in the production and the quotas and everything necessary to meet the production deadlines.

"It was Val Vreeland who thought it made good sense to have some of us trained to do multiple things so we could be moved back and forth for better efficiency," said Albrecht. "That's how I ended up learning to paint, and [to xerox] and to match paint in the Paint Lab, all within the first year. That was a pretty new concept and a unique experience." As a production rehire in the mid-1970s, Albrecht recognized the importance of this opportunity. "I was called back because they could move me from place to place. And this efficiency was critical at a time when you needed various capabilities covered, such as when

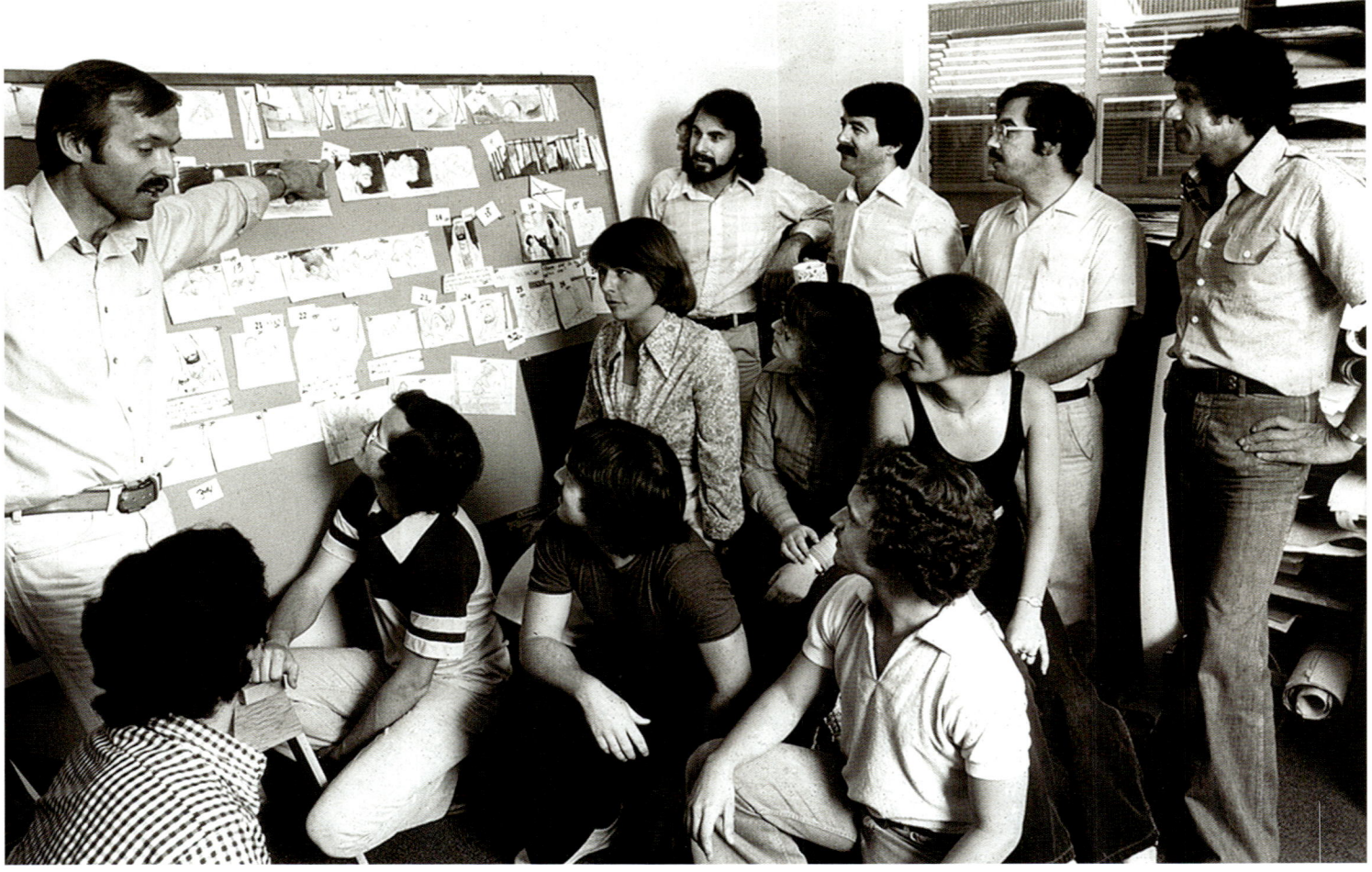

Story meeting for *The Small One* (1978): Don Bluth (lower left), John Pomeroy (back to camera), John Musker, Brad Bird, Jerry Rees. Middle row, left to right: Heidi Guedel, Linda Miller, Emily Jiuliano. Back row, left to right: Jeff Varab, Gary Goldman, Chuck Harvey, Bill Hajee.

production on a film was ramping up," she said. "You'd have somebody who could do three different things and you probably could keep them occupied for forty hours when there wasn't that much inventory to process."

TRAINING A NEW GENERATION

"It was obvious," Ron Miller recalled of the Talent Development Program. "We had the Nine Old Men[,] which most of them were there at that time—Ollie [Johnston] and Frank [Thomas] and Milt Kahl and others—and it was also obvious that we needed young talent. I felt a need. I knew something about story, but I didn't have that much knowledge about animation," Miller continued. "And Eric Larson was my right-hand person. He was so instrumental in developing all of that young talent."

Legendary producer Don Hahn noted about the program, "It was really driven by Ron Miller. He came to the conclusion of, 'if we don't do something, we're all gonna retire and animation will retire with us.'"

Larson first became involved in the training of new Animators in 1970. Larson crisscrossed the country in Walt's plane, seeking new talent from the leading art schools and colleges, reviewing portfolios in search of the best candidates. "Finding good Animators is as difficult as finding good actors," observed Larson. "An Animator has to understand how to act, draw, tell a story, and make music. But most of all, Animators have to create characters that the audience feels they know or want to know."

Hahn noted, "The first guys to show up were people like Glen Keane and Tim Burton, and others from CalArts." A number of obvious male candidates were in place, but continuing what Walt Disney had started decades earlier, Ron Miller determined, "We're going to make some women Animators."

A mid-1970s brochure explained the goals of the program: "We're looking for men and women with artistic flair. People who are attracted to the Disney style and tradition of animated storytelling. We're looking for people talented enough to create new worlds of believable fantasy and a new generation of color Disney Characters." With this new effort, entertainers with pencils were sought from a wide range of sources. "There was a very concerted effort to train women with this program," added Hahn, who later oversaw the Animation Training Program. "It was very deliberate because it was obviously still a very segregated world at that point."

Candidate selections were made based on talent and potential. "I submitted a portfolio," recalled Betsy Baytos, one of the earliest women in the renewed Animation Training Program. "They called and invited me to tour the studio and meet with Eric Larson and Donald Duckwall. I was shocked that they hired me. I didn't come from an animation program. I think they hired me because of my spirit and sense of adventure[,] and Eric took a chance on me."

Of her experience as a young illustration student at the Art Center College of Design, legendary Animator Linda Miller remembered, "I was sitting on a couch for over an hour watching these two old men look at my drawings. They said, 'These are good—we're going to present these to the review board.' The next day, they called and said, 'We want to hire you.'" A neighbor who worked at the studio informed Lorna Cook of the program. "I was studying illustration at Art Center. I created my own storyboard of a little dog story and something was there for them to say[, 'You] got it!'" A young animation student at CalArts, another candidate, Patty Paulick Peraza, was selected at the end

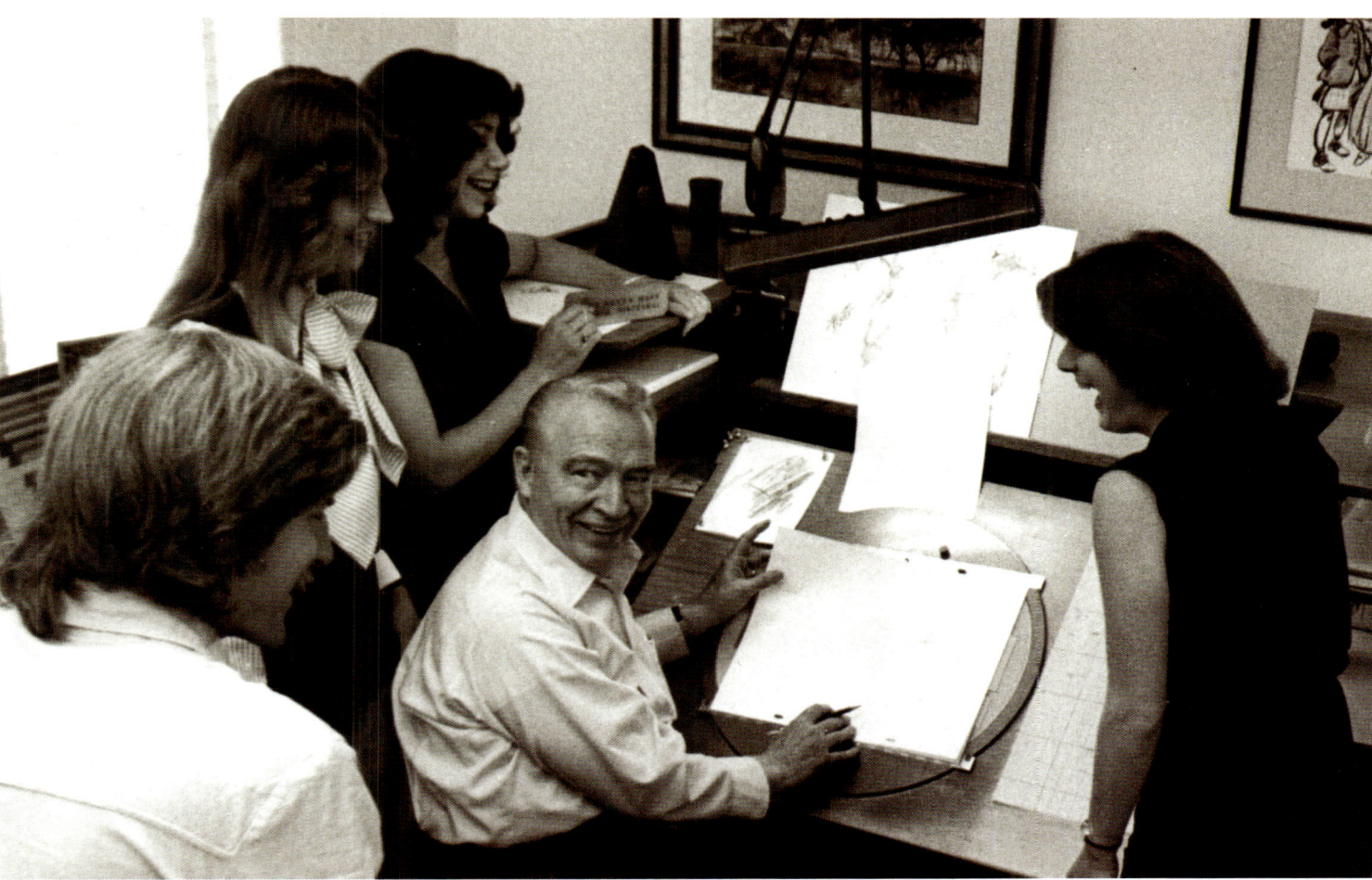

Legendary Animator Eric Larson (center) works with a new team of Animation Trainees, including Bill Kroyer (foreground), Heidi Guedel, Lorna Cook, and Emily Jiuliano (right).

of the school year. "We would show our student films to an elite group, including Ron Miller, Diane Disney Miller, Lillian Disney, Chuck Jones, and many studio executives," said Peraza. "Lillian Disney spent quite a bit of time talking to me telling me how happy she was to see a woman pursuing animation. She wanted to make sure I was given every opportunity the men were given in the program. I assured her I was." Peraza was among the earliest women from the CalArts program hired at Disney.

Each month new candidates were brought in for a one- or two-month tryout. In a large room on the second floor of the Animation Building, desks were lined with animation paper, timing sheets, and pencils. "It was an overwhelming experience to be there at Disney in D Wing," recalled Cook. "There was a sense that this was a turning point. Eric was a kindly and generous man. He spent time with me that first week working on the basics of animation. He told me, 'You draw like a guy,' which to me was a compliment. It meant that I could hold my own. I also worked with Burny and Sylvia Mattinson[,] who were wonderful. Sylvia knew her craft. There were very few women around and she wasn't going to create any kind of fantasy for me."

"I was in the room with all men—Henry Sellick, John Musker, and others. The program was incredible," recalled Baytos. "I was green as could be. I remember Dale Oliver and a couple other Animators standing at the doorway and they made a bet whether I would remain or not. I didn't have any preconceived ideas[,] so I wasn't intimidated by all these guys. I just had the time of my life because the older Animators were so wonderful to me," Baytos added. "Hanging out with Ken Anderson and Mel Shaw. It was just a wonderful experience. And with the Firehouse Five playing at lunchtime and being a dancer—it was like being a kid in the candy store.

"I remember there [were] roughly about ten of us the first month—mostly males," continued Baytos. "Then they brought in Emily Jiuliano and Rebecca Canfield and they expanded it with more males as well. We were given an exposure to the world of animation and Disney storytelling. One of the things you did was a personal animation test. Based on that they hired you on or let you go.

"A lot of other tests I saw were things such as a horse pulling a wagon, something that shows the feeling of weight and definitive movement," Baytos said. "My first test was a little ant walking along with a hobo stick [who] came across a tiny bridge. He did a twirl and a little dance movement where he backed up onto an anteater's tongue! Eric really loved the fact that I incorporated movement, dance, and a mini-story—that's what he really encouraged and he helped me to develop. The next month, I got hired!"

"The Trainees were brassy, bell-bottomed, long-haired, and iconoclastic," wrote Animator and historian Tom Sito of the next generation. "They rode bicycles through the hallways. For the hedonistic disco era, they were a well-behaved bunch . . . a breath of fresh air." For Eric Larson, shaping this new giddy generation of artists to carry on Walt Disney's vision for animation was one of the more important things he'd accomplished while at the studio. "Walt Disney and the entertainment plateaus he established and the tradition he built, have left a worldwide following today," stated Larson in a lecture to his Trainees. "In the Disney spirit, our imagination and our ability to graphically put down on paper and 'bring to life' that which we imagine will determine our success. If we make a good picture, the viewers will take it to their hearts and never let go."

LADY BOSS: BECKY FALLBERG

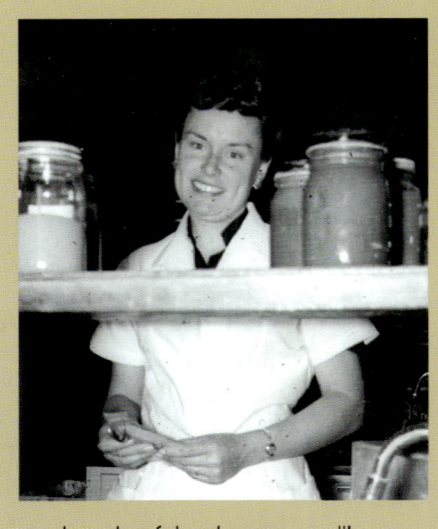

Following the lead of the Civil Rights Movement of the sixties, the Women's Movement became the voice of the decade. Throughout most industries in the 1970s, women struggled to rise through the ranks, yet at Disney Studios, women in management positions were commonplace. Before supervising the Ink & Paint Department, Becky Fallberg recalled, "I was a Supervisor of an art service department [Art Props] and I was the only woman of twelve men and that's where I had fun." Fallberg's staffers included: John Emerson, Don Hahn, and Greg Crosby. "We did a lot of framing and sign painting and things for live-action [film production]. Storyboards were photographed and then compiled into books so they could use them on the set by many different people. Odds and ends."

As a young assistant working in his first job on the lot, Don Hahn worked within Fallberg's department. "I was a floater, so I'd be punching paper or working in the Paint Lab. I would go in and help Lloyd Winegardner[,] who ran the paper punch and cel punch area. I worked with him a lot and I would do inventory and things like that. The Ink & Paint Department was scaled down a bit when I got there, it was just one floor." Supporting the women of Ink & Paint, Hahn reflected on the role of the department. "It was very serious work, and 'seat-of-the-pants' if they were on a deadline." Fallberg's Art Props Department also worked with those who managed the disposal of the cels once processed through camera and released. Hahn recalled, "There were big red cans out back where they put the film and cels. We could go and fish out cels from *Aristocats* and other films. . . . There were tons of them." The long-standing tradition of sliding around on cels to celebrate the end of each production also continued.

When Grace Bailey's replacement to run Ink & Paint wasn't working out, Becky Fallberg was asked to take over. A former Paint Lab Supervisor, she had worked her way up to managing the Art Props division and was now officially placed in charge of the Ink & Paint Department as well. "She came into 'office' the same time Gerald Ford came into [presidential] office when Nixon resigned," recalled Becky's daughter Carla. Overseeing her teams in Art Props as well as the Ink & Paint Department, Becky reflected on the challenges of management: "Yes, it's difficult, because you're juggling not only jobs, but people. And you have to know each one's skills and their personalities. Will they fit? You want people to be compatible because then you enjoy your work[,] and sometimes you can't make it that way and they stir up trouble and ugh! You listen a lot. You have to hear everybody's complaints and sometimes you can do something and sometimes you can't. You have to interview a lot of people [and] try to find people that are hopefully available when you need them. I like to be able to hire people, but then you lay them off after you've hired them and that makes me feel bad, so it's not a very easy job."

"Becky was a real down-to-earth gal," remarked Ginni Mack of her longtime boss and colleague. Practical in her approach to her staff, Becky had a washer and dryer installed in the department to economically ensure a constant supply of clean artist's gloves. On one particular visit to her mother's office, Carla recalled, "I found her in the laundry area and there was my mom on her hands and knees pulling Painter's gloves out of the dryer. My mom laughed[,] saying, 'Can you imagine Grace [Bailey] ever being in this position?'"

From over twenty thousand applicants in the ten years of the Talent Development Program under Larson's tutelage, about half of the 150 female and male trainees tapped had been placed onto productions as Inbetweeners and Assistant Animators. "He was one of the most wonderful people," Ron Miller recalled about Larson. "The young artists coming in had a tremendous respect for him. He was a kind gentleman you fell in love with and he had a certain patience with the young people. He really mentored the young Animators coming in. It was quite a group!"

GALLANT MICE & MADAME MEDUSA

As one of the earliest Animator Training Program graduates at the studio, Betsy Baytos quickly transitioned into production in late August 1976. "*Rescuers* was my first film, and they assigned all of us underlings to an Animator that fit your personality and style. The first Animator I was assigned to was Cliff Nordberg—one of the most underappreciated Character Animators. They put me with Cliff because he did all the wild, broad-humor animation and we had an incredible time. He bought tap shoes and we would go to the *Mickey Mouse Club* stage [which] was still on the soundstage—complete with footlights; I would have them turn it on and we would tap-dance together."

Dancing her way into Animation, Baytos noted, "The characters I was first assigned to were Evinrude and Madame Medusa from *Rescuers*." The film was based on the adventure books of Margery Sharp, and Eva Gabor returned for voice work on the lead crime-solving mouse, Bianca. Filling in with additional voice needs, once again, was longtime Inker and Painter Grace Godino. "I did a voice-over for *The Rescuers*," said Godino with a laugh. "I played the German mouse."

"I ended up back at Disney on *The Rescuers*," recalled Animator Jane Baer, who was back as a single mother after going through a divorce. "One of the differences I noted when I came back [was that] they were more encouraging towards women. I was lucky enough to work directly with Milt Kahl, who I just admired beyond words—he was a tremendous artist. He was doing Medusa at the time, which I think was his favorite character of all that he ever worked on.

"Mike McKinney, myself, and Stan Green were working directly with Milt and that was really nice," Baer said. "Ollie

Ink & Paint | 315

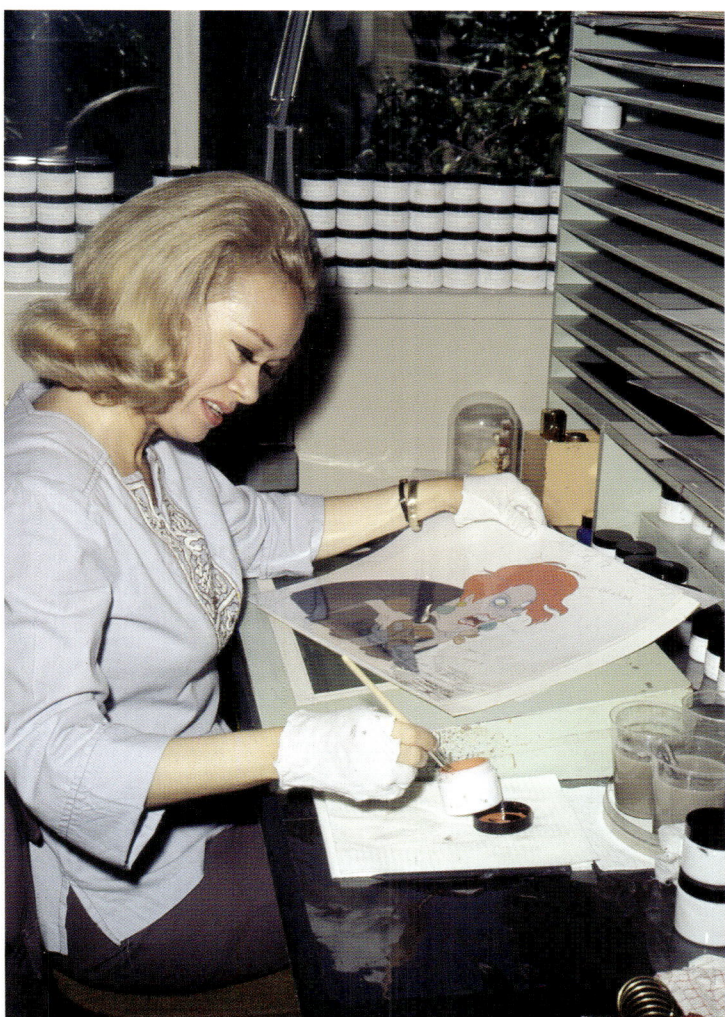

Left: Cherie Miller painting on a Xerox production cel of the villainous Madame Medusa from *The Rescuers* (1977).

Right: A Xerox production cel of Madame Medusa whose distinctive makeup, hair, and lengthy fingernails were inspired by several Ink & Paint artists.

Johnston worked closely with Heidi Guedel [a young Animator] and was very encouraging to her. Betsy Baytos was there at that time [animating], and she was quite a character. Dancing was her love and one time she was doing her exercises in her room and got her foot stuck somehow in the top level of a desk and couldn't get loose! She was very fun and very talented."

In addition to the energy of new talent, new refinements were developed for the Xerox process. Reflecting on these advancements, Frank Thomas and Ollie Johnston wrote, "It was not until we had perfected a gray line for *The Rescuers* that we were able to lose the harsh outline and regain a soft look. That simple change brought raves from critics who claimed we had developed a whole new style for this picture." Colored, thin lines were now achievable via the Xerox process, coming the closest yet to the delicacy of hand-inking, and achieved at a fraction of the cost. "Milt Kahl preferred the Xerox process," recalled Baer, "because none of his lines were disturbed."

Oscar-nominated songwriter Carol Connors, who penned the immortal theme for *Rocky*, cowrote the lyrics for three songs on *The Rescuers* sound track along with noted songwriter Ayn Robbins. Their lyrics, set to Sammy Fain's music, later garnered an Academy Award nomination for the song "Someone's Waiting for You." After three years of active production, *The Rescuers* was released on June 22, 1977. It featured strong characters and powerful animation transcribed onto 105,000 hand-inked and painted cels set against 750 painted backgrounds. The continuation of Disney animation was assured with the success rendered in part by the new generation of Animators.

ANIMATING ELLIOTT

A title explored as early as 1957, the Seton Miller screenplay *Pete's Dragon* began as a contemporary story based on the pure imagination of a young orphan boy who finds a family. What began as a completely live-action film utilizing shadows and visual effects to convey the imaginary dragon, later made the transition into a musical combination of live action and animated adventure in the winter of 1975.

"It was an artistic decision," recalled then-CEO, Ron Miller. "I think the only thing that made sense . . . [was] that the dragon Elliott was going to be animated. I couldn't see any other way of combining live action with the dragon." For this family musical, Miller cast Helen Reddy in the female lead role of Nora. Reddy was at the height of her fame, rising to prominence with her newly popular feminist anthem, "I Am Woman." Actress Shelley Winters took the role of grimy Lena, the mother of the villainous Gogans. Newcomer Sean Marshall played the title role of Pete, who tended to his pet dragon, Elliott.

With production well under way on the live-action portion, Ken Anderson was brought in to develop the animated form of Elliott. "Ron [Miller] wanted to put together a cartoon dragon at the same time try to use my experience in helping to train a group of promising new Animators to animate this character." Anderson explained his development of Elliott: "It was the dragon that saved the boy in the story. So I felt, why not a big bumbling Wallace Beery type of dragon.'

From Anderson's designs and story development, production was quickly under way. "I assisted John Pomeroy on animation for

Elliott," recalled Animator Betsy Baytos. "I learned the ranks of Inbetween and Cleanup and taught a dance class at night for all the Animators as well." Baytos studied eccentric dance with vaudevillian Gil Lamb, who had earlier served as the live-action reference model for Ichabod Crane in Disney's 1949 film *The Adventures of Ichabod and Mr. Toad*. With her dance background, Baytos served as a stand-in for the film's female lead, Helen Reddy, and designed movements for the film's animated lead. "*Pete's Dragon* was my first film that I did choreography for," Baytos recalled. "Don Bluth brought me in and they stuck a big foam tail strapped to my waist and filmed me doing dance movements for the dragon in the parking lot."

With the limited time frame to accomplish the animation necessary for *Pete's Dragon*, many of the young Animators were thrust into production. "There was a crunch, and I ended up as an Inbetweener on that show," noted Linda Miller. As Don Hahn recalled, "Photostats were made from the live action, then we would go in and do animation paper sized photostats of each individual shot. That way the Animator can draw into the frame, knowing her drawings will match the action. If someone reaches out and pats Elliott on the nose, the Animator can match the drawing to the action."

"Elliott the dragon served his purpose as a training ground for these young Animators," noted Ron Miller. "After having proved their ability to do this, they created a well-animated dragon." While live action combined with animation was presenting new challenges for the newly trained animation talent, production backed up, and the need for qualified artists within Ink & Paint was critical. With no time for training new artists and a deadline looming, a solution was needed.

"OLD BROADS" TO THE RESCUE

Difficulties for women in the workplace were prevalent in the 1970s, but for "women of a certain age," returning to the workplace was unheard of. But to meet the demanding schedule for completing *Pete's Dragon*, the Ink & Paint Department was woefully understaffed. "That's when they needed us 'old broads' to save the picture," laughed Ginni Mack. "Becky Fallberg and her Supervisor came to my house and asked me if I'd come back to work. I just turned fifty. I wasn't retired, but I had been out for quite a while raising my son, who left the day before for college. They said, 'We've got this film and it's not working without a dragon. It's supposed to be imaginary, but it doesn't seem to work. We're gonna have to put an animated dragon in it,' which meant that everything was going to have to be backlit and all opaque."

Longtime friends since both former Ink & Paint girls had been young mothers raising their families, Mack and Fallberg's friendship came full circle as they worked together once again. "It was only going to be ten weeks, so I went back and stayed until I finally retired many years later!" laughed Mack.

Production began November 8, 1976, with a new team of seasoned veterans including Edie Hoffman and Barbara Palmer, both Painters who had started in the 1940s and had not worked in more than twenty years. Mary Jane Cole, Joyce Walker, Eve Fletcher, and Joyce Carlson were on hand as well. "We still had steady hands and discerning eyes to get the job done," recalled Lucile Williams. "We felt pride to be called upon to revive the talents we hadn't used in years to reconstruct the film. With the maturity of the former young women, the talk was now about family, children, and our pride of coming back to save the picture. It was more like a club gathering with someone bringing in treats

Ink & Paint

Page 316, left: Xerox production cel of Elliott from *Pete's Dragon* (1977).

Right: Some of the multi-generations of Ink & Paint ladies who worked on *Pete's Dragon* (1977).

This page: Longtime Paint Lab chemist Steve McAvoy.

every day to celebrate family events."

The animation process was essentially the same, and the experienced artists were able to hit the ground running with the necessary work to be done. "There's a lot of inking on that character," remarked Don Hahn. "He's mostly gray Xerox lines[,] but his belly was all green and kind of chubby, and that was all hand-inked[,] which was time-consuming and difficult." "We were reworking cels, eliminating details[,] and adding effects," remarked Williams, who marked the differences with the studio. "The Swiss gardener was gone, the front gate had been moved, [and] there was a new parking lot, but generally things seemed about the same. Even if there weren't that many changes externally, without Walt's running, the things were certainly different internally." With ongoing jokes about "old home week," it was a remarkable return of talent and celebration. As Williams stated, "Betty Anne [Guenther] and all the other girls were still mostly there. A few had left over the years for marriage or freelancing. By the time I returned, my daughters were grown[,] so I was able to go back to work for the first time in twenty years. We all had our private lives and we weren't young and carefree anymore. Many had outside interest in the art field [such as sculpting, painting, and ceramics]. It was an interesting, talented group of women, both in the early days and later too."

This unusual range of ages created a thriving environment. Gretchen Albrecht, then a new Painter, noted, "We were fortunate to have arrived when we did[,] because we got to work with a lot of the ladies who were at Hyperion. One thing that really stands out is [that] the age differences were extreme[,] from twenty-two to the sixties, and yet, we all sort of treated each other like we were thirty-five. We shared humor, pride in our work[,] and determination to get the job done. We all had this commonality and age was never an issue."

With an accelerated schedule, the work—and pace—called for extensive overtime for the department. Williams recalled, "We were working so hard on the show, including weeknights, Saturdays, and Sundays, [that] there was no time for socializing. It was great to have the unique opportunity to work with a group of women, both in youth and maturity, who were talented, intelligent[,] and socially well-rounded[,] and to be able to spend so many working hours together in a thoroughly professional and emotionally centered atmosphere." As Ron Miller noted, "I'm happy for those people that came back. Let's face it, the Ink & Paint crew were so outstanding at what they did, there wasn't anybody that was . . . their equal anywhere else in the industry."

Following the eleven months of production and thirteen weeks of overtime for *Pete's Dragon*, many of the ladies stayed on, continuing into production for the holiday short entitled *The Small One*, directed and produced by Don Bluth. This short served as an additional proving ground for the various young Animators at the studio and featured a strong presence of female Animators, including Heidi Guedel, Lorna Cook, Betsy Baytos, Emily Jiuliano, and Linda Miller from the Animation Training Program, as well as Sylvia Roemer's layout and Daniela Bielecka's backgrounds.

PAINT & PROCESS

From the earliest days of "Opaquers," the sure consistency and solid coverage of a color was vital, particularly if a cel had to be opaque for backlight. For *Pete's Dragon*, "It was especially important that the paint be at the right consistency if you were painting to backlights," Gretchen Albrecht recalled. "We also had to watch out for bubbles. In some cases, there was a backing paint—a mid-value gray that we would paint on the back[,] too. Remember, in those days, you had to be wary of the thickness of the paint. You learn to determine the right consistency for this situation by stirring the paint and feeling the resistance. Typically, when we would get artists from other studios who used vinyl paint, they would always overwater the Disney gum paint. If you just float the paint, it will get too thick[,] and the vinyl paint needed to be quite thin for it to be flat. If the paint was too thick, when the finished cel was under the camera platen[,] it would cause Newton's rings on the image."

"The lab carted over whatever you wanted," recalled Don Hahn. "The paint would come in as powder[,] and those bins—there were probably thousands of primaries." Albrecht agreed: "We had big drawers of pretty colored pigments—beautiful, beautiful color. The lab had an extensive set of colors[,] and each family had what's called a Top Color[,] which would be the darkest value[,] which was then mixed with the mixing white. . . . Then we had all of these colors to tint, like Cad Yellow, Red, Orange, Cobalt, Ultra Marine, Browns, Green—all kinds of colors.

"All those mills that made the paint were ancient[,] but they worked and the paint was just beautiful," Becky Fallberg noted. "We tried to get it to the right consistency so that you could apply it to the cel easily without adding maybe one or two drops [of water]." With Ink & Paint utilizing gum-arabic paint, the background artists painted on illustration board and utilized a different

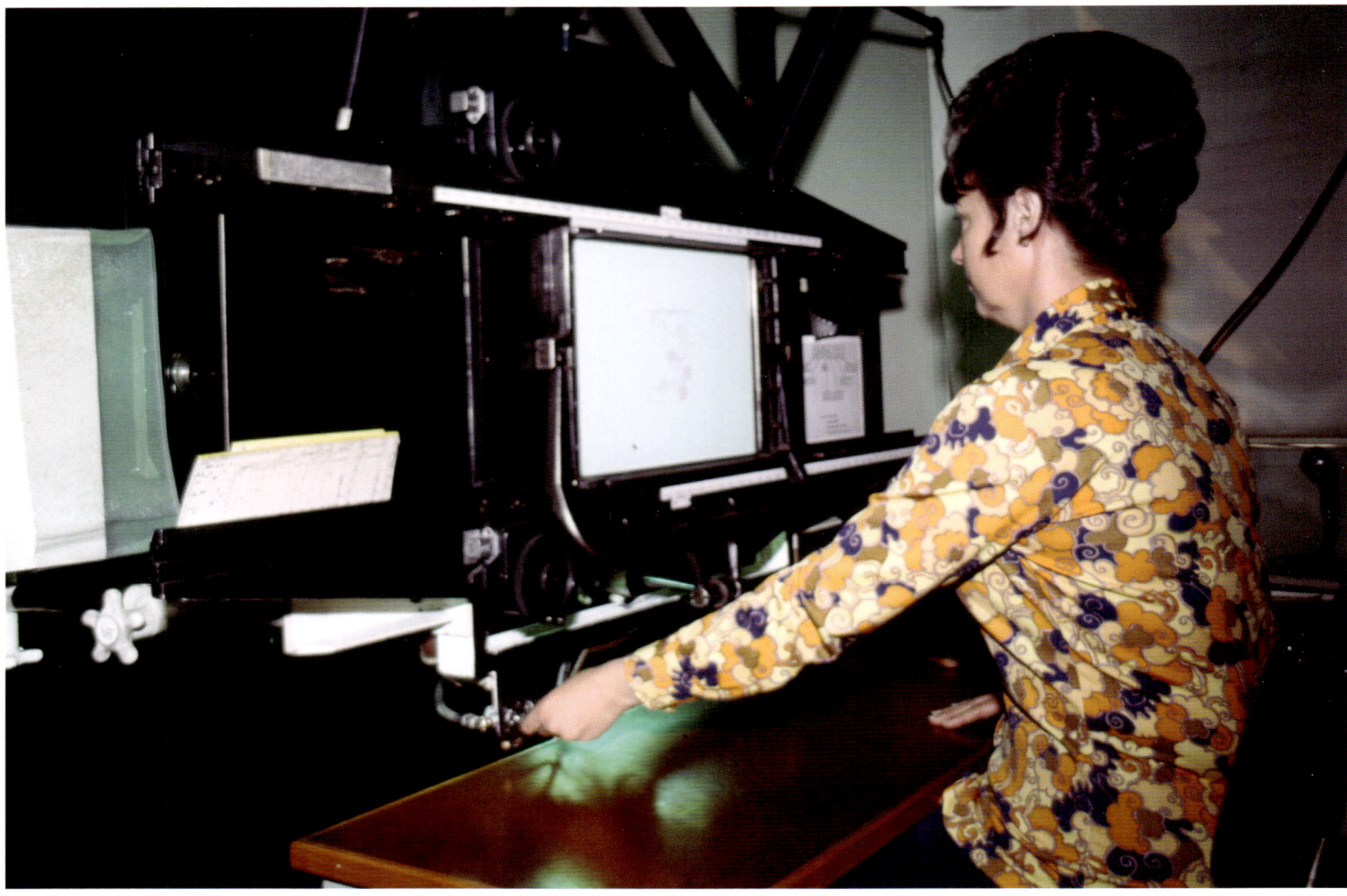

Janet Rea works the outside platen on the Xerox camera at Disney Studios, circa mid-1970s.

kind of paint—gouache. "We made beautiful watercolor paint for the Background Department," Fallberg added. "[It was different] because it was thicker, [so] you had to put it in tubes."

By 1973, the water-based paint binders were defined by standard formulas, yet problems would still persist. Sourcing vendors for the raw materials became a challenge as elements and manufacturers changed. As a Paint Lab manual pointed out, "The past few years, the purchasing of pigments has become increasingly difficult as so many companies have merged and in their turnover have discontinued a number of colors because of lack of sales, [for] which we have had to shop around for substitutes." Many companies instituted high-volume minimums for their purchase orders, and with smaller needs, the Paint Lab was sitting on a much larger inventory than what their output warranted. Paint would sometimes suddenly not adhere to a cel due to shifts in the cel's makeup. Paint tests were conducted on each new batch of cels received from the manufacturer. Fermenting often occurred, likely due to variables in new batches of binder elements. Paint might peel off or become too bubbly with changes in vendor sources. Streaks occurring in the paint were usually resolved by adding talcum and simply regrinding the color.

With so many variables, matching color was critical, and certain techniques were carried on through the generations. "You would always have the sample of what you were trying to mix," recalled Albrecht, "so you would get it to the value and you would drop in a little drop of the correct color and it would reveal to you what it needed. It was like magic! You would know if you needed to put in brown or yellow or blue or what. And then you would paint a strip of the color you were trying to get to with what you had so far and you would dry it and then you would look at it under camera lights and go back and forth until it was correct." Charts existed with various basic formulas, but as Albrecht confirmed, "it was primarily visual."

CONTINUED CHANGES

As David Bowie's rock anthem "Changes" topped the charts in the mid-1970s, change was prevalent around the world and at Disney Studios as well. "I was one of the agitators here at Disney," reflected Jean Erwin with a laugh, recalling the removal of the individual quota systems. "It was quite a dog-eat-dog thing. The moment they took away the ratings system and [stopped] keeping track of cels, the whole atmosphere changed. Then, when a girl made a mistake—which you will do in this business[,] because everything is different all the time—people would offer to help her. In the old days, when someone made a mistake—tough! 'Your average is going down and my average is going up.'

"I've always enjoyed the job because it's always something new, and [by eliminating cel counts], we [had] a small enough group where we [could] tell whether a girl [were] doing a fair day's work," Erwin remarked. "There's a talented, much more relaxed atmosphere, and much better production than we used to have."

Without the quotas, there would still need to be a bit of gentle prodding to meet the overall department cel counts. Albrecht noted, "I came across a memo from Ginni [Mack] to the Painters saying that we really needed to get cel counts up, and she was suggesting that they start promptly." While a Paint Supervisor, Albrecht observed the varying rates: "You had the ones that spent

Ink & Paint teams gather with Grace Bailey for a photo outside the studio's Animation Building in November 1973.

a lot of time in the bathroom all the time, or doing something, just not spending the time painting. Then you had the ones who were really fast. Like Marcia Sinclair[,] who could paint it, repair it, and get it dry again faster than anyone else could paint it in the first place. That's just the way she was."

PENTHOUSES & PANTSUITS

Several changes within the daily life of the studio reflected the wider progressions of the times. Office dress codes had been in place throughout industrial history. Specific wardrobe options established an aesthetic of professionalism—and for the women of Ink & Paint, standard attire in the workplace was still dresses, heels, and fashion finery. Slacks of any kind were only permitted when the girls were working Saturdays or overtime, and smocks or cloth bibs were standard protective wear. If a woman should arrive at the studio in anything other than a dress or skirt, she was sent home to change. "It just simply wasn't done," laughed Lucile Williams.

With the sexual revolution of the 1960s and the renewed wave of feminism of the 1970s, changes were inevitable. "It just wasn't seen as professional for women to wear pants," recalled Don Hahn of the early 1970s. "Most of the guys wore slacks and ties at the time, but the voice of women's rights was in the air." As early as 1970, women in New York offices were petitioning for workplace wardrobe changes, arguing that slacks would result in fewer sick leaves because pants were less drafty than skirts, and that covered legs would reduce male gawking and result in greater overall productivity.

In 1972, after briefly lobbying for change, women at Disney Studios were permitted to wear slacks to work. "Dress pants, not jeans," Carmen Sanderson said with a laugh. "That was a big deal for us girls." Soon, plaid pantsuits and polyester slack sets were standard styles for the day-to-day operations of the department. Don Hahn noted, "Those pantsuits were real breakthroughs."

"Guys and girls could go to the Tea Room," Hahn added, "but the girls couldn't go to the gym [in the Penthouse], until the girls complained." In 1977, after some kerfuffle, the circumstances changed. "The male-only Penthouse Club on the third floor of the Animation Building now became integrated," recalled Ron Miller, then head of the studio. "Times were indeed changing. Let's face it: men will be men when there are only men, and when you introduce women, the culture of the place changes. But it was time. Women were, and continued to be, more and more important to that company, all the time." A further reflection of the times: the Penthouse Club was eventually closed.

Integration happened in reverse for the women of Ink & Paint several years later. Gretchen Albrecht recalled, "I remember how upset the ladies were when we got our first man in the Paint corridor, because they felt that their conversation was now going to be completely limited." That person was Paulino Garcia. "He was a very good artist," Albrecht confided. "Men were always there in Xerox as camera people, but as we needed more and more Painters, we began to have men and people who had worked at other studios."

While a number of changes were prevalent throughout the studio in the 1970s, some societal structures remained stuck in the past. Albrecht noted, "I was in a full-time position at one of

Left: Celebrating Halloween and the traditional Ink & Paint costume party with Becky Fallberg (witch), Gina Wootten (Dracula), and DeDe Faber (seated).

Right: Grace Godino and Carmen Oliver celebrate the Bicentennial Fourth of July, 1976.

the most recognized companies in the world. While purchasing our first home, my husband and I were surprised to find the bank that was issuing our loan would not factor in my income for what we qualified for," simply because she was a woman.

SELLING CELS

Since the beginning of the industry, animation art had been intended to be short-lived—carefully created at the height of artistry, until it reached the camera lens and was recorded on film for all time. Once past the lens, cels were of no further use, except for the grand tradition of a "slip and slide" party among the Animators at the completion of the film. But just as Guthrie Courvoisier had understood with the artwork of *Snow White and the Seven Dwarfs*, the cels of Disney animation continued to hold a museum quality of artistry. Since cels were washed for reuse over the decades, original cels from some films are rarer than others. Over the years, as materials, resources, and conditions changed, films came and went, color palettes progressed with the times—and one piece of celluloid or acetate art might hold its form longer than another.

In 1974 the Consumer Products division of the Walt Disney Company reinstituted an art program in various galleries across the United States. "It was called Gallery Cels," said Carla Fallberg. "My mother wanted to keep her staff working." While briefly out of work following a feature, Becky Fallberg made a suggestion: "We could ink and paint some classic cels. If they could sell them, we could bring a little income into our department and then keep the people busy." With a positive response, Becky sought out the head of merchandising and, as Becky recalled, "That's when it took off." The Gallery Cels program was meant as an effort to keep the skills of her staff honed, but the idea spawned a renewed interest in the artistry of hand-rendered animation cels. "We wanted the quality to be outstanding[,] and they didn't cost so much when we first started out, and they were beautiful. It turned into something, . . . I had no idea it would ever get so big!"

As the value of animation art increased, so did the need for security within the Ink & Paint Department. Carla Fallberg said, "When the general public started to latch on and [become] very predatory with animation art [my mom] had to put her guard up. I remember one day she said, 'Someone came in and stole a whole scene off of my Inkers' tables—a whole scene!' The Animators had to do the scene all over again." Years later, while remodeling was being done at the studio, someone apparently stole thirteen cels featuring classic Disney characters. The police were called in, reports were filed, and word quickly spread. But apparently the would-be thief gained a conscience, because the cels were later found in a stairwell with a note attached apologizing for the theft.

1970s STUDIO LIFE

Returning to work at Disney Studios over twenty years after her first job as an Inker in 1954, Joanna Romersa said, "The old buildings were there. The studio store was now where we would clock in. The trees were short and when I went back, years later, the trees were all tall redwoods in comparison to what they were. But when you were on the inner streets, between the buildings, it was just like it was years ago."

As long as there were men and women together, social activities ensued. In 1972, a new single-page, company-wide newsletter entitled *MMRC* or *Mickey Mouse Recreation Club* debuted. Produced entirely by studio personnel, this weekly publication later became known as *Newsreel* and continues today announcing lunchtime events, screenings, athletic offerings, and various studio updates.

Among the Ink & Paint staff, meeting production deadlines and various seasonal opportunities provided frequent

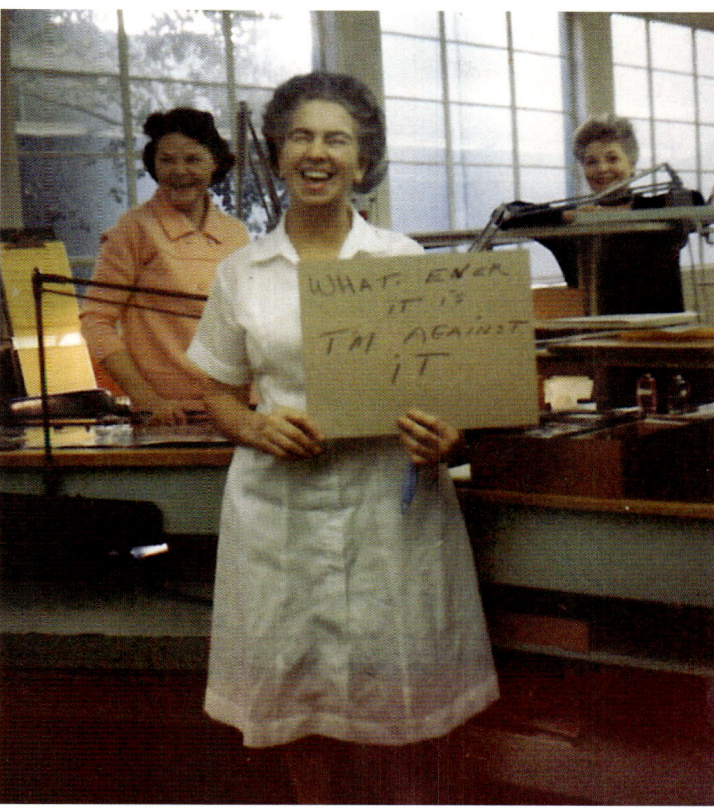

Left: Longtime Tea Room maven Vera Lelean displays her usual humor.

Right: Legendary Color Model Supervisor Mary Tebb and Paint Supervisor Zoe Parker at the Ink & Paint Christmas luncheon.

opportunities for a party. The Xerox crews quickly took the lead with finding any reason for a celebration. "They were the big partiers—Hat Day, Tacky Day, Hawaiian Day—you name it," laughed Carla Fallberg, Becky's daughter. "Halloween was crazy," remembered Becky Fallberg. "The youngest Animators would always dress up and then, after I took over Ink & Paint, it got more ridiculous. And then, the office people wanted to dress up, too.

"The artists started it," she remembered, "and then when the office people got into it, the artists didn't want it." Christmas holidays were always special for the department, as Carla recalled. "They set out a whole banquet on the Paint Lab counter. I remember Don Hahn, who's a musician, and he got all his musician friends in Animation and they went from department to department playing Christmas carols and holiday music."

OTHER STUDIOS

"After the second round of the Disney Trainee Program ended," recalled Lorna Cook, "I was hired almost the next day at Filmation Studios, but it felt like I had been sent to 'shark island.' Limited animation did not appeal to me, so I became a Layout Artist and I got an education with characters. I developed an idea for a TV show, which got created, but they gave me a thousand dollars and patted me on the head. I was so naive, it was a different kind of education. I wanted out of there and get back to Disney."

Xerox technology was now an industry standard and utilized throughout most major studios, but as Carla Fallberg recalled, the camera conditions varied from company to company. "I went to visit my dad at Hanna-Barbera Studios[,] where he was storyboarding at the time. He took me down to the Xerox process rooms and I was absolutely appalled. It was in the basement; no windows. It was terrible."

Television and commercial production kept most animation houses alive in Hollywood. Returning to work in animation in the 1970s, Phyllis Craig stepped into TV animation at Hanna-Barbera and noted the differences. "At Disney's [sic] I might work one week color keying a single scene, and then not get it finished. At Hanna-Barbera one season, I color keyed a whole ninety-minute weekly series by myself. At Disney's we had any amount of colors and any palette we wanted. If they didn't have what we wanted, they'd make it. At Hanna-Barbera at the time I left there, we had sixty-four colors, plus black-and-white and gray. You were told that was it. We could not mix special colors. We were told that you couldn't see any more colors on the [TV] screen. That was kind of hard to get used to, but you just did the very best you could with what you had."

"The fella who was in charge [there] was fired," said Joanna Romersa, who was hired in the 1970s as Supervisor of the Assistant Animators at Hanna-Barbera, where television animation was the primary content. "That was an education. There were ninety-six Assistants when I first took over that department and then of course we dwindled down to none. Those were hard days when more and more work [was sent] overseas. That was the beginning of the end." Television animation in Hollywood went overseas to Australia, then Taiwan, the Philippines, Korea, Japan, and India.

Caroline Leaf and Eunice Macaulay made their mark in Canada, winning international acclaim for their work. Academy Award winner Faith Hubley started Storyboard Studios in New York with her husband, former Disney Animator John Hubley. After a breast cancer diagnosis in 1975 and her husband's untimely death in 1977, Faith continued to create a prolific raft of internationally renowned short animated films. Abstract, experimental, and expressive, Faith's work was developed through various techniques with lighting and camera that gave it a distinctive look, known by insiders as "Hubley-esque."

THE 1980s

1980
- John Lennon is assassinated
- Mount Saint Helens erupts
- The Pac-Man video game is released
- The Rubik's Cube becomes popular

1981
- Sandra Day O'Connor is the first woman appointed to the United States Supreme Court
- Millions watch the royal wedding between Charles and Diana on TV
- New plague is identified as AIDS
- Personal computers are introduced by IBM

1982
- The first computer virus is detected
- Michael Jackson releases his *Thriller* album
- Princess Diana gives birth to her first child, Prince William
- The Vietnam Veterans Memorial opens in Washington, DC

1983
- Cabbage Patch Kids launch a toy frenzy
- New Age music debuts
- *Return of the Jedi* debuts in theaters
- Vanessa Williams is the first African American crowned Miss America

1984
- Indira Gandhi, India's prime minister, is killed
- The PG-13 movie rating is created
- Geraldine Ferraro is the first female vice-presidential candidate
- Singer Marvin Gaye is killed by his father

1985
- The first Internet domain name is registered
- Rock Hudson dies of AIDS
- USA for Africa's *We Are the World* recording session occurs
- The wreck of the *Titanic* is discovered

1986
- The space shuttle *Challenger* explodes
- The Chernobyl nuclear disaster occurs
- Halley's Comet passes
- The Supreme Court rules sexual harassment illegal

1987
- DNA is first used to convict criminals
- Aretha Franklin is the first woman inducted into the Rock and Roll Hall of Fame
- Congress declares March to be National Women's History Month
- The average woman earns 68¢ for every $1 earned by a man

1988
- The first World AIDS Day is held
- *The Phantom of the Opera* opens on Broadway
- Singer/songwriter Sonny Bono is elected mayor of Palm Springs, California
- The B-2 stealth bomber debuts

1989
- The Berlin Wall falls
- The *Exxon Valdez* oil spill occurs along Alaskan coastline
- Legendary actress Bette Davis passes
- The World Wide Web is invented

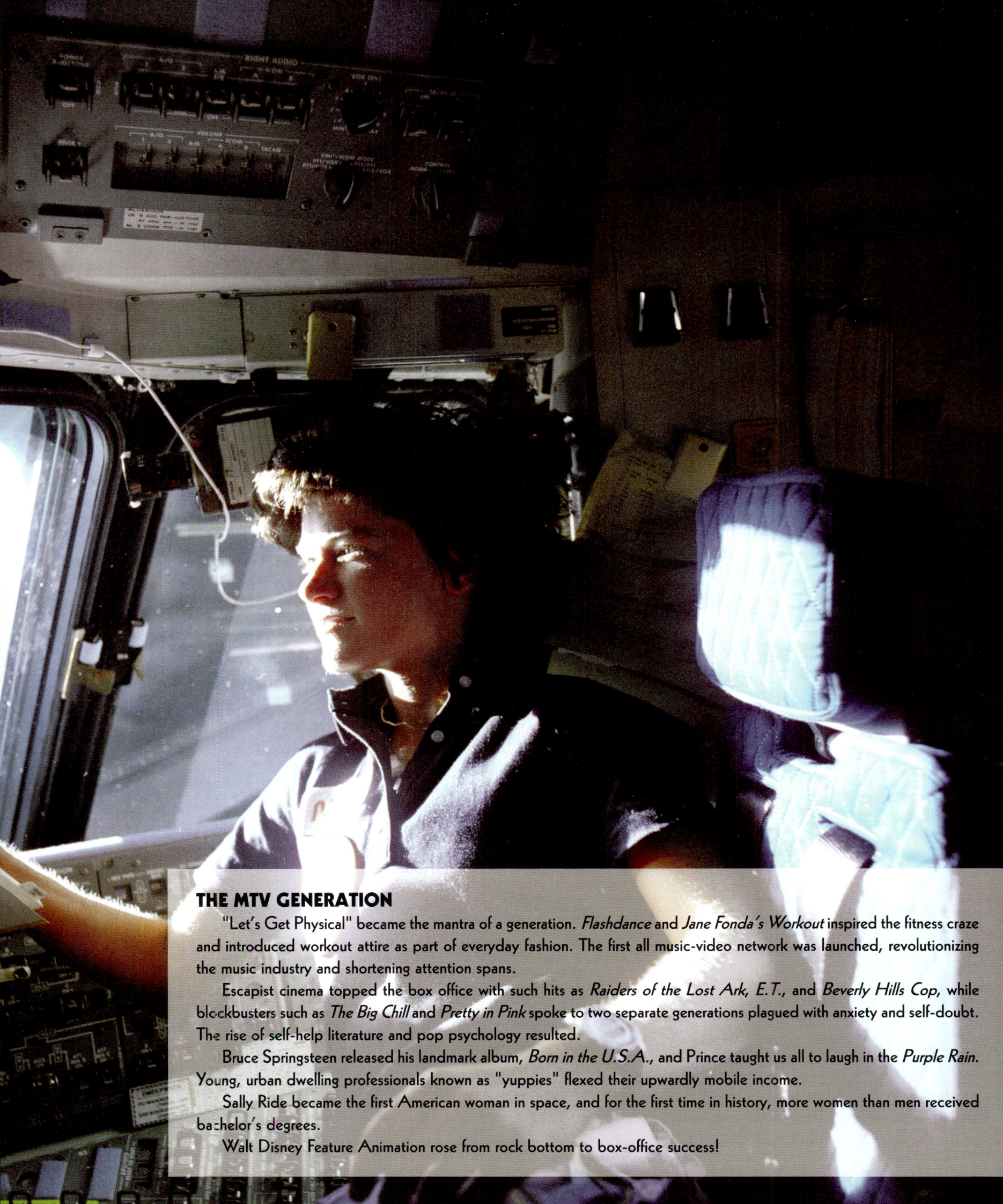

THE MTV GENERATION

"Let's Get Physical" became the mantra of a generation. *Flashdance* and *Jane Fonda's Workout* inspired the fitness craze and introduced workout attire as part of everyday fashion. The first all music-video network was launched, revolutionizing the music industry and shortening attention spans.

Escapist cinema topped the box office with such hits as *Raiders of the Lost Ark*, *E.T.*, and *Beverly Hills Cop*, while blockbusters such as *The Big Chill* and *Pretty in Pink* spoke to two separate generations plagued with anxiety and self-doubt. The rise of self-help literature and pop psychology resulted.

Bruce Springsteen released his landmark album, *Born in the U.S.A.*, and Prince taught us all to laugh in the *Purple Rain*. Young, urban dwelling professionals known as "yuppies" flexed their upwardly mobile income.

Sally Ride became the first American woman in space, and for the first time in history, more women than men received bachelor's degrees.

Walt Disney Feature Animation rose from rock bottom to box-office success!

LOW POINTS & REDEMPTION

> *"Around here ... we don't look backwards for very long.*
> *We keep moving forward."*
> — **Walt Disney**

The 1980s marked a seminal turning point for Disney animation. As Ron Miller noted, "In the 1970s, there was a lull of not knowing where we were going to go outside of *The Jungle Book*, but I think that lull was filled. *Pete's Dragon* helped with that. With the new trainees, then we were pretty consistent with animated films after that." Indeed, the studio's Animation Training Program proved successful with the discovery of some of the strongest original talent within all areas of production. For these new voices of animation, female and male, the 1980's marked a pivotal turning point at Walt Disney Studios.

The first generation of artists to matriculate from the earliest formal curriculum of the animation process were now applying their talents into the creative production pipeline at Disney Studios. Working alongside the creative old guard of Animators who established the tried-and-true traditions from Walt's day, this new breed of artists were eager to develop their talents and redefine the art form. This expansion into new and edgier approaches to animated films came with a few bumps along the way as the division traveled from the lowest of depths to ultimate heights of creative, technological, and box office success.

During the span of the 1980s, some of the most dramatic creative changes occurred within animation. Not since the 1930s transition from black-and-white shorts into full-color feature-length films had the industry witnessed such progressive movement. New voices and talent emerged, utilizing amassed techniques as well as forging new technological advancements that would forever change animation production processes and the visual artistry of the animation medium.

UNLIKELY FRIENDS

Uniquely blending the talents of the seasoned ranks of the old regime of Walt's masters with the new breed of a fresh generation of Animators, *The Fox and the Hound* told the story of two unlikely childhood friends later forced to become enemies. "I always liked the story," recalled the film's Executive Producer and studio head, Ron Miller. "That was my first true involvement in developing a story and seeing it through into an animated feature."

The voice talents of several noted ladies were featured, including the legendary film, stage, and television star Pearl Bailey as Big Mama, Tony-nominated performer Sandy Duncan as Vixey, and Jeanette Nolan as the Widow Tweed. *The Fox and the Hound* also featured a strong presence of female Animators. The young artists included Linda Miller, Heidi Guedel, Emily Jiuliano, and Lorna Cook, along with a considerable number of female Assistant Animators such as Sylvia Mattinson, Retta Davidson, Gilda Palinginis, Sally Voorheis, Cyndee Whitney, Vera Pacheco, Sue Kroyer, and Leslie Gorin.

The Layout team included Sylvia Roemer. "It was very interesting work," she noted. "It was like art school; you learn something new every day!" Background artists included Kathleen Swain and Daniela Bielecka. Patty Peraza, a recent graduate from CalArts, recalled, "I started on *The Fox and the Hound*, inbetweening effects, and the ladies of Ink & Paint applauded when they heard a woman was in Effects." It was an era of change.

With the addition of these ladies, change occured on many levels. "When I started working there at the main lot," recalled Patty Peraza, an Inbetweener on *Fox and the Hound*, "I was the only woman in my department. On my first day, there was a lot of drilling and hammering going on. The guys came by and joked: 'We hope you're happy,' referring to all the commotion. I stepped into the main hallway and they just finished converting a bathroom for women! As the only woman, that was pretty thoughtful!"

LACK OF LOYALTY

On September 19, 1979, the *New York Times* broke this news: "A severe blow was struck at Walt Disney Productions' Animation Department last weekend when 11 members—over fifteen percent of the department—resigned to form a rival company." Don Bluth, the charismatic Animation Director on *Pete's Dragon* and *The Small One*, left the studio along with a number of his Animators to launch his own animation company in direct competition with Disney. The timing was crippling, as nearly a third of *The Fox and the Hound* still needed to be animated. "I remember handing the Disney leaders my letter of resignation," said Linda Miller. "They were quite shocked. I wasn't seeing quality films ahead at Disney[,] so I left thinking that would be the case with Bluth. Funny thing is, that's the exact reason why I left Don Bluth's studio and came back to Disney a few years later."

Production on *The Fox and the Hound* was pushed back while the Animation teams regrouped. The studio went to the ranks of the animation students at CalArts, bringing qualified student artists on board and placing them straight into training. Rising above the circumstances, Ron Miller stated at the time, "The same thing happened to Walt twice. And it's going to happen again. We develop the finest artists in the field of animation in the world. It's typical of artists to want to spread their wings." The fates were favorable, as Don Hahn noted, "That's when a number of the top Disney artists today came to the studio."

CARRYING ON

With production back on track, animation continued and approved scenes were soon coming in to Ink & Paint. By this time, the use of color Xerox had developed into a more refined technique. Brown Xerox was implemented as a well-suited artistic adjustment for the world of Tod and Copper, but there were still problems. "Brown Xerox was a nice compromise," recalled Gretchen Albrecht. "It was a softer look to the characters than

Page 322: Astronaut and physicist Sally Ride became the first American woman in space, in 1983.

Page 325: Actress Cindy Morgan as Yori in a final film frame from *Tron* (1982).

Pager 326, left: Production cel of Big Mama from *The Fox and the Hound* (1981).

Ink & Paint Department Supervisors and Painters on *Mickey's Christmas Carol* (1983).

black, but very hard to paint to, because the brown line is somewhat see-thru [*sic*]."

"At first we had a lot of trouble with *The Fox and the Hound*," noted Ginni Mack. "Some of the Xerox in the brown was almost transparent, so it was translucent—you could see where the paint showed through the line. We had a lot of trouble with that. The brown lines looked nice, but the girls almost had to 'ink' as they painted. They had to paint over the brown Xerox line just right, to cover the whole line and not go over it so you couldn't see the line. That was a problem because it really slowed everything down, but they corrected it later on and that was the only time we used brown Xerox[:] on *The Fox and the Hound*."

In addition to their work on feature animation titles, the Ink & Paint Department continued to complete services for other studio productions, including the main title sequences and visual effects for a number of live-action titles including *Condorman*, *The Watcher in the Woods*, and *The Black Hole*. The work on these additional titles added further delays to the extended Ink & Paint production time of *The Fox and the Hound*. Over four years in the making, this transitional film ultimately required 360,000 drawings, which were transformed into 114,000 painted cels and over 1,100 painted backgrounds. Seven hundred forty-eight different hues and colors were utilized within this 78-minute film, totaling over 450 gallons of paint.

> "*We were changing the way the film industry created animation and live-action films.*"
>
> —**Raulette Woods**

A COMPUTERIZED WORLD

"I was trying to find a script with more of a wider audience," noted then-studio head Ron Miller. "I had dealt a little with computer animation and I thought it was an opportunity to do something unique and different. It was a gamble." A pioneering step into the future of filmmaking, *Tron* became the first film to feature computer graphics blended with live-action and traditional animation. Many of the computer images in this landmark film were achieved via traditional animation and hand-inked and painted cels. Of her experience playing Lora/Yori, the only lead female role in *Tron*, actress Cindy Morgan revealed, "I had no clue that it would become so big or that CGI would become the future of film."

Sixty-seven minutes of the story were set in the "electronic" world. Fourteen of those minutes were completely generated through sophisticated computer graphics, and the remaining fifty-three involved a complex blending of technology and the art of animation. Overseeing computer systems and software development for the film was Mark Kimball, who noted, "These scenes involve compositing live actors into the 'electronic' world by placing their image against a computer-generated background and among props that are animated with light." This created a surrealistic electronic world. "It was a new process that hadn't been done before," added Patty Peraza. "I worked on the motorcycle light patterns which were all hand rendered and it was challenging. You had to be very precise because those darn light cycles were pretty fast." The films Script Supervisor and former Ink & Paint secretary Edle Bakke agreed: "It was the first time everybody was really using computers to change things [dialogue, action, etc.] immediately, so it was very challenging in that respect."

Live action for the electronic world was shot over the course of three months on the studio back lot. Sets and costumes within the electronic world were only black-and-white. Most of the sets were flatly lit, while the backgrounds were flat-black velvet sheets to prevent glare. "When we filmed *Tron*, there were no colors. We stood there in total blackness with the other actors," revealed Morgan. Bakke expanded on how they approached the production challenges for this groundbreaking film: "That was tough because everything had to be imagined—every shot, what angle it was from, and whether it was all going to match one thing to another. We had to be aware every minute where everybody was. There would be pictures taken of the actors where they started and ended, so they could be sure that the backgrounds that were going to be used were in the right place, and the storyboards [that linked the animation and live action] were everywhere all over the set."

Delivering performances in this minimalist context presented challenges for the cast and crew. "When we made it, we were working blind," added Morgan. "Playing CGI ball without a ball was pretty difficult. It was like being a little kid again and using your imagination." Bakke added, "A few times, people were in the wrong place. So the editor and I said, 'Look, I think that's wrong, let's go.' So we would go and double-check it. It was a very difficult thing to do, and it was hard for the actors, but they were wonderful."

Crafting the score to suit the futuristic world of *Tron* required a new approach as well, and filmmakers reached out to the virtuoso synthesizer performer Wendy Carlos. "We [were] looking for a unique mix of electronic and symphonic sounds, which is why we went to Wendy," noted Director Steven Lisberger. "She understands classical music as well as she understands sound synthesis."

To Carlos, this presented an interesting challenge. "The way I write, the tune does not come first," she stated. "It all comes at once, simultaneously—counterpoint, harmony, rhythm, and the timbre are all very much a part of the original concept." Of her approach to *Tron*, she remarked, "I chose to try to be a little simpler than my normal style, for the sake of a motion picture audience, but I didn't feel cramped." Carlos's score broke new ground in cinema. "It's closer to the spirit of a symphony than any other form . . . but it essentially does do all of the dramatic things necessary for film music, and yet it stays honest, almost to being absolute music in its own way. . . . It was really a nice experience to write the kind of music that I felt was the best for the film, and I'm very grateful for being given the chance to do it, to be involved in a spearhead in a new direction in doing film scores, just like the visuals are sort of a new direction in the way motion pictures are made."

PAINTING WITH LIGHT

The combination of technology, live action, and animation defined *Tron* as a visual breakthrough in cinema, but the time and costs involved with achieving a production of this kind were uncharted. Associate Producer and Visual Effects Supervisor Harrison Ellenshaw noted, "*Tron* wasn't an animated film, it was a hybrid, and there was no way we could have thought of everything[,] because we had no idea what we were in for. I liken it to trying to tunnel through a mountain with spoons."

To achieve the dazzling colors of this electronic world, a photographic technique called Backlit Animation was utilized. Actress Cindy Morgan recalled, "In the movie, our uniforms glow—they're red, blue, and yellow, and all that is put in later. They were hand tinted." Mark Kimball explained this painstaking process: "The light comes from behind the cel illuminating any clear areas on the cel. By using a holdout matte to temporarily black out areas of the cel not to be illuminated, and placing a colored filter in the front of the camera lens, only the selected portion of the cel will be photographed in that color. This process may be repeated on the same frame using different holdout mattes and different color and diffusion filters until the frame is completed."

To establish the futuristic backlit look, Kodalith negatives, rotoscoping, and painting of cels were employed in the scenes requiring visual effects. Once live-action photography was edited, every frame was enlarged at least twice onto sixteen-by-twenty-millimeter Kodalith film. "It was specially made X-ray film," noted Ellenshaw, "but there was no such thing as registration pins to keep everything locked in." Each sheet of the Kodalith stock, as well as cels, was custom sized and punched by Lloyd Winegardner of the studio's Cel Services Department to match the Disney registration system. As many as six cels were made for each frame of the film, with each cel indicating color separations, shadows, and highlights.

As Kimball noted, the volume was staggering. "With seventy-five thousand frames to be shot, you have seven hundred background cels, seventy-five thousand body holdout mattes, seventy-five thousand continuous tone cels, seventy-five thousand high contrast reverse cels, seventy-five thousand circuit reveal mattes, [and] forty thousand holdout mattes just to expose the faces or eyes of the actors." To accomplish this mind-boggling matrix, a new approach to postproduction was required. "This had never been done before," Ellenshaw noted with a laugh. "We had no idea what we were in for!"

In the fall of 1981, the small team of Ink & Paint artists at the studio was put to work on the oversized fragile Kodalith negatives. As Ginni Mack recalled, "It was all in black-and-white and it was all done on negative film. We were working on big negatives, and negatives scratch very easily. Where they scratch, you get a whole lot of light coming through [as] it takes the film off of the cel, so you had to be extra careful." The production team's first glimpse at the effects, nevertheless, was a success!

With a summer 1982 release slated—and an underestimating of the time and labor involved with the animation process—Ellenshaw quickly determined additional staff were needed. However, with animation production in Hollywood at an industry low, finding qualified and available artists locally was not feasible. So, in January 1982, the film's producers sourced additional ink-and-paint services overseas to complete the monumental volume of Kodalith cels. Working with an animation house in Taiwan, over three hundred artists were hired and specifically trained to understand the unique inking and painting requirements necessary for this film. Overseas workers had been utilized by many of the TV animation houses, but never before on Disney animation—or on a film requiring this volume of effects work.

Once finished scenes of Kodalith cels were completely opaqued, then inked and painted as necessary, they were packaged up in specially built boxes and sent from Taiwan to Burbank for Camera and Optical Printing. Raulette Woods, a

The various 12.5"x 20" Kodalith elements utilized to create a single composited frame of film from *Tron*. Top: (left) Continuous Tone (positive) Kodalith element; (center) High Contrast negative Kodalith image made from a one-to-one contact print from the Continuous Tone element; and (right) Hand-painted Body Matte filled in over the clear circuits from the High Contrast negative.

Bottom: (left) Circuit Reveal with Matt, hand-painted on cel, with everything filled in except the areas with clear circuits; (center) Circuit Reveal with hand-painted slop matte extended to frame edges; (right) Computer-generated Background element on 12.5"x 20" Ektachrome color transparency.

Final composited film frame from *Tron* (1982), which includes additional face and eye reveal Kodalith elements.

UCLA graduate working in early motion graphic design for broadcast, was brought on board Ellenshaw's postproduction team. "I spoke the language of photography and enough of cel animation to keep pace with his ideas and his explanation of problems needing to be solved," recalled Woods.

KODALITH CONUNDRUMS

Coordinating the Burbank side of postproduction, Raulette Woods was on hand when the first shipment of Kodalith cels arrived from Taiwan. The box was sent straight to Camera for processing, and the next day a call came through: "It was a Camera person who was almost in tears," Harrison Ellenshaw recounted. "He was almost beside himself." In the rush to ship the cels from Taiwan back to Burbank, the drying time had been shortened, and the painted cels had not fully dried. Upon arrival, the Kodaliths were a stuck chunk of film stock. Each Kodalith needed to be peeled away from the others, completely marring the opaqued areas. The earnest Camera Operator "had endured a couple hours fixing it," noted Ellenshaw. "Finally he got to the point he shot so many cels that needed fixing that he was just exhausted from doing this."

To remedy the situation, extra staffers in Burbank were brought in to separate the troubled cels and help correct the opacity for camera. "They literally had a small army of workers there taking paint and blocking any light leaks around where there should not be light," recalled Mark Kimball. Production processes in Taiwan were modified with extended drying time and proper separation between each of the cels for the course of production.

With procedures corrected, the overseas studio averaged ten thousand completed Kodalith cels a week. They then shipped them to Burbank for final processing. The studio Ink & Paint team focused on the painstaking inking and painting detail for volumes of cels as well. "It was boring," Ginni Mack groaned, "because it was all either white suits with black buttons or black suits with white buttons. I hated working on it, but most of the girls felt that way; they didn't like it at all. It wasn't with color and with other characters [where] you look forward to their expression. *Tron* just didn't have anything that would appeal to the girl that was working on it." But for Ellenshaw, the ladies of Ink & Paint saved the day. "I was in awe of what they did."

As artwork became ready for the camera, new challenges unfolded. "We originally thought the four camera stands at Disney would be able to handle the load," Ellenshaw recalled, "but to meet our deadline, we had to outsource the work to fourteen camera stands at various studios across town." In addition to the logistics of shuttling artwork around Los Angeles, an unfathomable volume of artwork now began to accumulate before being processed through camera. "We ended up with six hundred thousand Kodaliths and associated cels," Ellenshaw stated. "We could only stack the custom-built boxes so high because they'd eventually crush[,] and we basically ran out of room. Staging these boxes was a challenge[,] and just like any animated feature in the old days, there's a huge issue with organization of artwork before and after it made it to Camera." Four large climate-controlled trailer trucks were parked on the back lot where the artwork was stored. "Everything was labeled and stacked chronologically, as it waited for processing," noted Ellenshaw. "There were no bar codes or apps to organize this."

Color was the final element to be integrated. "The camera itself had RGB [red, green, blue] filters," noted Kimball, "and could change those filters to re-create the color that you wanted on the cels. You would have the cels with the red area, then you'd put another mask cel on top of that to block it out, except for where you wanted the red[,] and you'd open the shutter for the amount of time that you needed and then close it and you've just added the red in the right places of the cel. So, you can understand how laborious a process this [was]." It was challenging and tedious, yet when the cels were seen together in final context, the dazzling light effect proved its worth. "We all knew we were

creating imagery that had never been seen before and we were identifying the 'look' of cyberspace for the silver screen," noted Woods.

The groundbreaking visuals and integration of these varied processes forged new methods in filmmaking. "It was a constant battle of getting the film done," recalled Ellenshaw, "but also facing the reality of doing something that had never been done before." Woods confirmed, "We were creating a change in how studios would produce films. We were all pushing the envelope. It's what we strive for as Visual Effects artists and filmmakers."

Ron Miller added, "To think back on it now, it had to be a hell of a challenge for all those people. You must seek new ideas— you reach for them, embrace them, and you hope to God that you made the right decision. . . . Quite frankly, I think we did."

LOST ON THE WAY TO PRYDAIN

Continuing with new ideas and seeking new directions in animation, the next green-lit production, *The Black Cauldron*, was anticipated as a mature step for Disney Studios. "I was reaching out to make a more 'adult' version of our typical animation," recalled Ron Miller. "I thought it had chances." Fraught with delays and rising costs, *Cauldron* is perhaps more known for its problematic production than its artistic accomplishments. The film's story was shaped from Lloyd Alexander's five-book series *The Chronicles of Prydain*, and studio veteran Joe Hale was assigned as the film's producer. The ambitious animated adventure was intended as an epic PG-rated film in the 70 mm film scope and scale of *Sleeping Beauty*. As it was the first film to be made without the guidance of the retired Nine Old Men, "It was a stormy period of change, transition from the old guys to the new," observed Animator Andreas Deja, who also worked on conceptual designs. "it was to be our generation's *Snow White and the Seven Dwarfs*."

As production ramped up on *The Black Cauldron*, a new phase of talent expansion was announced with the Disney School of Animation. Striving to develop two feature animation teams working on separate productions with overlapping schedules, Walt Disney feature animation recruited several of the earliest female animation students at CalArts, including Jill Colbert and her roommate Kathy Zielinski. A Student Academy Award winner for animation, Zielinski left CalArts after her sophomore year to begin her animation career. "Before we started animating," Zielinski noted, "we got to train with Eric Larson for about two months. He was such a great guy!" After Cleanup and Assistant Animating on the short *Mickey's Christmas Carol*, Zielinski moved up to feature animation. "On *Black Cauldron*, I did the three witches, and one of the embarrassing scenes I did in that film," she laughed upon reflection, "was the frog that got stuck in the witch's cleavage. Lucky me!"

Retta Davidson returned to the studio as coordinating Animator to train the young Animators working on *The Black Cauldron*. Animator Floyd Norman, who was also back at the studio, remembered of her return that "finally, another Retta had become a Disney Animator. No small matter in a studio once dominated by men. Even though she was now a grandmother, Retta embraced her new job with her usual enthusiasm. She hoped that her position would open up greater opportunities

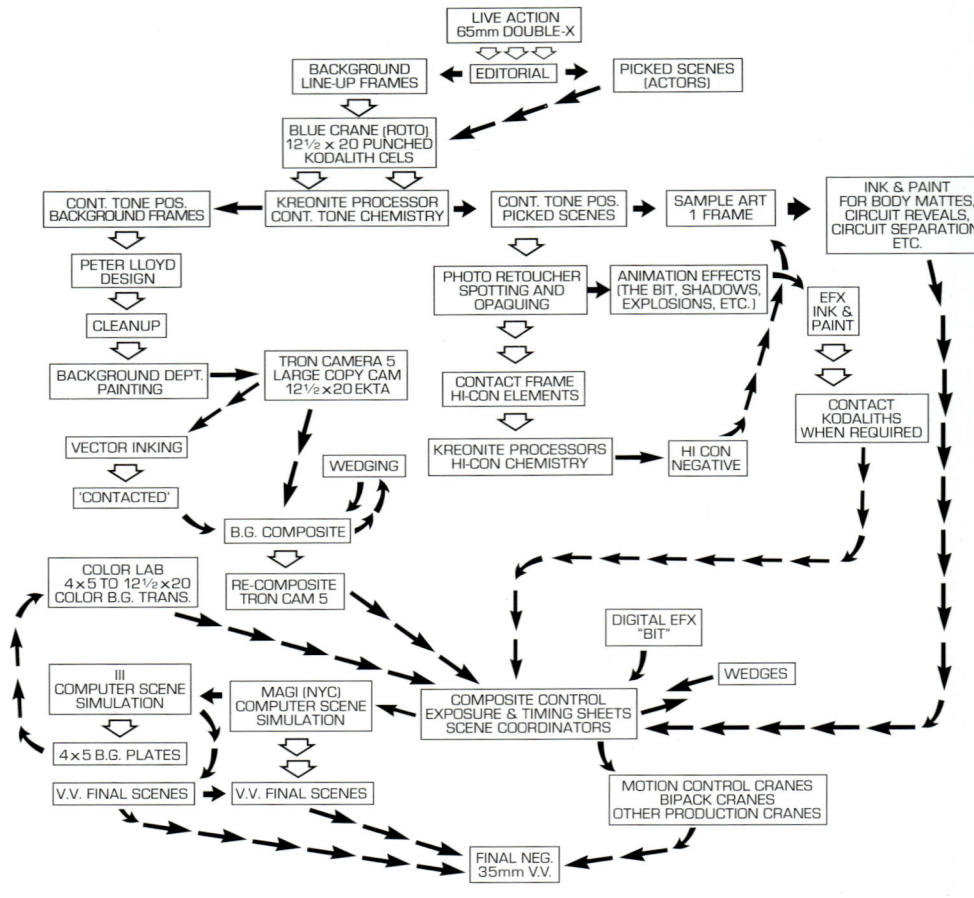

TRON POSTPRODUCTION FLOW CHART

for other young women who are currently in training as Disney actively began rebuilding their Animation Department."

Serving as a self-appointed den mother to the fledgling group of Animators, Davidson kept the young teams in line as animation on *The Black Cauldron* began in May 1981. This ambitious production featured the largest number of female artists ever, in every level of animation at the studio.

STRIKES & 3-D

In the summer of 1982, the Motion Picture Screen Cartoonists union voted for an industry-wide strike. For ten weeks, production continued with makeshift, all-hands-on-deck crews during the strike. "Yes, everybody left," recalled Becky Fallberg. "As Supervisors, we all painted cels of Xerox. We were on the Xerox crew and my boss was doing inbetweens [while] the Director was doing breakdown or animation. They just did all kinds of things because they were flexible and they had done many different classifications in their careers so . . . we had fun, you know . . . [a] roll up your sleeves [attitude].

"One of the Directors and my boss were back at the Animation desk doing their job," Fallberg said. "At break time I brought them ice cream cones. They thought that was wonderful. So it didn't last too long. I think the people that suffered the most were the ones that were out on strike; that's too bad, although financially the company did [too]."

But once the 1982 strike was resolved, further delays added to the production problems—and costs. As time wore on,

Ink & Paint | **331**

Page 330: Harrison Ellenshaw's "simplified" Post-Production flow chart created for *Tron* (1981).

This page, left: Production cel of Eilonwy from *The Black Cauldron* (1985).

Right: APT test cel of Gurgi, completed for *The Black Cauldron* (1985).

frustrations mounted. "Oh, my goodness, that show," remarked Paint Department head Gretchen Albrecht. "The thing about *The Black Cauldron* was it was very exciting in its original concept, but it kept being changed." More delays followed. "There was a clash of vision," recalled Andreas Deja. "Various artists wanted more entertainment, richer character development and humor, but others sought to trim the story. Then midway through production we had a management change and they felt it was too scary, so there was an attempt to tame it down for family audiences." As the production moved on, story was not the only point to prove problematic for *The Black Cauldron*.

The first 70 mm film since *Sleeping Beauty*, *Cauldron* featured Dolby sound and marked the first use of computer animation within a fully animated Disney film. "There were three scenes in *The Black Cauldron* that made use of computer-generated animation," recalled Roy E. Disney, who began overseeing the Animation division in 1984. "In one scene, there is a boat that is used as an escape vehicle when the castle explodes. The boat itself is computer-generated, and the first time I saw it I realized, for reasons that are impossible to explain, that it is so technically accurate that no human Animator could have done it." The Cauldron itself was also converted into a 3-D object, and filmmakers even attempted to incorporate a 3-D holographic sequence that would project the deathless Cauldron-Born into the theater. Even with the introduction of computerized imagery within *The Black Cauldron*, the Animators rose to the challenge. "Many still think the visions within *Black Cauldron* were computer generated," noted Patty Peraza. "I hand-rendered these scenes in charcoal to

achieve a hard edge and a separate soft edge. It was difficult and I don't think it has been done before or since." Acknowledging the ambition of these burgeoning technologies, Roy was quick to recognize that "of course computers can never replace human Animators, but they can be of tremendous assistance."

TECHNOLOGY TROUBLES

Once again, the Ink & Paint Department was the pivotal point for change as the problems with *The Black Cauldron* continued to mount. Looking to advance beyond the technology of Xerox, which had replaced hand-inking twenty years earlier, the newly developed Animation Photo Transfer process, or APT, was applied.

Hollywood was changing. Studios were shifting to independent producers for film content, which caused studios to shed many of the ancillary production departments. Without in-house films to cover, the Studio's Still Photographic Lab was running out of work. Dave Spencer, who ran the lab, developed a system to keep their department viable by taking an animation drawing and photographically transferring it to a cel, calling it Animation Photo Transfer (or APT). "It was photographic based . . . basically a film negative process," recalled Don Hahn, who was the film's Production Manager at the time. "You have a sheet negative and you put the drawing up and you expose it like a giant sheet negative to the drawing, which creates a negative image and then process that into a photograph negative. Then you put that against a positive piece of clear sheeting coated with UV sensitive ink, and expose light through the negative to the sheeting where the ink cures. Wash away the residue and you would end up with a nice, thin line just exactly like ink."

Limited color had been introduced to Xerox, but APT permitted a wider range of colors and shades, introduced the processing of self-colored lines, and was adaptable to any cel size. "It seemed a brilliant use of 'found' material," noted Gretchen Albrecht. First tested in small sections of the graveyard scenes in *Mickey's Christmas Carol* (and an entire eight-minute preshow short for the Circle-Vision presentation *American Journeys at Disneyland* entitled *All Because Man Wanted to Fly*), APT was perceived to be the next great animation process. "I was hired at Disney to help

Final frame from *The Black Cauldron* (1985), featuring the specialized effects of the cauldron.

finish painting *Mickey's Christmas Carol*," recalled Karen Comella when thinking back to the 1983 short film. "I was in awe—I got to paint Mickey, Goofy, Scrooge McDuck, and more. We also utilized APT in a few scenes as a test."

APT was quickly moved into production on *The Black Cauldron*; however, the process was not as promising as hoped and ultimately presented more problems, which consistently interrupted the overall production flow. "In reality," recalled Albrecht, "the APT material was somewhat repellant to the paint. So, the paint would crawl back from the edge and we didn't know what we were going to do." A colleague with a chemistry background identified the problem. "It needed a surfactant!" recalled Albrecht. "So we put dish detergent in the paint, which fixed it like a charm." Later, when a group of scientists came through Ink & Paint, they expressed concern about the longevity of the cels. "I replied, 'We have to get these to Camera—that's what we're worried about!'" As it turned out, being discarded after getting to Camera wasn't the only threat to the cels' longevity. As Albrecht noted, "The irony is . . . the APT lines faded away over time."

POLYESTER POSSIBILITIES

Organizing crews and material changes were necessary with the new APT procedure. Polyester cels were explored as an option. Becky Fallberg documented the circumstances in an office memo: "The Xerox camera can use the poly cels because they lie flat, which always helps the procedure, but when the Xerox crew members have to combine one level with another, they have to add another step in the process to get the image to stick to the cels. They have to introduce a negative charge to the plate in order to get the cel to pick up the image." This additional step also picked up more of the background imagery, adding further problems.

Persistent problems resulted from the softness of the polyester materials. The limp cels were difficult to handle and scratched too easily. Lines could not be removed with an ebony scraper, as even the simple act of cleaning the cels with a soft batiste cloth left scratches. Static electricity also became a factor with the polyester cels, adding further problems with dust and the tissues placed between each cel for transport, sticking to the cels and leaving scratches with attempted removal. A coated film on the cels also built up on the Inkers' gloves, hampering their ability to create smooth lines and adding to the problem of paint peeling off from the cel. Ultimately, the polyester cels were not utilized.

CAULDRON CONUNDRUMS

Using both the Xerox and APT processes caused inconsistencies in the quality of the linework on cels. To save time and money, producer Joe Hale attempted to apply these differences creatively to enhance the narrative. Issuing a memo in December 1983, Hale stated, "I would like to use only the Xerox line for scenes using the following characters: Taran, Eilonwy, Fflewddur, Gurgi, and Dallben. The APT process will be used for the darker characters, such as the Horned King, Creeper, Gwythaints, and Henchmen. There may be cases where both process can be used in the same scene." Though a creative solution in theory, this conglomeration of processes ultimately added to the confusion and frustration of the production.

Problems continued with the paint, as Gretchen Albrecht recalled: "Environmental issues affected the consistency of some of the ingredients used to make the Disney gum-based paint, so we had continuous problems with streaking. The cobalt blue

Effects Animator Patti Peraza working on *The Black Cauldron* (1985).

would fall out of suspension and you'd get blue streaks in a color that was supposed to be beige and things like that." The paint could only be applied within the climate-controlled corridors of the Ink & Paint Building. "You couldn't send the painting out," Albrecht added, "because it could get over-dry and pop off the cel, or . . . you could see a shiny halation ring, which means it's about to pop, or it would reabsorb the moisture and stick to things." To meet their weekly departmental footage quotas, Painters were placed wherever there was space. "Ultimately we [had] Painters all over that place," Albrecht said with a laugh.

The first scenes arrived in Ink & Paint on December 9, 1982. Crews put in more than a year of overtime, and in the last months of production, cameras ran twenty-four hours to keep production moving. "That's when we had a lot of men Painters, because they like to work nights," observed Becky Fallberg. Albrecht noted, "It was grueling. We had three months of six days a week of overtime and six months of seven days a week of overtime."

Pushing cels through Ink & Paint required all hands on deck. "We had to train a few of the men Animators to paint cels towards the end of production," recalled Ginni Mack. For many of these Animators, it was an eye-opening experience. "They thought we passed the same paint jars around to each other," Mack said with a laugh. "They learned new respect for Ink & Paint." Special Effects Animator Dave Bossert, in his first job out of CalArts, noted, "I had no hesitation whatsoever when Don Hahn asked me to help out with Ink & Paint. It was predominantly all women, you couldn't escape that fact, but I look back fondly on the experience because of how much I learned in the process. I got more of an education working in Ink & Paint for a few months than I did in all my years of college!"

Saskia Raevouri recalled working late on a Sunday with Albrecht for a particular deadline on *The Black Cauldron*. "Everybody else had gone home and it was just the two of us, collecting the dried work the Painters had left behind and wrestling to get the scenes in shape. Gretchen was the Supervisor, but she was a real trouper and not afraid to do the most menial of tasks to move the work forward. We could not leave until we were done[,] as there was no such thing as not making our footage. It got to be past two a.m., and we were frozen as they had turned the heat off in the building."

But that wasn't the only thing both were contending with. "We were also starving[,] as we had not eaten since lunchtime and there was no way to order anything onto the lot at that hour," Raevouri said. "Suddenly we remembered the fridge in the Paint Lab! What a feast we had—half-eaten tuna sandwiches, leftover pizza, yogurt, chocolate chip cookies, doggie bag surprises. That fridge saved our lives and kept us going for a few more hours."

Despite the commitment of the staff and their months of working overtime, there still weren't enough hands to complete the film in time for its target release date. "We got into a crunch at the end of production," pointed out Don Hahn, "and attempted to send work overseas to meet the deadline, which was being done regularly by other studios, but wasn't part of the normal Disney Feature Animation process. Rick Rich [the film's codirector] and I flew to Korea, and set up an Ink & Paint studio over there, to mainly paint special effects cels."

Painter Robin Police also went over to supervise production,

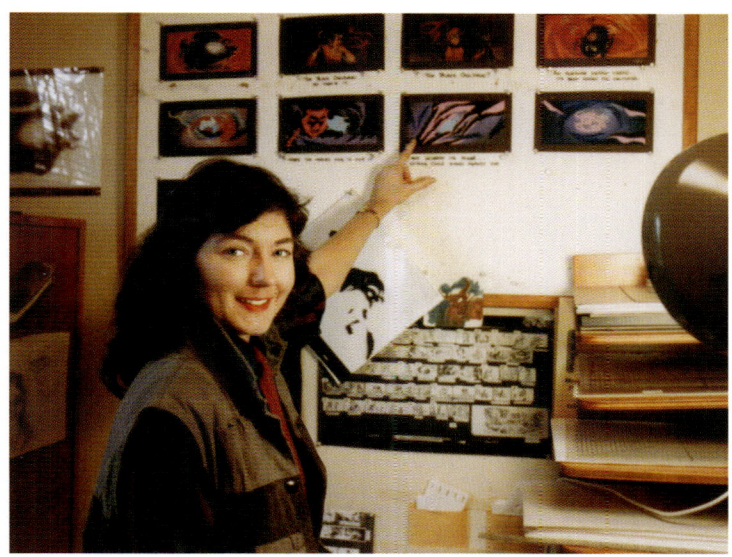

according to Hahn. "We sent over bubbles and shadows and a lot of mattes to paint. They were very talented women with a very linear style to their artwork and brush painting, so they were brilliant at inking and that kind of painting." Unfortunately, in a pre-Internet and overnight-shipping age, the logistics of a long-distance production site were counterproductive. "When you sent a shipping crate full of artwork to Korea, there was a commitment of weeks and months before you'd get it back, Hahn noted, "so it just didn't work out. That, along with the large format, and the demands of that show, made it very, very difficult."

After twelve years in the making with five years of actual production, 1,165 different shades and colors comprising four hundred gallons of paint were applied to over 460,800 cels utilizing with hundred brushes to create *The Black Cauldron*. But with poor box-office returns, this earnest epic ultimately represented a low point in Disney animation. While the APT process had its merits, winning the film an Academy Award for Technical Achievement, ultimately, it was costly, time-consuming, and cumbersome. "APT was going to be the thing of the future," noted Don Hahn, "but . . . in the end, it was abandoned pretty quickly."

Albrecht recalled, "We thought *Black Cauldron* might have been our last movie. . . . Hardly anybody saw it. I remember being called to a meeting at the Coral Room restaurant on the lot, with the Ink & Paint supervision[,] and we really thought we were going to our 'last supper' because we knew the film was not the best and it was expensive.

"But that's when Roy [E. Disney] took an active part," Albrecht said. "Between his efforts and Peter [Schneider] and Tom [Schumacher] and the folks they brought with them, we were able to get back on track."

Roy E. Disney was optimistic about the Animation division's future despite the *Cauldron* setback. "There's no question in my mind that we now have the staff and resources to accomplish the task. Happily, we're getting to the point where the staff is the best in the studio's history," Roy said. "Twelve years ago, the average age of a Disney Animator was fifty-seven and today it is thirty-three. When you are dealing with young artists who are already that good and still have the potential to grow, the odds are you're going to produce some great animation."

COMPUTERS & CHARACTERS

> *"I credit the success of my films to the teamwork in my organization. Whatever we accomplish is due to the combined effort."*
> — Walt Disney

Under the new regime at Walt Disney Productions in the early 1980s, animation was at a low point and live-action films took precedence. Quality production office space in close proximity to the main studio headquarters was amply available in the centrally located Animation Building. In March 1985, the Animation teams— which consisted of nearly two hundred people—were unceremoniously removed from the halls that Walt once roamed. Packing sixty years of Disney experience into boxes, the next generation of Animators moved to an outdated warehouse in nearby Glendale, California.

"It was very much like being sent to an island," recalled producer Don Hahn. "We were a little shell-shocked. The Ink & Paint Department didn't move because the Xerox machines were such a formidable thing, so they stayed where they were and we shuttled artwork between locations." Some time later, the Ink & Paint Department joined the team at the warehouse and as Color Model Supervisor Karen Comella recalled, "Off lot, things were a little looser, (but) it was a big transition."

Conditions at the warehouse were basic at best and less than optimum, as Animation Processing Supervisor Robyn Roberts later laughed, "Bugs would fall out of the vents . . . you'd never leave an open coffee cup, never!" Uninvited mice could be spotted late at night running across the top of the cubicle partitions. "We often joked it was Mickey," laughed Comella, adding, "When it rained, it used to rain indoors…but the show must go on! We had sheets of plastic protecting us and the computers." Yet, despite these environmental challenges, this burgeoning team of artists redefined the animation artform. "It was a remarkable time," remembered Gretchen Albrecht. "We were on an exciting trend."

FLOWER STREET & BAKER STREET

The studio was already in production on its twenty-sixth animated full-length film, *Basil of Baker Street*, which was later renamed and released as *The Great Mouse Detective*. Based on the novel by Eve Titus, this animated adventure featured a mouse-sized Sherlock Holmes, Basil, and his faithful sidekick, Dr. Dawson, teaming together to thwart the schemes of diabolical criminal Professor Ratigan in Victorian England. "I loved that show!" chimed Albrecht. "It was fun to paint! The challenge there, which caused some people to pull their hair out, however, was the gears."

The "gears" to which Albrect referred were part of a groundbreaking two-minute Big Ben sequence featuring conventionally animated, Xeroxed, inked, and painted characters moving through a scene consisting of fifty-four moving gears, winches, ratchets, beams, and pulleys all designed and manipulated by computers. "Mike Peraza and Phil Nibbelink came up with the idea of doing the inside of Big Ben with computer-graphic effects," said Don Hahn. "There were very dynamic camera movements, the first of its kind really." Pioneering Computer Animator Tina Price added, "They actually did it on the studio lot, down in the basement of a building using an old IMI Computer and hand-feeding the paper into a plotter [printer]." These early computer printouts were transferred via Xerox onto large-format (twenty-four-field) cels, which were then hand-painted.

Working on the cutting edge came with problems, as Albrecht noted: "Sometimes those lines would just stop—drop out. Areas would disappear and we would have to figure out how to transition the colors so there wouldn't be a paint pop."

TOON TRANSITIONS

The operational challenges of *The Great Mouse Detective* proved even more daunting than the artistic challenges. "It was a reaction to *Black Cauldron* and the feeling that we've got to do something if we're going to keep Animation," said Don Hahn. "There was a big push to make the films less expensive, so we transitioned from the Disney Registration Systems which had evolved from days gone by and we adopted the ACME system, much to the consternation of all of us. We even went to smaller paper. If the paper's 40 percent bigger, you're going to make a bigger drawing, [and] it's going to take more resources, more paint, more time; so not having such a custom business was really the idea."

In January 1985, Acme twelve-field—measuring ten and a half by twelve and a half inches—became the standard size for most of the scenes. All paper and cel punches, artist's pegboards, Inker's boards, checking systems, and camera platens—across the production pipeline—were sent to the machine shop for conversion.

In 1986, after over forty years with Walt Disney Studios, longtime Ink & Paint Department head Becky Fallberg retired, and former technical director George Gerba was brought in. Throughout the animation industry, cost-saving efforts were taking place. Ink-and-paint divisions were virtually dissolved and the work was sent overseas. Under Gerba's watch, the superior animation paint system that had defined Walt Disney's animation was scrapped and a Disney vinyl-paint system was developed. "We knew we needed a new type of paint," recalled Gretchen Albrecht.

For creative efficiency, it was evident the Ink & Paint Department would ultimately relocate from the main studio lot to join the rest of the production team in Glendale. This presented a challenge. As Albrecht noted, "The studio's gum-based paint had already proved to be problematic when we tried to use it outside of its controlled environment. But commercially available cel paint was not up to Disney standards and the color range was extremely limited."

The last Technician to mix the formulation of Walt Disney's gum-based paint was David Braden. "I was trained by Ray Owens. He'd been there for many years[,] since Steve McAvoy and Emilio Bianchi. Ray taught me well. It was a one-person operation," according to Braden. "The early Disney gum-based paint they made was very unique. It held the rich color throughout the whole process of filming it.

"Unfortunately, it was getting more difficult to get some of the pigments and getting more expensive to produce," Braden added. Times were indeed changing.

DIGITAL PRODUCTION PIPELINE: ATS

In 1983, breaking with their long-standing tradition of naming a "Man of the Year," *Time* magazine instead declared a "Machine of the Year," designating the personal computer as significantly symbolic of the previous year. No longer the impersonally ominous "Big Brother" of Orwell's *1984*, computers were now personalized, interactive, even playable. Indeed, this machine would soon revolutionize every facet of daily life.

Foreseeing the next logical step in animation, Roy E. Disney

Page 355: The mechanical junkyard characters from the first computer-generated animated short film from Disney Animation, *Oilspot and Lipstick* (1987).

This page, top and bottom: Computer-plotted gridlines for the Big Ben clockwork utilized in *The Great Mouse Detective* (1986).

Page 337, left: Painted production cel piece of the clockwork gears.

Right: Final production cel featuring Basil and Olivia from *The Great Mouse Detective* (1986).

stated, "Clearly, computers are going to change a number of things. The first major change will be in the postproduction area where we can go directly from the pencil drawing to color film by way of the computer. Backgrounds and Scene Planning are other areas where the computer might help us." Along with these changes, computers entered the world of Disney animation production early in 1986 through the advent of ATS, the studio's custom Animation Tracking System. Far from creative, this system served as more of an administrative tool to keep the checking flow of various scenes in order.

An entire production pipeline that was digitally linked seemed logical, as Kimball explained: "All the pieces of production would normally show up—digital exposure sheets would be built; Painters would be able to point to the cel and pull that off; [then] do their work and put it back. It would go through the Final Check and Compositing and Camera." The theory of this digital approach presented new cost-saving solutions. "We were explaining the whole process to Jeffrey Katzenberg," said Kimball, "and he was looking at the head count of the people in the different departments and fascinated with the fact that it could be done with fewer people." With this "must do" position, the animation teams stepped into the digital frontier. "There was this 'we-have-nothing-to-lose' energy," noted producer Don Hahn. "That's when you started to see great things happen."

While burgeoning computer technology was transforming the Disney animation process, legendary Animator Eric Larson passed away. As a founding father of animation, one of Walt Disney's Nine Old Men of animation, and the mentor to many of the new generation of artists, Larson's death marked a tender turning point to the world of animation.

CODED CHARACTERS

"I got the bug," laughed Tina Price, a Cleanup Animator at Disney who became an early pioneer of computer animation. "The studio put two Amiga computers in the Cleanup Animation Department, and I found myself sitting between these things and just got 100 percent hooked. With computers you have an idea of what you want to do, and by the time you figure out how to do it, you've learned twenty other things. It's really problem-solving," Price noted.

Computers were initially perceived as nothing more than an aid for visual effects within animation, but a young team of Animators with an interest in technology came together for a singular project. "The general feeling was 'these computers are just used to do design rendering. They are not used to tell stories,'" suggested Price. "John Lasseter was telling stories with computers at Pixar with short films in 3-D. Disney was known for its 2-D animation. We wanted to show that we could tell Disney animated stories with computers, we wanted to show that we could do it, and that we just weren't a production service department."

On their own time, a team of several Animators decided to change the perception of just exactly what computers could do for animation. "We were called 'The Late Night Crew,'" Price said, "because we did it on our own time late at night, after work. I had already built a bunch of models[,] so we broke them up and made them into a story to show technique with believable characters in an interesting world."

Purposefully striving for a different look from the work of John Lasseter's early sculpted-plastic look, Price and her colleagues made specific choices in their design. "We stayed in that 2-D world," she noted. "That was what Disney was known for."

338 | Computers & Characters

Production elements involved in creating a single frame from *Who Framed Roger Rabbit*. (Top left & right): Cleanup animation drawing; Xerox/inked and hand-painted cel. (Bottom left & right): Corresponding film frame reference; and the composite cel with film frame reference.

Characters were initially rendered in 3-D with a typical rounded plastic look, and then shaders or color codes were written and lighting algorithms were changed "so the characters would render relatively flat," Price emphasized. "We wanted to show that we could make it look like a two-dimensional film."

Computers had fully arrived in Walt Disney Animation with the first all-CG film, *Oilspot and Lipstick*, a whimsical short set within a computer-generated dump, featuring a junkyard dog made up of junk. In classic story form, Oilspot fends off the villainous Junk Monster to win his feminine counterpart, Lipstick. Utilizing preexisting renderings as the basis for the CG characters, *Oilspot and Lipstick* debuted in July 1987. "We took it to Siggraph [an annual conference focused on computer graphics and interactive technologies] and got some wonderful recognition," recalled Price. "It separated us from the more technical computer realm of Information Services and got us closer to being a viable creative tool for animation."

HAND DRAWN IN TOONTOWN

Based on the book *Who Censored Roger Rabbit?*, the landmark film, *Who Framed Roger Rabbit* marked a pivotal point for animation. Sensing the perfect scenario for an animated comeback, Ron Miller purchased rights and began film development on the story of a down-on-his-luck private detective who investigates a murder involving a washed-up cartoon character. Under the creative vision of director Robert Zemeckis, an international team of nearly seven hundred cast and crew members worked for over three years on the period film.

With new technologies, the approach to the mix of live action and animation resulted in essentially making two separate films and then carefully blending them together. Mechanical props and guides were created to assist the human actors in visualizing where their cartoon costars would exist. Over 140 preexisting animated characters were featured within this film, each painstakingly re-created in color and style. Eighty-one distinct Disney characters as well as numerous featured favorites from MGM, Paramount Pictures/Fleischer Studios, Universal Studios, 20th Century Fox, King Features Syndicate, and Al Capp cartoons made appearances within the film.

Production was based in London with noted Animator Richard Williams directing the animated portion of this complex hybrid film. To meet this challenge, Williams purposely sought to break with convention in combining animation with live action. He elected to move the camera as much as possible to prevent the animation looking "pasted" against flat backgrounds, utilized lighting and shadows at a level that had never been attempted before, and integrated a maximum of "Toon" interaction with real-world objects and actors. "This was uncharted territory," noted the film's Associate Producer, Don Hahn.

Ink & Paint | 339

Composite image of Jessica and Roger Rabbit, featuring shadow painting and application of the Blend.

Every frame of the live-action footage that featured animated characters was printed into a large still photograph and utilized by the Animators as reference for placement and alignment. "Dick [Williams] wanted me to do the scene with [actor] Bob Hoskins walking out of an office, passing a *Fantasia* ostrich as he moves downstairs," Animator Andreas Deja recalled. "I was given a huge box of photostats of the whole scene. After analyzing the ostrich from old model sheets and roughly sketching the action, I animated the character based on the camera move and perspective from the photostats." Once approved, the drawings moved on to Ink & Paint.

Introducing color to the animation in this groundbreaking approach presented new challenges, as Hahn noted: "Our *Roger Rabbit* Ink & Paint [system] was neanderthal. The London system was based on the commercial industry, doing TV adverts, as they call them. But there were some really good people there because Richard Williams had been working on *The Thief and the Cobbler* for twenty years by the time we showed up, and he had developed his Ink & Paint systems based on Disney.

"We certainly couldn't use the Xerox process they had at the studio, [and] we certainly couldn't afford to ink it," Hahn said. A simple solution was sought. "All of *Roger Rabbit* was copied on office copiers," Hahn revealed. "We bought a couple of standard office copiers. We 'tweaked' with them and put the animation drawing in the machine and cels in the tray. We used brown toner and the cels came out all scratched. It was low-tech, but it worked."

Pat Sito, a Final Checker on the London production team, recalled, "Occasionally, the Xerox fixer would have problems and the lines would actually raise up off the cel on the ends. You would just press it back down and keep going." The crudely Xeroxed cels were then painted with standard techniques to achieve complete opacity. To attain additional dimension, Ink & Paint artists supplemented the form of the film's curvaceous feminine lead, Jessica Rabbit, by utilizing the Blend technique patented nearly fifty years earlier by Mary Weiser. "We basically did the same approach as *Snow White* on each cel—by hand—before computers," Hahn noted. "It was like chiseling in stone, but we were very happy with her look."

SCENE STANDARDS & SWINGING LAMPS

Following Richard Williams's mandate to expand the use of lighting and shadow as never before, the monumental task of creating shadow cels for both the live-action and animated characters required well over one hundred thousand fully animated cels on separate levels. The Painting teams pushed the limits on one particular scene. Entering a darkened room with Roger Rabbit handcuffed to his arm, Eddie Valliant bonks his head on a low-hanging ceiling lamp, causing it to wildly swing around. To match the fluctuating light within the scene, Roger had to be painstakingly painted and repainted with subtly varying shades to match the timing of the changing illumination and shadows. Though fully aware that this was more detail than most audiences would ever observe, the dedicated teams continued forging ahead in their mission, undaunted. Their commitment to this scene later launched an industry term referring to the tremendous effort put into something that will likely never be noticed: "Bumping the Lamp."

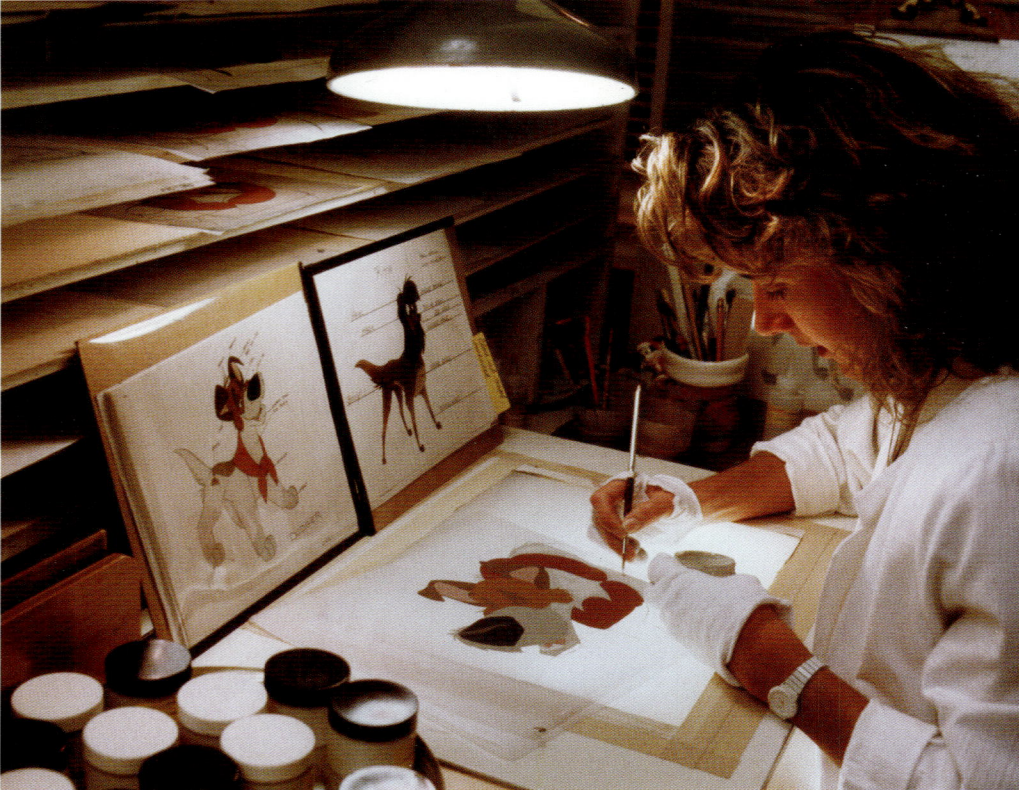

Final combinations of painted cels, mattes, and tone or shadow elements averaged between five to eight levels and were checked against individual photostat images for each frame of the live-action film. "We also completed video tests of each scene before we sent them off to Camera," Pat Sito said. Utilizing the relatively new technology of video tests permitted a chance to preview the cel interaction with live action and to catch any final issues. The teams of Ink & Paint in Britain worked seven days a week, with Friday evenings cleared for "pub nights."

Once through Ink & Paint, cels went off to Camera. Any scratching of the cels resulting from the crude Xerox process and combining the animated characters with live action was actually beneficial. "You shoot it in 'flip-flop,'" explained Don Hahn, "which means you shoot a frame on top lights and another frame on bottom lights, so you're creating a matte for the character." Anywhere on the frames where an opaqued character didn't appear, the live-action elements appeared, "So that took care of the scratches," Hahn added.

Final footage was sent to the visual effects wizards at Industrial Light & Magic (ILM) in California for compositing. State-of-the-art optical printing techniques combined live-action photography, animated characters, shadow cels, and various other special effects layers such as Jessica Rabbit's sequined evening gown and Judge Doom's dreaded "dip"—a clever Toon-dissolving invention composed of turpentine, benzene, and acetone—all paint thinners used to remove paint from surfaces. Andreas Deja's first scene with the *Fantasia* ostrich, "turned out to be the first animation/live-action scene in color that was sent from ILM after they did the final compositing, including highlights, shadows, and all final elements," Deja remembered. "It looked great and everyone was thrilled, but we had a long road ahead of us to finish the movie."

As deadlines passed, and with animation production falling behind, a Los Angeles animation house run by former Disney Animators Jane and Dale Baer was called in to complete some of the most detailed animation on this landmark film. "We did all of Toontown," noted Jane Baer. "We established the look of this cartoon world and everything in there from when Eddie Valiant enters Toontown. We also animated all of Bennie the Cab."

Working closely with director Robert Zemeckis, Jane and her crew of forty Animators completed long hours to meet the demanding deadlines set with this production. "The optics gave us that three-dimensional look, but it was very time-consuming," she added. "We worked day and night, very closely with Zemeckis, and he was always coming up with new ideas. We were overwhelmed with what we had to do, but we'd come home from a meeting and you couldn't sleep—you were so inspired and wide awake." The Walt Disney Studios Ink & Paint teams in Burbank painted the complicated scenes, and sequences were completed in Los Angeles.

A special homage to classic animation was made within the narrative of the film: "Walt sent me" is the password into the exclusive Ink & Paint Club, the nightclub where Jessica Rabbit performs. It is a fitting nod to the man whose visionary efforts propelled animation to the point of this landmark film.

"With *Roger Rabbit*, the breakthrough in filmmaking was so overwhelming," noted Publicist Arlene Ludwig. "Don't forget, it was an interaction of live action and animation unlike anything anyone had ever seen before, and the critical acclaim was incredible. It was all fun."

MAGIC IN THE MIX

Change was inevitable for the paint systems employed by the studio. Vinyl paints had long been utilized at other animation studios at the time, largely for creating Saturday-morning cartoons that required a minimal palette and approach different from Disney feature-length animation. "In 1985," Gretchen Albrecht said, "it was decided that we needed to create a Disney cel-vinyl paint that

Left: Character Model Sheet for Georgette from *Oliver & Company* (1988).

Right: Monica Marroquin paints a production cel of Dodger from the film.

Ink & Paint | 341

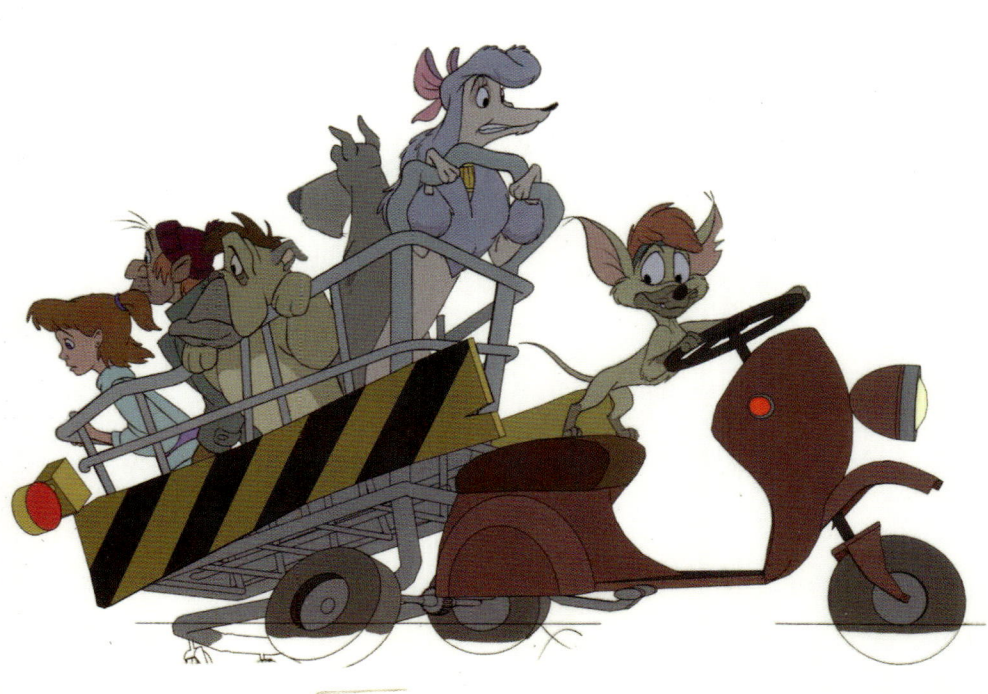

Final production cel from *Oliver & Company* (1988), featuring one of the computer-generated vehicles created by Tina Price and her team.

Feminine First

TINA PRICE: CGI

Disney's canine take on a Dickensian tale set in New York City set the bar higher for new methods of production and the integration of computer elements. "We built the cars and buildings in the city for *Oliver & Company*, but there was not even a name for what we did," noted Tina Price, who was later named the first Department Head of Computer Animation. "No one knew what to call it[,] so they just said 'Tina's Department' and we started to 'plug' ourselves in.

"We were not legitimized or included in the production pipeline, but we had our own digital checking system," Price remembered. "For those of us who were under the hood, we would sit together for hours and try to figure out how we were going to make this thing work. Then we would figure it out and then show the production teams." According to Price, "They would see it and it would always be great but they never really knew all that went on behind the scenes."

Price shared other insights into the process. For example, "The scene when the poodle is coming down the staircase, that was a huge undertaking to get that to work," she said, "developing the hidden line code and getting it so it would print out on paper properly, making sure it was pin-registered so that when you drew the character to it and it was composited into the final film, it would all wind out. It was a huge effort in lining things up."

would have the same palette of colors as the Disney gum-based paint, but could be removable for corrections. It was a rocky road to stability."

While vinyl paint was opaque when applied to most surfaces, it characteristically soaked into and adhered to the surface of the porous cels, making it virtually impossible to remove the paint without damaging the cel. "We could match and achieve the distinct Disney color palette," she recalled, "but we wanted the paint to be removable." Vinyl paints, once they were dry, would also not take on moisture again. "So they started to try to create a vinyl paint that would maintain some of the excellent properties of the gum paint," Albrecht stated. "However, as one solution was found, another problem arose. Trying to make the paint removable also made the color unstable and we had this drifting of color." Streaks, color infiltration, and inconsistencies in mixing occurred, "but we made it," Albrecht declared.

Created in conjunction with consulting chemists, the Disney vinyl-paint system utilized sixteen organic and inorganic masstone pigments to formulate and maintain the more than one thousand colors that were standard within the overall palette. Each color was a blended combination of three to five of these masstone pigments plus white. "They started by formulating a top color," Albrecht explained. "This was the darkest value of the color and given the number ten. Then, adding tints of white paint, increasingly lighter values of the top color were created from nine to one."

The studio's proprietary color formulas provided the more subdued Disney color palette, distinct from the palettes of other animation companies of the day. "We could do things with our colors that nobody else could do," noted Albrecht. "We had a palette of pastels and a muted color look that can't be achieved by others. Our magic was in the mix."

Development of Disney vinyl was not without problems as some pigments shifted off standard. Establishing basic tones such as black created problems for vinyl paint consultant Jim Elliot, as noted in his status report: "Black is one of the worst-case failures in a colorant database, as all colors in a database relate to a master black and a master white." This problem caused delays with production color approvals, but once resolved, Gina Wootten and David Braden completed *Oliver* color rushes for final approvals and reference manufacturing.

This new paint was pushed into production on *Oliver & Company*. "Because of the short amount of time," Albrecht revealed, "we had to produce such a large amount of footage. On the plus side, with this new paint, we were able to put Painters everywhere[,] since we did not have the climate-control issues of gum paint. We had Painters in the Paint Lab, there were Painters up in the loft area, over the mill, outside the Tea Room—they were everywhere." At the department's production peak for *Oliver*, Ink & Paint had a staff of 131 producing 4,800 hand-rendered frames with multiple levels of acetate cels each week—enough to spool three hundred feet of film. A total of 238,243 cels were utilized to create *Oliver*, and "We successfully covered about two-thirds of the film in the last three months of production," Albrecht stated.

342 | Computers & Characters

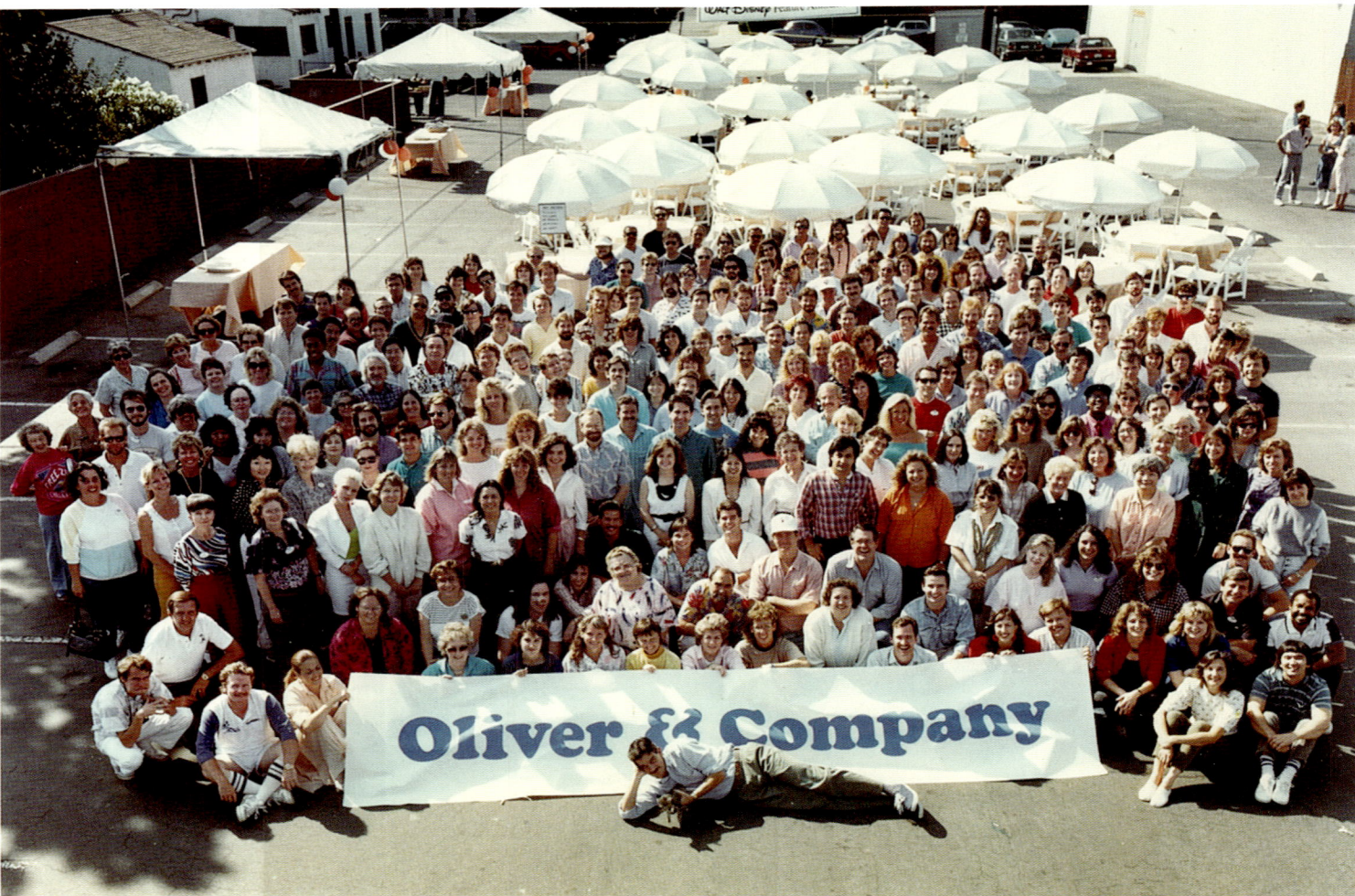

The production crew for *Oliver & Company* (1988).

CARTOON CANINES & CODING

Hand-rendered cels were combined with computer-rendered backgrounds and props to shape the Disney dog-themed take on *Oliver Twist*. Geometric shapes forming the cityscapes, cars, buses, bridges, sewer pipes, and even a piano for the film were created utilizing computer-generated imagery. At the Walter Lantz Animation Conference in June 1988, Tina Price introduced the advances computers were making within early Disney animation.

> We're just beginning to explore the advantages a 3-D computer can offer us to better express our stories. In *Oliver & Company*, we have twelve minutes of computer animation. Every frame that I generate on the computer is run through a process called "hidden line." We print it out on paper; if there's any character animation involved, the whole scene will go to the Character Animator. They'll draw right on top of my trike, or car, or whatever it is, and then it's shot under an animation camera stand, just like the rest of the film.

With this flawless integration of pixels with pencils, computers were now an established part of Disney animation.

Following the successful release of *Oliver & Company*, the Ink & Paint Department returned to a core group of twenty-four people comprising administration, artists, Paint Lab crew, Checking, and Xerox crew. Between productions was a time to catch up with mixing fresh paint swatches for every color in the lab, servicing equipment, inventory checks, paperwork, and general housekeeping.

A NEW VALUE

In 1984 a retired studio publicity staffer who collected animation art through most of his career sold his remarkable collection at auction. Never had such an array of high-end cels and their matching backgrounds, drawings, and concept art been available for review or sale. With unprecedented nationwide television and print coverage, this sale sparked the minds and hearts of generations, and animation art was notably back in demand.

Cherie McGowen of the Ink & Paint Department expanded the cel program, naming it Limited Editions. "The project got huge" McGowen remarked. "At one point, I had ninety people painting at one time." Traveling internationally, the artists did demonstrations at events held to celebrate the hand-rendered cel artistry of Walt Disney animation. Each artist now mastered the full canon of Disney characters created in limited runs and painted the prototypes for Disney Collectibles figurines.

Three types of artwork were developed. One, Sericels, featured ink lines and paint printed onto each cel through the serigraphic process; a second type of cels featured xerographic lines; and the third, traditional cels, were fully hand-inked and painted in the grand tradition of Disney animation. These hand-rendered cels offered through Limited Editions provided the opportunity for the return of several premium Inkers to the department. Maria Fenyvesi applied her artistry to many of the classic Disney characters. "Maria's work was spectacular," recalled Gretchen Albrecht. "We would get applicants from other studios who thought their experience with Rapidograph pens qualified them for an Inker position. We'd show them Maria's inking on the Blue Fairy, and they instantly knew they weren't qualified."

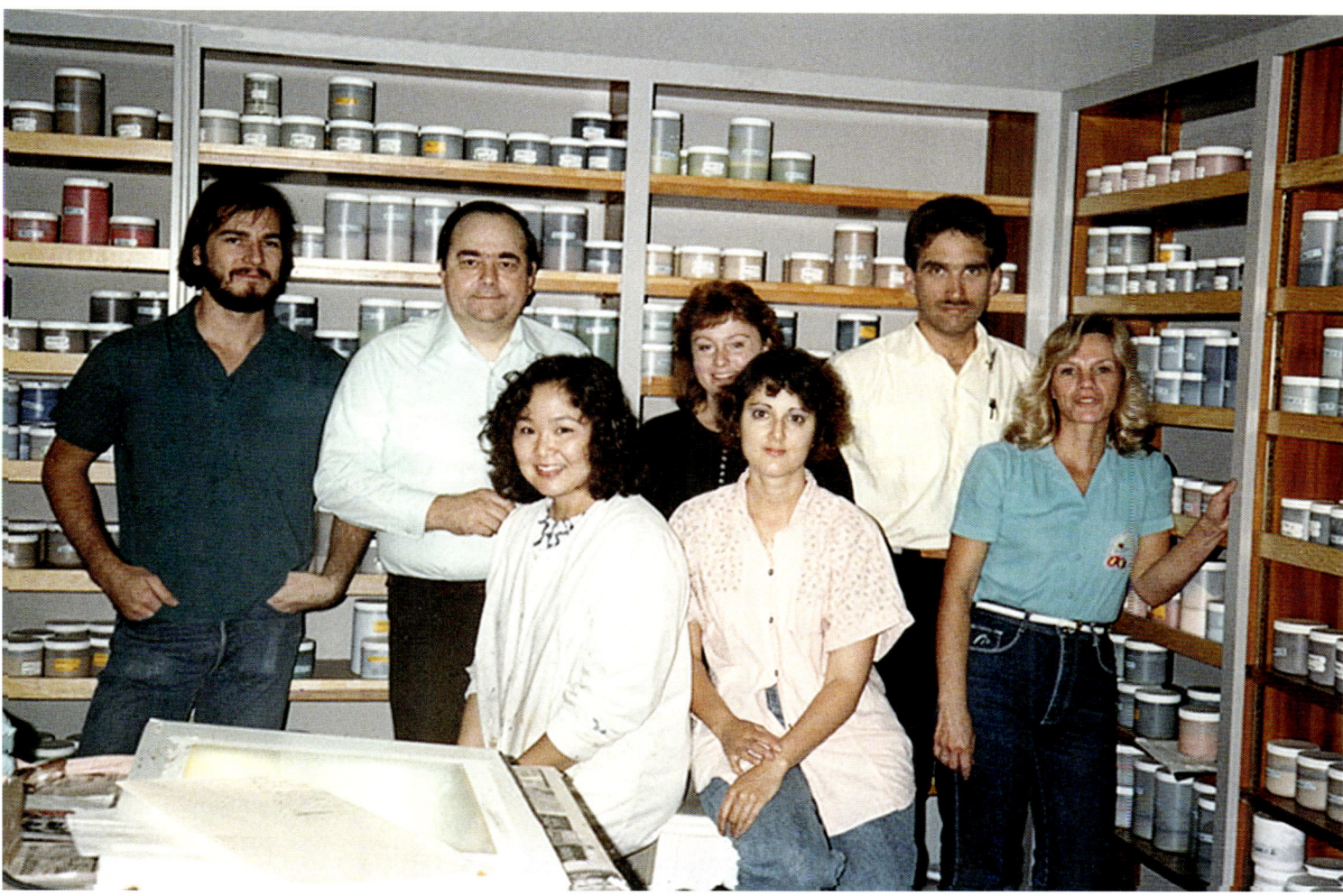

Part of the Paint Lab teams setting up the Disney Vinyl Paint system. From left to right: J. R. Russell, Vic Wolfe (paint consultant), Barbara Hamane, Debbie Siegel (front), Gretchen Albrecht (back), Jim Elliot and Penny Coulter.

The work of the Painters continued to evolve with vinyl paints; yet even after decades of refinements, problems continued. "We had wicking problems with the paint on the beard color for the Seven Dwarfs," recalled Ginni Mack. "That color, for some reason, sent little strands of colors up into the next color." Careful application preventing any overlap was the solution. "We felt a lot of pride in what we were doing," noted McGowen. "We were re-creating the past. The public grew up with these characters and they are a part of our heritage. This was a special way that we could share that legacy with them."

1980s STUDIO LIFE

The 1980s marked a lively period in studio history with major transitions dramatically altering the course of Disney animation forever. Ink & Paint continued throughout each production. The corridors remained quiet, but everyone was plugged into something. "Yes, back in the day, a lot of us were listening to soap operas," Painter Sherri Vandoli said with a chuckle. "We'd be listening on TV and occasionally, when something juicy was happening[,] we'd all look around and giggle, but you knew to keep working." In the early half of the 1980s, the Tea Room was still thriving as the center of activity—even for men, as Don Hahn recalled. "That was my break place. Guys and girls could go there, so you couldn't wait to have a break. It was very Tea Room-ish. The women wore little pink dresses with an apron over the top."

By 1985, with Michael Eisner helming the studio, many of the traditional methods and facilities established in Walt Disney's time vanished. In late January 1986, Gayle Musker, the last head of the Studio Library, closed her facility down, and the collection was integrated into Imagineering. At the Flower Street warehouse location, cubicles defined the studio's animation workplace, and the intention was to encourage more open communication among the artists. "There were a lot of crazy social things," laughed Don Hahn. "I think when you're sent off to an island with your colleagues, you throw people off. You love people, you hate people. . . . There was a sense of hunger, but there was also a sense of play because everybody was twenty or thirty years old.

"It was much like a second Hyperion studio in the sense that you were jammed in these warehouses where everybody's sitting on top of each other," he continued. "Everybody's young, everybody's dating, and it has an energy to it." Color Model Supervisor Karen Comella agreed. "When we worked off the main lot, some people brought in pets. Things were a little looser."

Shortly after the production team moved, the Walt Disney Studios' legendary Tea Room closed and production offices took over upper-level rooms that were once the domain of the Inkers on the main studio lot. With each passing production, the core Ink & Paint Department reduced in size, but would swell in numbers as production deadlines loomed. "When I first started here I was twenty years old," recalled the last of the studio's Painters, Sherri Vandoli. "The ladies were the sweetest people; they were all like my moms. There was lots of gossip, but they were so much fun—great people to work with." According to Vandoli, "They were very family oriented at the studio when most places weren't. If my kids were sick, I could bring them in and they could sit in my office with me."

GRETCHEN ALBRECHT

Originally hired in 1972 by Grace Bailey to work in Xerox on *Robin Hood*, Gretchen was named overall Head of Ink & Paint in October 1987, as Walt Disney Studios was entering one of the most exciting times in animation history. Trained by longtime Ink & Paint staff from Hyperion including Jeanie Young, Jean Erwin, Dodie Roberts, Katherine Kerwin and Wilma Baker, Gretchen was prepared to guide the department through the demands of compressed quota schedules, dramatic staff increases and a new paint system.

"When we went into *Oliver & Company*," Albrecht recalled, "one of my main roles was analyzing complexity and determining all that was needed for the scenes to flow from one department to the next to assure weekly footage quotas could and would be met." It was a challenging production for Albrecht and her team.

Hortensia Casagran and Ginni Mack take a break on the studio lot.

Lunchtime traditions and activities continued. Dating and mating were always part of everyday life at the Walt Disney Studios, as background artist Cindy Whitney observed. "You tended to marry the person who's on the other side of the wall." Whether romantic or platonic, lasting relationships were found and formed. Of her time at Disney, Comella noted, "I met the most artistic, talented, and friendly people. I have many lifelong friends from that time."

Animation studios, meanwhile, opened in Walt Disney World in 1989 with artists in every area of production at work in a facility that uniquely offered visitors an inside peek at the process of animation. The Burbank staff traveled to Florida to set up the facility where approximately nineteen artists—women and men—defined the Ink & Paint Department. Fran Kirsten supervised the Florida team and her husband, Al, ran the Xerox camera. "We helped each other with the various projects each studio was working on," stated Gretchen Albrecht, who oversaw both the Florida and Burbank Ink & Paint teams.

OTHER STUDIOS

By the 1980s women constituted 50 percent of the United States workforce, though they earned a mere fifty-five cents per each dollar a man made for similar jobs. Television animation was in its heyday with weekday afternoons and Saturday mornings filled with a range of children's programming. Throughout the animation industry, female numbers had gradually increased over the previous sixty years, yet women faced new challenges within competitive environments. Climbing through the ranks to produce and direct television animation at Hanna-Barbera, Joanna Romersa noted, "I think jealousy is probably tough on a lot of women[,] because I think women can be meaner in some ways and can be vicious in a way that men are not."

Despite these pitfalls, Romersa was quick to point out, "There's some wonderful women in our business." Of the woman who hired her to be in charge of the Assistant Animation Department at Hanna-Barbera, Romersa stated, "I think she respected me and she gave me confidence when I didn't have any, and she told me not to be afraid to make a mistake, which was probably the greatest advice anybody gave me. I learned that you make friends with your women first and work with the women in your area[,] and the men will always follow some way or another."

Working at Filmation Studios, Sharon Forward was one of the few women in the Storyboard Department. "At that time, the Storyboard Department was a zoo," Forward reflected with a laugh. "There were only two women artists, Lonnie Lloyd and myself, out of about fifteen to twenty artists. The [Story]board Department was pretty wild and I had to learn to swear to fit in as one of the guys. But I'm not the shy and retiring type, so I've mostly gotten along fine." Later becoming head of Storyboards at Ruby Spears Studio, Forward adapted well within her male-laden environment. "At the time, there weren't that many women in the business," noted Forward, "but I knew the people working for me were wonderful, so I just let them do their thing."

Effects animators Kathleen Quaife Hodge and Diane Landau expanded into live-action films. Having worked at several other studios, Painter Sherri Vandoli noted, "Other studios in town were mostly producing Saturday-morning cartoons. These were filmed fast, so you could get away with a lot of mistakes. At Disney, it was art—the best of the best. We strove for quality."

Top: Keeping Ink & Paint production moving during the 1982 strike: Carmen Sanderson, Dodie Roberts, Lloyd Winegardner, Joanna Phillips who was Ed Hanson's secretary, and Joe Morris from Art Props.

Lower left: Pete Renaday stepped in to work in the studio Paint Lab during the 1982 strike.

Lower right: Don Hahn takes a tea break while working during the strike in Ink & Paint with Wilma Baker, Jean Erwin, and Zoe Parker.

DIGITAL FRONTIERS

> *"Times and conditions change so rapidly that we must keep our aim constantly focused on the future."*
> — Walt Disney

"The first time I heard about the idea, I was sitting on a bus in 1983 at the SIGGRAPH conference, in Detroit," recalled Mark Kimball. "I was sitting next to Lem Davis[,] who was working with us on the Scene Planning System at the studio. He said, 'I think we should propose putting together a system to try to build our movies digitally.' And that's where it started." Not long after, producer Don Hahn and Davis had a fateful discussion over their Commissary lunches. "There was big news in the trades," Hahn recalled. "Hanna-Barbera was painting their cels on a computer. We thought, why aren't we doing that?"

As a leader of the department it would directly impact, Gretchen Albrecht recalled, "Everybody knew it was expensive to do what we were doing, and there was this technology out there for computer painting, although it was basic and that wouldn't have been adequate for us at Disney."

At this time, a number of early computer-based developments had progressed; ATS, 3-D, and other various early systems rolled into production, but a system designed to meet the specific needs of the Disney artists was the right solution. "Over a four- to five-year period," recalled Kimball, "we took on lots of different projects: [for example,] optical printer stock on *Tron*; I wrote the software computerizing animation cameras; special photographic effects, etc. At that point in the early 1980s, this whole technology thing was very foreign to the studios." As pioneering computer artist Tina Price recalled, "It was the Wild West of technology."

Page 347: The launch of the Pixar/Disney development of the CAPS system spearheaded by Frank Wells and Roy E. Disney, featuring, from left to right: CAPS Managing Engineer Lem Davis, Vice President of technology Bob Lambert, Pixar Cofounder Dr. Alvy Ray Smith, President of Disney Feature Animation Peter Schneider, and Roy E. Disney, Vice Chairman of The Walt Disney Company.

This page: Disney School of Animation recruits from the early 1980s. Front row left: Wes Chun, Jill Colbert (standing), Kathy Zielinski (seated), Dave Pruiksma (standing), Kevin Harkey (seated), Pat Ventura (standing), Matt O'Callaghan (seated). Back row behind desk: Tony Anselmo (seated), Frans Vischer (standing), Viki Anderson, and Patty Peraza (seated). Rick Rich pitches a *Black Cauldron* storyboard.

"We began thinking about what we could do," Roy E. Disney said. "We were on a track that said, 'how can we improve the 2-D cel animation side of the world?'" As head of Animation, Roy sparked the track of production: "I sold this [idea] to Frank Wells basically on the statement that we can fire the Ink & Paint Department[,] which [actually] more or less happened; thus we were going to make all those films a lot cheaper than we ever did before . . . yeah, right!" Thanks to Roy's efforts, the earliest development of CAPS—Computer Animation Production System—got under way. "It was Bob Lambert who developed the team," recalled Tina Price. "Disney hired Pixar to develop the engine that would drive this system to be able to do all the compositing and computations needed for Ink & Paint, from ground zero. Literally from scratch."

Working with Tom Hahn, Peter Nye, and Michael Shantzis from the Pixar team were Mark Kimball and Lem Davis, who were charged with exploring where computer graphics could be integrated into the studio's animation processes. Focusing on the world of Ink & Paint, Mark Kimball and his team began to build this early system. "Disney is the gold standard of how you do things," Kimball noted. "There's so much brilliance involved in the Disney process, and our thinking was we have to find a way to bring this into the digital world and keep all the checks and balances and flexibility in it." With this approach, the possibilities of streamlining efficiency and supplementing artistry became the key focus. "We could do multiplane shots and the things that were becoming rare due to costs or that took an exorbitant amount of time." Reflecting on the odyssey of integration, Kimball noted, "When I think of the technical challenges, especially then—the levels of complexity and speed and the things you need to be able to do that—we couldn't realize it would take a decade."

"We had nothing really built from a production standpoint," recalled Kimball. "Part of that was one of the very early desktop computers, which had about a 7-inch screen, and a 5-inch floppy disk [drive]. There was no network, you just had to load it off of the disk. I picked up some rudimentary software for filling [the lines with color]. There was no mouse [but] a digitizing tablet. I could point to a cel and fill it with a color [but] I had to basically hand draw all the separation lines between the various areas on the cel so they wouldn't leak digital ink."

Working with burgeoning computer graphics company Pixar, possibilities were explored. "There were extensive e-mails between Dave English and Alvey Ray Smith about where to start," laughed Mark Kimball. Early tests were under way with elements of a custom digital Ink & Paint process taking shape. "We knew we had a throughput problem," Kimball noted. "Ink & Paint was one of the larger links in the production chain, so how do you process that much artwork?

"What started as a cel painting thing," Don Hahn reflected, "[grew] into this humongous thing of which cel painting is a component." Kimball added, "It was a step-by-step building process of trust within the studio. We were looking at the entire production flow because once you change it to digital, there's no stepping in and out of it.

"It was scary—messing with the process that Walt Disney himself developed all those years ago," he admitted. "There is so much brilliance involved in the process of checks and balances. We had to find a way to bring this into the digital world, and we had to keep all the checks and balances and the flexibility in it."

As a young Animator at Disney, Randy Cartwright had a general curiosity about computers and was added to the development team. Visiting his friend Jerry Rees, who was working on *Tron*, afforded him early hands-on opportunities with a rare graphics computer. "After hours, we'd go through the

Feminine First

BRENDA CHAPMAN

Development of new talent was a priority for Disney, and in 1987 a young Animator joined the studio: Brenda Chapman. She stepped from CalArts into Disney's Feature Animation division as a Story trainee. Chapman contributed inbetweens on *Who Framed Roger Rabbit*, before becoming a Story Artist on *The Little Mermaid*. "At Disney, I had amazing mentors who were also my coworkers," she said. "Roger Allers, Ed Gombert, Gary Trousdale, Joe Ranft, Thom Enriques, Vance Gerry, Burny Mattinson . . . all men . . . and all incredibly open and helpful. I was just one of the Story Artists. I never felt I was singled out because I was a woman."

Chapman developed concepts on such story sequences as the "Part of Your World" reprise after Ariel saves Prince Eric and "The Tour of the Kingdom." Working closely with Allers, Chapman observed, "He would help me make my sketches clearer and think more deeply about character, story arcs, and plot consistency." But it didn't stop with Allers. "All of the story guys were incredibly supportive and helpful," she added. Years later, Chapman became head of Story and went on to direct several feature-length animated films. In 2013, Chapman became the first woman to win an Academy Award for Best Animated Feature Film—for *Brave*, which featured another strong female protagonist, Merida.

manual and try to figure out how to run the computer," he said. "We were mystified by the manual telling us to 'boot' the computer. . . . [So] do we kick it?

"We finally managed to create a simple picture of a transparent bottle on a beach," he confided. "I realized one day this would change everything. When I went back to Disney Animation, they were looking for an artist to work with the computer programmers in developing CAPS, so the timing worked out perfectly."

DEVELOPING THE SYSTEM

The team was made up of computer designers, animation artists, and production people. The system was now being fully developed. And the utmost secrecy was put in place. "It was all very hush-hush and ranked right up there with any national security," recalled Tina Price. "Part of the building was cordoned off [and] you needed to have permission to enter. There was a real fear that this would get out [and] it would be portrayed poorly[:] that Disney was moving computers in and people out." Ginni Mack added, "We had to be investigated for any suspicious history. They had us sign statements and we couldn't even talk to our families about what we were doing."

Animator Randy Cartwright applied an artist's sensibilities to the development of a digital process. "I wanted to know as much about the animation process as I could. I'd talk to the Background Painters and wander over to the Ink & Paint Building to watch the Painters and [explore] bins of powder in primary colors." Cartwright was determined to shift artistic paradigms with new concepts and languages marking a new frontier for creative technology. "Most computer systems I had worked with were designed by programmers for programmers. Terminology came from the computer world and the way things worked was not [designed] for an artist. For CAPS, I insisted the terminology come from animation jargon, and things should work in a way traditional Disney Animation equipment worked."

Retaining an intuitive sensibility with the layout and location of tools, Cartwright utilized clear and simple graphics for as many controls as possible. "I insisted on using the term 'cel' so everyone would know immediately we were talking about a painted character on a transparent background, [yet] this was different from a traditional cel[,] which only had a front and back. In CAPS, there was the background layer, the color layer, the line layer, the note layer, et cetera. To communicate this concept I had a control showing several layers floating above each other with a picture on each indicating its function. The Painter would click on the layer they wanted to work on and it would highlight."

The concept of clicking with a mouse or stylus was a far stretch from the subtleties of applying a brush filled with paint. The hand-eye coordination required in working with the computer was also dramatically different from the traditional artists' skills, but if properly applied, this new approach could revolutionize an entire art form.

DISCOVERING DIGITAL TALENTS

Very early on, in development, it was clear that the artists utilizing the technology needed to contribute to the process. "One thing I always wondered about was how everybody would adapt to it," recalled Don Hahn. "Because we had a crackerjack group of people, like Janet Bruce, and Robyn Roberts and Carmen Sanderson—people who are the best in the world at doing traditional cel animation." To test the system while still in development, the Ink & Paint Department was in constant communication. Gretchen Albrecht recalled, "We sent several people over to work with them: Ann Tucker, Carmen Sanderson, Ginni Mack, Leslie Ellery—she was a slow Painter, but there was nobody more meticulous and into methodology[,] and she would make sure the system was going to be what we needed."

After forty years in Ink & Paint at the studio, Sanderson was one of the first to step into the computer age. "Gretchen [Albrecht] asked me if I'd like to try. I just laughed because I knew I was going to retire. I had nothing to lose, so I said, 'Sure, why not.'" For Mack, it was a significant transition. "I was a Supervisor in Painting at the time. They called me over and wanted my critique on whether it would be better for us as Painters. You weren't holding a brush, so it was a whole different ball game. It was very

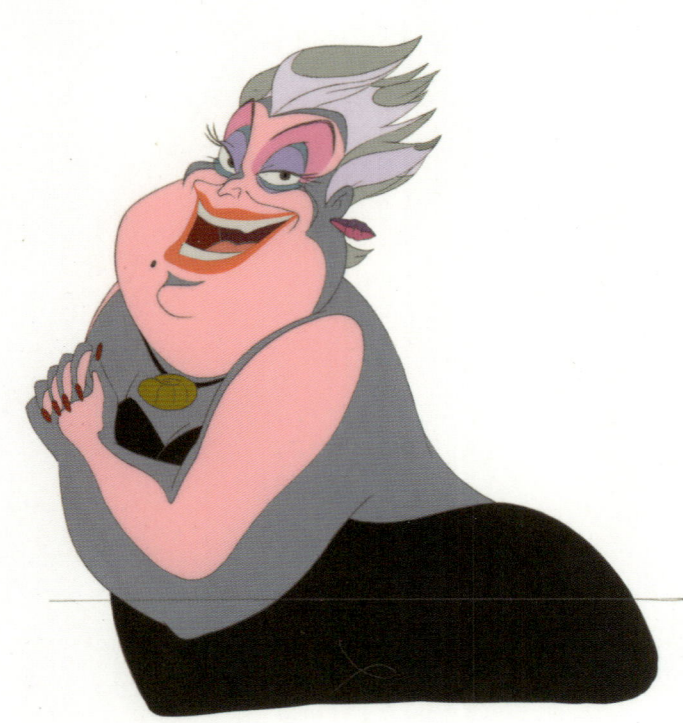
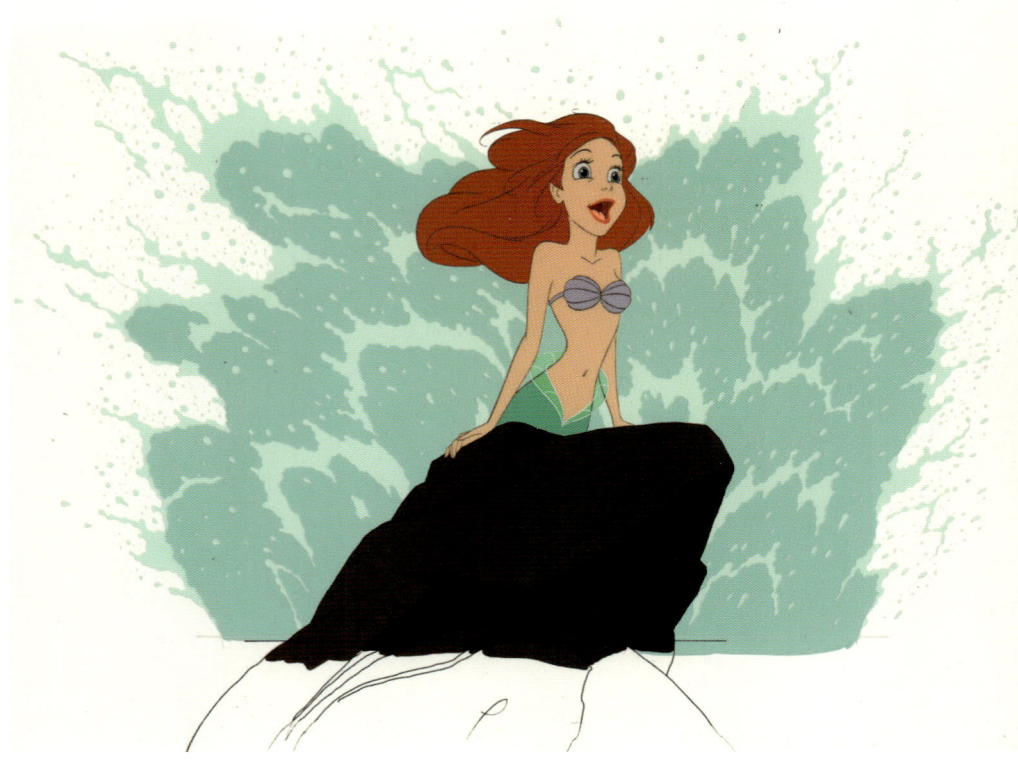

interesting[,] though I missed the hands-on feel of painting, as did others. But time marches on."

"You have to remember," cautioned Albrecht, "this was back in the late eighties. People didn't have computers." New tools and techniques required entirely new approaches, as Technology manager Graham Allen pointed out: "We take it for granted now, but at the time, it was a tremendous leap adjusting to 'I'm looking at something here, but I'm moving my hand down here.' It was the most challenging thing, especially for an artist."

Albrecht agreed. "Everything was very foreign to us, but they were able to make an interface that, of all the people we trained, I think only one person couldn't understand it," she emphasized. "That is really a testimony to the design team. Pixar came up with this really wonderful program and worked hand in hand with us as we needed it to be able to do certain things."

Of her transition with CAPS, Sanderson added, "There's nothing like hand-inked and painted cells, but the thing I liked about it was if you made a mistake, you pushed a button and that cleaned it. Years ago, when I used to paint and made a mistake[,] they would make me go upstairs and take it to the Inkers because that meant it had to be re-inked." Instrumental in the integration of CAPS, painting and Final Check Supervisor Hortensia Casagran observed that "before CAPS, we could only ink the most important characters. Now, some characters have ten to twelve inks." Albrecht held high praise for Casagran's contributions: "That was quite a juggling act and [she] was one of the superstars in making this technology work."

Producer Don Hahn noted, "One of the great things about the way CAPS was introduced was how all those people just put down the pencil one day and picked up the mouse the next day and kind of took off on the system." For Cartwright, the reward was clear: "I was pleased to find that a new Painter who had never seen a computer before could sit down and after a few minutes' training could be painting away on production art."

Kathleen Gavin, Senior Vice President of Production in the late 1980s, agreed: "The fact [is,] those people were able to do it, and they embraced it! They said, 'This is it! We're going to do it!' That, I think, was a great tribute to them. They really contributed a lot to how the system was designed." Select Ink & Paint teams shifted between paint and pixels. Development and testing continued on the experimental, top secret CAPS system while The Walt Disney Studios began production on its twenty-eighth feature-length animated film.

FINS, FLIPPERS & FISH TALES

Once again a female lead character led the way to a new era of animation. Reenvisioning the classic Hans Christian Andersen tale "The Little Mermaid," John Musker and Ron Clements brought a new heroine to the animated screen. "I knew that Ariel was the new kind of heroine just because it was the eighties," recalled Jodi Benson, the voice of Ariel. "This character had to be different, stronger, because it had been almost thirty years since *Sleeping Beauty*, so there were going to be a lot of changes in her personality. I think she is very different than the original classic heroines."

The villainous sea witch Ursula was voiced by veteran stage and screen actress Pat Carroll. "It's marvelous to play villains," noted Carroll about her character. "She's everything you hate and yet you're fascinated by it." Kathy Zelinski brought many of Ursula's sequences to animated life. "She was one of my favorite characters to animate, and that film established my animation talent," the artist declared. "It was just such an exciting time to be at Disney.

"You could just feel the creativity and everybody was just trying one hundred and twenty percent to do their best work," Zelinski added. Since the film took place in an underwater environment, the artists were required to animate a world with zero gravity. To add to the believability, an actress was hired to perform Ariel's scenes—underwater! Footage was captured to assist the artists in creating natural and believable underwater movement.

Page 350: Color Model cel of Ursula (left); and (right) combined production cel elements of Ariel from *The Little Mermaid* (1989).

This page: The final scene from *The Little Mermaid* (1989) was the first animated scene created via CAPS technology. Note the inverted rainbow colors.

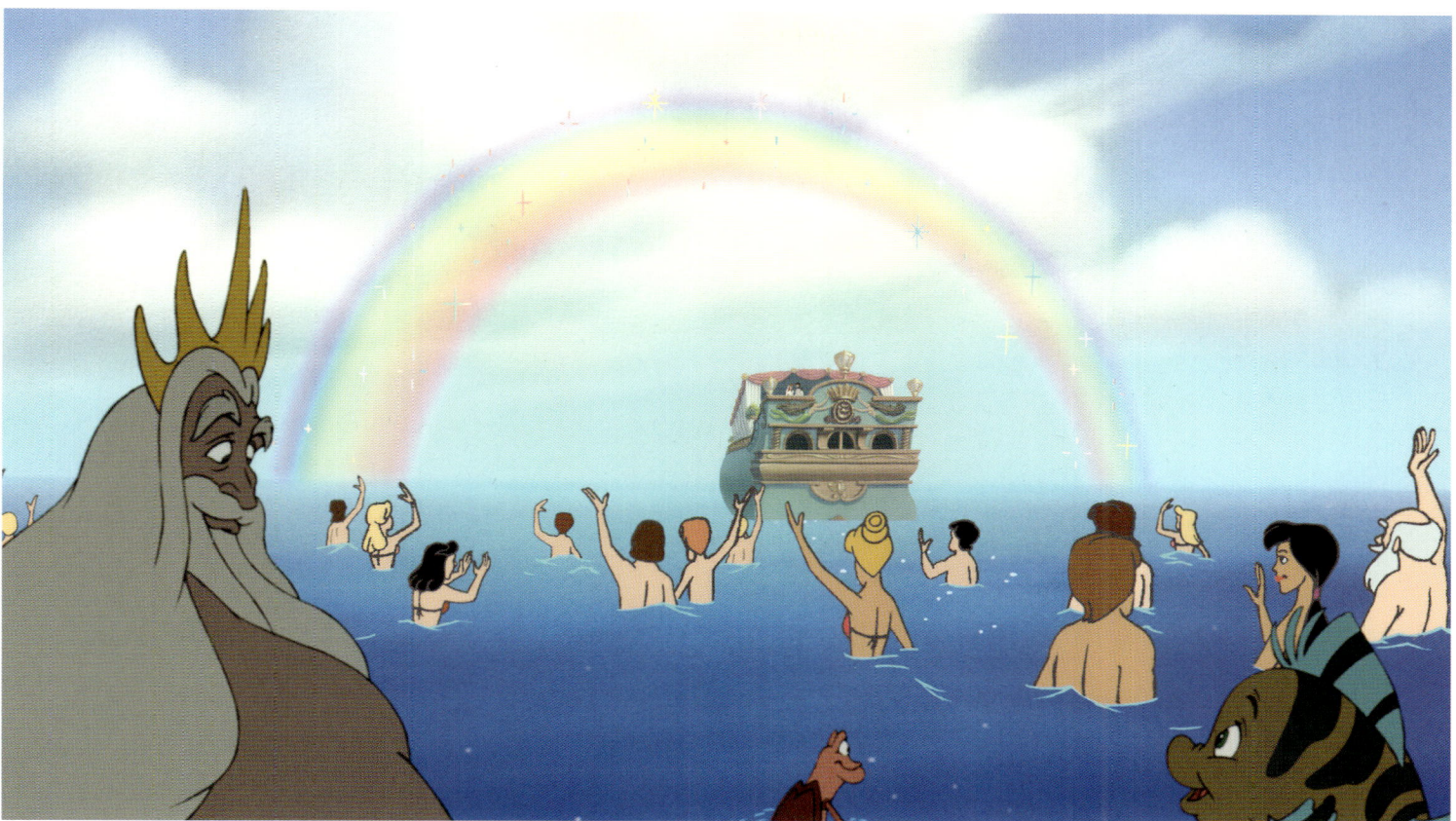

UNDER-THE-SEA ADVENTURES

With two-thirds of the story set underwater, a believable aquatic environment was achieved through careful use of color, production design, special effects, and various innovative animation techniques. Creating the watercolor world of Ariel's aquatic domain presented challenges for Background artist Kathy Altieri. "I got a call from Disney," recalled Altieri, recounting her hiring and entrance into the Disney animation world. "They needed someone who understood watercolors and how to make them look good on film, which is important. In a ridiculously short amount of time, I had been Supervisor on *Prince and the Pauper* and I went on to *Mermaid*. My first job on *Mermaid* was to help fix the skies in gouache, which had been messed up by some poor production assistant who spilled a cup of coffee across a stack of backgrounds which hadn't been shot yet."

Color design for each scene was established within the context of the film as a whole, and the carefully crafted color script illustrated the dramatic progress, visual flow, and character relationships. Compensation had to be made for the changing environments and light sources reflecting on skin tones and hair colors. To meet these differences, thirty-two different color models were created for Ariel alone.

While the Disney vinyl paints could match the muted color palette, the vinyl formulations proved problematic. Paint Lab technician David Braden pointed out, "It just didn't work. The acrylic product would not achieve the solid color on the reverse side of the cel and wouldn't remove." Paint Supervisor Ginni Mack recalled, "That caused us so many problems. You couldn't wash acrylic paint off, so to get it done cheaper, work would be sent overseas." Gretchen Albrecht added, "That wouldn't work for the quality of Disney Feature Animation. As luck would have it, this movie presented a completely different idea in color—a bright, cheery, happy mermaid! So, we decided rather than remix everything, let's start with Cartoon Colour [a brand of paints] because their colors were already that bright."

NEW "COLOURS"

In 1947, Ed Wilkerson of Catalina Color sold his animation paint company to his chief chemist, Hiram Mankin. Shortly afterward, Mankin named his new company Cartoon Colour. Mankin and his family had already had a long history in animation, and by the 1980s, when he developed an acrylic paint dubbed Cel-Vinyl, the company had built quite a reputation. "The environment and subject matter of *The Little Mermaid* called for a bright color palette," noted Gretchen Albrecht, "and it was the perfect opportunity to move to commercially manufactured paint." The vibrant palette of premixed Cel-Vinyl paint was suited for the subject. But to differentiate their heroine, the studio Paint Lab designed a new color for the mermaid's blue-green-colored fins, appropriately named "Ariel." In the summer of 1987, with a new paint system in place as a stopgap until CAPS was ready, the end of an era was marked with the dismantling of the studio's paint systems and a remodeled downsizing of the Paint Lab installed in the back of the building.

At Albrecht's recommendation, one batch of cel material numbering 550,000 cels was ordered to complete the project, as the film was projected to run longer than *Oliver & Company* and water sequences required multiple layers of cels, utilizing more cels per foot. Separate green and white Xeroxed overlays set slightly askew created a realistic water effect, an accidental but effective discovery made by the Xerox teams.

"I inked bubbles for six weeks," Eleanor Dahlen remembered with a smile. "Six weeks . . . nothing but bubbles . . . and they were all done on different cel levels. Bubbles have to be perfectly round; they can't be lopsided. On Ariel's cels, her fins were inked,

Digital Frontiers

> *"The future of the animated movie seems as limitless as the variety of things we can portray in it."*
> —Walt Disney

Tech Support Engineer Kent Gordon checks for problem frames at the CAPS Distributed Comping stations.

so that included the little band around her waist and her fins, her whole tail, and the movement of her lips and eyes—complete with individual lashes—[which] were all inked by hand."

By August 1989, there were over one hundred Painters working from home, at the Airway Building in Glendale, and on the studio lot in Burbank. "We need your help," Ginni Mack urgently wrote to her painting team. It was necessary to increase the minimum cel count from seventy-one cels per week per Painter to eighty cels in order to meet their production deadline. Three multiplane shots were created for this underwater adventure. "That's all we could afford," laughed Peter Schneider of the costly process. Final cels made their way into Camera in October 1989.

The only feature-length animated film to utilize every form of animation technology introduced from the earliest days of handcrafted animation to the advent of CAPS, *The Little Mermaid* was truly unique. After several years of development, CAPS was instituted for the final scene depicting Ariel's fairy-tale ending. A fairly simple scene became a complex combination of approximately six thousand image files when a vibrant rainbow fills the sky as Eric's ship recedes in the distance and legions of merpeople wave farewell to Ariel and Eric.

"From the standpoint of animation," Mark Kimball noted, "there was nothing remarkable about that scene, except it could only be created and composited via CAPS." Albrecht further added, "Introducing a scene that was completely built via technology still took all those hands, but now we just had better tools!"

When it premiered in November 1989, *The Little Mermaid* ushered in an entirely new animated era. "Then came *Mermaid*," recalled Roy E. Disney. "It was like an explosion . . . astonishing." Longtime studio Publicist Arlene Ludwig agreed. "The thing that really changed animation, and restored Disney Animation, was *The Little Mermaid*. The success of that film was incredible. From there it was one success after the other and that changed the face of animation forever."

PUSHING BOUNDARIES

Riding the wave of success from *The Little Mermaid*, the production teams of Walt Disney Feature Animation had crossed a digital threshold and there was no turning back. The costly, cumbersome, and time-consuming methods of traditional hand-rendered production were no longer necessary. Other studios were compromising artistry by simplifying their animation and sending work to overseas studios. "That wouldn't work for Disney Animation," declared Don Hahn. "We saw what CAPS was capable of on *The Little Mermaid*, but it was only for one scene. The logical thing would have been to road-test it with a short film, but the decision was made to move straight into a feature film." Prior to the development of CAPS, no one had successfully computerized a feature-length animated film before, and as Special Effects Animator Dave Bossert noted, "CAPS was the perfect foothold for stepping into a computer age."

The bold and risky decision was made by Roy E. Disney and Peter Schneider to utilize CAPS exclusively for the complete production of *The Rescuers Down Under*. "If you look back on it," said Schneider, "it was a stupid decision we made, because what if it hadn't really worked?" Facing the unknown, the announcement was made. "We were horrified . . . terrified," Tina Price noted with a wary laugh about the production team's reaction to the news. "It was crazy madness, but the crews were amazing. I think there was a loyalty to Disney and they all wanted to do it because Disney always does amazing things."

GOING DIGITAL DOWN UNDER

"It was a safe story," recalled Effects Animator Dave Bossert of Bernard and Bianca's continuing adventures. "It was a learning film for this new digital platform, and there were a lot of things that were done that really pushed the envelope of the technological abilities of that system." Indeed, this charming animated adventure endured a turbulent and monumental production process with a team of over 415 artists and technicians working for nearly three years to bring *The Rescuers'* continuing adventures to the silver screen.

In determining the scope and color palette of *The Rescuers Down Under*, director Mike Gabriel had his production teams study the work of legendary Disney Concept Artist Mary Blair. "Mary's brilliant color styling, backgrounds, and inspirational drawings from the 1940s and fifties lent tremendous influence on the color and values," Gabriel noted of the film. "The eye is drawn to the strongest area of contrast on the screen. By keeping the backgrounds generally even and making the central character brighter

Ink & Paint

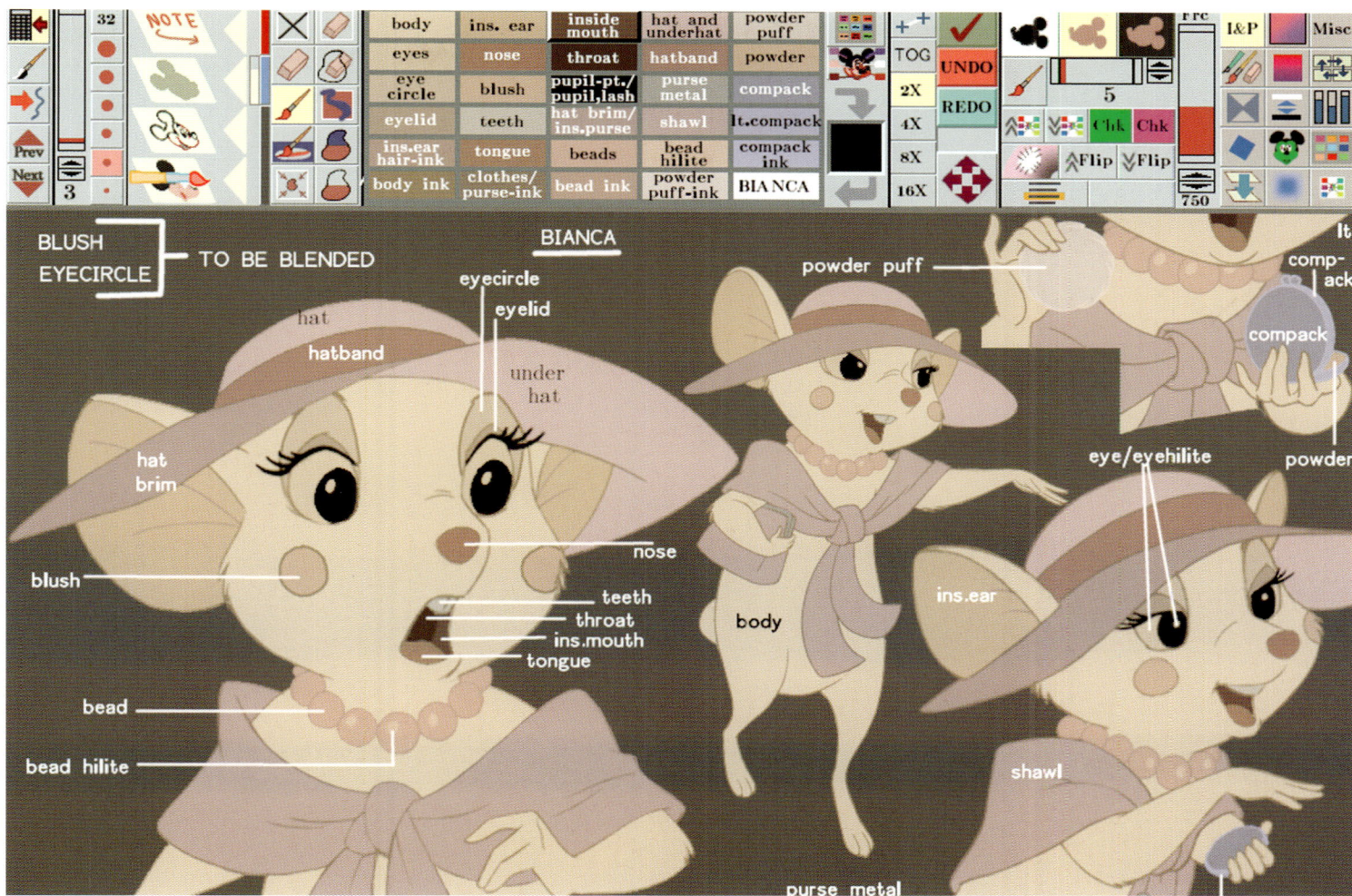

A view of the cel and palette Color Model markup screen within the CAPS system, featuring Bianca from *The Rescuers Down Under* (1990).

and with a black shadow, the audience is automatically drawn to the center of the action. We kept the background colors either a less saturated version of the character's hue or a complementary color so that they seem to belong together."

Gabriel offered insight into the wider palette of options made available through technology. "The CAPS system allowed us to simulate color ink lines without ink, but by digitally colorizing the Clean-up Department's pencil line drawings that had been digitized into the CAPS system." The scanning of the image along with the introduction of multiple colors added to line work within CAPS now rendered the Xerox and cel process obsolete. Color and design combined with sweeping shots never before explored in animation defined the ambition for Gabriel's direction. "We had a new digital version of the legendary Disney multiplane camera—but on steroids. It was crazy how freed-up we were to add as many levels of moving elements in our shots as we wanted in order to add the illusion of depth and wonder."

The digital age marked a wider presence for women in every aspect of animation. Allison Abbate, Susan Blanchard, Pam Coats, Patty Hicks, Sarah MacArthur, and Dorothy McKim stepped into Production Management. The Visual Development and Character Design talents of Jean Gillmore, Kelly Asbury and Sue Nichols defined the animated world Down Under. Lisa Keene supervised Backgrounds; Ann Tucker on Scene Planning; Animation Supervisor Kathy Zielinski and Lead Animator Debra Armstrong worked alongside the largest number of women animating on any production to date. Talented Assistant Animator Ellen Woodbury stepped into lead animation on *The Rescuers Down Under*. Moving into the digital age was exciting for Woodbury. "It's actually pretty cool! It stimulates your creativity," she said. Throughout her animation career, Woodbury became known as a hard worker. "I never settled for my first idea about a scene. Thought, imagination, brainstorming, and a critical mind make great animation."

DEFINING DIGITAL ROLES

Indeed, no one had successfully computerized an entire animated feature film before, and to achieve this high-tech feat, new terms, techniques, and production procedures were required to work within this burgeoning digital world. The introduction of artwork into CAPS through digital scanning, providing color models, adding color to cels, compositing artwork, checking, and preparing artwork for film all required new approaches.

To accomplish this, the role of the Ink & Paint Department—and its responsibilities—evolved throughout a lengthy process of discovery and development. A former Xerox Camera Operator who became a Scanning Supervisor, Robyn Roberts, observed, "It was a whole new group of people together. I'd never in my life met a technology person. That was the first time we were working side by side with them. They were depending on you and you were depending on them—it was quite a merging of two completely different types of people . . . two different worlds. [We] didn't think that would ever meld together, but it did."

Department heads such as Animation Checking Supervisor Janet Bruce defined new procedures for preparing artists and artwork for the digital process. By merging art and technology, a new, superior system was created that encompassed the same approach to the Disney production process—now accomplished

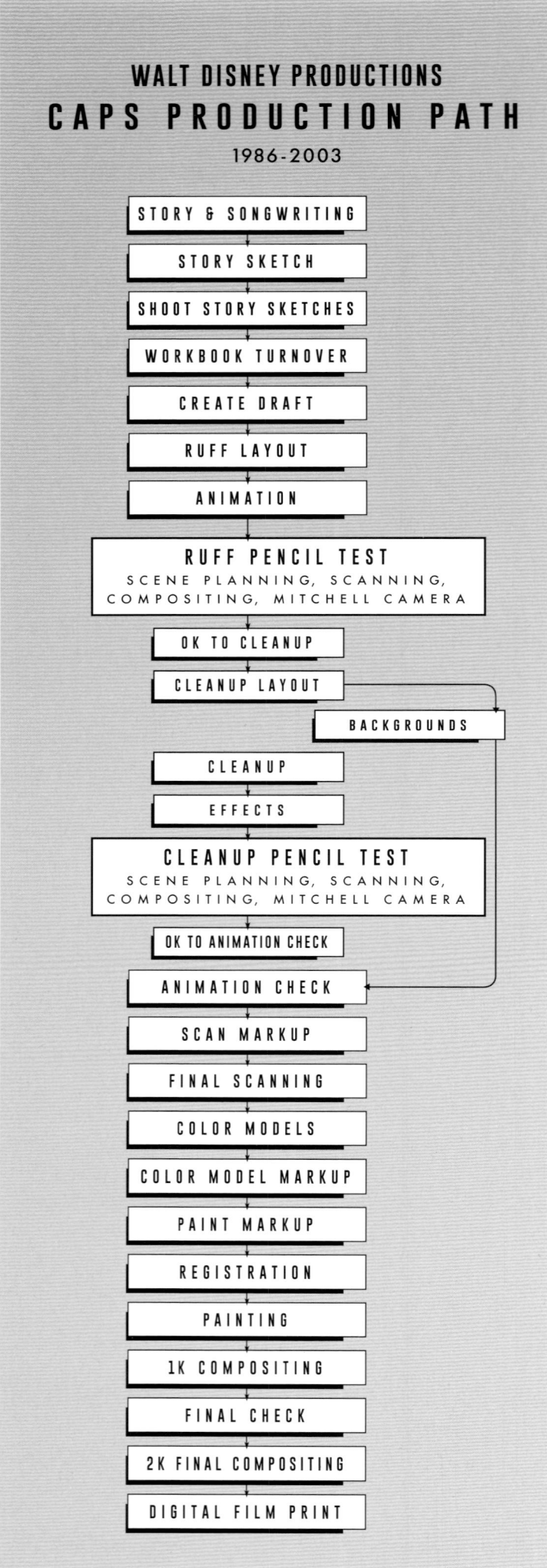

CAPS production flowchart.

digitally. The transition for each role required some modifications. Additional steps became minor adjustments for a production technology that ultimately expanded the artistic complexities and sophistication of color options, widened the range of storytelling capabilities with freer camera moves, and increased the quality and efficiency of the output per person.

PRODUCTION PROBLEMS

"An absolute requirement to keep the production flow moving is workable inventory, scenes that are ready for the various departments, whether it was CAPS or traditional," observed Ink & Paint Director Gretchen Albrecht. "With traditional Ink & Paint, you could end up with artwork that made it as far as Painting, which didn't have a color model, or you didn't have a background—which meant that the next department couldn't do anything with it, because you can't do anything without a background."

Tina Price noted, "Ink & Paint were the last in the line [so] they always got hit. In Story, we could take longer and they'd change things right up to the last minute, but the final deadline never changes and Ink & Paint had to make up for that. Unfortunately, CAPS couldn't fix that problem." But despite these challenges and delays, Ink & Paint came through. "That's right," said Albrecht, beaming, "we never missed a deadline."

With only nine paint stations, work was staggered. "So when anybody would get up, to take a break or go home, then somebody would jump in and paint," explained Albrecht. Keeping the production pipeline flowing became the largest challenge for the teams. "Painting had so much inventory," Albrecht continued, "but they couldn't put it online because everybody had to share the same ninety gigabytes." Without disk space and constantly reaching the technological threshold, files were taken off the system at night to open room for new work to be completed. "It was a pretty big orchestration of who needed what, when," Albrecht added.

Breaking new ground with computer technology required new approaches to high-volume data management—a new frontier in the late 1980s. "You really need to find a way of arranging the data that is aligned with the business's usefulness," recalled Graham Allen, Manager of Technology on the studio's CAPS system. "The amount of disk space we had to make the movie was pitiful, but it was absolutely the bleeding edge of its time. There is more power in my current cell phone than what was used to make that entire first digital film."

DATA SHUFFLES & BANDWIDTH BLUES

Working with extreme levels of data for that time, the tech teams developed some of the earliest approaches to data migration. "It was a deliberate design decision," Graham Allen noted of the original CAPS system. "There was an overall capacity. There wasn't enough space to have a scene stay on the computer, so they spent the night archiving off the material that was created or worked on that day, knowing they needed to be able to bring it back at some point onto the system just to push it through the pipeline," Allen continued. "So when Color Models was done

Ink & Paint | 355

Top: Final composited frame created within the CAPS system for *The Rescuers Down Under* (1990).

Bottom: Layered view of overlay and underlay elements against the final painted background.

and the Director had approved the color modeling, it would be taken off the system and put onto tape. Then it would be literally deleted from the disk to make room for what Ink & Paint actually needed to work on the next day."

Supporting the progress and needs of each department proved to be a juggling act for the Technical Directors. "All the data was being stored on DAT tapes," recalled Animator Dave Bossert. "They had to be loaded on a carousel." The film's Associate Producer, Kathleen Gavin, said, "People would have to request what scenes they were going to work on the next day . . . and then people would work all night loading those scenes on and taking everything else off the system." Planning ahead was crucial, as Bossert noted. "So the next day when you came in, you could actually access those particular scenes."

Disk space wasn't the only limitation to this primitive system, as bandwidth, or the ability to move data in and out of the system, also proved restrictive. "On rare occasions, production was allowed to keep two versions of a scene," Allen stated, "but most of the time, we kept [only] the last version that came out of each department because disk space was at such a premium. We spent an immense amount of that precious resource moving things on and off the system."

The nature of the technology meant limited connections between large disk units and the nine workstations. "Each workstation could only see the data that was on that connected disk unit, which were each about the size of a refrigerator," Allen reported. "And they were slow. It could take fifteen to twenty minutes to open the scene on your workstation. Artists would go into Ink & Paint mode in the morning; they would open a scene and then go off to the cafeteria to get breakfast."

Once a scene was completed, new problems would arise. "They had no idea compositing would take days sometimes to render before it would crash," recalled Tina Price. "People would have just painted the whole scene and it would be gone." The limitations at times were devastating. "Let me tell you," noted Allen, "there is nothing more horrifying to somebody who manages software to see fifty artists being sent home for the day because your system is broken."

RISKING IT ALL

"There was a point when it seemed clear that we could not actually complete the picture using CAPS," recalled Pixar's Tom Hahn. Peter Schneider proposed finishing the film conventionally and ordered an exploratory test. A traditional segment was cut together with the digital content and screened for the teams. "It

Left: The ballroom chandelier from *Beauty and the Beast* (1991).

Right: The enchanted Magic Carpet from *Aladdin* (1992) was created digitally, but the tassels had to be hand animated.

just didn't work," Hahn recalled. "The lights came back up and there was basically two choices: do it conventionally, which we couldn't do because it wouldn't work; or do it with CAPS[,] which we couldn't, because it wasn't ready." Kathleen Gavin called a meeting to weigh the options. "[It was] proved unequivocally that it could not be done on CAPS. But Gretchen [Albrecht] thought that it could, and I had always been very successful betting on Gretchen. So . . . I didn't actually bet on CAPS, I bet on Gretchen!"

To outsiders, that may have seemed a risky bet, but as Tina Price noted, "Not only were they trying to learn something and to perfect their craft at it, but the darn thing just wasn't ready. But they were amazing people. They would just push through." Production continued undaunted through the uncharted territory of digital production. "We worked on it through CAPS for about a year," recalled Gavin, "but actually we probably did the entire movie in the last nine weeks of production. It was a complete 'chewing gum and bobby pin' operation." With no stability to the overall system, there were more days of downtime than uptime. "What a challenge!" Albrecht remembered. "We had a lot of things go wrong. Everybody was there at all hours of the night. We were all-hands-on-deck!"

The Ink & Paint staff worked twenty-four hours straight for more than a week in the final days of production. Director Mike Gabriel added, "I admire the hell out of them [for how] they dove into this challenge. Through dogged determination and pulling all-nighters, these unstoppable women completed the impossible with great skill, great humor, and great after-hours parties." The volume of work accomplished in the final days of production "[set] a record for a single week's color footage through that system," according to Mark Kimball. "That was a tremendous feeling of accomplishment[,] to have gotten the system working in the last six, eight weeks and pushing a tremendous amount of footage through it."

The completed film required over 170,000 individually painted frames within CAPS and nearly nine hundred hand-painted backgrounds scanned into the system. Additionally, in excess of one million drawings—story sketches, pencil animation, and layouts—were created during the production process. It was a colossal volume of work accomplished in a short period of time with an untested production system, but Albrecht summed it all up: "We got it done."

Originally conceived as a system to increase the efficiency and output of the Ink & Paint Department, the CAPS system more than doubled the final output per Painter. On a traditional Xerox and hand-painted film, the average output per individual Painter was 5.5 feet of film footage completed. Even with characters averaging five different ink colors for *The Rescuers Down Under*, each Painter averaged 12.3 feet with CAPS. Success!

The Rescuers Down Under, the first digitally created animated film, opened on November 16, 1990. It was released solely on its storytelling merits with absolutely no mention of the digital production methods involved. Screening alongside this landmark film was *The Prince and the Pauper*, which was the last animated short film to feature hand-painted cels, the standard method of Disney animation for nearly seventy years, along with the Xerox technology that had been utilized by the studio for over three decades. Despite being released together in theaters, audiences seemingly did not notice any visual difference between these Disney animated films. With strong box-office success, *The Rescuers Down Under* quietly ushered in the digital age of feature-length animation.

Ink & Paint | 357

Left: CAPS composite of the wildebeest stampede sequence from *The Lion King* (1994).

Right: An example of Deep Canvas from *Tarzan* (1999) which rendered imagery into a 3-D frame context exemplifying depth. Painters could now assign brushstrokes and color palettes to specific areas within a 3-D context to create a moving background.

AN ANIMATION MILESTONE

"It was the movie that time forgot," noted producer Don Hahn, "but *Rescuers Down Under* really tested CAPS and made it what it is. Everything in that movie is because CAPS was able to make these amazing eagle-flight sequences with incredible depth. That was the first CAPS movie and the very first digital movie in Hollywood." Echoing the accomplishments of this landmark film, executive Peter Schneider stated, "It fundamentally changed the way our movies were perceived—putting into the hands of the filmmakers the ability to move the camera, to do multiplane, to create a softness in character and inked line. [It] changed people's perception of what a movie was about. Without CAPS [and] without Roy [E.] Disney to get it done, we would not be where we are today."

"We were off and running," noted Roy of the CAPS system and its application to Disney animated films. Following the success of *The Rescuers Down Under*, a progression of landmark films were created via the CAPS system. Roy continued, "We made 'em better and we did things that we could never have dreamt of in the days of cel animation. It was a question of constant discovery." While the technology continued to change and develop—growing more robust with each new project—CAPS remained an industry secret.

"They didn't want people to focus on the technology," recalled Gretchen Albrecht. "They wanted the focus to be on the story and the beauty of the films—not how we did it. CAPS technology was originally meant to increase the efficiency and reduce costs. What it did instead, was increase the artistry."

Continuing in the studio's grand tradition of story and artistry supported by technology, Disney animation advanced stronger than ever. Critical and box office success followed with *Beauty and the Beast*, which broke new ground with animated storytelling, receiving the first Best Picture Academy Award nomination for an animated film. Then computerized characterizations advanced with the Magic Carpet of *Aladdin*; the addition of live-action special effects bolstered *Tim Burton's The Nightmare Before Christmas*; and the successful integration of 2-D and 3-D animation in the wildebeest stampede scene of *The Lion King* made the African savanna come to life.

The development of CAPS had indeed signaled the end of hand-inked and painted cel animation at Walt Disney Studios and represented the largest advance in animation production methods since *Snow White and the Seven Dwarfs* captivated audiences in 1937. Over the years, the possibilities within the CAPS system continued to expand as animation progressed into exciting realms of deep canvas, a boundless camera, and infinite color possibilities. "The basic animation process was still there," noted Albrecht, "but as artists, we were now unlimited."

After ten years of secrecy, the Computer Animation Production System was finally revealed to the world with the record-breaking release of *The Lion King* in 1994. It would be another year before audiences entered the world of feature length Computer Generated Imagery with Woody, Buzz Lightyear and their friends in *Toy Story* (1995). The art form of animation crossed the digital threshold with seventeen complete feature films—from *The Rescuers Down Under* to *Home on the Range*, and four short films, created utilizing CAPS.

Audiences continue to fall in love with these animated stories formed from the same artistic standards and creative process envisioned nearly a century earlier by the master of animation himself, Walt Disney.

RETAINING THE ARTISTRY

> *"I have an organization of people who are really specialists. You can't match them anywhere in the world for what they can do."*
> — **Walt Disney**

From the earliest days of cinema, when the flicker of animated imagery through a film projector, hundreds of thousands of drawings were created to realize a final moving image. More than a momentary record, each one of these drawings was colorfully transformed onto celluloid sheets, and when linked together via celluloid film, they all came to animated life. Yet once the image was captured on film, the original artwork was deemed no longer necessary and often discarded. With the advent of digital technologies and CAPS at Walt Disney Animation Studios, cels were no longer utilized within animated film production.

For nearly a century, the standard policy at most animation houses was to dispose of the artwork that formed these moments of cinematic magic. Nitrate-based celluloid was highly flammable and therefore difficult to store. Acetate-based celluloid was less volatile, but if not properly cared for, it was easily damaged when subjected to heat and the ravages of time. On the other hand, backgrounds and animation drawings, which documented the original action, were less problematic to store and preserve and could be reutilized if there was ever a need to rebuild the original film.

Despite the problematic facets of celluloid, animation cel artistry became highly sought after over the years. Qualitative examples of the earliest hand-rendered animated cels are rare, but actual inked and painted artwork photographed for each film still proves indispensable in the study of color, design, movement, and form. Thankfully, the Disney Studios carefully preserves these visual masterpieces to museum quality standards today, mindfully retaining this artistry for future generations.

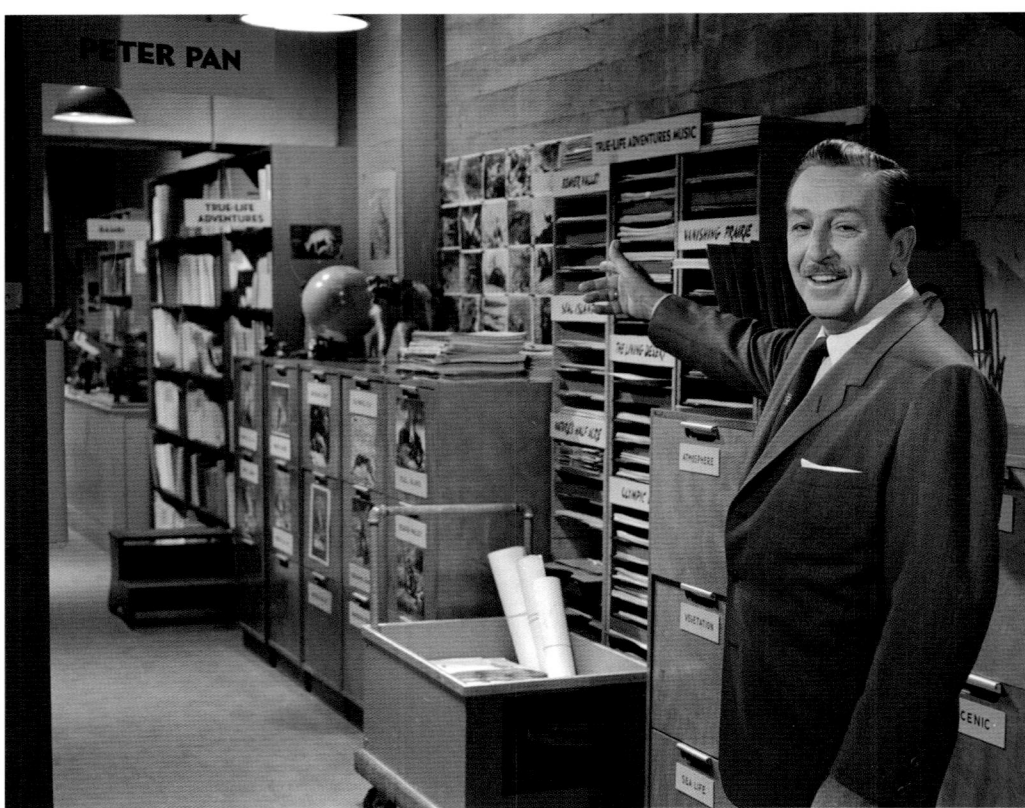

THE MORGUE

On September 25, 1957, Walt Disney introduced television audiences to a part of the studio lovingly referred to as the "Morgue," a place where artwork was stored. "In our Morgue," Walt noted, "these shelves, tables, and file cabinets hold all our history as a motion picture studio." In the 1930s, artwork had been stored within the studio's Library at Hyperion. Later, in Burbank, the entire artistic history of the Walt Disney Studios was kept in an area underneath the Ink & Paint Department. This was far from a place where artwork went to die. As Walt defined it, the Morgue represented "the repository, the well of our experience. And experience is the key to progress."

For nearly thirty years, Esta Haight ran the department of Art Props, which oversaw the Morgue. Once processed through Camera and the film completed, cels were sorted and either washed, trashed, or set aside for reference. The animation drawings were stored and retained to reuse, inspire, and reference as animation techniques and methods moved forward at the Walt Disney Studios. Pete Renaday, longtime Disney talent, recalled, "When I started at the studio in 1959, a fellow named Merle Ray Harlin was in charge of the Morgue. Later on Ralph Michaelson was put in charge." Loosely monitored, scenes of animation drawings were signed in and out on an honor basis for Animators to study and reference under the care of Jack Brady and other temporary staff over the years. As productions ended, new artwork would be boxed, filed, and stacked in the Morgue.

"When Dave Smith started the Walt Disney Archives in the early 1970s, we purposely sought to retain the materials and files behind the films," stated Archives Director Becky Cline. "All of the development and creative meeting notes, the stenographic story meeting notes for all the features came into the Archives[,] where we've retained the story behind how Walt and the teams of studio artists created these animated classics."

"Story development artwork and the animation drawings for the features stayed with the Animation library," noted legendary archivist Dave Smith. "The backgrounds for the features and the cels, they would have stayed there as well."

As a working library, the Morgue remained in the Ink & Paint basement within close proximity for the animation teams. "The Morgue was never a very fancy place," recalled Ted Thomas, son of Animator Frank Thomas. "It was literally a corner of the basement, with concrete floors and walls, dim hanging lights, and overhead pipes. I was there the summer after the Sylmar Earthquake, which happened in February 1971. When I started in late May, there were still alcoves where entire shelves with animation scenes had tipped over, spilling drawings all over the concrete floor. My job was to go through those drawings and reassemble scenes in order, put them back in the folders[,] and return them to the shelf. One of the big revelations was to pick up the storyboard drawings from *Destino*, a title about which I knew nothing at the time. It was a revelation to learn about Salvador Dalí working at the studio."

Upon Esta Haight's retirement in 1972, Art Props was placed under the direction of Becky Fallberg, who also later ran Ink & Paint. "I was always so nervous with all that artwork stacked under those pipes," Fallberg stated. Her fears were justified. As Floyd Norman recalled, "During a heavy rainstorm, the Ink & Paint Building would suffer a number of leaks. More than once the original Disney animation art was in danger of water damage." Other factors threatened the destruction of this artistic heritage. By the mid-1970s, a general disregard for the past took hold industry-wide as many of the amassed archives of various motion picture and animation studios were destroyed. Some of the greatest pieces of artwork and footage were hauled off as landfill to build Los Angeles's expanding freeways. While other studios burned their animation libraries to make room for offices or storage, art at the Walt Disney Studios, spanning throughout the decades of classic productions, was spared. Roy O. Disney chose to retain and preserve the studio's animation artwork.

Page 359: One of several temperature-controlled preservation vaults within Walt Disney Animation Studios' Animation Research Library.

This page, left: Storage of Disney artwork in the 1970s.

Right: Walt Disney visits the studio's Morgue in a segment from the *Disneyland* television series.

The collective teams of the Walt Disney Animation Studios' Animation Research Library, led by Mary Walsh. From back row, left: Tom Pniewski, Michael Pucher, Tammy Crosson, Tamara Khalaf, Darryl Vonture, Leon Ingram, Ann Hansen, Elda (Tita) Venegas, Kristen McCormick, Howard Green, Cassandra Siemon, Richard Kanno, Tracy Leach, Patrick White, Jackie Vasquez, and Bethany McGill. Front row (seated, from left): Fox Carney, Ajay Mamtura, Tori Cranner, Marisa Leonardi, Jamie Panetta, Mary Walsh, Jane Glicksman, Jill Breznican, Mat Fretschel, and Doug Engalla.

With Jack Brady's retirement in 1976, Leroy Anderson, a retired Norwegian farmer from Fargo, North Dakota, took charge of the Morgue with the newly coined title of Head of Animation Research. "It was really fascinating to come into something so different from anything I'd done before," Anderson stated in a late 1980s interview for the studio newspaper. In addition to overseeing the use of the materials for new Animators to study old techniques, Anderson's role encompassed a wide range of responsibilities, including assisting Frank Thomas and Ollie Johnston as they developed their landmark book, *The Illusion of Life: Disney Animation*; supplying the three theme parks and WED divisions with original drawings; and keeping the materials in some form of order.

"That was my first job," recalled legendary Producer Don Hahn, who worked in the Morgue with Anderson. "He was kind of the keeper of the artwork. It was a reference library. There was no door on it, so you could go in there and just look at things. My job was delivery. I'd pull a scene off the shelf and take it up to an Animator for reference. They kept some of the Ink & Paint artwork and that was cumbersome, but the more important things were the drawings and the backgrounds and the color models, so they had a record of everything if they had to reproduce it."

Hahn continued, "It was not archivally preserved very well. The old shorts were stored in the steam room, which is where the boilers were for the Ink & Paint Building. This was in the basement. The hot water heaters were in one place[,] and that's where *Plane Crazy* and *Steamboat Willie* were stored. The collection was vulnerable to leaky pipes, jammed shelves, and the occasional hungry mouse who would nibble away at the corner of a stack of drawings. The backgrounds[,] such as the long *Sleeping Beauty* backgrounds, were rolled up and stuck in ice cream buckets thrown out from the Tea Room. Leroy would wash them out, let 'em dry, then roll up the backgrounds and stick them in these ice cream buckets and set them on the shelf."

During his time in the Morgue, Don Hahn renamed the department to the more respectable—and apt—Walt Disney Studios Animation Research Library. With each passing film, more shelves of various concept art, development sketches, storyboard pieces, backgrounds, maquettes, color models, test cels, animation drawings, cleanup drawings, and final cels accumulated. The collection continued to amass. Despite the volume, the artwork continued to prove indispensible to the Animators, but as time wore on, the usage and conditions took a toll on these pieces of one-of-a-kind artwork.

In November 1987, Kaye Salz, who managed the Animation Research Library (ARL), was overseeing a small staff that maintained the collection and signed out scenes to artists for review and study. Salz later oversaw the transfer of the artwork from the studio lot to another nearby Disney facility, where the small team of dedicated researchers and collections specialists initiated the early organization and rehousing of the growing collection. By the mid-1990s this rare and treasured artwork was no longer lent out to the artists, but they could certainly come to the ARL for study and research. Following Salz's retirement in January 1995, a search went out for new leadership.

The new manager placed in charge of this extraordinary collection was Lella Smith, who came to The Walt Disney Company from an extensive background with the Natural History Museum of Los Angeles and the Armand Hammer Foundation. An expert in fine art, Smith initiated the documentation, preservation, and presentation of the collection with a growing staff of archival specialists. The collection was moved to a private location in 1999 and housed in a state-of-the-art facility where Smith later advanced to Director of the Animation Research Library. Her teams broadened the role of the ARL to include publishing, exhibitions, and the expansion of the collection in addition to their regular roles as keepers of the original Disney animation artwork. After a solid legacy and nearly twenty years overseeing the heritage of Walt Disney's animation, Smith retired in 2014.

PRESERVING THE PAST

Today, the Animation Research Library is the official repository for the original animation materials of the Walt Disney Animation Studios. Not open to the public, this private collection of over sixty-five million pieces is the largest assemblage of animation artwork in the world and the only collection of its kind, constituting nearly one hundred years of animation history. The primary responsibility of the ARL is the preservation of this historically vital collection, as well as making this unique body of work available for study and research and serving a variety of other purposes within The Walt Disney Company.

Mary Walsh, Managing Director of the ARL, is a twenty-year veteran of Walt Disney Animation Studios. "I am humbled daily by the artistic talent that is on display in the collection," Walsh remarked. "In addition to the physical artwork from the earliest days of the studio, we also care for the digitally born works of art that are currently being created by the Walt Disney Animation Studios, so the biggest challenge we face is maintaining a consistent level of safe housing and organization, in the appropriate environment."

Departments within the Animation Research Library include Research, Collection Management, Design, Image Capture, Exhibitions, and Administration. "I am surrounded by a team of passionate, dedicated, and skilled professionals," Walsh noted of the researchers, conservators, exhibition designers, and collection specialists who work to protect and preserve the artwork and oversee the outreach and utilization of these priceless assets. "The Animation Research Library team understands that the art under our care represents the creative legacy of this company, and we work to ensure its integrity, safety, and ability to inspire and inform current and future artists and storytellers."

THE ARTISTRY OF INK & PAINT

Walt Disney was proud of his animation and recognized the contributions of the hundreds of trained artists who achieved the height of animation mastery. "I can't hold a pencil to the artists in my studio," Walt declared. "I take great pride in the artistic development of cartoons." With the advancements of digital technology, the original inking and painting process is no longer applied in Walt Disney animation, though Walt Disney Animation Studios is the only major animation studio to retain artists skilled in the production of hand-inked and painted cel art.

"As the original legacy department of the company," noted Rikki Chobanian, Ink & Paint Department Manager, "where everything else changes, we don't!" Continuing the tradition, the last of the studio's Ink & Paint artists maintain nearly all of the traditional aspects of hand-rendered celluloid artistry from the golden era of Walt Disney's animation. A markedly smaller team applies these time-honored talents and skills to creating custom-collectible cels.

The last of the studio Painters is Sherri Vandoli, who started at Walt Disney Animation Studios working in the Xerox Department in February 1981 while *The Fox and the Hound* was in production. From production experience to creating collectible cels, Vandoli has a unique perspective. "Being a part of this incredible legacy has been a dream come true for me." She added, "It hasn't been a job; it's an incredible heritage and I don't want to see it go away."

Vandoli also oversees the Xerox Camera and paints cels and all the artists' maquettes, which are still utilized within Disney animation today. "My passion is creating this legendary artwork and I see the passion everyone has for these pieces. It truly means a lot to me to see the kid inside come out when people receive these pieces of art."

Master artist Antonio Pelayo continues the disciplined work of inking. Pelayo, who is also a noted photo-realistic fine artist, began training at Disney Studios in 1994 as an Inker on collectible cels. "My fine art is meticulous, detailed, and very intricate, which is also the case with inking. When I began inking at Disney Studios, I was nervous," he admitted. "I was taught to treat the cels like tender babies. To give you some idea of the level of artistry involved, many of the master Inkers who trained me said that it takes fifteen to twenty years of consistent work to be a good Inker.

"After twenty-plus years, I feel as I'm just becoming a true master Inker." Over the years, Pelayo also developed his airbrush skills and completes many of the visual effects applied to these hand-rendered masterpieces.

Maintaining the Paint Lab, Jim Lusby has been mixing and formulating the full range of colors that line the department's shelves since 1994. "We have close to four thousand colors today that we work with," noted Lusby of the work he creates within The Rainbow Room. "We are constantly adding new colors with new projects coming into our department." Working with acrylic-based paints formulated into the Disney palette of colors, Lusby prepares the necessary cels and the array of shades needed, just as the previous Disney Lab masters did.

Chobanian, who began as the Ink & Paint Department secretary in 1998, now administers the team. Working with vendors to source and stock the necessary supplies, she ensures all production quotas are met and chooses the scenes the team creates for each series of collectible cels. Chobanian noted, "The works created here are Disney masterpieces, and I feel it's important to keep this going."

Today, the inked & painted artistry of The Walt Disney Company continues with an entirely different purpose. Line by flawless line, brushstroke by careful brushstroke, the studio's last remaining Ink & Paint artists continue just as in the day of Walt Disney. "Many people don't realize this artwork is still created by hand," noted Vandoli. "It's very different from when we worked on feature films. Then, a lot of people buckled down to get each feature done. Now, it's the three of us, and a boss. It's different, but I'm proud that we're here. I think fans of Walt Disney's animation would miss it terribly if this process went away."

Though the department's numbers reflect the size of the earliest days of the Disney Brothers Cartoon Studio, the hand-rendered artistry of this tight-knit team retains the entire legacy of nearly one hundred years of Walt Disney Animation Studios. Of her department's highly collectible animation cels, Rikki Chobanian noted, "I'd like to think that this will continue forever, as long as The Walt Disney Company is around. I feel it's important to keep this going. These are treasures. Each cel is a captured moment of Disney magic."

Page 363 (top left & right): Paint Lab Technician Jim Lusby at work in the studio's lab; Painter and Xerox Processer Sherri Vandoli. (Center left & right): Inker and Fine Artist Antonio Pelayo; The Walt Disney Studio's Ink & Paint team. (Left to right): Jim Lusby, Lab Technician; Sherri Vandoli, Painter/Xerox; Antonio Pelayo, Inker; Rikki Chobanian, Department Head. (Bottom left & right): Paint Let-Downs and color swatches.

Ink & Paint | 363

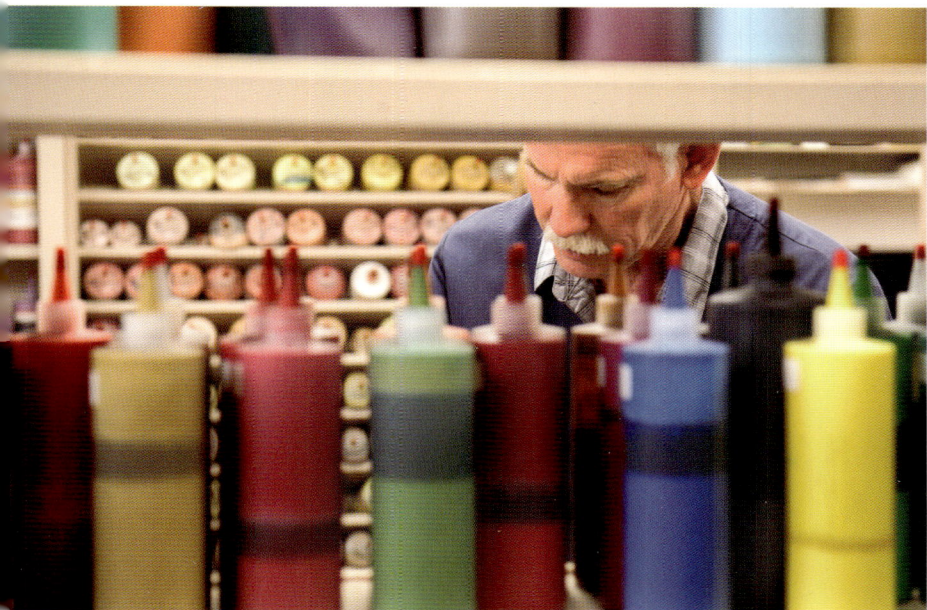
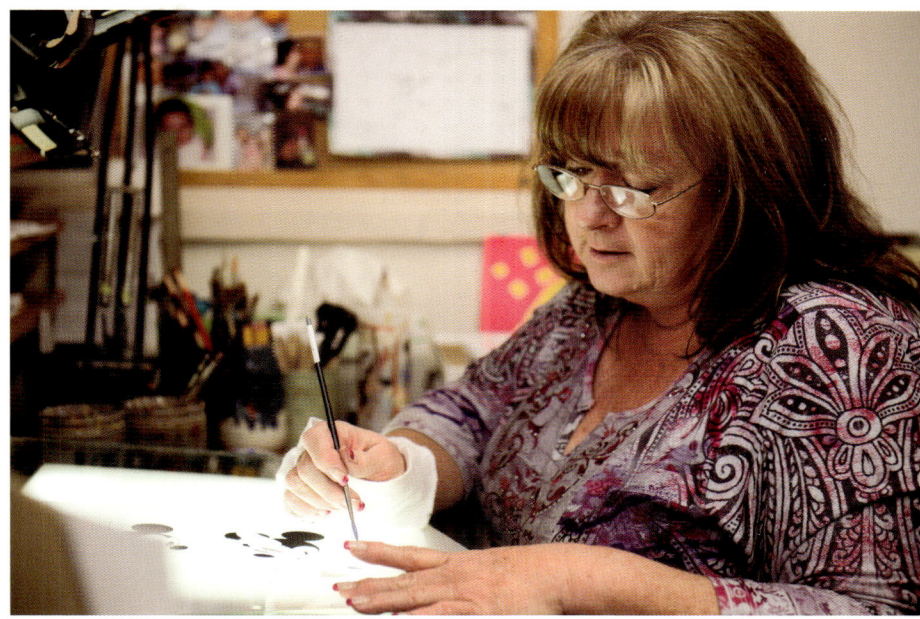
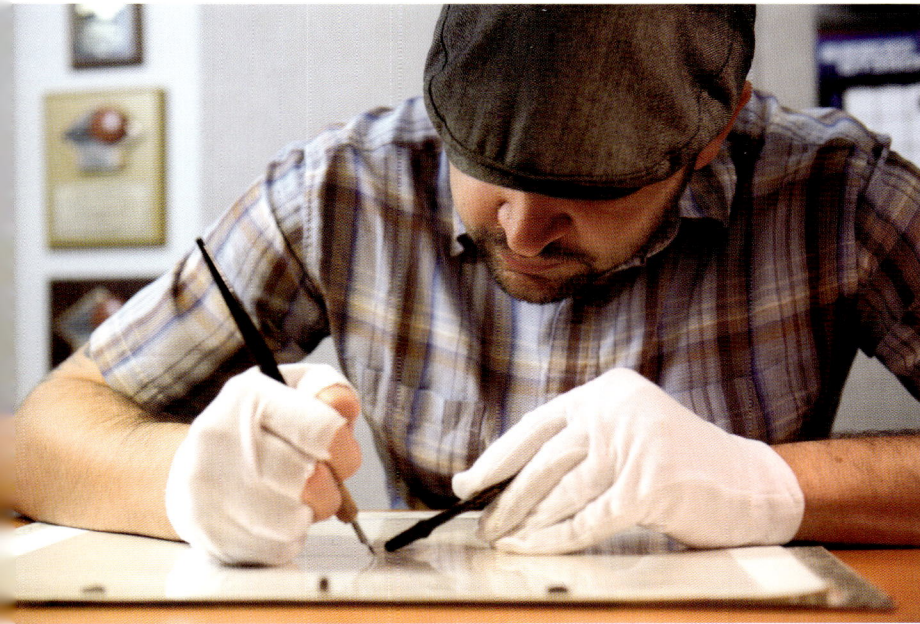

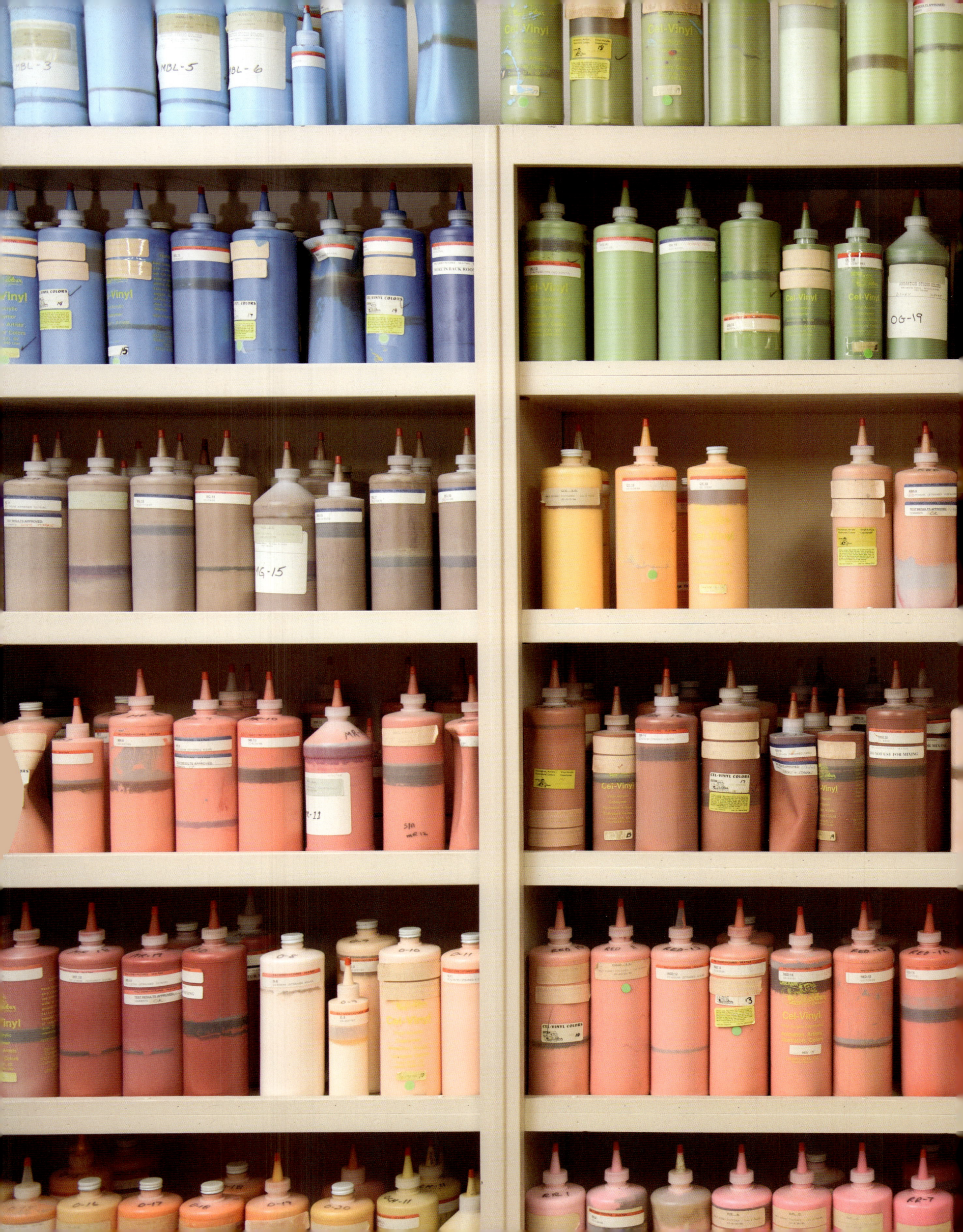

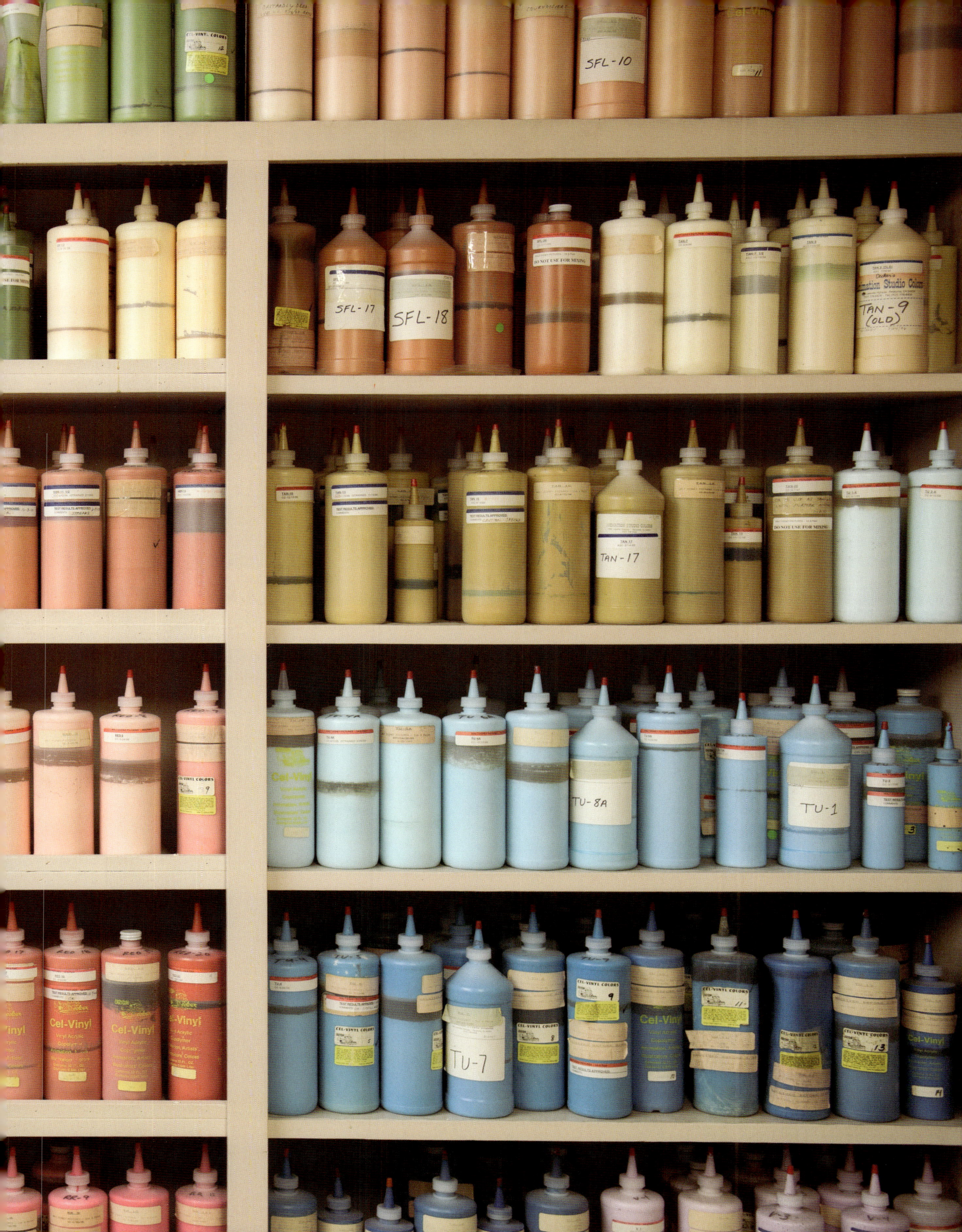

Artists

This story is told in as many first-hand accounts as possible—images of these women are featured throughout the book and within this gallery, which represents only a portion of the thousands of women who contributed to Disney animation over the years.

Virginia Ainsworth
Virginia Svendsen Ainsworth
1934–1936+
Ink & Paint

Marge Allison
Marjorie McCall Allison
11/36–1940+
Inker

Dorothy Bachom
10/31/38–12/19/42
Inking & Painting
Airbrush / Background

Jane Baer
Jane Shattuck Takamoto Baer
1955–1956 & 1976–1977
Inbetweener / Assistant Animator

Wilma Salmon Baker
7/1/37–1941 & 1945–4/26/96
Painter / Shadow Painter
Xerox Processor / Checker

Edle Bakke
1945–1961 & 1971–1974
I&P Switchboard & Production
Script Supervisor

Marjorie Belcher
Marge Champion
Live-Action Reference Model

Lucille Benedict
Lucille Benedict Martin
Walt's longtime Secretary

Shirley Berri
3/1/43–10/31/49
Inker

Barbara Blake
Barbara Luck Blake
8/17/43–9/11/78
Story Research / Librarian

Lois Blomquist
6/27/55–3/15/57
Inbetweener / Breakdown

Sandra Borgmeyer
1979–1986
Animator

Nora Cocreham
3/20/39–1941+
Stenotypist

Mary Jane Cole
Mary Jane Knott Cole
1936–1941 & 1/10/66–9/2/77
Inker / Painter / Xerox

Karen Comella
3/14/83–2/28/03
Painter / Color Model
Supervisor

Lorna Cook
1977+ & 1990s
Animator / Story Artist
Director

Lois Crisler
True Life Adventures Films
Wildlife photographer

Eleanor Dahlen
9/3/57–1959 & 1984–9/6/89
Inker / Painter / Xerox Check

Maria Fenyvesi
5/26/58–8/31/94
Inker

Virginia Fleener
3/29/43–6/9/44
Inker / Checker / Animation
Clean-up / Inbetweener

Eve Fletcher
5/6/46–9/14/90
Inker

Virginia Fontanella
5/2/38–6/29/73
Painter
Color Model Supervisor

Marcellite Garner
1/17/30–7/18/41
Ink & Paint / Voice Talent

Marie Gerard
6/12/39–3/3/69
Ink & Paint / Layout
Background / Blue Sketch

Ink & Paint | 367

Phyllis Barnhart
Naomi Phyllis Fowler Barnhart
1/25/44–11/19/45 & 1986
Painter

Teddy Barr
Florence "Teddy" Barr
1932–1941+
Painter

Lea Batchelder
Lea Adams Batchelder
1932–1935+
Ink & Paint

Violet Bayerl
5/8/39–2/22/80
Painter / Animation
Breakdown

Betsy Baytos
1976–1984
Inbetweener / Asst. Animator
Animator / Choreographer

Lila Beckton
3/13/44–2/6/45
Inbetweener

Frances "Flo" Brandt
9/25/45–4/3/56
Inker / Painter

Sue Bristol
Sue Brown Bristol
8/17/29–1935+
Ink & Paint Supervisor

Janet Bruce
8/2/65–1995
Ink & Paint / Color Models
Supervisor Animation Check

Marceil Clark
Marceil Clark Swanson Ferguson
8/8/32–1935+
Ink & Paint / Reference Model

Evelyn Coats
Evelyn Henry Coats
3/28/31–12/23/39
Inker / Supervisor

Inez Cocke
1/13/58–9/12/66
Story / Writer

Doris Detremaudan
Doris Detremaudan Pollack
8/32–1934+
Ink & Paint

Eloise May Dewerthemer
1932–1934+
Ink & Paint

Ann Dvorak
4/5/43–5/25/73
Inbetweener / Breakdown
Assistant Animator

Mary Ellison
Mary Idolette Ellison Allen
5/10/37–11/4/39
Inker

Dorothy Esgate
Dorothy France Esgate
9/28/37–4/29/77
Inker / Painter

Elinor Fallberg
3/24/41–12/19/47
Paint Lab / Blue Sketch
Assistant Animator

Eve Gerstad
Evelyn Gerstad Newman
5/10/37–11/24/41
Ink & Paint

Muriel Gibbs
12/8/36–1/25/71
Inker / Painter / Shadow Painter

Leota Eustace Gibeaut
11/23/36–6/19/42
Inker / Promotions

Frances Goellert
Frances Goellert Kuefner
1935–2/4/41
Inker

Vita Goolin
1940–1970+
Ink & Paint

Barbara Gorham
1938–1941+
Paint Lab

Artists

Betty Gossin
1962–1983+
Editor

Annie Guenther
1950s–9/9/77
Ink & Paint / Backgrounds

Flavilla Hagin
"Phil/Pat" Belle Hagin Goepper
11/15/37–5/31/46
Personnel / Production

Esta Haight
4/10/44 –12/19/66
Inker / Final Check / Layout
Blue-Sketch / Art-Props

Gloria Hamilton
1944–1947+
Music Editor

Joy Hankins
2/1/44–11/12/45
Clean-up / Inbetweener
Character Animation

Charlotte Huffine
1954–1958+
Animator

Caroline Jackson
2/24/38–5/10/68
Story Research / Librarian

Dorothy Jeakins
1936–11/41
Sketch Artist / Color
Multiple Academy Award Winner

Marie Johnston
Marie Worthey Johnston
8/8/40–3/3/41
Inker / Painter

Jeannie Keil
Jeanne Lee Keil
5/10/37–8/20/59
Inker / Assistant Supervisor

Beryl Kemper
Beryl Ward Kemper
5/31/44–8/20/59
Painter

Helen Ludwig
Helen DeForce Ludwig Hennesy
7/1/35–6/15/40
First Studio Librarian / Research

Marjorie Lusk
Marjorie Gummerson Lusk
1938–1941+
Studio Personnel

Ginni Mack
Helen Virginia Gilliland Mack
6/27/46–11/1/51 & 1977–1/6/91
Painter / Paint Match / Supervisor

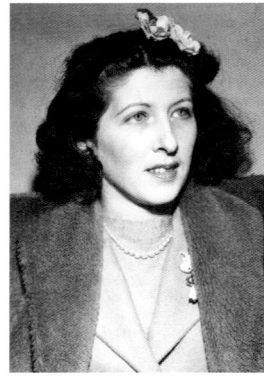
Nelda Marshall
5/10/43–8/23/45
Assistant Editor

Lucille Martin
1960s–2000s+
Walt's & Executive Secretary

Frances Matlock
1932–1935+
Ink & Paint

Dorothy Mullen
1948–1953
Studio Teacher

Miho Nagisa
7/5/72–3/1/77
Inker

Ann Neale
4/24/78–3/29/02
Painter / Paint Lab

Buf Nerbovig
Elizabeth "Buf" Nerbovig Beum
1936–1960 & 1970–1971
Ink & Paint / Scene Planner

Nellie Nevius
Nell Carpenter Nevius
10/30/35–9/15/41
Inker

Eve Newman
Eve Newman Loman
1935–1937
Inker

Ink & Paint | **369**

Cam Harding
Mary Campbell "Cam" Harding
2/2/37–5/23/41
Stenographer / Shorts Production

Juanita Hart
Juanita Light Hart Lundy
1932–1933+
Ink & Paint

Christine Hecox
11/6/64 – 1989+
Ink & Paint

Edie Hoffman
Edith Mae Moore Hoffman
10/19/42–1948 & 1976–9/15/91
Painter

Jean Holehan
11/14/38–11/24/41
Painter / Animator

Marge Hudson
Marjorie Faulkner Hudson
9/17/32–12/20/38 & 1955
Inker

Betty Kimball
Betty Lawyer Kimball
6/20/35–8/12/39
Painter / Paint Match

Katherine Kuhlman
1935–1/6/40+
Inker

Ann Lamb
Ann Asplund Lamb
5/10/37–9/12/41
Inker

Roberta Lanouette
7/5/39–19/28/41
Story Research / Writer

Ann Lloyd
Ann Lloyd Paeff
11/23/36–3/23/83
Inker / Color Model Supervisor

Arlene Ludwig
1963–2012
Publicity

Sylvia Mattinson
Sylvia Fry Mattinson
1950s–1983+
Inbetweener / Animator

Mary "Scotty" McAvoy
Mary Byres-Low-McAvoy
7/5/39–9/18/67
Paint Lab / Ink & Paint / Xerox

Cherie McGowan
Cherie McGowan Edmonds
1983–1989
Ink & Paint / Gallery Cel Manager

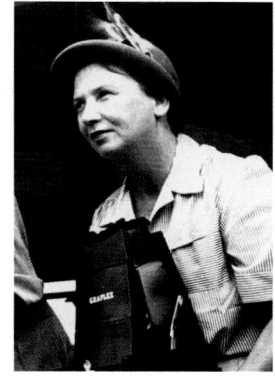
Elma Millotte
True Life Adventures
Academy Award–Winning
Cinematographer

Phyllis Mooney
Phyllis Mooney Williams
10/23/44–8/9/65
Inbetweener / Animator

Margie Moorhouse
Majorie "Petie" Moorhouse
9/7/38–2/9/51
Painter / Checker / Shadow Painter

Sylvia Niday
5/8/39–4/4/66
Ink & Paint / Animator / Cleanup
Inbetweener / Breakdown

Yuba O'Brien
Yuba Pillet O'Brien
6/3/35–7/13/45
Inker / Supervisor

Helen Ogger
2/1/31–11/14/41
Inker / Comic Strips
Special Effects

Barbara Palmer
3/27/44–9/18/89
Painter

Constance Phelps
5/14/56–8/28/78
Final Check / Animation Check
Assistant Paint Supervisor

Phyllis Pickles
1942–1947+
Inker

370 | Artists

Doris Plough
Doris Mackay Plough
7/9/54–4/25/69
Inker / Inbetweener

Peggy Plowden
7/8/40–9/78
Paint Lab / Color Model / Inker
Final Check / Xerox Check

Isabelle "Billie" Rushton Porter
8/14/39–10/2/40
Ink & Paint

Madeline Porter
8/7/39–3/22/68
Painter

Doris Pugsley
6/21/38–1941+
Stenographer

Marjorie Ralston
8/24/29–9/28/40
Ink & Paint

Gracie Robinson
Gracie Cunningham Robinson
5/1/39–11/3/74
Inker

Sylvia Cobb Roemer
1944, 1955–1985
Ink & Paint / Layout
Color Model Supervisor

Joanna Romersa
8/2/54–11/30/56
Inker / Assistant Animator

Faith Rookus
1938–1941+
Ink & Paint / Story Artist

Fini Rudiger
Fini Rudiger Littlejohn
5/15/39–5/18/40
Character Models

Edna Ruth
Edna Ruth Connor
1931–1934+
Ink & Paint

Eva Jane Sinclair
6/19/39–8/18/50
Story Research

Dorothy "Dot" Smith
5/28/31–1945+
Inking Supervisor / Painting
Check / Animation Checker

Edna Smith
3/16/36–12/31/74
Inker

Helena Sorenson-Thompson
10/29–11/36
Ink & Paint

Helene Stanley
Dolores Freymouth
Stompanato Niemetz
Live Action Reference Model

Betty Stark
10/10/44–5/30/87
Painter / Paint Lab
Assistant Supervisor

Margaret Trindade
5/8/39–6/28/85
Inking Trainer / Supervisor
Xerox Check

Betty Underhill
Betty Underhill Jewett
9/21/38–9/12/41
Painter

Dolores Voight Scott
1930s
Walt & Roy's Secretary

Edyth Vosburgh
12/29–1931
Ink & Paint

Valentine "Val" Vreeland
Valentine Glassell Vreeland Paul
3/28/31–9/13/74
Ink & Paint

Mary Lou Whitham
Mary Louise Whitham Eastman
8/23/37–11/24/41
Inker / Character Models

Ink & Paint | 371

Judy "Elice" Rawlins
8/9/54–11/13/58
Inker / Fan Mail / Publicity

Janet Rea
9/11/72–9/9/90
Xerox

Geno Meyers Renshaw
Leaf Pearson
1936–1941
Inker

Ruth Richards
Ruth Louise Richards Craig
5/20/40–3/13/59
Checking / Animation Checker

Alice Orcutt Rinaldi
3/7/38–11/24/41
Inker / Painter

Robyn Roberts
Robyn Roberts Parra
9/28/70–2006
Painter / Xerox / CAPS

Eva Schneider
3/3/52–2/16/68
Inbetweener / Breakdown

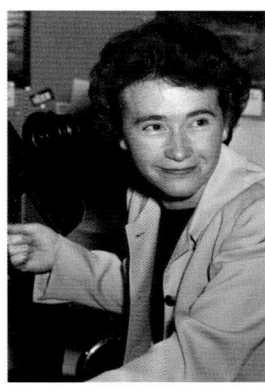
Bee Selck
4/26/37–1/9/53
Secretary / Music Editor
Assistant Director

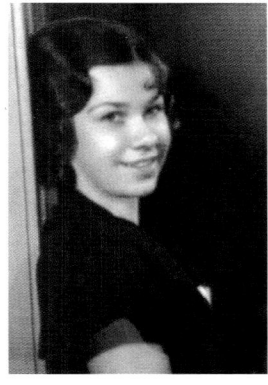
Marjorie Sewell
Marjorie Sewell Bowers Davis
1/1/51–7/22/55
Story Reader / Producer / Director

Carolyn Shaeffer
1930–1935+
Research / Walt's Secretary
Voice Talent

Helen Sibert
Helen Sibert Green
2/22/43–5/6/70
Inker / Paint Lab / Supervisor

Martha Sigall
Martha Goldman Sigall
Inker / Freelance

Sterling Sturtevant
7/9/45–7/12/46
Story Artist

Norma Swank
Norma Swank Carrier Haviland
9/1/43–1/2/71
Painter / Final Check / Xerox

Auril Thompson
Auril Thompson Pebley
1972–1973 & 1984–1985
Inker / Painter

Eloise "Toby" Tobelmann
8/14/35–1962+
Stenotypist / Film Library

Jeanette Tonner
Jeanette Tonner Whiteaker
11/17/34–10/26/43
Paint Lab / Supervisor

Emma Torrey
Emma Choens Torrey Smallhorn
5/10/37–10/12/48
Inker / Inbetweener

Cyndee Whitney
1979–1990
Animator

Tommie Wilck
Thelma England Blount Wilck
1958–1966+
Walt's Secretary

Lucile Williams
Olive Lucile Williams Bosché
10/22/45–10/15/52 & 1977
Inker

Gina Wootten
8/14/72–11/7/95
Inker / Painter / Xerox Check

Jean Young
4/11/36–4/5/65
Paint Supervisor

Liz Zwicker
Elizabeth Case Zwicker
4/23/56–12/13/58
Inbetweener / Animator

INDEX

Note: The abbreviation WD refers to Walt Disney.

—A—

Abbate, Allison, 353
Abeson, Helen, 188
Academy Awards, 72, 74, 76, 82, 130, 193, 260, 308, 315, 333, 349, 357
Academy of Motion Picture Arts and Sciences, 76, 193
Acme peg system, 92, 336
Adams, Edward A. "Tink," 131
Adventures in a Perambulator, 217
Adventures in Music series, 260
The Adventures of Ichabod and Mr. Toad, 223, 316
Aerology, 201
Airbrush Department, 158, 183, 186
Aircraft Warning Service, 199
Aladdin, 357
Albrecht, Gretchen, 14, 376, 310, *(310)*, 311, 312, 317, 318, 319, 320, 326, 327, 331, 332, 333, 334, 336, 340, 341, 342, *(343)*, 344, 346, 349, 350, 351, 352, 354, 356, 357
Al Capp cartoons, 338
Alexander, Lloyd, 330
Alexeieff, Alexandre, 168
Alice Comedies series, 40–43, 45, 47–49, 50, 52, 54, 240
Alice Gets in Dutch, 47
Alice Hunting in Africa, 41, 42
Alice in Cartoonland, 31–32, 33, 40
Alice in Wonderland, 214, 240, 242, 243, 244
Alice's Adventures in Wonderland, 126
Alice's Day at Sea, 40, 41
Alice's Egg Plant, 47, 49
Alice's Spooky Adventure, 43
Alice's Wild West Show, 43, 45
Alice's Wonderland, 36
Alice the Peacemaker, 45
All Because Man Wanted to Fly, 331
Allen, Barbara Jo, 264, 288
Allen, Graham, 350, 354–355
Allen, Paul, 142
Allen, Roger, 349
Alphonse's, 225–226, 281
Altieri, Kathy, 351
American Dreams at Disneyland, 331
Ames, Jane, 57
Andersen, Hans Christian, 350
Anderson, Bill, 198, 221, 224, 276
Anderson, Ken, 128, 140, 149, 154, 210, 221, 272, 273, 302, 308, 313, 315, 316
Anderson, Leroy, 361
Anderson, Mary, 264
Anderson, Viki, *(348)*
Anderson, Viola, 163, 181–182, *(188)*
Andrews, Julie, 295
Andrews Sisters, 222
Animation Department
 animated segments for live-action features, 126, 209–210, 221–222, 295–296, 308, 315–316
 Animation Check group, 94, 273, 276, 288, 302, 353
 animation drawings, 360
 Animation Photo Transfer (APT) process, 331–333
 Animation Tracking System (ATS), 337, 346
 animators' notations with colored pencils, 208
 assembly-line approach for, 84, 86, 91–92, 94
 blue-sketch techniques, 208, 274, 276, 288, 291
 building of, 13, 174, 225, 313, 334
 Character Animation, 196, 263, 314
 Cleanup Animation, 288, 316, 337, 353
 and computer animation, 327, 331, 334, 336, 337–338, 346
 Computer Animation Department, 341, 346
 Computer Animation Production System (CAPS), 348, 349, 350, 351, 352–356, 357
 Computer Generated Imagery, 357
 The Late Night Crew, 337
 layoffs in, 222
 Nine Old Men of Animation, 265, 312, 330, 337, 360
 rebuilding of, 214
 relocation to Glendale, 334, 343
 resignation of animators to form rival company, 326
 Scene Planning System, 346
 Retta Scott as first female animator in, 14, 155, 195
 Special Effects Animation, 158, 196, 205, 288, 296, 302, 326, 333
 and story development, 80, 84, 89, 111, 306
 and Talent Development Program, 312–314, 321, 324
 training in, 86, 103, 131, 155, 163, 182, 195–196, 265, 312–314, 315, 324, 326, 330
 women working in, 14, 155, 158, 195–196, 198, 200, 201, 205, 214, 216, 248, 263, 264–265, 289, 300, 306, 312–313, 317, 326, 330, 353
 working conditions of, 311
 See also animation production process
animation industry
 and celluloid transition, 281
 and color technologies, 71
 development of, 84, 344
 history of, 23, 24–26, 52, 53–54, 60
 pamphlet on, 232
 suppliers for, 133
 and television, 299, 300, 321, 328
 WD's early ventures in, 31–33, 36, 39–43
 and Xerox technology, 208, 298–299, 321
animation production process
 and Animation Tracking System (ATS), 337, 346
 backlit animation, 102, 316, 328
 and bandwidth, 355
 and Bray-Hurd method, 26
 "Bumping the Lamp," 339
 cel animation, 25, 26, 43, 45, 48–49, 109
 and celebrity tours, 231
 cleanup artists, 13, 77, 155, 195, 196, 200, 264, 276, 288, 337, 353
 and color processes, 71–74, 76–78, 81–82, 103
 and computer animation, 346, 348–349
 and Computer Animation Production System, 353–354
 and cycles, 49, 120
 in Disney Brothers Cartoon Studio, 42, 43, 45, 48–49
 and feature-length animation, 126, 128, 130–131, 133
 hierarchy of, 77, 84
 and high-volume data management, 354–355
 and human form, 82
 and overdubbing technique, 240
 shadow animation, 60, 121, 339
 sodium vapor process, 296
 and synchronization of sound, 57–58
 techniques of, 25, 48–49, 52, 61, 103
 technological changes in, 268, 324
 and tracebacks, 49, 119, 165, 207–208
 and wide-screen format, 260
 women as animators, 23, 25, 78–79, 80, 155, 163–164, 166, 299–300, 344
 Women's advancement opportunities in, 14, 56, 79, 155, 157, 163–164, 182, 183, 195–196, 198, 212, 265, 299
 and Xerox technology, 208, 268, 272, 273–274, 276–277, 288, 291, 296, 302, 311, 339, 340, 342, 351, 356
 See also Animation Department; inking; Inking & Painting Department; painting
Anselmo, Tony, *(348)*
anthology films, 222, 236
Appel, Eva, *(103)*
Archer, Frances, 251, *(251)*
Argentina, 209
Aristocats, The, 308, 314
Arliss, George, 70–71
Armitage, Karen, 257
Armstrong, Debra, 353
Armstrong, Louis, 35
Arriloa, Frances, 136, 139–140
Art Center College of Design, 131, 265, 312
Art Props Department, 314, 360
Arzner, Dorothy, 38
Asbury, Kelly, 353
Ashe, Marcia, *(195)*, 202, *(218)*
Astaire, Fred, *(13)*
Astor, Lillian Friedman, 79
Atlanta, Georgia, 221
Atwood, Donna, 204
Audience Reaction Indication (ARI), 218
Audley, Eleanor, 238, 255, 263–264, *(265)*
Austen, Jane, 10
Ayer, Jean, 149

—B—

Babbitt, Art, 182, 185, 232
Babbitt, Dina, 232
Babes in the Woods, 77
Bach, J. S., 163, 165
Bachom, Dorothy, 157, 158, 196
Baddeley, Hermione, 308
Baer, Dale, 340
Baer, Jane, 264, 265, 268, 280, 281, 314–315, 340
Bailey, Grace, 52, 70, 73, 78, 81, 82, 96, 100, 101, 103, 116, 182, 196, 198, 199, 212, 214, 218, 223, 229, 232, 244, 246, 265, 266, 268, 273, 276, 277, 278, 279, 286, 288, 297, 310, 311, *(319)*
Bailey, Pearl, 326
Baker, Wilma, 14, 102, 117, 121, 122, 123, 124, 139, 140, 142, 174, 184, 192, 196, 201, 214, 228, 229, *(345)*
Bakke, Edle, 210, 212, 218, 223, 226, 228, 229, 232, 246, 249, 327
Baldwin, Barbara Wirth, 122, 158, 168, 184–185
Ball, J. Arthur, 110, 207–208
Bambi, 148, 152, 154, 157, 166, 181, 183, 185, 186, 192, 195, 202, 204, 205, 206, 207, 208
The Band Concert, 81
Bankhead, Tallulah, 289
Baranova, Irina, 164
Barbour, Emily, 158

Barnhart, Phyllis, *(367)*
Barré, Raoul, 25
Barreto Jr., Antonio, 288, 289
Barrie, J. M., 126, 243
Baruch, Dorothy, 149
Basil of Baker Street, 336
Basset, Betty, 153
Batchelor, Joy, 232
Bauer, Cate, 289
Baxter, John, 190
Baytos, Betsy, 312, 313, 314, 315–316, 317
Beaumont, Jeri, 195, *(196)*
Beaumont, Kathryn, 231, 242–243, 244, *(244)*, 249, 280
Beauty and the Beast, 357
Beck, Daisy A., 30, *(30)*
Beck, Lisa, *(108)*
Beckton, Lila, 216
Bedknobs and Broomsticks, 308
Beethoven, Ludwig von, 165
Begg, Barbara, 262
Belcher, Ernest, 134
Bell & Howell cameras, 123
Benchley, Robert, 180–181
Benedict, Ed, 220
Benson, Esther, 56
Benson, Jodi, 350
Berger, Germaine, *(22)*, 23
Berger, Lucie, 23
Best, Patricia, 231
Betty Boop cartoons, 79, 166, 168
Bianchi, Ed, 178, *(278)*, 298
Bianchi, Emilio, 117, 178, 189, 201, 223, 298, 336
Bielecka, Daniela, 317, 326
Bielinska, Halina, 281
billiard balls, 18
Bird, Brad, *(307)*
Birren, Faber, 88–89, 223
The Black Cauldron, 330–333, 336
blackening, 52, 56, 61, 112
The Black Hole, 327
Black Maria studio, 18
Blackton, J. Stuart, 24, 25
Blair, Lee, 181, 187, 202
Blair, Mary, 14, 150, 181, 187, 188, 202, *(208)*, 209, 221, 222, *(222)*, 223, 240, 242, 261, 262, 263, *(239)*, 294, 352
Blanc, Mel, 243
Blanchard, Jean, 232
Blanchard, Susan, 353
Blank, Dorothy Ann, 91, 128, 133–134, 141, 148
Bliss, Lucille, 238
Blomquist, Lois, 264, *(366)*
blue-sketch techniques, 208
Bluth, Don, 316, 317, 326
Bode, Martharose, 152, *(152)*, 155, 158, 208
Bolivia, 209
Bond, Johnny, 200, 265
Booth, Margaret, 38, 60–61
Bosché, Bill, 228, 294
Bosché, Lucile Williams, 115, 179, 212, 214, 226, 227, 238, 240, 244, 246, 294, 316, 317, 319, *(371)*
Bossert, Dave, 333, 352, 355
Botticelli, 263
Bounds, Phyllis, 188, *(226)*
Bounds, Ruby, 56
Bowie, David, 318
Braden, David, 336, 341, 351
Brady, Jack, 360–361
Brando, Marlon, 235
Brandon-Madson, June, *(86)*, 152, *(230)*
Brandt, Frances "Flo," 277, 279, *(367)*
Brave, 349
Bray, John Randolph, 20, 25, *(27)*, 49
Bray-Hurd Patent Company, 49
Bray-Hurd Processing Company, 26
Bray Studios, 26
Brazil, 209
Brazner, Bill, 272
Brenon, Betty, 232
Breznican, Jill, *(361)*
Bristol, Sue, *(367)*
Britt, Herbert, 154
Bronnais, Victor, 225, 229
Bronson, Dorothy Castle, 159, 205
Brown, Beth, 61
Brown, Margaret Wise, 149
Brown, Robert, 283, 300
Brown, Sharon Mae Disney (daughter), 89, 31, 145, 169, 232, 251, 252, 253, 282, 283, 298, 300
Brown, Sheila Rae, 265
Brown, Victoria, 300

Ink & Paint

Brown Derby restaurant, 283
Browne, Georgiana, 149
Bruce, Janet, 349, 353, *(367)*
Brulatour, Jules, 20
Brumbaugh, Florence, 149
Bruns, George, 250
Bryan, Janey, 195
Bugs in Love, 77
The Bulletin (newsletter), 128, 138, 148, 174, 224, 225, 229
Burchett, Yvonne Beryl, 157
Burke, Sonny, 261
Burns, Harriet, 249–250, 254, 255, *(255)*
Burton, Tim, 312
Bushman, Bruce, 250
Bute, Mary Ellen, 78
Buzzi, Ruth, 308

— C —

California Institute of the Arts (CalArts), 293, 312–313, 326, 330, 333, 349
Calling, Steve, 163
Camilla, Karen, 343, 344
Campbell, Jack, 155, 157–158
Campbell, Virginia, 196
Canemaker, John, 61
Canfield, Rebecca, 313
Capp, Al, 338
Capra, Frank, 171, 195
Carbutt, John, 18
Carioca, Panchito, (210)
Carlos, Wendy, 327
Carlson, Chester, 270
Carlson, Joyce, 114, 196, 198, 218, 255, 268, 277, 280, *(256)*, 294, 298, 316
Carlson, Paul, 251–252
Carmencita, *(19)*
Carney, Fox, *(361)*
Carney, Marie L., 12
Carr, Bob, 187, 193
Carr, Darlene, 302
Carrell, Ruth, 250–251
Carroll, Lewis, 126, 240
Carroll, Pat, 350
Carthay Circle Theatre, 135, 141
cartoon cinematography, 129–130
Cartoon Colour, 281, 351–352
Cartwright, Randy, 348–349, 350
Casagrand, Hortensia, *(344)*, 350
Caselotti, Adriana, 134, *(134)*
Catalano, Armando, 251
Catalina Color Company, 77, 168, 351
cel animation
 and animation production process, 25, 26, 43, 45, 48–49, 109
 cel levels, 78, 107, 108, 110, 118–119, 122, 129
 cel matching, 49, 107–108
 and color processes, 71–73, 77, 78, 82, 108
 and Commercial Unit, 252
 and computer animation, 349
 Computer Animation Production System superseding, 353, 356, 357, 358
 and Courvoisier Gallery as dealer in, 143–145, 178
 for Disney Education readers, 149
 experimental approaches to, 207
 Wash-off Relief cel method, 110
 WD's early use of, 40–43, 45, 48–49
 and Xerox technology, 272, 274, 276, 277, 288, 332, 339, 356
 See also inking; painting
Celluloid Manufacturing Company, 18
celluloids
 acetate celluloid, 110, 178, 207, 274, 281, 302, 320, 358
 development of, 18
 flammability of, 124, 148, 178–179, 358
 nitrate celluloid, 26, 39, 50, 72, 77, 78, 82, 108, 109, 110, 121, 124, 133, 144, 148, 149, 178, 207, 358
 and photography industry, 18, 110
 as problematic canvas for inking and painting, 109–110
 Pyralin celluloid, 78, 109
 suppliers of, 109–110, 133
 See also cel animation; cels
cels
 cel sets, 111, 114, 117, 120
 discarding of, 210, 314, 320
 effect of heat on, 130, 148
 effect of humidity on, 106, 121
 and field size, 133, 222, 260, 261, 336
 as fine art, 143–145, 160, 320, 342, 344, 358–359
 frosted cels, 110
 Gallery Cels program, 320
 Kodalith cels, 328, 329
 Limited Editions, 342–343, 362
 manufacture of, 49
 marketing of, 257
 paint formulas for, 105, 153, 178
 paint tests on, 318
 and peg registration, 54, 92, 109, 110, 119, 328, 336, 341
 polyester cels, 332
 as problematic canvas for inking and painting, 109–110, 114, 121, 130, 138
 setups for, 144, 152
 stacking of, 49, 59, 153
 thickness of, 107
 traceback lines on, 119, 207–208
 washing of, 45, 60, 82, 105, 107, 108, 109, 110, 121, 123–124, 129, 138, 152, 178, 189, 210, 257, 262, 320, 360
Cel-Vinyl, 351
CGI, 327
Champion, Marjorie Belcher, 134, 141, *(142)*, 155, 164, *(366)*
Chaplin, Charlie, 58, 70, 141, 226
Chapman, Brenda, 349
character merchandise, 39, 193
Charles Mintz Studios, 166
Charles Ross & Son flat stone mills, 56
Chase, Polly, 196
Chase, Salmon P., 12
Chavers, Ona Mae, 195
Chicken Little, 201
Chile, 209
The China Shop, 82
Chip 'n' Dale, 201, 222, 260
Chobanian, Rikki, 362, *(363)*
Chomon, Segundo de, *(19)*, *(20)*
Chouinard, Nelbert, 131, 155, 263, 293
Chouinard Art Institute, 131, 155, 263, 293
Chrisney, Ellen, 154
Christianson, Grace, 60, 100, 177, *(135)*, 152, 177, *(177)*, 182, 183, 183, 184, 194, 195, 198, 223, 246
chroma, definition of, 24
Chun, Wes, *(348)*
Churchill, Frank, 77–78, 205
Cinderella, 9, 214, 216, 238, 240, 243
Cinemascope, 260–262
Circle-Vision, 331
Circus Story, 47
civil rights era, 285, 301, 314
Clampett, Bob, 67
Clarabelle Cow, 81, 149
Clark, Caroline Geis "Charlotte," 67
Clark, Jane, 89
Clark, Les, 52, 54, 58, 82, 221
Clark, Marceil, 82, *(367)*
Clark, Marguerite, 128
clay photography, 23
Cleave, Mary, 100, 152
Clements, Ron, 350
Cleworth, Lois, *(225)*, *(233)*
Cline, Becky, 306
Coats, Claude, 262
Coats, Evelyn, *(77)*, *(83)*, 98, 101, 114, 115, 116, 123, 152, *(112)*, 150, *(150)*, 175, 185, 186, 281, *(367)*
Coats, Pam, 353
Cochran, Dorcas, 216–217
Cocke, Inez, 295, *(367)*
Cocreham, Nora, *(366)*
Cohl, Émile, Un drame chez les fantoches, 24–25
Colbert, Jill, 330, *(348)*
Cold Turkey, 92
Cole, Mary Jane, 316, *(366)*
Coles, Joyce, 164
Collier, Constance, 242
Collins, Doris, 264
Collins, Paul, 243
Collodi, Carlo, 148, 154, 155
color
 Spectracolor, 281
 Technicolor process, 72–74, 76, 78, 81, 103, 105, 129, 135, 177, 209, 210, 222, 242, 258
 WD on, 134–135, 149, 205, 221–222, 263
 and wide-screen format, 260
Columbia Pictures, 53
Colvig, Pinto, 78
Comaneci, Nadia, 305
Comella, Karen, 332, 334, *(366)*
commercials, 14, 251, 281, 321, 339
communism, 235
Compton, Dorothy, 77–78
Condorman, 327
Conger, Gwyn, 251
Connell, Peggy, 295
Connors, Carol, 315
Cook, Lorna, 312–313, 317, 321, 326, *(366)*
Cooper, Merian C., 136
Corbett, "Gentleman Jim," 258
Corbett-Fitzsimmons Fight, 258
Corky and White Shadow serial, 250
Corley, Gwen, 195
Costa, Mary, 263, *(263)*
Cottrell, Hazel, *(187)*
Cottrell, William, 73, 150, 152, *(187)*
Coulter, Penny, *(343)*
The Country Cousin, 82
Courvoisier, Guthrie, 143–145, 152, 178, 320
Cowles, John V., Jr., 32
Cowles, John V., Sr., 32
Cowles, Minnie, 32
Craig, Phyllis, 244, 251, 252, 266, 273, 276, 279, 321
Cranner, Tori, *(361)*
Crisler, Lois, *(366)*
Cristadoro, Charles, 150

Crosby, Bing, 63, 223, 231
Crosby, Greg, 314
Crosson, Tammy, *(361)*
Culhane, Shamus, 79
cutting-machine operators, women as, 23, 38, 196

— D —

Dahlen, Eleanor, 101, 179, 268, 273, 277, 278, 297, 299, 300, 308, 351, 352, *(366)*
Dalí, Salvador, 217, 230, 360
Darlington, Marion, 205
Dasnoit, Marie, 222, 223
David, Mack, 238
David, Therese "Tissa," 281, *(281)*
Davidson, Retta, 182, 202, *(233)*, 264, 289, 326, 330
Davis, Alice Estes, 99, 209, 257, 263, 281, 289, 294, *(295)*
Davis, Bette, 202
Davis, Lem, 346, *(347)*, 348
Davis, Lisa, 289
Davis, Marc, 7, 91, 99, 131, 192, 209, 210, 221, 238, 242, 252, 257, 263, 264, 265, *(280)*, 281, 288, 289, *(289)*, 293, 295
Davis, Marion, 195
Davis, Virginia, 31–32, 40, *(43)*, 45, 47–48
Davy Crockett, 251
Dayton, Helena Smith, 23
D. C. Heath and Company, 149
Dean, James, 235
Deja, Andreas, 330, 331, 339, 340
DeMattia, Xenia, 79, 168, 195, 248
Dempster, Al, 302
De Pew, Mary Ann, 158
Destino, 230, 360
Detremaudan, Doris, *(367)*
Dewerthemer, Eloise May, *(367)*
Dickson, William, 18
Diefenderfer, Thelma, 182
Dietrich, Marlene, 141, 202
Disney, Edna Francis (sister-in-law), 33, *(33)*, 45, 46, 52, 53, 54, 57, 89, 128, 185, 210, 253, 281, 282, 293
Disney, Elias (father), 28, 30, 46, 145
Disney, Flora Call (mother), 28, 30, *(30)*, 46, 145, *(145)*
Disney, Herb (brother), 145
Disney, Lillian Bounds (wife), 14, *(41)*, 42, 43, 45, 46, 57, 72, 89, 145, 166, 169, *(187)*, 232, 249, 255, 281, 283, 300, *(300)*
Disney, Margaret (aunt), 30, *(30)*
Disney, Ray (brother), 145
Disney, Robert (uncle), 33, 36, 39–40, 46
Disney, Roy E. (nephew), 46, 331, 333, 336, 337, 348, 352, 357
Disney, Roy O. (brother), 28, 30, 33, *(33)*, *(37)*, 39, 43, 45, *(45)*, 46, 47, 50, 52, 53, 54, 56, 57, 60, 66, 67, 72, 73, 74, 89, 94, 126, 128, 140, 144, 145, 146, 177, 178, 182, 183, 185, 186, 187, 188, 210, 212, 214, 222, 236, 253, 272, 281, 282, 286, 295, 298, 301, 308, *(347)*, 360
Disney, Ruth (sister), 30, 46, 48, 145
Disney, Walt, *(33)*, *(37)*, *(41)*, *(104)*, *(169)*, *(187)*, *(282)*, *(283)*, *(287)*, *(296)*, *(298)*, *(300)*
 Air Force, Army, Navy Insignia Designs competition, 190
 as animator, 40, 41, 43, 348, 357
 on *Bambi*, 202, 204, 206, 208
 birth of, 28
 in California, 33, 35, 36
 and celebrity tours, 250
 on color, 134–135, 149, 205, 209, 221–222, 263
 creative process of, 246
 death of, 285, 301, 306, 308, 317
 early employment of, 30–31
 early life of, 28, 30
 and educational films, 220, 221
 education of, 30
 European trip of 1935, 89
 on fairy tales, 126, 238, 238, 240, 262, 295
 and family life, 145, 169, 232, 249, 253, 281–283, 300
 generosity of, 231
 health of, 231, 301
 hobbies of, 8, 231, 282
 Holmby Hills house of, 282–283
 Los Feliz hills home of, 169
 Lyric Avenue house of, 52–53, 54, 56
 marriage of, 8–9, 46, 52–53, 54, 169, 207, 261, 281–282
 on military training films, 200–201
 on Paint Lab, 277
 and Process Lab experimentation, 208
 on quality, 47, 49, 52, 72, 225, 268
 relationship with grandmother, 28
 relationship with staff, 277, 279, 280
 respect for women, 296, 300
 and rest periods for workers, 124
 and Sewell family, 46
 and South America, 187, 209
 and strike, 185–186
 and television, 248–249
 and P. L. Travers, 295
 typical day in studio, 300
 on unions, 183
 vision for animation, 313, 340
 voice audition method, 133–134
 "What I Know About Girls," 8–9
 on women animators, 78–79
 on women's opinions, 79, 81

Index

on women's salaries, 227
and women's work environment, 14
World War II efforts of, 190, 198, 210
Disney Brothers Cartoon Studio, 39, 40–43, 45, 46, 47–49, 50, 52, 362
See also Walt Disney Studios
Disney Foundation, 293
Disneyland, 235, 251253, 254, 255, 257, 277, 286, 294, 298
Disneyland Boosters and Backers Club, 253
Disneyland Emporium, 257
Disneylandia, 231
Disneyland label, 251
The Disneyland Story (television show), 249
Disney-Puder, Dorothy, 30, 169
Disney Registration Systems, 336
Disney School of Animation, 330
Dodd, Jimmie, 250
Dog Catcher, 45
Donald Duck, 7, 8, 70, 80, 87, 148, 149, 166, 195, 200, 209, 221, 243, 265, 280, 312
Donald in Mathmagic Land, 221
Dotrice, Karen, 296
Douglas, Jennie, 12
Douglas, Kirk, 251
Downs, Ruberna, 158
Doyle, Mary, 171
Drake, Joan, 289
Drake-Jekel, Lula, 195, 280
Dreiss, Jane, 108
Driscoll, Bobby, 231, 243
Duckwall, Don, 302, 312
Dukas, Paul, 160
Dumbo, 176, 181, 183, 185, 188, 189, 308
Duncan, Sandy, 326
DuPont, 49
Durando, Betty, 152–153
Dvorak, Ann, *(367)*
Dwan, Allan, 38
D. W. Griffith Studio, 38

— E —

Earle, Eyvind, 262–263
"Easter Eggzibit," 226, 227
Eastman, George, 18
Eaton, Susan, *(141)*, 157
Ebsen, Buddy, 251
Edison, Thomas, 18, 20–21
Edison Studios, 20–21
Edmunds, Robert, 52
educational films, 14, 220, 221, 236
Eisenhower, Mamie, 235, 261
Eisner, Michael, 343
Ellenshaw, Harrison, 328–330, *(330)*
Ellery, Leslie, 349
Elliot, Jim, 341, *(343)*
Elliott, Maggie, 257
Ellison, Mary, 106, *(109)*, (114), 138, 140, 142, *(367)*
Elmer Elephant, 80
Emerson, Caroline, 149
Emerson, John, 314
Engalla, Doug, *(361)*
English, Dave, 348
English, Liz, 308
Enriques, Thom, 349
Equestrian Center, 226, 277–278
Equity, 184
Erwin, Jean, 56, 175, 184, 186, 195, 310
Escape to Witch Mountain, special effects on, 311
Esgate, Dorothy, 154, *(367)*
Estes, Alice, 263
Eugster, Al, 61
Evans, Katherine Carlson, 140
Evans, Lillian, 195
exposure sheets. See X-sheets

— F —

Faber, DeDe, 276, *(320)*
Factor, Max, 158
Fain, Sammy, 315
Fairbanks, Douglas, 57, 70
fairy pantomimes, 21
Fallberg, Becky Dorner, 69, 176, 221, 227, *(225)*, *(232)*, *(251)*, 260, *(276)*, 279, 291, 296, 308, 314, 316, 317, 318, 320, *(320)*, 321, 330, 336, 360
Fallberg, Carla, 69, 314, 320, 321
Fallberg, Elinor, *(367)*
Fantasia, 122, 157, 160, 162, 163, 164, 165, 166, 168, 181, 193, 196, 207, 339, 340
Fantasound, 163
FBI, 199
Felix the Cat, 39, 47, 53, 61
Felton, Verna, 188, 238, *(238)*, 261, 264, 288, 302
feminist movement, 305, 314, 319
Fenter, Alma, 163
Fenyvesi, Maria, 266, 268, 342, *(366)*
Ferdinand the Bull, 143, 149
Ferguson, Norm, 71, *(187)*
Ferguson, Stuart, 175
Ferrara, Helen "Beanie," 195
Field, Luisa, 163, 196

Field, Rachel, 163
Field, Robert D., 88
Fields, Bonnie Lynn, 249
Filmation Studios, 7, 268, 321, 344
Film Daily, 61, 148
film distribution, 39, 40, 42, 43
film editors, women as, 38–39, 196, 201
Film Exchange, 31
Finefrock, Peggy, 298, 301
Fischer, Ethel, 30
Fishy Story, 45
Fitzgerald, F. Scott, 70
Fitzsimmons, Bob, 258
Flannery, Ann, 196
Flannigan, Mary, 67, 81, (81), 148, 225
Fleener, Virginia, 114, *(197)*, 199–200, 209–210, 228, *(366)*
Fleischer, Max, 26, 31, 39, 47, 61, 79, 168
Fleischer Studios, 79, 96, 166, 168, 338
Fleming, Victor, 60–61
Fletcher, Eve, *(226)*, 266, 316, *(366)*
Flip the Frog, 262
Florida, 301
Florimond, Mme., 22
Flowers and Trees, 72–74, 128, 134
Flynn, Dessie, 223
Foley, Marie, 201
Fontanella, Virginia, 221, *(366)*
Food Will Win the War, 200
Foray, June, 7, 243
Forbes, Harry W., 45
Ford, Gerald, 314
Ford, Henry, 35, 84
Forest, Sally, 196
Forward, Sharon, 344
Fourel, Henri, 22
Fowler, Jane, 195–196, 263, *(264)*
The Fox and the Hound, 291, 326–327, 362
Fra Angelico, 263
Frances, Marion, *(38)*
Freed, Alan, 235
Freleng, Allen, 56
Freleng, Friz, 54, 56
Fretschel, Mat *(361)*
Friedman, Lillian, *(79)*,166
Frolicking Fish, 71
Frost, Mary Jane, 14, 158, 184, 186, 300
Fujikawa, Gyo, 166, (168), 193–194
Fun and Fancy Free, 222
Funicello, Annette, 251
Furnish, Marjorie, *(154)*, (156), (159), (201)

— G —

Gable, Clark, 168
Gabor, Eva, 308, 314
Gabriel, Mike, 352–353, 356
Gale, Ann, 218
The Gallopin' Gaucho, 57, 58
Garbutt, Barnard, 204
Garcia, Paulino, 319
Garity, Bill, 94, 103, 106, 107, 135
Garland, Judy, 168
Garner, Marcellite, 64, 66, 67, 68, 69, 96, 113, 114, 165, 184, 186, 188, *(366)*
Gavin, Kathleen, 350, 355–356
Gay, Margie, 47, (48), (51)
George, Hazel, 7, 193, 231, (231), 250, 253, 300
George Borgfeldt & Company, 67
Gerard, Marie, 196, *(233)*, *(366)*
Gerba, George, 336
Gerry, Vance, 349
Gerson, Betty Lou, 238, 289
Gerstad, Eve, *(367)*
Gibbons, Cedric, 74
Gibbs, Muriel, 138, *(367)*
Gibeaut, Leota Eustace, *(367)*
G.I. Bill, 229
Gibson, Blaine, 255
Gibson, Lydia, 195, 196
Gifford, Frances, 181
Gile, Beverly, 251, (251)
Gilkyson, Terry, 308
Gillam, John, 175
Gillett, Burt, 59, 67, 72–73
Gillies, Joyce, 195
Gillmore, Jean, 353
Gillott pens, 113, 192
Gleeson, Catherine Virginia, 182
Glicksman, Jane, *(361)*
Glyn, Elinor, 38
Goddard, Grant, 158
The Goddess of Spring, 82
Godino, Grace, 14, 70, 71, 86, 106, 111, 123, 136, 138, 139, 141, 164, 165, 174, 175, 178, 179, 182, 184, 185, 186, 204, 214, 227, 228, 230, 255, 278, 281, 295, 301, 308, 314, *(309)*, *(320)*
Godsel, Margaret, 196
Goellert, Frances, 194, *(367)*
Goethe, Johann Wolfgang von, 160
Goff, Harper, 298
Goldman, Gary, *(307)*

Goliath II, 288
Gombert, Ed, 349
Goodman, Benny, 217
Good Neighbor Program, 187, 209–210, 214
Goodrich, Mary, 91, 162
Goodwin, Gerry, 195, 216
Goodwin, Hannibal, 18
Goofy, 81, 114, 200, 209, 217
Goolin, Vita, *(367)*
Gordon, Anita, 222
Gordon, Kent, *(352)*
Gorham, Barbara, *(367)*
Gorin, Leslie, 326
Gossin, Betty, 289, *(368)*
Gracey, Yale, 255
Graham, Don, 133, *(182)*
Grant, Cary, 230
Grant, Joe, 150, 188
Grauman, Sid, 73, 297
Gray Advertising Company, 30
Great Depression, 63, 64, 66, 67, 68, 69, 77, 78, 79, 98, 100, 101, 131
The Great Mouse Detective, 336
Green, Frances, *(192)*
Green, Helen, *(278)*
Green, Howard, *(361)*
Green, Stan, 314
Greene, Ward, 260
Gremlin "Fifinella" insignia, 190
Grieg, Edvard, 58
Griffith, Don, 302
Griffith, D. W., 262
Griffith Observatory, 226
Griffith Park, 253
Grimoin-Sanson, Raoul, 21
Grumbacher company, 72, 76, 168
Guedel, Heidi, *(307)*, 315, 317, 326
Guenther, Annie, 266, 277, 302, 308, *(368)*
Guenther, Betty Anne, 81, *(85)*, 101, 114, 115, 123, 138, 226, 228, 240, 266, 317
Guenther, Velma, 226
Guice, Carlos, 298
Gunderson, Wanda, 196
Guttman, Lee, 266
Guy-Blaché, Alice, 38

— H —

Haber, Hans, 246
Hagin, Flavilla, *(368)*
Hahn, Don, 312, 314, 316, 317, 319, 321, 326, 331, 333, 334, 336, 337, 338, 339, 340, 343, *(345)*, 346, 348, 349, 350, 352, 357, 361
Hahn, Tom, 348, 355–356
Haight, Esta, 360, *(368)*
Halas, John, 232
Halas and Batchelor Animation, Ltd., 232
Hale, Joe, 330, 332
Halladay, Theo, 163, 178, 192, 217, 220, 226, 230
Haloid, 270
Hamane, Barbara, *(343)*
Hamilton, Gloria, *(308)*
Hamilton, Irene, *(45)*, 48, 52
Hamilton, Rollin C., 42, 45, *(45)*, 48
Hand, Dave, 204, 208
Hankins, Joy, 196, *(368)*
Hanna-Barbera, 272, 281, 299, 321, 344, 346
Hansen, Ann, *(361)*
Happy Harmonies series, 78
Harbach and Company, 21
Harding, Laverne, 79
Harding, Mary Campbell "Cam," 131, 133, *(369)*
Hardwick, Frances, 47
Hardwick, Lois, *(47)*, 47–48
Hardwick, William, 47
Hardy, Oliver, 226
Harkey, Kevin, *(348)*
Harlin, Merle Ray, 360
Harman, Hugh, 32, *(45)*, 48, 52–54, 78, 168
Harman, Walker, *(45)*, 48, 52
Harman-Ising Studios, 135, 136, 139, 168
Harmon, Doris, 131
Harper, Thurston, 43, *(45)*
Harris, Joel Chandler, 221
Hart, Juanita, *(369)*
Harvey, Chuck, *(307)*
Hatlo, Jim, 40–41
Hays, Will, 149
Hays Code, 63, 149, 163
Hayward, Lillie, 249
Heath Readers, 149
Hecox, Christine, *(369)*
Heid, Elsie Jane, 89
Hench, John, 135
Henderson, Inez, 89
Henderson, Marie, 60, 100, *(150)*, 152
Hennesy, Helen DeForce Ludwig, 89
Hepburn, Katharine, 193
Her Father's Daughter, 193
Heydric, Mary, 196
Hicks, Patty, 353
Higashida, Peggy, 265

Hill, George, 60–61
Hitchcock, Alfred, 257, 308
Hitler, Adolph, 182, 188, 200, 266
Hodge, Kathleen Quaife, 326
Hoff, Geraldine, 171
Hoffman, Eadie, 316, *(369)*
Holehan, Jean, 182, *(369)*
Holland, Sylvia Moberly, 160, 162, *(162)*, 163, 166, 183, 217, 220, 226, 230
Hollywood, California, 53, 57
Hollywood Athletic Club, 53
Hollywood Camera union, 242
Hollywood Canteen, 202
Hollywood Studio Club, 68
Holmes, Doris, 196
Holmes, Sally, *(233)*
Holocaust, 232
Home on the Range, 357
Honolulu Academy of Arts, 144
Hopper, Hedda, 300
Horace Horsecollar, 81
Horsley, Erma, 196
Hoskins, Bob, 339
Howard, Thelma, 283
Howell, Harriet Alice, *(30)*, 30–31
How to Catch a Cold, 243
How to Get Rid of Mosquitoes, 200
How to Have an Accident at Home, 221
How to Have an Accident at Work, 221
Hubley, Faith, 321
Hubley, John, 281, 321
Hudson, Marge, 70, 82, 99, 100, 114, 115, 116, 124, 244, 251, 301, *(369)*
Hudson, Virginia, 195
hue, definition of, 24
Huemer, Dick, 26, 49, 52, 84, 86, 124, 162, 163, 166, 188, 238,
Huffine, Charlotte, 289, *(368)*
Hughes, Peggy, 148
Humorists Salons, 23
Humorous Phases of Funny Faces, 24
Huntington, Grace, 80, 128
Hurd, Earl, 25, 26, *(27)*
Hurrell, George, 251
Hurrell, Phyllis (niece), 251, *(252)*, 272
Hyatt, John Wesley, 18

— I —

I'm No Fool series, 221
Indelli, Leontina, 166
Industrial Light & Magic (ILM), 340
Ingram, Leon, (361)
inking
 artistry of, 13, 56, 60, 73–74, 76, 78, 96, 98, 112, 291, 362
 cels as problematic canvas for, 109–110, 138
 and Color Model teams, 112
 desired qualities of, 102
 for Disney Brothers Cartoon Studio, 40, 42, 45, 46, 48
 implying speed and motion with, 115
 ink check, 116–117
 and lines and form, 113–115, 291
 physical challenges of, 116, 124
 private inking services, 299
 specialized inking, 288
 techniques of, 25, 40, 41, 48–49, 52, 56, 59, 60, 112–113, 114, 115, 175
 tools of, 113
 training in, 100–102
 Xerox technology substituted for, 207–208, 268, 270, 272, 273, 291, 294, 315, 331, 334
Inking & Painting Department
 art shows of, 227
 assembly-line approach for, 118
 and The Blend technique, 136, 206, 339
 Burbank building, 172, 174–175, 178–179, 334, 360
 and celebrity tours, 230–231, 251
 and cel matching, 49, 107–108
 Cel Setup Department, 144
 Checking Department, 103, 116–117, 122–123, 165, 206, 224
 Christmas parties of, 227, 321
 and color markup teams, 111
 and color matching, 104, 106, 109
 Color Model Department, 92, 94, 103–104, 105, 108, 110–112, 117, 123, 164, 178–179, 181, 206, 221, 223, 242, 279, 288, 289, 291, 302, 334, 355
 and color processes, 72–74, 76–77, 78, 81–82, 110–111
 and color systems, 108–109, 177
 and color theory, 88–89, 99, 223
 and Computer Animation Production System, 353, 356, 362
 and Disney Education readers, 149
 dustless environment required in, 14, 106, 152, 175, 176, 189
 effect of computer animation on, 346, 348, 349, 350, 356, 357
 effect of high temperatures on, 86, 88, 106, 130, 138, 148, 175
 effect of humidity on, 106, 121, 175
 efficiency measures in, 179–180, 198, 218, 278, 300, 310, 311–312, 318–319
 friendships of, 229, 244
 functions of, 94, 96, 100
 gloves and clothing worn in, 39, 102, 112–113, 119, 123, 178, 189, 314, 319, 332
 growth of, 81–82, 96, 98
 Halloween parties in, 70, 227, 321
 Hyperion building, 86, 96, 105, 128–129
 Inker's Shuffle, 179
 job applicants for, 98–100
 and language dubbing, 214
 layoffs in, 186, 192, 266, 273
 and live-action features, 252, 327
 men working in, 52, 60, 106, 117, 176–177, 178, 189, 201, 223, 254, 265, 298, 314, 319, 333, 336, 343, 360
 and military films, 201
 Morgue of, 178–179, 228, 360–361
 and multiplane camera, 130, 348, 352
 and overseas studios, 328, 329, 333, 336
 Paint Dispensary, 103–104
 Pastel Effect, 163–164
 Ping-Pong rallies of, 226
 quality standards of, 310, 344
 reassignment of inkers, 273
 relocation to Glendale, 336, 343, 352
 restructuring of, 182
 salaries of, 68–69, 218, 227
 Shadow Department, 278
 and special effects, 14, 94, 119, 122, 123, 129, 158, 163–164, 308, 311, 327, 328, 362
 specialized groups within, 103
 staff of, 96, 98, 101, 134, 138, 139, 141, 154, 175, 180, 218, 246, 302, 308, 310, 311–312, 314, 316–317, 329, 341, 342, 343, 362
 and Tea Room, 124, 175, 180, 214, 226, 227, 319, 343
 techniques of, 98, 107–108
 and 3-D technology, 260
 and title sequences, 327
 training in, 88–89, 96, 98, 99, 100–102, 105, 152, 195, 196, 198, 199–200, 218, 266, 268, 311
 women working in, 13–14, 42, 52, 56, 59–60, 64, 66, 68–69, 70, 76, 98–99, 148, 154, 153, 181, 182, 185, 192, 198, 199, 202, 212, 214, 218, 226, 228, 229–230, 232, 238, 240, 242, 244, 265–266
 working conditions in, 102, 106, 107, 138, 139–140, 141, 152, 179–180, 192, 214, 226, 265–266, 278–279, 311, 318
 World War II conditions in, 194–195, 196, 198, 201, 212, 214
 World War II consulting of, 192
 and Xerox technology, 268, 273–274, 276–277, 291, 311, 331, 334
 See also Paint Lab
International Photographers Union, 242
Irvine, Kim, 198, 254, 255
Irwin, Mae, *(19)*
Ising, Rudy, 31, 32, *(45)*, 48–49, 52, 78, 168
Iwerks, Don, 272, 273, 276, 277
Iwerks, Mildred, 57
Iwerks, Ub, 43, 45, *(45)*, 47, 48, 54, 56, 57, 58, 59, 74, 78, 92, 100, 166, 178, 207, 240, 252, 262, 272, *(272)*, 276, 296, 298, 302
Iwerks Inking & Painting, 166

— J —

Jackson, Caroline, 89, 295, *(368)*
Jackson, Wilfred, 57, 58
James, Marcia, 158, 163
Jane, Edith, 164
Japanese Americans, during World War II, 193–194
Jardon, Mary, 158
Jay Ward Studios, 232
Jazz Age, 35
Jeakins, Dorothy, 186, *(368)*
Jeffords, Frances, 251
Jekel, Gus, 280
Jekel, Lynn, 280
Jenson, Carl, 89
Jewell, Margaret, 196
Jewett, Eleanor, 142
Jiminy Cricket, 155, 221
Jiuliano, Emily, *(307)*, 308, 312, 313, 317, 326
Joerger, Fred, 254
Johns, Glynis, 295
Johnson, Karen, 223
Johnston, Ad, 148
Johnston, Jimmy, 148
Johnston, Marie, 112–113, 114, 115, 116, 118, 119, *(368)*
Johnston, Ollie, 66, 102, 105, 111, 112, 128, 129, 204, 205, 223, 224, 291, 312, 315, 361
Johnstone, Peggy, *(163)*
Jolson, Al, 57
Jones, Berta, 195
Jones, Bill, 150
Jones, Bob, 150
Jones, Chuck, 7, 243, 262, 313
Jones, Lois, 196
José Carioca, 209
Journal of the Society of Motion Picture Engineers, 174
Jun, Kim Sun, 279
The Jungle Book, 301, 302, 308, 324
Justice, Bill, 110, 133, 195, 201, 210, 254, 277
Justice, Marie Foley, 100, *(150)*, 180, 185, 199, 201, 230, 277, 278

— K —

Kahl, Milt, 265, 312, 314–315
Kalmus, Herbert, 72
Kalmus, Natalie, 72, 76
Kanno, Richard, *(361)*
Katerndahl, Ruthie, *(150)*
Katzenberg, Jeffrey, 337

Kaufman, J. B., 49
Kaye, Danny, 242
Keane, Glen, 312
Keaner, Diane, 265
Keaton, Buster, 58
Keene, Lisa, 353
Keil, Jeanne Lee, 114, 115, 209, *(226)*, 266, *(368)*
Keith, Brian, 297
Kelly, Walt, 80
Kelsey, Dick, *(193)*
Kemper, Beryl, *(368)*
Kendall, Mary, 195
Kennedy, Ethel, *(294)*
Kennedy, Evelyn, 196, 261, 291, 302, 308
Kennedy, John F., 285
Kenney, Mary Jean, 295
Kern, Bonni Lou, *(249)*
Kerry, Margaret, 244
Kerwin, Katherine, 66, 68, 102, 119, 120, 121, 140, 142, 196, 212, 214 242, 265, *(277)*, 302
Khalaf, Tamara, *(361)*
Kimball, Betty, 81, 99, 100, 104, 106, 107, 111, 114, 118, 119, 121, 129, 134, 138, 141, 164, 188, *(369)*
Kimball, Mark, 327, 328, 329, 337, 346, 348, 352, 356
Kimball, Ward, 142, 188, 189, 195, 202, 224, 240, 246, *(250)*, 260, 262
Kinetoscope, 18
King, Billie Jean, 305
King Features Syndicate, 338
King Neptune, 77
The King of Jazz, 71
Kinney, Jack, 66, 67, 68, 69, 148, 159, 162, 175, 182, 185, 192, 193, 200, 246
Kipling, Rudyard, 302
Kirchner, Margaret, *(192)*
Kirsten, Al, 344
Kirsten, Fran, 344
The Kiss (1896), 18
Kissane, Ruth, 300
Klinge, Christal, *(271)*
Kodalith negatives, 328, 329
Korean War, 279
Kornei, Otto, 270
Kotex Corporation, 220
Kowal, Elizabeth, 216
Krazy Kat cartoons, 78
Kroyer, Sue, 326
Kuhlman, Katherine, *(117)*, *(369)*
Kuhn, Edmund, 20–21
Kulp, Nancy, 308
Kulsar, Ethel, 160, 162–163, *(164)*, 166, *(180)*, 183, 217
Kuscsik, Nina, 305

— L —

Lady and the Tramp, 216, 260, 262, 266, 280, 291, 302
Laemmle, Carl, 53
Lamb, Ann, *(369)*
Lamb, Gil, 316
Lamb, Herb, 208
Lambert, Bob, *(347)*, 348
Lambertson, Phyllis, 183–184
Lambert the Sheepish Lion, 243
Landau, Diane, 326
Lange, Dorothea, *(66)*
languages, and foreign markets, 214, 216, 220, 251
Lanham, Sammie June, 289
Lanouette, Roberta, 166, *(369)*
Lansbury, Angela, 308
Lantz, Walter, 71, 79, 166, 262, 281
Larson, Eric, 82, 94, 155, 159, 204, 238, 261, 302, 312, 313, 314, 330, 337
Lasseter, John, 337
Latchford, Nannette, 56, 74, 150
Laugh-O-grams studios, 31–33
Laurel, Stan, 226
La Verne, Lucille, 134
Lawrence, Viola, 38
Leach, Tracy, *(361)*
Leaf, Caroline, 321
Lebrun, Rico, 204
Le Clerc, Adrienne, 131
Lee, Peggy, *(260)*, 261, *(261)*
Lees, Marcia, 163
Leffingwell, Beverly, 216
Lelean, Moyra, 214
Lelean, Vera, 214, *(321)*
Leonardi, Marisa, *(361)*
Lerner, Gerda, 10
Lessing, Gunther "Gunny," 68
Ley, Willie, 246
Libby, Elsa, 150
Lichine, David, 217
The Light in the Forest, 250
Lindbergh, Charles, 39, 54
Linston, Hazel A., *(45)*, 48
The Lion King, 357
Lisberger, Steven, 327
The Little House, 262
The Little Mermaid, 349, 350–352
live-action features
 animated segments for, 126, 209–210, 221–222, 295–296, 308, 315–316

Index

live-action sequences, in Alice Comedies series, 40, 45, 47
The Living Desert, 250
Livingston, Jerry, 238
Lloyd, Ann, 70, 100, 111, 123, 138, *(369)*
Lloyd, Lonnie, 344
Lockheed, 194, 198, 273, 276
Longworth, Ellenetta, 277
Loomis, Ann B., 40, 43, 45
Looney Tunes cartoons, 168
Loos, Anita, 38
Lord, Ann, 138
Los Angeles Conservatory of Music, 293
Los Angeles Times, 184, 222, 264
Los Angeles Zoo, 202, 204
Lott, John, 45
Lounsberg, Larry, 69
Lowry, Jean, 133
Lucas, Dick, *(225)*
Luddy, Barbara, 261, 264
Ludwig, Arlene, 166, 294, 296–297, 301, 340, 352
Ludwig, Helen, *(89)*, *(368)*
Lukens, Glen, 80
Lumière, Auguste, 18, 20
Lumière, Louis, 18, 20
Lusby, Jim, 362, *(363)*
Lusk, Don, 67, 155, 159, 174, 204
Lusk, Marjorie, 174, *(369)*
Luske, Ham, 45, 82, 186
Luske-Finefrock, Peggy, 298, 301
Lycett, Eustace, 298

— M —

MacArthur, Sarah, 353
Macaulay, Eunice, 321
McAvoy, Mary "Scotty," 175, 298, *(369)*
McAvoy, Steve, 106, 175, 254, 265, 298, *(317)*, 336
McAvoy, Steve, II, 254, 298
McCall Pattern Company, 67
McCay, Winsor, *(24)*, 25, 26
McCormick, Kristen, *(361)*
McCoy, Bessie, 26
MacDonald, Jimmy, 225
McGill, Bethany, *(361)*
McGowen, Cherie, 342–343, *(369)*
Mack, Ginni, 107, 108, 113, 114, 115, 117, 118, 119, 179, 180, 217, 218, 223, 226, 227, 231, 244, 246, *(278)*, 280, 297, 311, 314, 316, 318, 327, 328, 329, 333, 343, 349, 350, 351, *(368)*
McKim, Dorothy, 353
McKinney, Mike, 314
MacLean, Barbara, 196
magic-lantern slides, 16, 18, 20, 21
Maintenance and Operations for Norden Bombsight, 200
Majolie, Bianca, 80, 128, 154, 160, 162, 166
Make Mine Music, 216–217, 221
Mamoulian, Rouben, 74
Mamtura, Ajay, *(361)*
Manchester, Charlot, 196
Mankin, Hiram, 351
Manriquez, Carlos, 59
Marceline, Missouri, 253, 282
March, Diana, 91
Marcus, Mike, 45, 54
Marine Corps Photographic Division, 192
Marion, Frances, 38, 57, 60
Marr, Fran, 264
Marroquin, Monica, *(340)*
Marshall, Kay, 188
Marshall, Nelda, 196, *(368)*
Marshall, Sean, 315
Martin, Janet, 155, 166, 183, *(186)*, 187, 195, 207, 227–228
Martin, Lucille, *(368)*
Marx, Groucho, 168, 202
Mary Poppins, 294, 295–296, 297, 301, 308
Mason, James, 251
Massie, Nancy, 179–180
Mathis, June, 38
Matlock, Frances, *(368)*
Mattinson, Burny, 265, 313, 349
Mattinson, Sylvia Fry, 264, 265, 313, 326, *(369)*
Mayer, Louis B., 60–61
Medby, Kelly, 299
Medby, Rae, 82, 101, 115, 138, 141, *(182)*, *(193)*, 195, 198, 199, *(225)*, 228, 229, 299
Méliès, Gaston, 22
Méliès, Georges, 18, 20, *(21)*, 21–22
Melody, 260
Melody Time, 217, 222, 223
Mengele, Josef, 232
Merritt, Russell, 49
Merry Melodies, 78, 168
Messmer, Otto, 25
Metropolitan Museum of Art, New York, 143, 144, 160, 257
Metro Studios, 39
MGM Studio, 39, 53, 60, 74, 126, 139, 168, 338
Michaelson, Ralph, 360
Mickelson, Gail, 196
Mickey Mouse, 13, 54, 57–58, 60–61, 64, 66, 67, 70, 71, 76, 77, 78, 80, 81, 82, 99, 103, 114, 121, 148–149, 164, 166, 200

The Mickey Mouse Club (television series), 80, 249–250, 251, 314
The Mickey Mouse Melodeon (newsletter), 69
Mickey's Christmas Carol, 330, 331–332
Mickey's Garden, 92
military training films, 192, 193, 196, 198, 199–201, 210, 232, 261
Millay, Edna St. Vincent, 128
Millay, Kathleen, 128
Miller, Cherie, *(309)*, *(315)*
Miller, Chris, 283, 300
Miller, Diane Disney (daughter), 89, 28, 31, 46, 53, 81, 145, 169, 208, 232, 253, 279, 282, 284, 294, 295, 300, 301, 313
Miller, Glenn, 171
Miller, J. Howard, 171
Miller, Linda, *(307)*, 312, 316, 317, 326
Miller, Ronald (son-in-law), 283, 308, 312, 313, 314, 315, 316, 317, 319, 324, 326, 317, 330, 338
Miller, Ronnie, 300
Miller, Seton, 315
Millotte, Elma, *(369)*
Milne, A. A., 311
Minnie Mouse, 32, 54, 57, 67, 115, 188
Mintz, Charles, 45, 53–54, 78, 166, 262
Mintz, Margaret Winkler, 14, 39–43, 45, 47, 53–54, 61, 166
Miranda, Aurora, 210
Missakian, Baron, 33
Miss Disneyland Tencennial, 255
MMRC (Mickey Mouse Recreational Club), 320
model sheets, 92, 150
Moder, Mary, 77
Modernism, 35, 38
Monroe, Marilyn, 235
Moore, Annabelle, 18
Moore, Colleen, 47
Moore, Freddie, 204
Moorhouse, Margie, 152, *(369)*
More Kittens, 82
Morgan, Cindy, *(325)*, 327, 328
Morris, Joe, *(345)*
Mosley, Ben, 196
Mosley, Violet, 196
Motion Picture Cartooning, 232
Motion Picture Producer's Guild, 39
Motion Picture Production Code, 63, 149, 163
Motion Picture Screen Cartoonists, 330
Moulton, Garda, 195
Moviola, 291
Ms. magazine, 305
MTV generation, 323
Mullen, Dorothy, 242–243, *(368)*
multiplane cameras, 129–130, 158, 348, 352, 353, 357
Munsell, Albert H., 24
Munsell color system, 108, 223
Museum of Modern Art, New York, 144
Musial, Stan, 230
Musker, Gayle, 343
Musker, John, *(307)*, 313, 350
Mussorgsky, Modest, 168
Muybridge, Eadweard, 18

— N —

Nagisa, Miho, *(368)*
Nash, Ducky, 280
National War Emergency Program, 192
Natwick, Grim, 99, 281
Neale, Ann, *(368)*
Neilan, Marshall, 39
Nerbovig, Buf, 226, *(368)*
Nerbovig, Helen, 144, 145, 150, *(174)*, 226, 228
Nevious, Nell, 138, *(368)*
Newell, Esther, 130–131
Newman, Eve, *(368)*
Newman's Laugh-O-grams, 31–32
Newsome, Ora E., 30
Newsreel, 320
New York Times, 216, 326
Nibbelink, Phil, 336
Nichols, Sue, 353
Niday, Sylvia, 195, 289, *(369)*
Night, 71
The Nightmare Before Christmas, 357
Nine Old Men, 264, 312, 330, 336, 360
Nineteenth Amendment, 12
Nissan, Betty, 196
Nixon, Richard, 314
Noel, Hattie, 164
Nolan, Jeanette, 326
Nonguet, Lucien, *(19)*
Norberg, Cliff, 314
Norconian Hotel, 142
Norman, Floyd, 242, 252, 264, 265, 266, 268, 286, 288, 289, 330, 360
Norris, Tania, 257
Norton, Mary, 308
Nye, Peter, 348

— O —

Oberon, Merle, 300
O'Brien, Kelan, 229
O'Brien, Yuba Pillet, 66, 114, 229, *(369)*

O'Callaghan, Matt, *(348)*
O'Callahan, Marion, 299
O'Connor, Joan-Patricia, 298
O'Connor, Ken, 238, 298
O'Connor, Mary Alice, 238
O'Day, Dawn, *(47)*
Office for Emergency Management, 193
Office of Inter-American Affairs, 220
Ogger, Helen, 136, *(369)*
Ohman, Vera Gunvor, 196
Oilspot and Lipstick, 338
Okuyama, Reiko, 281
Old, Mary, 148
The Old Mill, 129, 130
Old Yeller, 250
Oliver, Carmen, *(320)*
Oliver, Dale, 313
Oliver, Patsy, 123
Oliver & Company, 341–342, 344, 351
One Hour in Wonderland (television special), 249
One Hundred and One Dalmatians, 288, 289, 291
opaquing, 52, 56, 57, 58, 317
Orbison, Joan, 79, 139, 184, 185, 195, 201, 202, 228, 281, 299
Ormes, Jackie, 169
Orwell, George, 336
Osborn, Blanche, *(192)*
Ostwald, Wilhelm, 223
Oswald the Rabbit cartoons, 53–54, 56, 78, 79, 166
Otis Art Institute, 131
Owens, Ray, 298, 336

— P —

Pacheco, Vera, 326
Page, Patti, 235
painting
 and airbrushing, 122, 155, 157, 158, 288, 362
 application methods for, 152–154, 317
 artistry of, 13, 56, 60, 73–74, 76, 98
 cels as problematic canvas for, 109–110, 121, 130, 138
 and color matching, 104, 106, 318
 and color-model sheet, 117
 and Computer Animation Production System, 354, 356
 computer painting, 346, 349–350
 desired qualities of, 102
 for Disney Brothers Cartoon Studio, 40, 43, 46
 Lillian Disney's work in, 42
 and drybrushing, 155, 220, 242, 288, 311
 effect of high temperatures on, 138, 175
 flattening method, 153
 and gouache paint, 105, 178, 318
 and gum-arabic paint, 106, 176, 317, 332–333, 336, 341
 and Latex Paint, 207
 and lines and form, 119, 220
 mastery of, 118–119
 paint check, 119–120
 paint crawl, 189
 "Painter's Bible," 153
 and paint "let-downs," 49, 77, 108
 paint requirements, 176
 and pigments, 208, 223, 277, 317, 318, 336, 341
 shadow painting, 121–122, 138, 149, 176
 Marion Stirrett's work in, 157, 206
 techniques of, 60, 102, 105, 106, 109, 117–119, 136, 152–154, 155, 175, 308, 317–318, 349–350
 tools of, 117–118, 119, 136, 152–154
 training in, 102, 105, 153, 310
 translucent paint, 165
 transparent paints, 138, 176, 177
 vinyl-paint system, 336, 340–341, 343, 351
 and Xerox technology, 273, 291
 See also Paint Lab
Paint Lab
 and acrylic paints, 362
 and animation production process, 288
 Emilio Bianchi as supervisor of, 178, 298
 and chemistry of color, 107
 and color formulas, 105, 136, 154–155, 177, 178, 209, 341
 and color markup, 111
 and color matching, 104, 106, 107–108, 154
 and Color Model Department, 291
 colors used by, 103–104, 117, 129, 136, 138, 152
 and color systems, 108–109, 168, 177, 222–223
 and color theory, 88
 custom paint mixed within, 121, 291, 321
 "de-bubbler" machine in, 117
 and efficiency of Inking & Painting Department, 174, 310
 Becky Fallberg as supervisor of, 314
 function of, 302
 management of, 198
 men working in, 314
 and military training films, 192
 and milling pigments, 56, 104, 105, 106, 121, 175, 317
 order counter of, 181, 226
 order sheets sent to, 112
 paint color names, 302, 351
 and paint matching, 311
 and paint standards, 176
 and *Pete's Dragon*, 317

and pigments, 103, 104, 105, 106, 152, 178, 206, 277, 318, 336
 research program of, 152, 175
 safety in, 148
 staff of, 152, 154, 175–176, 242, 246, 342, 362
 staff refrigerator in, 277, 333
 and Technicolor, 222
 Jeannette Tonner as acting manager, 177
 Top Color, 317
 and training, 102, 153
 and vendors, 318, 336, 362
 and vinyl paints, 351
 Mary Weiser as supervisor of, 88, 104, 105, 108–109, 129, 136, 152, 175, 176, 177
Palinginis, Gilda, 326
Paliwoda, Amby, 142
Palmer, Barbara, 316, *(369)*
Palmer, H. Marion, 149
Palmer, Robin, 149
Panchito, 209
Panetta, Jamie, *(361)*
The Parade of the Award Nominees, 76
Paramount Pictures/Fleischer Studios, 338
Paramount Studios, 39, 53, 126
Paris, Dawn, 47
Parker, Claire, 168
Parker, Fess, 251
Parker, Zoe, *(321)*, *(345)*
Parks, Etta, 216
parlor games, 16, 18
Pathé, Charles, 22
Pathé cameras, 45
Pathé Frères company, 21, 22–23
Patten, Luana, 222, 231
Patterson, June Walker, 66–67, 86, 88, 155, 158–159, 198–199
Paul, Les, 240
Paul Bunyan, 248
Paxton, Marian, 279
Pearce, Perce, 202, 204
Pearl, Harold, 188
Pearl Harbor attack, 192–193, 195
The Peculiar Penguin, 174
Peet, Bill, 288
Pelayo, Antonio, 362, *(363)*
Pender, Carol Coor, 216
Peraza, Mike, 336
Peraza, Patty Paulick, 312, 326, 327, 331, *(333)*, *(348)*
Peregoy, Walt, 291
Perri, 250, 278
Peru, 209
Peter Pan, 214, 243, 244, 249, 261
Peterson, C. O., 152, 178, 210
Peterson, Ken, 257
Pete's Dragon, 315–317, 324, 326
Pfahler, Dick, 276–277
Phelan & Collander, 18
Phelps, Constance, *(369)*
Philadelphia Art Alliance, 69
Phillips, Joanna, *(345)*
Phillips Memorial Gallery, Washington, DC, 144
Philpott, A. J., 143–144
photographic copying. See Xerox technology
photography industry, 18, 20
Pickford, Mary, 38, *(38)*, 70, 126
Pickles, Phyllis, 228–229, *(365)*
Pickley, Leonard, 122
Pickwick Pool, 226
Pictorial Clubs Film Distribution, 31
Pinocchio, 148, 150, 154, 155, 157–158, 159, 174, 180, 186, 202
Pioneer Pictures, 74
Pixar, 337, 348, 350, 355
Plane Crazy, 54, 57, 58, 92, 361
Plochere, Gladys, 223
Plochere, Gustave, 223
Plochere color system, 108, 223
Plough, Doris, *(370)*
Plowden, Peggy, *(370)*
Plumb, Edward, 205
Pluto, 114, 148–149, 166, 217
Pniewski, Tom, *(361)*
Police, Robin, 333
Polk, Johnny, 179
Pomeroy, John, 315–316
Ponchielli, Amilcare, 162
Popeye cartoons, 79, 166, 168
Porter, Cole, 70
Porter, Isabelle Rushton, *(370)*
Porter, Madeline, *(370)*
postcards, 18, 20, 21
Pounds, Patti, *(273)*
Powers, Frank, 169
Powers, Pat, *(70)*, 166
Pregnancy Discrimination Act, 305
Presley, Elvis, 235
Price, Elizabeth, 208
Price, Tina, 335, 336, 337–338, 341, *(341)*, 342, 346, 348, 349, 352, 354, 355, 356
Prince (artist), 323
The Prince and the Pauper, 351, 356

Profetto, Marie, 158
Pruiksma, Dave, *(348)*
Pucher, Michael, *(361)*
Pugsley, Doris, *(370)*
Purnell, Idella, 149
Push Pin Players, 148

— R —

radios, 278
Raevouri, Saskia, 333
Ralston, Marge, 67, *(370)*
Randolph, Jane, 204
Ranft, Joe, 349
Raphael (artist), 143
Rathbone, Basil, 223
Raven, Peggy, 231
Rawlins, Judy "Elice" *(371)*
Rea, Janet, *(318)*, *(371)*
rear-projection technique, 210
Rector, Enoch J., 258
Reddy, Helen, 315–316
Redmond, Dorothea, *(256)*, 257
Rees, Jerry, *(307)*, 348–349
Reichenbach, Henry, 18
Reihm, Julie, 255
Reiniger, Lotte, 60
Reitherman, Wolfgang "Woolie," 141, 174, *(181)*, 289, 302, 308, 310
The Reluctant Dragon, 166, 180–181, 185, 231
Renaday, Pete, *(345)*, 360
Renfrew, Evelyn, 196
Rennahan, Ray, 73
Renshaw, Geno Meyers, *(85)*, *(371)*
The Rescuers, 314–315
The Rescuers Down Under, 352–356, 357
Reynolds, Aletha Pearl, 32
Riabouchinska, Tatiana, 164, 217
Rich, Rick, 333
Richards, Ruth, *(371)*
Rice, John, *(19)*
Ride, Sally, *(322)*, 323
Ridgeway, Robert, 223
Riefenstahl, Leni, 195
Riggs, Bobby, 305
Rinaldi, Alice Orcutt, *(371)*
RKO Pictures, 53, 81
Robbins, Ayn, 315
Roberts, Dodie, 108, 109, 154, *(310)*, *(345)*
Roberts, Robyn, *(299)*, 349, 353, *(371)*
Robertson, Kathryn, 196
Robin Hood, production of, 308, 310–311
Robinson, Gracie, 246, 310, *(370)*
Rockwell, Norman, 171, 195
Roemer, Sylvia, 103, 289, 291, 293, 302, 308, 317, 326, *(370)*
Rogers, Ginger, 13, *(13)*, 230
Rogers, Wathel, 254, 255
Romero, Chuck, 254
Romersa, Joanna, 252, 254–255, 266, 277, 280, 299, 320, 321, 344
Romersa, Tony, 280
Ronell, Ann, 78
Rookus, Faith, 154, *(370)*
Roosevelt, Eleanor, 70, 193
Roosevelt, Franklin, 78
The Ropes at Disney (booklet), 224
Rossi, Mildred, *(162)*, 163, 165, *(180)*, 181
Rossini, Gioachino, 81
rotoscoping, 328
Rubens, Peter Paul, 143
Ruby Spears Studio, 344
Rudiger, Fini, 150
Rule of the Nautical Road, 200
Rush, Mildred, 158
Russell, J. R., *(343)*
Ruth, Edna, *(370)*

— S —

St. Joseph's Hospital, 301
salaries, of working women, 12, 20, 23, 68–69, 157, 218, 227
Salkind, Mary Brown, 89
Salten, Felix, 148, 206, 278
Saludos Amigos, 209
Salz, Kaye, 361
Sanderson, Carmen, 116, 179, 210, 214, 218, 222, 230, 243, 251, 260, 273, 276, 277, 278, 279, 297, 301, 308, 319, 349, 350
Santa's Workshop, 77
Schaefer, Carolyn, 69
Schenck, Joseph, 73–74
Schlesinger, Leon, 78, 168
Schlesinger Studios, 168–169, 182
Schneider, Eva, 264, *(371)*
Schneider, Peter, 333, *(347)*, 352, 355–356, 357
Schubert, Franz, 163, 165
Schultheis, Herman, 164
Schumacher, Tom, 333
Schuster, Mary, 195, 240, *(250)*
Scott, Dolores Voght, 66, 98–99, 300, *(370)*
Scott, Gladys R., 20
Scott, John, 20
Scott, Retta, 14, 108, 155, 183, *(181)*, 183, 188, *(188)*, *(204)*

Scott and Van Altena, 20
Screen Actors Guild, 184
Screen Cartoon Guild, 182, 183–184
Screen Gems Studios, 166, 182, 281
Seal Island (Disney True-Life Adventure documentary), 228
Sears, Ted, 78, 91, *(187)*
Seibert, Helen, 240
Selby, Margaret, 152
Selck, Bea, 130, 201, *(371)*
Selective Services, 224
Select Pictures Corporation, 31
Selig, William, 22, 24
Selik, Henry, 313
Sennett, Mack, 24
Sericels, 342
series photography, 18
Sewell, Blanche Irene, *(18)*, 38–39, *(40)*, 46, 60–61
Sewell, Claudia, 138
Sewell, Glenn, 39, 46, 48, 56
Sewell, Hazel, 36, 39, *(40)*, 41, 46, 54, 56, 57, 59–60, 64, *(69)*, 70, *(71)*, 72, 73, 74, 76, 77, 78, 81, 96, 98, 99–100, 102, 109, 110, 115, *(123)*, 129, 140, 141, 150, 152, 169, 187
Sewell, Marjorie, 39, 42, 46, 53, 56, 145, 169, *(371)*
Sewell, Velon, 216, *(216)*
Seymour, Merrill W., 110
Shaeffer, Carolyn, *(371)*
The Shaggy Dog, 249
Shakespeare, William, 23
Shantzis, Michael, 348
Sharp, Margery, 314
Shaw, Alice May, 196
Shaw, Mel, 313
Shaw, Ruth Faison, 88
Shaw Finger Paint Studio, 88
Sheldon, Isabel, 195
Shellhorn, Ruth, 254, *(254)*
Sherman, Richard, 291, 293, 295–296, 297, 300, 308
Sherman, Robert, 291, 295, 297, 300, 308
Sherwood, Evie, 140
Shireav, Alexandr, 24
Shore, Dinah, 202, 217, 222
Shrewsbury, Katherine, 30
Shrimpton, Joan, *(116)*
Sibelius, Jean, 160
Sibert, Helen, *(371)*
Sibley, Brian, 295
Siegel, Debbie, *(343)*
Siemon, Cassandra, *(361)*
Sigall, Martha, 77, 79, 149, 168–169, 185, 196, 276, *(371)*
Siggraph conference, 338, 346
silhouette cutting, 60
Silly Symphonies series, 58–59, 60, 64, 69, 71–74, 76–77, 78, 80, 82, 99, 103, 128, 129, 131, 134, 149, 160
Silvey, Shirley, 300
Simpson, Nadine, 31, 32–33
Sinatra, Frank, 171
Sinclair, Eva Jane, 222, 223, *(370)*
Sinclair, Marcia, 195, 319
Sinclair, Upton, 12
Singer, Carmen, 216
Sito, Pat, 339, 340
Sito, Tom, 313
Skinner, Georgia, 196
Skinner, Kathlyn Jois, 196
Sleeping Beauty, 254, 262–266, 268, 272, 281, 286, 288, 330, 331, 350, 361
The Small One, 317, 326
Smith, Alvey Ray, *(347)*, 348
Smith, Betty, 182
Smith, Dave, 360
Smith, Dodie, 288
Smith, Dot, 76, 102, 116, 177, 135, 140, 152, *(176)*, 177, 182, 183, 184, 194, 195, *(370)*
Smith, Edna, 138, 226, *(276)*, *(310)*, *(370)*
Smith, Enid, 196
Smith, Kathleen Dollard, 40–43, 45, 48, 54
Smith, Lella, 361
Smith, Marion, 195, 226
Smith, Paul, 52, 54, 250
Smith, Webb, 91
Smoke Tree Ranch, 300
smoking, 124, 148, 158
Snow White and the Seven Dwarfs, 13, 61, 63, 101, 128, 129, 130, 131, 133, 134–136, 138, 139, 140, 141, 142, 143–145, 146, 150, 154, 157, 160, 163, 201, 202, 232, 320, 330, 339, 357
So Dear to My Heart, 216, 222–223
Soderstrom, Shirley, 150, *(150)*, 163, 166
Song of the South, 221–222, 231
Sorenson, Betty, 195
Sorenson-Thompson, Helena, *(370)*
Sorrentino, Alphonse, 225–226
South America, 187, 209, 279
Southern California Models Club, 131
spectrophotometers, 106
Spencer, Dave, 331
Spencerian pens, 192
Spin and Marty serial, 249
Spinner, Francis Elias, 12
Springsteen, Bruce, 323

Springtime, 60
Stalling, Carl, 58
Stanley, Helene, 238, 263, *(370)*
Stanzell, Grace, 216, 289
Stapp, Nancy, 268
Star Films, 21
Stark, Betty, *(370)*
Stark, Sandra, 131
Steamboat Willie, 57–58, 67, 361
Steinem, Gloria, 305
stereopticon slides, 20
Stewart, Jimmy, 168, 235
Stirrett, Lloyd, 157
Stirrett, Marion Wylie, 157, 186, 206
Stokowski, Leopold, 160, 162, 163
Storyboard Studios, 321
The Story of Menstruation, 220
Strand Theatre, 39
Stravinsky, Igor, 165
Sturtevant, Sterling, *(371)*
Sullivan, June, 240
Sullivan, Pat, 25
Sullivan Studios, 61
Sumner, Kae, *(85)*, *(88)*, *(117)*, 148
Sundblad, Charlene, 89
Svendsen, Julius, *(250)*
Swain, Kathleen, 326
Swank, Norma, 214, 222, 223, *(226)*, 230, 251, *(371)*
Swanson, Gloria, 38
Swartz, Vina Katrine, 158
Swift, Gini, 281
The Sword in the Stone, 291, 293
Sykes, Wanda Elvin, 250, *(250)*
Sylmar Earthquake, 360

— T —

Talmadge, Constance, 38
Talmadge, Norma, 38
Tamargo, Berta "Bea," 214, 216, *(216)*, 244, 264, 268
Tam O'Shanter restaurant, 138, 225, 283
Tashima, Kimi, 265, 289
Tatum, Donn, 308
Tchaikovsky, Pyotr, 162
Tebb, Mary, 56, 58–59, 166, 223, 242, 243, 246, *(294)*, *(321)*
TecArt Studios, 67
Technicolor process, 7174, 76, 78, 81, 103, 105, 129, 135, 177, 209, 210, 222, 242, 258
Teitel, Harry, 131
television, 14, 248, 249250, 251, 252, 258, 286, 291, 299, 300, 321, 328, 360
Temple, Shirley, 141
Terry, Paul, 78
Terry Toons, 78
Thach, John, *(201)*
Thalberg, Irving, 38
Tharpe, Rosetta, 235
Thaves, Bob, 14
Thiele, Margaret Ann, 216
Thomas, Bob, 145
Thomas, Frank, 66, 102, 105, 111, 112, 129, *(187)*, 204, 205, 223, 224, 265, 291, 312, 315, 361
Thomas, Ted, 360
Thompson, Auril, 168, 252, *(371)*
Thompson, Phyllis, *(182)*
Thompson, Riley, *(180)*, 229
Thorbus, Ruth, 158
Thorne, Narcissa Niblack, 231
Thornton, Hilde, 152
Thornton, Mimi, *(85)*,196, 212, 214, 242, *(277)*
3D Jamboree, 260
3-D technology, 260, 331, 337, 342, 346, 357
The Three Caballeros, 198, 209, 210, 221
Three Little Pigs, 77–78, 82
The Three Orphan Kittens, 82
Thuillier, Elisabeth, 21, 22
Thurman, Lois, 308
Till, Margaret, 25
Time magazine, 302, 336
Timner, Elsa, 181
Tin Pan Alley, 78
Titus, Eve, 336
Tobleman, Eloise "Toby," 141, 222, *(371)*
Toby Tyler, 249, 288
Todd, Richard, 231
Tompson, Ruthie, 42, 43, 45, 67, 68, 70, 82, 100, 101, 105, 108, 111, 112, 117, 119, 121, 122, 123, 124, 136, 142, 160, 178, 179, 184, 185, 189, 196, 201, 212, 214, 230, 242, 278, 301, 302
Tonka, 249, 308
Tonner, Jeanette, 102, 152, 177, 192, *(371)*
Toombs, Harvey, 198
Toombs, Leota "Lee," 198, 254, 255, *(255)*
Toot, Whistle, Plunk and Boom, 260
Torrey, Emma, *(371)*
Towsley, Don, 202
Toy Story, 357
tracing, 52, 56, 57, 58, 59–60, 98
 See also inking
Tracy, Spencer, 168
Travers, P. L., 295–296, 297, 308

Trick or Treat, 243
Trindade, Margaret, *(137)*, 154, 266, 268, 288–289, 301, *(370)*
Tron, 327–330, 346, 348
Trousdale, Gary, 349
True-Life Adventures documentaries, 250
Tucker, Ann, 349, 353
Turner, Mary Jane "MJ," 334
2-D technology, 337, 348, 357
20th Century Fox, 53, 126, 338
20,0000 Leagues Under the Sea, 251, 252
Tytla, Bill, 131
Tytla, Harry, 69

— U —

The Ugly Duckling, 149
Underhill, Betty, *(370)*
unions, 35, 182–186, 196, 199, 222, 224, 242, 302, 330
United Artists, 53, 72, 73, 74, 78, 126
United Productions of America (UPA), 281
Universal Studios, 20, 25, 53, 78, 166, 182, 338
US Army, 192–193, 194, 198, 199–200, 210, 212, 228

— V —

Valentino, Rudolph, 35
value, definition of, 24
Vandagriff, Jack, 175
Vandoli, Sherri, 343, 344, 362, *(363)*
Van Pelt, Peggy, *(256)*, 257
Van Tassel, Katrina, 223, *(223)*
Varab, Jeff, *(307)*
Variety, 58
Vasquez, Jackie, *(361)*
Venable, Evelyn, 155
Venegas, Elda "Tita," *(361)*
Ventura, Pat, *(348)*
Verne, Jules, 252
Vernick, Edith, 61, 79
Victory Through Air Power, 198, 200, 201
Vietnam War, 285, 301
Vischer, Frans, *(348)*
Vitagraph Studio, 38
Vitascope projectors, 20–21
Voght, Dolores, 64, 66, 99, 300
von Braun, Wernher, 246
Von Kessel, Glendra "The Baroness," 255, *(257)*, 278
Vonture, Darryl, *(361)*
Voorheis, Sally, 326
Vosburgh, Edyth, *(370)*
Vreeland, Valentine, 311, *(370)*

— W —

Waldner, Ann, *(192)*
Walin, Betty Miskimen, 138
Walker, Card, 308
Walker, Joyce, 316
Walker, Mildred, 25
Walsh, Mary, *(361)*, 362
The Walt Disney Christmas Show (television special), 249
Walt Disney Company, 67, 306, 320, 334, 362
Walt Disney Feature Animation, 323
Walt Disney Imagineering, 254, 257, 343
Walt Disney Music Company, 298
Walt Disney Presents (television series), 251, 252
Walt Disney Studios, 13, 14, 39, 46, 52, 54, 56, 57–58, 59–60, 61, 64, 66, 67, 68–69, 70, 71, 76, 77, 78, 80, 81, 82, 84, 86, 88, 89, 91–92, 94, 96, 99, 106, 107, 109, 110, 111, 116, 122, 123, 124, 126, 128, 129–130, 131, 133, 138–141, 141, 142, 148, 149, 152, 157, 158, 159, 162, 163, 164, 166, 168, 172, 174–175, 177, 178, 179–180, 182–186, 187, 188, 189, 192, 193, 194, 195, 196, 198, 199–200, 202, 205, 206, 207, 208, 210, 212, 214, 216, 217, 220–221, 222, 224, 225–228, 229, 230–231, 235, 236, 238, 240, 242, 243–244, 246, 250, 251, 260–264, 268, 272, 277, 278, 279–280, 281, 286, 289, 291, 293, 294, 295, 296, 297, 298, 300, 302, 308, 314, 316, 317, 318–320, 321, 324, 326, 327, 329–330, 331, 332, 333, 336, 340, 343, 344, 349, 350, 351, 352, 356, 360, 361–362
 See also Animation Department; Inking & Painting Department; live-action features; Paint Lab
Walt Disney World, 253, 254, 255, 257, 301, 305, 344
Walter Lantz Animation Conference, 342
Walters, Margaret, 81
Walt in Wonderland (Merritt and Kaufman), 49
War Film Library, 193
Warner, Harry M., 39, 40
Warner Brothers, 39, 53, 182, 232
Watcher in the Woods, 327
Wavle, Ardra, 149
Wayne, John, 196
Weber, Kem, 172
Weber, Lois, 38
Webster, Dorothy, 262
WED Enterprises, 253, 254, 255, 263, 293, 294, 361
Weeks, Claire, 195
Wegener, Paul, 60
Weiser, Mary, 88, 102, 104, *(104)*, 105, 108–109, 111, 122, 129, 136, 152, 153, 175, 176, 177
Welfare of Workers, 193
Wells, Frank, 348
Wells, H. G., 70
Wentworth, Martha, 289, 291

Wesberg, Margaret, 164
Westward Ho the Wagons!, 250
Wharton, Leota, 195
White, Beryl, 158, 182
White, Patrick, *(361)*
White, T. H., 291
Whitford, Annabelle, *(19)*
Whitham, Mary Lou, 111, 164, 206, *(370)*
Whitlock, Katherine, 152
Whitmer, Thelma, *(263)*
Whitney, Cyndee, 326, 344, *(371)*
Who Framed Roger Rabbit, 338–340, 349
Who Killed Cock Robin?, 92
Why We Fight documentary series, 195
Wickes, Mary, 289
wide-screen films, 258, 260, 286
Wiese, Mildred, 220
Wilck, Tommie Laurine, 295, 300
Wilkerson, Edgar, 77, 351
Williams, Guy, 251
Williams, Lucile. See Bosché, Lucile Williams
Williams, Phyllis Mooney, 195, 216
Williams, Rhoda, 238
Williams, Richard, 338–339
Williams, Roy, 80
Willie, Ingaborg, *(85)*
Wilson, Bertha "Bert," 276
Wilson, Fred, 175
Wilson, Meredith, 199
Winegardner, Lloyd, 298, 314, 328, *(345)*
Winkler, George, 47
Winkler, Margaret. See Mintz, Margaret Winkler
Winkler-Mintz Productions, 54
Winkler Pictures, 47
Winnie the Pooh and Tigger Too, 311
Winters, Shelley, 315
Witmer, Thelma, 196, 240, 262, 288–289, 302
Wolfe, Vic, *(343)*
Women Airforce Service Pilots (WASPs), 190
Women in Defense, 193
Women's education, 323
Women's history, 10, 12, 13, 14, 23, 35
women's movement, 305, 314, 319
Wonderful World of Color (television series), 300
Wonderful World of Disney (television series), 249
Wong, Tyrus, 186, 202, 206
Wood, Madilyn, 232
Wood, Marilyn, 232
Wood, Tom, *(151)*
Woodbury, Ellen, 353
Woodland Cafe, 80
Woods, Ilene, 238, 240
Woods, Raulette, 328–330
Woodward, Betty, 158
Wootten, Gina, *(320)*, 341, *(371)*
Working for Peanuts, 260
World's Fair of 1964–65, 255, 293–294
World War I, 30–31, 35
Wright, Ruth, 222

— X —

Xerox Check, 276, 288
Xerox Department, 273–274, 276–277, 302
Xerox Markup, 276, 288
Xerox Processing, 288
Xerox technology
 and animation production process, 208, 268, 272, 273–274, 276–277, 288, 291, 296, 302, 311, 339, 340, 342, 351, 356
 and cels, 272, 274, 276, 277, 288, 332, 339, 356
 and color lines, 296, 315, 326–327, 331
 Computer Animation Production System superseding, 353
 and desktop copiers, 272
 as industry standard, 321
 and inking, 207–208, 268, 270, 272, 273, 291, 294, 315, 331, 334
 invention of, 270
 refinements of, 315

— Y —

Young, Clara Kimball, 38
Young, Jeanie, 278, *(371)*
Yumibe, Joshua, 20
Yunger, Vera, 181

— Z —

Zecca, Ferdinand, *(19)*
Zemeckis, Robert, 338, 340
Zielinski, Kathy, 330, *(348)*, 350, 353
zoetropes, 16
Zoll, Janet, *(299)*
Zorro (television series), 250, 251
Zwicker, Elizabeth Case, 264–265, 268, *(371)*

BIBLIOGRAPHY

BOOKS

Adventures of a Hollywood Secretary—Letters of Valeria Belletti, edited and annotated by Cari Beauchamp. Berkeley and Los Angeles: University of California Press, 2006.

The American Animated Cartoon: A Critical Anthology, edited by Danny Peary and Gerald Peary. New York: Dutton, 1980.
Including works:
- *A Day with J.R. Bray*, by John Canemaker
- *The Early History of Animation*, by Conrad Smith
- *A Talk With Dick Huemer,* by Joe Adamson
- *Mickey, Walt, and Film Criticism from Steamboat Willie to Bambi,* by Gregory A. Waller
- *The Making of Cultural Myths: Walt Disney*, by Robert Sklar
- *An Interview with John and Faith Hubley,* by John D. Ford
- *Women and Cartoon Animation, or Why Women Don't Make Cartoons, or Do They?* by Barbara Halpern Martineau

The American Animated Cartoon: A Critical Anthology, edited by Gerald Peary and Danny Peary. New York: E.P. Dutton, 1980.

America's Film Legacy: The Authoritative Guide to the Landmark Movies in the National Film Registry, by Daniel Eagan. New York: Bloomsbury, 2009.

Animated Cartoons: How They Are Made, Their Origin and Development, by E. G. Lutz, Charles Scribner & Sons, 1920 (reprint) Applewood Books / Bedford, MA, 1998

The Animated Man: A Life of Walt Disney, by Michael Barrier. Berkeley and Los Angeles: University of California Press, 2007.

The Animated Raggedy Ann and Andy: An Intimate Look at the Art of Animation: Its History, Techniques, and Artists, by John Canemaker. Indianapolis and New York: Bobbs-Merrill 1977.

Animation Art and Industry, edited by Maureen Furniss. Bloomington: Indiana University Press/John Libbey Publishing, 2009.

Animation: From Script to Screen, by Shamus Culhane. New York: St. Martin's, 1990.

The Art and Flair of Mary Blair: An Appreciation, by John Canemaker. New York: Disney Editions, 2003.

The Art of Walt Disney, by Robert D. Feild. New York: Macmillan, 1942.

The Artist's Handbook of Materials and Techniques, by Ralph Mayer. New York: The Viking Press, 1953.

Before Mickey: The Animated Film 1898-1928, by Donald Crafton. Cambridge MA, and London: MIT Press, 1982.

Before the Animation Begins, by John Canemaker. New York, 1996.

Building a Company: Roy O. Disney and the Creation of an Entertainment Empire, by Bob Thomas. New York: Hyperion, 1998.

Cel Magic: Collecting Animation Art, by R. Scott Edwards and Bob Stobener. Sacramento, CA: Laughs Unlimited Incorporated, 1991.

"Colour by Stencil: Germaine Berger and Pathéécolor," an interview by Jorge Dana, translated by Niki Kolaitis. *Film History: An International Journal*, vol. 21, no. 2, 2009.

"Colouring the Nation: Spectacle, Reality and British National Colour in the Silent and Early Sound Era," by Simon Brown. *Film History: An International Journal*, vol. 21, no. 2, 2009.

The Creature Chronicles: Exploring the Black Lagoon Trilogy, by Tom Weaver, David Schecter, and Steve Kronenberg. Jefferson, NC: McFarland, 2014.

Cubed: A Secret History of the Workplace, by Nikil Saval. New York: Doubleday, 2014.

* *Did You Grow Up With Me, Too? An Autobiography of June Foray*, by June Foray, with Mark Evanier and Earl Kress. United States: BearManor Media, 2009.

Disney During World War II: How the Walt Disney Studio Contributed to Victory in the War, by John Baxter. New York and Los Angeles: Disney Editions, 2014.

Disney's Grand Tour: Walt and Roy's European Vacation, Summer 1935, by Didier Ghez. United States: Theme Park Press, 2013.

"Early Colour," by Kim Tomadjoglou. *Film History*, Vol. 21, no. 1, 2009.

Earning Power: Women and Work in Los Angeles, 1880-1930, by Eileen V. Wallis. Reno and Las Vegas: University of Nevada Press, 2010.

Fantasia of Color in Early Cinema, by Tom Gunning, Joshua Yumibe, Giovanna Fossati, and Jonathon Rosen, Eye Filmmuseum / Amsterdam University Press, 2016.

Felix: The Twisted Tale of the World's Most Famous Cat, by John Canemaker. New York: Pantheon Books, 1991.

The Female Experience: An American Documentary, introduction and edited by Gerda Lerner. United States: Oxford University Press, 1992.

50 Years In the Mouse House: The Lost Memoir of One of Disney's Nine Old Men, by Eric Larson. Edited by Didier Ghez & Joe Campana. California: Theme Park Press, 2015.

"Georges Méliès and the 'Feerie,'" by Katherine Singer Kovacs. *Cinema Journal*, vol. 16, no. 1, Autumn 1976.

Go West, Young Women! The Rise of Early Hollywood, by Hilary A. Hallett. Berkeley, Los Angeles, London: University of California Press, 2013.

The Hand Behind the Mouse: An Intimate Biography of Ub Iwerks, by Leslie Iwerks and John Kenworthy. New York: Disney Editions, 2001.

Hollywood Cartoons: American Animation in Its Golden Age, by Michael Barrier. New York: Oxford Press, 1999.

The Illusion of Life—Disney Animation, by Frank Thomas and Ollie Johnston. New York, Disney Editions, 1981.

Inside the Dream: The Personal Story of Walt Disney, by Katherine and Richard Greene. New York: Disney Editions, 2001.

Inside the Whimsy Works, by Jimmy Johnson. Edited by Greg Ehrbar and Didier Ghez. Jackson: University Press of Mississippi, 2014.

In the Service of the Red Cross: Walt Disney's Early Adventures,1918-1919, by David Lesjak, United States: Theme Park Press, 2015.

Jackie Ormes: The First African American Woman Cartoonist, by Nancy Goldstein. Ann Arbor: University of Michigan Press, 2008.

Justice for Disney, by Bill Justice. Dayton, OH: Tomart Publications, 1992.

Kem Weber, Designer and Architect, by Christopher Long. New Haven, CT, and London: Yale University Press, 2014.

Living Life Inside the Lines: Tales From the Golden Age of Animation, by Martha Sigall. Jackson: University Press of Mississippi, 2005.

The Lost Notebook: Herman Schultheis and the Secrets of Walt Disney's Movie Magic, by John Canemaker. San Francisco: Walt Disney Family Foundation Press, 2014.

The Magic Kingdom: Walt Disney and the American Way of Life, by Steven Watts. Columbia: University of Missouri Press, 1997.

The Majority Finds Its Past: Placing Women in History, by Gerda Lerner. London: Oxford University Press, 1979.

The Making of Tron: How Tron Changed Visual Effects and Disney Forever, written and published by William Kallay. United States, 2011.

Mouse in Transition: An Insider's Look at Disney Feature Animation, by Steve Hulett. United States: Theme Park Press, 2014.

Moving Color: Early Film Mass Culture, Modernism, by Joshua Yumibe. Newark, NJ: Rutgers University Press, 1974.

Moving Pictures: How They Are Made and Worked, by Frederick A. Talbot. Philadelphia: J.B. Lippincott Company, 1914,

Mr. Technicolor: An Autobiography, by Herbert T. Kalmus with Eleanore King Kalmus. Absecon, NJ: Magic Image Film Books, 1993.

Off With Their Heads: A Serio-Comic Tale of Hollywood, by Frances Marion. New York: Macmillan, 1972.

Please Let Me Fly: The Grace Huntington Story in Her Own Words, by Grace Huntington. United States: Berkeley Brandt III @ Lulu.com, 2008.

Plochere Color System – A Guide to Color and Color Harmony, by Gladys and Gustave Plochere, Los Angeles, 1948.

Reel Women: Pioneers of the Cinema 1896 to the Present, by Ally Acker. New York: Continuum Publishing Company, 1991.

Ruth Shellhorn, by Kelly Comras. Athens: University of Georgia Press, 2016.

BOOKS CONTINUED . . .

Talking Animals and Other People, by Shamus Culhane. New York: St. Martin's Press, 1986.

The Secretary and Her Job, by Marie L. Carney. Charlottesville, VA: The Business Book Library, 1939.

Service With Character: The Disney Studios & World War II, by David Lesjak. United States: Theme Park Press, 2014.

The Story of Color: From Ancient Mysticism to Modern Science, by Faber Birren. Westport, CT: The Crimson Press, 1941.

The Story of Walt Disney, by Diane Disney Miller as told to Pete Martin. New York: Henry Holt, 1956.

"The Technicolor Notebooks at the George Eastman House," by Ulrich Ruedel. *Film History*, vol. 21, no. 1, 2009.

They Drew as They Pleased: The Hidden Art of Disney's Golden, by Didier Ghez. San Francisco: Chronicle Books, 2015.

They Drew As They Pleased: The Hidden Art of Disney's Musical Years, by Didier Ghez .San Francisco, Chronicle Books, 2016.

"Tinting and Toning at Pathé: The Jacques Mayer Notebook," by Stephanie Salmon. *Film History : An International Journal*, vol.21, no. 2, 2009.

A Trip to the Moon, Back In Color, GroupamaGan Foundation for Cinema and Technicolor Foundation for Cinema Heritage, 2011.

"Unnatural Colours: An Introduction to Colouring Techniques in Silent Era Movies," by Paul Read. *Film History*, vol. 21, no. 1, 2009.

Walt Before Mickey: Disney's Early Years, 19191928, by Timothy S. Susanin. Jackson: University Press of Mississippi, 2011.

Walt Disney: An American Original, by Bob Thomas. New York: Simon and Schuster, 1976.

Walt Disney and Assorted Other Characters: An Unauthorized Account of the Early Years at Disney's, by Jack Kinney. New York: Harmony Books, 1988.

Walt Disney's Encyclopedia of Animated Characters, by John Grant. New York: Hyperion, 1993.

Walt Disney's Missouri: The Roots of a Creative Genius, by Brian Burnes, Robert W. Butler, and Dan Viets. Kansas City, MO: Kansas City Star Books, 2002.

Walt Disney: The Triumph of the American Imagination, by Neal Gabler. New York: Alfred A. Knopf, 2006.

Walt in Wonderland: The Silent Films of Walt Disney, by Russell Merritt and J.B. Kaufman. Baltimore: John Hopkins University Press, 1993.

The Walter Lantz Story, by Joe Adamson. New York: G.P. Putnam's Sons, 1985.

Walt's People series, edited by Didier Ghez. Xlibris United States: Theme Park Press.

 Volume 1 Joyce Carlson interviewed by Jim Korkis, 1998 and 2000

 Marc Davis interviewed by John Province, 1991 and 1992

 Volume 7 Paul Smith & Hazel George interviewed by David Tietyen, 1978

 Grace Turner interviewed by Christopher Finch and Linda Rosenkrantz, June 29, 1972

 Adriana Casselotti interviewed by Brian Sibley, 1985 to 1997

 Volume 8 Tommie Wilck interviewed by Richard Hubler

 Volume 11 Ruthie Tompson interviewed by Didier Ghez, December 21, 2007

 Volume 12 Al Eugster interviewed by John Culhane, June 22, 1986

 Evelyn Coats interviewed by Alan Coats, August 11 & 25, December 22, 2001, and January 26, 2002

 Marge Hudson and Evelyn Coats interviewed by Alan Coats, October 27, 2002

 Theo Halladay about Sylvia Holland interviewed by Didier Ghez, 2008 and 2009

 My Family Disney Dynasty by Edle Bakke and her family, January 2006

 Olive Bosché interviewed by Didier Ghez, 2011

 Leota Toombs Thomas Lecture given at the WEDWAY chapter of the NFFC (Disneyana Fan Club), June 1988

 Kim Irvine interviewed by Didier Ghez, September 10, 2008

 Volume 13 Becky and Carla Fallberg interviewed by Michael Broggie, June 9, 2005

 Volume 15 Peggy Finefrock interviewed by Jim Korkis, March 2012

Warp and Weft: Life Canvas of Herbert Ryman, by John Stanley Donaldson. United States: Incanio Ltd., 2010.

Wide Screen Movies: A History and Filmography of Wide Gauge Filmmaking, by Robert E. Carr and R.M. Hayes. Jefferson, NC: McFarland, 1988.

Women's Work: The First 20,000 Years, by Elizabeth Wayland Barber. New York and London: Norton, 1994.

Working With Walt: Interviews With Disney Artists, by Don Peri (interview with Marcellite Garner). Jackson: University Press of Mississippi, 2008.

Working Women on the Hollywood Screen: A Filmography, by Carolyn L. Galerstein. New York and London: Garland, 1989.

ARTICLES / PAPERS

"The Amazing Inside Story of How They Made Snow White," by Kirtley Baskette. *Photoplay*, April 1938.

"Ambivalent Dreams: Women and the Home after World War II," by Elaine Tyler May. *Journal of Women's History*, vol. 13, no.3, Autumn 2001.

"Animated Cartoon Production Today," by Carl Fallberg. *American Cinematographer*, August 1942.

"Animation and Cartoons," by Walt Disney. *The Complete Photographer*, vol. 4, 1941.

Animation Cels Shed Light on Preserving Plastics." *The Getty Magazine*, Spring 2014.

"The Artist's Part in the Production of an Animated Cartoon," by Ralph Hulett. *American Artist*, May 1955.

"At Last Movie Cartoons in Color," by James Bowles. *Modern Mechanix*, January 1932.

"Beautiful But Not Dumbo Walt Disney's Comments on the Working Girl are Animated." *Glamour*, December 1941.

"Behind the Scenes with Mickey Mouse," *DuPont Magazine*, February 1935.

"Breathing Life into Cartoon Characters." *Popular Mechanics*, March 1935.

"Caricature Art in Clay," edited by Henry Havens Windsor. *Cartoon Magazine*, vol. 7, no. 4, April 1915.

"Cartoon Animation," by Frank L. Goldman. *Minicam Photography*, April 1947.

"Color Consciousness," by Natalie M. Kalmus. *Journal of the Society of Motion Picture Engineers*, August 1935.

"Coloring the Kingdom," by Patricia Zohn. *Vanity Fair*, March 2010.

"Color-Shooting in Fairyland." *Popular Mechanics*, January 1940.

"Designing Woman," by John Canemaker, *Disney Magazine*, Fall 2003.

"Dina Gottliebova Babbitt dies at 86: Auschwitz survivor fought to regain portraits she painted there," by Larry Gordon. *Los Angeles Times*, August 1, 2009.

"Discovering Helen," by Ron Barbagallo. *Animation Collector*, August 1997.

"Disney Characters," by Janet Martin. *Your Charm*, August 1941.

"Disney Girls' Beauty Show." *News Dispatch*, July 24, 1941.

"The Disney Team at Work." *Picture Post*, March 23, 1946.

"Disney Tells Union Threat – AFL Accused of Vow to Turn Studio Into Hospital of Beaten Men," *Los Angeles Times*, March 1, 1941.

"Disney's Secret System." *Computer Graphics World*, July 1994.

ARTICLES / PAPERS CONTINUED . . .

"Disney's *The Fox and the Hound*: The Coming of the Next Generation" by Tom Sito. *Animation World Magazine*, Issue 3.8, November 1998.

"Do You Want a Job in the Studios?" *Photoplay*, May 1931.

"Exhibition of the Original Celluloid Cut-Outs for Snow White and the Seven Dwarfs," by Walt Disney. San Francisco Museum of Art, September/October 1938.

"Film Music Editor: Evelyn Kennedy as told to Robert Osborne," by Evelyn Kennedy. *Music Educators Journal*, March 1977.

"Girls at Work for Disney." *Glamour*, May 1941.

"The Great Society: Highlights from the Early Years of the Editors Guild Women in the Cutting Room," compiled by Jeff Burman and Michael Kunkes. *Editors Guild Magazine*, 2005.

"Hand-coloring of Motion Picture Film," by Gustav F.O. Brock. Delivered at the Spring J.S.M.P.E. meeting, Hollywood, CA, 1931.

"How Animated Cartoons Are Made," by Quinn Martin. *The Sunday World Magazine*, September 28, 1930.

"How Disney Combines Living Actors with His Cartoon Characters," *Popular Science*, 1944.

"How I Used Color in *Melody Time*," by Walt Disney. *Redbook*, July 1948.

"How the Silly Symphonies Are Made," by Ernest Betts. *Daily Express Film Book*, 1935.

"How We Made Mary Poppins," interview by Anna Tims. *The Guardian*, December 2, 2013.

"I Live With a Genius," by Mrs. Walt Disney, as told to Isabella Taves. *McCall's*, February 1953.

"An Interview with Wendy Carlos," by Randall D. Larson. Originally published in *CinemaScore* #11/12, 1983.

"Joe Grant Disney's Master Storyteller," by Mindy Johnson. Walt Disney Studios Home Entertainment, 2010.

"Latest Tricks of the Animated Film Makers," by William E. Garity, *Popular Mechanics*, May, 1938.

"The Live Wire: Margaret J. Winkler and Animation History," by J.B. Kaufman. Unpublished essay, 2004.

"Magical History Tour," by Don Hahn. *Disney Magazine*, Winter 1998/1999.

"Making Mickey Mouse Act for the Talkies," by Gordon S. Mitchell. *Modern Mechanics*, March 1931.

"The Making of Little Pinocchio: Paint and Ink Mysteries of Walt Disney's Studio." *The World's News*, March 23, 1940.

"Meet Hollywood's Men of Action." *Ogden Standard Examiner*, May 13, 1935.

"A Message From Roy," by Roy Disney. *The Disney Way*, July 1967.

"Mickey Mouse Now Air-Conditioned." *Film Daily*, July 2, 1938.

"Movie Cartoons Come to Life," by Ub Iwerks. *Popular Mechanics*, January 1942.

"Multiplane Techniques and Color Reproduction," by Sam Armstrong. Walt Disney Archives.

"My Job at Walt Disney's, by Mary Lou Whitman. *The Lyre*, 1941.

"Oliver & Company," by Robert Haas. *Persistence of Vision*, Fall 1998.

"A Painted Lady: An Interview with Phyllis Craig," by Jim Korkis and John Cawley. *Animation Art Buyer's Guide*, 1992.

"The Painted Puppet, Thousands of Drawings on Plastic 'Canvases," by Clark Richard., 1941.

"Pat Sullivan's Cartoons Score." *The Moving Picture World*, April 29, 1916.

"Pat Sullivan's Cartoons Score." *Motion Picture World*, April 1916.

"Pinocchio, the Painted Puppet," by Clark Richards. *Monsanto Magazine*, 1940.

"The Production of Animated Cartoons," by William Garity. *Journal of the Society of Motion Picture Engineers*, April 1933.

"Rainbow Over Hollywood," by Bruce Buttles. *The Christian Science Monitor Weekly Magazine Section*, April 3, 1935.

"Retrospective Exhibition of the Walt Disney Medium." *Los Angeles County Art Museum Catalogue*, 1940.

The Ropes at Disney, Walt Disney Studios Production.

"Screen Specialists: She Cuts the Stars." *Modern Screen*, September 1941.

"Snow White and the Seven Dwarfs," by Andrew R. Boone. *Popular Science Monthly*, 1937.

"Some Critical Perspectives on Lotte Reiniger," by William Moritz. *Animation Journal* 5:1 (Fall 1996) 4051.

"The Teacher I Remember Best…"by Walt Disney. *The Journal of the California Teachers Association*, December 1955.

"Technicolor—The Color Process Born in a Railroad Car 19 Years Ago," by Lennox Foster. *The Film Daily Cavalcade*, 1939.

"The Technicolor Notebooks at the George Eastman House," by Ulrich Ruedel. *Film History*, vol. 21, 4750.

"Tronic Imagery," by Peter Sorenson, *Cinefex* expanded by Harrison Ellershaw interview, 2015.

"Walt Disney, an Educator Remembers Daisy," by Walt Disney. *California Teachers Association Journal*, December 1955.

"Walt's Women: Two Forgotten Influences," by Jim Korkis. *Mouse Planet*, May 2, 2007.

"What I Know About Girls," by Walt Disney. *Parents*, January 1949 (via Jim Korkis).

"Whose Paintings Are They?" by Thomas Fields-Meyer. *People*, February 19, 2007.

"*Wisdom, the Book of Knowledge,*" edited by Leon Gutterman. The Society for the Advancement of Knowledge, Learning and Research for Education, Beverly Hills, CA, December 1959.

"Women Behind the Disney Scene," *The Australian Women's Mirror*, April 9, 1940.

"Work and Some Imagination Make Good Cartoons," by Pat Sullivan. Motion Picture News, April 29, 1916.

WEBSITES / BLOGS

"Behind the Scenes with Disney Hollywood Studios Ink & Paint Team," by Dara Trujillo. Disney Parks Blog, August 31, 2010.
http://www.artofdisneyparks.com

"The Bray Animation Project," by Thomas J. Stathes. June 1, 2011.
http://www.brayanimation.weebly.com

"Bray Studios on TCM," by Tommy Stathes and David Gerstein.
http://cartoonresearch.com/index.php/bray-studios-on-tcm/

"The Centennial of American Animation," by Ray Pointer.
http://inkwellimagesink.com/pages/articles/CentennialOfAmericanAnimation.shtml

"Children's Television Archive," Hollywood Heritage.
http://www.childrenstvarchive.com

"Dina Babbitt," by Jake Friedman. Babbittblog, November 19, 2012
https://babbittblog.com/

"The Fantastic Mystery of Milicent Patrick," by Vincent Di Fate. October 27, 2011
www.tor.com

"The 50 Most Influential Animators in Disney Studio History," by Grayson Ponti.
http://www.50mostinfluentialdisneyAnimators.wordpress.com

"The First Treasury Girls," by Claudia Swain. Boundary Stones: WETA's Washington, DC, History Blog March 1, 2016.

"Forgotten Disney Heroines: The Disney Secretaries," by Jim Korkis. WDFM Blog, April 27, 2011.
http://wdfm.org

"Great Women Animators," by Heather Kai Smith; additional contributor: Skye Lobell.
http://greatwomenAnimators.com

"Ink and Paint"/ Deja View, Andreas Deja.
http://andreasdeja.blogspot.com/2014/07/ink-and-paint.html

Bibliography

WEBSITES / BLOGS CONTINUED...

"Inking at Disney, circa 1931" by Michael Barrier. June 27, 2011
www.michaelbarrier.com

"Marcellite Garner," by Ralph Daniel. July 2, 2011.
http://www.michaelbarrier.com

"Memories of Classic Alfonse's Restaurant in Toluca Lake." March 7, 2010.
http://museumsanfernandovalley.blogspot.com

"The Miniature Worlds of Walt," by Jim Korkis. Walt Disney Family Museum Blog, March 30, 2011
http://wdfm.org

"My Family Disney Dynasty, Part 1 & 2," by Edle Bakke. *Mouse Planet*, February 22, 2006.
http://www.mouseplanet.com/

"The Mystery of the Female Disney Animator," by Jim Korkis. November 1, 2006.
http://www.mouseplanet.com/8166

National Women's History Project (NWHP) Writing Women Back Into History
http://nwhp.org

Plastics Historical Society
http://www.plastiquarian.com/index.php?Id=55

"A Talk with a Disney Legend: Joyce Carlson Part 1 & 2," by Jim Hill. Jim Hill Media.
www.jimhillmedia.com

Technicolor Color Control Department
http://eastman.org/technicolor/company/color-advisory-service/

"The Treasurer" / US Department of the Treasury
http://www.treasury.gov/about/organizational-structure

"Walt's Field Day 1938," by Todd James Pierce. Disney History Institute.
http://www.disneyhistoryinstitute.com/2013/09/walts-field-day-1938.html

Who's Who of Victorian Cinema
http://www.victorian-cinema.net

Wings Across America.org & WASP on the Web, Nancy Parrish, Executive Director
http://www.wasp-wwii.org/

Women Film Pioneers Project / Columbia University Libraries Information Services Center for Digital Research and Scholarship
http://wfpp.cdrs.columbia.edu

"Women in Early Film," "Partners in Winning the War," and additional online exhibits National Women's History Museum
http://nwhm.org

PODCASTS / BROADCASTS / DVDs

1420 Flower Street Wake Video, by Walt Disney Feature Animation Production Teams.

Back to the Black Lagoon Documentary, A Creature Chronicle, by Universal Studios Home Video, written and directed by David J. Skal.

June Patterson Interview / Corner Booth Podcasts. http://www.thecornerbooth.net

Lotte Reiniger: Homage to the Inventor of the Silhouette Film, directed by Katha Raganelli. Diorama Film GMBH, 1999

The Extraordinary Voyage, by Serge Bromberg and Eric Lange. Lobster Films, 2011.

The Story of Mickey Mouse, by Walt Disney. Broadcast on University of the Air, 1948.

They Spoke Out: The Dina Babbitt Story, Disney Education Productions, 2009.

Disney's Women, BBC, written and produced by Brian Sibley

Julie Andrews

Jodie Benson

Adriana Caselotti

Diane Disney Miller

Dave Smith

Bob Thomas

Ilene Woods

INTERVIEWS

Gretchen Albrecht, multiple, 2014, 2015, 2016
Graham Allen, May 2015
Bill Anderson, Studio Oral History
Jane Baer, August 2015
Katherine Bailey, March 2015
Wilma Baker, January and August 2015
Edle Bakke, June 2015
Bobbie Barker, April 2015
Hnr. Antonio Barreto Jr., October 2014
Betsy Baytos, August 2015
Kathryn Beaumont, 2012, 2014, 2015
Ed Bianchi, April 2015
Moyra Blackwell, October 2014
Lucile Williams Bosché, June 2015
Dave Bossert, September 2015
Stephen Born, Jan 2016
David Bradon, August 2015
Karen Comella, February 2015
Randy Cartwright, August 2015
Marge Champion, September 2009, April 2016
Brenda Chapman, August, 2015
Rikki Chobanian, January and October 2015
Becky Cline, February 2015
Alan Coats, August 2014
Karen Comella, April 2015
Lorna Cook, May 2016
Stephanie Coolihan, June 2016
Mary Costa, April 2008, September 2014
Eleanor Dahlen, January 2015
Kathleen Davidson-Cansler, April 2015
Alice Davis, December 2014, August 2015
Andreas Deja, June 2015

Maribeth DeSantis, March 2015
Walt Disney, Pete Martin Interviews
Bobbie Ekstein, February 2015
Harrison Ellenshaw, October 2015, February 2016
Jean Erwin, Studio Oral History
Becky Fallberg, Studio Oral History
Carla Fallberg, April 2015
Maria Fenyvesi, September 2015
Mark Finn (Emilio Bianchi), April 2015
Virginia Fleener, January 2015
Gyo Fujikawa, October 1966/Unknown
Breck Furnish, June 2016
Mike Gabriel, July 2015
Caprice Glaser, January 2016
Theo Gluck, September 2015
Harper Goff, Studio Interview
Kent Gordon, March 2015, August 2016
Dick Grills, Studio Oral History
Ann Guenther, January 2015
Don Hahn, November 2014, July 2015
Jim Hatlo, October 2015, May 2016
Valerie Imhof, January 2015
Kim Irvine, August 2015
Dave Iwerks, June 2015
Don Iwerks, February 2014
Lynn Jekel/Lula Jekel, January 2016
Hollis Jordan, November 2015
Katherine Kerwin, Studio Oral History
John and Virginia Kimball, March 2015
Mark Kimball, March 2015
Nannette Latchford, May 2016
Arlene Ludwig, January 2015

Jim Lusby, October 2015
Don Lusk, October 2014, March 2015
Ginni Mack, multiple, 2012, 2014, 2015
Burny Mattinson, September 2016
Steve McAvoy, January 2015
Cherie McGowen, March 2015
Kelly McSpadden, May 2015
Linda Miller, August 2015
Ron Miller, August 2015
Jeannie Mintz, February, April, July 2015
Floyd Norman, December 2014
Mindy O'Brien, March 2014
Kelan O'Brien, February 2015
Tracy O'Brien, February 2015
Joan Patricia O'Connor, May 2016
Dave Pacheco, May and December 2015
Kim Patterson, March 2015
Antonio Pelayo, January and October 2015
Patty Peraza, October 2015
Walt Peregoy, December 2007
Hans Perk, May 2015
Helen Picken-Jordan, March 2015
Tina Price, June 2015
Pete Renaday, November 2015
Wylie Rinaldi, August 2015
Robyn Roberts, March 2015
Sylvia Roemer, September 2015
Carmen Sanderson, August 2012, July 2015
Richard Sherman, June 2015
Ken Shue, March 2015
Pat Sito, September 2015
Tom Sito, May 2015

INTERVIEWS, CONTINUED...

Dot Smith, Studio Oral History
Lew Stude, March and April 2014
Norma Swank-Haviland, May 2016
Nancy Thompson Katona, April 2016
Ruthie Tompson, February 2014, October 2015
Bill Taliaferra, May 2015
Sherri Vandoli, January 2006, October 2015
Jeannie Winkler, April 2015

ACADEMY OF MOTION PICTURE ARTS & SCIENCES ORAL HISTORY

Marc Davis
Ruthie Tompson
Ink & Paint: The Art of Hand-Drawn Animation

PAUL ANDERSON INTERVIEWS

Ken Anderson

THE ANIMATION GUILD ORAL HISTORY ARCHIVES with Steve Hulett

Kathy Altieri
Sharon Forward
Ann Guenther
Joanna Romersa, April 8, 2014
Martha Sigall
Kathy Zielinski
Now That Was a Wrap Party, September 12, 2006

THE ANIMATION GUILD GOLDEN AWARDS INTERVIEWS

Harvey Deneroff
Betty Brenon
Lillian Friedman Astor
Grace Godino
Betty Anne Guenther
Betty Smith
Jean Selby Thorpe

MICHAELBARRIER.COM

James Bodrero, interview by Milton Gray
Frank Thomas and Ollie Johnston, interview by Michael Barrier
Fred Kopietz, interview by Michael Barrier

RICHARD HUBLER INTERVIEWS 1967-68

Marc Davis
Edna Disney
Lillian Disney
Roy O. Disney
Ward Kimball
Jimmy MacDonald
Diane Disney Miller
Tommie Wilck

PETE MARTIN INTERVIEWS

Walt Disney
Diane Disney Miller

PASADENA HERITAGE ORAL HISTORY PROJECT

Ruth Shellhorn

SMITHSONIAN INSTITUTE

Dorothy Jeakins Oral History interview, June 19, 1964, Archives of American Art, Smithsonian Institute

TELEVISION ACADEMY ORAL HISTORY FOUNDATION

Roy E. Disney

UCLA CENTER FOR ORAL HISTORY RESEARCH

Richard Huemer interview, July 24, 1968

UNIVERSITY OF NEBRASKA-LINCOLN LIBRARIES

"Greetings from the Queen: the Life and work of H. Alice Howell," Alan Nielson

WALT DISNEY FAMILY FOUNDATION MUSEUM ROUNDTABLE INTERVIEWS:

Becky Fallberg
Grace Godino
Marie Justice
Carmen Sanderson
Ruthie Tompson

WOMEN IN ANIMATION COLLECTION
UCLA Center for Oral History Research

Frances Arriola
Betty Brooks
Martha Buckley
Marc and Alice Davis
Xenia De Mattia
Becky Fallberg
Mary Jane Frost
Gyo Fujikawa
Grace Godino
Joan Orbison
Sylvia Roemer
Joanna Romersa
Martha Sigall
Gini Swift
Auril Thompson
Barbara Wirth Baldwin

CORRESPONDANCE / SCRAPBOOKS COLLECTIONS / ARCHIVES

The Gretchen Albrecht Collection
Mary Ellison Allen journal, courtesy of the O'Brien family
The Graham Allen Collection
The Bianchi/Finn Collections
Phyllis Craig/Ink & Paint materials, courtesy of Lew Stude
The Margaret Herrick Library/Academy of Motion Pictures Arts and Sciences
Martino's Bakery, Burbank, CA
Marcia Ashe Nichols scrapbook (1942-1964)
Yuba O'Brien scrapbooks, courtesy of the O'Brien family
Rae McSpadden correspondence & scrapbooks, courtesy of the McSpadden family
The Reluctant Dragon screenplay drafts, courtesy of the Jim Hollifield Collection
Mary Tebb correspondence, courtesy of Mark Sonntag
Walt Disney Studios Archives, various production memos, correspondence, materials, records
Walt Disney Studios Photo Archives, multiple production images and records
Walt Disney Animation Studios, Animation Research Library, production materials & artwork
Walt Disney Animation Studios, Ink & Paint Department, various production materials

CORRESPONDANCE, CONTINUED...

Walt Disney Imagineering Resource Center, various production materials & artwork
Walt Disney Consumer Products Creative Resource Center—various production materials
The Ingaborg Willy Scrapbook (193637) by Ingaborg Willy
The Walt Disney Family Museum

PHOTO/ARTWORK COLLECTIONS

Bachom Family Collection
Jane Baer Collection
Edle Bakke Collection
Bobby Barker Collection
Stephen Born/Grace Godino Collection
Alan Coats Collection
Karen Comella Collection
Kelly Comras Collection
Stephanie and Greg Coolahan Collection
Davis Family Collection
Andreas Deja Collection
Disney Family Foundation
Harrison Ellenshaw Collection
Becky Fallberg Collection
Fleener Family Collection
Furnish Family Collection
Randy Gibeaut Collection
Kent Gordon Collection
Margaret Herrick Library, Academy of Motion Picture Arts and Sciences
John and Virginia Kimball Collection
John Lasseter Collection
Vera Lelean Family Collection
Library of Congress
Los Angeles Public Library
The Howard Lowery Gallery
Steve McAvoy Collection
Cherie McGowan Collection
McSpadden Family Collection
New York Public Library
Floyd Norman Collection
O'Brien Family Collection
Miss Mindy (Allen) O'Brien and Family
Dave Pacheco Collection
Patty and Mike Peraza Collection
Hans Perk Collection
Les Perkins Collection
Tina Price / Penny Coulter Collection
Dorothea Redmond Collection
Steven and Virginia Reeser Collection
Rob Richards Collection
Wylie Rinaldi Collection
Elizabeth Spatz Collection
Untitled Art Gallery
Van Eaton Galleries
Roger Vilcria Collection
Walt Disney Animation Research Library
Walt Disney Animation Studios Ink & Paint Department
The Walt Disney Family Museum Archives
Walt Disney Imagineering Resource Center
Walt Disney Archives Photo Library
Walt Disney Archives
Lucile Williams Collection
Winkler/Mintz Family Collection
Wonderful World of Animation Gallery

ACKNOWLEDGMENTS

> *"The artist—disturbs, upsets, enlightens and . . . opens ways for a better understanding. Where those who are not artists are trying to close the book, [she] opens it, shows there are still more pages possible."*
>
> — **Robert Henri**

Walt Disney referenced Robert Henri's work, *The Art Spirit*, when expressing the importance of the creative process for his animated films. As Henri recognized, within any creative process the medium must stay malleable while the mysterious course of discovery unfolds into its final form. These "possible pages" of women and their artistry could not have been properly told without the diverse talents and vital efforts of many, over the years, as this volume became a reality.

My deepest thanks to:

The women, and their families, who graciously shared their experiences, stories, materials, and talents to "open" this book and "enlighten" others "for a better understanding" of our animated past.

Wendy Lefkon for her constant belief, keen editorial eye and vibrant humor throughout this colorful journey.

Tamara Khalaf for her valued patience and persistence in defining a fitting setting for such an epic story.

Marybeth Tregarthen, Monica Vasquez, Danielle Degrado, Diane Hodges, Jennifer Eastwood, Ken Shue, Illiana Lopez, Dushawn Ward and the valued team at Disney Editions for keeping it all on track.

Becky Cline, Kevin Kern and Ed Ovalle along with the extraordinary Archives team for their valued support and efforts in piecing this story together, including Justin Arthur, Nate Rasmussen, Dennis Emslie, Maggie Evenson, Joanna Pratt, Steven Vagnini, Alesha Reyes and to Dave Smith for preserving this unique history.

Michael Buckhoff, Holly Brobst, Todd Swanson and Jeffrey Golden for helping to find rare jewels in the Walt Disney Archives Photo Library and to Ty Popko for sharing his wonderful photographic talents.

Mary Walsh and the stellar team of the Animation Research Library and the Ink & Paint Department whose names and vital work are celebrated within this book.

Vanessa Hunt, Mike Jusko and Denise Brown with the Imagineering Art Library, Aileene Kutaka and David Stern with the Imagineering Resource Center, and Libby Spatz at the Disney Consumer Products Creative Resource Center for their valued roles in preserving the contributions of their divisions.

Kristen Komoroski, Michael Labrie and Mark Gibson with the Walt Disney Family Museum, for graciously sharing their extraordinary collections within these pages.

Faye Thompson and the brilliant staff at the Margaret Herrick Library / Academy of Motion Pictures Arts and Sciences for their essential resources and support.

Joe Campana for his intrepid ancestral sleuthing and pivotal discoveries, Virginia and Steven Reeser and Kent Gordon for their valued talents and enthusiastic spirits, Gretchen Albrecht for brilliantly sharing her extraordinary world of Ink & Paint, Libby Simon and the Women In Animation Archival teams for their foresighted efforts, and the Disney-Miller family for their constant belief and support.

My many esteemed colleagues, artists, authors and historians whose generous efforts, insights, humor and patient responses to my random queries proved a constant source of encouragement, discovery and laughter along the way: Alice Davis, Mary Costa, Kathryn Beaumont, Marge Champion, John Canemaker, Don Hahn, Howard & Steinunn Green, Didier Ghez, Hans Perk, Tina Price, Theo Cluck, Alan Coats, Paula Sigman-Lowery, Jim Hollifield, Ted Thomas, Brian Sibley, Lucas Seastrom, Andreas Deja, Roger Viloria, Burny Mattinson, Carla Fallberg, Sue Burns, Mary Fleener, Kevin and Snow Mack, the McSpadden Family, the O'Brien Family, Jim Smith, Michael Haight, Robert Bader, Tracey Goessel, Betsy Baytos, Lu Abbott, Greg Johnson, Jerry Beck, Claire Lockhart, Randy Haberkamp, Bettina Fisher, Jake Friedman, Harrison Ellenshaw, Tom Sito, James Layton, David Pierce, Dave Bossert, Devon Baxter, Scott Weitz, Tom Weaver, Alex Rannie, Amy Rogers, Maggie Perkowska, Brett Thompson, Amanda Miano, Jeff Kurtti, David Nimitz, Robin Thaler, Lauren Marems, David Gerstein, and Joseph Titizian.

Finally, a tremendous debt of gratitude is owed to the pioneers of early animation, Walt and Roy Disney and the women—then and now—whose contributions continue to advance this art form.

— *Mindy Johnson*

Thousands of women contributed creatively to the first century of animation beyond the women noted within this book. If you, or someone you knew, are among the female artists who worked within early animation, and would like to share your story, please contact the author via the Walt Disney Archives.